"EYES OF THE EIGHTH"
A Story of The 7th Photographic Reconnaissance Group
1942-1945

PATRICIA FUSSELL KEEN

Published by
CAVU Publishers, L.L.C.
1996

Copyright © 1996
by Patricia Fussell Keen

All rights reserved. No part of this book may be used or reproduced in any manner whatsoever without the written permission of the publisher, except in the case of brief quotations embodied in critical articles and reviews.

Library of Congress Catalog Card Number 95-073099

I.S.B.N. Number: 0-9649119

First Edition

Printed in the United States of America by Meaker The Printer
for CAVU Publishers, L.L.C.
16810 Boswell Blvd., Sun City, Arizona 85351-1270

To All Who Served

The 7th Photographic Reconnaissance Group

ಬಿಐಬ

Distinguished Unit Citation
French Croix de Guerre With Palm

ಬಿಐಬ

Battle Stars

Air Offensive Europe

Normandy Campaign

Northern France Campaign

Rhineland Campaign

Ardennes Campaign

Central European Campaign

FOREWORD

The Eighth Air Force is undoubtedly the most famous of all United States air formations of the twentieth century. The largest air striking force ever committed to battle is usually associated with B-17 Fortress and B-24 Liberator heavy bombers forging a passage through formidable enemy defences to reach their objectives, or P-51 Mustangs and P-47 Thunderbolts besting the Luftwaffe in air combat. Yet the Eighth was composed of several combat units raised for other missions, none more exacting, perilous and rewarding than those of the photographic reconnaissance squadrons. The premier organization for the task of obtaining visual images of the enemy's activities was the 7th Photographic Reconnaissance Group at Mount Farm airfield, near England's university city of Oxford. For twenty-six months the Group's squadrons served as the eyes of the Eighth, pilots flying out in their unarmed Lightnings and Spitfires to obtain the thousands of photographs that provided the day by day intelligence required to keep the offensive force headed for victory. The contribution of photographic reconnaissance to that victory may be beyond precise estimation but it was none the less considerable and vital. In the past the work of the reconnaissance units has been sadly neglected in the telling of the story of the illustrious Eighth Air Force and this detailed record of the 7th Group is a long overdue acknowledgment. However, it is much more than a very well researched and comprehensive history. Here indeed is the chronicle of an outstanding military organization. Long may its lone icy contrails stand proud in the annals of the Eighth.

Roger A. Freeman

Dedham, England

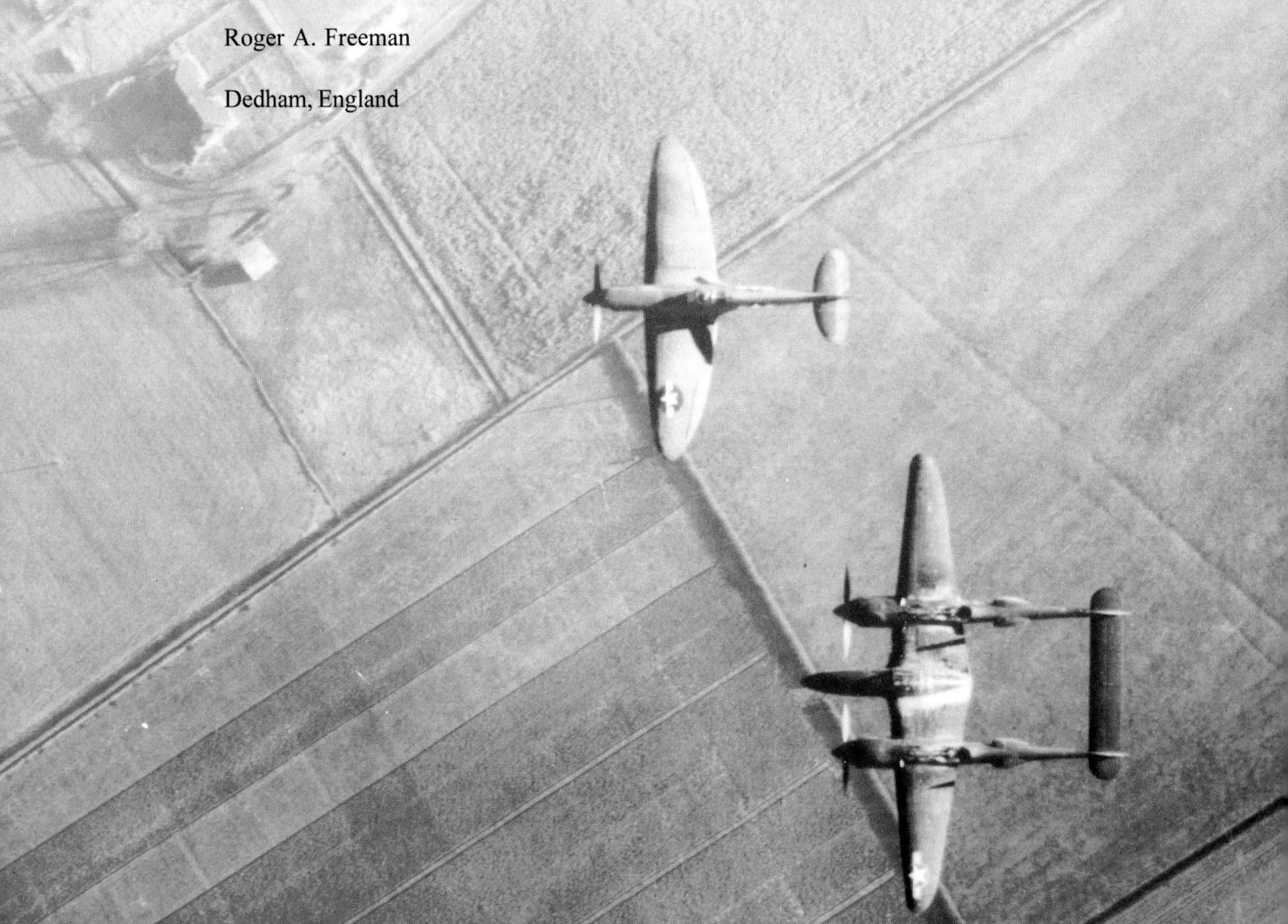

CONTENTS

Introduction .. viii

Part I The Combat Squadrons Beginnings ... 1
Chapter 1. The 13th Photographic Reconnaissance Squadron .. 2
Activation A New C.O. Podington Mount Farm First Sortie
Chapter 2 The 14th Photographic Reconnaissance Squadron ... 22
Activation Bivouac Peterson Field Mount Farm Spitfires
Chapter 3. The 22nd Photographic Reconnaissance Squadron ... 37
Activation Raton *Queen Mary* Mount Farm First Sortie
Chapter 4. The 27th Photographic Reconnaissance Squadron .. 43
Activation A New C.O. Bivouac Transatlantic Mount Farm

Part II The 7th Photographic Reconnaissance and Mapping Group 47
Chapter 5. July August September 1943 ... 48
Lt. Col. James Hall Spitfires F-5 Flaws Col. Homer Sanders Flak
Chapter 6. October November December 1943 ... 68
Sergeant Pilots *Skaterink* New Name 27th's First Sortie Col. Paul Cullen

Part III 1944 .. 83
Chapter 7. January February March 1944 .. 84
Col. Paul Cullen Local Disaster First Shuttle Flight Attlebridge Berlin
Chapter 8. April May 1944 ... 103
1000th Sortie Bari, Italy Maj. Norris Hartwell New C.O.s Russia
Chapter 9. June 1944 ... 120
Interdiction Loire Bridges D-Day 2000th Sortie Poltava, Russia
Chapter 10. July 1944 .. 141
Dilly V-1 Sites Courier Flights Record Day Beachhead 381st Air Service Sq.
Chapter 11. August 1944 .. 153
Komet Aphrodite Col. Clarence Shoop Kennedy Killed Paris Free?
Chapter 12. September 1944 .. 172
New Camera *Dolle Dinsdag* Market Garden Mustang Glenn Miller
Chapter 13. October 1944 .. 191
Smoke and Deception Aphrodite Heligoland Droop Snoot *Miss Nashville* V-2s
Chapter 14. November December 1944 .. 209
Rocket Trails Pets 27th at Denain/Prouvy "Photo Lightnings" Ardennes

Part IV 1945 .. 237
Chapter 15. January 1945 ... 238
P-51s Battle of the Bulge Infantry Recruits *Legacy* 18th Weather Squadron
Chapter 16. February March 1945 .. 260
Gun Packages Operation Clarion 325th Wing Crossing the Rhine Denain/Prouvy
Chapter 17. April May 1945 .. 287
Move to Chalgrove Berlin Falls Liberation VE Day POWS Hitler's Hidden Treasure
Chapter 18. Deactivation June-November 1945 ... 305
Batson and Howard Childress 7th C.O. VJ Day Deactivation Wrap Up

Epilogue .. 309
Sources and Bibliography .. 310
Sortie List .. 311
Wartime Casualties .. 373
Index .. 375

Map 304

Photos. Endpapers: Nurnburg. Part I: F-5 buzzing Mount Farm. Part II: Flight Line.
Part III: St. Pol/Siracourt V-weapon site. Part IV: Misburg Oil Refinery.

v

PREFACE

"Who is this?" Ed Parsons asked after a long pause. I asked if he was the Lt. Edward B. Parsons who had been shot down and captured on a beach in France in 1944. "Who is this?" he repeated. The history professor wanted to know how I knew about events 35 years past. It was his story he told his students of flak and capture to enliven their study of World War II.

I introduced myself and told Parsons about an Englishman's search for an American pilot shot down and captured in reality and on film. At the end of the war, an RAF Flight Lieutenant, Beresford Winspear, found the German film in an abandoned office on the Channel Island of Guernsey. Over the years he tried without success to identify the pilot. Now retired, he asked if I could help find out who the American was. He sent me a series of photographs taken in 1944. For information about the aircraft and captured pilot in the photos I called the British author Roger Freeman, an authority on the Eighth Air Force. From the pictures he identified the aircraft as an unarmed photo P-38 of the 7th Photo Reconnaissance Group and directed me to the Group's unit contact, Claude Murray.

With their clues I searched, frequently looking at those photos of a young pilot, wet and uncomfortable, surrounded by uniformed Germans, on a beach sometime, somewhere. Murray compared the face with photos of pilots in his 22nd Squadron and identified Ed Parsons. After almost two years, the successful search culminated in the telephone call. It also introduced me to the 7th PR Group, Parson's World War II air force unit.

Roger Freeman enlisted my help in searching the Group's records for missing data on its sorties for his book *Mighty Eighth War Diary*. This led to more research and interviews in the United States for the British author. Freeman suggested I research the 7th Group's part in the air war against Germany and write about its little known role.

Accepting the challenge I began gathering information and interviewing veterans. Beginning with microfilm records from Maxwell Air Force Base, the outline of the 7th's story took shape. It would be wonderful if all historical records were systematic, uniform, correct, and complete. This is not the case. Often, little is systematic or uniform, errors outnumbered only by gaps in chronology. At one point I became convinced that all the loose paper in the 7th Group's offices had been boxed up, returned to the States, stored, and then filmed for posterity. It also appeared that the papers had been thrown in the air and microfilmed in the order in which they landed.

If my interest flagged, hearing stories of the men who made up the unit restored it. One particular interview convinced me that the 7th Group's story should focus on the men. I was told about a pre-dawn search to wake a pilot for an early mission. The duty officer passed his flashlight beam over the bunks. He found his man deep in sleep, hugging a tiny puppy. By the end of the day, the young pilot had been lost over Germany. This was the real story from the memories of the clerks and cooks, mechanics and pilots, film processors and interpreters. It is what I set out to tell.

GLOSSARY

ACIU Allied Central Interpretation Unit (originally CIU)
Bletchley Park British Government Code and Ciphers School Headquarters (center for code-breaking where Enigma ciphers were read)
Cover Term used to indicate photographic coverage of any target.
ELINT Electronics Intelligence
ENIGMA *Geheimschreiber* cipher or German coding machine
ETO European Theater of Operations
ETOUSA European Theater of Operations United States Army
F-5 Photographic configuration of Lockheed P-38
GAF German Air Force (Luftwaffe)
Job Request from various sources for photographs covering an area of interest to the source. Often broken down into parts.
ME ME-109, ME163, ME262 Messerschmidt
Medmenham RAF Medmenham, location of ACIU. Name synonymous with photo interpretation.
Oblique Photographs shot at an angle as opposed to vertical.
OKW *Oberkommando der Wehrmacht* (High Command German Armed Forces)
PI Photo Interpreter or Interpretation

PR Photographic Reconnaissance
Program Group and squadron assignments from various sources for either special or regular cover of specific targets or jobs.
PRU Photographic Reconnaissance Unit
POINTBLANK Combined strategic bombing assault on Germany
RAF Royal Air Force
RCAF Royal Canadian Air Force
Recce/recon Reconnaissance. Most strategic reconnaissance was from photography. Tactical reconnaissance was often visual.
SHAEF Supreme Headquarters Allied Expeditionary Force
SIGINT Signals Intelligence
Target In photo reconnaissance, the objective assigned to the PR pilot for photography.
ULTRA British security classification for intelligence gleaned from deciphering intercepted ENIGMA messages.
USAAF United States Army Air Force
USSTAF United States Strategic Air Force
Vertical Photographs shot directly downward as opposed to oblique.

AUTHOR'S NOTE

All errors and omissions are my responsibility. In a perfect world we would make no mistakes. It isn't and we do. In that perfect world, everyone would have perfect recall and written history would be precise. They don't and it isn't. Contradicting memory and records always challenge those of us who strive to get it right. The quality, lack of, or the closing of records under that dreaded, "Not to be opened for 25, 50, 75, or 100 years" confounds all of us who seek to learn and write about past events. We have passed 25 and 50 year limits on World War II documents but 75 years remains daunting for most of us and 100 — impossible. Thus we go with what we have. It is almost certain that the day after the presses roll some missing box of records will turn up in some archives.

Without the dedication, steadfast support, and backing of Claude Murray and Hector Gonzalez this publication would not have been possible. Added support came from Kermit Bliss, Larry Redmond, and the late Ed Vassar. The first Historian/Archivist for the Group Association, Marshall Williams offered help and guidance along the way. Of course I am indebted to Beresford Winspear and Ed Parsons who introduced me to the 7th Group. Special thanks goes to Roger Freeman for his suggestions and assistance. Wherever I sought information and guidance, I received generous response particularly from historians Stephen Ambrose, Forrest Pogue, M.R.D. Foot, and the late Ronald Lewin. Extensive interviews with Gen. Robert J. Dixon, Brig. Gen. George Goddard, Cass Hough, David K. Rowe, and Robert R. Smith were invaluable.

Individuals and staff at various reference facilities cooperated producing almost more than I could handle. I would like to single out Bill Heimdahl, Chief Archivist at the Office of Air Force History; and Duane Reid, Chief, Special Collections, Air Force Academy Library. George Clout and the staff of the reading room at the Imperial War Museum, London, England, kept me supplied with documents, books, and maps. Also in London, my work at the Public Record Office would have been less successful without the assistance and insight of Mary Z. Pain, who worked at Bletchley Park during the war. She helped me through the intricate catalogs of the PRO finding many obscure but helpful records. Grateful thanks to Mrs. Sheila Walton, Curator, Air Photo Library, Keele University, Staffordshire for assisting me with the enormous collection of aerial photos from Medmenham. Thanks also goes to Lt. Gen. Albert P. Clark and Maj. Gen. John Huston for their assistance and encouragement. Sharing their expertise and knowledge were authors Dana Bell, Pat Carty, Jeff Ethell, and Michael Gibson. For information about aircraft recovery in Holland, Gerrie Zwannenburg shared time and records. Also in Holland, I was received warmly by Claude Murray's helpers Jan Dobber and the Rozendaals. I found Gys and Willie Regtuyt living on Florida's west coast, where they generously shared the story of Murray's time at their farm.

Without the generous hospitality of my good friends, Joan and Admiral Bob Hilton, both at their home in Virginia and while stationed in Belgium, I could not have spent so many hours searching records. Their support and assistance cannot be underestimated. Thanks also to my editor Donna Born who offered her expert advice before moving north to Jacksonville. Unstinting help from coordinator Jo Anne Stevens and the staff at Meaker the Printer came through my fax intermediary, Jackie Scott.

To mention every person risks the unintentional omission but I must try to thank those who contributed to this effort and take the risk. Every person I spoke to gave me what help he could. I am grateful to Walter and "Tattie" Spaatz Bell, John and Virginia Blyth, Dick and Jean Bramley, Frank and Vera Gaccione, John and Leona Ross, Claude and Shirley Murray, John and Beth Richards, and "Trip" Russell for inviting me into their homes.

For their help, I wish to thank Gerald Adams, Peggy Ambrose, Albert Arrieta, Robert Astrella, Joe Barancyk, Kay Bettin, Joe Bognar, Ed Bova, Bob Brismaster, Dick Brown, Richard E. Brown, Dick Brunell, Don Buckallew, Dan Burrows, Jackson Byers, Telford Byington, Henry Calderaio, Frank Campbell, Paul Campbell, Allan Cassidy, Hubert Childress, Ronald Comstock, Bob Coyne, Dave Davidson, Howard DeVault, Ed Douttheil, Michael Durante, Wib Eaton, Bruce Edwards, John Egan, Amos Ellerd, George Epsom, Lawrence Exner, Donald Farley, Vern Farrow, Ross Garreth, Dick Hairston, Norris Hartwell, Ray Heath, Walter Hickey, Bob Hilborn, Ed Hoffman, Jim Hotaling, Tom Johnson, Julius Kindervater, Bob Kinsell, Ray Korczyk, Al Kugler, William Lanham, George Lawson, Art Leatherwood, Vern Luber, Tom Markley, Ben Michener, Ed Murdock, "Smitty" Mysliwczyk, Bob Neault, John Neff, Jack Niehaus, Bob Niehus, Daryl Nooner, "Chuck" Parker, Grover Parker, Tony Pircio, Patsy Piscitteli, Bernie Proko, Sam Quindt, Irv Rawlings, Jim Riggins, John Robison, Elliott Roosevelt, Stan Sajdak, Hugh Scott, Dale Shade, John Shatynski, the Shoop family, George Simmons, Richard L. Smith, Tony Steiert, Walter Tooke, Leonard Tullgren, Hershel Turner, Marshall Wayne, Paul Webb, John G. Weeks, Harold Weir, Walt Weitner, Jim Wicker, and "Willie" Williams.

Introduction

Aerial photography and reconnaissance were instrumental in the development of air warfare in World War I. The first armed aircraft targeted observation balloons, photographic, and reconnaissance planes. In order to protect these sources of intelligence, armed escorts began to accompany the photo and reconnaissance planes, which led to the inevitable conflicts that became famous over the trenches of France, the dogfights.

Photo mapping, vital to both sides during the war, especially of the vast trench systems, carried over into the peace that followed in 1918. In the United States, peacetime aerial photography concentrated on cartography while its use as an intelligence source declined. Not until the 1930s did tactical and strategic photography become important again. To circumvent the terms of the Versailles Treaty that ended World War I and forbade German military forces, Germany secretly rebuilt its air force and developed intelligence gathering capabilities through air photography under the cover of route mapping for the German national airline, Lufthansa. The British, having a more worldwide overview because of their colonies around the globe, developed intelligence in areas of strategic interest through cartographic photography, particularly in the Mediterranean. Both Britain and Germany created interpretation establishments to take advantage of information gathered from their air photo resources.

Lacking detailed maps of huge areas of the country, the United States used aerial photography primarily for surveying and mapping. As in many countries, limited appropriations prevented the United States from developing all aspects of this resource. After 1936, American experts saw the face of future conflicts forecast in the Spanish Civil War, where German participation previewed the fast moving battle tactics, which became known as *Blitzkrieg*, "Lightning War." Warfare, no longer static trenches and slow moving observation planes, required faster advance planning. Strategic intelligence gathering must forge ahead. Just as they had played "catch-up" in war-oriented development in World War I, the United States had to do so again in World War II.

By 1941, contingency plans existed for an air war against Nazi Germany in the event the United States could no longer remain a noncombatant. Part of the plan was tactical and involved strategic intelligence gathering through aerial photography. Projected bomber forces slated to attack German industrial targets in the air war plan would require timely target data and damage assessment. In order to furnish this intelligence, the plan called for the formation of photographic reconnaissance units to be assigned to the air forces in the European Theater of Operations.

Among the many units projected in the plan, in the event the United States entered the war, were squadrons, groups, and wings designed to furnish photo intelligence and support to the strategic bombing campaign to defeat Nazi Germany. If drawn into the war, the United States agreed with Britain to commit their primary assault against Germany and its European ally, Italy. The Pacific war would be a holding action awaiting the German defeat. World events amended details of the overall plan. After the Japanese attack at Pearl Harbor on 7 December 1941, and the German declaration of war on the United States, 11 December 1941, war plans were altered to spread the proposed United States forces in a much larger global theater. Only a few Army Air Force photo squadrons were sent to England to support the air war against Germany instead of the many originally planned.

The first of these, the 13th Photographic Reconnaissance Squadron arrived in England late in 1942, beginning operations in early 1943. More units arrived bolstering the photo recon capability in the theater. In July 1943 they were assigned to the newly created 7th Photographic Reconnaissance Group. The Group comprised four combat photo squadrons: the 13th, 14th, 22nd, and the 27th. Other units, including the 381st Air Service Squadron, 1274th Military Police Company, and the 55th Station Complement Squadron, joined the Group. Several name changes for the Group and its squadrons illustrated the changing perception of the duties and goals of the unit in the eyes of senior commanders in Washington.

From the time of its activation in 1943 through 1945, the 7th Photographic Reconnaissance Group performed many tasks with its camera planes reflecting developments in technique and equipment as the war progressed. The history of this unit is a story of its photo and support squadrons, its men, aircraft, and equipment taking in most of the air war and much of the land war in Europe.

In Part I the combat squadrons are treated separately until they become part of the 7th Group. Part II covers Group history in 1943. Tumultuous 1944, the year of the Normandy invasion, V-weapons, Operation Market Garden, deadly German jet aircraft, and the Battle of the Bulge is the setting for Part III. The end of the war and the disbanding of the group and its individual squadrons make up Part IV. "Eyes of the Eighth" uses the chronological time frame incorporated with the operational story of the squadrons and the group for continuity. Upon this larger background, personal events unfold.

Part I
THE COMBAT SQUADRONS
BEGINNINGS

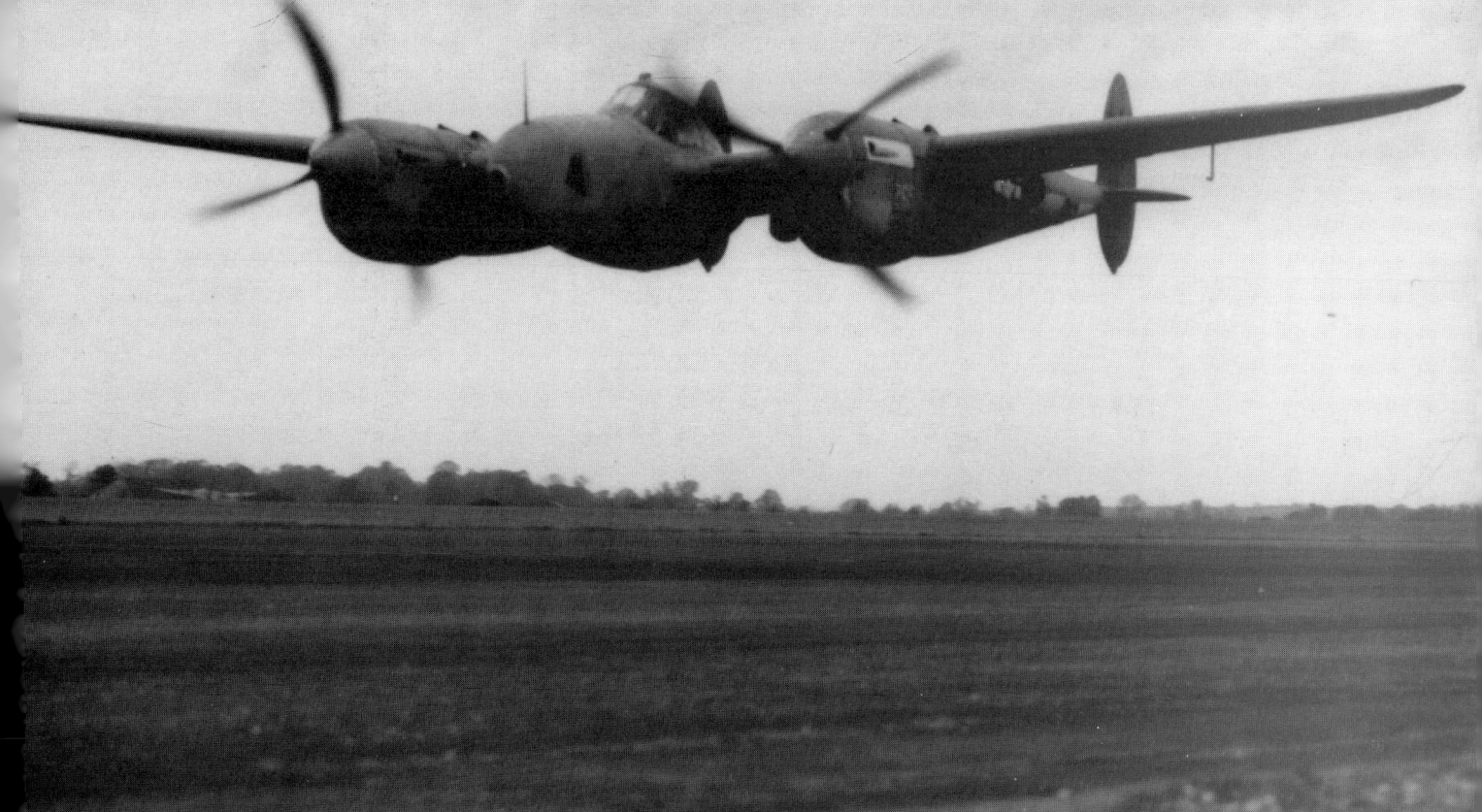

Eyes of the Eighth

Chapter 1
The 13th Photographic Reconnaissance Squadron
20 June 1942 — 7 July 1943

The story of the 7th Photographic Reconnaissance Group has its origin within the PROTU, Photo Reconnaissance Operational Training Unit, stationed in Colorado Springs, Colorado. In the spring of 1942, squadrons destined to fly U.S. photo recon in all theaters came to Colorado Springs to take advantage of the clear air as well as the proximity to the Air Force Photographic School at Lowry Field, Denver. After training, flying personnel from this large general unit would make up the nucleus of the soon-to-be-formed 13th Photographic Reconnaissance Squadron.

The PROTU was not yet ready to begin training, so when the pilots arrived there was nothing for them to do. As there were no aircraft to fly nor any personnel to give lectures or demonstrations or drills, the commandant issued fourteen day leaves to the men.

When the pilots returned to Colorado Springs on 6 June, many of them were assigned to the 10th Photographic Squadron of the 2nd Photographic Group. On 9 June 1942, the squadron became the 10th Photographic Reconnaissance Squadron, a name change foreshadowing others that would take place in this division of the Army Air Force. At the same time, other squadrons constituted included the 13th Photographic Reconnaissance Squadron, which awaited activation and manning.

There were no housing facilities on the airbase, which was still under construction at the Colorado Springs Municipal Airport seven miles east of the city. Quarters and classrooms had to be found within the community. The Colorado College campus could accommodate most of the men. Some quartered in a men's fraternity house in Halbert Hall. Those not housed on campus were quartered on the fifth floor of the Antlers Hotel.

On the ninth of June, the 10th PR Squadron started a small ground school in Hagerman Hall studying aerial photography in the morning and afternoon. On 14 June, the new C.O., Maj. Harry T. Eidson addressed the squadron. Since no aircraft had arrived for training, morale was low among the pilots. Eidson gave them a pep talk with an announcement of future plans, which included promotions, combat aircraft for training, and the prospect of overseas duty within a few months. As for now, he informed the pilots that they were to report to Wright Patterson Field, Dayton, Ohio, for high altitude pressure tests.

Early mapping flights of photographic reconnaissance had been flown in multi-engine aircraft at moderate altitude. The steady slow-moving aircraft satisfactory for unopposed mapping were vulnerable to enemy action. The British realized the need for swift high-flying photo planes early on and the Spitfire became the aircraft of choice. No country had yet developed a plane specifically for fast high altitude photo reconnaissance. The United States thought its twin-engine P-38 Lockheed Lightning would be suitable. At the proposed altitudes deemed necessary, above 30,000 feet, pilots had to be tested for their tolerance for flight in an unpressurized cockpit.

After returning from the pressure chamber tests, the pilots were to build up flying time in something less exciting. Until the P-38s came in, flying time was in L4-B Piper Cubs. The pilots built up hours and collected their flight pay flying their Cubs, checking out the Broadmoor Hotel, Garden of the Gods, Austin Bluffs, and other local landmarks. Many chased each other around in mock aerial combat which they called "rat-racing." On a less adventurous scale, the 10th PR Squadron held a Field Day and a march down the highway from the airbase to the town of Colorado Springs.

13th Squadron Activation

Activation for the 13th Photographic Reconnaissance Squadron occurred on 20 June 1942, at Hagerman Hall, Colorado Springs, with assignment to the 3rd Photographic Group. Lieutenant Shipway became commanding officer. On the 25th, Maj. Harry T. Eidson assumed command of the 13th Squadron. The next day, 21 officers and 99 enlisted men from the 10th PR Squadron transferred to the new squadron. Other personnel came from the Air Corps Replacement Training Center (ACRTC) and other specialist schools. Major Eidson told the men they were number one squadron for overseas.

Hagerman Hall, Colorado College, Colorado Springs, Colorado.
(George P. Simmons)

Fourth of July Parade in front of the Antlers Hotel, Colorado Springs, 1942. (Gerard E. Degnan)

Personnel remained quartered on the Colorado College campus and at the Antlers Hotel pending the completion of the airbase. The men performed the usual garrison duties and trained in both technical and military fields. Instructors used college classrooms to teach courses in the varied and often complicated aspects of photography. Out in the field, experienced transportation personnel checked out the men over an obstacle course in a two and a half ton, six wheel drive Army truck in preparation for overseas duty. Some men spent their spare time hunting prairie dogs.

Morale quickened at the end of June with a lecture on control systems of the Lockheed P-38, their combat aircraft. Meetings at the airbase about communications and flying regulations increased anticipation of the arrival of the aircraft themselves. In the meantime, the pilots continued to build up flying time in the Piper Cubs, frequently chasing antelope across the vast open land lying east of the airbase. It was a way to put a little excitement in their lives while waiting for what they wanted most, the P-38s. There were still no combat aircraft at the end of June.

Photo Lab Fundamentals
Upon activation, the 13th Squadron Photo Lab personnel trained in the Butler Building behind Hagerman Hall on the campus. At first the short lab roster lacked experienced men from seasoned photo outfits, however the squadron found enough to train the newcomers in army photographic methods. Outdoor classes, conducted on campus and the territory surrounding Colorado College, familiarized the men with two ground cameras, the C-1 and C-3. The C-1 was an 8x10 studio camera while the C-3, a Speed Graphic, was the kind used by newspaper photographers. The aerial camera used for training was a K-3B, soon replaced by the newly developed K-17. Courses in the fundamentals of aerial photography, the use of aerial cameras, mathematics of photography, and photographic chemistry were held in the Physics and Science Building of the college. Corporal Ben B. Hines, future overseas lab chief, taught aerial photographic mathematics in Hagerman Hall.

Assigned to the squadron on 26 June 1942, 2nd Lt. Edward M. Shepherd became Squadron Adjutant; 2nd Lt. Vernon M. Stokely was assigned as Supply Officer. The first lab commander, 2nd Lt. Ben Michener, promoted to first lieutenant on 28 June, acquired the official title of Photographic Officer. 2nd Lt. Robert D. Bickett became his assistant and Sgt Charles E. Bresee, lab chief. Soon lab personnel from ARCTC schools at Lowry Field, Colorado, arrived to train under field conditions.

After classroom training, the Photo Lab personnel began a series of field trips with the portable laboratories more commonly known as A-2 Trailers. In Cheyenne Canyon, about six miles outside the city, trailer lab teams competed to see which team could set up and produce the first print from ground camera negatives. Subject matter came from the surrounding landscape. Much of the work was done outside the trailers except when sudden mountain rain and hail storms drove the lab personnel to run for cover. Less than ideal field conditions handicapped the photo technicians during these competitions but the trailer operated by Lieutenant Bickett and Sergeant Bresee, usually took first place.

On 22 July 1942, the 12th and 13th PR Squadrons engaged in a mock battle with the 15th PR Squadron on

Out in the field near the Garden of the Gods, Robert Jung holds K-3B aerial photo camera used for training. Cunningham, Bankiewicz, and Carr look on. (Robert W. Jung)

Eyes of the Eighth

field maneuvers to the nearby Black Forest area. Lab personnel set up trailers and were on alert at all hours to finish hundreds of prints of the "enemy." One night the call to lab duty came at 2030 hours, the lab working all night to finish hundreds of prints of the "enemy's" positions. On another occasion, when commanding officer Major Eidson dropped reconnaissance film from a plane, the lab finished the prints in record time guaranteeing successful maneuvers for the 13th Squadron.

The pilots left the Black Forest bivouac on 25 July and went back to Wright Patterson Field in Ohio for more High Altitude Pressure Chamber tests. When they returned to Colorado Springs most of them had unlimited altitude ratings. The strength of the 13th PR Squadron on 31 July 1942 was 33 officers and 155 enlisted men.

Arrival of P-38s
With the Colorado Springs Army Air Base completed, 4 August 1942 became a banner day for the 13th PR Squadron when their P-38 Lightnings arrived. On the 12th, the

Bailing out of their campus quarters are 2nd Lts. Herschel Turner in mid air and Donald Schultz on the edge.

(Herschel Turner)

squadron moved to its new location, where the photo lab men set up their portable labs next to the new orderly room. The Photo Lab office, in fact, was set up in a corner of the Orderly Room sharing space with Film Viewing, First Phase Interpretation, Lab Drafting, and Filing. That same day, the 15th PR Squadron left for North Africa by way of England. The men of the 13th would not be first to go overseas after all but at least now they had their combat aircraft.

With the arrival of the F-4s (the photographic configuration of the P-38E), training accelerated. For the first three days, pilots logged cockpit time familiarizing themselves with the aircraft, starting, and running the engines but never leaving the ground. Because the single seat P-38 had a tricycle landing gear, the similarly-equipped North American B-25 "Mitchell" medium bomber was used to train the pilots in this unfamiliar equipment. The B-25, like the P-38, was a twin-engine aircraft allowing multi-engine training as well. Pilots had to learn the location of controls, gauges, and cockpit equipment by touch as well as sight. After a blindfold check there was a 30 minute transition ride in the "Mitchell" to gain experience and flying time before soloing in the "Lightning."

Soon the air around Colorado Springs was busy with twin-tailed F-4s, their pilots practicing, increasing flying hours, and learning the aircraft they were to use overseas. Training was pushed six, sometimes seven days a week. Pilots flew cross country hops and local sorties over the usual landmarks. Occasionally they raced the Rock Island Rocket, the Colorado Springs and Denver-to-Chicago Streamliner train speeding across the Colorado prairie. Even the majestic mountain called Pike's Peak suffered countless photo attacks.

A New C.O.
On 12 August 1942, 1st Lt. Lewis H. Richardson replaced Major Eidson as new commanding officer until 10 September, when Maj. James G. Hall relieved him. The makeup of Hall's new officer corps was an unusual one; one major and 23, green second lieutenant pilots all from flying school classes '42D, E, or F. Major Hall, in contrast, was a veteran Army officer in his 40s. A native of Atlanta, his career had begun in 1916 when he received basic training in Mineola, Long Island. Like many other pilots at that time, he was sent overseas to France where he completed advanced flight training at Clermont-Ferrand. With only 40 hours flying time, Hall entered combat in French skies, downing three German Fokkers and winning the *Croix de Guerre* with Palm and Star. After the Armistice, Hall continued flying, setting speed records and competing, flying the Hall Racer, which he

The 13th Photographic Reconnaissance Squadron

Maj. James G. Hall new commanding officer 13th Photographic Reconnaissance Squadron. (George P. Simmons)

designed, in international air races in the United States; all this while holding a seat on the New York Stock Exchange. Volunteering his services to the Army Air Corps after Pearl Harbor, this 45 year old part Cherokee now took command of the 13th Photographic Reconnaissance Squadron.

Hall appointed 2nd Lt. Hershell Parsons as his Operations Officer. The command of A, B, and C Flights went to 2nd Lts. Ray Mitchell, Robert C. Brogan, and Vernon Luber respectively. It was their job to get the squadron's pilots ready for their assignment overseas and this meant as many hours in the F-4s as possible. As they gained experience, the 13th's pilots began logging longer cross country time. Many pilots paired up and flew long flights to distant airfields, then refueled before returning to Colorado Springs. Some were able to fly near their homes, sometimes buzzing their relatives', or girl friends', houses. High spirits accompanied them during their training with anticipation of imminent overseas duty.

First Fatality
On 15 September 1942, 2nd Lts. Robert C. Kinsell and Vernon Luber, who had previously flown cross country flights together, teamed up again for a flight in formation at altitude down to Albuquerque, New Mexico. The flight was intended to familiarize the pilots with altitudes around or under 12,000 feet. At the last minute a third plane was added to the formation. Neither Kinsell nor Luber knew the third man, 2nd Lt. R. J. Copeland. Luber remembered the briefing, "I told him that after take-off I would make a big circle around Colorado Springs with time enough to let them join up and the three of us would head out to Albuquerque, New Mexico. I climbed out at 15,000 feet, saw Kinsell who joined on me rather promptly but we had trouble raising Copeland on the radio. We had him visually for a while and were urging him to come on in so we could monitor him, but we had no success. I don't know what his problem was. He never told us of any mechanical problem."

Kinsell and Luber continued waiting for Copeland to join them and trying to contact him by radio. They finally lost sight of Copeland as he headed off in the wrong direction. Thinking he might have compass trouble they returned to the Colorado Springs Army Air Base and landed. It was a late afternoon mission; the two more experienced pilots landed safely in the poor visibility of dusk. Copeland was not so lucky and was killed when he crashed while attempting a landing in the semi-darkness at the airfield. He was the first fatality in the 13th Squadron.

By mid-September preparations for combat duty overseas were almost complete. The men awaited their orders. Major Hall assigned 2nd Lt. Edward M. Shepherd to duties as commander of the ground echelon and appointed 2nd Lt. Albert Krug, Squadron Adjutant.

During July the air war plans against Germany underwent major changes. Critical requirements in the Pacific theater raided the proposed Eighth Air Force complement of bombers, fighters, and photo recon planes for men and equipment. Added to this, the newly-planned invasion of North Africa also took a large share. The latter was to be a ground-oriented campaign with little strategic bombing calling for the type of photo reconnaissance slated for the 13th PR Squadron. Rebuilding the huge force planned for England would delay the transfer of the 13th to England. Many units that had previously been rushed to England were short on training and experience with their aircraft. It would turn out to be to the 13th's advantage to remain in training in Colorado Springs until bases and facilities were ready on the other side of the Atlantic.

A Close Call
Lt. Hershell Parsons, the 13th Squadron's Operations Officer, called Lieutenant Luber in on 1 October 1942 and asked him if he would consider flying a P-38, F-4, off the Colorado Prairie. Of all his pilots, Luber had

Eyes of the Eighth

Looking east out across the prairie from Colorado Springs Army Air Base. (Gerard E. Degnan)

logged the most flying time in '38s. One of the young inexperienced pilots had made a forced landing on the prairie south and east of the airfield. The aircraft was okay. It was checked out by a mechanic and considered safe to fly out of the pasture where it remained overnight under armed guard.

The next day Luber, a maintenance officer, and several others drove out across the prairie to the pasture where the F-4 was sitting in the corner of a fenced-off field. The men cleared brush, kicked the cactus away, and scraped a little strip in the prairie. The guard was still on duty. Luber looked the situation over and felt he would be able to get the F-4 off the ground in the limited space. He climbed in the cockpit and glanced over the knobs and switches and dials. He checked the controls, the elevators; everything appeared normal. Firing up the engines, he straightened the plane out pointing it toward its escape route. He brought the engines up, cut the turbo-chargers in, released the brakes. Everything appeared normal.

The twin Allison engines roared as the F-4 accelerated down the rough little prairie strip. Unbeknownst to Lieutenant Luber, the guard had spent the night in the cockpit to get shelter from the cold. Curious about all the switches and dials, he twisted a few knobs then returned everything to its normal position except for one item, the rudder trim tab. The guard left that cranked to full right rudder. The altered trim tab control, always at zero, escaped Luber's attention during the cockpit check. Now it began to affect his control of the aircraft.

Luber remembers picking up speed for take-off. "By the time I got an airspeed of about fifty I felt this rudder pressure building up at a tremendous rate and by the time I got up near take-off speed — it didn't dawn on me what was wrong — I started checking my engines to see if a turbo had dropped out or an engine was failing. That was my major concern with all this rudder pressure building up." He pushed down hard on the rudder pedal keeping the aircraft straight. The pressure kept building against him. Luber strained to keep the plane level, "By the time I got to a hundred I thought my leg was going to compress at the knee." The F-4 cleared the strip and became airborne. Luber couldn't hold the rudder any longer and began to ease up and into a turn. With the wheels up he determined he had two good solid engines and it must be something else. "I looked down at that rudder trim and there that sucker was. I started bringing it back. Scared the hell out of me. I limped on that leg for three days."

Shipping Out

On 14 October, Lts. Hershell Parsons, Howard E. Lott, Donald D. Schultz, Burton M. Bowen, Jr., and Vernon Luber joined up in formation, unaware that the day of their departure for parts unknown was at hand and made their last flight over Colorado Springs. Suddenly orders arrived alerting the squadron for overseas duty. For three days and nights the men worked to pack up, grabbing a few hours of sleep when they could. They loaded box after box and tons of equipment onto the freight cars backed onto the airbase rail siding. At 1220 hours on a rainy 17 October 1942, the troop train left Colorado Springs. Ten coaches, many flat cars and boxcars, all 13th Photographic Reconnaissance Squadron men and equipment, moved eastward, away from Pike's Peak and the Rockies. After crossing the Great Plains to Lincoln and Omaha, through Des Moines, they crossed the Mississippi River at Davenport, Iowa. Passing through Chicago and Gary, Indiana; through Canton, Ohio; Pittsburgh and Philadelphia, the troop train reached Fort Dix, New Jersey, at 0330 hours on the 20th of October 1942.

The 13th Squadron stayed at Ft. Dix for five weeks awaiting its date of embarkation. The men were put through an intensive physical training and toughening program of long hikes, field exercises with full equipment, calisthenics, close order drill, and many hours on

the firing range. On 2 November 1942, the squadron moved from Area T-O-5 to Area T-A-5 where, housed in tents, the men remained until leaving Fort Dix on 23 November. They entrained at 1800 hours for New York City Port of Embarkation. At 0300 hours the following day, they boarded the great Cunard ocean liner *Queen Elizabeth*. Now serving as a transport on "His Majesty's Service," the *Elizabeth* sailed back and forth across the Atlantic taking American forces to England in Operation Bolero, the positioning of U.S. airmen and soldiers for the defeat of Germany.

The troopship sailed at 0600 hours on 24 November 1942 for England, escorted the first two days by United States Navy destroyers and blimps. Two days out to sea the members of the British crew prepared a Thanksgiving dinner with English dishes for their American passengers. The same day the escort left and the ship sailed on alone, depending on her great speed for protection against U-boat attacks.

Podington

A few days later, as the troopship neared England, Royal Air Force planes took up the watch for German U-boats. The *Elizabeth* passed Ireland on 30 November 1942. Zigzagging around the islands off the coast of Scotland, the transport docked at 1900 hours in the sheltered harbor of Greenock. The next morning, the first of December, the men disembarked at 1100 hours and entrained for their new base at Podington. Leaving Scotland, they traveled south and arrived about midnight at their new station, AAF Station 109. Podington, near the village of Wollaston in Bedfordshire, was 75 miles north of London. Encircled by woodland, the base was under construction and relatively isolated from the center of American air forces nearer London.

Maj. James G. Hall assumed command of Station 109 on 2 December 1942. The 13th Squadron's headquarters section was set up to establish Base Headquarters directly under the 1st Bomb Wing of VIII Bomber Command.

The first morning at Podington, an intelligence officer from Wing addressed the squadron on security. European Theater of Operations United States Army (ETOUSA) regulations restricted the newly arrived enlisted men to the station for three weeks. When this period was over, "liberty runs" for the men went to Bedford, and for the officers, to Northampton. The Wollaston villagers invited the men to their Saturday night dances. The men of the 13th Squadron began to settle in.

When the 13th arrived in England, there were rumors that the squadron, which had been attached to the 3rd Photographic Group now stationed in Algiers, would also go there. The last occupant of Podington, the 15th Bomb Squadron, had moved to North Africa to support American forces of Operation Torch on 8 November 1942. After the landings, the Americans were advancing from the west to meet British forces who were pushing the Germans back from Libya. Tobruk and Bengazi had fallen to the British Eighth Army. But Axis troops occupied Tunisia. Commanding general of the famed *Afrika Korps*, Field Marshal Erwin Rommel, with only 35 tanks and remnants of two battered divisions, had escaped from a tarrying General Montgomery at El Agheila, Libya. Prospects for the Germans were decidedly bleak. Reports from the theater indicated that there were sufficient units already in North Africa to take care of that theater's photographic reconnaissance requirements. The 13th Squadron seemed more likely to remain in England.

A Deal is Struck

With these conditions in mind, Major Hall set about to formulate a new position in England for the 13th Photographic Reconnaissance Squadron. During the last few days of 1942 and the beginning of 1943, Major Hall conferred with Brig. Gen. Laurence S. Kuter of 1st Bomb Wing, Maj. Gen. Newton Longfellow of VIII Bomber Command, and Maj. Gen. Ira C. Eaker, new commander of the Eighth Air Force. The consultations resulted in a decision giving Hall the authority to build a reconnaissance and mapping unit in England to serve the Eighth Air Force.

Major Hall was not satisfied with conditions at Podington and thought it would be advantageous to be closer to the Royal Air Force Photographic Reconnaissance Headquarters at Benson, near Oxford. He requested

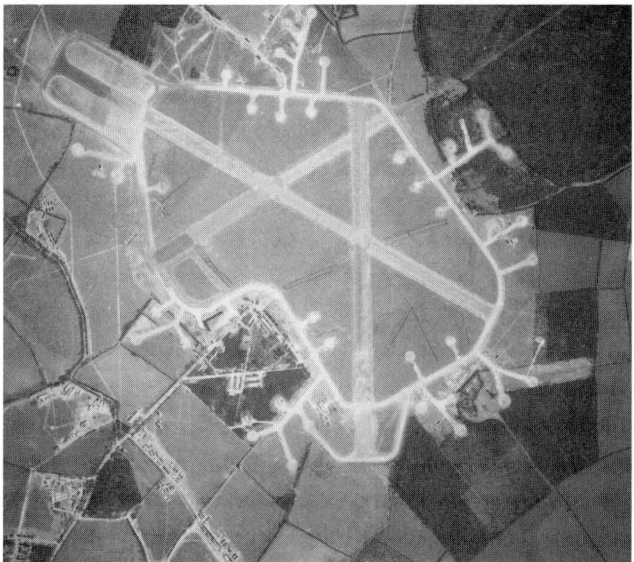

Podington Airdrome, 13th Squadron's first home in England.
(Robert Bickett)

a base close to Benson which would also be near the Central Interpretation Unit (CIU) at Medmenham and Eighth Air Force Headquarters at High Wycombe. After looking at Mount Farm, a satellite field of Benson, Hall asked General Eaker to obtain this field for USAAF operations, specifically for his 13th Squadron. The RAF was not keen to make this move as it had two squadrons operating there and needed the satellite airfield to augment Benson operations. However, General Eaker prevailed upon Air Marshall "Bomber" Harris of RAF Bomber Command to turn the base at Mount Farm over to the Eighth Air Force.

All 13th Squadron pilots had been through checkout indoctrination in European Theater of Operations (ETO) procedures and communications at Bovingdon Airbase by 6 December 1942. Major Hall, Lts. Robert J. Kinsell, Burton Bowen Jr., Jack R. Campbell, Telford S. Byington, and Vernon Luber left for detached service at Benson preceeded by a week of sightseeing in London, Marlow, and Oxford. At the RAF Photo Recon base, seasoned British pilots coached them in the type of flying that would be required in the ETO. After their tour of orientation at RAF stations, the pilots returned to Podington. Lt. Thomas B. O'Bannon, appointed Operations Officer, assigned Piper Cubs and British Tiger Moths to the pilots to gain experience and flying time.

While the pilots trained with the RAF at Benson and elsewhere, the ground echelon carried out garrison duties and made such improvements to Station 109 as were necessary for their short stay. The enlisted men cleaned up and policed the airdrome. Roads were cleared, fences built, and buildings repaired. Lt. Ralph E. Esposito established a Post Exchange in mid-December. The enlisted men gave a party to celebrate their first Christmas overseas. Guests invited included the squadron officers and girls from nearby towns and villages of Wollaston, Podington, Wallingboro, and Bedford. Army trucks provided welcome, but utilitarian, transportation for the girls.

The New Year Begins Badly
The New Year began as it had ended with extremely cold weather lasting through January. Heavy fog over the field made flying dangerous. Whenever possible, pilots kept the Tiger Moths and Cubs in the air, familiarizing themselves with the countryside. Once again they were waiting for their combat aircraft. This time it was the F-5A (the photographic version of the P-38G). The pilots were anxious to get their operational aircraft and see action. The slow light planes weren't as exciting as the fast twin-engine Lightnings although occasional highjinks added thrills. Just being in the cockpit kept the men from, "going berserk," as one pilot put it. For two of the young exuberant pilots luck was about to run out. Lt. George Owen and another pilot were in a Tiger Moth practicing touch and go landings on 9 January 1943. Lts. Howard Lott and Burton Bowen, Jr. were in a Piper Cub, Bowen as passenger. At 0845 hours Owen was just getting airborne again after touching down on a practice landing when suddenly the Cub flew dangerously close to the Tiger Moth. Lott pulled the Cub up, narrowly missing the Tiger Moth but climbing too steeply. The Cub stalled, flipped over on its back and dove nose down into the ground near the perimeter track. Both Lott and Bowen were killed instantly. These were the first fatalities overseas for the 13th Squadron. The squadron buried the two men at Brookwood Cemetery near London.

First F-5s Arrive
Later on the same day, Major Hall flew the first F-5 photographic reconnaissance aircraft to Podington from Burtonwood Aircraft Depot. The modified Lockheed P-38G Lightning aircraft assigned to the 13th Squadron, had been shipped to Liverpool and delivered to nearby Speke Airfield. There, squadron pilots collected and flew them to the depot for radio modifications. Several days after Major Hall's flight, three pilots went to Speke to ferry planes to Burtonwood. On 15 January, they took off from Speke Airfield for the short flight, part of which was through a narrow corridor of barrage balloons trailing their deadly steel cables. Lt. Vernon Luber and another pilot successfully navigated the corridor and landed safely at the Burtonwood airfield. Lt. Kenneth V. Burnette, flying the third aircraft, apparently became confused while trying to thread his way through the corridor. It was touchy navigating. The winter light was fading; visibility was poor and Burnette, disoriented in the haze, made some navigational errors. He thought he saw a flat straight strip ahead where he could get his aircraft safely on the ground. Unfortunately, it was a water-filled canal and Burnette's F-5 crashed in the water, killing Burnette instantly. The squadron buried another man at Brookwood Cemetery.

New Name
Frequent name changes for active air force units were not unusual. In a sweeping order affecting many similar units overseas and at home in the United States, the USAAF redesignated the squadron: 13th Photographic Squadron (Light) on 6 February 1943 while the squadron prepared to move to its new base at Mount Farm.

The Move to Mount Farm
The Royal Air Force completed the arrangements for

The 13th Photographic Reconnaissance Squadron

Mount Farm Airdrome, primary base for 13th PR Squadron. 15 April 1943. Thames River in lower left corner. Dorchester-on-Thames in lower middle edge. (Robert Bickett)

the transfer of Mount Farm Airdrome, Oxfordshire, to the Eighth Air Force. On 16 February 1943, orders released the squadron from assignment to the 1st Bomb Wing and assigned it to the Eighth Air Force. The Quartermaster Corps transported ground personnel and equipment in convoy to the new base, now designated AAF Station 234. They arrived at Mount Farm, a satellite field to the main RAF photographic reconnaissance airbase at Benson a little over three miles away. Two RAF photo recon squadrons still operated out of Mount Farm under command of Squadron Leader Cooper. Spitfires and Mosquitoes parked all over the field led some of the men to wonder if they were at the right base. Later in the day, the squadron's 13 F-5s swept low over the field in "grass cutting buzzes" (low-level flying) led by Major Hall. Every man on the station craned his neck to watch the daring formation.

Surrounded by farm land, the site of the 13th Squadron's new base included parts of Mount Farm (hence the airfield's name) with its attendant farm houses and out buildings. Another section of the base encompassed King Farm, a game preserve owned and stocked by a London ship builder. Two of the farm houses be-

came quarters for the C.O., Major Hall, and other officers, while the farm families continued to live in houses on the property while maintaining their fields and crops thoughout the war.

The airfield consisted of a few buildings, a water tower, and three runways, one of 1,500 yards and two others each 1,100 yards in length. The only permanent Royal Air Force personnel on the field at that time were ground crews sufficient to maintain the functions of a satellite field and approximately 85 members of the Women's Auxillary Air Force (WAAF). When the men arrived, facilities existed for two operating squadrons on the station but they eventually proved woefully inadequate. Until improvements could be made, the 13th Squadron made the best of what it had. The men moved into the available quarters and began setting up their respective sections in preparation for long-awaited operations.

When the 13th Squadron arrived at Mount Farm, the RAF complement, although already overcrowded, accommodated the communications section with quarters and room for supplies. Until American personnel became familiar with operating procedures, RAF and WAAF staffed

F-5 "beating up" the airfield at Mount Farm (Edward R. Murdock)

all communication facilities. They furnished switchboard, teletype, radio, and flying control operators; wireless and radio maintenance personnel. Gradually the Army Air Force replaced RAF and WAAF technicians. The RAF officially handed over the airfield on 15 March 1943. Initially, to give the 21 men assigned to the communications section of the squadron more time to become familiar with RAF procedures, a few WAAFs and RAF specialists remained at Mount Farm on detached service from Benson. Later, American and British com-

bined procedures for use in all theaters. Almost all RAF and WAAF personnel, the latter much to the sorrow of the men from the 13th, left the station by 10 April. After April only a few RAF supply and flying control staff remained.

On the 16th of February, Major Hall, Lts. Ray C. Mitchell, Robert C. Brogan, Jack R. Campbell, and Vernon Luber moved to quarters at Benson airbase on temporary detached duty (TDY) to observe the RAF procedures in photo reconnaissance and to dove-tail 13th Squadron and RAF operations. After returning to Mount Farm, the pilots continued with training flights, test hops, and a few extracurricular activities which came to the attention of their commanding officer. Major Hall lectured them to quit "beating up" (buzzing) the Benson Spitfires with their F-5s. Buzzing was a forbidden maneuver in the British Isles for virtually every pilot except U.S. photo recon pilots who flew low over the field to notify Camera Repair that they had film to be processed. It was easy for high-spirited young men eager for action to stretch this limitation as they had in Colorado. British flying control did not appreciate these high-jinks in England's crowded air space. Major Hall ordered his pilots to restrict low-flying buzzes to their own airfield at appropriate times.

Unfamiliar Radios
Adjustments to life on a new base in a foreign country had more twists than language and driving on the "wrong" side of the road. British terminology was different and now they had unfamiliar equipment in their familiar aircraft. Astonished, Communications Section men learned that instead of their familiar SCR-274-N radios the new modified F-5s were equipped with the SCR-522-A, a very high frequency Bendix radio set. The section had test gear and spare parts only for the former set and now needed a complete replacement of spare parts and test equipment to fit the new ones. Retraining radio technicians became a priority. A small contingent, SSgts Richard A. Spellerberg, Eugene S. Zientkiewicz, and Joe F. Pittman, with TSgt Hurlie J. Davis went to Burtonwood for a two-week course in the maintenance and study of the SCR-522-A. They got a good introduction to their new equipment. By frequent reference to technical orders and maintenance instructions, and by trial and error methods they improved their maintenance techniques.

Setting Up the Photo Lab
The lab men set up their section and made countless supply trips to Cardiff, Wales; Burtonwood Depot; and Poynton. They assembled the two E-2 type fabricated laboratory trailers, shipped from the States to Podington and then to Mount Farm. Photo Lab commander, Capt. Ben Michener, named Lt. Robert D. Bickett his assistant. Warrant Officer (W/O) Charles E. Bresee became the Assistant Photographic Officer while TSgt Raymond E. Karales, became Lab Chief with TSgt Ben Hines appointed his assistant.

During February, delegations of lab men spent time in RAF laboratories working with personnel studying their photographic methods. At Mount Farm, Photo Lab set up their equipment and used the two trailers until early in March. They remodeled half of the headquarters building and converted it into a laboratory for the complete processing of aerial negatives and prints. The two E-2 Transportable Photographic buildings became storage space for photographic equipment. The photo lab was ready to process the film when the squadron flew its first sortie.

Camera Repair
Camera Repair moved, in March 1943, from its first location in Building T-3 to the Headquarters Building. Although spacious, the new quarters, like those of the photo lab, needed remodeling for laboratory work. Supply problems cropped up frequently but MSgt Alfred Ward, whenever possible, circumvented the bottlenecks to stock scarce equipment.

Work proceeded to bring the department up to full readiness. Personnel cleaned, repaired, and installed cameras in aircraft for local operations. Frequent camera failures appeared immediately. The camera mechanisms froze at the extreme low temperatures of high altitude flying. Technical publications recommended the use of heavy lubricants but the freezing continued until the technicians experimented with light instrument oil which solved the problem. Camera Repair sent recommendations back to specialists at Wright Patterson who amended technical orders because of this discovery. The department continued to pioneer in the field. Problems found and solved led to valuable changes important to other photographic units.

First Sortie: A Bargain Made; A Bargain Kept
Major Hall's bargain with Eighth Air Force Headquarters to have his squadron ready for operations by April 1943 needed only a successful readiness inspection. Maj. Gen. Ira C. Eaker, commanding general of the Eighth Air Force, inspected the base and men at full dress parade on 27 March 1943, after which the general declared the 13th Squadron fully operational.

The next day, the 13th's C.O. Maj. James Hall took off for the first American photographic reconnaissance

The 13th Photographic Reconnaissance Squadron

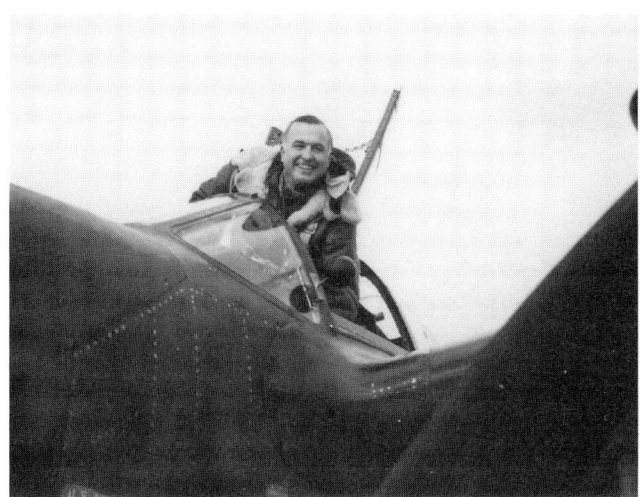

13th Squadron C.O., Maj. James G. Hall. First U.S. photo reconnaissance sortie, 28 March 1943. (George P. Simmons)

sortie over German-occupied territory. Hall made two runs over his objective, the French port of Dieppe. Clouds covered the area but the coastline northeast of Dieppe was clear and he photographed a 22-mile strip of the coast including Le Treport and the Dieppe Derchigny Airdrome. The sort of weather conditions and decisions Major Hall experienced would become ordinary to his pilots: when the primary target is cloud-covered, take the opportunity to get what you can on film.

Mechanics, camera repairmen, anyone who had anything to do with the preparation of the plane and its mission anxiously waited for the sound of those two Allison engines. By the time Major Hall returned, a crowd had gathered. He landed his F-5 and taxied toward the waiting crowd. The men rushed to greet him and surrounded the F-5 as the engines stopped. Smiling broadly, the veteran Hall climbed out of the cockpit to be greeted with handshakes and congratulations. The crowd was so dense around the plane, the men from Camera Repair couldn't get to the aircraft to remove the film magazines. From now on their job would hold priority over all others with returning photo planes. Magazines in hand, the Photo Lab technicians went to work to process the photos from sortie AA1.

Major Hall sent a communiqué on 28 March 1943 to the Commanding General, Eighth Air Force, that the "first USAAF photographic reconnaissance mission flown in the European Theater was completed successfully March 28 by a photographic plane F-5A (P-38), of the 13th Photographic Squadron (L) which became operational by VOCG Eighth Air Force March 27th." To this he attached interpretation reports and photographs of Le Treport.

To the men of the 13th Squadron this day represented the culmination of months of patient effort, adherence to duty, and hard work. No one knew this more than their commanding officer and in appreciation of the squadron's efforts Major Hall issued the following notice:

To: The members of the Thirteenth Photographic Squadron.

It is with a great feeling of pride and satisfaction that I convey to you the following favorable comments of our Commanding General, Major General Ira C. Eaker on the occasion of his recent tactical inspection of the Thirteenth Squadron, the only tactical unit directly under his command.

It is obvious that the Thirteenth Photo Squadron is ready for operational duty. Reports of the high morale of this organization have come to me from more than one source, and after conversations with a number of officers and men I am pleased to confirm these reports. I am tremendously impressed with the caliber of

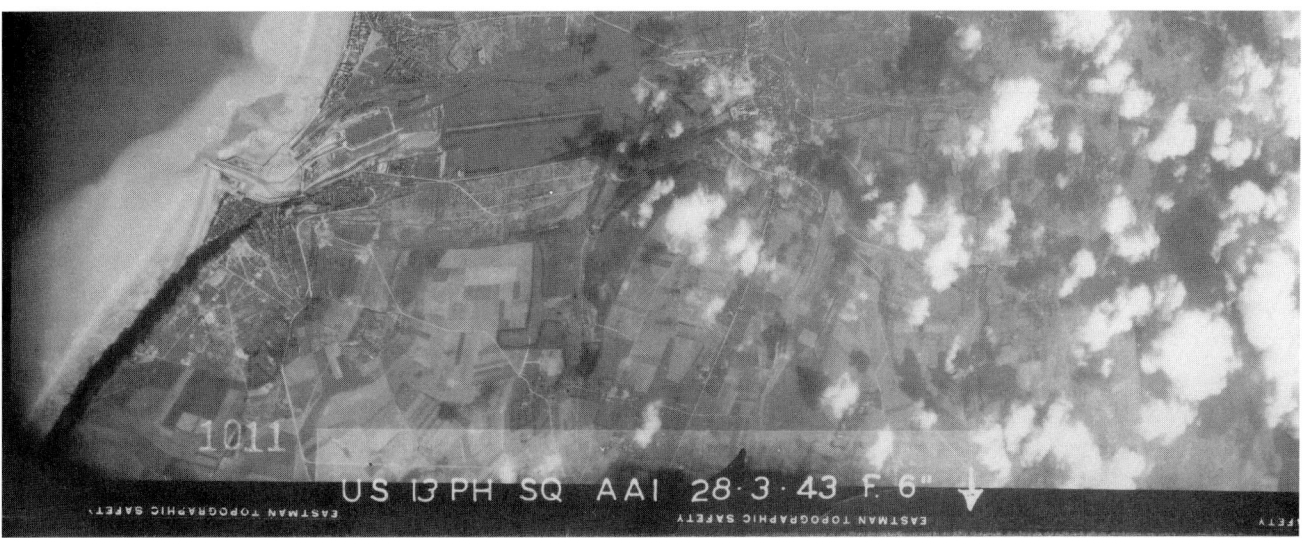

Photo of Le Treport taken by Major Hall on first U.S. PR sortie AA1, 28 March 1943. (Robert Bickett)

men in this organization. It is a pleasure to have all of you in my command and I wish you every success. You shall have my support in every respect.

The most eventful day of any wartime military organization is the day on which it commences operations against the enemy. May I take this opportunity, on the most eventful day of the Thirteenth Squadron's history, to express my sincere appreciation of your cooperation and support in the administration of the squadron.

The success of an operational flight does not depend entirely on the pilot of the aircraft. Successful missions are made possible only through the combined efforts of all individuals in the squadron and there is not one pilot who is not fully aware, and appreciative of the important parts played by the men on the ground who 'Keep 'Em Flying.'

It is a pleasure and privilege to be the Commanding Officer of the first Photographic Reconnaissance unit to operate in the European Theater.

James G. Hall
Major, Air Corps,
Commanding.

Early Missions
After that first mission, the senior pilots, the Operations Officer, and Flight Commanders in the squadron cut cards to see who would fly the next sorties. Each cut the deck. Capt. James S. Wright drew the highest card and the second sortie. Then, in descending card value; Lieutenants Parsons, Mitchell, Campbell, Brogan, and Luber drew their sortie order. Operations assigned first missions to French or Belgian coastal areas. This remained the routine for most pilots. Those first targets, even though not far inland, were not safe targets.

Captain Wright flew Sortie AA2 on 3 April 1943. He photographed Boulogne, Le Touquet, and a coastal strip in between. During Wright's first run over Boulogne, an unidentified but presumed enemy aircraft dove at him from about 1,000 feet above and ahead. Wright turned toward the diving aircraft, which made a skidding turn away and out of sight. On the processed film from the sortie, Intelligence identified two minesweepers, 13 E/R Boats (small swift attack boats), four heavily-armed Tank Landing Craft, and a merchant vessel of about 5,000 tons in Boulogne harbor. Photo Interpreters at Medmenham, in a department especially set up to monitor enemy controlled shipping, identified the same merchant ship at Dunkirk on photographs taken two days later on another sortie.

Ships of particular interest to the interpreters, the German blockade runners, occasionally appeared in Channel ports but usually docked in the ports of the Bay of Biscay; *i.e.* Bordeaux, Royan, Paulliac, and La Pallice, France. Transporting technical equipment, blueprints for new weapons, special steels, and mercury to the Far East, blockade runners carried supplements to Japan's most essential deficiencies. They returned from the Far East with Germany's most critical needs: crude rubber, edible vegetable oils and fats, tungsten, tin, and quinine. Up until this time, RAF photo reconnaissance planes provided the only cover. From then on American photo planes would add to extensive shipping coverage filed at CIU Medmenham.

On the same day, Lt. Hershell Parsons, flying sortie AA3, photographed two marshaling yards and the harbor at Calais, France, where interpreters located a *Sperrbrecher* (Barrage-breaker, a type of German mine sweeper), and 9 E/R Boats on photographs of the harbor. On sortie AA4, Lt. Ray Mitchell found his principal target, Ostende, Belgium, cloud covered. He turned westward and photographed Nieuport and two nearby airdromes. He remembered to photograph his "targets of opportunity" when his principal one was obscured. A photograph of a harbor or airfield only an hour or so after prior cover could, and often did, reveal intelligence to the trained interpreter.

The 4th of April 1943 was a warm spring day at Mount Farm. Operations assigned the heavily defended Belgian port of Antwerp to Lt. Jack R. Campbell, next to Major Hall and Captain Wright, the squadron's most experienced pilot. When Campbell did not return, the squadron learned that he had not answered two radioed recalls, which warned him of enemy fighters over his target. Listed as missing, he was confirmed as killed in action by Eighth Air Force Headquarters. This was the first combat casualty of the 13th Squadron.

Teething Problems
The realization that the American aerial photos were inferior to those of the RAF tempered the excitement of those first operational missions. Capt. Ben Michener and his men in the photo lab began checking for the cause. First they removed the protective glass window installed over each camera port on all the aircraft and checked the flatness of the glass. Not one window was usable. The British helped the squadron obtain new sections of glass and taught the men how to pick out the flat sections for use in the windows. This change helped, but the pictures still did not come up to RAF standards. Checking began on the K-18 cameras, particularly the lenses. The

13th Squadron Photo Lab, with the help of the Royal Aircraft Establishment at Farnborough, tested the cameras to discover the trouble. The technicians found lenses of high quality but some poorly ground filters. About five percent of the filters known as "minus blues," when checked for flatness, passed testing. Ross Optical Company of London reground the unserviceable filters. Pilkington Brothers, St. Helens, replaced the low quality glass. Captain Michener filed reports to the authorities in the States to correct the installation of this faulty equipment on similar aircraft still under construction. The reports eventually resulted in correct installations on new equipment.

There was another problem involving the aerial cameras. When pilots flew over their targets with cameras running they could not hear anything over their radios. The noisy intervalometer motors, which controlled the automatic timing of the various cameras, combined with noisy interference radiating from the camera mechanism prevented the pilots from hearing critical radio warnings sent during these photo runs. The Communications Section cooperated in experiments to eliminate most of the interference. The squadron sent an F-5 to RAF Farnborough, the Wright Field of England, to determine the most efficient means of squelching out the radio frequency disturbances.

Technicians found a solution. They connected 001 MFD condensers from the high tension lines of camera and intervalometer motors to ground. The 13th Squadron ordered 1,000 of these condensers. In fact, they depleted the entire stock held by the SAD (Strategic Air Depot) and the main depot as well. The cameras and intervalometers modified with noise suppressors improved radio reception and gave the pilots better communications with homing facilities on the ground.

Problems with extraneous noise remained in spite of the improvement. Pilots still complained of raucous noises in their headsets and the limited 20-mile range of their VHF sets. The noise was so disagreeable some pilots refused to turn their radios on. The SCR-522-A, a VHF (Very High Frequency) set necessary for British flying control, proved ineffective when installed in the F-5. On the ground, with the engines off, the VHF sets operated perfectly. In flight and particularly at high altitude, interference from the plane itself made so much noise that the pilots could not use their sets. Lieutenant 's failure to answer the two warnings sent during his fatal first operational flight on 4 April 1943 raised critical concerns about the F-5 and its equipment. The squadron sent complaints to Eighth Air Force Service Command. Radio mechanics SSgt Sol Teitelbaum, Sgt William J. Livingston, Sgt Eugene O. Weindel, and Sgt James R. Leonard worked on a solution.

Radio technicians thought the noise must be caused by the aircraft electrical system or lack of proper bonding and shielding within the system. After two weeks of experimentation they discovered a way to increase the range of the set to 50 miles; however, this cut down on the dependability of the set. The men working on the sets knew that when the squelch relay in the receiver was open no signal was received. An incoming signal closed the relay. Technicians modified all sets by routing the audio output wire to this relay in such a way that the audio would be grounded until an incoming signal activated the relay to unground the audio and make a complete output circuit. This meant that the very weak signals could not be received. The delicate relay adjustments had to be made with the engines running. Ground crew set the F-5's brakes, secured wheel chocks, and revved the twin Allsion engines up to run at high cruising speeds. The radio men climbed on the wing into the maelstrom and made the necessary adjustments to set the relay at such a point that the aircraft engine noise would not be enough to complete the audio circuit but where a fairly weak audio signal could be heard. Out on the hardstands on those early spring mornings, observers expected to see SSgt Joe Pitman and Sgt Stanley J. Sajdak blown off the wings of the straining F-5s.

Unfortunately, the adjustments which cut the noise also severely cut the radios' range. Finally, radio technicians from the Bendix Corporation, radio engineers, and a radio maintenance officer who specialized in tracing radio frequency (RF) interference, arrived on the station to clear the aircraft of all troublesome VHF interference. They worked and experimented on the F-5s and the radio sets, spending several nights pouring over the aircrafts' electrical diagrams. Technicians reduced the interference, traced to the ignition harness and the starting booster circuits, by installing ignition hash filters in the aircraft ignition system. By isolating the battery circuit from the main line switch and by incorporating filters in the booster circuits the hash (static) was cut down to a bearable level. The sets ended up re-modified to their original form and now operated at an improved range of approximately 150 miles at 20,000 feet altitude.

Focus Cats
Solid cumulus cloud covered Cherbourg on 8 April 1943. This happened to be the 13th Squadron's 13th sortie. Lt. Dale Shade found occasional breaks in the cloud cover and photographed bits of Cape de la Hague. When he returned with the photos he received credit for a successful mission and added a symbol to his aircraft.

Eyes of the Eighth

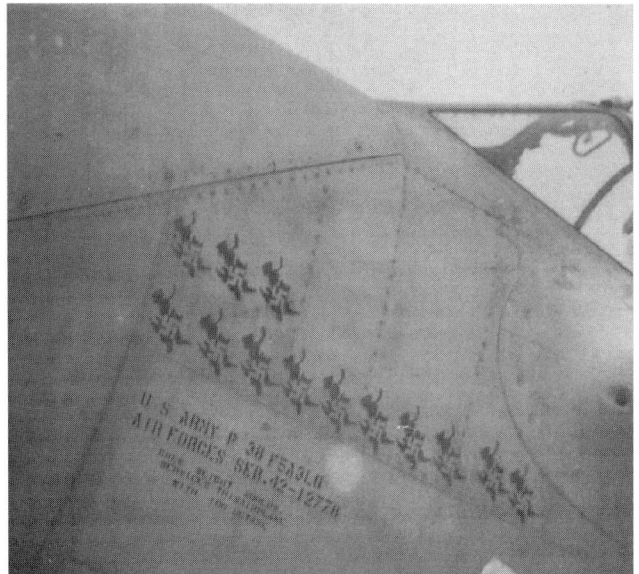

Focus Cat insignia with swastika on F-5 (George P. Simmons)

An aircraft symbol on fighters usually indicated a kill. The stenciled bombs on bombers represented a bombing raid. Unarmed photo aircraft neither dropped bombs nor shot down enemy fighters. Various marks went in and out of fashion on photo planes. On the fuselage of Lt. Dale Shade's F-5, the chosen symbol consisted of a swastika stenciled over a representation of the 13th Squadron's "Focus Cat" insignia. Walt Disney Studios designed the insignia which depicted, on a sky background replete with lightning bolts, a caricature of a black cat, red tongue curled up the side of his mouth in anticipation of a successful pounce upon an unsuspecting target. In this instance his weapon was a winged aerial camera.

Murky sky over Mount Farm on the morning of 12 April 1943 limited operations. By noon the overcast lifted sufficiently for Lt. George Owen to take off for his primary objective, a pin point target at Chateau Briant in France. Thick cloud cut off all view of the ground from 1,200 feet over Mount Farm until Owen flew into broken cloud over the River Loire in France. Unable to locate the small target, Owen, in spite of over 6/10ths cloud cover, managed to get two useful strips of territory totaling 100 miles. On his return he had to fly through solid overcast across the Channel where he landed at the first clear field, Chelveston. He refueled there before continuing on to Mount Farm. Owen had been airborne for three and a half hours.

More "maiden" flights went out the next day including Lt. Telford Byington's. He covered Dieppe, Fecamp, and coastal areas in between. The sortie produced some excellent photographs, the ones of Dieppe the best taken of the port to date. Lt. Robert R. Clark took more excellent pictures of another port, Cherbourg. Strips taken with 6" focal length cameras produced material for a mosaic of the northern end of the Cherbourg Peninsula. Clark covered all five plotted wireless stations in the Cape de la Hague area as well.

On the same day, Lt. Raymond Beckley added to shipping intelligence, his pictures showing, among other things, five sub chasers in the port of Le Havre. While making a run at 27,000 feet Beckley's oxygen system failed and he had to abandon his mission.

Mazurek Missing in Action

One pilot flying his first photo reconnaissance mission on 13 April was not a newcomer to combat in the European Theater. Lt. Raymond Mazurek had 27 operational hours over Europe in Beaufighters with a Royal Canadian Air Force Night Fighter Squadron before transferring on 24 November 1942 to the USAAF. He joined the 13th Squadron on 19 January 1943. Mazurek took off from Mount Farm at 1215 hours and flew a route similar to Beckley's. His target, the Triqueville Airdrome in France. A RAF Fighter Command RDF (Range Direction Finder) Station plotted Mazurek as far as Le Havre at 1315 hours but then lost the plot. The other three pilots flying that day, Beckley, Owen, and Byington, had not reported any enemy action, neither fighters nor flak. When Mazurek failed to return the squadron listed him as MIA (missing in action). When they were notified, Eighth Air Force Headquarters informed the squadron that Lieutenant Mazurek was a prisoner of war in a hospital in Cherbourg.

The Last Original 13th Maidens

Three pilots flew their first missions on 15 April 1943 clearing the roster of 13th Squadron "maidens." Operations assigned Lt. John H. Watts to make oblique photographs with 6" focal length cameras of the Cherbourg Peninsula from 10 miles off shore. Watts took his pictures from 31,000 feet, the highest altitude for operational photos made by the 13th up to that time. Lt. Walter Tooke had similar instructions for obliques of the Le Havre—Fecamp area while the same specifications guided Lt. Herschel Turner to take obliques off the coast at Dieppe. The loss of Campbell and Mazurek tempered the excitement and satisfaction the men of the 13th felt after so many of the pilots had successfully completed their first missions.

Following the Bombers

The first American photo reconnaissance (PR) missions directly following Eighth Air Force bombers covered attacks against German U-boat installations at Lorient and Brest, France, on 16 April 1943. Operations sent two

14

pilots to St. Eval, a RAF forward base on the extreme southwestern coast of England, to refuel for the long flights. Capt. James Wright, flying only the second sortie using drop-tanks, took off from St. Eval at 1615 hours, two hours after B-17 Flying Fortresses of the 91st, 303rd, 305th, and 306th Bomb Groups attacked the power station and U-boat pens at Lorient. Over Morlaix, Wright's F-5's port engine cut out at 24,000 feet. He also reported a dead gyro (gyroscope). Advised to return to base, he released his drop-tanks and returned to St. Eval.

Only five minutes after Captain Wright left, Lieutenant Parsons took off from St. Eval to follow 19 B-24 Liberators targeting a *Sperrbrecher* in No. 7 Dry-dock in Brest Harbor. German defenses put up an effective smoke screen, hindering the attack. Several hours later, when Parsons made his runs over his objective, the smoke had cleared. While going in to the target Parsons sighted two single-engine enemy aircraft considerably below and behind. This was the second reporting of enemy aircraft sightings by returning 13th Squadron pilots.

Photo Lab and Intelligence considered Parsons' photos the best taken to date, revealing almost every bomb crater. The Brest harbor photos also revealed a large *Sperrbrecher* leaving port. (The same ship appeared 30 miles farther west on photos taken the following day on another sortie.) Other pictures clearly showed two airdromes, one of which Intelligence confirmed as a dummy field from this cover.

Target Assignments

In the squadron's Intelligence section large wall maps of the European Theater bristled with colored pins marking targets for coverage. A board of assignments listed requests for photo cover either as regular targets, special jobs, or damage assessment. Regular targets remained on the board. Other targets stayed on only until photo interpreters considered the coverage successful and complete. Often, cloud cover prevented full photography of targets. Photo aircraft returned again and again until the bits and pieces combined to satisfactorily cover the request. Heavy smoke screens and defenses made some targets especially difficult to photograph. Lorient was one of those.

On an almost perfect day for flying, Captain Wright returned to Lorient and attempted to complete his mission aborted the day before. Taking off on 17 April 1943 from St. Eval with full drop-tanks, Wright reached Lorient without incident and made one run over the target before spotting three enemy aircraft. Two of them were about 1,000 feet above and when they turned toward him he released his drop-tanks and headed for home. Wright could not cover the power station but did get photos of the submarine pens and other military objectives in the harbor area.

Lorient

Damage assessment of the bombers' attack on the Lorient power station, on 16 April, remained on the Intelligence Department's assignments. The 13th Squadron had tried twice to get the photos; the RAF Photo Reconnaissance Unit (PRU) at Benson tried once, all three without success. Strategic planners in the ongoing campaign against German U-boats had pin-pointed power stations as vulnerable targets in U-boat installations. The thick concrete pens (covered boat slips), under which U-boats anchored during refitting for new forays in the Atlantic against Allied shipping, protected the submarines from any bombs presently in use by either the USAAF or the RAF. Damage photos would reveal whether more attacks on the target had to be made.

Lt. Ray Mitchell made the fourth sortie to Lorient on 20 April. Taking off from St. Eval, he flew to the target and made three runs over the city. As he made a turn at the end of his third run he noticed about 30 bursts of flak accurate for height but considerably behind. Mitchell didn't know how long the AA batteries had been firing at him. He took evasive action making sudden turns, changing speed and altitude. His runs completed, Lieutenant Mitchell continued flying north from the city, across the Brest Peninsula, his cameras clicking all the way and picking up good photos of Kerlin/Bastard Airdrome. During debriefing back at Mount Farm, Mitchell told intelligence officers about the flak, the first such report by a returning 13th Squadron pilot.

Upon receipt and study of the long-awaited Lorient cover furnished by Lieutenant Mitchell's sortie, Central Interpretation at Medmenham reported, "Pictures obtained are the best thus far from U.S. cameras. Quality is excellent and coverage adequate for detail assessment of bomb damage." In addition to other damage shown on the photos, the interpreters saw at least two hits on the power house which was the target of the bombers. The pictures, taken from 14,000 feet, considerably below the recommended altitude, also revealed three U-boats, three *Sperrbrechers* and several auxiliary craft in the port of Lorient. Intelligence marked 12 "probable" JU-88's on the Kerlin/Bastard Airdrome. The various departments at Medmenham chose the individual pieces of intelligence to fill in their particular daily reports. The airfield section noted the JU-88's. The naval section marked the location of the U-boats and *Sperrbrechers*. The latter's position usually forecast the imminent arrival or departure of submarines or blockade runners. Each sortie furnished a piece of an intelligence puzzle being worked out in Washington and London.

Eyes of the Eighth

Engine Trouble
More problems plagued the F-5 Lightnings. According to overly-optimistic standing orders, no photo recon aircraft should be flown over enemy territory under 24,000 feet; they were considered too vulnerable to enemy anti-aircraft fire below that altitude. Unfortunately, pilots found that the Allison engines suffered early detonation at altitude high enough for normal photo reconnaissance work. Lt. Robert Kinsell, the 13th Squadron's trouble shooter, conducted a series of experiments on overheating carburetors. Unless some correction could be worked out quickly, the 13th feared that Eighth Air Force Headquarters would cancel the squadron's operational status.

The engine trouble proved difficult to correct. The Allison Company sent one of its civilian experts to determine the exact nature and cause of the plane's trouble. He was quite interested in the experiments being conducted by Lieutenant Kinsell, but could offer no ready solution to the problem. He explained that the early detonation and carburetor overheating was common to all the P-38G (F-5A) Lightning models then in use. The intercooler system installed in the leading edge of the wings, cooled compressed air before it entered the carburetors. Unfortunately it did not operate well at high altitude. He added that the same problem existed in other operational theaters, particularly North Africa. Allison engineers thought they had licked the problem in newer models with enlarged air intakes under the engines, but the changes could not be effected in the F-5A in use by the 13th Squadron.

There was another ominous situation also attributable to mechanical problems. Lockheed P-38 Lightning fighter aircraft, faced with the same difficulties of limited capability and engine trouble, could not compete with Luftwaffe fighters. Eighth Air Force Headquarters temporarily withdrew them from combat until newer models became available. The 13th Squadron now had the only operational Lightnings in the ETO. Enemy pilots could attack any of the easily recognized F-5 Lightnings they encountered, knowing them to be unarmed.

Increased vigilance, quick recognition of trouble, and a hasty retreat remained paramount to survival. Within the limitations of their aircraft and weather conditions the photo pilots flew successful missions deeper into German Occupied France, Holland, and Belgium. On 14 May 1943, Lt. Thomas B. O'Bannon completed the longest flight made into France to date, covered Metz and St. Dizier/Robinson airfields (A/Fs) and railroad marshalling yards (M/Ys), as well as the airfield at Crecy-en-Ponthieu.

The following day, 15 May 1943, Major Hall officially, "Received from the Commanding Officer, Royal Air Force Station, Benson, Oxon, the Airdrome, known as Mount Farm, together with all the buildings thereon and all light, heat, power, water and gas required by the United States Army Air Force at Mount Farm, Oxon."

Three days after the loss of Lieutenant Mazurek, line crew waited in vain for another of their pilots. Lt. Telford Byington failed to return on 16 May 1943 from a sortie to photograph four airfields near Paris, France. Until the squadron received word of his fate, he would be listed as missing in action.

First Over Paris
Major Hall became the first American PR pilot to photograph Paris, his targets on 19 May 1943: Le Bourget, Villacoublay, and Guyancourt/Caudron Airfields. Recalled on his first attempt because of enemy fighters in the area, Hall returned later in the day to bring back photos of his targets. The photo lab made a mosaic (contiguous aerial photos pieced together to show terrain) of the city to brief photo pilots before damage assessment sorties to the Paris area after Eighth Air Force raids.

Lt. Telford "Tip" Byington listed MIA 16 May 1943
(George P. Simmons)

16

Telford Byington

Lt. Telford "Tip" Byington took off on 16 May 1943 to photograph airfields near Paris. Climbing out from Mount Farm, Byington crossed the Channel, and passed into German occupied France over the port of Dieppe. Byington activated his cameras, picked up targets of opportunity, then proceeded toward his primary targets. The weather was clear at all four airfields; Creil, Beaumont-sur-Oise, Beauvais/Tille, and Coulommiers. Lieutenant Byington completed the runs, sure his pictures would be the best taken to date. He set course for home.

As he approached the French coast he spotted brown and red marker flak thrown up far ahead of him by German anti-aircraft batteries, which indicated his course to intercepting fighters. Byington turned immediately toward Le Havre, where he gambled there was less opposition. He lost. All he gained was more brown flak ahead. The pilot pushed the throttles forward and crossed out over the coast between Fecamp and Dieppe. Gaining as much altitude as possible, Byington reached mid-Channel when he spotted three Focke-Wulf 190s in pursuit. The F-5's Allison engines began to pop and bang with high altitude pre-detonation. His plane slowed. The enemy fighters closed quickly. Byington maneuvered to avoid the FW 190s' attacks.

The lieutenant dodged and darted away from the fighters, which forced him back toward the French coast. Turning into the attacking aircraft he ran between them heading back toward England. Successful once, Lieutenant Byington again tried a "hammerhead" maneuver when attacked; pushed full power and pulled straight up, then chopped one engine and kicked hard on that rudder. The F-5 winged over and dropped back past the trailing attacker. Cannon fire from the enemy planes put one 20mm shell into the radio behind Byington's seat, striking the armor plate and bending it into the pilot's back. Two more shells went through the F-5's right wing directly ahead of the aileron. Its airflow spoiled, the aileron was almost useless.

The right engine caught fire with the F-5 climbing and almost at the top of the maneuver. Flames came through the control cable tunnel near the pilot's right leg. Byington looked back and saw the red cowling of his attacker over the F-5's horizontal stabilizer. On fire and about to get hit again, Byington jettisoned the heavy canopy. It lifted off the rail, flipped up in the airstream, and flew back into the German's propeller. Thirty seconds later, the FW 190 exploded.

Byington, eased the throttle, killed the burning right engine, and climbed out on the wing. Air pressure forced him against the side of the cockpit. Aware of the danger in a bailout of striking the wide horizontal surface between the F-5's twin tails, Byington hesitated on the wing before jumping. In another type of aircraft he could slide off the wing to fall free before opening his chute. Slipping off the wing of the F-5 would drop him into the box formed by the twin booms and horizontal stabilizer. Often the plane's forward velocity swept the stabilizer into a falling pilot with deadly results. The F-5 spiraled downward turning into its dead right engine. To Byington, the centrifugal force that pinned him onto the wing seemed to push the boom away and offer an exit. He rolled into a ball. Fierce wind blew him off the wing toward the opening between the booms. The horizontal stabilizer swept by inches below his falling body.

The pilot clutched his D-ring and tumbled toward the Channel below. When Byington thought he was low enough he pulled the ring. His chute opened, jerking him with such force his collarbone snapped. A strong NNW wind pushed him back toward the French coast where he dropped into the sea just short of land. His wind-filled canopy blew him through the water and, by pulling on the risers with his good hand, Byington managed to get on the beach where the wet chute caught on dry sand and collapsed. Armed soldiers lined a sea wall, a hundred yards away. Between the American and the wall lay a mine field. Lieutenant Byington dropped his .45 and escape kit discretely in the surf and awaited capture.

For 30 minutes, the Germans shouted orders for the pilot to cross the minefield and he returned shouts of refusal. A German officer finally came down behind a sergeant with a mine detector, took Byington prisoner, and the three retraced the safe footprints. After keeping him in holding cells for several days, the Germans had their medics strap up Lieutenant Byington's ribs and injured arm before sending him by train to Frankfurt and the interrogation center for Allied air crew. For the next three weeks he remained at the Hohemark hospital for treatment prior to transfer to a prisoner of war camp.

Eyes of the Eighth

Lt. Hershell Parsons in F-5 cockpit after mission.
(George P. Simmons)

First Over Germany
On the same day that Major Hall covered Paris, Lt. Hershell Parsons made the longest sortie to date and the first over Germany for a 13th Squadron pilot. Much of the Eighth Air Force bomber effort at this time targeted German U-boat production. On 19 May, B-17s from 1BW and 4BW (Bomb Wings) attacked the U-boat yards at Flensburg and Kiel, Germany. Parsons, assigned damage assessment cover, waited in Operations for information on the targets until 1630 hours. Briefed about the raid, he took off 30 minutes later. Parsons landed at Ludham, Norfolk, refueled, and was airborne again at 1805, climbed on course out over the North Sea to 31,000 feet without reaching contrails.

Contrails, lingering tracks in the sky formed from the condensation that streamed off aircraft at altitude, marked the path of enemy and friend alike. Photo pilots used the contrail level for security when they could. They climbed until condensation began to stream from their planes, then reduced altitude to just below that level. If enemy aircraft pulled a contrail trying to attack from above they would have some warning. Seasonal meteorological conditions caused variations of thousands of feet in the contrail altitude. On this day, Lieutenant Parsons found it high enough to use effectively.

Parsons flew toward his target at 31,000 feet for about 30 minutes. He then began to feel uncomfortable symptoms of bends in his right wrist that disappeared when he decreased his altitude to 30,000. Crossing the enemy coast over the island of Sylt slightly after 1900 hours, Parsons photographed Sylt/Westerland Airdrome and continued on to Flensburg. Fires were still burning after the attack as he was making his first run over the target. "I noticed a few bursts of flak very low and a good distance behind." He completed his runs over Flensburg and set course for Kiel. Spotting a large vessel with smaller ones alongside in the harbor at Eckenforde, he made a photo run and received six to ten bursts of flak, again below and behind.

Smoke and flames marked the great port of Kiel. Parsons began his first run over the U-boat yards when he noticed the smoke increasing rapidly due to activated smoke screens. The Germans threw up a heavy, intense flak barrage directly behind and slightly below but becoming more accurate both in direction and altitude as the photo run continued. "I finished the first run and changed altitude 1,000 feet approaching the target from a different angle," Parsons reported. The flak batteries opened up again with accurate altitude, still behind but closer. As he completed the run the flak burst close enough behind and to starboard to affect the altitude of the plane. Parsons started evasive action by changing altitude and direction frequently. He headed westward toward the North Sea. When he looked back at Kiel, the sky seemed filled with black puffs from bursting shells.

On the return flight he made two photo runs over Heligoland Island, which had been attacked by Eighth Air Force bombers on 15 May. Anti-aircraft batteries at Heligoland fired inaccurate flak, a welcome 5,000 feet below, and considerably behind. Parsons landed at Mount Farm at 2140 hours.

Studio Portraits
In May 1943, CWO Charles E. Bresee, 13th Squadron Photography Officer and a 14-year veteran Air Corps aerial photographer, set up a station portrait studio. With the help of Sgt Early Thompson, the chief warrant officer constructed a camera around a 24-inch lens from an aerial camera salvaged from a crashed photo plane. They made numerous modifications arranging the elements and shutter mechanism, building a highly satisfactory portrait camera. For a background they stretched a bed sheet tightly over a frame and stenciled it with aircraft silhouettes using soot from a stovepipe. The original idea for the studio had come as a result of requests of friends and relatives for photographs of pilots killed or missing in action. At first, men, probably hesitant about the studio's macabre beginning, literally had to be dragged in to be photographed. In time, Bresee's and Thompson's excellent work, which could be used for less grim circumstances, created a thriving portrait business.

As the month drew to a close, Lieutenant O'Bannon made a flight on 28 May 1943 to get damage assessment photographs of Wilhelmshaven, which had been bombed

by the Eighth Air Force on the 21st. He also photographed Jever and Wangeroog Airfields in Holland. The month ended on a high note when the 13th Squadron's commanding officer, Major Hall, received his promotion to lieutenant colonel on 31 May 1943.

June 1943
During June the Eighth Air Force's bombers continued to attack German U-boat installations in France and Germany. Whenever weather permitted, the 13th Squadron sent aircraft out to cover targets. Operations ordered two sorties on 3 June. Capt. George F. Owen flew one for damage assessment of La Pallice, France.

Second Bomb Wing B-24 Liberators attacked the U-boat facilities at La Pallice on 29 May and as yet there was no photo cover of the damage. Captain Owen flew from Mount Farm in 10/10 cloud cover south over France until just below the Loire River near La Rochelle where the clouds began to break up. Owen could not see La Pallice, which remained covered by clouds. Without recognizable landmarks and not sure of his position, he flew around and tried to find holes in the clouds. Just about where he thought La Pallice lay under the clouds, German fighters intercepted Owen, who made a run for home. After crossing the English coast and very short of fuel, he landed at the Selsey Landing Ground, the first available airfield. He refueled and returned to base.

Turner and Brogan MIA
Whenever weather permitted, the 13th Squadron flew sorties covering various targets. Operations scheduled two for 11 June. Lt. Herschel Turner took one of these, a sortie into Germany covering targets planned for attack by Eighth Air Force bombers within a few days. As the hours passed and Turner became long overdue, the 13th Squadron waited again for word on the fate of one of its pilots.

Five sorties were flown during the next week. Weather prevented Capts. Vernon Luber and Robert Brogan from taking off on missions to photograph damage assessment (D/A) of U-boat yards at Kiel, Bremen, and Vegesack on 18 June. Clear weather two days later allowed both pilots to attempt coverage of their targets. Captain Luber returned with photos of the U-boat yards.

Brogan refueled at Ludham, taking off at 1815 hours on a course toward his targets at Bremen and Vegesack. RAF Controllers last reported his aircraft, F-5A-3 number 42-12779, flying approximately 75 miles north of the Frisian Islands with weather clear to 20 miles off the coast and 10/10 cirrus at 25,000 feet. They plotted him on course until out of range. When he failed to return, squadron Operations listed Brogan as missing in action.

Later the 13th Squadron learned Brogan had been killed in action but there were no details.

22nd Squadron Joins Operations
A new photo reconnaissance squadron began operations on 24 June 1943 when the 22nd Squadron flew its first combat sortie. (See Chapter 2) The 13th flew four missions to France on the 24th and four more on the 25th. The 13th and 22nd squadrons dispatched nine aircraft on 26 June, one, piloted by 13th Squadron's Lieutenant O'Bannon, for photos in the Paris area. Three F-5s were dispatched to France on the 27th; another three, on the 28th. Over a week had passed since the loss of Lieutenant Brogan. Another squadron shared the work load with more help to come.

Kinsell and Shaffer MIA
On the morning of 29 June 1943, Lt. Robert Kinsell took off to take D/A photos of the lock gates and port area of St. Nazaire, which had been bombed the day before by B-17s of the 1st Bomb Wing. Plotting Kinsell by RDF (radio direction finding) at 1015 hours south of Cherbourg, the RAF controller reported that a German radio conversation had been picked up in which it was heard that an aircraft had been brought down in the area of Kinsell's track, and that a parachute had been seen opening. When Kinsell failed to return he was listed as MIA.

The same afternoon, Lt. John Shaffer took off to cover the St. Nazaire targets. The RAF Fighter Command controller's RDF plot tracked him across the Brest Peninsula and fixed him heading south over water southeast of Brest at 1515 hours when he passed beyond plotting range. Again it was reported at the time, as in Kinsell's case earlier in the day, that a German radio conversation had been picked up saying that an American aircraft had been shot down. When Lieutenant Shaffer failed to return he also was listed as MIA. It took several weeks for Eighth Air Force Headquarters to confirmed that Shaffer had been killed in action. There was better news about Kinsell, who was a prisoner of war.

A Dangerous Target
The targets that caused the loss of two 13th Squadron pilots remained marked with "active" pins on the wall maps in Intelligence. They were important ports for many reasons and were heavily defended. All combatants used the oceans as a lifeline of transport, carrying vital food, war supplies, and fighting men. This lifeline, if broken, was enough to affect the course of the war. All the will, determination, bravery, and skill would count for nothing without the means to wage war effectively. The

Prisoners of War

The Eighth Air Force bombers planned to attack U-boat yards at Bremen, Germany on 13 June. VIII Bomber Command requested pre-attack photos of the target. Operations assigned targets in Vegesack, Bremerhaven, and Bremen to Lt. Herschel Turner on 11 June 1943. Turner left Mount Farm flying NNE past Cambridge, over the fens and marshes of Norfolk, by the body of water known as "The Wash," and out across the North Sea. When he reached Bremen, intense flak prevented Turner from flying his pattern. Six Focke-Wulf 190s bounced him as he turned to go to Bremerhaven. "I got shot up, pretty bad, lost an engine, was heading north." Turner realized he might not get picked up in the North Sea. He turned back toward Germany. Just over the North Sea coast, he bailed out at 2,000 feet. German civilians, feeling no fear of one lone plane, watched from nearby farms to see if the single aircraft would be brought down by their fighters or anti-aircraft fire.

Rewarded on this occasion, the civilians captured Turner and fortunately turned him over to military authorities without taking any revenge. His captors treated the American pilot in a local hospital for shrapnel wounds in his shoulder and one leg, then sent him to a larger hospital. Turner remained there for almost three weeks while his wounds healed.

After his release from the hospital, German Luftwaffe guards took Lt. Herschel Turner to *Auswertestelle West*, their air crew interrogation Center at Oberursel just outside of Frankfurt. Turner, a large man, had barely enough room to stand in his tiny cell. In almost total isolation, he had to press a signal lever in the wall next to the door to alert the guards when he needed to use the bathroom. Never allowed to see or talk to one another, when one prisoner was out of his cell all others remained behind closed and locked cell doors. On one of Turner's walks down the long silent hall to the bathroom, he saw a familiar name on one of the closed doors, Kinsell. Turner never saw Kinsell and in a few days the Germans transferred Lieutenant Turner to the nearby hospital at Hohemark to receive treatment for his injured leg now stiffened by the close confinement. Turner returned to Oberursel for interrogation, then went to Stalag Luft III at Sagan in Silesia, east of Berlin.

Lt. Herschel Turner carrying his parachute and dinghy. Listed missing in action 11 June 1943. (Weeks)

means had to be transported over the sea in vulnerable ships. In World War I the Germans attempted to use U-boats to break the lifeline. Now, with continually improving submarines, equipment, and tactics, they set out to destroy, particularly in the Atlantic, this lifeline between the United States and its allies.

In Germany's battle for the Atlantic and the sea war across the world's oceans, St. Nazaire, La Pallice, Lorient, Bordeaux, La Rochelle — major ports on the Bay of Biscay — held great importance. German raiders and U-boats ranged thousands of miles from their bases, many of which were in the Bay of Biscay, wrecking havoc upon merchant and military ships. Allied merchant ships suffered massive losses. In spite of the frequent breaking of the German Enigma codes by the British, and the subsequent reading of its revealing traffic, (See Appendix), especially the U-boat (Shark) Enigma, there were gaps in the intelligence needed to cripple U-boat operations. Dr. R.J. Overy, in his book *The Air War 1939-1945*, states that, "the shipping losses of 1942 and the first half of 1943 were so severe that the Atlantic Battle assumed a significance much greater than the Allies had initially expected, or for that matter Hitler himself."

Bomber Command decided that it was better to meet the U-boat threat by attacking sources of production such as the U-boat yards at Emden, Wilhelmshaven, Kiel, and Vegesack, Germany, rather than the end product at sea. It mounted attacks against the bases along the French Atlantic Coast in hopes of disrupting supply and repair.

It's efforts, including those of the Eighth Air Force were not successful in destroying the U-boat bases. At some targets bombing caused severe damage in the areas near the submarine pens but no penetration of the enormously thick concrete roofs of the pens themselves. The Allied high command worried about the destruction and danger to the French populace near these installations. Nevertheless, bombing continued in the belief that support facilities, communications, power stations, the ports themselves, lock gates, supply storage, and transportation were vulnerable and, therefore valid targets. This must have been the conclusion of the Germans as well because they reinforced the already heavy defenses by even heavier concentrations of flak batteries. Allied air crews would pay a high price.

New Command – New Commander
Colonel Hall relinquished command of the 13th Squadron on 7 July 1943 to take over as C.O. of the newly-formed 7th Photographic Reconnaissance and Mapping Group. Captain Wright went to the Group as Operations Officer. Capt. Hershell Parsons became the new Commanding Officer of the 13th per order number 1 of the 7th Photographic Reconnaissance and Mapping Group, dated 7 July 1943.

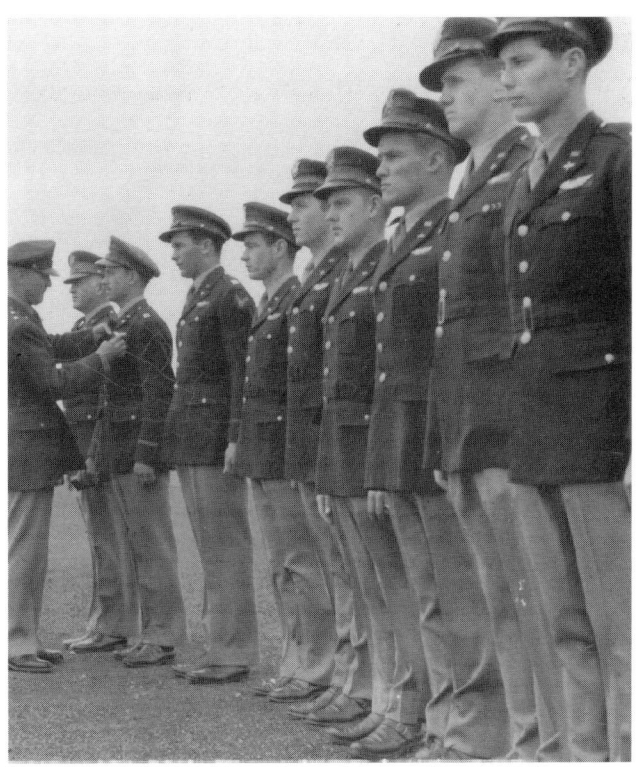

General Eaker presents Air Medals to L to R; Col. James Hall, Capts H.E Parsons, James Wright, Ray Mitchell, Vernon Luber, and Lts Thomas O'Bannon, Howard Neilson, John Shaffer, and Robert Kinsell. (George P. Simmons)

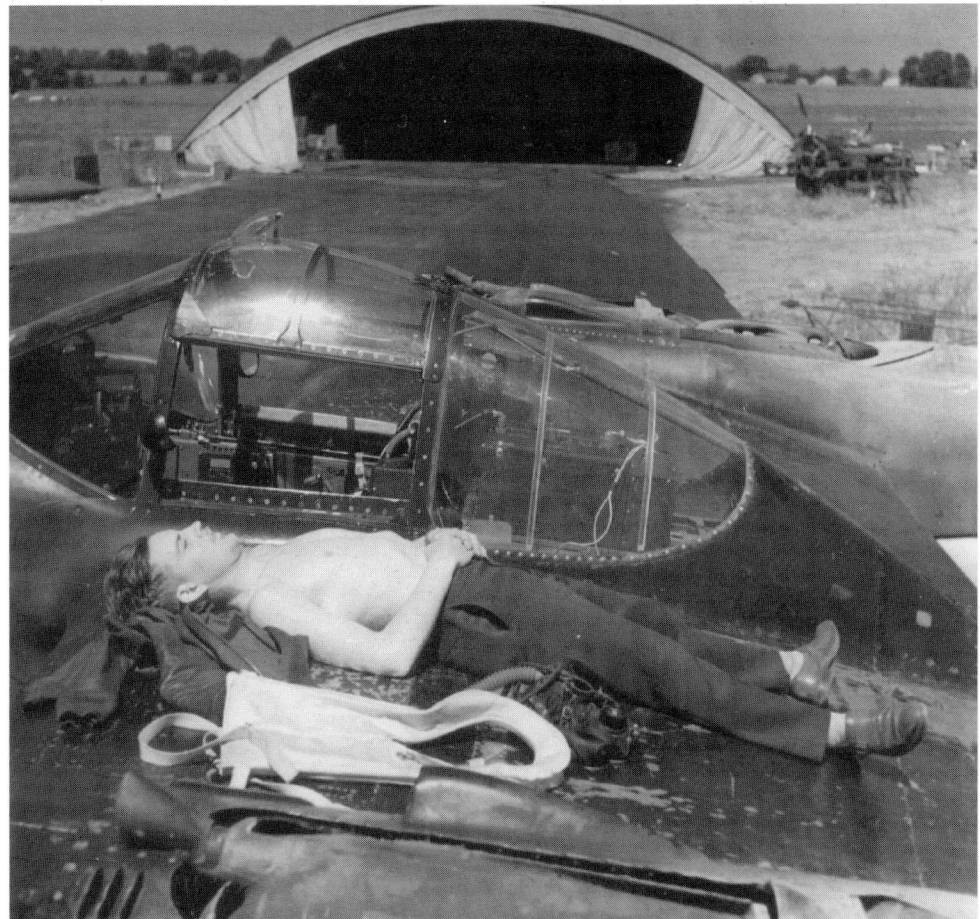

Lt Thomas O'Bannon enjoys a quiet moment on a warm and sunny July day in the 13th Squadron dispersal area. O'Bannon lies on the wing of his F-5 with his Mae West life jacket, helmet, and oxygen mask at his side. His heavy flight jacket serves as a pillow. The pilot seems ready to fly a mission if needed. In the foreground and just beyond the cockpit are the turbo superchargers. In the background is an Over Blister hanger, a curved steel frame covered by corrugated steel built over a hardstand. The canvas curtains pulled back on either side of the opening can be closed for some shelter in bad weather.
(Roger Freeman)

Chapter 2
The 14th Photographic Reconnaissance Squadron
20 June 1942—7 July 1943

The Army Air Force's Photographic Operational Training Unit in Colorado Springs activated the 14th Photographic Reconnaissance Squadron on 20 June 1942 by a confidential letter announced in General Orders Number 4. Second Lt. Richard W. Willis became its first Commanding Officer.

Virtually a paper organization, the 14th Squadron, like many of the squadrons being formed in the Army Air Force (AAF) at this time, consisted of a few officers assigned to hold the squadron number. The squadron occupied part of the Kaufman Building on South Tejon Street in Colorado Springs until completion of the new Army Air Base. The men, sharing with personnel of the 7th Photographic Reconnaissance Squadron (Training), slept on the second and third floor, and the rear half of the first floor. Headquarters for the two squadrons occupied the front of the first floor with the Supply Departments using space in the basement.

Lt. W.C. Kator, Jr., commanded the Squadron Intelligence Section (S-2) until 11 July, when Lt. James D. Mahoney took over as S-2 Officer, Kator being assigned assistant S-2 with additional staff duties. While newly-activated squadrons responded to changes in their staffing, they awaited some permanent core of enlisted men. The squadron at this time did not possess any aircraft, flying field, nor activated training program. As a result the officers reported for duty each morning at 0800 hours and remained, virtually without duties, until 1730 hours.

The personnel who would make up the first real cadre of officers and men remained in other squadrons or training units. Many of the enlisted men who would soon be members of the 14th Squadron were, until 18 July 1942, in the 12th Photographic Reconnaissance Squadron of the 3rd Photographic Group. On that date, the two squadrons made an almost complete personnel exchange. The 14th Squadron moved out to the newly-completed Army Air Base on 1 August, set up its various departments, and started its training programs.

The Army Air Force classified enlisted personnel according to training received in short-term specialists schools. When assigned to the 14th Squadron, these men usually filled positions they had trained for. Housekeeping jobs of the squadron took the unclassified men. The S-2 section also drew from the unclassified pool. At this time no school existed to train enlisted personnel for S-2 work. For Intelligence to function successfully, the enlisted men had to be chosen and trained carefully. This gave Lieutenant Mahoney, the squadron's S-2 Officer, double or triple duty. He also had to sell the commanding officer on what his department could do for the C.O. and how S-2 could assist in training the pilots.

F-4s and B-25s
The pilots assigned to the 14th flew as often as possible to gain experience in the F-4s (P-38E). Just as for other squadrons using this twin-engine, single-seat aircraft, the B-25 Mitchell substituted as a training plane. An instructor flew with the new pilots to help familiarize them with the landing gear and twin-engine operation of the F-4. Even so, there wasn't a practical way to demonstrate the perils of loss of an engine on either take-off or landing. Counter-rotating propellers made the P-38 particularly unforgiving when turning into a dead engine. Pilots learned what to do and how to do it but some circumstances prevented any recovery from such an emergency.

Peterson Killed
The 14th Squadron lost one of its pilots on 8 August 1942. Just after 1st Lt. Edward J. Peterson, Jr. lifted off for a flight to Wright Field, Ohio, one engine failed and his F-4 crashed on the runway. The station crash crew rushed to the burning plane and, in spite of suffering burns themselves, pulled the pilot out. Although still conscious when rushed to Glockner Hospital, the 24 year-old pilot from Englewood, Colorado, later died from his injuries.

While engineers built new runways and operational facilities at the small Colorado Springs municipal airport, the Army Airbase needed working space for its office personnel. Just as other Army Air Force's operations, classrooms, and billets occupied temporary space in college buildings, fraternity houses, and hotel rooms, the airbase personnel found space in this building at 327 Pikes Peak Avenue for their headquarters.

Borgerding Killed

One of the many Army Air Force (AAF) personnel quartered at the Antlers Hotel, 2nd Lt. William H. Borgerding became the second 14th Squadron casualty while on a local training flight. Witnesses saw his F-4 in a flat spin before it crashed at 1600 hours on 16 September 1942 about two and a half miles east and slightly south of the airbase.

Mass Transfer

A second major transfer effected the final composition of the 14th Squadron. Another photographic squadron, the 17th, had been activated on 23 July 1942 and assigned to the 4th Photographic Group. The 17th Squadron retained a cadre of officers and, on 18 October 1942, transferred the enlisted men en masse to the 14th Squadron. Capt. John L. Foltz took over as Commanding Officer with 2nd Lt. James M. Kendrick his executive officer. The new Adjutant, 2nd Lt. Ernest P. Spaeth, had been in the 14th for some time before the big transfer. In Squadron Headquarters, rosters had to be made, status reports changed, and endorsements put on service records of the enlisted men. The staff had its hands full. Sgt Joe G. May, the new Sergeant Major, and Pfc John M. Neff supplied the new squadron with special equipment: scissors, staplers that worked, pencil sharpeners, and other little items carefully accumulated in the 17th Squadron. Acting 1st Sgt Jules Peskin directed the move and took care of 20 enlisted men who had just been transferred to the 17th before the move over to the 14th.

The squadron moved to a new location at the extreme southern end of the Colorado Springs Army Air Base. Captain Foltz and his staff began the organizational training of the new 14th, which now included 23 pilots.

Photo Lab

In the Photo Lab Department, which occupied the smallest building on the entire field, over 50% of the men had just completed Photographic School at Lowry Field in Denver. The others had served in the old 6th Training Squadron. Soon after the move the squadron added more men to bring it up to strength; Photo Lab received their share. Lt. Alan A. Buster took over the laboratory with Lt. Richard H. Brunell as his assistant. Pvt Everett W. Hoagland, a member of the old 14th at the time of the transfer, received permission to stay in the new squadron with his brother, Harold.

Squadron Mess

The confusion caused by the juggling of men and departments during the formation of the 14th upset organization of the squadron's Mess. At first, the 14th's men ate in the 7th Photo Reconnaissance Squadron's Mess Hall. Then, a week later, they moved to the 10th Photo Reconnaissance Squadron's Mess. Two more weeks passed before they moved to their own building on 26 October 1942. Lieutenant Kendrick, the Mess Officer, and Mess Sergeant Andress Dickey found their new mess hall modern and good to work with. They used china plates instead of the usual stainless steel trays. At Thanksgiving and Christmas, the staff served turkey dinners with all the trimmings on tables set with white linen. Although he served under five different mess officers while at Colorado Springs, one enlisted man, Pvt Maynard Duquette, remained with the department, progressing up through the ranks.

Setting Up

The switch in squadron personnel affected every section. Bernard T. Wendel, Eugene Thielen, and James W. Thompson from the 17th Squadron, joined by 15 men from Scott Field, made up the 14th Squadron's Communications Department. Previously, the three men had been doing the line work in the 13th and 15th Squadrons. However, little work could be accomplished due to the limitations of material and aircraft.

The Springs area offered many diversions but communications men concentrated on horseback riding due to their resident instructor, Pete Barendrest, a former polo pony trainer. Thompson, W.F. Black, and Warren W. Binder took him up on lessons in countryside made for riding, which became a popular pastime.

In a few days the department had its own operational aircraft, with Lieutenant Bernheim in charge and crewed by Eugene Thielen. With just one incomplete tool kit between them, the men started servicing the aircrafts' radios and other directional equipment in limited working facilities. Divided into two shifts under the control of Thompson and Leo Smith, they took care of all the work on the ships. Harold Brady, Alex Raith, G. Smith, and Howard E. Weddle operated a field unit from a truck.

Lt. Robert M. Roberts commanded the Supply and Transportation Departments until January 1943. Lieutenant Spaeth replaced him and three weeks later left to await orders for flying school. Second Lt. Anthony U. Steiert, who previously served as the Base Supply Officer (S-4) for six months, transferred from the 373rd Air Base Squadron to the 14th Photographic Reconnaissance Squadron, and assumed command of the Transportation department on 2 February 1943. On the 3rd, Steiert assumed the command of Supply as well.

When the 17th and 14th Squadrons switched personnel, the Engineering Department had no aircraft and still

Eyes of the Eighth

carried the 17th Photo Reconnaissance designation. Most of the mechanics, fresh out of Aircraft Mechanics School, lacked the experience to crew aircraft. To give the men the necessary experience, the entire department went on temporary duty with the 6th Photo Squadron. Here, under the hard-boiled old 6th Photo Line Chief, MSgt Piffer, the men gained plenty of practical experience which helped the department begin independent operation with surprisingly little confusion when the time came.

Battered Wrecks and New F-5s
The squadron received its first group of F-4s on 15 October 1942. They were the most battered wrecks on the airfield at that time. Each plane had at least one flat tire. Obviously unsafe for flight, it became questionable whether the planes could sit safely on the ground. Before making them flyable, the 14th Squadron Engineering Department had to put the aircraft in condition to stand on their own two wheels instead of jacks.

Engineering counted its aircrafts' hours in the air as proof of achievement. Although the men repaired the tires and worked hard to get some ships into the air, they had few flying hours to show for all the maintenance performed. A few weeks later, those old F-4s went to another unlucky squadron and the 14th received several F-5As (P-38Gs) in exchange. With new aircraft in the squadron, the total weekly flying hours leaped to new records and the mechanics finally saw the results of good maintenance.

The line crews, newly formed and mostly inexperienced men just out of school, caught on and progressed quickly. During its stay in Colorado Springs, 14th Squadron Engineering's mechanics inspected and placed over 35 F-5 aircraft on operational status. The department's aircraft amassed a record 235 flying hours in one week, the highest mark yet reached by a photo recon squadron at that station.

Through the training period at Colorado Springs, the 14th's Engineering Department shifted personnel to gain just the right teams to process the squadron's aircraft. Unfortunately, just as soon as a crew chief had a new plane in flying condition with a few flying hours on it he had to send the plane to another organization and start all over again on another new aircraft. This procedure discouraged the mechanics, but in the long run they benefited from the extra experience.

The Training Program
The S-2 Section believed training should follow a strenuous line to prepare the squadron for operations overseas. The general program for the 14th Squadron's pilots included checking out in a B-25 and P-38. After flying ten or more hours in the P-38, pilots began flying an assigned photo mission on each flight thereafter. The missions covered strips of highways and railroads from specific start and stop points, pinpoints of railway junctions, marshalling yards, choke points, and bridges. Mapping specific areas, they covered cities and airfields by parallel and criss cross runs.

The pilots learned to figure out their own navigational data for these missions. By inspecting the processed film and prints, they checked for details of the coverage; if they had achieved the desired scale, and overlap required for the mission. Although camera technicians set the cameras for light conditions of the targeted area and time of photography, the pilots learned these proper camera settings. All lessons learned at this stage of their training advanced the pilots' chance for successful photo coverage of their assigned targets in future operations.

Intensive training started immediately. Pilots accumulated flying time in the F-5s and practically lived in the Link Trainer. At the beginning of the training period the pilots had an average of 30 hours in F-4s and 5s with eight hours in the Link. They started with the usual two-hour local flights near Colorado Springs, advancing to longer cross-country flights. On the latter, if a return flight could not be made on the same day, ingenious pilots found ways to stay overnight at cities known for nightlife or some special attachment. Kansas City held a great attraction for some pilots and appeared frequently on the situation board as an overnight stop. On the 15th of November, Lt. Walter Weitner flew to New York non-stop in a squadron record time of five and one-half hours.

In December, Base Intelligence chose the 14th Squadron to fly a mock operational mission over "enemy" lines near Pueblo, Colorado. The pilot, briefed before leaving by hordes of S-2, found more hordes waiting to interro-

Lt. Whitehouse buzzes the camp. (Paul Campbell)

24

gate him on his return. Intelligence considered the mission, carried out in much the same way as the real thing, successful. Several more similiar missions achieved equally good results.

Base Intelligence underwent Field Condition Training in December. Officers from the Base Photo Section who accompanied Lt. Alan Buster, oversaw the careful camouflage of the A-2 Photo Trailer and equipment set up near a small brook in Cheyenne Canyon. Except for some minor mechanical difficulties, film processing and printing went according to schedule. Fixing these small malfunctions taught the men to be ever on the alert for breakdowns, which could ruin the processing of the film, and taught them which parts could be expected to cause trouble in the future. The squadron declared the exercise a success.

A Special Assignment
Orders came down in December from the Director of Photography in Washington, D.C., requiring every pilot to fly a perfect strip from Denver to Pueblo, Colorado. The 14th's Photo Lab believed their reputation for the best work on the field got the squadron the special assignment. The pilots flew their routes and waited for the Lab men to do their part. With the photographs developed and plotted on maps laying out a flight "footprint" (a path across a map made up of an outline of each photo drawn in sequence), the squadron's pilots learned that, although a few crooked plots appeared, on the whole they did very well. Other squadrons and students at Lowry Field used thousands of prints made from sortie 63, an almost perfect photo recon flight, for training purposes. The 14th received high commendation for its work.

Christmas
Christmas arrived and the squadron commander, Captain Foltz, gave half of the men leave to go home for the holiday. The C.O. authorized a few personal cross-country flights, some of which became extended beyond the usual limits. Everyone always had good reasons: weather, mechanical problems, extenuating circumstances. Lieutenant Whitehouse became stranded in Louisville so long he appeared to have acquired a southern accent by the time Lt. Kermit Bliss got down to rescue him. Lt. Robert C. Alston had some mysterious trouble getting away from Atlanta and Lieutenant Reardon crash-landed at Muroc, California. Kansas City again appeared frequently as an overnight stay on the operations board. After Christmas, Operations ordered unpopular four-hour local and triangular cross-country flights to increase flight time experience. Everyone now remained at the base overnight instead of more glamorous places and the pilots became fairly sick of the local countryside.

The New Year, 1943
The new year arrived. An assignment came in to the 14th Squadron, a job of mapping a large area of Texas down near the Mexican border. Operations, and Intelligence sent out photo ships to begin the mapping. Several successful flights had been completed with good results when, suddenly, without explanation, the squadron received orders canceling the assignment.

In preparation for its anticipated move overseas, the squadron continued to shift and transfer personnel seeking the best allocation. Through the month of January 1943, Lt. Walter Weitner took over command of the squadron while Captain Foltz recuperated from surgery. On 9 January, promotions elevated the squadron's staff sergeant pilots to fight officer. Applications for Officer Candidate School (OCS), aviation cadet, and other transfers, kept the Headquarters Section deep in paper work. Lt. Nicholas Sary transferred from the 7th Photo Squadron to become the 14th Squadron's Communications Officer.

In early February there were promotions in many departments. Promoted to corporal in November, John Neff became, according to the office staff, "the Acting for the Acting for the Acting 1st Sergeant" after 6 December 1942. In February, 1943, he became Sergeant Neff and the squadron Sergeant Major. John Mates, of the Orderly Room, who had come to the squadron as a private from Fort Logan Clerical School, made private first class in November, and had been promoted to corporal by February.

Wind and Sand
Occasionally, strong winds plagued the airbase located on the western edge of the Colorado Prairie. The winds seemed to blow everything into the 14th Squadron's area including the sand on and around the airbase. This sand-blasting damaged the equipment in the Photo Lab and filtered into the tiniest places. The winds played havoc with tenting used in conjunction with the Lab's A-2 Trailers set up on the base. Lab personnel battled the wind to save the tents. Finally, after many struggles, the men, wearing gas masks for protection from the sand, succeeded in saving the canvas and getting it safely stored away. Each time a sandstorm blew in they had to fight the elements all over again.

Changes
The Photo Lab lost several of its men before the big move came. Two of them, Lt. Richard Brunell and Private

Morel, left for cadet pilot training. Capt. Samuel A. Thomas came from the 6th Photo Squadron to assume command of the squadron laboratory. He brought Sgt Joseph T. Conrath with him as the new Lab Chief. Lieutenant Buster remained with the lab and worked with the Camera Repair Section.

On 2 February 1943, Lt. Tony Steiert took over as Transportation Officer and set about improving the qualifications of his men. He made arrangements with the Base Transportation and Base Ordnance Officers for all 14th transportation men to train two weeks in maintenance. The men learned how to change and rebuild engines, overhaul, and service all vehicles. They also learned how to assemble all types of engines and vehicles.

Having taken over the Supply Department at the same time and having found it in a muddle in spite of the hard work of the men, Steiert set about putting things right. On his first day he announced, "Corporal Washmon, you can lock the front door for the rest of the morning. Before we can do anything else we have to straighten out this office so we can see what we are doing, so let's roll up our sleeves and go to work."

And they went to work. Lieutenant Steiert, Sgt Nathan Weisstein, Cpls Roland M. Gephart, James F. Washmon, and Pvt Richard R. Alix turned the chaos into order. They arranged and properly filed all circulars, regulations, memorandums, requisitions, shipping tickets, vouchers, correspondence, bulletins, orders, and every other paper item. Before the day was over the office, at least, presented a business-like appearance.

With this done, preparations continued for shipping the squadron overseas. The squadron C.O., Captain Foltz, introduced Lieutenant Steiert to key personnel in all the departments. Foltz stressed that any department short of any inventory must get its lists ready and everyone must help out the four men in Supply who could not do the job alone. Not much time remained to get ready; the men didn't know it yet, but their orders would come in three days.

Orders and Re-designations

The squadron had been on Warning Orders since 22 December 1942. Movement Orders came on the 5th of February. To increase confusion, four days later the squadron was re-designated the 14th Photographic Squadron (Light), the Reconnaissance being dropped according to some Headquarters wag, "because no one could spell 'reconnaissance'." That same day, newly-promoted 1st Lt. James Kendrick led the squadron in the Post Parade and Review.

By the time the flight training program came to an end in the middle of February, the pilots averaged 160 hours of F-5 time and 35 hours in the Link Trainer. All had their instrument cards but experience would prove the pilots needed more training in instrument flying to fully prepare them for the fickle weather of the European Theater of Operation. Flight training in the high clear air of Colorado, with its preponderance of good flying weather, did not offer enough bad weather experience. Safety prevented practice flying on instuments in such weather in any case. Time under the hood of the Link remained the only safe way to practice. Actual experience would come in the theater.

Instructors placed very little stress on high altitude flying, although the pilots passed the High Altitude Pressure Chamber Test at least three times. The program also relegated to a secondary role two other critical requirements for the lone photo pilot, navigation and actual picture taking. Without a clear vision of combat requirements for photo reconnaissance, planners in Washington had not developed a program preparing photo pilots for the conditions they faced. Training did not fully reflect the conditions of combat flying in Europe.

Black Forest Bivouac

The squadron went on bivouac from the 18th to the 25th of February. With full field equipment the men marched 20 miles north from the airbase to the area known as the Black Forest. During the rest stops, they gathered in small groups by the side of the road and exchanged opinions of what might be in store. Any of the men who could not make it all the way on foot got a ride to the campsite in trucks and had their blistered feet tended to by the medics. The cooks had gone out ahead of the regular group and had a hot meal prepared in short order. When the men arrived, a brief rest and then the usual chow-line rush revived their tired spirits. There would be plenty of time after their meal to find suitable sites for pitching tents.

Supply personnel did not move to the Black Forest but remained at the field packing equipment. The overburdened Supply Department schedule now included the added burden of supplying tents, cots, bedding, field and field mess equipment. These were ready for the men when they reached the bivouac. Soon a camp formed in the forest and before too long signposts sprouted on tents and nearby trees proclaiming, "Frozen Inn," "Withering Heights," and "The Antlers."

After the evening meal, men scouted the area for wood for a bonfire. With tents set up and work over, they gathered around the fire for a song fest and bull session. The severe cold hit them as soon as the men left the fire and most of them slept in their clothes to keep

Winter Bivouac in the Black Forest (Paul Campbell)

warm. As time went by, wood-gathering to keep the fires going took up a large portion of the mornings and afternoons.

To build latrines, Lieutenant Buster had the men build fires to soften the frozen ground. After they dug the slit trenches, they placed canvas backgrounds at the most conspicuous spots. Although inconvenient and drafty, the arrangement worked successfully.

Freezing

Tacked to a tree outside the Orderly Room tent, the dreaded KP and guard duty roster drew anxious, finger-crossing soldiers each day. In that bulletin lay their fate for the following day. While on bivouac, Pvt Elmar Rivers helped morale by holding Mail Call around the bonfire. Letter writing became a challenge. With fires not allowed in the tents, pens worked sluggishly if at all. The clerks in the Headquarters tent tried to keep their fingers from freezing in the sub-zero weather and to get enough heat to operate the typewriters while typing morning reports and other paper work. Two of the Orderly Room staff, both qualified as paratroopers before joining the 14th Squadron, Cpls John Mates and Edward Fergal, invented a small charcoal burner. To make charcoal, the two men burned wood then splashed water from G.I. cans on the hot wood coals to stop the burning, thus making charcoal. They made gallon fruit cans into containers, gathered these coals and burned them in the bottom of the cans.

The bonfires proved to be the most effective way to combat the intense cold. The men spent the evenings sitting around the roaring fire. Everyone did his part to help entertain. They enjoyed the singing, especially solos by William R. Nerbovig, Albert Arrieta, and Alfred Ward.

Bivouac conditions tried the ingenuity and patience

Smoke rises from fires softening frozen ground for the latrines. Canvas screening on right. (Paul Campbell)

Eyes of the Eighth

Singing around the campfire. L to R, Patsy Piscitelli, Gordon Lombard with accordian, Sam Fredo, and Albert Arrieta singing. (Paul Campbell)

of all departments. Keeping hot meals hot in the freezing weather frustrated the cooks. The Mess Department kept the men fed even though the cooks had little experience with the gas pressurized stoves. Stories abounded of artic-like difficulties including one "it was so cold" tale about pancakes. It is said that on the few mornings the Mess tried to serve hot cakes, it was so cold that by the time the men passed through the always eager chow-line they had to use an axe to chop the frozen pieces off and melt them over the fire to eat. Water meant for cooking froze and it was a challenge to drink coffee before it froze in the cup.

The aircraft mechanics and men from Camera Repair left every morning to service the planes and do other jobs on the airfield. They returned to the bivouac each evening to spend the night in tents. Men performing duties back at base missed the daily adventures of the rest of the squadron out in the forest where daily hikes to nearby towns and ranches occasionally resulted in the learning experience of "finding camp when you are lost."

Making Do
One of the main objects of the trip was to gain experience developing film under adverse conditions. Sgts Irvin Carr and Joseph Conrath took charge of film taken by the photo planes and driven up from the airbase to the bivouac area by truck. They developed the rolls in the Photo Lab tent, passing them outdoors for washing and drying. To dry the film, they stuck four poles in the ground forming a square and wound the film horizontally around them. The more experienced the men became with this primitive arrangement the fewer nicks and digs appeared on the finished product. The system worked surprisingly well.

A tent, used as a dark-room, had small light leaks, which the men blocked with a covering of pine boughs.

Improvised drying racks in field exercise. (Paul Campbell)

The windshield of a Jeep, with Coleman lamps as the light source for the exposures, substituted for the printing glass. Cpl Kenneth Damon mixed the chemicals in helmets and in buckets borrowed from the mess hall. They used large pans, also from the mess, as developing and washing tanks. The paper used for these prints didn't require lengthy washing. Print drying occurred on the tent, ground, or nearby trees, wherever appropriate space could be found. After two days of experimenting under freezing field conditions, the Lab men turned out satisfactory work and considered the training quite successful.

Bivouac over, the men marched back toward the airbase. Snow had fallen the night before and the snow-covered pine trees gave at least one man an eerie impression of "tall ghosts hovering over the trail." The squadron returned to the airfield, hot showers, warm beds, hot food, and packing.

Getting Ready
Preparations for shipping out forged ahead. At the 14th

Crating equipment. L to R, Everett "Junior" Hoagland and Ken Damon. (Paul Campbell)

Squadron area every man possible went to work hammering nails, painting, or heaving boxes. Rumors abounded. Mitchell Field, New York; Bolling Air Base in Washington, D.C.; a different destination, featured in each conversation. When the men began painting the fancy blue trimming on the drab Army green they knew it meant overseas. The men began sending home photographs, extra flight jackets, radios, and any extra articles for safe-keeping.

By the end of February, Lieutenant Steiert had the Supply Department well organized and running smoothly; the packing up continued. Photo Lab and Camera Repair packed most of their own equipment with supply personnel supervising and helping with the indexing. Sgt Charles Hinchee and Cpl William T. Goetz worked continuously with Sgt Raymond E. Heath and Pvt. Ross J. Franklin and Private Just to pack Photo Lab equipment. Sgts Larry Redmond and Clair L. Myers packed the Camera Repair Department's equipment including the aerial cameras. The 14th's new flight surgeon, Lt. James R. Savage, directed medical personnel and helped pack medical supplies and equipment.

Special purpose vehicles such as the radio truck and trailer, decontamination truck, Cletracs(tractors for towing aircraft), and Portable Photo Lab Trailer, had to be overhauled and prepared for shipment. Cpl Vernon Harkrader and the Transportation men accomplished this within a week, then Supply completed the indexing, sealing, and marking. The squadron shipped general purpose vehicles to the Base Ordnance Officer. New vehicles would be issued to the squadron upon arrival at its new station.

The mountains of boxes accumulated during all the packing created a storage nightmare. Moved from one part of the squadron area to another, the boxes ended up piled away from the buildings to lessen the fire hazard. They were covered with tarps for protection from the winter weather. Snowfalls two or three times a week during February and March covered the "mountains". Unlike the real thing, these box "mountains" had to be dug out, uncovered, swept clear, re-stacked, and re-covered.

Peterson Field
In the midst of all the packing turmoil, the 14th Squadron learned that the Army Air Base at Colorado Springs would be known after 15 March 1943 as "Peterson Field" in honor of its own Lt. Edward J. Peterson, Jr., killed in a crash at the airfield, 8 August 1942.

Last Minute Changes
When the movement order, dated 16 March 1943, arrived at 14th Squadron Headquarters, part of the order added extra work to an already overburdened schedule. The flight echelon, instead of leaving with the rest of the squadron, would follow later. Its equipment, parachutes, kits, and flying clothes already inspected, exchanged for new as necessary, and packed as directed earlier, had to be dug out, unpacked, and given back to the pilots.

During the last weeks at Colorado Springs, regular lectures supplemented by training films on weapons, tried to cover any problems that each department might come up against. On 23 March 1943, the squadron received some 1903 Springfield rifles and .45 caliber pistols. Cpl John F. Hunter, Jr. and Pfc Raymond Michael, who held classifications as armorers, functioned as an Ordnance Department under Squadron Supply. The squadron added close order drill with the newly issued Springfields as a part of each afternoon's activities. Inspections became more frequent. Packing and re-packing went according to posted lists, which detailed what was or was not to be packed in the various government-issue bags.

The most popular forms of diversion during the last days at the airfield included softball, sun-bathing in any sheltered warm spot, and patronizing the soda fountain at the Peterson Field Post Exchange. The officers bet the enlisted men two ponies of beer that they could beat them in a softball game. The officers bought the beer. A sudden burst of patriotic fervor stimulated the sale of War Bonds. Sobering realization of imminent overseas duty prompted some of the men to take out more Soldier Insurance and increase their dependent allotments.

A New Commanding Officer
In the midst of all this hectic preparation, Captain Foltz left the 14th and transferred to the 10th Photo Squadron. The new commanding officer, Capt. Marshall Wayne, a

celebrated diving champion and gold medal winner in the 1936 Berlin Olympics, transferred from the 10th Squadron on 25 March 1943. Wayne had another more useful experience: he had successfully bailed out of the uniquely configured P-38.

April Fools' Day 1943 and orders to ship all squadron equipment to Boston Port of Embarkation arrived at squadron headquarters. Squadron strength stood at 36 officers and 187 enlisted men. Loading of the trains brought to the airbase rail sidings began early the next day. All squadron personnel reported to their departments in the squadron area at 0700 hours. Everyone, including the pilots, loaded the freight cars.

By noon they had loaded Cletracs, Radio Truck, Decontamination Truck, and Photo Lab Trailer on flatcars, well-blocked and anchored them, taking every precaution to avoid damage during transit. Although some of the boxes were very large and weighed over a ton, the cranes and manpower finished the remainder of the loading before 1900 hours. Box-cars sealed, government bills of lading completed, the shipment 4565-T was on its way at last. Finally the 14th's personnel began to believe they soon would be overseas.

After the 1st of April a change in the squadron Table of Organization (T/O) sent eight pilots to other squadrons. Lieutenant Kendrick became Adjutant, Lt. John F.S. Rees went to Operations, and Lt. Ralph E. Flanagan became Mess, Transportation, and War Bond Officer.

The C.O. appointed Lieutenant Rees acting Supply Officer when a small contingent of men composed of Lieutenant Steiert, recently-promoted Sergeant Weisstein, and Corporal Washmon left Peterson Field for Boston on 7 April for coordination and clearing of the 14th's equipment. On the trip east Sergeant Weisstein developed an earache so severe that he spent over a week at Camp Miles Standish Hospital 50 miles outside Boston.

Movement orders arrived at Peterson Field on the 10th ordering the 14th Squadron to report to Fort Dix, New Jersey, by 1600 hours 27 April 1943. The advance party of three had orders to report 48 hours prior to the main unit's arrival at Fort Dix.

Moving Out
On the 24th the men lined up by platoon in full field pack wondering whether it was another dry run. When they saw the First Sergeant and officers tearing their hair out over a couple of last minute AWOLS, they gathered correctly that it was the real McCoy. Lt. James "Maxie" Campbell assumed command of the squadron in transit while Captain Wayne and the other pilots remained at Peterson Field. They would fly overseas later by military transport.

The men boarded the train by platoon then rushed for the Pullman compartments; everyone wanted to be with his buddy. They scrambled to find room to store the field packs, gun belts, gas masks, and other soldiers' equipment. After considerable jostling everything was crammed under the seats, up in the racks, on the hooks, or out in the aisles. Fortunately, a detail of men stored the large barracks bags aboard in a baggage car. By 2130 hours they caught their last glimpse of Peterson Field as the train rolled out of camp. The familiar wind and sand, which would not be missed, beat against the windows.

Quickly, the porters began to make up the berths for the night. Lively discussions broke out over who would occupy a lower berth hardly ample for two husky GIs. Coin tosses decided who slept up and who slept down. Despite the crowded conditions, the men managed to comply with the unpopular order to shave every day. Keeping clean was one of the chief difficulties on the journey. Cinders somehow got into eyes, ears, and clothes even though the train had air-conditioned cars. The travelers followed some routines in spite of a general air of holiday. The first morning, the First Sergeant woke the men at an uncharacteristic 0800 hours. This was something they hadn't anticipated on their cross-country jaunt. They didn't see any particular need for it at the time even if it was later than usual.

Lieutenant Flanagan, the Mess Officer, organized the chow-lines by railroad car. The men from one car tramped down the aisles through six or more other cars to the freight car kitchen where the cooks and KPs operated. This special car had been scrubbed and outfitted as a kitchen on the siding at Peterson Field and the cooks prepared all meals in transit here. The Mess Officer had previously arranged, through the Rail Transportation Officer at Peterson Field, for all rations to be put aboard at various stations along the route. The mess served up the food on paper plates; coffee, in paper cups; then the men tramped back to their seats with their food before the next car-full went through in turn.

At night, orders kept the windows blacked out and only after "lights-out" could anyone raise the shade to look out at the lights of towns and cities they passed through. The men passed the time in various ways, looking at maps, playing cards, reading, and just looking out the windows. Any kind of reading matter was well dog-eared by the time the trip was over, from *Harper's Monthly* to *Whiz Bang*.

Occasionally, when the train stopped for supplies or water, the men wanted to get off and stretch their legs. At one stop a second lieutenant, tommy gun slung over his shoulder, herded everyone out for a brief session of calisthenics. One soldier remarked that, "Gawking onlookers stared, no doubt taking us for prisoners because of the lieutenant's gun."

In the cool dim light of dawn on 27 April 1943 the 14th Squadron men arrived at Fort Dix, New Jersey, "literally and somewhat mentally in a fog," remembered one man. After everyone disembarked, the officers lined the men up on the station platform. The soldiers sounded off to roll call and marched up the street to the allotted tent area. Sergeants drew their details from the ranks almost immediately. The important but dreaded KP detail reported to the new Mess Hall, which was in an old wooden building much in need of scouring. They had only two and a half hours to clean it up and prepare the first meal of "A" Field Rations but Lieutenant Flanagan, the Mess Officer, and his crew got it done.

Fort Dix
Nothing could have looked less cheerful than the rows of dilapidated pyramid tents that greeted the 14th Squadron men at Fort Dix. Weary from the long train ride, most of the men had expected to be billeted in wooden barracks like those in staging areas heard about from scuttlebutt or seen in movies.

Their designated area didn't live up to expectations. In fact, it was a disaster. This particular area had been used by troops in the last war and it looked like it. The obsolete out-house scheme of plumbing in the latrine attested to the general lack of modernity. One man commented that, "When Uncle Sam streamlined his World War II Army this was definitely a corner that was overlooked." The tents had rotting board flooring and side walls and the canvas leaked. A small stove kept the occupants warm when fuel was available. Some of the men sneaked to abandoned tents and swiped floor boarding for firewood. The tent city had little to enliven it until one night when a tent caught fire. The fire didn't injure anyone, the occupants found other quarters, and the excitement relieved the boredom.

While at Fort Dix the officers divided the squadron into four platoons, by departments, and assigned adjoining tents accordingly. Guard duty became a new factor in the daily routine. This was an unfamiliar duty to these "elite technicians of the Air Corps," as one man put it. Soldiers knew all about KP, but these soldiers had to learn about guard duty, especially at night. The nights seemed particularly long and unfriendly, especially with another new experience, total blackout. No light, not even a cigarette, could be shown. From now on this would be the usual, not the unusual.

Many of the men had never drawn guard duty before but everyone took it seriously and tried to do his job well. Just how well, one green lieutenant found out one night when he approached a guard, who happened to be a World War I veteran. Twice the order to halt rang out. The officer continued on past the guard until the latter yelled "halt," for the third time and drew back the bolt of his rifle. After recognizing the officer by the authorized procedure, the veteran warned, "Don't ever try that again, Lieutenant. My gun is loaded and my orders are to shoot." First Sgt Edgar Knight considered green lieutenants one of his chief headaches in preparing the squadron for overseas.

During their week-long stay at Fort Dix, the men had security and pep talks by their Intelligence Officer, Captain Mahoney. The acting C.O., Lieutenant Campbell, helped prepare them for the fast-approaching day when they would board their troopship. They turned in the Springfield rifles and exchanged them for the much-publicized M1 .30 caliber Carbine, which they took out on the firing range. In a driving rain, they fired 15 rounds from their new weapons.

The 14th squadron lined up new activities, dental inspections, shots at the infirmary, dry runs, and inspections. An infantry colonel inspected the squadron, which took great pains to do the right thing. Happily, the colonel thought the inspection stacked up well with the infantry outfit he had seen. This pleased the airmen.

On 4 May 1943, a blast from the first sergeant's whistle signaled time to move out. A mad scramble into their packs and minutes later the men lined "company front" answering roll call. At 1500 hours they boarded train 16-Y and moved out of Fort Dix. After dark the train stopped in a railroad yard where the men stepped off and, after answering to another roll call, heaved their barracks bags up on their shoulders and marched off to the ferry in the best order they could maintain in the blackout.

Once on the ferry and heading out into the river, the men sprawled out for a few winks or looked out into the blackness straining to see something. Before long they began passing the lines of docks which once held the famous passenger liners. At least one was still there, the great French liner *Normandie*, lying on her side where she had capsized at her pier, a victim of sabotage. As the ferry moved up the river, an unexpected sight astonished the 14th Squadron men. They saw a brightly-lit pier where a band played. The ferry bumped against the pier and the men went ashore carrying their heavy equipment. They stared up at the sleek hull of the world's fastest luxury liner, Britain's *Queen Elizabeth*.

The Red Cross served hot coffee and doughnuts and handed out packets of cigarettes, candy bars, and gum on the pier. They gave out miniature barracks bag comfort kits containing pencil and paper, playing cards, pocket-size books, sewing kits, razor blades, soap, shoe laces, and cigarettes. For those who had thought departure would

be a silent, secret affair, the festive send-off was a pleasant surprise. Another roll call and men answered with first names and middle initials then walked up the gangway to be, as one man put it, "swallowed up in an orderly fashion like so many Jonahs into the huge belly of the *Elizabeth*."

Transatlantic On the *Queen*
Cards handed out as the men filed on to the ship told them where to bunk and at what times they would eat their two meals a day. Before leaving port, everyone scrambled up on the top decks getting into their life preservers for an emergency drill. In the midst of settling in, at 2345 hours, a small group celebrated S/Sgt "Pop" Porter's swearing in as warrant officer.

Some of the men quartered in P Section, others in R Section, both on D Deck. P Section had been freshly painted white and the deck covered with linoleum. It contained cots, tables and benches, and excellent toilet facilities including two bath tubs for use with salt water only. The other sections had hammocks, which took a little getting used to. The 14th Squadron was fortunate that it did not have to share its quarters with outsiders nor sleep in shifts as the men up on deck and in the staterooms had to do. The remainder of the squadron billeted in H Section and slept on iron cots which folded down from the wall.

The men jokingly referred to their quarters so far below water level as "Torpedo Junction." For the first few days PBY's, Liberators, and blimps escorted the ship. From then on they traveled without escort but to the men's knowledge U-boats never trailed the *Queen*. They peacefully crossed the Atlantic without incident in spite of rumors and scuttlebutt.

Other squadrons and civilians prepared the meals, giving the 14th's Mess Department a holiday. When the men ate the English cooking the first morning at breakfast, they found it unfamiliar and tasteless. Each meal began with a long wait in an endless line, which the British called a "queue." Then the men arrived in the mess hall where they got a meal of mutton, cabbage, and fried tomatoes or some other unfamiliar food. After eating they waited in another long queue to wash their mess gear. The shipboard PX sold Hershey bars and cookies, which became comfort food for the G.I.s. Some men skipped the chow lines altogether and lived on candy and cookies. Others paid the stewards to bring them Spam sandwiches.

The ship's captain called frequent boat drills both night and day and, as always, the MPs prodded the laggers and kept the various lines moving. Most men passed time reading, sunning on deck, queuing for the barber shop, bumping into old friends, or studying the GI issue of *A Short Guide to Great Britain*.

The *Elizabeth News*, the ship's daily one-page newspaper, and regular nightly communiqués over the tannoy (loudspeaker) kept the men informed of war news. North Africa topped the bulletins on this British ship. During the 14th Squadron's stay at Fort Dix, the news had been about heavy German resistance in a Tunisian valley the GI's called the Mousetrap. Hill 609, General Omar Bradley's U.S. II Corps' objective, dominated the valley. Even after the capture of the hill on 1 May 1943, the Germans still fought tenaciously for the Mousetrap. The *Elizabeth's* tannoy broadcast welcome news that the American 1st Armored Division had broken through the German lines on the 3rd of May. While the ship sailed toward England, the American Ninth Division captured Bizerta on the 7th and the Germans surrendered unconditionally in northeast Tunisia two days later. The British crew on the *Queen Elizabeth* celebrated the final assault on Tunis by the First British Army. The Americans were newcomers to the theater but for the British it had been a long and bloody campaign of two and a half years.

Going Ashore
One sunny morning, a grateful voyager recalled, "We awoke to see the gray, misty hills of Scotland in the distance." The *Elizabeth* sailed up the broad Firth of Clyde and passed the cliffs of Garrock Head into the interior waterway, which sheltered many large naval vessels. As their ship rounded a headland toward the mouth of the Clyde, the passengers could see several of the famous lochs of Scotland splitting the hilly land portside. On the starboard side lay the docks of the seaport towns of Gourock and Grennock. The liner dropped anchor off Grennock on 11 May 1943. Small barges pulled alongside. The men crowded the decks, taking in the foreign scene and awaiting orders to go ashore. It seemed strange to be in a harbor deep in mountainous country. In the distance, Grennock's buildings spread up the hillside like tiny dollhouses. Across lush green fields lined with neat hedgerows stood a castle.

Barges landed the 14th Squadron contingent ashore on a pier where crowds of townspeople, a host of pink-cheeked children, and a kilted bagpipe band greeted the Americans. Among many tunes, the band played an interesting combination of "Marching Through Georgia" and "Dixie." Heavy accents proved too difficult when some of the men did their best to strike up a conversation with a couple of British MPs and Redcaps. British civilians and Red Cross personnel passed out doughnuts and cups of hot tea on the platform next to a waiting train. In comparison to American trains, this one had smaller cars

divided into compartments holding six or eight people each.

As the train pulled out of the station, the Yanks did what every other train load of Yanks had done, showered the citizenry with Hershey bars and cigarettes. Everyone along the way waved or gave the "V" or thumbs up sign.

The train traveled south and stopped early the next morning at the Derby Station. In the half-dark of British Double Summer Time (similar to Daylight Saving Time), British soldiers poured out tea and gave the men paper bags containing meat pies called "pasties" and English style chocolate bars. At 1000 hours the train arrived at Culham Station. The weary travelers lugged their backpacks, gas masks, equipment, weapons, and bags onto the platform and to waiting GI six-by-six trucks which took them the few miles to their new home, Mount Farm.

Mount Farm

When the 14th Squadron arrived at Mount Farm on 12 May 1943, the 13th Squadron, already flying operational missions, had settled in at AAF Station 234. Compared to the brittle, dry air and dusty prairies of Colorado, everything here seemed green and damp, even wet. Instead of an airfield between towering mountains and endless grazing land, Mount Farm's airbase had an operating farm alongside the runways where everyone went about growing crops as if the Americans and their warplanes weren't there.

No one could miss the contrast between their old home and the new one. Towns were miles apart on Colorado's vast open prairies. In England's green countryside, villages bumped up against each other. Narrow curving lanes wound through the land, some with ancient hedgerows towering over the roadsides creating blind corners and tunnel-like stretches dangerous to the careless driver who forgot to drive on the left side of the road. The River Thames passed near Dorchester-on-Thames, one of the many little villages within two or three miles of the airfield. It wouldn't take long for the 14th's men to find the neighborhood pubs, with their warm beer and friendly local patrons, and fit right in.

The 14th Squadron set up offices in space available on the crowded base. Two rooms in a building near station headquarters would serve the Executive Officer, Orderly Room, and Captain Wayne, the squadron C.O., when he arrived with the contingent of pilots. 1st Sgt. Edgar Knight and Pvt Wendall P. Gardner set up nearby in a duty office where they began organizing squadron paper work. A week after arriving at Mount Farm, the 14th welcomed its baggage escorted by Sgt Roland Gephart and Cpl James Washmon, who had remained in Scotland with the Rail Transportation Office to see that everything belonging to 14th Squadron men got safely to the new station.

Without aircraft to maintain, the Engineering Department had little work for its men. Rather than remain idle and risk being highjacked for other duty, many men turned their talents to useful jobs. Sgt Earl Kinder and Cpl "Patsy" Piscitelli discovered a shortage of barbers on the post. Each had some civilian experience and, with the few tools they had with them, set up a barber shop, which operated for several months.

Spotting another possible enterprise, Cpl Horace Neece spent all of his off-duty hours buying, repairing, and selling used bicycles. Eventually, almost everyone had one. It took concentration to renew bicycle-riding skills while riding on the left, referred to by Americans as the "wrong side," down those winding roads. On early rides out in the country lanes, a moment of inattention on the rider's part brought him face to face with trucks, cars, or farm carts. The nearest escape route often lay through a ditch or into a hedgerow. Most inexperienced riders tumbled off collecting nicks, scrapes, and bruises, but no serious injuries.

Everyone pitched in helping set up the squadron's quarters, offices, and duties. MPs guarded the front gate of the base at all times. Two men, Pfcs Paul Jewell and Roy Boutwell, volunteered for guard duty rotation helping relieve the 13th Squadron MPs. Cpl Melio Napolitano and many others found scrap lumber, which they transformed into bedside cabinets and foot lockers.

Just as with guard duty, pooling of departments on the station had advantages for some of the men. The squadron Mess Department, after several weeks without cooking duties, found itself pooled with the 13th's Mess and the men worked one shift on and then two shifts off. Additions of other units spread the duties among more men relieving one squadron of excessive responsibilities.

Engineering

Due to a shortage of mechanics in the 13th Squadron, the station C.O., Major Hall, ordered the 14th's Engineering Department to help take up the slack. In order to remain a 14th Squadron unit, the department set up an engineering office in a Nissen hut. From this office, Engineering assigned 14th Squadron men to duty; several men helped maintain the 13th's aircraft, others went on detached service to Allison, as well as Curtiss Propeller Schools; American Electrics, and Hydraulic School. Engineering shifted personnel to different positions each week thereby reducing the possibilities of cliques and dissension within the two squadrons. This arrangement also gave the 14th's engineering officers a chance to judge the capabilities of each man in various positions.

Eyes of the Eighth

Capt. Sam Thomas holding a tomato from the Victory Garden.
(Joe Conrath)

The two-squadron maintenance system gave the 14th Squadron mechanics an opportunity to get their first experience maintaining aircraft for combat flying, since none had been assigned to the squadron. Through this plan they gained valuable knowledge they would use when their own aircraft arrived. No two engineering departments did things exactly the same way and friction over the differences caused dissension. The 14th Squadron's mechanics disagreed with some of the maintenance practices of the 13th. They also found it difficult to engage wholeheartedly in another squadron's progress. Everyone became dissatisfied.

Other departments organized their offices and waited for aircraft to service. The Photo Lab learned methods used by the 13th and how the work connected to RAF Benson and Medmenham. Some of the men from the Communications Department found work in the 13th Squadron; Robert Arnott on the flight line; Warren E. Heraty on teletype; George Smith and Alex Raith in the control tower; Leo Smith, Henry Blackburn, and Eugene Thielen with the IFF (Identification Friend or Foe) system.

Victory Gardening

Without planes to carry their cameras, Camera Repair shared space with the 13th Squadron under command of the 13th's Camera Repair Officer, Capt. Arthur Stelle. Without sufficient space or work for all, some of the men decided to start a garden. For over a month they spaded, graded, seeded, and cultivated the area around the Camera Repair Shop. The place had been full of high spots, low spots, tree stumps, weeds, and a little grass. The gardeners smoothed it off, cleared it of cinders, filled the garden with good soil, graded it, and laid paths and parking slots.

The Photo Lab had little work to do and the Lab officer, Capt. Sam Thomas, along with others, including Sgts Thomas J. Gillean, William R. Rudnicki, and Pfc Ross Garreth, took part in the gardening operation. The Communications Department detailed two men regularly to the Victory Garden. All the hard work paid off with a better looking area which produced tomatoes and other vegetables for the mess.

In June, after five weeks of gardening, the Camera Repair men, subdivided into smaller crews, went back to their usual jobs. They still worked with the 13th Squadron's men in the shop and on the flight line. All of them eagerly awaited the time when they had their own aircraft and pilots to start operations.

Spitfires

The Engineering Department's two-squadron hook-up ended with mutual relief when the 14th acquired five British Spitfire Mark Vs for maintenance on 3 June 1943. They had been used by the RAF in combat and, now stripped of their guns, would be used as training aircraft for the American pilots. Flight Officer (F/O) Harry Witt of the 13th, an American formerly with 541 PRU (Photo Recon Unit) Squadron, RAF Benson, ferried in the ancient clipped wing Spits (this particular model had the usually rounded wing tip squared off). Assigned to the mechanics of the 14th Squadron, the Spitfires became the center of attention on the airfield. Mechanics crawled all over them marveling at all the strange gadgets and comparing them to aircraft used by the USAAF. At first, nothing about the Spit seemed to relate to aircraft the men had learned on. The British names for various common parts completely baffled them. Instead of a storage battery, the RAF had an accumulator, something Americans might look for in the hydraulic system. It took the men two weeks to figure out that a split-pin was the British name for cotter pin. Stranger still, British aircraft did not have wings. All RAF maintenance instructions called this essential part of the aircraft "main planes."

The RAF mechanics at Benson gave MSgt James T.

34

The 14th Photographic Reconnaissance Squadron

Spurlock and his line men as much helpful instruction as they needed. A week after their arrival the first of the Spitfires had been inspected and placed on the Ops Board as "Ready for a test hop." Flight Officer Witt volunteered for the test flight. The whole Engineering Department gathered to watch as the pilot taxied out to the runway, took off, and flew their Spit around the countryside. Witt returned from the test hop and reported the Spitfire in first class flying condition to a proud gang of mechanics.

Each day after that, another Spitfire rolled out of the hanger until all five passed flight tests ready for operation. Several men had to be recalled from the 13th Flight Line to service aircraft as the number of fly-able Spitfires increased. With only one 14th Squadron pilot, Lt. "Maxie" Campbell, on base other pilots on the station flew these planes constantly from early morning until the last evening light. A total of 15 mechanics remained with the 13th Squadron, but under the rotation system worked out by the 14th's Engineering Officer, those men got a chance to work on the Spitfires every other week.

MSgts James Spurlock, Sam Quindt, Henry Navarrot, and two new men, SSgt V.D. Grubb and Sgt L.J. Geary, went on detached service to RAF schools to learn about airframes and Merlin engines, returning two weeks later convinced the RAF knew how to run a technical school. Fifteen men from the line eventually completed the course and returned to teach the rest. The Spit-

Ex-RAF Flight Officer Harry Witt of the 13th Squadron.
(John Weeks)

Clipped wing Spitfire with three blade propeller in rear left behind officers lining up for presentation of Air Medals. Front row L to R, Brig. Gen. Ira Eaker and Lt. Col. James Hall.
(Cecil Milford)

fire was a much easier aircraft than the F-5 to maintain. Although working in unfamiliar territory in the beginning, before long the 14th Flight Line operated its Spitfires at peak efficiency.

Communications
Not long after the arrival of the Spitfires, on 11 June the Communications Department sent Capt. Nicholas J. Sary, Sgts Leo Smith and H. Blackburn, along with Cpls W.W. Binder, A. Derosier, E. Nordwall, W. Sirica, F. Seese, J. Thompson, and B. Wendel to Cranwell Radio School for familiarization with the radio equipment used in the ETO. Captain Sary put Sgt Eugene Thielen in charge of the men remaining at Mount Farm, who continued working with the 13th and doing squadron detail. Robert Arnott took charge of all telephone maintenance on the base and two 14th Squadron men went to Benson to learn the procedure and functioning of the Direction Finding (DF) Station.

The enlisted men from Mount Farm, with their typical American openness and comparative lack of rank consciousness, found the strict rank distinction at Cranwell, common to not only RAF but also British life, complicated and awkward. As time passed, however, they became more familiar with the procedures and camp set-up, intermingled with the RAF personnel, and adjusted to all facets of life on a British base. All, that is, except the food, which they never liked. They returned to Mount Farm at every opportunity for a meal and American rations. Exposed to the limited, boring, and sparse British diet resulting from years of war and rationing, Americans who had so recently come from bountiful meals, even Army Messes Stateside, understood the reasons but never learned to like it. The experience sobered them and in many cases made them all the more generous with their rations when they met and made new British friends.

At Cranwell, the instructors placed great importance on the radio and, in these men's minds, the British school fared better than similar institutions Stateside. With a well-rounded course of Very High Frequency (VHF) radio, the school ran for six weeks. The Americans spent a few days learning the part that the RAF, radio, and radar played in saving England from the Luftwaffe onslaught during the already legendary Battle of Britain and in the 1940 Blitz that followed. Besides a shop course of the elementary work of radio repair and maintenance, Cranwell gave the 14th's Communication men an opportunity to operate a ground station and its units to experience real operational conditions. The Americans had a high respect for their instructors, who gave the men a good understanding of the subject and sent them back to Mount Farm with sets of notes and diagrams, which would prove helpful.

Recreation and lessons shared time at Cranwell. Dances, a friendly WAAF Station, and sightseeing occupied spare time. The Yanks visited the neighboring towns and villages whenever they could. On one trip to Lincoln, Sirica, Derosier, L. Smith, Blackburn, Binder, Nordwell, and Thompson had to sleep on park benches when stranded for the night. However, two fortunate fellows found beds with the local constabulary.

The Americans repaid British generosity at Cranwell when the men from Mount Farm gave the RAF American softball. Before long two well-developed teams played on the field each day for an hour of recreation. Sirica and Wendel gave the star performances of the season. The 14th Squadron team felt Nordwell deserved a Purple Heart after being injured in one game and spending a week in the hospital.

Impedimenta Arrives
At Mount Farm, Transportation operated as a pooled department under one office, although the 14th Squadron kept its Transportation Officer, Lieutenant Steiert. He set up his office and staff to be ready for the shipment last seen being loaded in Colorado Springs. The equipment sent from Peterson Field finally arrived late in June at Culham Station on small freight cars, which the British called goods wagons. Remembering all the crates they had piled on the larger cars in the States, the men thought it must have taken a complete train of those very small wagons to carry all of the 14th's equipment.

A New Assignment
Early in the month of July 1943, a re-organization of photographic reconnaissance in the Eighth Air Force created an overall command for the individual squadrons at Mount Farm. On 7 July 1943, the newly activated 7th Photographic Reconnaissance and Mapping Group took over the station. General Orders assigned the 14th Squadron to the Group.

Chapter 3
The 22nd Photographic Reconnaissance Squadron
2 September 1942 — 7 July 1943

General Orders constituted the 22nd Squadron Photographic Reconnaissance Squadron on 14 July 1942, which led to its activation on 2 September 1942 in Colorado Springs as a member of the 5th Photographic Group. Command of the new squadron fell to 1st Lieutenant Tracy on 16 September. Lieutenant Devine joined him awaiting personnel to fill the squadron's Table of Organization. The two officers remained with the 22nd until 20 October when they transferred to another outfit leaving the squadron unmanned. Until 21 December 1942, the 22nd had neither officers nor enlisted men. It was, in fact, held open on paper to preserve the squadron designation for future use.

Special Orders, dated 21 December 1942, effectively activated the 22nd Squadron by transferring and assigning to it 12 officers and 129 enlisted men, all from the 10th Photographic Reconnaissance and Training Squadron. Capt. George A. Lawson became the commanding officer with Capt. Leslie Kunkel his adjutant.

The squadron set up the Orderly Room and the men moved into barracks the following day. The 22nd shared the 10th Photo Squadron's mess hall until it moved into its own newly completed facility the beginning of January 1943. Between Christmas and New Year's, other departments set up their offices and the squadron began functioning independently of other units.

SSgt Robert A. Neuser, operating Chief of the Photo Lab, designed a squadron emblem that featured a dragon with a camera in its claws diving on the enemy. The squadron sent the design to the Commanding General, Army Air Forces, in Washington, D.C., for approval, which came through the War Department. As one of its first uses, the new insignia appeared on invitations produced by the Photo Department for a formal dance party planned for 5 February 1943 at the Antlers Hotel. Cpls Paul Webb and Fred Carder planned and managed the invitations, entertainment, and corsages for the ladies. To cover expenses, Sgt Julius Becker and Pfc William McGivern collected donations from the enlisted men. SSgt Edgar C. Erwin and the men from Camera Repair decorated the ballroom; SSgt William O. Cihlar oversaw transportation; Sgt Leo Fahnlander handled the finances; Mess personnel under Sgt Jessie R. Expitia and Cpl Paul V. Mittnacht's direction supplied the refreshments. It was a lively party and a great squadron ice breaker.

Field Exercises
The day after the party, the squadron learned that it had been re-designated the 22nd Photographic Squadron (Light). It also learned it had orders to bivouac at the northeast end of the base on 27 February. There, with the warm barracks and mess hall in full view, the men would learn about living and operating under field conditions in a Colorado winter. What may have been marginally comfortable now became tantalizingly luxurious by comparison.

Tent camp at 22nd Squadron bivouac before the big snow storm. Earth banked up around tents to keep cold wind out.
(Sam Burns)

Eyes of the Eighth

Robert Astrella washing mess kit at bivouac. (Sam Burns)

Snow swirling around the barracks on the Friday the 22nd Squadron returned from bivouac. (Sam Burns)

Cooks prepared food in field kitchens and all personnel ate from mess kits. Tank trucks supplied water. The Medical Corps supervised the open-air latrines, which may have been built correctly but did nothing to prevent winter chill. Only those working on the flight line or in the photo lab could leave the area, and guards, posted throughout the area saw that everyone obeyed this restriction.

After three days the weather worsened. The thermometer dropped to 18 degrees below zero; heavy winds drove blinding snow. In spite of near-blizzard conditions, very few men reported at sick call. Reveille was at 0530 and Taps at 2200 hours. Mess staff set up stoves in tents and cooked meals under difficult field conditions. Personnel marched in formation to and from their respective departments, carried on their daily work, and returned to the tent area for meals and sleep. On 5 March 1943, the squadron moved back to the barracks, warm showers, hot meals that stayed hot, and other civilized comforts. While on bivouac, the men learned the airbase had been renamed Peterson Field in honor of a 14th Photographic Squadron pilot who had been killed in training.

Raton, New Mexico

In early April the squadron went on a field exercise at Crews Field, Raton, New Mexico, to prepare the men for combat zone conditions. Everyone loaded into trucks, which formed up in a convoy for the trip. The road south climbed along the high plateau on the eastern edge of the Sangre de Cristo Range of the Rockies through Pueblo toward Trinidad, the last major town in Colorado. Just after crossing the state line, the convoy reached 7,834 feet topping Raton Pass. From here the road twisted and dropped steeply into New Mexico. This notorious stretch of road, tough on brakes, gears, and nerves going down, would prove a grinding, gear-changing climb on the way home. Their destination, Raton, lay at the end of the descent in the foothills of the Sangre de Cristo Range in northern New Mexico. The previous unit on maneuvers at Crews Field, the 23rd Photographic Squadron, vacated

Walter J. Staab on guard duty in Jeep during bivouac. (Sam Burns)

Goat Hill with its red neon sign at Raton, New Mexico. (Sam Burns)

The 22nd Photographic Reconnaissance Squadron

Tents and aircraft during maneuvers at Crews Field, Raton.
(Sam Burns)

its tents and 28 officers and all enlisted men of the 22nd Squadron took them over.

The squadron deployed on the airfield setting up three separate sections: Camera Repair and Photo Lab, Flight Line operations, and living quarters. Soon after its arrival, the 22nd passed an inspection by Capt. Paul M. Thorngren, commanding officer of the 5th Photographic Group. During the group commander's visit, one of the 22nd Squadron's pilots, F/O M.D. Hughes, buzzed the airfield in an F-5. The fact that Hughes' low-flying aircraft was upside down and streaming gasoline from its drop-tanks made the action doubly embarrassing for the 22nd's C.O. Captain Lawson, who spoke eloquently to convince Captain Thorngren that Hughes was an excellent pilot and much needed for the war effort.

The 22nd pilots flew regularly scheduled missions, Camera Repair installed the film and cameras, the Photo Lab made the prints, and Intelligence handled the interpretation. On one of the missions, Flight Officer Wendell W. Blickensderfer's aircraft ran out of fuel and he had to bail out at low altitude when he couldn't locate a landing strip. Several road accidents marred what had been a safe driving record. During a dispatch run to the Photo Lab area, Pvt James St. Clair went off the road, putting his Jeep in a ditch. Fortunately no one suffered any serious injuries.

While at Raton, the 22nd was the subject of a movie about a photo squadron made by the First Motion Picture Unit of Culver City, California. The squadron also participated in the local War Bond drive, marching down the main street together with local, county, and civic groups, while the pilots flew over and showered the town with leaflets urging the townsfolk to buy "A Share In America."

Drill — Drill — Drill
The men knew that the squadron had gotten its Warning Orders for shipping out before leaving for Raton. Morale was high when they returned from New Mexico. Their C.O., a former Physical Education teacher, stressed physical preparedness with athletic programs and training. Every day, officers and enlisted men participated in calisthenics. Daily dry-runs of falling out fully loaded in formation kept the men guessing whether this was the actual day to shove off. During the last few days at Peterson Field, the men went on field marches of five and ten miles with full pack. On the last march around the field, Captain Lawson led the squadron. To liven up the schedule, the enlisted men split into two groups and held a sham battle on the open prairie. Some commented they felt more like infantry than air corps.

Moving Out
Two days after the big battle, the First Sergeant's whistle alerted everyone in the 22nd that the day had come to leave Peterson Field. The men loaded up all their gear and walked out into a heavy spring rain. "The barracks floor was as empty as a ballroom," remembered one of the men. They fell into formation and after roll-call marched through the rain to railroad sidings and waiting Pullman cars. Most of the 22nd Squadron left Colorado Springs on 17 May 1943. Only the pilots and squadron C.O. stayed behind. They would fly overseas on military transport.

The squadron suspended most duties en route except two considered vital, guard duty and KP. Cooks prepared meals with field stoves and ovens set up in a converted baggage car. In the Pullmans, the men passed the time reading or playing blackjack and poker. Buffet tables of peacetime travelers became the gambling tables of in-transit GIs. During the evening, guards stood at each end of every car.

Raton Pass on the way home to Colorado Springs. (Sam Burns)

39

In the afternoon of 3 May 1943, the train entered Canada via Port Huron, Michigan, and crossed back into the United States at Niagara Falls. The falls came into view just at sunset. At dawn the next morning the 22nd Squadron reached Camp Kilmer, New Jersey. The men shouldered their packs and marched to designated areas. After a welcome breakfast and hot showers, they had time to catch some sleep in their bunks.

Army camp routine returned in earnest the next day. Preparations for overseas meant checking clothing, taking physicals, and enduring inoculations. Physical fitness training continued on the drill field with added conditioning over obstacle courses. Each night half of the men had passes to go into New York City. Most of them had never been to such a large city with so much to see. The city observed a lowered-light regulation called a dim-out but the bright lights remained in spirit and no one suffered from the lack of neon. They knew that complete blackout lay ahead in the war zone overseas.

Scuttlebutt and rumor covered every destination from North Africa to England. The battle for Tunisia had ended on 12 May 1943 when German General Von Arnim surrendered Axis forces in North Africa. In the Mediterranean, Allied air raids against Sicily had begun. Secret war plans moved ahead. At the Trident Conference in Washington, D.C., final plans to invade Sicily set 10 July as D-day for the landings. The Conference also decided that the invasion of northwest Europe, Operation Overlord, would take place in May of 1944 and be preceded by an unprecedented bombing campaign by the RAF at night and the United States Eighth Air Force by day. The Army Air Force committed the 22nd Squadron to support the Eighth in England. Not privy to the secret plans, the men waited in Camp Kilmer and continued to guess at their destination.

Queen Mary

After noon-day chow on the last day of May, the 22nd Squadron left Camp Kilmer for New York City and Pier 90. At the pier the men assembled in a dockside warehouse, each man in field uniform, pack on back, and a crammed barracks bag digging into his shoulder. Red Cross workers passed out sandwiches, coffee, and sweets. In orderly ranks, the men boarded His Majesty's Ship 505, the majestic Cunard Liner *Queen Mary*, and went to their assigned quarters.

The insides of the Second and Third Class accommodations had been ripped out and replaced with mess tables, tier upon tier of bunks, and hammocks. First Class cabins had extra bunks crammed in. The huge ocean liner transports needed every available foot of space to carry as many men as possible.

The men wore their life preservers constantly. The preserver was a sort of twin pillow affair; one pillow forward and one aft, which made the wearer feel like a combination of two pin-up girls, each going in the opposite direction. The preservers did have their compensations; they acted as shock absorbers when the men bumped into one another in the narrow companionways and on the ladders.

The weather was good, the sea calm, and the voyage fortunately uneventful. Few of the men got seasick but they all suffered from a new malady common to all troopships and a fixture of military life — lines. A line on this British ship had a new name, a queue, but it remained a line to those in it. There were lines for everything. "There were lines for chow, lines for washing mess kits after chow, lines for the PX, and lines for the latrines," one man complained. "Oftentimes a man waiting in line for an hour and a half for a warm Coke found himself at the latrine door. It was much more disconcerting when it was the other way around," he added.

A USO troupe performed during the evenings. The men read, wrote letters, and played various games. Anyone looking for action could find poker, blackjack, craps, and bridge. A mixture of currency, familiar American dollars and quarters with confusing British Sterling of pounds and shillings enhanced the excitement of gambling. England became the predominant destination in "Latrine-O-Grams." Then a few days out of New York a booklet passed out to the passengers, *A Short Guide to Great Britain*, solved the mystery.

Briefly escorted by US Navy blimps after leaving New York, the *Queen Mary* traveled most of the way alone, relying on her speed and frequent course alterations to avoid German U-boats. Near Ireland, RAF Sunderland Flying Boats arrived overhead to escort the *Queen* and at 0800 hours on the morning of 6 June 1943 the travelers sighted the Irish coast. Late in the day the ship entered the Firth of Clyde. The liner anchored in the port of Gourock, Scotland, that night.

Warm Reception

The following morning ferries took the men from the ship to the dock where they piled their barracks bags into the freight cars, which the British called goods wagons, and boarded the waiting train. Scottish Red Cross workers served tea and buns while a Scottish Bagpipe Band in

Highland dress played both British and American military tunes. The train got under way and the men made themselves as comfortable as possible in crowded compartments. The packages of C rations, which had been issued on board the ship, made up both the evening and morning meals. At 0900 hours on 8 June, Captain Lawson and the pilots, who had flown over earlier with Transport Command, met the train at Culham Station. Trucks carried the 22nd Squadron's men on the rest of the journey to their new home at AAF Station 234, Mount Farm, Oxfordshire.

Several other units occupied the station when the 22nd Squadron arrived at Mount Farm; the 13th and 14th Photo Squadrons as well as the 381st Air Service Squadron. The 1274th Military Police Company arrived at the same time as the 22nd. Colonel Hall, station commander, assigned space to the 22nd at least a half mile down a road from the other squadron areas. The road became known as the Burma Road for its infamous condition, mud in rainy weather and ruts in dry. Segregated by distance from the other squadrons, the 22nd became a close-knit unit. The usual ETOUSA regulations restricted the enlisted men to base for the first three weeks. They acquired bicycles and learned, or re-learned, to ride them around the airfield. By the end of the restrictions they had plenty of practice.

Since no Headquarters Squadron had been assigned to the Station, 22nd men filled in and did headquarters work along with officers and enlisted men from other squadrons. Expecting to work as a squadron, the ground crews, Camera Repair, Photo Lab, and Communications men found themselves working in a pooled effort rather than independently. Men from other sections found work in the Victory Garden and around the base. As had all others, the 22nd Squadron's pilots took orientation courses on operational and radio procedures. With their planes still in transit, the pilots borrowed aircraft from other squadrons to familiarize themselves with the countryside. They began flying assigned missions in the borrowed aircraft instead of waiting for their own F-5s.

First Sortie
Capt. George Lawson, Squadron C.O., flew the 22nd's first operational mission, AA 116, on 24 June 1943. As others before had done on their first photo trips to enemy-held territory, Lawson flew an F-5 to the French coast and photographed Cap Gris Nez.

Two days later, Lt. Norris Hartwell took off from Mount Farm at 1407 hours to cover a strip from Le

L To R: Col James Hall, Station C.O., congratulates Capt George Lawson, C.O. 22nd Sq, after his first combat mission on 24 June 1943, as Maj James Wright, Station Operations Officer, looks on.

Touquet to Cap Gris Nez in the same borrowed F-5. He could see all the way from Dungeness, England, to Boulogne, France, and his aircraft made no contrails until 32,000 feet. At 1450 hours he crossed in over German occupied France at Le Touquet, covered his target, and crossed out at Cap Gris Nez at 1500 hours landing at Mount Farm 28 minutes later. The following day, 27 June 1943, Lt. Robert Smith flew his first mission, again using F-5 number 969. Low cloud covered the English

L To R: Capt. George Lawson greets Lt. Norris Hartwell after his first mission 26 June 1943. (Marshall Williams)

Eyes of the Eighth

Channel coast. The Channel and North Sea were cloud free. Almost-solid low cloud covered northeast France as far as Smith could see, but he managed to get photos of a strip from Cap Gris Nez to Calais through 6/10ths cloud.

Captain Lawson flew another sortie on the first of July and, two days later, Lt. Vernon Black flew his first operational mission to photograph a strip from Cap Gris Nez to Cayeux. Lieutenant Hartwell attempted his second sortie on 4 July, his target a strip from Ostend to Cap Gris Nez. When crossing the English coast a turbo charger blew out and he lost his starboard engine. Hartwell feathered the propeller and returned to base, landing safely on one engine. Capt. Steven Scott completed his first sortie giving the 22nd Squadron a good beginning.

The 7th Group

The first week in July brought the independent squadrons together in more than pooled duties. The Eighth Air Force activated the 7th Photographic Reconnaissance and Mapping Group on 7 July 1943 at AAF Station 234, Mount Farm. It also assigned the 22nd Photographic Squadron (L) to the new group.

Lt. Hartwell's F5A 42-12770 being towed for repairs after blowing a turbo-charger, 4 July 1943. (Ed Hoffman)

Chapter 4

The 27th Photographic Reconnaissance Squadron

9 February 1943 — 4 November 1943

Activated on 9 February 1943 at the Colorado Springs Army Air Base, the squadron along with two other photo squadrons also designated Light (L), and a Headquarters Squadron made up the 6th Photographic Group. The records of the 27th Squadron list 2nd Lt. James W. Kappes as the first man assigned to the squadron and as the man who assumed command on 19 February 1943. Headquarters 6th Photographic Group also assigned Corporal Gentry to the 27th. However, in the morning report of 20 February 1943, 2nd Lieutenant Willis is assigned and assumed command.

Another change, on 7 March, moved Lieutenant Willis to the 26th Photographic Squadron (L) and 2nd Lieutenant Cameron assumed command of the 27th. The squadron gradually acquired more personnel. On 11 March five pilots joined from the 10th Photo Squadron (L), among them Lts. Franklin K. Carney, Charles D. Cassaday, and Lawrence S. McBee. Also from the 10th came two pilots, Lieutenants Kappes and Baird. Baird took over as C.O. from Lieutenant Cameron who transferred to the 25th Squadron. Lt. Adam Tymowicz joined from the 7th Photo Squadron (L).

Additions to the developing unit included aircraft. Lieutenants Tymowicz and Cassaday flew to Patterson Field, Ohio, on 15 March to ferry two F-5A aircraft back to Colorado Springs. The addition and subtraction of personnel continued with Lieutenant Hardee replacing Lieutenant Baird as commanding officer on 16 March. Five days later, Hardee went to New York to pick up an F-4 from New York Port Service Command and discovered it was the same ship that he had belly-landed at Great Falls, Montana, almost a year before. Another new pilot, Lt. Hubert Childress, transferred in on 23 March from the 25th Photographic Squadron. By now some of the personnel had settled in on a permanent basis; Lt. Ben H. Case as Adjutant; Lt. Richard T. Bailey as Mess and Transportation Officer; Lt. Frank R. Campbell, Engineering Officer.

All key men of the squadron went to Orlando, Florida, on Detached Service (DS) to the Army Air Force School of Applied Tactics to take the orientation course for newly-activated groups. Leaving on 30 March, the men traveled by train with personnel from the 25th and 26th Squadrons, as well as the 6th Group Headquarters. After four days of travel they arrived in hot and sultry central Florida for a stay of a little over three weeks. In Lieutenant Hardee's absence, Lieutenant Kappes assumed command. On 31 March 1943 the squadron numbered 18 enlisted men and 28 officers.

More shuffling of personnel continued into April when on the second, Flight Officer (F/O) Gerald M. Adams transferred in from the 14th Photo Squadron (L). Lieutenant Childress went on Detached Service to attend Oxygen School at Randolph Field, Texas, for ten days. Training in various aspects of photographic reconnaissance continued as the 27th Squadron prepared to go overseas. Officers and men attended classes in their specialties, adding proficiency in new fields.

New C.O.

On 4 May 1943 a new commanding officer took over the 27th Squadron. First Lt. Cecil Haugen replaced Lieutenant Hardee who transferred to the 26th Photo Squadron with nine other men and assumed command of that squadron. Flight Officer Adams returned to the 14th Squadron. Major transfers completely changed the face of the squadron. Up until this time, the 26th and 27th Squadrons shared personnel and facilities, but on 8 May 1943 the two squadrons moved to their own barracks

Hangers, Operations, and part of Flight Line. Tanker truck trailer parked in foreground. Peterson Field, Colorado Springs, Summer 1943.
(Marshall Williams)

Eyes of the Eighth

Mess tent, 27th Sq. Bivouac. (Gerard E. Degnan)

and Mess Halls. The 27th began operating as an independent unit.

Lts. Cecil Haugen, Donald A. Farley, Charles Cassaday, Hubert Childress, Laurence McBee, and Franklin Carney left on Detached Service 4 June 1943 to test-fly aircraft at the Lockheed Modification Center in Dallas. In Haugen's absence Lieutenant Axelson assumed command, but after Axelson left four days later, Lieutenant Tymowicz took over as acting C.O.

The War Department sent Warning Orders effective 1 October. The squadron would stay in the States until fall. Personnel continued to transfer into the unit which, in the month of June, gained three officers, one warrant officer, and 176 enlisted men. On 27 June, the 6th Photographic Reconnaissance Group ordered the 27th Squadron to set up camp on the west side of Peterson Field.

Bivouac
Life in the new camp on the other side of the runways began with lessons in setting up tents. A windy location and unruly canvas caused problems until personnel, particularly from the Mess and Orderly Room, figured out how important proper placement was. Dust storms rolled in across the field from the open prairie. Any tent not situated or tied down properly ended up full of grit or, in the worst case, flapping down the road. The squadron worked as an operating unit with a Flight Line, Photo Lab, and Camera Repair departments learning how to operate in the field. Through July the men got the feel of how things might run overseas. They went on long marches, one of 25 miles, improving their physical fitness. By the end of the month the squadron was at 95% strength with 34 officers and 218 enlisted men.

New Name
August brought more changes to the 27th. The squadron C.O., Cecil Haugen, became a captain on the second. Four days later he left on ten days leave with Lt. Jack Campbell taking over as acting C.O. The squadron had a name change on 15 August 1943 when it became the 27th Photographic Reconnaissance Squadron. First Lt. Walter P. Hickey transferred from detached service at Fort Washington, Maryland, and the 25th Squadron, to become the new Intelligence Officer.

Photo Lab area and tents, 27th Sq. Bivouac.
(Gerard E. Degnan)

Fender Benders
Pilots flew cross-country trips and practice missions as much as possible. The Flight Line put in hours of maintenance and service to keep the planes flying, building up time and experience in maintenance. Occasionally they had damage to repair. As long as pilots didn't suffer injury, the line chiefs and mechanics could put things right after accidents. The Engineering Officer, Lt. Frank Campbell, saw many strange dings and scrapes on his aircraft. Lieutenant Carney brought back an F-5 after an altercation with a fence post. Carney had made an emergency landing in a field in Wyoming. When he flew the ship out of the field he hooked the horizontal stabilizer on a fence post but got the F-5 airborne and back to Peterson Field.

The chiefs had extra work when the same Lieutenant Carney had a narrow escape in a midair encounter. Another plane crossed too closely over the top of Carney's aircraft and raked one of the F-5's wings right down the middle of the upper surface from end to end. Both pilots escaped injury. Carney burned the brakes out in a difficult landing.

The 27th's men left the bivouac area on the west side of the runways on 28 September 1943 to move all of one mile back to their barracks. Flying operations continued from the bivouac area until hanger space became avail-

Photo Lab area, 27th Sq. Bivouac. (Gerard E. Degnan)

able. Experiences of other photographic reconnaissance squadrons already stationed in England suggested more emphasis on instrument flying. The Link trainer gave good practice in theory but the best rehearsal for flying conditions remained in-flight training. The squadron acquired three B-25s during September for pilots to obtain necessary instrument flying time. Although assigned on the 29th to the 89th Reconnaissance Wing, Will Rogers Field, Oklahoma City, the squadron remained based at Peterson Field.

Ready to Roll
The men spent the early part of October enjoying all the comforts of barracks life they had been missing in the dusty bivouac area: beds and mattresses, latrines, and hot showers, especially the latter. Crating and packing of all the squadron equipment continued at a rapid pace. Everyone listened to latrine rumors with growing anticipation and waited for the big day when they would ship out. That day came on 8 October with orders to be ready at 1500 hours, packed and fully equipped to ship out. At 1900 hours all blackjack games ceased and an hour later the 27th Photographic Reconnaissance Squadron entrained and left Peterson Army Air Field.

The train ride across the country was a change from duties at Peterson Field. When the 33 officers, two warrant officers, and 223 enlisted men arrived at Camp Kilmer, New Jersey, mid-morning on 11 October 1943 they went right to work with the usual staging area duties — processing, replacement of clothing and equipment, salvage, and inspections. Those men who had never seen New York City got their chance when on three successive days the squadron issued 12-hour passes. Even heavy rains didn't dampen their enjoyment.

Nine days after arriving, the 27th Squadron left Camp Kilmer by rail at 1020 hours on 20 October 1943 for the New York Port of Embarkation. Red Cross women handed out doughnuts and coffee while a brass band played on the pier. Early in the afternoon the men boarded the *Athlone Castle*. Impatient to be off, the squadron had to spend its first night on board snugly tied to the pier. The next day, tugs moved the ship away from the dock and the voyage began just after noon. Faces of eager GIs filled the portholes of the *Athlone Castle*. Everyone wanted a last glimpse of U.S. soil as the ship moved slowly out of New York harbor and past the Statue of Liberty.

Athlone Castle
Little hint remained of the *Athlone Castle's* former glory as a luxury tourist ship along the southern coasts of Africa. All the glamorous appointments had disappeared as well as ballroom orchestras, tinkling champagne glasses, and beautifully dressed women. Now the very British, old one-stacker carried GIs on their way to war. Anti-aircraft guns on deck made grim reminders of the war across the ocean. Steel-helmeted gunners startled many of the men with unexpected gun chatter when they let go a few practice rounds. One fellow wishing for more elbow room thought the ship had the population of a small city without enough living space, "It was a helluva crowd. A New Yorker might say it was like living in a subway train during the rush hour without the benefit of a seat or a strap to hang on."

The officers in charge of housing the men divided the 27th, like other units, into groups quartered all over the ship. Sections of B Deck housed a group of corporals sleeping in hammocks, on and under the mess table, on the floors, in the passageways — anywhere a man could find a few feet to curl up. One lucky traveler noted that, way down on A Deck, "were our sergeants in three-tier bunks sleeping with rifles, equipment, barrack bags, and helmets, all in danger of having their skulls cracked if their neighbors made a quick move. Ventilation was, to put it mildly, poor and sweat rolled down with every roll of the ship. There was a humorous side to it at that, for how often did the lowly private get a chance to see sergeants, buck to master, really sweat?"

Getting a meal was a chore. The maze of chow lines took three days to untangle. A few men claimed it took that long to get their first meal and when they did they didn't know what it was. Fortunately, considering the length of the chow lines, the cooks served only two meals a day. The Americans, faced with flat-tasting and unfamiliar wartime British food, didn't miss the third meal.

After outlasting the line and getting served, one GI commented, "Of course, once you manage to eat — and hunger is a great leveler of tastes — your woes were far from over; now came the lines anew. Mess kits had to be washed in salt water, most of the time cold, and in a boxlike room in which three was a crowd. Cups, spoons, knives, and forks turned the colors of the rainbow. Either you continued to eat with them and suffer the consequences — the well-known 'GIs' — or you discarded them and went hungry. There was concrete evidence of men doing both."

The men tried to keep up their appearances under difficult conditions. Again the lines had to be endured. In spite of efforts at personal cleanliness, anything white turned a dingy gray. Most men shaved as little as possible; a few tried out various designs of facial hair. It seemed a good idea. One man related, "Everyone liked to draw mustaches on magazine pictures — a vicarious affair at best. Now they tried the real thing. Van Dyke

beards, walrus mustaches, and long sideburns of every variety appeared but vanished just as quickly when the novelty wore off."

Cut and Deal
The 27th's crossing on the *Athlone Castle*, which was in a five-knot convoy, was much slower than the speedy crossings of the previous squadrons. Time seemed to pass slowly at sea. Men relieved boredom in just about the same way on every ship that crossed loaded with troops. They played cards. The *Athlone Castle* was no exception. "You can pack the boys like sardines, you can deprive them of food, you can make them sleep on hard floors or not sleep at all, you can make 'em sweat line until doomsday, but you can do nothing about those decks of cards which always appear, as it were, out of thin air," wrote one chronicler of the trip. Small favors meant a lot, a GI recalled, "the Red Cross so thoughtfully provided every man with a cloth bag containing razor blades, soap, stationery, chewing gum, books, — and a pack of playing cards..."

In Frank Campbell's cabin, he and three others played Gin Rummy 12 hours a day for the whole voyage. "We didn't pay off until after we docked and there wasn't a dollar difference," Campbell said.

Duties were light; routine geared to shipboard conditions. The squadron historian at the time wrote, "A little sweeping and cleaning of quarters with the limited facilities and crowded conditions, and policing the decks with a hose and brush was a new experience for soldiers. There was guard duty which was pulled by an outfit other than ours — Amen — and all the inevitable KP done by those who brought their own food to their tables. All in all a man had his hands full trying to keep his stomach the same way. There was plenty of food twice a day but a doughnut and coffee would still have fetched a king's ransom. Every day at 1100 hours a bell clanged loudly for boat drill and men poured from every nook and cranny to their appointed boat station on the upper deck carrying cookies, chocolate, candy, anything edible. They spent the next hour or two eating, reading and playing cards."

While the sun shone, sunning on deck passed some time. Then after a few days, rain and clouds made the upper deck less popular. Fairly smooth seas kept seasickness to a minimum and rumors of U-boats and the Luftwaffe remained just rumors. Very little interrupted the card games. On one thing everyone agreed, "That little hunk of blue depicted on all the maps and labeled the Atlantic was a damned big ocean..." After ten days on board ship that ocean got extremely tiresome.

Land at Last
October ended and everyone wanted one thing — land, any kind of land. On 1 November 1943 they finally sighted, as described by one of the weary men, "a dreary, dismal, fog-bound something jutting out of the ocean. It was still a thing of joy to behold." The next day, the *Athlone Castle* anchored outside Liverpool in a thick fog. The men chafed to get off and chanted "Let's go! Let's go!" They had another day to suffer confinement. Vibrations of the ship's engines on 3 November alerted everyone and the old British vessel moved slowly into the Liverpool docks.

At 2010 hours in the cold dark, the men of the 27th Squadron gladly disembarked from the *Athlone Castle*. Packs and rifles seemed three times as heavy and only a little moonlight relieved the blackout. At the rail station, ragged gaps in the roof gave evidence of the bombing Liverpool had suffered. After boarding the train, the men settled into the coaches, six men to a compartment. Cheerful British and American Red Cross women served hot coffee, doughnuts, cigarettes, and chewing gum.

Mount Farm
The train pulled out of Liverpool at 2100 hours, traveling all night to arrive at Culham Station the next morning in a typical English fog. Trucks waited to take the men on the last leg of their journey. Drivers strained and groped their way through the soup. The convoy arrived at Mount Farm and AAF Station 234 at 0730 hours on 4 November, where the 27th joined the 7th Photographic Group (R) already on the station.

Part II
THE 7TH PHOTOGRAPHIC RECONNAISSANCE AND MAPPING GROUP

Eyes of the Eighth

Chapter 5
July August September 1943

Tragedy and doubt overshadowed the usual upbeat emotion attending the formation of a new unit. During the week prior to the activation of the 7th Photographic Reconnaissance and Mapping Group, the original and most-experienced squadron, the 13th lost two pilots, bringing its June casualties to four men. Plagued with less-than-satisfactory aircraft and poor weather conditions, the photo squadrons attempted to fulfill their assigned mission. With combat losses and a lack of aircraft replacements, the new Group listed only 11 operational F-5s.

Coming directly from the 13th Squadron, the new 7th Group C.O. knew the shortcomings of the only aircraft available to him. The rate of loss was unacceptable and must not continue. Colonel Hall, a veteran flying officer who flew operational sorties, never asked his men to do more than he would do. Until the air force assigned his group more reliable F-5 models, the pilots would have to fly the ones they had within the limitations. The missing men could not tell their stories to give insight into the cause of such losses.

Order Number One
When, on 7 July 1943, he became commanding officer, Lt. Col. James Hall assigned Capt. Hershell Parsons as the new C.O. of the 13th Squadron per Order Number 1 of the 7th Photographic Reconnaissance and Mapping Group. He also assigned Capt. Edward O. Gwynn as Ground Executive Officer and Capt. James Wright, Air Executive. The 7th Group's Table of Organization proved inadequate to provide enough personnel for all jobs required by the Group and the Station. Therefore, many officers and enlisted men worked on Group duties while still members of the various squadrons.

Every man contributed to the Group's effort in the collection of aerial photo intelligence. The men on the line maintained the aircraft and Camera Repair kept the cameras in good order. The Photo Lab produced the quality material required and all the other departments saw to their responsibilities to keep the squadrons in operation and prospering.

Departmental Changes
Early in July, the 14th Squadron Tech Supply and Assistant Engineering Officer, Lt. W.J. Booher, and another Assistant Engineering Officer, Lt. P. Casteloin, received orders transferring them to another station. Sgt Amos L. Ellerd, the ranking NCO in that section, took on the responsibility of maintaining an efficient Tech Supply. The

Adolph Menjou helps the Red Cross hand out coffee.
(Marshall Williams)

two remaining officers, Lt. W.A. Nelson and W/O B.E. "Pop" Porter, assumed other vital duties. By now all department personnel had worked at almost every position a flight line has to offer. Lieutenant Nelson decided it was time to make some permanent assignments. He promoted James T. Spurlock to master sergeant and appointed him Line Chief; selected SSgt H.T. Navarrot as Flight Chief of Spitfires and SSgt E.L. Peterson as As-

Bob Hope and Frances Langford entertaining the 7th Group.
(Paul Campbell)

48

July August September 1943

sistant Flight Chief. TSgt Owen B. Thomas, former Squadron Inspector and Sergeant Nerbovig, a ground echelon man went on loan to the new Station Technical Inspection Office.

Special Services
In early July, Lt. John G. Anderson of the 22nd relieved Lt. Gordon Puffer as Special Services Officer. This section had the responsibility of providing diversion, sports, entertainment, education, and, as the name implied, something special. The first section officers, Lt. Edward Shephard of the 13th and Lt. Gordon Puffer from the 22nd squadron, organized supplies and equipment for baseball, football, softball, basketball, and any other sports the men might want, trying to keep pace with the growing contingent at Mount Farm. They arranged for parties and entertainment with visits from various USO shows. Late in June 1943 the Hollywood star, Adolph Menjou, came to the airfield and entertained the men. Bob Hope and Frances Langford put on a two-hour show in one of the blister hangers on 9 July.

Losses
A flight line accident proved fatal to a 13th Squadron man when Cpl James Mousley walked into a spinning propeller blade on 14 July 1943. The squadron buried Corporal Mousley at Brookwood Cemetery.

Three days later, the 13th lost another pilot when Lt. Edward L. Haight, Jr., failed to return from a mission to Huls, Germany. Huls' synthetic rubber plant had been on the damage assessment list since the 1st and 4th Bomb Wings' attack of 22 June but weather over Huls had been unsatisfactory until now. On 17 July, Operations predicted enough clear weather to complete the assigned job and briefed Haight, who left shortly before noon to photograph the Deelen/Arnhem, Soesterburg, Amsterdam/Schipol, and Woensdrecht airfields as well as the elusive Huls. Later in the day, the Group received a report that a RAF controller plotted Haight's route until fighters attacked the F-5 in the Scheldt area at 1424 hours. Twenty minutes later, a German radio transmission intercepted by British Coastal Command reported an aircraft shot down over Holland. Eighth Air Force Headquarters confirmed Haight as killed in action.

Arrival of the 14th Squadron Pilots
Morale went up 100 per cent in the 14th's Engineering Department when the squadron's pilots arrived at Mount

2nd and 3rd from left, Group S-2 Officer Capt. George Gregg and 7th Group C.O. Col. James Hall discuss mission with Lt. Robert Kinsell while other officers look on. Kinsell listed as missing in action in June 1943. (George P. Simmons)

Kinsell

Colonel Hall had come to rely on Lt. Robert Kinsell's ingenuity during their short time at Mount Farm. When faulty F-5A turbo-chargers threatened to ground his small contingent of aircraft, Hall encouraged the lieutenant's trouble-shooting. Poor performers at high altitude, the F-5's super-chargers often over-revved at full throttle causing the turbine to disintegrate with disastrous results. Kinsell discovered one possible problem; the super-chargers' control linkages had to be adjusted properly or the throttles would be miss-matched at altitudes over 30,000 feet. When a pilot pushed his throttles forward for more speed, the miss-matched turbo-charger could fail. Kinsell verified the adjustments in his own plane then worked on the squadron's other aircraft and tested them at altitude to confirm the corrections. One of the planes under his supervision was Hall's F-5, *Dim View*.

The night before Lt. Robert Kinsell took off on his 29 June sortie, he had flown his sixth experimental night photo mission (another project of Hall's) with an RAF crew in a Vickers Wellington twin-engine bomber from nearby Benson Airdrome. Colonel Hall wanted to try night photography using flares and asked the RAF to furnish a suitable aircraft. Hall felt that the familiar night bomber might escape special notice. The RAF crew, who preferred to drop bombs, did not share Hall's confidence but, as yet, they had not suffered any extra attention.

When Kinsell returned to his room early in the morning of 29 June, he found a note pinned to his pillow. Colonel Hall wanted his aircraft checked as soon as possible because he thought the super-chargers on *Dim View* were no longer properly matched. After getting some sleep, Kinsell adjusted the super-charger linkage on the C.O.'s F-5 and took it up for a test flight. Upon landing he turned the aircraft over to the ground crew and went to his briefing for St. Nazaire. Capt. George Gregg, S-2 Officer of the 13th Squadron, oversaw his briefing, which stressed the importance of the target and its dangers. Heavy flak and Luftwaffe fighters protected the area from squadrons of bombers as well as single photo planes.

Kinsell arrived at his target, and as the weather briefing had predicted, 3/10s low cloud partially obscured the U-boat pens at St. Nazaire. Solid cloud lay to the west. Kinsell flew along the coast and photographed targets of opportunity then returned and made several runs over the pens. He could see flak several thousand feet below at the usual maximum height of the German AA batteries. On his third run he suddenly found himself in the middle of deadly, black bursts. The salvo was 5,000 feet higher than any flak previously reported.

His plane rocked. He knew he had been hit. The falling fuel pressure in his right engine confirmed damage but when the pressure stabilized Kinsell left the engine running on reduced power and headed for home. Then he saw four FW-190s in pursuit using the flak bursts to home in on him. Kinsell thought they wouldn't catch him. His plane could sustain full throttle speed longer than the Focke-Wulf which would need its five minute burst of extra power. Another surprise awaited the American when three of the aircraft continued to close on him after they should have fallen back. These 190s were new and had *ten* minutes accelerated speed. They caught up with Kinsell and fired at him, the first tracers igniting a fire in his right engine. He turned the F-5 back toward France with the fighters behind and firing. Kinsell released his canopy to bail out just as a 20mm canon shell ripped into the radio compartment behind him, hitting the armor plate and sending shrapnel into the pilot's dinghy and parachute pack.

Behind the F-5, the jettisoned canopy caught in the windstream and smashed into the nearest fighter's propeller sending the FW-190 earthward. Fire swept into his cockpit and as Kinsell stood to push himself out of his crippled aircraft the remaining Germans fired again. A .30 caliber shell grazed his head slapping the pilot back down into his seat. Kinsell chopped the throttle on his left engine. The F-5 rolled over throwing him out past the dreaded horizontal stabilizer and downward.

He let himself freefall as long as he dared fearing attack by the German fighters, which followed him down. When he reached the low cloud layer at 1,500 feet, he pulled the ripcord. His chute popped open; the jolt snatched Kinsell out of his right boot and shoe. Above him, shrapnel shredded panels ripped,

July August September 1943

but the canopy held. The ground rushed toward him. Jerking his legs up to avoid a post, Kinsell plunged down slamming his tail bone on a tall stone cross. He blacked out; his wind filled parachute dragged him across a corn field where he came to under the guns of German soldiers.

Kinsell kept passing out and awoke later in a hospital ward at Le Baule, a town a few miles northwest of St. Nazaire. As he drifted in and out of consciousness, he became aware of a fellow patient two beds away, who seemed to pay uncommon attention to him. Kinsell's French nurse spoke some English and told the American that the other man was the German pilot brought down by the F-5's canopy. Expecting anger and animosity, Kinsell discovered his Luftwaffe counterpart quite cheerful and congenial. The German's nurse brought Lieutenant Kinsell a glass of champagne and through her German to French and his nurse's French to English, the American learned his opponent wanted to toast Kinsell for getting him out of the war alive.

Although the champagne further dimmed his already blurry consciousness, he managed to learn the German's story through the three language conversation. Kinsell also found out why those FW-190s caught him. The Luftwaffe pilot had been stationed at another field but had moved down to an old French airfield with three new, extra-boost-capacity Focke-Wulfs in his command. He said that earlier in June he had shot down two B-17s. On this day he added two P-38s to his total. His last victim was Kinsell. After the F-5's canopy struck the 190's propeller, the German pilot tried get his plane safely down in a field but instead he plowed into a hedgerow tearing up the aircraft and breaking his back. He also told Kinsell that his wing man had followed the F-5 down through the low cloud and saw it crash into a wall near a Catholic school in the ancient village of Guerande. He assured his American counterpart that no one had been hurt, except, of course, the two of them. Their war was over. He had four kills and would recover from his broken back.

Kinsell was not so sure about his injuries. The champagne acted as a painkiller but even when it wore off he could stand but not walk. The doctors told him that he had dislocated his tail bone when he hit the stone cross. He had to be carried everywhere. One day, when two orderlies carried him into the latrine, Kinsell slipped from their grasp and dropped heavily onto the seat. His tailbone popped back into alignment bringing mobility and agony, astonishing the doctors, and allowing Kinsell to walk again.

After a short stay at the Le Baule hospital, Kinsell left under Luftwaffe guard. They traveled by train through France and into Germany to the Luftwaffe's Interrogation Center outside Frankfurt at Oberursel. Here he underwent the questioning other pilots had before him and newcomers would experience after he left. Kinsell didn't know it at the time but one of his friends, Lt. Herschel Turner, was in a cell just down the hall.

Soon after he arrived, a guard took him into an office where a German interrogator waited. He handed Lieutenant Kinsell a notebook with the pilot's name on it. As Kinsell flipped through the pages, he saw clippings of press releases sent to his hometown paper. Promotions and awards, the usual innocuous things that public relations offices told the homefolks about how their particular airman contributed to winning the war. Nothing secret but seeing it all in a German notebook disturbed Kinsell nevertheless. Here was everything about him neatly clipped and collected just as if they had been waiting for him to arrive. The last entry was a plot of his flight to St. Nazaire right up to the point where he got shot down. The startled Kinsell made a disturbing discovery. The plot was not his. He had flown directly to St. Nazaire from Mount Farm. This plot showed a course from the forward British coastal airfield of St. Eval where the radar tracked plane refueled before continuing south to St. Nazaire. Luftwaffe fighters shot down this pilot just as they had Kinsell. This was Lt. John Schaffer's plot. Kinsell did not tell his captors they had made a mistake.

From Oberursel, the Germans sent Bob Kinsell to Stalag Luft III at Sagan. There he found two old friends from Mount Farm, Lts. Herschel Turner and "Tip" Byington. They remained together at Sagan for many months and because lectures on security had told them to never talk about their flights, Byington and Kinsell did not know that both had knocked out their pursuers with jettisoned canopies.

Farm on 14 July 1943. Squadron C.O., Capt. Marshall Wayne, relieved Lt. James "Maxie" Campbell, who had been commander of the 14th's ground echelon since bringing it overseas. Campbell had not been inactive during his two months at Mount Farm. He flew 13th Squadron aircraft in preparation for combat and flew his and the 14th Squadron's first operational sortie on 26 June 1943. By the time the other pilots arrived he had two missions and flew a third three days later.

The pilots took an intensive training course to learn operational conditions, British radio procedure, and flying regulations. They attended lectures on escape and evasion, use of safety equipment, and security. Briefings pointed out the different weather conditions they could expect in this theater. Instructors gave top priority to instrument flying and time in the Link Trainer. With missions to the south coast of England in borrowed F-5s and local flights in anything available, the pilots learned all the check points and surrounding terrain.

Although they had no operational aircraft of their own, the 14th Squadron pilots checked out in the war-weary Spitfires so carefully tended by the SSgt Navarrot's line crews. The Supermarine Spitfire was a legend after the heroic Battle for Britain where the RAF with the Spit and its less-famous workhorse companion, the Hawker Hurricane, performed marvels in combat with German aircraft. Its aerodynamic efficiency at high altitudes and relatively low air speeds made the Spit attractive for aerial photographic reconnaissance. Ever since Australian Sidney Cotton and Wing Commander Fred Winterbottom developed the RAF Photo Reconnaissance Unit (PRU) in 1939, the Spitfire had been the primary PR aircraft for the British. Lighter and smaller than the American F-5, the British Spit V used a control stick rather than a wheel and yoke. Besides the obvious difference of one versus two engines, standard tail wheel versus tricycle landing gear, the two aircraft handled quite differently on the ground. It was here that most problems occurred in the beginning.

Tricky Spitfires

The Spitfire was an unfamiliar aircraft with its own quirks. In an F-5, the pilot had an elevated position and unobstructed view from the center pod cockpit, but in the British ship with its tail lower than its nose, his forward view was obstructed. In a Spit, to see where he was going, the pilot had to taxi weaving back and forth while looking out the side of the cockpit window. When ready for takeoff, he pushed the throttle forward and accelerated down the runway still unable to see ahead until the tail wheel lifted off the ground. Lifting the tail quickly to see where he was going was easy and the Spitfire obliged quickly; too quickly and the old wooden props on those war-weary Spit Vs lashed the runway grinding off the tips. Since each blade ground off evenly, the damaged propeller remained balanced and quite often unnoticed by the pilot. The mechanics on the flight line noticed and it embarrassed them to ask for so many replacement props from their British supplier.

One of the pilots, Lt. George Nesselrode, according to one of the line crew, "got the half-hour cockpit check, strapped in, started the engine, taxied to the end of the runway, poured the coal to it, shoved the stick forward to see where he was going, took off, flew around for an hour, made a nice landing, taxied in, shut down and climbed out raving about what a great plane it was. Then he saw the prop. He'd sheared three or four inches off each blade trying to see the runway on takeoff."

The Spitfire was very sensitive to the controls and responded on the ground almost as swiftly as it did in the air. This responsiveness coupled with a totally different control system caused more than one pilot to swerve off the runway or perimeter track. During landings, the Spitfire's close-set wheels allowed far less latitude than the wide-set and stable tricycle landing gear of the F-5. In the early days, braking during practice landings exposed big problems. The Spitfire's brakes were a hand control on the rudder stick while the F-5 had pedal brakes. Pilots coming in for landings used rudder controls to fishtail their aircraft, aligning it with the runway before setting down. If the Spitfire rudder stick wasn't straight when they hit the brakes, the plane might ground loop or pitch over on its nose, ruining the wooden props.

Uneven braking and skewed wheel alignment on touchdowns quickly wore out tires. The mechanics on the Flight Line used to watch these hot landings and know that another set of tires had been burned. It was so bad that each set lasted only two or three landings.

Line Chief Spurlock welcomed the help when F/O Harry Witt, a transfer to the 13th Squadron from the RAF with valuable Spitfire experience, came over and proceeded to "check out those nose-gear minded, twin-engine dedicated P-38 Jocks in a tail-wheel, no forward visibility bird." Witt told the pilots, "I'm going to show all you guys how to land a Spitfire," and proceeded to shoot 25 landings, going up and around and down again and again, demonstrating how it should be done. He fish-tailed the plane, straightened it out, set it down gently, and after 25 landings, the mechanics said, "You could hardly tell he'd touched the ground with the tires." From that point on everyone tried to see how many landings they could get out of a set of tires. Any foul-up, especially standing a Spit on its prop or digging a wing tip in the ground, brought a ribbing.

July August September 1943

Limited Operations
About the time the 14th's pilots arrived at Mount Farm, the USAAF confirmed disturbing evidence of major flaws in its main photo reconnaissance plane. The Eighth Air Force knew that its primary camera platform could not perform satisfactorily at high altitudes. More successful in other theaters, the P-38 experienced severe mechanical difficulty and failures at high altitudes in the cold damp European skies where its cockpit was excruciatingly cold in minus 50 degrees at operational altitude. Photo recon aircraft, which flew regularly above 30,000 feet, obviously suffered more altitude-related problems than fighter aircraft operating at lower ceilings. By the middle of July 1943 it became apparent to headquarters that the limitations of the P-38G (F-5A) had probably cost lives. As well as altitude problems, the unarmed F5-A, which used speed to evade pursuit, had problems escaping enemy aircraft when carrying drop-tanks on long flights. The high loss of pilots under these conditions prompted the USAAF to issue an order on 15 July 1943 restricting aircraft of Station 234 to a 300-mile radius on operational missions. As a result of this order, the newly-formed 7th Group had to refuse many requests for photo cover and turn the jobs over to the RAF. These problems would not be solved until the newer model F-5s arrived.

There were frustrating weeks ahead for the 14th Squadron pilots who wanted to fly more than local hops. Without their own operational aircraft and with new limitations on the ones remaining in the Group, they hoped for better news. For their C.O., Captain Wayne, there was one consolation when he received his promotion to major on 23 July 1943.

Changes in the 22nd Squadron
Continued organizational shifting and doubling up moved men and officers from squadron to squadron as the 7th Group acquired more staff and took shape. Promotions in the 22nd Squadron moved Captain Lawson up to major on 17 July, and Lts. Norris Hartwell and James A. Norton to captain. Since the 7th Group was short of men, the squadron transferred Cpls John F. Steen and William L. McGivern into the Group. Some of the squadron officers added station positions to their regular squadron duties; Capt. Leslie Kunkel became Assistant Ground Executive Officer and Captain Morton took on the tasks of Assistant Combat Intelligence Officer, Assistant S-2 Censorship Officer, and Assistant S-2 Public Relations Officer. Capt. Norris Hartwell, already Station Athletic Officer, added the job of Assistant S-3 Officer in charge of Administration. Warrant Officer Perry Haughton became Assistant Camera Repair Officer and Capt. Caspar Harstead, Assistant Ground Communications Officer.

Group C.O. Hall named W/O William D. Beckwith to the position of Station Technical Inspector. The 22nd Squadron lost a few men through transfers: Lieutenant Montgomery to VIII Bomber Command, Lieutenant Wasilieff to the 1st Bomb Wing, and Lt. Albert Betz to the 13th Squadron just across the hall. At the end of the month, Cpl Joseph Anders also was sent to the 13th.

O'Bannon Killed
The RAF and USAAF authorized a comparative performance test of the three major photo planes. Two were twin-engine aircraft, the American F-5 Lightning, and the DeHavilland Mosquito, the famous "Wooden Wonder" of the RAF. The third plane was the RAF's Supermarine Spitfire. Group Operations assigned 13th Squadron pilot Capt. Thomas C. O'Bannon, Jr., to fly an F-5A during Test Flight 80 on 24 July 1943. After taking off from Mount Farm at 1129 hours, O'Bannon climbed to 25,000 feet where he joined up over the RAF PR base at nearby Benson with F/O A. Glover in the Spitfire and S/Ldr. M.D.S. Hood in the Mosquito.

The trio flew northward. Below 2,500 feet there was poor visibility with light clouds but above 10,000 feet the sky was cloudless. Winds below 7,000 feet were light and variable. First, they tried out their respective aircraft in a level-flight speed trial. The Spitfire drew ahead immediately and won that contest. The Mosquito, fitted with drop-tanks, proved only slightly faster than the F-5A. About ten minutes later, the RAF flight leader, beginning the rate-of-climb test, gave orders to the other pilots to begin a turn to starboard and climb to 30,000 feet. The Lightning and Mosquito climbed at about the same rate but again lost to the Spitfire, which reached 30,000 feet with the other two planes still 2,000 feet below. Test completed, they set course for home base.

When O'Bannon's F-5 got far ahead of the formation and did not respond to radio calls, Flight Officer Glover in the Spitfire went ahead of the Mosquito and caught up with the Lightning. They made a turn allowing the Mosquito to catch up. The Mosquito pilot, Squadron Leader Hood, ordered maximum cruising speed for ten minutes and another turn. The Lightning responded immediately, but instead of a level turn, it began a descending turn at a 45 degree angle which took O'Bannon down into the haze characteristic of skies around Britain's industrial areas.

Hood and Glover did not see Captain O'Bannon's F-5 again. When O'Bannon did not return to Mount Farm the squadron hoped to hear he had landed safely at another field. Unfortunately, he had crashed, the wreckage discovered approximately six miles WNW of Warwick.

Captain O'Bannon had almost 400 solo hours and

Eyes of the Eighth

157 hours P-38 experience. His aircraft, destroyed on impact with the ground and the resulting fire, had a total of 131 hours at time of the crash. O'Bannon had been killed instantly.

Capt. Kermit Bliss and W/O "Pop" Porter investigated the crash site. Porter found the tail assembly some distance from the rest of the aircraft wreckage. He and Bliss searched for anything that could shed light on the accident. "Pop" Porter looked at what was left of the tail assembly and, upon close examination, found that the bolt that adjusted the elevator trim tab push rod had broken. They took their findings to representatives of the Lockheed Corporation investigating the crash, who insisted that the bolt was stronger than the rod and it couldn't have broken. Bliss and Porter convinced them to test some bolts until they broke. The tests revealed that, during compression, a bend ran down into the under-sized bolt causing it to sheer off. Lockheed ordered rods with bigger bolts installed in all P-38s.

In spite of restrictions, during July 22nd Squadron pilots managed to fly sorties to coastal France. Lts. Steven A. Scott, Norris Hartwell, Vernon Black, Robert R. Smith, F/Os M.D. "Doc" Hughes, and Richard Hairston had mixed results. Some failures resulted from poor weather conditions. Occasionally British Controllers recalled pilots due to enemy fighter action in the target area, as happened to Major Lawson and Lieutenant Scott late in July. Lt. Carl Chapman attempted two Meteorological (Met)

Texan F/O Richard Hairston in F-5 cockpit. (L. Exner)

Lt. Carl Chapman, 22nd Sq. Pilot. (L. Exner)

sorties to report on weather conditions over sections of France. On both occasions he found the assigned areas covered with cloud. Lieutenant Scott tried to cover a job for the British Air Ministry on 27 July but VIII Fighter Command fighter sweeps in the Rouen area prompted his recall. The next morning Scott completed the task with 6" focal length photos of a strip in the Dieppe area.

A Close Call

Operations assigned Lt. Robert R. Smith to photograph strips in the Cherbourg area on 28 July. Although unpromising low cloud covered the base, the weather officer assured the pilot that Cherbourg should be clear. Airborne at 0906 hours Smith flew into the low cloud at 700 feet altitude and disappeared from view. Smith said, "England has kind of stinky weather and we all had arrived without much actual weather time. We had time under the hood on the Link but since photography requires clear weather we didn't have too much occasion in Colorado to fly instruments so we weren't too proficient in it." He pushed his F-5 up through the cloud with his attention more on his mission than his rate of climb. "I had dropped some maps on the floor and I reached down to get them," Smith felt his plane roll and, "The next thing I knew my artificial horizon had tumbled and I probably did a Split-S or something." Tumbling about, he became disoriented until his aircraft came out of the clouds and he saw the ground straight ahead and coming up fast. The pilot hauled back on the stick, which began chattering in his hands. The nose came up only 10 or 15 degrees.

July August September 1943

Lt. Robert R. Smith in an F-5. (L. Exner)

In a flash he remembered what to do. In an un-nerving move he pushed the stick forward then pulled back very slowly. The plane responded and Smith watched the nose rise slowly. Ahead lay water. His plane leveled off perilously close to the surface of the Thames River. "I felt I was looking up at the river banks and that any minute my props would pick up water and throw it back over the canopy." Except that the F-5 no longer had a canopy. He didn't know exactly when it had happened but the violent maneuvering of the plane had torn off the canopy although it had been closed and locked. Smith flew up and down the river a few minutes to regain his composure before calling base and landing.

At his dispersal area he offered no explanation but asked the crew chief for another plane. He knew he had to get back in the air quickly. Less than an hour after his first attempt he took off again for Cherbourg but was recalled almost immediately by British Controllers.

Lieutenant Smith had another chance later in the day. He watched his rate of climb closely, climbing out through the clouds very carefully, "sort of like driving without your driver's license," and broke out on top by the time he crossed the Channel coast. This time he successfully covered his target returning at 1341 hours.

Lieutenants Scott, Black, and Chapman also completed missions that day. On the 30th of July, Flight Officers Hughes and Hairston finished out the month with successful sorties. Hughes left Mount Farm to get 6" film strips of the Poperinghe area in Belgium. The weather was very clear as far as he could see except for some high cirrus at 32,000 feet and 1/10th cloud along the French coast. When crossing the Belgian coast at Ostend, Hughes saw a single-engine enemy aircraft in the direction of Ghent, which turned and proceeded south, evidently not seeing him. He took his photos and returned to base. His landing gear failed to lock and Hughes had to make a wheels-up belly landing, which damaged the propellers but not the pilot.

New Facilities

As new units arrived on the station, facilities ample for one squadron rapidly became overcrowded. To alleviate this condition, the 342nd Engineers began a new construction program at the beginning of August 1943. Their program called for the construction of 40 Nissen Huts for living quarters, enlarging the main Mess Hall, building new barber and tailor shops, a new Post Exchange building, and an amusement hall, which could be used for religious services. Plans called for new quarters for the commanding officers, seven Nissen Huts for supply storage purposes, a large hut for the Quartermaster, and two Air Corps supply buildings. The Engineers scheduled construction of a new Photo Lab building, a new headquarters for Operations and Intelligence, a parachute stores building, 26 hardstands, 200 yards of concrete roadway, and the digging of a new well. Since the station technically remained British property, an official watchdog kept his eye on all alterations and new construction. A stickler for rules and regulations, RAF Flt/Lt. A.J. Terry, Clerk of the Works, became known by various other names like "monkey wrench" for his perceived bureaucratic interference.

Throughout the activity of expansion and normal operations, farming continued. Most of the Mount Farm buildings continued to be occupied by farmers who carried on tilling the soil, raising sheep and cattle, apparently undisturbed by the humming activity. The farm likewise provided a source of enjoyment for the GIs, who raided the potato fields to secure the raw material for French fries, which they cooked on top of the stoves in the barracks.

The 14th Squadron Flight Line

The 7th Group assigned seven operational F-5As to the 14th Squadron on the first of August. The Flight Line had to be reorganized and this time every man had a specific job. It moved to a new dispersal area located at the most distant corner of the station where there were two blister hangers, two Nissen Huts, and four hardstands large enough to accommodate three F-5s each.

In two days the Engineering Department moved every piece of equipment to the new area. Lieutenant Nelson and W/O "Pop" Porter started making the necessary personnel assignments. The old Spitfire training planes went to the 381st Service Squadron. TSgt Peterson, SSgt Grubb,

Eyes of the Eighth

TSgt Sam Quindt, Crew Chief for 14th Sq. C.O., Maj. Marshall Wayne. (Smitty Mysliwczyk)

and Sgt Geary remained with the planes until the 381st mechanics learned to maintain their new aircraft. MSgt Spurlock kept his position as Line Chief. He had three Flight Chiefs under him in the air echelon: TSgt R.E. Mayden, TSgt R.L. Steinbach, and the former Spitfire Flight Chief, TSgt H.T. Navarrot.

Spurlock divided the seven F-5As among the three flights and crews made up of Tech Sergeants Graveson, J.D. Miller, Kinder, Nelson, S.W. Quindt, N.O. Buley, and C.D. Reed. Each of these men obtained plenty of crew chief experience and Line Chief Spurlock expected them to crew other ships coming into the squadron in the future.

Lieutenant Nelson activated a hanger crew headed by MSgt John Robinson to back up the air echelon and ensure swift and thorough completion of periodic inspection. The crew consisted of all the specialists assigned to the Engineering Department and included instrument men, electrical specialists, a welder, and a sheet metal worker.

In addition to performing their regular duties on aircraft, these men designed and constructed several tools and pieces of equipment which helped speed up repairs on aircraft. The welder, Cpl Bill Libbert, devoted his spare time to changing the design of the Government Issue "Crew Chief stands" by cutting them down to a size more practical for use on F-5A aircraft.

Cpl James Nichols, Engineering Department sheet metal worker, thought there must be a better way to install new needles in the Stromberg Injection Type Carburetor. He invented a tool which saved three hours of difficult labor.

During engine installations mechanics, using the wrenches furnished in Allison Engine tool kits, found it difficult to remove the Allison's Cuno Oil Filter until TSgt Clarence Bean and Sgt J.C. Martin designed a new wrench. All the mechanics agreed it cured the Cuno removal problem.

The combined efforts of this group also aided in producing a welding table, slip-proof aircraft wheel chocks, and a device to prevent mud from getting on aircraft camera windows during take-off.

Operational

Usually the commanding officer of the squadron flew its first sortie but by the time the 14th Squadron officially became operational on 7 August 1943, one of its pilots, the newly-promoted Capt. "Maxie" Campbell, had chalked up eight and a half combat hours in planes borrowed from the 13th Squadron. On the 26th of June he had flown his first combat sortie bringing back obliques of Cap Gris Nez, France. His flew his second, to photograph Beaumont/Le Roger Airfield, on the third of July and on the 17th, he completed another successful mission with pictures of the Ostende and Dunkirk areas. Again in July Campbell flew to Belgium to get D/A (damage assessment) photos of Ghent and the Coxyde/Furnes A/F on the 27th. Campbell flew his fifth mission on 16 August returning with D/A photos of Flushing. By the time the 14th's C.O., Major Wayne, completed the first official squadron sortie, Campbell had eight and a half operational hours to his credit.

6 August 1943, the 14th Squadron C.O., Maj. "Marsh" Wayne, took first place in the one meter dive and second in the three meter dive at ETO swim meet. (Marshall Williams)

56

July August September 1943

L to R Lt. Harlan Fricke, Capt. "Maxie" Campbell, Capt. George Nesselrode greet Major Wayne after his first mission, 18 August 1943. (Al Hill)

TSgt Sam Quindt informed Operations on 12 August that he had Major Wayne's aircraft ready for operational flying. After waiting for poor weather to clear, Wayne took off on 18 August, for his first sortie. Unfortunately, the weather did not clear enough for him to get pictures. The next day two other pilots had better luck and successfully completed their first missions when Capt. George Nesselrode took off at 0835 hours to photograph obliques of Calais to Cap Gris Nez and Capt. Walter Weitner, airborne at 1130 hours, photographed obliques of the same area.

The 22nd Squadron's target area had clear weather on 15 August and Major Lawson and Lt. Steven Scott flew sorties. Scott took off late in the afternoon to photograph Ypenburg Airfield (A/F) for damage assessment. On a line from Clacton on the English coast to The Hague, Holland, there was 10/10 stratus cloud. Scott flew on instruments the whole way. In the vicinity of Ypenburg he dropped down to 24,000 feet but cloud still covered the target and he returned to base. The next day Lieutenants Smith, Black, and Chapman successfully covered their targets. Black's sortie involved several jobs, one of which was a British Air Ministry request for cover of Amiens/Glisy and Abbeville/Drucat A/Fs. On the 17th Captain Hartwell and Flight Officer Hairston also flew successful sorties. Hartwell's assignments included damage assessment Job 279 for United States Bomber Command, as well as targets at Vitry en Artois A/F, and Lille/Vendeville A/F.

The 7th Group's First Job

Airfield cover made up a large part of the requests during the summer of 1943. The first job given to the 7th Group involved coverage of 90 airfields in the German Occupied Countries of France, Belgium, and Holland. Sometimes coverage was for activity; Intelligence kept an inventory, which they updated with continuing coverage of the airfields. Everything interested Intelligence: increasing or decreasing Luftwaffe strength at a certain field, construction of new buildings and runways, new types of aircraft, and anything out of the ordinary. Often, separate sorties covered the same airfield on the same day, sometimes minutes, sometimes hours apart, collecting information for Intelligence to record and digest.

Plans for the invasion of Europe, due sometime in the spring of 1944, called for extensive coverage. Luftwaffe airbases and landing grounds would come in for heavy bombing just before the invasion. This would drive the fighter units farther away from the coast by making their airfields inoperable through a bombing technique known as "post-holing." Most 7th Group pilots would become very familiar with many of the airfields as they flew sorties over them again and again.

Another reason for the thorough coverage of Luftwaffe airfields resulted from code-breaking. British Intelligence, at its operation at Bletchley Park, could read the German Air Force (GAF) codes sent and received on Enigma machines. These codes, sent between units, headquarters, and Berlin, covered much of the daily business of the Luftwaffe elements, all of which told British Intelligence who was where and in what strength. British Intelligence had made the decision early on that any information gleaned from the coded transmissions must be protected by a cover of other sorts of intelligence gathering. One of these was aerial photography. Information from the Enigma cyphers, classified by the name ULTRA, prompted coverage of many targets assigned to the 7th Group.

Operation Point Blank

Early in 1943, after the January Casablanca Conference, Allied leaders formulated a plan to insure maximum bombing effort in preparation for the cross-Channel invasion. This plan, the Combined Bomber Offensive (CBO), set forth the basis for target priority. A major operation against the German aircraft industry, associated factories, the Luftwaffe and its bases in occupied countries, began in June 1943 with the implementation of Operation Point Blank. Cloudy weather over the Continent during the summer hampered both the bombers and the photo reconnaissance planes. The bombers received some help when in the autumn they acquired radar "blind

bombing" devices, but this did not help camera planes.

Luftwaffe airfields, especially those in western France, took on added importance when cryptographers, reading the Japanese diplomatic, so-called "Purple" cyphers between Tokyo and Berlin, discovered that the Germans planned to increase their submarine attacks in the Atlantic. The Bay of Biscay was the main route for the U-boats from their French ports into the Atlantic. The Allies needed air supremacy here as well as over the proposed invasion beaches. Without Luftwaffe air cover, the submarines would not be able to travel on the surface day or night. There had been a lull in U-boat effectiveness since June when new auxilliary aircraft carriers and other defensive means caused the Germans to discontinue their wolf pack tactics against Allied convoys. Through the same Japanese communications, the Allies also learned that the lull would end after doubled submarine production began to put new and more effective U-boats into service. For photo pilots, the summer respite from coverage of the deadly sub-pens would soon end.

A Long Hot Summer
The station continued to grow, adding a new Quartermaster Detachment and establishing a Post Exchange under Capt. Ralph A. Esposito. The Engineers built a new building for the PX. Ice-cold beer and Coca Cola proved popular in the summer heat. Checking it out, Colonel Hall remarked that the new PX looked like a regular country store.

The newly arrived Americans of the 7th Group didn't know how unusual the weather was that August of 1943. The familiar cool, damp, mild English summer warmed up more than usual making the crowded conditions in the technical buildings all the more difficult. In the severe August heat everyone looked for ways to cool off. During the day the Photo Lab night shift cycled to the swimming pool at nearby Benson while those who hadn't pulled night duty swam in the nearby Thames.

Late in July Base Camera Repair went on three eight-hour shifts; 0800 to 1600, 1600 to 2400, and 2400 to 0800 hours. Doors and windows could be opened during the long summer daylight hours of Double Summer Time, as the British called their double Daylight Saving Time, making decent working conditions for the day and evening shifts. But when the graveyard shift, due to blackout regulations, had to work with all the doors and windows closed and blackout curtains drawn, the situation became critical. With the lack of sufficient ventilation, the men suffered severely not only from a lack of fresh air but also from the fumes of carbon tetrachloride and cleaning solvent. It became difficult to get any sleep in the daylight of the summer months.

Blackout regulations complicated the work of the Line crew, who could not work outside after dark. The lack of space and appropriate working areas became even more complicated by much longer operational hours. Pilots returning from missions late in the evening meant film to be processed, cameras to be maintained, and aircraft to be serviced for first daylight, which was only a few hours away.

Major Lawson made more promotions in the 22nd Squadron, moving Captain Kunkel to major. James J. Hayes, the Photogrammetrist Officer; Gordon Neilson, the Lab Commander; pilot and Operations Officer, Robert R. Smith, made captain while Gilbert P. Briggs, Lawrence J. Exner, Peter Mulligan, and Albert S. Raff moved up to first lieutenant. SSgt Willy Mitchell became a tech sergeant; Elmar F. Taylor, staff sergeant; James H. Hotaling and Harry Rockoff, sergeant. Two Pfcs, Abram Green and Earl Anderson, put on corporal's stripes. On 11 August 1943, Captain Hartwell transferred into the 7th and became Assistant Group Operations Officer.

"Doc" Hughes
Many mission assignments for 7th Group pilots were numbered Jobs divided into parts for easier plotting. These requests for large area cover usually came from the Eighth Air Force or various planning organizations. Frequently a pilot flew a sortie with parts of two or three separate jobs on his program. On 18 August 1943, Operations assigned F/O Malcolm "Doc" Hughes two parts of two jobs. One, Job 279, was part of the same assignment of airfields in northern France, which Hartwell had flown the day before. The other was Job 98, a strip of the

Col. Hall and Capt. Ralph Esposito try a cool drink in the newly opened PX. (George P. Simmons)

Hazebronck area, on a six inch focal length camera. Settling into F-5 42-13099, Hughes lifted off the Mount Farm runway, "I took off at 0720 hours to photograph my target near Lille, France. After gaining altitude I passed over base at 15,000 feet and continued to climb to 35,000 feet. The mission was not deep into enemy territory so I carried no extra fuel tanks. I headed south and east directly towards my target, in 10/10ths cloud."

Hughes flew on instruments, climbing through the murky overcast when, "At 35,000 feet I felt my aircraft surge once or twice and noticed light hail on the windscreen. The storm didn't seem unusually severe. Then, with a shudder, the altimeter started up and climbed rapidly to about 40,000 feet where it suddenly stopped and started down with another shudder. I had not moved the controls."

He looked behind and to his amazement, the tail assembly had disappeared. With his aircraft out of control, Hughes' first thought, "was to bail out, and I jettisoned the hood. But by now what remained of my kite was in a spin and the air speed was mounting rapidly. I couldn't move; the centrifugal force pinned me to the cockpit." Hughes' nose began to bleed. The airspeed indicator registered 450 miles an hour. Finally able to roll down his left window and using the rear view mirror for a brace, he pulled himself out. "The strong wind carried me off the wing, pulling the mask off my face. I felt my leg strike the boom. Then I felt a stinging sensation about my face but thought it was the wind. I started falling, tumbling over and over again, but there really was no sensation of falling — just the rush of air and fog against me." Just before he left the cockpit he had checked the altimeter, which indicated 25,000 feet and, having no oxygen bail-out bottle, Hughes delayed opening his chute until he reached a lower altitude.

As he tumbled over and over he started to pull the rip-cord but, afraid of being too high, delayed longer. He seemed to fall forever and just when he thought he could wait no longer he suddenly broke through the clouds. He could see water about 5,000 feet below him. Hughes jerked the ripcord, his chute opened and he found himself hanging by his left leg, head downward. Struggling with the chute, he managed to untangle his leg from the shrouds, get himself upright just as he floated across a coastline and down toward the ground.

Hughes landed in a sugar beet field. He had no idea where he had landed, "This was the first time I had seen the ground since I took off from my airdrome. My parachute had opened over water but I had drifted half a mile inland, but in what country? I didn't know. I landed facing into the wind and had some difficulty spilling my chute and it dragged me." Hughes kept looking about to see if anything looked familiar. He saw three military trucks parked in the distance but he couldn't identify them. At first he thought he might be in enemy territory and began to think of making his escape when he spotted two people on the other side of the field rushing towards him. He couldn't hide, much less escape. "The two people turned out to be English girls and I was never so overjoyed in my life at seeing English girls. I knew I had landed in England." The girls found a battered but relatively uninjured pilot standing before them. After his oxygen mask had been torn off, the hail, which had pelted his aircraft, battered his face. Only a few cuts required stitches.

F/O Malcolm "Doc" Hughes, battered by hailstones after bailing out when his F-5's tail broke off in a violent stormcloud over England on 18 August 1943. (Marshall Williams)

The first report of the incident, which came into Mount Farm teletype, indicated the pilot had bailed out over Manston after a mid-air collision with another aircraft. Hughes' account of the accident and the loss of his aircraft's tail seemed strange indeed. Upon examination of the tail assembly and controls in the wreckage of the F-5, investigators found that the fault lay in the trim tab control rod which had allowed elevator flutter to develop and caused the aircraft's breakup. This accident combined with the similarly-caused crash of Lieutenant

Eyes of the Eighth

L to R. TSgt Buley, Capts. Campbell, and Nesselrode.
(Smitty Mysliwczyk)

O'Bannon's aircraft in July, resulted in the Station Commander grounding all 7th Group F-5As on 23 August 1943. The Group thought its aircraft would be back in service within two weeks after the Lockheed Overseas Corporation at Langford Lodge, Northern Ireland, manufactured modified rods to replace the faulty ones.

A few days later, the 14th Squadron's Engineering Section removed all elevator control rods and returned them to Air Force Supply. Five days later, their replacements had not arrived. Finally, Air Force Supply issued two and assured the squadron of more to come.

From the last of August until 7 September the 14th Squadron still had only two elevator trim tab control rods available for its seven aircraft. Mechanics moved the rods from plane to plane. Whenever other mechanical trouble grounded a plane with good rods, they transferred them to another aircraft. This supply situation created havoc along the Flight Line.

Flight Officer Hughes got back in the air on 3 September 1943, the first sortie since the grounding of the F-5s, to photograph Lille/Nord and Lille/Vendeville A/Fs for damage assessment. He found poor weather conditions in some areas and pulled consistent contrails at 28,000 feet but managed to get obliques of Calais.

The next day, Capt. Walter Simon successfully covered Cherbourg. Hughes flew again on 6 September in somewhat better conditions and successfully completed part of his assignment. Southeast of Ghent, Controllers warned him of "bandits" in the area. Immediately, he saw three single-engine aircraft approaching from the south about one mile away. Hughes headed for the coast at Ostende and lost them.

Continuing trouble with the elevator rods seriously curtailed flying in September. The squadrons put up as many planes as they could. The Eighth Air Force's bombers attacked airfields near the coast in France and VIII Bomber Command needed damage assessment (D/A) of the airfields. Operations assigned the targets to the 14th Squadron. On 7 September, Capt. George Nesselrode flew a D/A sortie to Caen/Carpiquet A/F and Capt. James Campbell brought back D/A photos of the Watten area. The next day Major Wayne successfully covered D/A of Caen/Carpiquet A/F.

The limited range of the present aircraft, the pilots' early flights restricted to shallow penetration, and poor weather frustrated the men. Weather would be a continuing factor and was the cause of most mission failures.

Guardian Angels

Replacement pilots transferring into the Group had different levels of experience. They came from varied backgrounds, some just out of flying schools and others with several years of flying in civilian life or in one of the other services, the Royal Air Force or Royal Canadian

Protestant communion services in the PX, 29 Aug 1943. (Edwin J. Douttiel)

July August September 1943

Capt. George Lawson pitches horseshoes with L to R: Lt. W. W. Blickensderfer, Lt. Carl Chapman, Capt. Steven Scott, Lt. Dan Burrows, and F/O John Blyth. (Roger Freeman)

Air Force. Many Americans joined these services to get in on the action early. Hector Gonzalez, a Mexican-American from Los Angeles, had some civilian experience when he joined the RCAF in October 1941. He trained in single and multi-engine aircraft in Canada before going to England in September 1942. By then, with the United States in the war, Gonzalez requested a transfer to the USAF in October. In March 1943 he transferred as a flight officer to the 92nd Bomb Group where he flew B-17s. Unable to see a future in the pilot's seat in bombers Gonzalez searched for another billet where he could fly alone. He found photo reconnaissance and after an interview with Major Hall, became convinced PR was just what he wanted. In June 1943 he joined the 13th Photo Reconnaissance Squadron.

Like all replacements he had to become familiar with new aircraft, in this case the Spitfire and F-5. First he flew the old Spitfires, learned the local landmarks and procedures, then began flying F-5s. Having flown multi-engine aircraft, Gonzalez needed little twin-engine instruction but the F-5's two counter-rotating props needed careful trimming and handling. If an engine suddenly quit, or one turbo-charger ran out of control, the resulting torque from the full-power engine rolled the F-5 over and out of control. Life or death depended on a quick reaction to regain that control. Sometimes a helping hand from higher up meant the difference.

On 8 September, newly promoted Lieutenant Gonzalez had help from somewhere. He had flown about six hours in an F-5 on local practice missions when he went on a long cross-country flight to Land's End in Cornwall, the western most point on mainland England, a distance of more than 250 kilometers in each direction. After taking his pictures, Gonzalez turned back for his base. He realized that he had been running his engines with too much power and might not be able to reach Mount Farm without refueling. Determined to make it back on what he had left in his tanks, Gonzalez throttled back to conserve fuel. When near his home base, he knew it would be close. Gonzalez let down to 1,000 feet altitude. He flew alongside the field, wheels and flaps down, on his downwind leg. Just before he began a turn to his final approach, his left engine quit. On the airfield, an assistant crew chief in the 13th Squadron, Sgt Richard L. Smith watched stunned as the F-5 rolled over on its back heading down. Everyone out on the field stood transfixed at the unfolding tragedy. Inside the F-5, something told Lt. Hector Gonzalez, on his back and going in, to cut his good engine. With both engines dead he pulled the stick back and the aircraft rolled back over completing an unplanned Split-S. Gonzalez pulled full flaps and the F-5 banged down hard in the grass. With the help of his "Guardian Angel," Lieutenant Gonzalez had completed a Split-S under 1,000 feet and finished it off with a dead-stick landing. He would be forever grateful.

The August heat, unseasonably hot for England, continued into September. Conditions in the Camera Repair Lab did not improve. Men who worked the last shift suffered most from the heat, fumes, and poor conditions. Many had to stay off duty for several days at a time to recuper-

Lt. Hector Gonzalez, a transfer from the RCAF. (Hector Gonzalez)

Watten

September operations in the 14th Squadron started slowly. Late in August, the Eighth Air Force began bombing operations against a new type of target, which would prove difficult to destroy. Ever since early June 1943, the photo recon units of both the RAF and Eighth Air Force had been photographing an area of the French coast within, at first, a 120 mile radius of London. Later the area increased to a radius of 140 miles. The Germans had new weapons under development and photo interpreters, reading the resulting photographs, identified unusual structures around the Pas de Calais and Cherbourg Peninsula. Intelligence believed that a large construction on a site at the village of Watten near Calais, should be destroyed or at least delayed. The first bomber attack against Watten, a V-weapon site, came on 27 August and now, on 7 September, the 3BW of the Eighth Air Force hit the site again. Poor weather prevented almost two thirds of the bombers from striking the target on the early morning raid. The 7th Group sent Capt. "Maxie" Campbell of the 14th Squadron to photograph the results. He returned with film of that target and several others. This would not be the last time 7th Group pilots visited these secret German installations.

14 Sq. F-5A 42-13319 with ground crew. (Smitty Mysliwczyk)

Captain Weitner only partially completed his mission on 9 September. Due to worsening weather over the target, Operations canceled Lt. Richard Sheble's first sortie. Two days later, Sheble tried again but poor weather over the target prevented coverage of his assigned 6" obliques of Cherbourg. The next day with marginally suitable weather for photo flights over the Continent came on 15 September when the 14th Squadron tried three sorties.

Telephone:
Clifton Hampden 77

BURCOTE BROOK. **ABINGDON.**

2nd September. 1943.

Dear Sir,

 I shall be obliged if you will give orders to the men at your station to keep off this property in future. They break through the fences, and systematically steal wood, fruit nuts and mushrooms. They have been repeatedly cautioned; but a word from yourself will be more regarded. May I ask you to be so kind as to give this word.?

 Yours sincerely,

John Masefield.

An illustrious neighbor, the poet John Masefield, asks for help from the C.O. (Harold Fox)

Capt. Kermit Bliss brought back the 6" obliques of Cherbourg, flying the only successful mission of the day for any squadron. Cloud obscured Lt. Robert Alston's target, Le Touquet.

On the chance that he could find enough holes in the clouds to photograph Dieppe, Lt. Harlan Fricke crossed the Channel but found the port covered by overcast. On the return trip the weather worsened and he climbed through heavy weather to try to get on top. Suddenly something went wrong. Fricke felt a tremendous force that caused his F-5 to surge and roll, "My artificial horizon went out and I knew the ship was in a dive. The controls leaped around like mad. I didn't have time to check the speed but I must have been falling very rapidly. The noise was terrific and the whole plane shuddered and fluttered like tissue paper in the wind."

Fricke remembered the advice of a former test pilot, "When she dives out of control, gun 'er and use the trim tabs." It worked and the plane recovered. Fricke returned Technical Sergeant Buley's F-5 number 313 to the Flight Line at Mount Farm with the metal covering on the horizontal stabilizer bent and torn.

The next day, Group Operations sent out 11 sorties. On one of the seven successful missions, 13th Squadron pilot, Lt. Raymond E. Beckley successfully covered damage assessment of the Renault Motor Works at Billancourt near Paris. At the factory, bombed by the Eighth Air Force on 4 April 1943, repair work had been allowed to continue. Through coverage by RAF PRU and the 7th Group, Intelligence followed the progress of the repairs. Just before Renault appeared ready to begin production, it would be hit again. That day came on 15 September when bombers of the 100th and 390th Bomb Groups of VIII Bomber Command delivered another damaging blow. How much damage would be judged by the photo interpreters reading Beckley's photos.

Misdirection

Beckley's sortie had its difficulties. After taking off he trimmed his aircraft for normal climb and called *Dreamin'*, the VHF/DF station at Benson for a radio check. Satisfied with the check he flew on to France at 32,000 feet over a complete overcast, which lasted all the way to Paris. Fortunately, Billancourt was clear and he made his runs over the Renault factories then headed home. He climbed above the clouds for the return journey. When he thought he must be within range of the VHF/DF station at Benson he gave them a call, "Immediately I received an answer and a vector to steer for base. After homing for about 15 minutes I found that I had been steered right over Paris." Clever English speaking German operators often tried to fool Allied pilots with false homings. Amazed at being drawn in by the fake, Beckley thought, "That operator had the best Oxford accent I had ever heard. My course had been changed so cleverly that I hadn't realized I was going in a large circle. But if I had used my head instead of the vectors I had been given, I would have easily realized their falsity." He set course for home once again and kept glancing about for "bandits". Suddenly three black specks appeared above his left wing. As they grew larger Beckley nosed down slightly and pushed the throttles to the gate. They were FW-190s and he kept his eye on them.

After 10 minutes he saw they had not gained on him and in fact seemed to be slowly disappearing. Beckley thought he was within range of Benson and called *Dreamin'* again. He could barely hear a faint reply. Beckley called again and again until he heard an answer and a weak vector.

On the ground at Mount Farm, the men in the Communications Department had rigged a set to listen to radio chatter. They could hear transmissions to and from Benson and Mount Farm aircraft on their set, which had no broadcast capability. They heard Beckley repeat the vector wrong, but could do nothing about it.

Beckley steered the vector for about five minutes. When he called Benson there was no answer. Getting low on fuel and not sure of the height of the cloud base, Beckley switched over to Channel C on his radio and called MAYDAY. A station answered with the call sign *Humbug*. He steered the vector given and then lost contact with them. With his fuel rapidly being used up, Beckley had to risk a descent through the clouds to try to find the nearest airfield. He began to let down cautiously. As the altimeter unwound slowly, he wondered just how accurate his altimeter had been set and what sort of terrain lay hidden by the murky cloud. A slight mist enveloped the F-5 at 500 feet. Then Beckley saw the ground, "I was at treetop level. Straight ahead was a long runway. I chopped the throttles and let her down." Beckley landed at Chelveston about 60 miles from Mount Farm.

Interception

Due to the poor performance of the available models of P-38 fighters, the 7th Group's F-5 models were the only Lockheed Lightnings on combat operations from England during the summer of 1943. This compounded the usual dangers of interception. The Luftwaffe knew that this highly recognizable twin engined, twin boom aircraft was unarmed and therefore vulnerable.

The photo reconnaissance pilot had speed, altitude, and constant vigilance to protect his aircraft from enemy fighters. Their commanding officers expected them to

Eyes of the Eighth

Orphans arrive for a party on 16 Sept. 1943 planned by the 7th Group men. Both hosts and children had so much fun, the men planned more parties for other orphans. (Paul Campbell)

avoid interception, to run for home with the pictures, and not tangle with the Luftwaffe. A good swivel head, eyes always looking about, and constant attention could sometimes prevent a nasty surprise. They also had others watching out for them even though most of the time they flew alone. RAF Controllers tracked their aircraft and looked for approaching fighters. While still in range, the radio warnings broadcast by the British helped them spot the enemy before he could get in a shot.

Also on 16 September, while Captain Nesselrode photographed his assigned targets of St. Omer/Longuenesse and St. Omer/Fort Rouge Airfields from 28,000 feet, RAF Controllers warned him by radio of enemy fighters ahead. He looked up and saw three FW-190's coming toward him. Making a diving turn, he watched the three aircraft pass over his F-5 and continue on. Nesselrode returned to base his mission partially successful.

Change of Command

In mid September the War Department recalled Col. James Hall, newly promoted to full colonel, to Washington, D.C., to take over the Army Air Force's Photo Reconnaissance program. During Hall's tour of duty as commanding officer of the 13th Squadron and then the 7th Group, all the original pilots, but one, had earned the Air Medal for completing five operational sorties over enemy occupied Europe. Many pilots received Oak Leaf Clusters to their medals for each additional five sorties. This arrangement did not continue uniformly throughout the history of the 7th Group much to the disadvantage of many of the flying personnel who arrived later. A mapping team composed of Majors Wright and Parsons, and Captains Luber, Mitchell, Owen, and Neilsen received the DFC for successfully completing four mapping missions well inside enemy territory. Colonel Hall had been awarded the Air Medal with Cluster, and the DFC to add to his many decorations received as

Col. James Hall and his staff. Back row L to R: Capt. Wm. Lanham, Asst S-2; Capt. A.M. Hill, Adj.; Maj. E.O. Gwynn, Exec.; C.O. Col. Hall; Maj. Geo. Gregg, S-2; Lt. John F.S. Rees, Asst. Adj.; Lt. Rbt. N. Loyd, S-1. Front row L to R: Capt. Ralph Esposito, S-4; Lt. Edw. M. Shephard, Transp. Off.; Capt. Kermit E. Bliss, Eng. Off. & Pilot; Maj. James Wright, S-3 Air Exec; Capt. Norris E. Hartwell, S-3 Asst. Ops.; Capt. Frederick Hixon, S-3 Ground Ops. (Al Hill)

July August September 1943

a flyer in World War I. From the day the 13th Squadron became operational until his departure, Colonel Hall worked both as an operational pilot and as Station Commander.

Col. Homer L. Sanders

The new 7th Group C.O. took over command on 14 September 1943. Col. Homer L. Sanders, a fighter pilot with 50 sorties in the Pacific, had brought down two Japanese fighters on one mission. His decorations included the Silver Star, Distinguished Flying Cross, and Air Medal. Soon after his arrival on base, Sanders paid the 13th Squadron's Engineering department a visit to take one of the F-5s up on a local flight. The Crew Chief checked the colonel out in the cockpit and began to explain the peculiarities of the F-5A in very different flying circumstances than the colonel had known in the South Pacific. The colonel cut the chief off as he grew impatient to get in the air. Sanders taxied out and took off. Half an hour later his aircraft approached the field on one engine. Crash trucks hurried into position for the new C.O.'s emergency landing.

The men watching on the Flight Line thought the landing was a real thriller and the Crew Chief gave thanks for the return of Colonel Sanders and the aircraft. The F-5 taxied to a halt with a large hole in the right boom where the turbo super-charger had blown up, shrapnel-like pieces tearing up several other parts of the plane including the right coolant radiator. Impressed with their new C.O.'s flying ability, the men on the Flight Line found even more respect for the man when Sanders informed

Col. Homer Sanders and Col. James Hall in front of the C.O.'s quarters. (L. Exner)

Group S-2, Intelligence Section: Capt Bill Lanham, Capt Carroll Wetzel, Maj Geo. Gregg, Capt "Pappy" Doolittle, Capt Ted Ames, Capt James D. Mahoney. (Al Hill)

the Crew Chief that the failure occurred because he had, "pushed the ship a little too hard", and not because of careless or improper maintenance.

Ubiquitous Flak

Vigilance, speed, and altitude were not always enough against flak. The F-5 performed poorly at the high altitudes necessary to stay above the range of the anti-aircraft batteries. Flak was unseen until it exploded around the aircraft. There were signals though, strange, whining noises in a pilot's radio headset, when German anti-aircraft batteries caught the intruding photo plane in a Radar beam that they used to direct fire. Over heavily defended installations flak could not be avoided but whenever possible routes to and from targets skirted this danger. Briefing officers pointed out heavy flak concentrations near the pilot's proposed course on maps prepared, from photo cover furnished by RAF and 7th Group pilots, in a special department at Medmenham.

Only a few miles down the Thames from Mount Farm, Medmenham was the headquarters of The Allied Combined Interpretation Unit. Specialists in various fields interpreted all intelligence gathered by aerial photography. Their reports were of inestimable value to all the forces. Flak was one of their specialties. The bombers needed to know where the concentrations were to plan their bomb runs. The Germans had masses of fixed batteries protecting their industrial centers, notably the Ruhr, facetiously known as "Happy Valley" or "Flak Alley." Other heavy concentrations defended Hamburg, Berlin, and especially the synthetic oil plants around Leipzig, such as Leuna. Other types of mobile flak batteries, especially those mounted on railcars, could be moved nightly to new positions. One of the photo jobs requested by Medmenham was railroad cover for movement of troops, damage assessment, and the moveable flak wagons. They issued daily reports for use by any unit that might be exposed. Depended upon primarily by much lower flying bombers, the maps, nevertheless, gave appropriate warning to photo pilots.

When assigned to cover a target, a photo ship usually made several runs over the same area, a pattern well known to the Germans. Only by altering his altitude and speed could the pilot hope to confuse their aim or they could get his range on the first run and let go with a barrage on the next.

Late in September, Lt. Carl Chapman tangled with both flak and fighters. On the 27th, operations assigned him to photograph shipping at the Loire River port of Nantes, France, Job 410 for United States Bomber Command (USBC). When he arrived at his target, cloud cover was 10/10. Two other assignments, Rennes A/F and Rennes/St. Jacques A/F were open. On his second run at 27,000 feet over the latter, heavy flak accurate for height and direction burst around him. He knew he had been hit but not how badly. A few minutes later he spotted three enemy aircraft he believed to be FW-190s and headed for home. Ten miles northwest of the Channel Island of Guernsey, fire broke out in the port engine. Chapman prepared to bail out and jettisoned the canopy, but the fire went out. Chapman thought that he would try to make it back to England. He reached the English coast and landed at Bolthead Airfield, the first one he saw.

The capricious English weather was good enough on 29 September for the 14th Squadron's Lt. Gerald

Flak batteries on a stereo pair of aerial photographs used by photo interpreters. (Jackson G. Byers)

July August September 1943

Illustrations of railway flak wagons used by photo interpreters. (Jackson G. Byers)

Adams' first operational mission to Cherbourg. Captain Weitner, also of the 14th, completed his third operational mission on the same day, the good weather enabling him to get photos of Vitry-en-Artois and Masingarbe Airfields.

Furloughs

There was joy in the ranks of the 22nd Squadron in September when, after three months overseas, the C.O. issued seven-day furloughs. Many began with a short trip to London and at least an overnight stay to see the sights and pleasures. Some men saw their first extensive bomb damage. Those who stayed in London toured the usual hot spots around Piccadilly Circus and Leicester Square. Others hitch-hiked or took the 12-hour train trip up on the "Flying Scot" to Edinburgh, Scotland. Wherever they went they learned more about the peculiarities of language as spoken by Americans, British, and now Scots. Most had a hard time when trying to pronounce the "burgh" in Edinburgh like the "burgh" in Pittsburgh only to learn it was like the "boro" in Wilkesboro. The natives called the city "Auld Reekie." Pittsburgh natives recognized the meaning of "Auld Reekie" when they saw the familiar industrial smog, the result of too much coal smoke common to both cities.

1stSgt John Mates playing the links at St. Andrews in Scotland. (John Mates)

Eyes of the Eighth

Chapter 6
October November December 1943

By the beginning of October 1943, the Eighth Air Force began to see the results of its continuing campaign against Luftwaffe fighter airfields in France and Holland. Late in September, VIII Bomber Command added a new aid to navigation and target identification with the introduction of the Pathfinder Force (PFF). Three 482BG B-17s equipped with a British ground-scanning device known to the RAF as H2S and to the Americans as *Stinkey* led a mission to Emden, Germany on 27 September. Intelligence used strike photos and damage assessment photos by the 7th Group and its RAF counterpart to verify the effectiveness of PFF. As with many innovations, later development led to improved performance and in this case H2X (*Mickey*), the major American blind bombing and navigational device in the Eighth Air Force.

Increased attacks by the bombers against enemy targets required stepped up activity in photo reconnaissance as much as weather allowed. Supply depots attempted to address the shortage of aircraft, particularly later model, more reliable F-5s. It took time and training to replace the heavy losses from the pilots' ranks.

Flight Officers and Sergeant Pilots
The urgent need for Army Air Corps pilots in the early 1940s prompted a relaxation of the two-years of college requirement for aviation training. Men who passed all other qualification tests became student pilots under a program utilizing eligible men, some from other army units. In this special group, although holding enlisted ranks of three-stripe sergeants and higher, these men had the same training and experience as other pilots in the air force. Their wings were the same but they sewed their staff sergeant rank on their sleeve rather than pin it to the uniform shoulder.

In a search for men to fill photo reconnaissance openings, many of the sergeant pilots ended up in advanced PR training in Colorado Springs. During their training, the enlisted rank divided them from their commissioned fellow pilots in almost every instance except flying. Promotions to flight officer moved them up a step to warrant officer level. At their airfield in England, the 7th Group flight officers served with the same status as commissioned officer pilots, the only distinguishing mark on their shoulders being the rounded blue bar, edged in and banded with gold. ETOUSA orders effective 30 August promoted 15 men to second lieutenant: 13 Sq., H. Gonzalez; 14 Sq., G. Adams, V.K. Davidson, W.B. Eaton, R. Nelson, R. Dideriksen, W. Graves; 22 Sq., L. Aubrey, W. Blickensderfer, J. Blyth, R. Hairston, C. Hawes, M.D. Hughes, B. Sears, and E. Snyder.

Skaterink
When the American photo recon pilots began operating from Mount Farm they used the homing station at RAF Benson, call sign *Dreamin'*. From the very beginning, the RAF offered help to the new units, training pilots in proper British radio procedures and teaching technicians about unfamiliar new equipment. As operations increased and new squadrons came on line, the Benson station became overcrowded with air traffic. Colonel Hall made urgent requests to headquarters for a VHF/DF (Very High Frequency/Direction Finding) station at Mount Farm to carry the increasing load. The Lockheed Overseas Corporation, Northern Ireland, constructed a direction finding station made up of a combination of aircraft sets, amplifiers, and a directional antenna. The first of this model went to AAF Station 234, Mount Farm. The station, call sign *Skaterink*, officially opened 1 October 1943. During the D/F station construction, SSgt William F. Black, Jr.; Sgt Charles W. Anthony of the 14th; and SSgt Theodore Roos of the 22nd trained at Benson in the techniques of operating directional VHF equipment. These three men along with Sgt Henry R. Morelli of the 22nd Squadron, Sgt Clarence R. Whittier, Pfc Sidney Stutman of the 13th, Cpl Glen A. Olsen, Cpl Rodney Conrad, and Pfc Julian H. Parks of the 55th Station Complement Squadron operated the station with Sergeant Black in charge. At first many 7th Group pilots continued to use Benson's D/F station although *Skaterink* had a range of 100 miles. In an emergency, Benson's *Dreamin'* offered welcome backup.

Reorganization
From the very beginning, the 7th Group suffered from an unsatisfactory Table of Organization (T/O). The T/O, a virtual recipe of ingredients for the composition of a military unit, prescribed how many officers of each rank and occupation. It laid out the organization and how to staff it with the correct numbers of corporals, privates, sergeants in various grades, their qualifications, levels of training, everything needed to operate the particular unit. As long as the formula followed old lines in standard army units, the T/O worked well. Photo reconnaissance did not fit the standard unit profile. A fast developing field in a war situation requiring invention and ingenuity, PR units found their T/Os lacked many of the positions and technical positions necessary to do the unit's job. The Adjutant General's Office of the War Department in Washington, D.C. issued new orders, which reorganized

October November December 1943

Preparing a pig for a barbecue, L to R: Ed Vassar, Virgil Landwehr, George Nesselrode, Robert Moss, "Chick" Batson, and Donald Schultz.
(Irv Wigton)

Early on, 13th Sq men gathered together a flock of chickens to keep them supplied with fresh eggs. L to R: Harvey Wagner, Vernon Luber, "Pappy" Doolittle, Harry Witt, Al Ames, Ray Beckley, Bill Lanham, and Dale Shade.

Eyes of the Eighth

the 7th Group under a new Table of Organization (T/O) 1-752 on 4 October 1943. This readjusted the personnel of the Group to conform more closely to the requirements of the job. Nevertheless, the Group still had to use many of its officers and enlisted men in various subsidiary organizations.

New Names on the Roster
Promotions and transfers shifted and added personnel throughout October. Capt. Orville B. McCoy arrived on 1 October from the 16th Air Depot to replace Capt. Caspar Harstad, the 22nd Squadron medical officer, who left for another assignment. In mid-October, orders came to the Group for the return to the Zone of the Interior (Z.I.) of many 13th Squadron officers. The men returning to the United States included Majors Wright, Michener, Gregg; Captains Luber, Owen, Nielsen; Lieutenants Beckley and Clark, as well as Captain Stolte of Group, Captain Campbell of the 14th, and Captain Black of the 22nd.

The transfer of Captain Hartwell to the 7th Group, along with Black's departure, left the 22nd Squadron with openings in its table of organization for two operational pilots. Two second lieutenants, Earl V. Skiff and Edward B. Parsons, reported from the 12th Replacement Control Depot to fill the vacancies. The squadron C.O. promoted two former flight officer pilots, Richard M. Hairston and Malcolm D. "Doc" Hughes to first lieutenant after they had been in grade only one month.

Seven of the original 13th Squadron pilots remained: Major Hershell Parsons, Captain Mitchell, Lieutenants Shade, Wagner, Tooke, Witt, and Watts. Through the summer months, replacement pilots added new names to the roster. Lts. Glen Allen, Hector Gonzalez, Arthur Waldron, Peter Manassero, and Franklyn Van Wart took up duties with the 13th. Lts. Clyde T. Giles, Ralph Kendall, Robert R. Clark, Bernard Proko, Charles Parker,

Cameras used in an F-5A displayed in a mock-up. Four K-17s, the forward one is for vertical charting, the next for vertical reconnaissance, and the laterally directed pair for oblique photos. (Wallace Starret)

and John R. Richards, joined them on 29 October 1943 bringing the 13th Squadron pilot strength to 19.

Map making

Many organizations used photographs taken by 7th Group to fulfill their particular requirements. Detailed photo mapping went to headquarters of land forces for their use. From the photographed areas, cartographers laid out the topography and gridlines used to locate targets for assault, artillery strikes, tactical bombing, lines of march, strategic defense points, and the future landings on the Continent.

Group Headquarters received a request from the 660th Engineers, whose cartographers made maps from 7th Group photos. They wanted to know details about the photography. In October, TSgt Larry Redmond took sufficient aerial camera equipment to the 660th to insure that the engineers could see all that was involved producing the photos before the engineers received the finished product.

A Tough Machine

About the only areas not under cloud on 30 October 1943 were Lt. Arthur Waldron's assigned airfields in France and his home base at Mount Farm. After taking damage assessment coverage of Evreux/Fauville and St. Andre-De-Leure, he turned his F-5 back toward England. While flying his route completely in heavy cloud on instruments, Waldron lost his compass. He located a friendly radio signal, and followed it back. He crossed the English coast near Dover and slowly let down through the overcast. Coastal area balloon-barrages, which protected ports and installations against low flying enemy aircraft, made this a dangerous passage on instruments. The balloons' steel cables dangled below to catch friend or foe. In zero visibility conditions, the safe corridors between barrages became elusive. Waldron flew with extreme caution but suddenly, at 800 feet altitude, one of his aircraft's propellers tore into a balloon cable with a terrific jolt. The cable parted whipping the nacelle, bending the props, and damaging the engine. Waldron cut the power to the crippled engine, trimmed the shuddering F-5 and kept flying toward Mount Farm. He managed to get back to base and land safely. His report, in an understatement, said that he had, "released a balloon from the Dover barrage." An official from the British Air Ministry came to the Mount Farm curious to assess the damage and understand why Waldron hadn't been killed. Just a half an hour before the American's narrow escape, an RAF Typhoon had cut a cable with its wing and crashed, killing the pilot. Waldron's survival attested to a generous measure of good luck and a Lockheed Lightning F-5, which proved to be a tough machine in spite of its faults.

In general the performance of this aircraft was satisfactory up to 30,000 feet, the operational altitude in practice at this time by the Group. Engine failures for various reasons continued to plague the F-5, mainly faulty detonation. Very hot compressed air from the super chargers passed through the intercoolers before it entered the carburetors. In the F-5A, these intercoolers located in the leading edge of the wing failed to bring the air down to the desired temperature. As a result, occasionally the fuel mixture exploded in the cylinder before the piston reached the top of the compression stroke. These explosions could blow out the piston head, cause bearing failure, or break the connecting rod, which usually went through the crankcase.

Engine changes from this cause exposed another difficulty. Particles of metal in the lubricating system made it necessary to replace the oil coolers. It was almost impossible to obtain supplies of these coolers for the F-5A-10s. This was dealt with in some cases by the use of salvaged F-5A-10 coolers, and in others by the sub-

Lt Arthur Waldon's damaged engine after surviving an encounter with a balloon cable in the Dover barrage.

(Edward R. Murdock)

Eyes of the Eighth

stitution of F-5A-3 cores, of which there was an adequate supply, and could be made to fit the F-5A-10 shells.

This same high carburetor air temperature sometimes caused the fuel mixture to explode prematurely and backfire through the intercooler causing damage to the rather delicate aluminum alloy baffle plates used to prevent turbulence in the intercooler duct. High coolant temperatures were encountered in many cases due to a deficiency in the coolant radiator. This flaw was corrected in later models which had adequate coolant systems.

There were two particularly memorable instances when the turbo-supercharger failed through overspeeding. Back on 4 July, Capt. Norris Hartwell, 22nd Squadron, was on an operational mission. As he crossed over the English Channel, upon reaching 30,000 feet, the right engine turbo-supercharger turbine wheel disintegrated. Pieces exploded out of the turbine, lopping 18 inches off one propeller blade, others ripping into the aircraft severing the hydraulic lines and destroying Hartwell's radio equipment. Shutting down the engine, he feathered the prop and turned for home base. The weather was marginal and without radio equipment, communication for navigation was nil. Neither did he have contact with the Mount Farm control tower. Finding his way home he made a harrowing approach and landing in low visibility using his emergency hydraulic system.

The other instance was the explosion of the turbo-supercharger when the new C.O., Colonel Sanders over-revved his engine on his "orientation" flight soon after his arrival. Failure was not due specifically to any structural defect, but a weakness was recognized in this connection and was corrected in later models. Lockheed placed "red line" limits on aircraft as a regular standard and did not recommend revving engines above this level. But the pilots in combat situations found this a peacetime constriction which was ludicrous when their lives depended on using every ounce of power supposedly in the engines to escape ME-109s and FW-190s. They looked forward to newer aircraft which would not fail in emergencies and could fly satisfactorily at much higher altitudes where they were being forced as German fighters and anti-aircraft fire reached higher and higher.

Replacements for F-5A aircraft were very difficult to obtain and the Station was chronically short even of this type. Partly for that reason some Mark XI Spitfires were obtained under the reciprocal aid program from the RAF and were operated along with the F-5s from Mount Farm from November 1943 until April 1944. Even though the photo recon program was struggling under the limitations of the USAF's chosen camera platform there was heated resistance in Washington to American pilots flying anything but American planes. Fortunately

Officers from 13th Sq returning to the Unites States in Oct shown after Sept awards ceremony. L to R: James Wright, George Gregg, Vernon Luber, Ben Michener, Howard Neilsen, Art Stolte, George Owen, and Ray Beckley. (Al Hill)

this short-sighted opinion was overruled.

The Photographic Spitfire carried two cameras and flew easily at 40,000 feet. It was not as smooth in flight at high altitudes as the F-5 but it was considerably faster and had a much higher ceiling. Although its declared maximum range was less, it had been used in practice at longer range than the F-5 because of its greater speed and lower fuel consumption. No outstanding maintenance problems were encountered on Spitfires operated from Mount Farm.

November

On the first of November 1943 Major Wayne taxied a new Mark XI Spitfire into the 14th Squadron area and announced two more were on the way for operations, not training. Lt. W.A. Nelson reorganized his Engineering

Capt Vernon Luber and Lt Arthur Waldron relax as Lt Ray Beckley puts the finishing touches on his art work. (Al Hill)

October November December 1943

Spitfire VB EP249 on 381st Flight Line. (Riggins)

Department to accommodate the new aircraft on the Flight Line. He established a Spitfire Flight and consolidated the F-5s into two other flights. Three men loaned to the 381st Air Service Squadron, TSgt Earl Peterson, SSgt Vernon Grubb, and Sgt Leonard Geary, returned to the 14th. Nelson named Peterson the Spitfire Flight Chief, SSgt Grubb the Crew Chief to the first Spitfire and assigned the two others to TSgt Kinder, the former barber, and TSgt E.J. Nelson.

The remaining F-5 flights remained in the hands of TSgts Steinbach and Navarrot. TSgt Mayden, former F-5 Flight Chief, took over the hanger crew, which had been enlarged to expedite inspections. Now, in addition to the specialists, the crew included five aircraft and engine mechanics. The department needed to produce more efficient and timely inspections. Lieutenant Nelson believed that by putting these extra men in the hanger crew they would become specialists in performing periodic inspections and could get out better ones in less time.

In order to replace the Squadron Inspector TSgt Ross Montgomery, who transferred to another station, TSgt Bill Nerbovig returned from the Technical Inspector's Office. Warrant Officer "Pop" Porter handled most of the Engineering Department's administration until Colonel Sanders called him away temporarily to serve as the Station Liaison Officer. With this move, Lieutenant Nelson lost a valuable asset. "Pop" Porter had a reputation as the man who could produce virtually any part needed when there were no parts to be had, officially, that is. With a list of impossible to obtain bits and pieces, Porter could hop in one of the station's utility aircraft, direct the pilot to one place or another, and soon return with the unavailable valve, bolt, connection, wire, or whatever. Either because he thought him irreplaceable or soon to return, Lieutenant Nelson did not replace Porter immediately.

The new arrangements in the Engineering Department worked well. Cleaner inspections came out of the hanger two or three days ahead of the time required to complete them under the old system. This group continued to make improvements around the 14th Squadron hanger and department area. They established a sheet metal shop in a vacant Nissen Hut near the hanger, lessening the dangers of fire around welding and metal work in the maintenance area.

With the Spitfire's consistent ability to reach and maintain altitudes of over 40,000 feet combined with its cruising speed, the range of the Group's operations increased by more than 200 miles. The Camera Repair Department had new technical details to learn. Two department men, SSgts Salvator R. Cofoni and Philip B. Johnson went to Benson for quick familiarization instructions about the cameras used in Spitfires. The new aircraft had British F52, 36" and F8, 20" focal length cameras.

During Eighth Air Force high command talks about increased capabilities of the new Spitfires in the 7th Group, someone with little knowledge of aircraft structure decided to try an American 6" focal length camera in the Spitfire for mapping. In the middle of November, TSgts Larry Redmond and Clair Myers went to work on Mark XI MB946. The work involved a lot of experimentation with mounts, mountings, and adjustments. They manufactured several different mounts before a finding a suitable one. In order to install the mount, the seat, radio, and oxygen equipment had to be removed, then replaced after installation of satisfactory camera mounts. Before the mount could be set in place the camera mounting bulkheads had to be moved to allow clearance. The technicians did most of the alterations at night after hours, continuing regular operations during the day.

After several weeks, Redmond and Myers installed the camera and one of the pilots took MB 946 up to give the camera an in-flight check. To everyone's disappointment the installation position caused an unacceptable cutoff on the film due to the wide angle of the camera. To correct this the camera had to be lowered several inches, which would require moving control cables. Men from Vickers-Armstrong started the job in December and it took them until Christmas to finish. Again, the camera was re-installed and given an in-flight check, this time with satisfactory results. Newly equipped 946's first operational flight came just before the end of the year.

During November at a meeting of the Engineering Department, Major Wayne outlined a plan which would change the 14th Squadron's operations completely. He told the men that headquarters might make a change in the squadron's operations adding aircraft and weather recording equipment for advance forecasting. Specially equipped British DeHaviland Mosquito would replace the present aircraft, which would be transferred to another

Eyes of the Eighth

Hoop shots outside the Supply Room at Mount Farm.
(George P. Simmons)

squadron, establishing the 14th as a new Weather Reconnaissance Squadron. Major Wayne told his men that these aircraft would fly both day and night missions, and he predicted the 14th would become one of the busiest squadrons in the ETO.

Lieutenant Nelson selected as many Crew Chiefs and other mechanics as could be spared and sent them to Mosquito airframe school for one week, then to Merlin engine school for two weeks. Capt. Kermit Bliss attended school with the first group and, as soon as they returned, the indispensable Warrant Officer Porter, borrowed from his liaison job for a few weeks, joined the second group. Before Lieutenant Nelson and his group finished their training, the Eighth Air Force dropped plans for a 14th Weather Reconnaissance Squadron due to a shortage of Mosquitoes. Insufficient production of the plywood aircraft gave priority to the supply of RAF squadrons, not American ones.

27th Squadron Arrives

The 7th Group welcomed its fourth combat squadron on 4 November 1943, when the 27th Photo Reconnaissance Squadron, under the command of Capt. Cecil T. Haugen, arrived at Mount Farm. Fog covered the area hiding the details of the new base. The men lived 14 to a Nissen Hut. The cold damp English weather permeated everything; the tiny coke-burning stove in each hut barely warmed the few men huddled around it. Strictly rationed and delivered only once a week, the coke supply had to last. The newcomers soon learned to guard their supply carefully. For the first few days they unpacked

White Lightning and the Sheriff

Policing an air force base is usually a straight forward operation enforcing military regulations. The popular "sheriff" in charge of Mount Farm, C.O. of the 1274th Military Police Detachment, Lt. George Epsom had a special problem. It was a case of illegal production of a substance infamous in independent minded backwoods country areas of certain states across the Atlantic. Moonshine. White Lightning. He knew someone had a still hidden on the base but he didn't know where and no one was going to tell him no matter how much they liked him. The MPs carried out futile searches. It was rumored that one of the enterprising women living on the farm trundled a supply out of the main gate of the base in her baby's perambulator.

Then the frustrated Epsom got a break in the case. Dan Burrows, a 22nd Squadron pilot had received some half-pint bottles of Old Granddad bourbon from home. One night in the Officer's Club, he saw a 13th Squadron officer taking a nip from a familiar bottle and assumed it was part of his cache. One taste proved it to be another form of spirit not unlike that also made in Kentucky but without benefit of federal stamps and license. This fellow had taken one of Dan's empty bottles for his own supply. Days later, in a conversation with George Epsom, Burrows aroused his interest when he told him the story.

With this clue, Epsom set about putting a stop to the making of illegal hooch at Mount Farm. He didn't want to embarrass his friends who knew where the still was. Following the man from the 13th hadn't revealed the location so he made a clever plan. He called George Nesselrode, C.O. of the 13th Squadron, and told him that he had located the still. "Do you want to get together at the site and figure out how to handle things?" When Nesselrode said he would pick him up at his office, Epsom said, "I'm at the other end of the base. I'll meet you there." Unbeknownst to Nesselrode, Epsom was on his motorcycle near 13th Squadron headquarters. When the C.O. drove his jeep to the location, Epsom followed from a discreet distance. The ruse worked. Epsom innocently pulled up behind Nesselrode and the two went into the farm house in the middle of the base. There they found the still, complete with copper tubing, boilers, and corn mash, hidden in a small room at the top of the house. Thus ended the white lightning enterprise at air base 234, Mount Farm, Oxfordshire.

October November December 1943

Capt Cecil Haugen, C.O. 27th Squadron. (James D. Mahoney)

and tried to get their bearings but until the fog lifted the men of the 27th didn't realize their new airfield lay right in the middle of a working farm

Just as all the others had done, the new men learned new methods, manners, and money. British terms stumped them as much as they had the men from the other squadrons. Right off the ship they learned their gear would be transported in a goods wagon instead of a freight car; they would ride in a railroad carriage not a car. At least cars were automobiles but they drove on carriageways, and road meant way but not highway, which seemed to be used with robbery. Coaches were buses. A car boot meant the trunk; the hood was the bonnet; the horn was a hooter, and the steering wheel was on the wrong side. New mechanical terms brought some puzzling moments. The Engineering men soon learned about the British aircraft on the base, especially that they had planes not wings, which was the name the British used for automobile fenders. Very quickly the terminology seeped into the hangers and barracks.

They also learned quickly that rationing was a fact of life, and understandable, since so much of England's sustenance depended on convoys constantly under attack by U-boats. After a few passes and visits to the neighboring villages and towns, one 27th Squadron newcomer remarked, "We could readily see how fortunate we were." They worked out shillings and pounds instead of dollars but it took awhile to work out pounds of weight into stones. Most British welcomed the Yanks and generously shared their meager rations with their new friends. It didn't take long for the GIs to share their more bountiful supplies with the townfolk. Newspaper reports of the war, which naturally played up the British participation more than the American, annoyed many of the men. To the Americans, with their innocent cockiness, the accounts seemed so lopsided that one new arrival commented that he expected to read any day that, "Several Spitfires made raids on targets in France and were accompanied by about one hundred Flying Fortresses."

New 13th Squadron C.O.
Orders came to 7th Group on 15 November 1943 recalling the 13th Squadron's commanding officer, Maj. Hershell Parsons, to the States. Parsons, awarded the first Distiguished Flying Cross to a 13th Squadron pilot for his 19 May sortie to Keil and Flensburg, received a second in September. Capt. Ray Mitchell replaced Major Parsons as the squadron C.O. and Lt. Dale Shade became Operations Officer replacing Captain Nielsen.

Allen killed
Combat sorties continued from the base during November with weather as the primary limiting factor. Three squadrons now flew assigned missions and the newer ones increased their participation throughout the month. Aircraft availability had a profound effect on numbers of missions dispatched. The older F-5As needed many more hours maintenance than newer aircraft promised to the Group. In the 13th Squadron, Lts. Harvey Wagner, Walter Tooke, and Harry Witt as flight leaders trained the replacement pilots who arrived in October in preparation for their first missions. On 24 November, one of the 13th's new pilots, Lt. Glen Allen took up an F-5 on a local training flight. At 1100 hours, witnesses saw his plane spinning out of control. The F-5 crashed one and one half miles NE of Mount Farm airfield killing the pilot instantly. The squadron buried Lieutenant Allen at Brookwood Cemetery.

The 27th Squadron began working with the other squadrons on the base. On 23 November, Captain Haugen assigned Lt. Walter Hickey as Assistant S-2, Combat Intelligence Officer; Lt. Conley Hayslip, Photo Lab Officer; Capt. Carl Fritsche, Surgeon; and Lt. Gordon Bailey, Postal Officer. Four days later, the C.O. detailed Lt. William Dhority as Officers' Mess Officer and ordered Lt. Hickey to RAF, Highgate, on detached service (DS). The month ended with Lt. Frank Heidelbach, SSgt Norman A. Sommers, and Sgt Gerald F. Donovan leaving on DS to Cranwell, Lincolnshire, for radio school.

Contrails
Weather conditions influenced sorties in many ways. Bad weather grounded aircraft and clouds over the targets prevented effective photo cover. Contrails, the condensation streaming from aircraft surfaces at altitude, offered pilots a weather-related condition to use to their advantage when possible. The condensation layer occurred at

Eyes of the Eighth

Colonel Sanders, C.O. 7th Photo Group, with three orphans at Nov 1943 party. (Al Hill)

Men from the station set up a carpenter shop to produce toys to give out to orphans at a Christmas party. Medic Henry Gloetzner of the 381st making toys. (Joe Bogner)

different altitudes and varied in depth depending on the season. If pilots could, they flew where their own aircraft did not "pull" any trails. If the photo plane flew below the layer, any aircraft attacking from above would be revealed by its trail. Lt. Eugene P. Snyder took off from Mount Farm on 26 November 1943 to cover a Ninth Bomber Command request and damage assessment of Cambrai/Epinay airfield. Crossing in to France, Snyder took pictures of the French coast between Boulogne and Le Touquet then headed toward his primary targets. Flying at 35,000 feet over cloud and in contrails from Samur to Arras, he sighted an aircraft also pulling contrails approaching him from an easterly direction five miles away and 2,000 feet above. Snyder altered course to the south. After two minutes he saw more contrails 8,000 feet below and five miles away as two aircraft flying north entered the contrail layer. At this point all three aircraft altered course and headed for the F-5. Snyder released his drop tanks and headed for the coast, soon drawing away and out of sight of the enemy aircraft. When the pilot asked for a homing, radio interference drowned out the heading. This happened four or five times and, unable to locate Mount Farm without the correct bearing, Snyder landed away from base, returning two days later.

Another New Name

The progression of name changes for air force units continued when Washington renamed the Group and reassigned its combat squadrons. The squadrons had been known as Photographic Squadrons (Light) until 13 November when orders changed them to Photographic Reconnaissance Squadrons. The new official order did not mention the newly-arrived 27th Squadron, which remained listed as "attached," not assigned.

Stan Sajdak directs the Polish boys in a song. (Joe Bognar)

After the successful party for orphans in September, the squadrons organized more parties and saved their candy and other treats for the children. Lt Tony Steiert, 14th Sq, and Polish officers with a group of orphaned Polish boys. (Smitty Mysliwczyk)

October November December 1943

Medic Joe Farrell, 381st, sanding down a toy for the orphans. (Joe Bognar)

Orders redesignated the 7th Photographic Reconnaissance and Mapping Group, the 7th Photographic Group, Reconnaissance, on 29 November 1943. At the same time the orders relieved the 13th, 14th, and 22nd Photographic Reconnaissance Squadrons of current assignments and assigned them to 7th Photographic Group, Reconnaissance, per Secret Letter, Headquarters, Eighth Air Force, dated 24 November 1943. In spite of a very complicated sounding move, very little change occurred in the operation of the units except that clerks had new names to remember.

December
On 1 December, Operations assigned a 22nd Squadron pilot, Lt. Wendell W. Blickensderfer, Job 114 (USET), which covered an area between Paris and Nantes. This particular assignment covered Parts I, F, J, and G of the overall job. While making the turn at the end of the first run over the target at 34,000 feet, Blickensderfer saw two FW-190s 1,500 feet directly below and climbing toward him. He dropped his auxiliary tanks and headed for home with the enemy fighters in pursuit. Pushing his aircraft hard he kept ahead of the German fighters. One broke away but the other followed him all the way to the French coast. Blickensderfer had another complication when his compass went out and he had to complete the sortie on gyro. He landed at Northweald airfield in England at 1230 hours. He returned to Mount Farm by motor transportation. When the Photo Lab processed his film Intelligence saw that in spite of his interception Blickensderfer completed part of his assignment on Job 114.

Learning the Job
The last month of 1943 began for the 27th Squadron with more changes as it continued to organize and train for operational duty. The commanding officer promoted 1st Lt. Frank Campbell to captain; 2nd Lts. Daniel Alvino, Edgar L. Brewster, Frank Heidelbach, and Robert H. Weber to first lieutenant. Three men, TSgt Robert Niehaus, SSgts James J. Taper, and John Zetek reported to Reading on detached service(DS) and 2nd Lt. Norman Wedekind and W/O Harry Toubman reported on DS to Rolls Royce Ltd, in Derby. The 27th sent two more men, Sgt James Galloway and Cpl Walter P. Domagalski, to radio school at Cranwell. TSgts Ewin L. Philpott, John S. McGee, and Sgt Roger H. Carnes left on DS for Engine Maintenance School at Vickers Armstrong Ltd, Reading, Berkshire.

The numbers of men going to various technical schools increased dramatically throughout the month of December. Pilots went through the same indoctrination and orientation procedure as the other squadrons' pilots had on their arrival at Mount Farm — radio, communication and flying regulations, instrument training and practice in the Link Trainer — all in preparation for the first operational sortie across the Channel.

27th Squadron's First Sortie
The big day for the 27th Squadron came on 20 December 1943. In less than ideal weather, the squadron C.O., Capt. Cecil Haugen, flew an F-5C to photograph a strip of coastal France from Calais to Dunkirk. He returned safely to base in spite of poor flying conditions with photos of the French coast from Calais to Dunkirk.

Headquarters, Eighth Air Force, ordered the 27th Photographic Reconnaissance Squadron assigned to the 7th Photographic Group (R) on 21 December 1943 completing the combat squadron complement of the Group.

Lt. Charles Cassaday, 27th Squadron Operations Officer, took a sortie request from Eighth Air Force Headquarters for cover of Cherbourg 22 December and returned with good pictures of his target. Intelligence found the information it had requested on ships and military installations in the port covered on the photos.

Worsening winter weather affected all squadron's operations. Some new pilots in the 13th tried all month to finish five missions. On 4 December, Lt. Charles Parker flew his second sortie over cloud most of the way to Bremen but found his target there obscured and returned with photos of Utrecht, Ijmuiden, and Haarlem, all in Holland. Lt. Arthur Waldron, after his tussle with the barrage balloon cable at Dover, made three trips to cloud-covered targets before achieving a partially successful mission on 20 December when he ran mapping strips in the Le Mans area. Bad weather prevented Parker from flying his next sortie until 24 December when he fol-

77

Eyes of the Eighth

lowed Eighth Air Force bombers to the Pas de Calais area. After about 30 minutes of mapping, Waldron had to return to base with a failure in his oxygen system. Another 13th Squadron pilot challenged the weather when Lt. Hector Gonzalez made two abortive attempts at targets in France during December.

The 13th Squadron lost more men off its roster to the 7th Group with the transfer of Captain Gwynn to the post of Station Executive Officer, Captain Esposito to Group S-4, Captain Gregg to Group S-2, and Captain Wright to Base Operations Officer. Other organizations raided Eighth Air Force personnel to staff new outfits. The build-up to the planned invasion of Europe included the strengthening of the tactical air commands and no strategic squadron was sacrosanct. Just as the Mediterranean Campaign had siphoned off much needed replacements of men and aircraft from the Eighth Air Force, now the Ninth Air Force reached deep into the pockets of the Eighth and its components.

Fricke Killed

On 11 December, Lt. Harlan F. Fricke, a 14th Squadron veteran since the rookie days in the States, took off for his fifth sortie in TSgt Sam Quindt's aircraft *Lu Mar*. Fricke's assignment was a Meteorological mission to the Abbeville and Poix areas to scout weather conditions over a target. Soon after his takeoff the weather at Mount Farm changed, with fog enveloping the field and surrounding area. On his return, Lieutenant Fricke could not locate the field and crashed at 1230 hours near Wantage about

F5A-42-13319 *Kay*. On top L to R: Capt Walter Simon, MSgt O.B. Thomas (7th Group aircraft inspector), Lt Harlan Fricke (KIA 11 Dec 1944), TSgt Ed Nelson. On ground L to R: Harry "Meatball" Marder, Sam McKinney holding "Dottie," Bill "Tex" Naylor, Patsy Piscitelli, Harry Judson, Ross "Monty" Montgomery, Russell "Crash" Mayden on the 14th Sq Flight Line. (Smitty Mysliwczyk)

October November December 1943

F-5A 42-13312 on 14th Squadron Flight Line with L to R: Melio "Nappy" Napolitano, Crew Chief Sam Quindt, and Carl Nordsten. The small inadequate air intakes under the engines on this model of the P-38G show clearly in this picture. *Lu Mar* was 14th Sq. C.O. Maj Marshall Wayne's plane and was destroyed in the crash on 11 Dec 1943, which killed Lt Harlan Fricke. (Smitty Mysliwczyk)

eight miles from the Mount Farm. Harlan Fricke was the first pilot from the 14th Squadron to be killed. The enlisted men from the squadron took up a collection and purchased a $500 War Bond for the pilot's infant son, Harlan F. Fricke II. They all signed a letter expressing their affection for the pilot and sent it to the tiny baby. Lieutenant Fricke had never seen his son because little Harlan was born after Fricke's arrival in England. The lieutenant's widow sent a thank you letter and picture of the baby in appreciation of the squadron's generosity.

The bad weather continued through December and slowed operations to an occasional mission whenever conditions would permit. Three new F-5Bs arrived at the 14th Squadron in mid-December and the squadron transferred the three oldest F-5As to other organizations. Three Crew Chiefs, TSgts Quindt, Novak, and Graveson, began pulling acceptance checks on the new aircraft.

Steven Scott Lost

The 22nd Squadron lost a very popular pilot and its Operations Officer on 23 December 1943. Capt. Steven Alton "Scotty" Scott took a PR sortie to Osnabruck and Munster, Germany in Spitfire XI number PA 851. A coastal flight control station received a distress call at 1020 hours. At the time Scott stated that his engine was out and he was gliding at 15,000 feet altitude. The control station maintained radio contact continuously through the next eight minutes in which they gave numerous vectors to the nearest point of land to the pilot. They lost

Eyes of the Eighth

radio contact at 1028 hours when Scott reported his altitude as 5,000 feet. Control notified the Air Sea Rescue Service which immediately dispatched Walrus aircraft to the last point of cross vectors. Personnel aboard the Walrus reported a concentrated oil slick on the water at the probable point of the crash.

There were various reports at the time of the incident that Scott drowned within sight of his rescuers but later investigation into radio contacts and reports from Air Sea Rescue Service concluded in June of 1944 that this was not correct. When the Walrus reached the scene there was no sign of the pilot. Scott had almost made the coast of England; his aircraft went down only about ten miles off the North Sea coast of Suffolk near the town of Southwold.

Sanders Transferred
Late in December, Eighth Air Force Headquarters transferred the Group C.O. and former fighter pilot, Col. Homer Sanders to the Ninth Air Force Fighter Wing. Col. Paul T. Cullen, an expert in photo recon replaced him as 7th Group C.O. Before leaving, Colonel Sanders, who had been only the second commanding officer of 7th Group, sent these words in his Farewell and New Year's Greeting to Group personnel on 29 December 1943,

"My short period of duty as your commanding officer has taught an old fighter pilot a lot of respect for what the other fellow does. We have guns to fight back with and friends to watch our tails. You have only the speed of your craft, an alert mind, and I suspect a nod from God now and then to depend on your survival. Yours is a fascinating task. I sometimes wonder if most of you realize your worth in furthering the cause of victory. You drop no bombs on target for tonight, squeeze no triggers, watch no steam shoot forth from locomotives or river boats which you have just ventilated; you don't even have the pleasure of chasing little men into foxholes for you fly too high to see them. You probably think yours is a small part of this war. You are wrong and I can prove it. To quote from a letter recently received from Lt. General Ira C. Eaker, Commanding, USAAF in United Kingdom.:

'Please say to your organization how much it merits and has won the admiration of all the other combat commands in the Eighth Air Force and of other commanders and their staff echelons as well, who have had no opportunity to observe their great work often under severe handicaps.'

It must be borne in mind by all, that while the pilot of the airplane obtains the direct results, his work would be impossible without the crew who maintains his airplane; the camera repairman who installs the camera; the technician who develops his pictures; the cook who cooks his food; the guard who protects his plane during the long dark hours, and the host of other personnel necessary to the functioning of the team. If there are stars on the team, it is only common consent, for others just naturally look up to the lone pilot who single-handedly goes out to challenge the best the foe has to offer.

My regret at leaving this command and new found friends is tempered by the knowledge that you are left in capable hands. Your new commander is an officer of wide and varied experience. Under his guidance, I am confident that success will attend you."

After wishes for the New Year he went on to say, "General Henry H. Arnold, USAAF Chief, in a few words described the purpose and value of photo reconnaissance when he said, 'Fighter planes win battles, but camera planes win wars.'"

Communications
When formed in July 1943, three combat squadrons and the 381st Air Service Squadron were the largest units comprising the 7th Group. Capt. Dennis V. Neill, the Group Communications Officer and other squadron officers worked together in various Group jobs. Capt. Nicholas Sary took charge of all land line facilities. With the arrival at Mount Farm of the 27th Squadron on 4 December, the Communications Department was complete. The 27th's Lt. Frank Heidelbach took up the duties of Cryptographic Security Officer and took charge of the teleprinter operators and the message center.

To fill out the department, enlisted men from different squadrons filled posts to which they were best suited. Sgts Martin H. Comen of the 27th and Leonard O. Walls of the 14th went to Group Communications clerking jobs. Another 14th Squadron man, Sgt Warren Heraty took charge of the teleprinter operators. The 13th Squadron's TSgt Joe Pittman took over the radio shop.

TSgt Joe F. Pittman, 13th Sq, in charge of Group radio shop.

October November December 1943

The radio shop worked under Captain Sary making improvements to the inter phone system that they installed in the Control Tower. Eighth Air Force Headquarters sent a communiqué complementing Sary and the Communications Department for these improvements.

Landlines were an important part of communications within as well as outside the base. The original equipment at Mount Farm consisted of one 50 line switchboard with 10 outlets for outside lines. The telephone system in Britain came under the General Post Office. Due to a shortage of manpower at the GPO, it could not service the Station as quickly as needed, so the squadrons' linemen received authorization to make repairs and new installations. The GPO furnished the Station with private wire facilities to Eighth Air Force Headquarters, Benson, Stanmore, and Chalgrove and installed an additional 90 line board.

Under the supervision of a GPO official, Captain Sary's linesmen installed a complete operational telephone system. The 14th Squadron's SSgt Robert G. Arnott and his men, Sgts Leslie Grant also from the 13th, Elbert Keel(27th), Howard Weddel(14th) and Cpl Albert Kugler of the 55th Station Complement Squadron, installed, moved, and rerouted phones and lines. As the station enlarged they added extra exchange lines and installed a pay phone in the Post Exchange that later became the Red Cross Aero Club. The GPO furnished scrambler telephones for the use of the commanding officer, intelligence officers, and weather officers.

14th Sq Communications men. L to R, Back row: Cpl Elbert Nordwall, Sgt Howard Weddel, Sgt Warren E. Heraty. Front row: Sgt Bernard T. Wendel, SSgt Leo G. Smith.

The first teleprinter section in May 1943 consisted of one British Creed teletype machine connected to RAF Station Benson. In June and July, Communications installed American teleprinter machines connected to lines leading to VIII Bomber Command, "Pinetree," soon to become Eighth Air Force HQ. Two lines for the weather station also used Creed machines, which constantly needed repair and adjustment. By December 1943, enough equipment became available to the maintenance men to install only American machines. Sgt Luther A.C. Cooper of the 13th Squadron did practically all of the installation with Sgt John U. Nattkemper of the 27th, Cp.l Jacob J. Elchel of the 55th and Cpl Hubert L. Gallagher of the 22nd assisting and doubling as operators.

13th Sq Communications men. L to R: Cpl John J Maskrey, Sgt Clarence R. Whittier, Sgt Sidney Stutman, Sgt Leslie Grant, Cpl Freeman Smith, Sgt Joseph S. McCaffrey, Sgt Luther A.C. Cooper.

Communications worked to improve the radios installed in the Spitfires. The radios were American VHF (Very High Frequency) sets but they used English dynamotors. With the Spitfire's greater range, missions lasted longer requiring more hours running time for the dynamotors. Inferior to American dynamotors, they burned out at a rate faster than anyone expected. Another problem developed with radio tuning due to the vibration of the single engine plane. The slightest movement of the tuning shafts made them useless. Changing sets and dynamotors sooner than specifications required helped solve both problems.

Some men from different areas of the Group wanted to see more action than they felt they had with a photo recon unit. It was hard for some to understand their contribution to a strategic air force in this much misunderstood realm of the air war. For ground crews and office personnel it was especially difficult to see where their contribution counted. Many pilots desperately wanted to shoot at something or drop some tonnage on the enemy. A few of them transferred to fighter units where they satisfied their longing for armed combat. The Communications Department transferred several enlisted men who wanted a more active combat roll. Three men from the 13th Squadron, Sgts Richard A. Spellerburg and Archie Queen, as well as Cpl Mervin Richmond hounded

Eyes of the Eighth

Lt Jack Tuggle Jamison was killed on the last day of 1943 when his F-5 crashed in the Severn River Valley.

the Communications Officer for transfers to bombardment groups. They did not feel that they were taking an active part in the war at Mount Farm. After the transfers they had varying success. Richmond flew missions on bombers before transferring to a depot group. Queen discovered that he could not fly due to airsickness.

Sergeant Spellerberg had haunted the 92nd Bomb Group at Alconbury looking for an opening to fill and when his transfer came through he became a radio operator and gunner in the 326th Squadron. The sergeant completed 18 missions, including the infamous 17 August Schweinfurt raid. On the next raid to Schweinfurt on 14 October 1943, Spellerburg's B-17 went down. The sergeant became a guest of the Luftwaffe at Stalag Luft 17-B near Krems, Austria. (Patton's forces liberated the POW camp and Sergeant Spellerburg in 1945.)

Cryptography

Within the Communications Department there were no qualified cryptographers. The department had to train its own. Two 13th Squadron men, SSgt Arnold Hermeling and Sgt J. S. McCaffrey learned the American systems from Captain Neill and then went to RAF radio school in Worcester for one month to study the British systems.

The material comprised both American and British documents and devices. Cryptographic men and all teletype operators had to be cleared to handle secret material and equipment. Cryptographic clerks decoded daily the "Bomber Strike" messages transmitted by wireless telegraph from the Eighth Air Force bombers over the Continent. Instead of waiting for calls from higher commands, these messages enabled the Group to know what targets had been hit. They could get photo ships over the targets more rapidly. When Hermeling transferred to another group to assist setting up its decrypt system, Communications trained Sgt Bernard T. Wendel of the 14th to take his place.

Jamison Killed

The year ended on a sad note for the Group. The 22nd Squadron's second casualty occurred on 31 December 1943 when Lt. Jack Tuggle Jamison failed to return from his first flight. Lieutenant Jamison's transfer to the squadron filled the opening in the squadron's T/O when Carl Chapman transferred out. New pilots usually began their pre-operational flights on photo runs over local territory with airfields and military construction sites the usual targets. For his first flight, Operations assigned Jamison a target in the southwest of England in the Okehampton area, requested by the Royal Engineers.

Jamison took off from Mount Farm at 1400 hours for a short flight. He was due to return at 1530 hours just before the early winter sunset on this New Year's Eve. On his return flight, at 1500 hours he disappeared from local flight control. Jamison had not sent any radio communication indicating trouble with his aircraft.

The day was cloudy and dull. Below in the Severn River Valley, farmers worked their land. D'Arsey Tilley of Whiteshill Farm plowed land above Broadmead Brook with his team of Shire horses. Suddenly, he heard an aircraft screaming straight downward at very high speed. In a flash a plane plunged into the brook at the bottom of the valley between two farms. On impact, the aircraft virtually disappeared into the deep soft clay just to one side of the stream. The terrified horses tried to bolt and the equally terrified Tilley fought to control the powerful animals.

Tilley raced to a phone to report the crash. The authorities sent out USAAF guards to watch over the impact site and wreckage. They camped out near the brook over New Year's Eve and for several days into the new year. Tom and Arthur Fishlock, who farmed nearby Harcombe Farm, used their horses to pull some of the wreckage out of the ground. Investigators examined what they could of the mangled F-5 but did not discover the cause of the crash.

When the investigation ended, the USAAF cleared the site of visible wreckage, smoothed over the scarred ground and left the land to heal. They sent the pilot's remains to Brookwood Cemetery for burial. On the first day of 1944, Jack Jamison would have been 22 years old.

Part III

1944

Chapter 7
January February March 1944

A new year began and the big talk was about the invasion. When would it come? Probably in the Spring, but few people knew for sure. Those who did know could not talk about it. Operations dispatched missions whenever weather permitted. Many of them covered the V-1 flying bomb sites in France. The buildup of troops and supplies gathered momentum and lanes and byways all over the southern part of England became storage areas. As the leaves unfolded on the bare-limbed trees they sheltered tons of material stacked under camouflage nets. Pilots in low flying-planes from Mount Farm could see the masses of armament intended for the invasion and men driving on the lanes themselves wondered at the sheer numbers of vehicles lined up along the hedgerows.

How much did the Germans know of the plans? While Allied photo reconnaissance planes could cover the entire Continent, Allied air superiority limited the German Air Force (GAF) photo reconnaissance program to flying mainly where the RAF allowed. Very few GAF photo planes gained access to the skies over the crowded Channel ports and many photographed areas without critical concentrations of troops and material or locations rigged with false targets to fool German Intelligence. Naturally the RAF allowed as much cover of the area of southeast

Winter fog makes miserable conditions in the air and on the ground. (Harold Fox)

Colonel Homer Sanders and new 7th Group C.O., Col Paul T. Cullen. (Paul Cullen)

England where the fictitious First United States Army Group (FUSAG) under Patton threatened the Pas de Calais. The fields and roads in the FUSAG area had fake inflated or plywood tanks and trucks posing for photographs by German photo recon. Another area considered a safe target lay in Scotland where the equally fictitious British 4th Army posed a threat to Norway. Deception was the name of the game and it was up to the intelligence gathering and interpreting services to do their best at breaking through. Whichever side did would win the war. The 7th Group had its part to play and a wily new commander to direct them.

Colonel Paul T. Cullen

The new C.O. of the 7th Photo Group took over on 1 January 1944. Col. Paul T. Cullen replaced Col. Homer Sanders when Sanders returned to his real love, fighters, at the Ninth Air Force Fighter Wing. The Peruvian-born Cullen had a distinguished background and experience in photo reconnaissance. Previously stationed in the Middle East and West Africa, this pilot understood the peculiarities of the job.

On 7 January, Lt. Arthur S. Waldron of the 13th Squadron, went on a mapping mission in the area of St. Nazaire, a place well known by all Allied airmen as a hot

January February March 1944

Capt A.M. Hill and RAF F/O A.J. Terry, Clerk of the Works, discuss construction underway at Mount Farm. (Al Hill)

Capt Harvey Wagner, killed in action on 7 Jan 1944. (Marshall Williams)

spot for flak. This sortie was no exception. As Waldron made his runs flak bursts blossomed around him. He varied his altitude and maneuvered to prevent the German anti-aircraft batteries from getting an accurate fix on him, all the while clicking away with his cameras. When he finished his mission he brought back photos of his targets and a few frames showing his own contrails bracketed with flak.

Wagner Lost
That same day, another 13th Squadron pilot, Capt. Harvey Wagner, took off from Mount Farm at 1342 hours and crossed in the enemy coast at Caen, France, to cover targets in the Nantes area. Time for his return came and passed. His line crew and friends worried about this quiet, experienced pilot nearing the end of his tour of 25 missions. When he did not return, 7th Group made inquiries but British Flight Controllers had not been able to track Wagner and make a plot on his aircraft due to Fortresses and fighters in the area. Eighth Air Force Headquarters later reported Lieutenant Wagner killed in action.

Spitfires Only
Another squadron had better news on 7 January when the 14th Squadron heard from Group C.O., Colonel Cullen, that all the Spitfires on the station would be transferred to the 14th. The other three squadrons would divide the F-5s between them. It took only a week to complete the transfer and for 14th Squadron Engineering to have six of the new planes ready for operations. Having previously acquired experience in Spitfire maintenance, the mechanics considered it an easier aircraft to maintain than the F-5. The change pleased everyone. Through the transfer, the 14th regained the old Mark V training planes and put them in a separate flight with TSgt Steinbach as the flight chief.

The Spitfires, with their longer range, brought an increase in operational time and photo cover calling for more photo interpreters. To fill the need, the 14th acquired its first on-base photo interpreter on 8 January when Lt. John L. Robinson transferred to the squadron from the Strike Attack Section at Medmenham's Central Interpretation Unit (CIU). Prior to this, 7th Group had only three American photo interpreters (PIs) at Mount Farm, none assigned to the 14th Squadron.

From the beginning of operations at Mount Farm, First Phase Interpretation of Eighth Air Force and RAF Bomber Command requests had been done at the RAF photo reconnaissance base at Benson. British and American interpreters worked together as one unit. As soon as a U.S. photo recon plane returned to base, Camera Repair removed the camera's film magazines. The Photo Lab at Mount Farm then processed film from American sorties at their base laboratory. An American interpreter viewed the film for picture quality and proof of target cover, then chose the best negatives for further interpretation. The Lab rushed printing of the selected negatives and sent the prints to Benson for further interpretation.

Eyes of the Eighth

Intelligence officers discuss pilot's photographs over a map mosaic of the Ruhr laid on floor for plotting. (Roger Freeman)

Longer and Farther

The new Spitfires with their longer range and high altitude capabilities gave 14th Squadron Operations much deeper targets to cover. As the pilots learned to coax miles out of their aircraft, the range for targets stretched out. The Spitfires had few mechanical failures and accumulated record operational hours. Lt. Robert Alston set a squadron record when he flew TSgt Kinder's Spitfire 946 on a four-hour mission deep into Germany.

New 14th CO

The Group C.O., Colonel Cullen, transferred Major Marshall Wayne to the 381st Service Squadron on 12 January 1944. He named the 14th Squadron's Operations Officer, Captain Walter L. Weitner, as the 14th's new commanding officer.

Evidence in Camera

For over a year, men at the highest levels of government in Britain had seen evidence of something new and ominous in their intelligence reports. From Cabinet level down, those who knew about the information feared that a new German development could change the course of the war and threaten the planned cross-Channel invasion. The special area photography, begun in June and July of 1943, of mysterious sites within a 140 mile radius of London, had continued through the remainder of the year. A confusion of intelligence information about a secret weapon delayed solving the mystery. Confusing and contradictory data led experts to split into two camps, those who believed and those who did not. Fortunately, those who believed the Germans capable of developing a super weapon prevailed. Hitler had warned as early as 1939 that he would do so.

Long before the Americans began operations in England, photos from PRU sorties out of Benson went to Medmenham for routine interpretation. Even though the WAAF specialist in enemy aircraft, Constance Babington Smith, evaluated the photographs during routine Third Phase Interpretation and did not find anything fitting the criteria for the suspected weapons, she did find some suspicious construction and made note for the first time of the name Peenemunde, a remote place on an island in the Baltic.

In December 1942, reliable news reached London

Crew Chief Forrest Graveson's Mark XI Spitfire MB 952. (Allan Cassidy)

86

about a long-range rocket under development at a German research facility on the Baltic. Allied Intelligence did not know at the time that the Germans also first tested their flying bomb in December. The V-1, as it became known, had to be launched from a ramp pointing toward its target. At Peenemunde, the rocket research facility on the Baltic, the Germans had several new weapons under development, among them, the new flying bomb and a more powerful long-range rocket. At first, British Intelligence assumed their information referred to only one weapon. That assumption and the mixing of information on the two programs caused all the confusion and skepticism among the experts.

MI4 Branch of the War Office in London issued orders to Medmenham on 13 February 1943 to be on the lookout for, "some form of long-range projectors capable of firing on this country from the French coast." They told the interpreters to look for any suspicious construction of rails or scaffolding. In May, Duncan Sandys, head of the committee to investigate the flying bomb, suspected that not one but two weapons were being developed and he recommended looking in the coastal regions of northwest France for any suspicious new construction. This instigated the long campaign to find and photograph V-weapon sites.

Intelligence mounted a secret weapons inquiry under the code name Operation Bodyline, a Cricket term for an unsportsmanlike type of bowling. The British chose all code names and cricket terms became commonplace in the area of secret weapons. On 27 November 1943, Operation Bodyline became known as Crossbow, a new and appropriate name of a weapon which made all its predecessors obsolete. Operation Crossbow was the overall campaign against the new secret weapons. The targets within the campaign acquired another cricket term name, Noball, inferring that this new "ball," released too late by the German side, would give a run to the Allied side.

By 2 December 1943, 64 sites had been photographed and reports from ground sources inside France indicated that, ultimately, the number constructed would exceed 100. Almost all sites were in the Pas de Calais and Dieppe area and within 140 miles of London. Early in December, Intelligence reported that 20 or more sites were within three months of completion.

When the photo interpreters at Medmenham found what appeared to be a launching point at Peenemunde, Intelligence requested a search for a cruciform shape which just might be the key to one of the new weapons. Again the WAAF interpreter, Flight Officer Babington Smith, poured over photos. Carefully searching each photo of Peenemunde, late in November 1943 she located a tiny cross-shape, an aircraft with a 20-foot wing span, sitting on a launching point. This was the first sighting of a V-1 pilot-less flying bomb. The pieces of the puzzle began to fall into place making the connection between Peenemunde and the mysterious sites in northwestern France

As photographs of V-weapon sites became available, Medmenham supplied them to bomber and fighter commands with other relevant target data. On 24 December 1943, ten combat wings of Fortresses and Liberators totaling 722 planes, escorted by 12 groups of fighters, the largest American bomber operation to date, attacked Noball installations. Four photo planes followed the bombers to the targets in the Pas de Calais making their runs just after the strikes. The campaign against the V-1 and V-2 had begun.

Flying Bomb Sites

The bombers of the Eighth Air Force went after 25 flying bomb sites in the Pas de Calais area on 14 January. Five photo planes followed the bombers to photograph the results. Hard targets to hit, the sites occasionally sustained bomb damage delaying completion without destroying them. The experiments carried out on test sites constructed at Eglin Field in Florida proved just how difficult the task would be. Here the air force experimented with various types of bombs and bombing techniques but the Germans continually adjusted their construction methods and designs. The 7th Group and RAF PRU continued to record these changes and stages of development on film furnished to Intelligence.

Local Disaster

The cold foggy weather in December 1943, which had limited operations for the 7th Group, continued into January. Often, when photo aircraft needed to follow bombers to a target which had clear weather, they could not take off from a fog-bound Mount Farm. Eighth Air Force Headquarters thought that temporarily placing a few pilots and their planes near the bomber bases in East Anglia might take advantage of any good weather in that part of England. In mid-January, a group of pilots took their planes to Honington and Steeple Morden fighter bases in East Anglia hoping for better weather. Again it was the same story. When the weather cooperated on the English side of the Channel, the bombers could use equipment to bomb through cloud on the Continent, but the photo plane needed a clear patch for accurate damage assessment work. Honington and Steeple Morden became fogged in and the exasperated 7th Group pilots heard that Mount Farm was clear and dispatching other missions. While waiting for clear weather for almost a week they kept in

Eyes of the Eighth

Capt Robert J. Dixon while serving with #6 OTU of Coastal Command RAF at Dyce, Aberdeen, Scotland.

contact with base operations by telephone. On the morning of 19 January, the Operations Officer reported that Mount Farm had a 1,000 foot ceiling and told them to come back. The pilots took off from East Anglia and started the short trip to their home base.

Conditions change rapidly in the Thames Valley and soon after the photo planes became airborne in East Anglia, fog began to close on the Mount Farm airfield lowering the ceiling to a more-dangerous 500 feet. Alerted by Operations that 7th Group had aircraft on their way from Steeple Morden and Honington, the men who manned the new DF Station at Mount Farm hurried there, turned on their newly installed equipment and waited. Minutes passed as the weather worsened and the ceiling dropped below 300 feet. At the DF Station, a huge blue flash stunned the operators and all the equipment went dead. Pilots of the incoming aircraft began calling the control officer for homing and landing assistance. He told them to go over on Channel C and call *Dreamin'* at Benson for homings. In the confusion, all the pilots seemed to be calling *Dreamin'* at once.

One of the pilots flying in the thickening fog that day, Lt. John Blyth of the 14th Squadron, remembered his lack of experience flying on instruments when he left training at Colorado Springs. He also thought of all the extra time he spent in the Link Trainer in England to build up experience and confidence, "None of us had much instrument training and very little actual instrument time. All we had was a four channel VHF set in the aircraft and a Direction Finding (DF) Station at Mount Farm. They could give us a vector, tell when we passed over the station and, if one had practiced, an instrument approach of sorts." Blyth wondered if the other men now out in the fog had done extra instrument work as well. He knew several of them were veterans, one, Capt. Robert Dixon, had flown for the RAF, was an excellent pilot familiar with instrument flying and the British VHF equipment. Operators at Benson guided the pilots down through the dense cloud. Dixon, Blyth, and Childress kept going for Mount Farm and broke out about 250 feet above the ground, landing safely. Lt. Lawrence Aubrey landed at Benson. Others returned to the fighter bases.

Two 22nd Squadron pilots, Lt. Earl V. Skiff, known as "Lil' Boat," and "Blick," Lt. Wendell W. Blickensderfer, tried to find the field in the heavy fog. Attempting to reduce to an altitude below cloud without radio contact or safe vectors, the two pilots strayed too low to clear low hills in the area. Skiff crashed about a mile and a half south of Watlington. Blickensderfer's F-5 went down near West Wycombe, the pilot bailing out too late for his parachute to open.

When word reached Mount Farm, investigators went to the sites confirming that both pilots had been killed. One of the men, recognizing "Danny" Burrows' flying boots on one body, returned to the base thinking his friend

Lt Wendell Blickensderfer. (John S. Blyth)

had been killed. As he walked into the pilot's room he saw Burrows talking to another pilot. Burrows assured him he was not a ghost and realized the dead man had to be Earl Skiff who had borrowed his boots that day.

After the tragedy, inspectors discovered that a high voltage wire had been routed near a high power resistor in the rectifier of the new Mount Farm VHF/DF Station. The insulation had gradually burned from the wire until the fateful morning when the wire made contact with the resistor and caused a short in the plate circuit of the rectifier. This caused excessive current in that circuit and burned out the rectifier tubes. The inspectors thought that faulty design in high voltage circuit caused the failure. Even before the event, requests for a more dependable set had been submitted to HQ Eighth Air Force Service Command.

New VHF equipment arrived in late January and technicians set it up as quickly as possible starting operations in early January. The complete SCS-3 setup was comprised of the SCR-573-A, SCR-574-A, and SCR-575-A. Range was approximately 250 miles in early tests of the equipment. After the former limited range, this was phenomenal. Repairmen made continuous checks and monitored the equipment while in operation. They had emergency facilities if a breakdown occurred. If a receiver or transmitter failed, the repairman on duty merely switched over to a second receiver or transmitter and inspected for the weaknesses in the first unit taking any necessary action to correct the problem.

On 27 January 1944, Lt. Charles Parker transferred from the 13th Squadron into the 14th. The men on the flight line, who were very protective of their high-powered charges, looked upon any new pilot with suspicion. Sometimes the best of pilots accidentally got off on the wrong foot. During his first week with his new squadron, Parker had the misfortune to run one of the old Mark Vs off the perimeter track. This temporary setback in his popularity with the crew chiefs lasted a very short time, as he proved to be highly competent.

While the men on the flight line worked with their new pilot, the 14th Squadron's Engineering Department struggled with a problem of record keeping. The controversy lay in the paper work on the reverse Lend Lease Spitfires. The RAF didn't like Engineering discarding their forms and using complete AAF maintenance records on the British airplanes. The Station Technical Inspector said that as long as the 14th Squadron remained in the USAAF, they had to keep U.S. records. Late in January, they worked out a compromise. SSgt Red McKinney and Sgt Harry Marder, clerks working with Lieutenant Nelson; Captain Hart, Station Engineering Officer; and Flight

Lt Charles Parker standing beside his Spitfire, *Kisty I*.
(Charles A. Parker)

Officer Lewis, an RAF maintenance advisor, devised a system of recording Spitfire maintenance which proved satisfactory to both the RAF and USAAF.

First Shuttle Flight

Many targets requested by various sources lay deep into Germany or France, beyond the range of photo aircraft, even those carrying auxiliary tanks. A planning group with men from Eighth Air Force Headquarters and officers from 7th Group devised a strategy making use of bases acquired by the capture of Mediterranean territory, especially the islands of Sardinia, Corsica, and parts of mainland Italy. Theoretically, aircraft would leave Mount Farm and fly southeast over their targets on the way to bases in Italy, where they would stay overnight. On the return trip other targets, heretofore out of range, would be covered. On paper it worked, but would it in practice?

To prove the theory, Group Operations assigned a shuttle sortie to Maj. Norris Hartwell, who had been a member of the planning group. Hartwell's targets, previously out of range, would be covered for the first time. Between the major and his destination lay enemy occupied and well-defended territory. Operational voice radio and IFF (electronic aircraft Identification Friend or Foe) frequencies had to be set up to communicate in the Italian area. The base at his destination, Pomigliano, Italy, had to be notified of the purpose and time of arrival of the aircraft. Capricious weather could cause major problems,

and even if nothing else went wrong. Hartwell's navigation must be faultless to find his targets and get across a lot of land and water to reach Pomigliano. Major Hartwell and the planners felt these were acceptable risks.

His F-5 fully loaded with fuel, cameras, and film, Hartwell took off at 1117 hours on 29 January 1944 for a challenging mission. He crossed the Channel leaving friendly England behind and headed over France, "As I proceeded over France I had an eerie feeling and felt very lonesome. Although I had previously flown missions deeply into France, this was different. When I arrived at the 'point of no return' I knew that I had to forge ahead."

It was a beautiful day, sunny and clear. The weather, so dreaded by all pilots, was good. "Too good," Hartwell thought, "I would have welcomed a few clouds to give me a little better feeling of security — at least psychologically. I felt that if I encountered enemy fighters, a few clouds would give me a place to play hide and seek. This might help evade a one-sided shoot-out — me with cameras, they had guns."

Major Hartwell photographed his assigned targets in the Dijon area in France, "I saw a lot of beautiful country including the Alps." The major didn't have time to appreciate the beauty of the scenery. Although the Germans sent some flak up, their fighters were his main concern. He kept a sharp lookout across France but never saw any.

As he approached the Corsica-Sardinia-Italy area, he switched the aircraft IFF to the frequency assigned to him. He tried unsuccessfully to make radio contact. Without a radio fix he used his own navigation to get to the base at Pomigliano. As Hartwell neared the west coast of Italy, "two British Spitfires intercepted me. Apparently my IFF was not working or was on the wrong frequency. The Spitfires flew formation with me and played around me for awhile and then flew away." Hartwell was glad he was flying a readily identifiable P-38 type aircraft.

Still unable to obtain radio contact, the major let down and headed for Pomigliano. Ahead lay the field. Unable to raise anyone on the radio he buzzed the runway and waggled his wings. There appeared to be no wind and he chose the runway for a landing. He began the approach and as he neared his end of the runway, "two fighter aircraft in formation were coming in for a landing and heading straight towards me. I peeled off, came around, and landed in the other direction. It was a very close call." Happy to be back on the ground, Hartwell had completed the first leg of his mission.

On the ground, Hartwell learned he had the wrong frequency. In spite of this mix-up and lack of communication establishing radio frequencies, he felt shuttle missions could be a regular part of photo reconnaissance operations. After spending two nights in Italy, Hartwell left Pomigliano on 31 January 1944. On an uneventful return trip to Mount Farm, he photographed the ball-bearing works at Annecy, France. After a round trip of over 960 miles, which completed his 13th and 14th sorties, Major Hartwell more importantly opened a new chapter in photo reconnaissance. The results of the mission pleased the Intelligence Departments in the ETO. His commanding officer, Col. Paul Cullen, an experienced photo recon pilot himself, appreciated what Hartwell had achieved in planning and execution and recommended him for a Distinguished Flying Cross.

During the month of January, the 27th Squadron shifted and promoted men, filling its Table of Organization for better management. It transferred some enlisted men into the 13th and 14th Squadron. One pilot, 2nd Lt. Waldo Bruns went to the 22nd Squadron on 16 January. Captain Haugen became a major on the 23rd.

Newly-promoted 1st Lt. Thomas O'Conner took a mission on 25 January, to France. He crossed the Channel at altitude and as he approached the coast one of his engines began to falter. O'Conner turned back and, flying in a heavy overcast, managed to make the south coast of England just as his engine quit. Unable to keep his aircraft under control, O'Conner jettisoned the canopy and tried to bail out but he couldn't get out of the cockpit. Somehow his parachute had become hooked onto the seat. The wind whipped his body and whistled in his ears as he struggled to get himself free of the falling aircraft. Sud-

Maj Norris Hartwell made the first round-trip shuttle mission to Italy at the end of January 1944.

denly he fell free. His parachute opened and he landed near the coast, injuring himself slightly in the fall. His aircraft crashed nearby, plunging 15 feet deep into a farmer's field, the concussion jamming shut the front door of the farm house. Fortunately, no one on the ground was hurt.

The squadron C.O. promoted Lts. J.L. Campbell, Franklyn Carney, Hubert Childress, and Lawrence McBee to captain; and 2nd Lt. Cameron to first lieutenant on 31 January finishing the month on a high note for the 27th Squadron.

February 1944
Winter hours of daylight remained in short supply in February. Bicycling in narrow country lanes could be dangerous during the day, much less during dark nights of a blackout. Usually the bicyclist escaped a hazardous adventure with a few scrapes, bruises, and wounded pride but in January, 1944, one of the 27th's enlisted men, Cpl Fred M McConn broke his collarbone in a bicycle accident during the blackout. On 5 February, the 27th Squadron lost Cpl Donald Bernau, who died at the Second General Hospital in Oxford from injuries received when his bicycle collided with a truck.

On 5 February, Lt. Robert C. Floyd gained the dubious distinction as the first 27th Squadron pilot attacked by German fighters. He flew a sortie to France and covered his targets. Over Chateaudun, France, three ME-109s jumped Floyd who eluded them after a ten minute run toward the Channel. He landed at Mount Farm with his assigned targets on film safely in the cameras.

Farley's Close Call
On the morning of 5 February 1944, the 27th Squadron's Intelligence Officer, Lt. Walter Hickey briefed Lt. Donald A. Farley on the Gilze/Rijen airfield. He warned the pilot to look out for the phony Gilze/Rijen airfield the Germans had built right next to the real one, which the Luftwaffe tried to camouflage. Farley took off, crossed the Channel and began his photo runs over his Belgian target. Although Farley had flown many missions he had never been jumped or shot at and was used to what he termed "my milk runs." This mission would change that experience for the tall, skinny-legged pilot, affectionately known to his friends as "Bird Legs."

Over the target, Farley's F-5 developed engine trouble, and on the second run his right engine blew a piston. The cockpit began to fill with smoke. Farley did not know what happened. "It just blew up. No enemy action, no gunfire, no nothing. It just blew up." Farley feathered his right prop and continued photographing his target in spite of the smoke in the cockpit. After finishing the run, he thought the smoke seemed to be clearing and decided he would try and make it to England. He turned toward the Channel but did not ask for an emergency vector in fear of the enemy intercepting the message and sending up fighters.

When he reached mid-Channel he asked for an emergency vector. After crossing the English coast, Farley decided to try to reach Mount Farm. "It was a low visibility day and I wanted to come in high so I would make the field." Because of heavy ground haze, Farley could see the field only when directly over it. He made several approaches and was told to go on around again. Farley decided three approaches on a single engine was enough and when told to go around again he tried to land but overshot the runway. Again the tower told him to go around. His airspeed falling and his gas tank gauge reading empty, Farley panicked. "I tried to fly it into the ground, which was a mistake. Then when I leveled out, of course the airplane bobbed up." The pilot tried to pull up his landing gear but with only one engine there was not enough hydraulic pressure. Wheels down and the airspeed fallen to 70 miles an hour, Farley's plane was stalling at a critically low altitude with no room to maneuver. Farley remembered what his instructor had said in Primary about stalling, "And I did the only thing I did right all day. I pushed the column forward. That was the hardest thing I ever did but I think it saved my life."

All around the airfield men had watched the drama develop as the crippled F-5 circled trying to land. On this last attempt, they watched the plane overshoot the runway, clear the end of the field, cross the road outside the base, and disappear into the trees along the Thames with a terrible metal-shredding crash. In a moment, silence. Stunned, few of the horrified onlookers thought Farley had a chance and some turned away. Others grabbed Jeeps or bicycles and raced toward the crash scene.

Farley himself admitted he thought, "Well, this is it," as the grove of trees loomed ahead, but as his plane crashed through the trees it was, "shucked like an ear of corn." Trees sheared the wings off. The F-5 struck a plow, one engine tore off, and Farley felt the cockpit spin, "the piece that I was riding in did a complete 180 degree flat turn in the air." Whirling around as it crossed the Thames, what was left of the plane crashed backwards into the riverbank with remnants of the booms and vertical stabilizers driven like stakes deep into the soft ground. The cockpit was in the river, anchored to the bank.

The water almost filled his cockpit and Farley stretched hard to get his mouth and nose free. "I know I wasn't knocked out because I would have drowned. If I was, I must have come to immediately." Farley struggled to get out forgetting he was still strapped in. Undoing

Eyes of the Eighth

The plow, which Lt Farley's F-5 struck on its way to the Thames. Shattered and stripped trees show where the aircraft's wings and tail ripped off. (Marshall Williams)

Two men inspect the area where Farley's plane shed metal sections before crossing the river. (Marshall Willaims)

the seat belt and shoulder straps, he got his shoulders above the water. His parachute held him down and he had to unfasten that before he could crawl out onto the remains of his plane. At this moment he saw where he was, "I was anchored on the bank and in the river heading back where I had come from. I had crossed the Thames River."

The men from the base rushed down to the river expecting wreckage all through the trees. They pushed their way through the shredded undergrowth and scarred tree trunks along a trail of wreckage all the way to the river. Unbelievably their "doomed" pilot sat atop his cockpit on the opposite side of the river. Farley had worn shoulder straps that day. "The 'hot' pilots wouldn't wear shoulder straps but when they came out there and saw my airplane all smashed up and I was sitting there with hardly a scratch, one of them, George Nesselrode, called across

5 Feb 1944. F-5B-67330 resting in the Thames after being turned around in mid-air as it tore through the trees on the other side of the river. What was left of one tail boom jammed into the river bank and suspended the cockpit section partially above water. The left engine and boom have been torn off but the right engine remains with the tip of one propeller blade sticking above the water. The aircraft is pointing back toward Mount Farm airfield. (John Richards)

January February March 1944

the water, 'Hey, Farley, were you wearing your shoulder straps?' and when I said yes, he answered 'That's good enough for me' and left."

Lt. George Epsom of the 1274th MP Company (Avn), dressed in a brand new uniform and ready to take a friend out for dinner, called out that he would swim over and help Farley off the wreck onto the riverbank. Though Farley protested he did not need help and could crawl over onto the bank by himself, Epsom, afraid Farley might be injured, swam over anyway, helped his friend to dry land, ruined his new uniform and ended up as the casualty of the day when he reported to the doctor with chills.

During this drama, another was taking place as the base ambulance rushed to the site of the wreck expecting the worst. Learning that the plane had crashed on the far side of the river, the driver drove down along the country lanes to the nearest bridge, across the river and then raced up and down the farm fence looking for a gate. Farley wondered why they didn't cut the wire and drive across the field but he wasn't hurt and eventually walked over to the ambulance with George Epsom for the ride back to base.

Salvage crews dragged the remains of the plane from the river the next day and returned it to the base. The Camera Repair men removed the film from the cameras and took the film magazines submerged in GI cans filled with water, to the Lab for processing. Surprisingly, only the first few feet and an inch along the sides of the film were wet after all the dunking. The Lab washed the film thoroughly and processed it getting good results except, to Farley's chagrin, he had taken the phony airfield after all.

Waldron Killed

One squadron did lose a pilot that same day. Two close friends, both with the 13th, Lts. Hector Gonzalez and Arthur S. Waldron, chose between two different assignments. One took off on a long photo flight deep into the wine country of France while the other flew a recently repaired F-5 around locally on a test flight.

Lieutenant Gonzalez made his runs over the target. Before heading home he checked his fuel gauges and to

Lt Arthur Waldron, who was killed in the crash of an F-5 he was testing on 5 Feb 1944.

his horror, the left one registered near empty. He had no idea what had happened. Unknown to him, a faulty valve or some other phenomenon had siphoned the fuel out of the tank. Gonzalez feathered the left prop and continued toward home on one engine. Could he make it to England? When he reached the Channel, he radioed for help. By mid-Channel, Belgian piloted RAF Spitfires met him leading the way to the nearest airfield, a narrow grass strip on rolling green fields atop white chalk cliffs rising above the rough water.

The pilot started his left engine to use the last of the fuel to land. As he came in the tower warned him it was a short strip and he was coming in too hot. Gonzalez pulled up as he shot out over the high cliffs. Going around again, he put the F-5 down carefully on the small landing ground at Beachy Head, the highest cliff on the south coast, 534 feet above the English Channel. He went to the control tower to check in, where the RAF operator had Mount Farm's tower on the phone. They confirmed that Gonzalez had landed there and handed over the telephone receiver. On the Mount Farm end of the line, Flight Officer Little told Gonzalez that Mount Farm thought the Group had lost two pilots. Relieved to find Gonzalez safe, Little told him that Waldron had taken the F-5 up and called in to the tower reporting trouble at 20,000 feet. Flying Control heard him say that he might have to bail out, then silence. Little told Gonzalez that the squadron learned a short time later that Waldron had crashed in a pasture near Swindon. Witnesses reported that the plane went straight in and the wreckage lay deep within the impact site.

Belgian pilots stationed at Beachy Head took the distraught Lieutenant Gonzalez to their quarters where they spent most of the night commiserating over a few bottles. In the morning, Gonzalez left for Mount Farm. As he approached the runway, about three miles out something went wrong with the auto pilot which took over control of the aileron. When the lieutenant pushed the stick over to make a left turn to the runway he could not move the stick left or right. The control tower heard Gonzalez screaming into his radio that he couldn't move the stick.

Crater caused when Lt Arthur Waldon's F-5 crashed on 5 Feb 1944, killing the pilot.

93

His friend Bert Sears, in the tower at the time, later told Hector, "you were really excited." Colonel Cullen witnessed the landing as Gonzalez used his rudder to skid the aircraft around and line up with the runway. When the plane rolled to a halt, Cullen climbed on the wing wanting to know what had happened. Gonzalez told the colonel that he was unable to budge the stick to either side. Cullen tried and failed. Testing revealed the faulty control took 40 pounds of pressure on the stick to override the auto pilot. Colonel Cullen had all the auto pilots on F-5s in the Group removed until the fault could be found and corrected. Previous problems with hydraulic leaks in the auto-pilots of F-5C models had been at 20,000 feet or higher.

Bad luck continued for the 13th when on 14 February Lt. John A. McGlynn took off on his second operational sortie to do a mapping job from Villacoublay A/F near Paris to Romilly. Operations and the men on the Flight Line waited for his return. When he didn't turn up at Mount Farm or any other base Operations listed him as missing in action.

Second Shuttle Mission
Capt. Robert R. Smith, commanding officer of the 22nd Squadron, flew the second shuttle mission on 15 February 1944. Taking photos of his targets on the way, Smith experienced a small amount of flak at Bordeaux and Marseilles just as he crossed out the south coast of France. He landed at Alghero, Sardinia, at 1515 hours. The next morning, as Smith prepared to return to Mount Farm, the RAF weather officer at Alghero gave a casual briefing and told him the weather was good in England but there was cloud over the Continent. The amount of cloud alarmed Smith as he approached the French coast at Marseilles. A great dark blanket lay ahead of him, the French city barely peeking out from under the edge. Instead of turning back, the pilot trusted the weather officer's clear weather forecast for England and entered the cloud. Pushing his F-5 climbing through the rain, looking for the top, Smith flew toward England on instruments. A small hole appeared ahead. He could see land and, being a good PR pilot, Smith turned on his cameras while flying through the clear patch. Unknown to Smith, he photographed Chateaudun. The weather closed in around him again. As he neared what he reckoned to be the English Coast the fog and rain got worse. He saw unidentified water through another small break. The captain called again and again for a vector still in thick cloud and on instruments. Finally a station picked him up and gave him directions, but not until he had flown blindly through a small space between balloon barrages on the outskirts of London. The fact that no other planes were flying in England that day was a good indication of how bad the weather was in spite of the weather information he had been given in Alghero. That really set "Smitty's" teeth on edge. Flying control directed him out over water again on the eastern coast of England and brought him in to the airfield at Bradwell Bay.

More Bad Weather Flying
Darkness still came early in February, shortening available time for photography over the Continent. Pilots flying long sorties often returned in less-than-ideal conditions. Fog, low overcast, and heavy weather sometimes forced the photo ships to land away from their home base and return on the next clear day. It was often a matter of discretion, if not of necessity, on the part of the pilot whether he tried to make Mount Farm under these conditions. Operations and Intelligence always wanted the film in the cameras as quickly as possible. Timely target information could be critical. A few tried to return home in spite of conditions either because of overconfidence, acceptance of the danger, or sheer foolhardiness. More than one paid with his life. Others knew their limitations, considered the options, and made it safely.

Accepting the responsibility and the danger, a few had adventures with comic overtones. Lt. John Blyth of the 22nd Squadron returned in just these circumstances one evening. Heavy cloud reached all the way up to his altitude at 36,000 feet. He had gotten to the Mount Farm area without trouble. At that altitude, just above the weather Blyth had good visibility, but exactly where was the airstrip? He could see nothing below but solid gray. He began letting down hoping that from a lower altitude he could see the orange Pundit Light that sat on a truck

Lt John Blyth in a Spitfire of the 14th Squadron. (John Blyth)

January February March 1944

McGlynn Evades the Germans

Photo reconnaissance pilots, who flew alone over enemy territory, almost always had their tracks followed by British radar. When enemy aircraft appeared near their target or course, RAF Air Controllers sent warnings or recalls. If something happened to the lone pilot, the controllers could offer a few details. On 14 February 1944, Lt. John A. McGlynn failed to return from a sortie. His course had not been plotted. The official Missing Air Crew report assumed he had crossed into enemy-held France and listed him as missing in action.

Five weeks later, Major Doolittle went to London to identify a pilot who claimed to be Lt. John McGlynn of the 13th Squadron. When Doolittle officially verified his identity, McGlynn returned to Mount Farm with a story to tell. He had a willing audience from other squadrons as well as his 13th.

Lieutenant McGlynn's assignment was a mapping job southeast of Paris, where he began his cameras over the Villacoublay Airfield. While flying over Romilly-sur-Seine between 29,000 and 30,000 feet, he saw flak burst below and to the left of him. Suddenly, a shell burst nearer but higher. The third one exploded in the left engine of his F-5. "I feathered the prop and flew on at 26,000 feet. The oil pressure started to drop off, the right engine started to smoke and then stopped dead."

McGlynn set the switches that would blow up his aircraft if it was not destroyed when it hit the ground. Both engines dead, the F-5 remained level. McGlynn released his straps and equipment, jettisoned the canopy, and tried to climb out. His dinghy caught in the cockpit. "I crawled back in and grabbed the wheel. I was turning the aircraft over on its back when I blacked out and dropped free of the plane. I was convinced that I was draped over the tail." McGlynn pulled the ripcord after telling himself this fear of all P-38 pilots was an illusion and he had truly fallen free of his plane.

High winds at altitude that day blew the pilot's chute across the city far from where his aircraft crashed. As he neared the ground, McGlynn could see two men running to keep up with him. He floated toward a high tension power line. McGlynn pulled his legs up high. "I just skimmed over the line and landed in a backyard in six inches of mud. The chute split against a fruit tree and I was not dragged." The two men arrived breathless from their chase, panting, "*Deutsch? Anglais? American?*" McGlynn replied, "American. Without another word they gathered my chute, took my Mae West and dinghy and hid them. The men pointed east, south, and west, quickly saying '*Boche, Boche, Boche.*' They indicated I should run north." The two men took McGlynn's flying suit and disappeared into an orchard.

Lt John A. McGlynn of the 13th Squadron. (John Weeks)

Thinking that running would make him more conspicuous, the American pilot walked for five or six blocks past some houses. Lieutenant McGlynn looked for a place to hide and when he found a cellar door open at one of the houses he entered and hid there while keeping a lookout for any patrols. He felt sure that the Germans must have seen the parachute. The pilot had hidden in a wine cellar with a rack and some bottles. "I took one and climbed up on the top rack. It was very dark. The wine steadied my nerves. I lay there holding the bottle like a club for anyone who might walk in. I filled my water bottle with the rest of the wine and put 200 francs into the bottle before returning it to the rack. There were no signs of a search so I left."

McGlynn walked out onto the main street. No one stopped him as he walked several miles before reaching a highway. He walked down the highway for what he thought might be four miles. People he passed stared at him but did not speak. "I decided to ask for help. I approached an antique shop and saw an elderly person alone inside. I walked in and took out my language card. I was immediately hustled into the back." Others came and McGlynn answered questions and convinced the French he was an American. They gave him civilian clothes and conversed with the help of a small dictionary.

The Frenchmen brought bicycles and took McGlynn to a house where they made arrangements for McGlynn's journey out of France. When he came to this spot in his story, McGlynn could not tell his friends the rest of his tale. The secret lines of escape must remain so and if one of his listeners had the misfortune to be captured, he might unwittingly reveal who had helped McGlynn. As was the practice, Eighth Air Force Headquarters did not allow returned pilots to fly combat sorties again for the same reasons McGlynn could not tell about his escape. They sent Lt. John McGlynn back to the States. Headquarters awarded him an Air Medal for "courage, cool judgment and skill displayed under most hazardous conditions."

Eyes of the Eighth

in the middle of the field. In good conditions the light was visible for 360 degrees. Under these conditions, he would have to be right on top of it to see it. RAF Flight Officer Gibbons manned the control tower that evening. Blyth asked for instructions and Gibbons told him he was shooting off flares. Could Blyth see them? Still letting down, Blyth finally got across to Gibbons that it was *Angels 36* on top and he didn't think the flares reached *36,000 feet*. Breaking out under the low ceiling Lieutenant Blyth could just see the field in the haze and made a safe landing. He knew that a new flare path scheduled to go into operation in March would help in similar circumstances.

This wasn't the last time John Blyth would be counting on his experience and a big dose of luck to get him through thick "soup." On another occasion, flying back to Mount Farm, radio out, in an overcast, he spotted a hole and let down through it to break out underneath a very low ceiling. Picking up a railroad he started following it south with visibility getting worse. Blyth made a turn and headed north until he spotted a green train, which meant he was over the Southern Line and south of London. All the training in the Link gave him confidence in his instrument flying but the local flights learning the country side and its particulars gave him the information he needed. Flying toward London he worried about the balloon barrages but thought he must still be far enough west. Turning again, this time west toward Oxford, he hoped to pick up a familiar landmark. Then he saw the Thames and again the railroad. Mount Farm must be just ahead. When the home base runways appeared, Blyth landed with a sigh of relief.

Cullen Leaves for Secret Mission
Eighth Air Force Headquarters needed its most experienced photo recon officer for a new and secret mission. They recalled Colonel Cullen early in February, naming 22nd Squadron's C.O., Lt. Col. George Lawson, as acting commanding officer of the 7th Group. Lawson appointed Capt. Robert R. Smith to take his place as C.O. of the 22nd.

London Blitz Encore
In a spurt of activity on 22, 23, and 24 February. the Luftwaffe reminded Londoners of the early days when, on three consecutive nights, German bombers dropped their ordnance on the city. Men from the 7th on leave in London saw up close what so many people had lived through several years before. On the first night of the raids a stray bomber dropped its bombs close enough to Mount Farm to rattle doors and windows in the barracks. There at the field, 60 miles from London, the glow of fires, bursts of Ack Ack, and distance-dulled explosions of the bombs brought the men outside to watch.

Eighth Air Force Bomber Command requested damage assessment cover of three heavily-defended targets deep in Germany. Lt. Robert W. Diderickson of the 14th Squadron flew the sortie on 25 February 1944. After several runs over each target he turned his Spitfire for home. Intercepted by enemy aircraft, he rapidly climbed, pushed his Spitfire, and ran for home, evading the fighters. His mission successfully covered the requested targets.

March 1944
Men on the Flight Line always waited for their pilots to return. They prepared the ships and knew how long their aircraft would be gone. As the time approached for the aircrafts' return, they watched the skies. When that time passed and no plane appeared, the crew chief began figuring out how much time in the air his pilot had left. On 1 March 1944, TSgt Grubb waited for Lt. Franklyn Van Wart to bring his Mark XI Spitfire home. When no call came in and no sign of Van Wart, the sergeant figured gasoline consumption and thought his pilot could stay aloft another two hours. At the end of that time and still no word, Grubb and the Flight Line knew they had an aircraft and its pilot missing. At first, they hoped he had landed away and a telephone call would relieve their minds but it never came. The Group listed Van Wart as missing in action.

Berlin
The battle for air supremacy over the Continent continued into March. German fighters ferociously attacked bomber formations causing heavy losses. The escorts took their toll of Luftwaffe fighters as the heavies went after the German aircraft industry in Operation Pointblank. Causing heavy losses to the enemy's aircraft in the air or in production was the prime objective of the operation. The more Messerschmitts and Focke-Wulfs drawn into battle, the more that could be destroyed. During "Big Week," the 19th through 25th of February, bombers attacked major German fighter production centers in such force Headquarters believed that they had struck a decisive blow. In the face of ever-increasing American escorts, the Luftwaffe began to pick and choose its opportunities and did not respond in force to every attack. Headquarters knew there was one target that would bring them up — Berlin.

Capital of Nazi Germany, Berlin had large industrial areas, rich in targets for precision bombing. A prestigious target, Public Relations considered anything to do with "Big B" a plum. The Eighth Air Force planned to strike Berlin early in March. Cold windy conditions with

January February March 1944

An F-5 buzzes the bomber boys over a snowy airfield at Attlebridge. (W. Starret)

Attlebridge

Eighth Air Force Headquarters continued attempts to improve and increase accurate assessment of its bombing results by photo reconnaissance. In preparation for the invasion of the Continent, the Eighth also prepared for operations flown from forward areas supporting ground troops. The Eighth Air Force ordered 7th Group to send a detachment to Attlebridge Airfield to set up operations under field conditions. The detachment would study the feasibility of photo recon detachments operating independently under limits of weather, over which it had no control, and marginally acceptable PR aircraft, which were being upgraded by replacements. Accordingly, 7th Group sent Flight "B" of the 22nd Squadron to Station 120, at Attlebridge in East Anglia, on 14 February 1944. The commander of the flight, Capt. Malcolm D. Hughes, led the detachment composed of three other pilots, four ground officers, and 29 enlisted men.

The previous occupant, an RAF squadron, vacated the airfield just before the 7th Group detachment arrived. Preparations continued getting the base ready for a new and permanent tenant to join major bombing operations with the Eighth. Setting up temporary headquarters, the detachment squeezed Operations, the Engineering Office, and the Intelligence briefing room into the corner of a Nissen hut. Photo Lab technicians set up an F-3 Laboratory Tent for developing and printing film brought back by the pilots, Captain Hughes, Lts. Clark Hawes, Ed Parsons, and Eugene Snyder.

The air echelon of the 466th Bomb Group flew its B-24s into Attlebridge on 21 February, one day after Lieutenant Snyder flew the first PR sortie from the base. From the very beginning, this alien little group of swift Lightnings caused heads to turn. To the envy of bomber pilots, the photo pilots continued their "grass-cutting" buzzes at Attlebridge, although over the winter-white fields the sweeping passes might better be called "snow-plowing."

In order to distinguish the regular Mount Farm flights, the Central Interpretation Unit assigned a new BB prefix to Attlebridge sortie numbers. For the time being, CIU would list 7th Group sorties AA from the main force at Mount Farm and BB from the Attlebridge detachment. Numbering began at BB1 with Snyder's mission to photograph Leeuwarden Airfield in Holland.

Captain Hughes attempted the second sortie on 22 February but the next successful ones came on the 23rd with Hawes and Parsons covering targets in Holland. Good weather over the Continent for the next two days produced many sorties both from Mount Farm and two each day from Attlebridge. Then, poor weather kept the number of their sorties to a minimum and March began with cancellation of the only two detachment sorties planned.

After three weeks at Attlebridge, the detachment returned to Mount Farm. Of the scheduled 15, six sorties were unsuccessful. One of these, Lieutenant Hawes' flight on 29 February, had to return after being intercepted near the target. Partly due to a good percentage of successful missions, the experiment exposed the weakness in the plan. Intelligence Officer Capt. James Norton noted in his report that it was, "not practical to turn out many prints from an F-3 Laboratory Tent." He also recommended that print production of mapping or strips taken at random should not be required when the tent is used under field conditions.

snow flurries caused a raid on 3 March to be aborted except for 29 B-17s and their P-38 escorts that made it to the target after the bombers failed to hear the recall. The first American bombs dropped on Berlin were scattered and did not impress the Germans but they did warn them. The Americans would be back.

Spitfires allowed 14th Squadron pilots to fly longer missions, and missions deeper into Germany. One major target remained primary in everyone's mind, Berlin. When the big raid came, Headquarters would want damage assessment photos. Group Operations considered only 14th Squadron Spitfires capable of the range needed. The Germans usually targeted lone photo recon planes and whichever pilot took the mission could expect trouble very deep inside Germany. The squadron C.O., Maj. Walter Weitner, would fly the sortie.

Poor weather canceled the next mission planned for 4 March. Headquarters scheduled another for two days later. Crew Chief TSgt Harry Novak prepared Weitner's Mark XI Spitfire 892, *High Lady*. With the plane fueled and ready to go, Camera Repair men loaded and installed the two 36" focal length cameras, Frederick M. Seese and Bernard T. Wendel installed the radio tuned and set by James W. Thompson. Each man had done his share on this most important mission. Now it was the major's turn.

While Novak prepared the Spitfire, Weitner planned his route and waited for word that the mission had begun. Over in East Anglia at their bases, 730 bombers of the 1st, 2nd, and 3rd Bomb Division took off from snow-covered fields. They circled and gathered together into protective formations before heading toward Berlin with 796 escort fighters. When the time came, Major Weitner lifted off from Mount Farm and began his mission. Climbing rapidly to gain altitude, he crossed out over the English coast. Weitner leveled off at 39,000 feet to follow the bombers to Berlin. With the huge formations ahead of him he knew there would be fighters and kept looking in all quarters. Occasionally he rolled *High Lady* up on her side to check beneath him. At one point he saw some shapes below and behind. They followed the Spitfire and Weitner thought they were getting too close. To conserve fuel, he began a gradual climb up through 40,000 feet and leveling off at 41,500. Below him, the three fighters split trying to cut him off if he ran but they began falling behind. The Spit out-distanced them and they soon faded from sight.

The bombers main target, the Erkner ball-bearing factory, was in a suburb of Berlin. Winter clouds and industrial haze partially obscured the ground. Over the city, Weitner lined his ship up and began his runs. As he neared the main target, smoke and dust clouds from the

Capt Walt Weitner caught by the flashbulbs on his return from the first assigned American photo recon mission over Berlin. The captain landed after dark and out of fuel. He is still wearing tinted glasses for protection from the afternoon sun while flying westward from Germany. (James D. Mahoney)

bombs swirled up into the sky. He took photos of everything on his list of targets hit by the bombers and any other area where the bombers left a smoky mark. Weitner knew his pictures of Erkner would not be very clear. Some flak tried to reach him but he was so high none of it caused any damage. He spent as much time over the target as possible then turned for home carefully watching his fuel supply. After crossing in over the English coast, Weitner maintained more altitude than usual hoping to glide back to Mount Farm if he miscalculated and ran out of fuel. Late afternoon light had faded by the time he landed at 1748 hours. He taxied toward his dispersal area where an anxious group of mechanics, officers, and camera men waited. *High Lady's* engine sputtered and died. Major Weitner's Spitfire rolled slowly to a stop, fuel tanks dry. Men rushed forward, flash bulbs popped catching the startled and tired pilot in the cockpit. As he climbed out everyone tried to shake his hand at once. The squadron's public relations men, SSgt Walter J. Staab, Cpl Raymond J. Korczyk, and Captain James M. Morton, also the Group Historical Officer, got busy gathering what information they could relay to the folks at home. Headquarters awarded Weitner the Silver Star for his mission.

January February March 1944

Berlin caught in the cameras of Capt Walter Weitner on 6 March 1944. Only small whispy clouds mar this late afternoon view of the city. Clouds and smoke obscure Weitner's assigned target, the Erkner Works, on photographs scheduled too soon after the attack. Points of interest include: (A) The old Reichstag on the banks of the River Spree with a curved water-filled tank barrier in front. (B) Herman Goering's Air Ministry. (C) The Brandenburg Gate straddling the grand boulevard Unter den Linden. To the right lies the open park of the Tiergarten. (D) Hitler's Chancellery. (Robert Bickett)

Eyes of the Eighth

Eighth Air Force target in Berlin burning after raid on 8 March 1944. Photographed from Lt Charles Parker's Spitfire.
(Robert Bickett)

The Photo Lab processed the film and when Intelligence men saw the photos they were disappointed just as Weitner knew they would be. Berlin was there, some parts of the central city marred only by some wispy cloud but the targets were covered by smoke and dust from the raid as well as the usual industrial haze. No damage assessment could be done from these photos. The argument against photo ships following so closely after bombers made points this day. The raid was too late in the day for PR to be scheduled long enough afterward for the immediate dust and smoke to clear. A favorable wind might blow some of the obscuring smoke away from the target but neither the photo recon pilot nor photo interpreters could count on that good luck each time. Short winter days prevented many same-day covers. If Intelligence wanted proof of bombing results it would have to be patient until the camera's eye could see the target.

One way in which Intelligence could gauge an attack's possible result was through strike photos taken from the bombing aircraft. These usually showed the first explosions in the area and the bombing pattern. The resulting damage had to be evaluated from later PR coverage. At least the strike photos showed if most of the bombs fell in empty fields or other ineffective sites.

If the sole purpose of the Berlin mission had been to bring up the enemy fighters to destroy them, it succeeded, but at a terrible price. What the raid did not accomplish was the destruction of the Erkner Works. The 6 March mission to Berlin was the costliest one ever flown by the Eighth. To the shock of pilots and crews who survived this raid, another came two days later. The 7th Group assigned another PR sortie of the capital. Again a Spitfire from the 14th Squadron, flown by Lt. Charles "Chuck" Parker, followed Eighth Air Force bombers, which were making their third trip in four days to Berlin. Clear weather promised better bombing results as well as clearer photographs. Parker took his Spitfire over the German target in spite of an attempt by two enemy aircraft to intercept him on the way in. He evaded by climbing to 41,000 feet, an altitude that gave him a view of fires and columns of smoke as he approached Berlin. The pilot made two runs over the smoking Erkner factory, which had been badly hit by the bombers this time. Anti-aircraft batteries threw up about 15 bursts of accurate flak on his first run but he wasn't hit. More flak, getting closer all the time, came up when he turned for his second run. Lieutenant Parker lost altitude and changed direction to get away from the deadly puffs. Over his target, his engine began missing. In spite of this, he completed his photo runs then headed home. As Parker neared the English coast he knew he could not make it all the way to Mount Farm. He landed with empty tanks at the nearest airfield,

Bradwell Bay, a regular refueling base on the eastern coast of England. After refueling, he returned to Mount Farm. His film covered the targets under much better conditions for photography than for the pilot.

Oak Leaf Clusters

A General Order of 16 March 1944 awarded Oak Leaf Clusters to Air Medals to Captains Carl J. Chapman and Malcolm D. Hughes, Lts. Verner K. Davidson, Robert R. Nelson, Willard R. Graves, and Robert W. Diderickson for a joint mission. The same order awarded Lieutenant Diderickson a second Oak Leaf Cluster, "For meritorious achievement while on a photographic reconnaissance flight over Germany" flown on 25 February.

The Berlin Conundrum

When Lieutenant Diderickson flew his mission to Germany on 25 February 1944 in his Spitfire, one of the cities he photographed had not been assigned — Berlin. The assigned mission to Berlin had been set to follow the bombers in early March but Diderickson took photographs of the city before that date. Whether it was known to command at Mount Farm is not recorded but the photos of this mission appear in a book of photos produced by the RAF at the time and list Diderickson in a Spitfire as the pilot. There was no RAF photo pilot by that name. The award of the second Oak Leaf Cluster for that mission is an interesting clue. In the Central Interpretation Unit (C.I.U.) records this sortie is the only one marked with an asterisk. Rumors circulated about the mission but no one seems to know for sure. If they do, they are not talking. Just a little mystery from hectic days.

Air/Sea Rescue

Any pilot flying from England to the Continent had to fly a portion of his mission over water. The shortest "wet" flights crossed the Channel and, except in miserable weather when he could not see anything, a pilot saw both England and France from altitude. This gave some a sense of security. Even if he had to ditch in the Channel, help seemed much closer in this smaller patch of water. Targets in northern Germany, by contrast, quite often required long legs across parts of the North Sea, a much more menacing body of water. Cold, vast, and frequently rough, it was a particularly unwelcome place to terminate a flight. The 22nd Squadron had lost Lt. Steven Scott to those icy waters in December 1943. Pilots put their lives in the hands of many people when they took off for missions. For those over water, the RAF's Air/Sea Rescue (ASR) service watched for airmen who had to ditch in "the drink." A network of listening posts along part of England's North Sea coast could pin-point distress signals and direct help to the location. RAF Air/Sea Rescue, a well-respected group of men, located and plucked downed air crew from the water by flying boats or surface craft. A downed pilot fortunate enough to be located quickly and reached by these men was returned with amazing efficiency. No one liked to think of the alternative.

After mapping in the Le Mans area of France on 16 March 1944, Lt. Clyde T. Giles of the 13th Squadron, had only the Channel to cross on his way back to base. The sky was overcast as he flew toward Mount Farm. Suddenly, his F-5 lost an engine and became uncontrollable. As he released his canopy it caught in the slipstream and dragged his right arm back dislocating his shoulder. With one useless arm, Giles struggled to free himself and bail out. The force of the wind dragged him out of the cockpit spraining his left arm. Giles' right arm hung useless, his left one almost as bad. He managed to pull the ripcord and floated down toward the waters of the Channel, disappearing into the low overcast. The crew on an RAF Air/Sea Rescue boat saw the plane crash in the Channel off Shoreham, Sussex. Reckoning by wind direction where a parachute would take the pilot they made for the spot. Fortunately for Giles they were "on the money" and saw him float down out of the overcast. Just as he fell helplessly into the water, the boat reached his side. Giles could not grasp the line thrown to him as much as he struggled. He began to go under, unable even to inflate his Mae West much less his dinghy. One of the boat crew dove over the side and swam to help Giles. He held the pilot up until Giles could be taken on board.

They gave him medical attention on the boat and then took the lieutenant to the Royal Naval Swansborough Hospital at Lewes, Sussex, for further medical care. When well enough to travel, Giles transferred to the Churchill Hospital at Oxford. Nearer to Mount Farm, he had visi-

Still wearing his Mae West and flight gear after returning from a successful mission, Lt Clyde T. Giles talks to officers and ground crew. To his left, Capt Ray Mitchell and Lt Virgil Landwehr.

Eyes of the Eighth

tors from his squadron who heard his story and praise for the men of Air/Sea Rescue. Whether they admitted it, the word from one of their own was of great comfort to those pilots who worried about any future dips in the sea.

Down in the Suburbs

On the same day that Lieutenant Giles parachuted into the Channel, Lt. Douglas D. Burks of the 27th Squadron took off around noon to photograph a strip in the area of Rouen, France. Shortly after running into an overcast south of London, Burks lost his right engine. Unable to control his aircraft, he had to bail out. Burks knew he had flown long enough to be somewhere in the southern suburbs of London. His flight path had been across the Wimbledon area but he was not sure of his exact location as he floated down through murky skies. The thought of his aircraft crashing into a populated part of the city flashed through his mind. Below, in Norbury, Mrs. Frankie had walked out of her kitchen just a few minutes before she heard a terrible roar and crash from the back of the house. Lieutenant Burks' F-5 crashed into the gardens in the back of the houses along the avenue, its fiery remains ending up in Mrs. Frankie's kitchen. No one was injured and Lieutenant Burks floated safely to earth in a nearby street.

Colonel Hall Visits

Colonel James Hall, former CO of the 13th Squadron and the 7th Group, returned to Mount Farm on an inspection trip as Chief of Reconnaissance of the U.S. Army Air Forces on 28 March 1944. It was the anniversary of his first mission, the first PRU mission of American forces in this theater. He celebrated the event by flying an F-5 around for a little under an hour. Colonel Hall, the pilot, preferred to be in the air behind powerful engines tearing up the sky instead of behind a polished desk. During his brief stay at the base he managed a few more flights from his old station before leaving for the Mediterranean Theater.

Just before 1:00 pm on 16 March 1944, Mrs. Frankie left the kitchen of her house on Norbury Avenue in London, S.W.16. Within minutes Lt Burks' F-5 crashed into the gardens in the back of the houses along the avenue, demolishing her kitchen. Houses were damaged but no one was hurt. (Roger Freeman)

April May 1944

Chapter 8
April May 1944

Late in 1943, President Roosevelt met with Churchill and Stalin in Tehran. On his way back to Washington, he stopped to see General Eisenhower, Supreme Commander of Allied Force Headquarters (AFHQ), at an airfield in Tunis on 7 December. Roosevelt's staff placed the president in Eisenhower's staff car. The general sat down beside his commander in chief who almost casually commented, "Well, Ike, you are going to command Overlord." With these simple words Roosevelt concluded months of agonizing maneuvering between and within American and British governments to put the right man at the head of the great Allied force planned to invade Europe and defeat Nazi Germany on the Western Front.

Having gathered together the best American and British officers when he organized AFHQ in 1942 for the invasion of North Africa, Eisenhower now planned to take with him as many as he could for Overlord. Eisenhower had to assert his new influence to keep top men such as his valuable bulldog chief of staff, General Walter Bedell "Beetle" Smith. He wanted, demanded, and got Air Chief Marshall Sir Arthur Tedder as his deputy and Commander in Chief Allied Air Forces. Ike considered him, "thoroughly schooled in all phases of strategic bombing and more particularlly in the job of supporting ground armies in the field." Eisenhower took all his British officers to his new command, especially his G-2, a man he thought was the Allies best intelligence man, the tall Scot General Kenneth Strong. General Spaatz, who had come to North Africa from the Eighth Air Force, returned to England as commander of all strategic air forces in Britain. Gen. Ira Eaker left the Eighth and succeeded Tedder as C in C Mediterranean Air Command. Gen. Jimmy Doolittle took over the Eighth. As the commander of the Mediterranean Allied Photo Reconnaissance Command (MAPRC), Col. Elliott Roosevelt joined the new Overlord team with instructions from Spaatz to study existing photo and weather operations and make appropriate recommendations. Following Roosevelt's report, the Eight Air Force established the 8th Reconnaissance Wing (Provisional) on 18 February 1944 and named Col. Elliott Roosevelt its new C.O. the next day.

Among the first units assigned to the new Wing were the 7th PR Group and its various components. Originally at Cheddington, by the midddle of April the 8th Recon Wing moved to its permanent home at High Wycombe. The reorganization of the American photo reconnaissance effort began in earnest at the new Wing Headquarters.

By early April 1944, spring weather and the arrival of British Double Summer Time extended flying hours and pressed men working to keep the cameras operating and aircraft in good flying repair. Occasionally an aircraft needed a bit more maintenance than usual due to enemy action — or the action of the pilot. Capt. M.D. "Doc" Hughes, 22nd Squadron, had a reputation as a lucky if not bold flyer. Some on the station remembered his adventure with the thunderstorm back in August of 1943 when he lost the tail of his F-5. Others remembered his brazen and luckily-successful inverted pass over the base at Raton, New Mexico, in March 1943. On another occasion at Raton, Hughes entertained his fellow pilots, who interrupted their perpetual poker game to watch, by flying across the field with both props feathered. They watched in amazement as Hughes restarted one engine, then the other, and circled in for a normal landing. Having survived those adventures, the displeasure of his commanding officer, and, so far, the Luftwaffe, no one was surprised when Hughes pulled another stunt.

Buzzing anything was forbidden to most pilots. The exceptions to the rule were photo reconnaissance pilots at

Lt Malcolm "DOC" Hughes. (Riggins)

Eyes of the Eighth

Operations and Intelligence Buildings at Mount Farm with Blister Hangers in background. (John Richards)

Mount Farm. Coming back from a successful mission, they buzzed the field to alert Camera Repair men, Photo Lab, Intelligence, and anyone else interested, that they had film — "come and get it." On this particular day, 10 April, everyone went about his business as usual, some waiting out sorties. Capt. Malcolm Hughes approached the field at the end of his mission. He had film to be processed.

Inside Intelligence, people worked at their jobs, surrounded by their huge wall maps decorated with various colored pins sticking in targets to be covered, half-covered, or needing repeat cover. Plots of previous flights and loose papers lay on desks, busy people pouring over them. "Pappy" Doolittle bowed his balding head over his work at the long briefing table. Capt. Walter Hickey, Intelligence Officer of the 27th, worked on squadron sorties. Sgt Paul Webb concentrated on his project. Outside in front of the Group Operations Building, which faced the field, pilots waited for missions or just hung around enjoying a fine spring day. The 22nd Squadron C.O., Bob Smith, stood just inside the door talking to George Nesselrode, who was outside with 22nd Squadron Operations Officer, Danny Burrows. Nesselrode and Burrows knew what Hughes planned to do courtesy of "Doc's" Crew Chief. Smith did not. Hughes planned to buzz the Intelligence building, his favorite, lower than any other pilot had done before.

They waited while the F-5 approached the field. Hughes let down until his plane was just above the grass, illustrating the low-level buzzing term, "grass cutting," as he skimmed over the field toward his chosen target. Mount Farm's situation included a slight rise between the end of the runway and the main operations area. The F-5's disappearance below the crown of the field surprised even Nesselrode and Burrows. They had never realized the hump in the runway would hide a low-flying — really low-flying — plane. Suddenly the Lightning reappeared aimed directly at the two men who sprinted out of harm's way. Throwing his hat in the air, Nesselrode shouted, "My God, look at this guy." Smith looked out the open door, saw a P-38 heading straight for him and threw himself on the ground.

April May 1944

Briefing Room in Intelligence Building.

Hughes pulled back the stick a little to lift the F-5 over the Intelligence Building. With a sickening sensation the aircraft mushed slightly, catching the flat roof with the tips of one propeller, pulling it down even more. There was a terrible rattling explosion. Straight ahead lay the 381st Service Squadron's hanger.

Inside the Intelligence Office, the room fairly exploded with sound; dust went everywhere. Papers flew off tables; pins shot out of maps all over the floor. The suspended fluorescent light fixtures swung madly. Some broke loose on their chains, dangling precariously over the heads of the stunned men while pieces of the particle-board ceiling showered over everything. It was over in an instant leaving the Intelligence Room foggy with dust.

While inside all was pandemonium, outside Hughes hauled the stick back, his plane vibrating so violently he couldn't read the instruments. He feathered a prop, fortunately the correct one and barely cleared the hanger. Regaining control and enough airspeed, he began a new approach to the field.

With mixed reactions, some men rushed out to see what had happened; some raced away to locate the final resting place of the plane and its pilot, while others more fatalistic went back to doing what they were doing. "Pappy" Doolittle, a ghostly white figure shrouded in plaster dust, stumbled out the door of the Intelligence Building nursing a slightly bleeding bald spot, which some thought should have qualified him for a Purple Heart. Those looking for the plane found it, but not crumpled on the ground. Off in the distance, appearing from behind some trees in a climbing left turn heading back to the runway, the wounded F-5 limped back with one prop feathered, landed, and taxied toward a growing crowd. Nesselrode and Burrows ran over just as Hughes braked to a stop on the taxi-way right in front of Group Operations. Hughes killed the surviving engine, climbed out of the cockpit on to the wing and said to an astonished

Eyes of the Eighth

audience, "Let's see you bastards beat THAT one."

The 22nd Squadron's Engineering Officer, Capt. Bob Neault, surveyed the damage and found gashes about three feet apart in the roof. Group Commander, Lt. Col. George Lawson ordered the roof fixed as quickly as possible. When Wing found out about it, he did not want to lose a good pilot to excessive punishment, "court martial, loss of wings and other nasty punitive measures." Lawson made a good argument when Wing began making serious noises. "Why ground a talented pilot, when we need him to fight the war and not be stuck in some office back in the boondocks?" With losses running 33 per cent and pilots in short supply, his argument stood up. He grounded Hughes temporarily and fined him.

1,000th Sortie
Taking his Spitfire deep into Germany to cover targets at Brandenburg, Weisswarte, and Stendahl A/Fs, Lt. Robert Dixon flew the Group's 1,000th sortie on 11 April 1944. Another record fell the next day when Maj. Robert R. Smith, commanding officer of the 22nd Squadron, became the first pilot in the 7th Group to complete 25 sorties. He successfully flew a mission in the Pas de Calais area photographing Noball targets.

The 14th Squadron with its Spitfires and accompanying reputation for long, high flying sorties attracted pilots from other squadrons who had experience in Spitfires and wanted to fly them operationally. One of these was Lt. John Blyth of the 22nd. On 17 April he transferred to the 14th and got his wish.

Work piled up in April, more territory to cover and not enough pilots to fly the missions. After his second operational mission, it became obvious to medical personnel that one of the 13th Squadron's pilots, Lt. Peter Manassero, could not fly at high altitudes for the long hours required of ETO photo reconnaissance pilots. The

Every man on the base had a job to do supporting the goals of the Group. Two very necessary jobs were taking care of the medical and culinary needs of the men. Medic SSgt Harold Zabloski gives cook Cpl Joseph Hampton a little first aid.
(Norris Hartwell)

Group transferred Manassero to another base where he continued to fly as a test pilot. On the 17th, five new pilots, Lts. John Anderson, Charles Batson, John R. Leaser, Robert Moss, and Frank Sommerkamp transferred into the 13th. It became the job of Captains Shade and Witt to get the new pilots integrated into the 13th as quickly as possible. On 21 April, Leaser and Anderson flew their first missions. The next day Sommerkamp completed his first, followed the next day by Lieutenant Moss.

Another squadron filled pilot slots on 17 April when Lts. Alexander Kann, Jr., James B. Matthews, Irl R. Cosby, Glenn E. Miller, and James E. Wicker joined the 22nd. Including the transfer of Blyth to the 14th, the 22nd gained four pilots total.

Emerson Lost
On 21 April, Sgt Paul Hartung of the 27th's Line waited in vain for the return of his plane and pilot, Lt. Jack G. Emerson, from a mapping mission in the area of Nevers, France. Even after Hartung knew that Emerson had exhausted his fuel supply, he hoped the pilot had been able to reach another airbase. When no such word came, 7th Group listed his aircraft as missing. The loss of Emerson was a sad first for the squadron.

The Silk Riggers
Whenever a pilot went up whether on a test hop, local flight, a little "rat racing," or on an operational sortie he put his life in the hands of the men on the ground. The Line crews took pride in keeping their planes in top condition. They knew the pilots appreciated and depended on their time and effort. A well cared-for airplane with finely tuned engines gave a sense of security to men who had to fly long distances and depend on a lot of

L to R Capts L. Aubrey, and Malcolm Hughes welcome Maj Robert R. Smith after his 25th mission. Smith shakes hands with crew chief Joe Barancyk. (John Weeks)

April May 1944

Parachute riggers: L to R John Boggan, Don Buckallew of the 27th Sq, and Eugene Peters of the 381st. (Don Buckallew)

John Boggan folding one of the 27th Squadron's parachutes. (Don Buckallew)

equipment. Radios, cameras, instruments, all were important. More than any other, pilots trusted one particular piece of equipment to work every time they needed it. Whether trouble came from the enemy or something mechanical, they counted on their parachute, carefully folded in the pack hitched to its harness.

In the long room where they packed and inspected parachutes laid out on long tables, the parachute riggers practiced their art hoping it would never be needed. They arranged the shrouds carefully and traced the silk (now nylon but referred to as silk) for signs of wear. Then they folded the canopy and packed shrouds and silk into the packs making sure all the harness, catches, releases, and D-ring rip-cord were properly attached. The chutes must work perfectly if needed.

Each squadron had riggers, all working in the same area and assisting each other when necessary. The riggers of the 27th Squadron had too many occasions to prove their worth during the early months of 1944. One of them, Cpl Johnny Boggan, a man of small size and big talent as a rigger, was proud of the chutes which saved two 27th Squadron pilots in less than a month. Lt. Douglas D. Burks bailed out on 16 March. Another pilot had to hit the silk and trust one of Boggan's chutes on 6 April when Lt. Ernest E. Johnston's plane caught fire near Swindon. His Boggan-packed chute opened over his head after he pulled the ring and he landed safely without a scratch. In late January, Lt. Thomas Conners returned to base safely after he bailed out, floated to earth under one of Sgt Donald H. Buckallew's chutes, and landed in a farmer's field.

Operation Grapefruit

Developments in new weaponry for the Eighth Air Force continued throughout the war. The Eighth's job combined destroying the Luftwaffe in the air and delivering heavy explosives with accuracy to the target. They explored and tested many ways to accomplish the latter with less risk for the air crews. The Germans developed many exotic weapons, some unsuccessful, others, such as the V-weapons, dangerously so. Some developments, such as glide bombs, had mixed success. The USAAF also developed several types of glide bombs using different methods of direction but none achieved the operational success desired.

Operation Grapefruit was the code name for experiments with the GB-1, a 2,000 lb. bomb with 12 foot glider wings and a tail assembly. Armorers fitted B-17s with exterior shackles for two glide bombs, one under each wing. Flown within range of the target, the B-17 would release the bombs, which would glide in free fall, automatically stabilized to accurately hit the target. The Eighth planned a test against targets at Cologne for 26 April 1944.

Group Operations Officer, Maj. Carl Chapman, Majs. Robert Smith and Kermit Bliss, along with Lt. Hector Gonzalez, left Mount Farm on 25 April. They flew to a base in East Anglia in preparation for missions covering an experimental weapon the following day.

After supper and a short night's sleep someone awakened them a few hours after midnight for the mission briefing after which they waited for the green light to accompany units of the 41st Combat Wing, specially trained to deliver the GB-1. Finally 62 B-17s from three groups, the 303BG, 379BG, and 384BG, escorted by 43 P-47s of the 361FG, 47 P-51s of the 357FG, and the four F-5s from the 7th Group formed up and started across the Channel for their target at Cologne. Increasingly poor weather prompted a recall to the bombers and photo planes in mid-Channel canceling Eighth Air Force Mission 319, Operation Grapefruit, for that day. The fight-

Eyes of the Eighth

ers continued on and carried out sweeps attacking any target of opportunity. The F-5s returned to Mount Farm.

The Eighth attempted the operation against targets at Cologne in May. The same photo pilots did not accompany this one. Unfortunately, the stabilizers on the GB-1 glide bombs proved unable to adjust to varying high winds at altitude. Without good accuracy for operations, Headquarters abandoned the trials.

Italy-Bound
An exchange made in late April brought three pilots from the 15th Combat Mapping Squadron, 5th Photo Group of the Twelfth Air Force, stationed at Bari, Italy, to Mount Farm. Lieutenants Irons, Packer, and Bullard stayed three weeks in England flying a few sorties with the 7th to learn how the Group operated. They ferried new planes back to Italy on their return to the 15th Squadron. The 7th Group, as part of the arrangement, sent five of its pilots and planes on detached service to Bari. Capt. Harry Hughes of the 13th left on 24 April and ran a mapping strip in the Bourges area on the way down. Along with Hughes, Capt. Franklyn K. Carney and Lt. Ernest E. Johnston of the 27th Squadron; Lts. David K. Rowe and Everett A. Thies from the 22nd Squadron flew missions out of Bari with the 15th.

Captain Carney, the first of the 7th Group pilots to take a sortie out of Bari, flew the only one dispatched from the base on 29 April. The next day he took one of five sorties and had a little excitement when the Germans threw up some flak at both Linz and Omstellen, Austria. Then two ME-109s chased him but he escaped by outrunning them and diving into clouds.

Restricted
Late in April, Supreme Command arranged an operation that caught a lot of startled people in unusual places. In preparation for the invasion of Europe, Headquarters called for massive restrictions issued on short notice, which literally stopped everyone in their tracks. Orders restricted all officers and enlisted men to their bases all over the ETO. British and American military police took anyone off base into custody, including men returning to base from furloughs and passes. Two 27th Squadron men, SSgts Joseph H. Cadorette and Casimir Kostrewski of Communications, were on the last two days of a ten day furlough in Leeds. The British took them into custody. An English captain assured them, "Mind you, Sergeant, you are not under arrest," as he closed the massive steel doors and locked the seven bolts. After spending recent nights on thick downy mattresses in their holiday hotel, the night in the Leeds clink made them wish for their GI cots. Their British jailer was unmoved by their pleading.

Camera Repair Commendation
Eighth Air Force Headquarters sent a commendation for the men of the Camera Repair Department in a letter, dated 25 April 1944. The commendation recognized the fine work of the men for the assistance given to the Operational Research Section of Headquarters in connection with an investigation into the fuel consumption of heavy bombers. Camera Repair installed cameras in the cockpits of about 150 aircraft to obtain running photographic records of the engine and flight instrument readings during combat operations.

They had sufficient cameras for the job but a shortage of appropriate intervalometers almost scuttled the project. Rather than give up, 13th Squadron's SSgt James Michels suggested that satisfactory intervalometers could be improvised and made at 7th Group's Camera Repair Department. SSgts Michaels, Edward Ward, and TSgt Larry Redmond of the 14th took on the job and completed it in face of considerable difficulties. The letter of commendation stated, "The finished product, an excellent example of creative ingenuity and mechanical skill, is now being used in the investigation mentioned above."

May
The month of May 1944 began with beautiful weather. The Eighth put up everything that could fly. Bombers hit Crossbow targets in the Pas de Calais, airfields near

Jack L. Niehaus of 13th Sq Camera Repair enjoys the Spring weather sitting on the nose of an old F-5A *Huckelberry Duck*, which has been canabalized for parts. (Jack Niehaus)

108

the coast, and rail targets in France and Belgium. Whenever possible the Liberators and Fortresses reached deep into Germany. The pilots of the 7th Group flew more and more sorties. The increased demand for cover of damage assessment, flying bomb sites, marshaling yards, airfields, and secret preparations for the invasion taxed the various sections of the Group. Line crews worked overtime to keep planes in the air. Pilots often flew two sorties a day. Camera Repair serviced the cameras while the Photo Lab turned out record numbers of prints.

A new but experienced pilot, Lt. Fred Brink, transferred to the 13th Squadron on 3 May. The lieutenant had flown in the Mediterranean Theater in combat where he had injured his neck and back in a bail-out from a P-38. Now recovered, he wasted no time and flew his first mission two days later when he covered targets in the Poix-Amiens area of France.

Bari

In Bari, Italy, the 7th Group pilots continued to fly sorties with the 15th Mapping Squadron. One of the reasons for the exchange, supposedly better weather in the Mediterranean, had not materialized. The location of Bari on the upper part of the heel of Italy gave the pilots from the Group a very different type of terrain under their wings. To the east, on the way to many of the targets, lay, first, the wide Adriatic Sea. Once across the water and the jagged coast of Yugoslavia, the land rose ruggedly with ridge after ridge of hills and mountains, much of which was remote and uninhabited. Beyond Yugoslavia, the great Danube River bent and twisted on its route to the Black Sea. On a nice day, except for the violent reaction of the present German occupants of France, Belgium, Holland, and Luxembourg, flights over the green and cultivated countryside of northern Europe were quite benign. Most of this territory looked less hospitable even without the ack-ack and Luftwaffe.

Lieutenant Rowe flew his F-5 across the Adriatic toward Yugoslavia to cover rail targets on 2 May. At Bergane he photographed a train in the marshaling yards, covered other yards at Paracin before crossing the Balkan Mountains. Ahead lay the Danube and the broad fertile uplands of the Transylvanian Alps. After crossing the Danube, Rowe made his runs over the Pitesti area on the southern slopes of the mountains. Heavy cloud, not unlike that in more familiar skies, prevented cover of his remaining targets and he returned to Bari.

Overcast skies blotted out most of the Austrian areas Captain Hughes had on his target list on 3 May. He found one small hole in the cloud layer and photographed a spot on the Danube River. A detail overlooked by the planners seemed to be that bases may have been in the Mediterranean but targets were still on the Continent. So far things were not all that different in Italy — clouds, flak, and the Luftwaffe.

The next day, Lieutenant Thies covered a few targets near Budapest, Hungary, but trouble with his cameras prevented completion of the mission. Lt. David Rowe took off before seven in the morning of 5 May and flew to Yugoslavia again to cover Kotor Port on the Adriatic, a possible storage dump in the Visegrade area near Sarajevo, and more rail targets. He managed to cover ten marshaling yards before heavy cloud cut short his mission.

Markings on Intelligence's map of Ploesti, Romania, Lieutenant Johnston's target on 6 May, indicated heavy flak concentrations. From the beginning of his approach and throughout his photo run over the Ploesti marshaling yard, flak burst all around him. The batteries continued to reach for him until he cleared the city area. After camera failure on his last mission, Lt. Everett Thies flew a successful weather mission to the Belgrade, Yugoslavia, area on the eighth. In all, the pilots from Mount Farm spent three weeks with the 15th Squadron and managed to get in a little recreation at the seaside.

Lieutenant Rowe's last mission from Bari covered ammunition dumps and marshalling yards in the Po River Valley of northern Italy on 13 May. The flight north up the Adriatic gave Rowe a view on his left of the Appenine Mountains running the length of Italy. He covered targets in the Venice area then flew along the Po Valley over Padua, Verona, Milan, and Bergamo at the foot of the Alps.

Giles Pays a Visit

A 6 May celebration on the station at the opening of a new game room coincided with a visit to the base by Lt. Clyde Giles. Although the doctors had his arm, shoulder, and side encased in a plaster cast, Giles was in good spirits and looked forward to going home to recover from his injuries.

New Group C.O.

The Ninth Air Force continued to drain men from the 7th Group. Wing Commander, Col. Elliot Roosevelt, transferred 7th Group's C.O. to Ninth Air Force Headquarters A-3 (Operations) Section as a specialist on Photo Reconnaissance on 5 May 1944. Lt. Col. George Lawson, had commanded the Group since Colonel Cullen's departure in February. The native of Huntsville, Alabama, rose from a second lieutenant to lieutenant colonel in just three years. On 7 May, his replacement, Maj. Norris Hartwell, transferred from Wing and took command of the Group.

Eyes of the Eighth

Delicate camera equipment suffered from the low temperatures of high altitude and the shaking from violent maneuvers pilots made escaping flak and fighters. The men of Camera Repair kept cameras clean, repaired, and ready. Sgt David Vagt works on the lens mount for the Fairchild K-17 aerial camera on the work bench. (Norris Hartwell)

Proko and Leaser Lost

After Capt. Walter Tooke returned to the United States to Instructor duty at Will Rogers Field, Oklahoma City, on 14 March 1944, Lt. Bernie Proko filled his place in the 13th Squadron's T/O. The replacement pilot flew several successful missions before taking a sortie on 8 May to cover targets in the Lens-Rheas area in France. When he did not return the Group added another pilot to the growing list of missing in action and waited for some further word.

That same day, Lt. John R. Leaser, also a 13th Squadron pilot, had targets in the area of Lyon, France. Leaser's career with the 7th Group had been rather exciting. He transferred in on 13 April and flew his first mission on the 21st. He flew two more uneventful sorties, but on his fourth, as he was taking off, both engines cut out. He swooped across the field barely missing the Officer's Mess building and side-slipped his plane into a field for a crash landing. Unhurt in the impact, he got out onto the wing and jumped off just as the F-5 burst into flames. Surviving that incident, he completed two more successful sorties. On his mission to Lyon, Leaser's luck ran out and he did not return. Two losses in one day stunned the 13th Squadron who added Leaser to the list of the missing.

As usual, Spring weather in England could go from beautiful to awful in hours. On the good days the photo pilots could get out and complete jobs as long as their target areas had decent weather. Clouds were the enemy of good photography and many planes leaving Mount Farm with propects for clear skies on the Continent often returned with photos of alternate targets or unused film in the magazines. One day on which all pilots sent out by the Group found good conditions over their targets came on 9 May. From this day's coverage the lab turned out 45,000 prints. Everyone worked to get the job done. Pilots went to Leipzig, Berlin, Brunswick, Kassel, all places not known for their hospitality. Happily, after the losses of the previous day, the pilots returned safely. The Group continued trying to keep squadrons' pilot rosters filled. Accordingly, Group transferred a 27th Squadron pilot, Lt. Adam P. Tymowicz to fill one of the vacant spaces in the 13th's pilot roster.

The first two weeks of May had the longest and best operational weather to date in 1944. In the 27th Squadron, Captain Hayslip and MSgt Roy Chapman put in overtime; the Lab worked 24 hours a day turning out prints. Captain Cassaday, Operations Officer, sent his pilots out filling requests for cover. On the 15th, the weather changed.

The next day Supreme Command ordered another 24-hour restriction all over England. Good practice for the big day, D-day, but awkward for those on passes. As each day passed, scuttlebutt increased. After three days the weather began to change for the better in areas over France. Both the RAF and USAAF photo recon flew sorties over the beaches chosen for the invasion keeping track of the obstacles being constructed in the sand, in the water, and behind the beaches. German workers filled fields that could be used for glider landings with antiglider stakes, jokingly called Rommel's Asparagus. All

Photos taken of French beach by low flying PR plane reveals obstacles developed by the Germans to defend the coast of occupied Europe.

April May 1944

Men from Camera Repair remove film magazines from an F-5 just returned with photos. They will rush the film to the Photo Lab for processing. (Norris Hartwell)

of this activity was filmed, filed, and analyzed.

The Supreme Command made certain that PR aircraft appeared almost twice as much over areas not in plans for Neptune, the cover name for the amphibious assault. Under the code name Fortitude, many deceptions kept the Germans guessing. Part of this deception included actions and information to convince Hitler that the invasion would come through the Pas de Calais. Heavy photo cover of suspected V-weapon sites in the area helped promote the Pas de Calais conclusion.

Photo reconnaissance continued to watch over the areas outside the invasion site proper, where the Germans stationed their reserves. Intelligence scoured the photo cover for any indication that the reserves might be moving toward Normandy. Allied Intelligence had important information in this area; the corroborating evidence from the Ultra decrypts to indicate any movements of German troops toward the invasion beaches.

Eighth Air Force bombers pounded French airfields and rail facilities instead of their usual industrial targets. When General Eisenhower, the Supreme Commander, acquired temporary command of both the RAF's and the Eighth's bombers to concentrate on tactical targets in preparation for and during the invasion, the air commanders argued vigorously against their loss of control. The British, determined to bomb Germany's industrial areas at night and the Americans, just as determined that oil was the Achilles heel of Germany, wanted to expend all their energy on their priority targets. Giving up control of their forces did not sit well with either Air Marshal "Bomber" Harris or General "Tooey" Spaatz.

The ominous progress in the flying bomb sites in the Pas de Calais worried everyone aware of the implications. There were too many targets for the available forces. After much argument, Supreme Command made some concessions allowing the bombers to strike their preferred targets when weather prevented them from bombing those chosen by Supreme Command.

Major Changes of Command

The 7th Group made major changes in its command on 19 May 1944 when it changed all the squadron commanders to improve operational performance. Maj. Robert R. Smith of the 22nd took over the 13th Squadron replacing Maj. Ray C. Mitchell who assumed command of the 27th. Maj. Walter Weitner of the 14th replaced Major Smith at the 22nd. Major Haugen moved to the 14th. Attendant transfers of various officers by the new commanders kept clerks busy until the new C.O.s had sorted out their new commands.

SSgt Thomas Roos, one of the radio men who kept in touch with pilots from the Group. (Norris Hartwell)

Sgt Almon Maus smokes his pipe and watches SSgt Clark Vincent tackle the reams of paperwork clerks have to cope with in the Group's operations. (Norris Hartwell)

Eyes of the Eighth

Lt Eugene Snyder in the cockpit of an F-5. Snyder suffered back and facial injuries in a crash on 19 April 1944 when his right engine caught fire on take-off. He feathered the prop and called the tower for an emergency landing. His left engine cut out and Snyder tried to stretch his glide to base but crashed one mile north. (L. Exner)

More pilot changes occurrred during May in the 22nd Squadron with the transfer of Lt. Robert E. McManus from the 27th. The squadron added Lts. Benton C. Grayson Jr., Donald A. Farley, and Robert L. Mitchell to its roster. One of the squadron's original pilots, Lt. Eugene P. Snyder, recovering from jaw and back injuries suffered when he cracked up an F-5, was transferred to the Detachment of Patients, 97th General Hospital, pending return to the States. The 22nd Squadron lost three more pilots when Capt. Daniel Burrows returned to the States for 30 days rest and recuperation. Transfers moved Lt. Richard M. Hairston to the 20th Fighter Group and Lt. Waldo C. Bruns to the 13th Squadron.

On 22 May 1944, Capt. Walter Shade, Operations Officer, and Lt. Hector Gonzalez, Commander of "D" Flight, both from the 13th, left for the States on indefinite leave of absence. Two new replacement pilots arrived on the 24th, Lts. Glen E. Wiebe and Robert W. Windsor. Windsor transferred almost immediately into the 22nd Squadron as a replacement for Bruns.

Hasselt 23 May Raid

The Eighth Air Force target for 23 May 1944 was a vital railroad bridge at Hasselt over the Albert Canal in Belgium. A force of 89 P-51s from the 359th and 361st Fighter Groups flew the mission with 75 bombing, the first use of P-51s as fighter bombers. The remaining 14 acted as escort. Lt. Robert C. Floyd of the 27th Squadron accompanied the Mustangs to photograph the action. Terrific ground fire against the attacking planes claimed one fighter from the 361st FG. Floyd remained over target during the entire bomb run to film the test

On 22 May 1944, VIII Fighter Command dispatched 130 P-47 fighter-bombers from the 56FG, 78FG, 353FG, and 356FG against rail bridges at Hasselt and Liege. Two 7th Group pilots, Capts Carl Chapman and Charles Cassaday, covered the attacks at Hasselt. Cassaday took this photo of near-misses by the P-47s. (J. Byers)

112

April May 1944

Two 7th Group pilots, Capt Kermit Bliss and Lt Robert Floyd, covered the fighter bomber attacks against the Hasselt Rail Bridge on 23 May 1944. 103 P-51s attacked and destroyed the bridge in the first P-51 fighter-bomber attack. Lt Floyd's cameras caught these near misses. (John Ross)

One of the men of the 381st Service Squadron uses a powerful press to repair an aircraft motor part. Sgt Richard Adams' previous job was that of English professor at the University of Kentucky. (Norris Hartwell)

bombing. The bridge was destroyed.

During the last part of May the weather cleared again for increased activity. On 24 May Captain Cassaday flew the longest sortie to date, covering targets on the Baltic coast at Lubeck and Stettin, Germany. On the 30th of the month he flew to Poznan in eastern Germany. The 7th Group's planes were really reaching out. With the very good weather the volume of activity increased to a fever pitch.

New Leading Edge Wing Tanks

The 27th Squadron finished off the month with a huge mapping project on 31 May. Two separate teams of four F-5s each covered Berlin. Captains Cassaday and McBee, along with Lieutenants Brewster and Floyd, flew their mission early in the day and encountered heavy flak but returned without any major damage. In the late afternoon, the second group of Captains Childress and Campbell with Lieutenants Cameron and Alley also mapped Berlin. Near Luneburg, they saw a large force of enemy fighters, which they estimated at 50. In their debriefing, they told Intelligence the fighters were in two sections, 20 above and 30 below the PR flight's altitude. Fortunately, the fighters did not intercept the F-5s. New leading edge wing tanks made all this long range work by the F-5s possible.

113

Repairing aircraft engines was the usual job of SSgt Harold Davidson of the 381st Service Squadron. This one is from a crippled B-17 that landed at Mount Farm. (Norris Hartwell)

The early aircraft flown by the Group had very limited range as well as poor performance at high altitudes. The F-5A had intercoolers in the leading edge of its wings. These proved troublesome and adjustments never solved the problems satisfactorily. Parts for the early planes were almost nonexistant and replacements slow in coming. Newer model aircraft began arriving in the winter of 1943. In December, the Group received ten F-5Bs, a photographic production model of the P-38J-5. Unfortunately this aircraft and the F-5C, a converted and modified version of the same P-38J, suffered the same engine problems endemic in the early aircraft. The new F-5s had more powerful Allisons and the increased allowable speed in the super-chargers made them less likely to fail under strain. Allison recommended certain limits, red-lining the top RPMs pilots should use, to prevent damage to engines and super-chargers. The red-lined limit might work very well in casual flight but pilots with Messerschmitts and Focke-Wulfs on their tails did not consider the limits reasonable. They welcomed the extra 3,000 RPMs in the newer models.

Enlarged intercoolers under the engines helped solve the engine cooling problems. New leading edge fuel tanks, designed to extend the range of the P-38 fighter, had not been installed in the Group's new aircraft at the factory. Modifications had to be made at the overseas Lockheed facility at Langford Lodge in Northern Ireland when tanks became available. Colonel Cullen, while commander of the 7th Group, tried to get these tanks installed in all the F-5B and C models. During February and March many planes received the new tanks in Ireland. The shortage of operational PR planes at Mount Farm reached a critical stage by March 1944, partially due to heavy losses. Unable to upgrade all its aircraft in Ireland the Group had two refitted on the station by the 381st Service Squadron who transferred the leading edge wing tanks from two fighter P-38Js. Colonel Cullen's tenacity speaking up for fellow PR pilots and continued attempts to get his group equipped with the new tanks paid off, even after he left on his special mission. In the past, fighter aircraft held the highest priority for replacement but now the Group had a higher one for available new tanks.

Russian Interlude

Events in Soviet Russia during the latter part of May began to explain the sudden disappearance of the 7th Group's previous commanding officer, Col. Paul Cullen, and a number of the men from different departments and squadrons. Like all large busy organizations, decisions from the top affected the men below, most often without their knowledge of the background and reasoning. Unless immediate decisions put men "in harm's way," soldiers might not look too deeply into the background. That is not to say that men did not have opinions occasionally about the sanity of the high command's reasoning. Few considered such things and even fewer could have known the convoluted reasons for this particular operation.

The combined British and American air campaign against German industry drove factories farther north and eastward to escape the bombers. Some built underground but others remained vulnerable to air attack from above. Reaching them and dropping tonnage was only part of the mission; returning home — refueling and returning home — was the problem. In Washington, senior air officers thought that the ideal solution lay in a Lend-Lease arrangement with the Russians, similar to the one with the British. Airfields in Soviet Russia could be used to refuel bombers that would return to their English bases in a shuttle mission hitting targets on the return leg as well. The United States already had Lend-Lease arrangements with the Soviets, sending them tons of material and equipment. Part of the exchange could be the air bases. A logical solution, if dealing with a logical government.

Experience in the past should have warned Washington. The Soviets always wanted — demanded more. They accepted any offer of bombers but always refused to have foreign troops on their soil. Part of their opposition was political as was part of the American reason for being there. In October 1943, the American government asked the Soviets to loan them six bases in Russia and allow at least 2,000 air and ground crews to man them in support of Operation Pointblank. The United States Ambassador to the USSR, W. Averell Harriman, knew the Russians and how difficult, if not paranoid, their totalitarian government was about everything. With Maj. Gen. John R. Deane, the new head of the U.S. Military

April May 1944

Mission to Moscow, Harriman tried to work out an arrangement for the bases. Stalin had agreed "in principle" in the fall of the previous year but "in principle" to the Soviets meant stalling, not planning. President Roosevelt met with Stalin at the Tehran Conference, late November 1943, and personally requested the bases, again getting an agreement "in principle." In February 1944, a delegation including the president's son, Col. Elliott Roosevelt, met in the Kremlin to discuss details setting up Russian bases for American shuttle bombers and photo reconnaissance planes. "In principle" began to turn into real agreement.

General "Hap" Arnold sent his most experienced photo recon man, Col. Paul Cullen, as part of a three-man team to settle details of the shuttle plans. Any American entering Soviet territory must have a scheduled and specific place to stop, a visa, and after arrival, an identity card. Most Americans entered in groups under a group visa but PR pilots flew in alone. Colonel Cullen's primary concern was the safety of his PR pilots. Even with their consent and permission, the Russians must understand and recognize these lone aircraft crossing in and out of their territory. With ominous and prophetic words, General Deane was quoted as saying, "I would much prefer to risk my chance of survival on a landing in an African jungle than on a landing in Russia without proper documents."

US Naval Attaché Capt Frank maneuvers Jeep through downtown Murmansk in April 1944. (R. Brown)

General Spaatz sent Maj. Gen. Robert L. Walsh to head the Air Division of the U.S. Military Mission in Moscow and named Col. Paul Cullen, Deputy Commander of Operations. Timing was critical. General Spaatz needed supplies for the shuttle bases to be in Russia as soon as possible. Runways needed lengthening, quarters set up, communications agreed to, tons of supplies packed and shipped. The pace was furious planning logistics to begin operations before the invasion. Not without amusement, the Russian shuttle mission was known as Operation Frantic.

Possible means and time tables for shipping supplies to Russia gave General Spaatz little leeway. In fact, he decided to send supplies before the Russians' official final approval. He chose the fastest and most dangerous way, the convoy route from England to Murmansk through the gauntlet of U-boats, acknowledging a possible loss of 50%. He could send five ships with the next convoy leaving in March to arrive in early April.

Earlier, in February, TSgt Richard Brown had just returned from leave with friends in Scotland. Back in the photo lab at Mount Farm he and the lab technicians put in 12-hour shifts, seven days a week, working in a special reproduction laboratory processing all of the film of coastal areas from Norway to Spain. The film came from both RAF and U.S. PR missions. Due to the massive number of duplicate prints required, they used British equipment which could handle the odd-sized RAF film and worked much faster than American multi-processors. Brown had spent six weeks at Farnborough and knew the Williamson film processor well. In the midst of a shift, he got a call to report immediately to Station Headquarters.

Brown went directly to Headquarters in dirty fatigues, a day and a half growth of beard, and smelling of

Photo taken onboard the Liberty Ship Edward B. Alexander on the way to Murmansk. Developed and contact print made in small lab built in Navy Signalmen's quarters. (R. Brown)

115

Eyes of the Eighth

hypo. A panel of officers interviewed different men about an assignment that would take whoever was chosen, away for special duty. Sergeant Brown thought his appearance and his married status might go against him but the panel chose him over the others. They told Brown to report to the American Embassy in London within 24 hours.

With some hesitation about going off into the unknown overcome by youthful eagerness, TSgt Richard Brown reported to the embassy as ordered and joined five others for a mysterious journey. They had their photographs taken without insignia or rank, passports issued identifying them as airway employees and officials. Issued vehicles, tents, heavy weather clothing, and everything necessary to sustain them for 30 days in sub-zero weather, they drove to Merseyside, Liverpool, to board Liberty Ships. Brown and his companions, three officers and two tech sergeants from quartermaster units, had been charged with the security of all supplies being shipped to Murmansk, Russia.

The supplies went aboard ships in the harbor and Brown, with Lt. Sidwell Brecky, boarded the *Edward P. Alexander*, one of six ships loaded with supplies General Spaatz had to get to Russia as quickly as possible. The *Edward P. Alexander* carried 62 tons of oil, 654 tons of gasoline, 691 tons of bombs, landing mat, quartermaster supplies, and vehicles for the shuttle bases. Sergeant Brown's ship, along with the *John Davenport*, had the most volatile cargo of Spaatz's share of the convoy.

After leaving the Mersey River, the ships went northward to Oban, Scotland, to rendezvous with a convoy from the United States. This part of the trip gave Brown the opportunity to fill in as a loader on a Navy 3-inch gun when the regular crew member reported sick. Brown and some photo-bug signalmen onboard built a small lab and contact printer up in the crew's quarters, making prints of the voyage.

The convoy left the relative safety of Scotland's waters and for the next five days, the men wore life preservers 24 hours a day. On the starboard side, Brown's ship had the *USS Milwaukee*, a cruiser going under a skeleton crew to the USSR under the Lend-Lease agreement. After passing Bear Island, the veteran convoy commander decided to go farther north where the ships had to patrol only the southern flank as the northern one would be protected by ice. During the passage, in severe cold weather, the convoy came under attack by U-boats. The little group of six saw the action and heard the depth charges but the Liberty Ships of Operation Frantic got through safely. Final approval for Frantic came through from the Russians with the ships at sea. Spaatz's gamble had paid off.

The convoy split with many ships going on to Archangel. The Murmansk section arrived in the river off the port on Easter Sunday where it underwent more attacks, this time from the Luftwaffe. Brown saw bombs falling among the anchored ships, a few sustaining hits, and he thought of the relative quiet at Mount Farm. "From the bleak Russian shores covered with snow and ice, belched anti-aircraft fire the likes of which I hadn't seen even in London." After the raids, the ships had to unload with their own cargo booms, the port's antiquated equipment unequal to the task. Mostly women stevedores worked on the docks unloading on 12-hour shifts without relief. The men onboard the ships wanted to offer them hot coffee but they learned that the Russians frowned on any contact between their people and foreigners. The bosses refused to allow this simple kindness.

Ambassador Harriman and some staff from the Military Mission came up from Moscow and briefed the men on what was expected of them. They had the responsibility of this cargo from its unloading through transport to the Ukraine to set up three bases. In a month, cargo unloaded and ready for shipment south, Lieutenant Arbach and TSgt Brown went to Moscow to report to Harriman. They packed everything they might need on the three and a half day train trip. Even in so-called First Class, they could not depend on Russian amenities or food. The beauty of the countryside, much of it timbered wilderness, overcame the roughness of the travel conditions for Sergeant Brown, a native of the American Northwest.

After reporting to the ambassador, the lieutenant and Sergeant Brown boarded a rough-looking Russian-marked C-47. All the way south to the Ukraine, the pilot flew at 300 feet or less, following the contour of the ground faithfully like an aerial roller-coaster. His navigation seemed to be by road and rail. Brown saw up close the damage in the country and destroyed cities passed on the way. Upon arrival at Poltava, the main base for Operation Frantic, Brown stepped off the plane and saw a familiar face, that of a previous commanding officer. Col. Paul Cullen also recognized one of his men from the 7th Group. "Sergeant, what are you doing here?"

"Colonel, I could ask you the same thing," Brown replied. He knew now where his C.O. had gone when he so mysteriously left Mount Farm in such a hurry in February. No one had said anything then and now he knew why. The colonel's new base was here in the Ukraine in a unit called Eastern Command, USSTAF.

Another detachment of men left Mount Farm on 21 March to join their former commander in Soviet Russia. When General Spaatz chose the shorter, faster, more dangerous route for the vital supplies needed to build the bases, he decided that American personnel to man the

stations would go the longer southern route. A contingent of 13 enlisted men and three officers, highly trained technicians from the Photo Lab, Camera Repair, and Engineering Department, began a very long trip to Eastern Command at Poltava. From the 14th Squadron, Lt. Alan A. Buster of Camera Repair and Sgt William Rudnicki of Photo Lab joined other men from the 7th Group. Major Gordon E. Neilson, MSgt Charles L. Sands, TSgt William S. Litawa, and SSgt Douglas Cumbers from the 22nd Photo Lab, along with TSgts James I. Meacham and Daniel L. Noble, SSgts Samuel Burns and Robert F. Bigham also from the 22nd Squadron proceeded to Stone, England. There they gathered with men from other bases into squadrons to prepare for travel, securing rations and any others needs for their long trip. Few had any idea that their travels would resemble a journey on the "old Silk Road."

On 25 March they boarded a British liner, which one man enticingly reported, "as loaded to the gunwales with WAAFs." The ship joined a convoy to Egypt to begin the first part of the Odyssey, suffered only one sub alert and arrived at Port Said on 12 April. The next day they went to Camp Russell B. Huckstep, a GI camp serving as a transfer point between theaters of war.

Camp Huckstep proved an oasis to men straight from rationed living in England. It had theaters and a PX soda fountain serving ice cream, hamburgers, and American beer. After being restricted to base for physicals and processing, the men from the 7th Group became tourists. They took tours to the city of Cairo, the mosques, the pyramids of Giza, and the ancient Egyptian capital of Memphis before leaving Camp Huckstep on 23 April to continue the journey.

From the comforts of Huckstep it was back to reality when they boarded a filthy train for one day's ride to Haifa, Palestine. After the joys of American hamburgers and ice cream, the meal at Haifa came as a shock. One disgruntled traveler thought they might be back in British hands when he saw what he described as, "cold, rotten mutton."

On the road to Poltava the convoy crosses a pontoon bridge. (Douttiel)

Children watching the GI tourists. (Douttiel)

The vast bread-basket farmlands of the Ukraine along the railroad to Poltava. (Sam Burns)

Eyes of the Eighth

A corner of the airbase at Poltava with tents set up inside and outside ruined hangers. (Sam Burns)

Supplies stacked near the Photo Lab set-up at the base. A B-17 coming in for a landing with others in the distance. (Sam Burns)

They left Haifa in a British controlled convoy with American trucks, Indian drivers from the British Army, but American rations, welcome even if only C Rations, at noon. The American contingent's own cooks prepared hot meals at breakfast and supper. Long days on the road, starting at 0500 hours meant getting up two hours earlier. The trucks averaged 25mph and traveled most of the day stopping for water or at refueling points along the route. At night the men slept on the ground in tents in British rest camps. The convoy passed through Palestine, Trans-Jordan, Iraq, and Iran.

When they arrived in Hammondan, Iran, they stayed at Camp Park, a typical desert camp with hot days and cold nights. It was an American camp. Snow-covered mountains almost surrounded them, a beautiful sight after days in the desert. The most welcome sight of all was the mail waiting there for them. Their journey continued from this American trucking camp in GI Diesel trucks with GI drivers. Each truck carried 25 men crammed in with all their equipment and luggage. The first day on the road, 5 May 1944, they crossed into Russian-controlled territory and covered 250 miles. Until then the men had not known their destination. Now they learned their new airbase was at Poltava, in the Ukraine.

The convoy's next stop was Tabriz, Iran, 218 miles away over rough gravel roads through rugged mountains. There they unloaded the trucks and stacked their equipment. Chow lines formed and at the end hungry soldiers found fried Spam. A sudden and tremendous downpour interrupted their supper drenching men and equipment

American F-5 *Dot & Dash* is surrounded by Americans and Russians after Col Paul Cullen completed flight from Italy to Poltava on 25 May 1944. The aircraft is painted in Synthetic Haze camouflage except for the unpainted leading edge of the wings where new wing tanks were installed. Hidden by a propeller blade is a white cross on the fuselage below the data block to indicate this installation. (Roger Freeman)

before either could get shelter. The surroundings deteriorated into a sea of mud that had to be crossed after the Spam repast to reach the waiting train.

The Russian train was similar to the English ones with cars divided into compartments, four men to each. When it came time to sleep the men bedded down on straw mattresses and pillows supplied on the train. In the morning they found that all the mud tracked in the night before as well as their shoes had been washed and cleaned by the two Russian women porters in each car. On the night of 7 May the train passed through mountainous terrain and onto Russian soil.

Two days later the detachment saw the Caspian Sea from high up in ancient-looking mountains. War damage was everywhere now as they traveled through territory recently taken from the Germans. Arriving at their destination the night of 12 May 1944, they parked on a siding and watched Russian sappers sweep for mines right where they were to unload. The advance party at Poltava had set up rows of tents for sleeping quarters. May nights were still cold and even though each man had four blankets, they were not enough and the men each traded two of them to the Quartermaster for sleeping bags.

Wreckage from bombing and shelling littered the landscape; the airfield itself had been badly damaged. The Russians had recaptured the area less than five months before. Russian workers filled in wherever needed, especially lengthening the runways to take B-17s. The men learned that many of the Russians laying the steel matting shipped in through Murmansk were on the Soviet's equivalent of R and R, rest and recuperation. The Russian groups spent their days challenging each other, which could lay the most matting in a day. This was just the beginning of the Americans' education about a very different society.

An old friend, Dick Brown, greeted the detachment from Mount Farm. Originally, Sergeant Brown's orders only covered the shipment and arrival of the supplies but now he had new orders extending his stay as part of the Eastern Command. He welcomed his friends from Mount Farm and filled them in on the situation. The men learned that Colonel Cullen was also there.

Setting up a facility supporting photo reconnaissance in the midst of such destruction challenged the Americans. Some of the detritus became part of the new installation. They set up two pyramidal tents, one set inside the other, for a light-proof dark room. For print pre-washing, the men set up an old bath tub, salvaged from a wrecked building, in one corner. Water, important in many ways, was a special problem during the set-up days for the Photo Lab. They needed a lot of water for processing and a place to store it. All water had to be hauled from a nearby town in American tank trucks driven by Russian drivers. In among some wreckage, the lab men found two 300 gallon tanks, riddled with holes. Russian welders helped patch them up. The lab men and the Russian workers hoisted them 20 feet in the air and secured them on the supporting beams of a bombed-out hangar. Trucks hauled water 11 miles and pumped it into the tanks. Depending on the amount of work in the lab, they filled the tanks at least once a day.

The Photo Lab had other problems. Preparing to process film from the first photo reconnaissance missions, they discovered a generous supply of hypo for developing but absolutely no acetic acid for a stop bath. TSgt Brown commandeered all the powdered lemonade in the Mess department when the Russians refused to supply the Americans with the critical element. The Photo Lab now waited for its first major job.

On 25 May 1944, the first two pilots flew up to Poltava from Italy completing half of the first shuttle runs planned for this base. Colonel Cullen arrived within 15 minutes of Capt. Carney of the 27th Squadron. The Lab worked half the night and finished the prints from the two sorties the next morning. The 7th Photo Group detachment at Eastern Command, Poltava, was off to a good start.

Rechlin

The Germans tested new aircraft under development at several bases in Germany, often at fields next to the factories that built the planes. Photo Interpreters at Mount Farm and Benson carefully checked cover of these fields. Specialists at Medmenham took great care looking for any sign of new activity. On 31 May 1944, Lt. Charles F. Parker took off on a mission which included Rechlin, an airfield at the southern end of the lake, Muritzee. The lake, a familiar navigational marker for pilots, lay just north of Berlin. Lining up for his run over the target Parker crossed the lake and took his photos which included the Rechlin Aircraft and Engine Test Group. Experts in aircraft matters at Medmenham went over his film and found important pictures of a new Junkers JU 287, forward-swept wing jet-propelled bomber. Something new for Intelligence to watch. Rechlin was a regular target and remained so as long as the GAF operated.

Chapter 9
June 1944

Halcyon — 1 June 1944, had come. In order to set a date, D-day, for the invasion without tipping its hand, the Supreme Command used Halcyon to indicate the date on which to begin the countdown. When it sent the key word Halcyon to Washington, the Supreme Commander, General Eisenhower, added the four days, setting Halcyon plus four as D-day. The invasion of Europe would come on 5 June. This set into motion the air plan against vital tactical targets.

The Eighth Air Force bombers struck targets in the Pas de Calais to destroy Noball, V-Weapon sites and coastal defenses. The strikes figured strongly in the deception plans to encourage the Germans to expect an invasion in the Pas de Calais area. Poor weather for photo reconnaissance limited the 7th Group to two successful sorties on 1 June, Lt. Glen Wiebe's cover south of Antwerp and Lt. David Rowe's sortie over the Orlean-Fecamp area.

The next day, the 27th Squadron learned good news from its flight surgeon, Capt. "Doc" Fritchie. Lt. Jack Emerson's wife sent a letter to "Doc" relaying information she received from the War Department that her husband was a prisoner of war in Stalag Luft III at Sagan.

Poor weather still prevented most photo sorties over the Continent but the bombers continued pounding coastal defenses and other targets in the Pas de Calais. They added rail targets near Paris and airfields behind the intended invasion beaches in Normandy. In addition to deception plans, both Allied bomber commands took part in tactical attacks under the direction of the Supreme Commander, all in support of the coming invasion.

Interdiction

Everyone on base knew the long awaited invasion was imminent. Pilots flying low over the southern English countryside could see the enormous amounts of store, equipment, motor transport and armor parked under trees and camouflage in fields and along the roads and country lanes. Driving and bicycling almost anywhere in the area revealed the same extraordinary buildup. Transport aircraft crammed airfields just to the north and northwest of Mount Farm ready to take paratroops and gliders into the invasion area. The Germans were not privy to this sight. Air domination by the Allies was complete enough to allow Luftwaffe photo recon to see only what Supreme Command wanted it to see. It was obvious to the Germans that there was going to be an invasion of the Continent — and soon — but where, and when?

Allied air forces expended great effort to gain superiority over the Luftwaffe. Once achieved, Allied planners felt that with this superiority, the French coast, although heavily defended, could be breached. Supreme Command knew that the initial assault troops had to hold the highly vulnerable beachheads long enough for reinforcements, equipment, and supplies to arrive. The German commander of the defenses had the same opinion about the importance of the beaches. Field Marshal Irwin Rommel commanded Army Korps B and was in charge of the defenses of Northwestern Europe — the heralded Atlantic Wall. The "wall" was not as Rommel would have had it. Constant bickering within the German High Command, as well as a shortage of concrete for the Todt Organization's constructions, prevented him from accomplishing a solid line of imposing and impenetrable fortifications. Gaps remained in the lines. Rommel believed that if the Allied invasion forces were thrown back off the beaches before gaining a foothold they could be defeated with a terrible cost of Allied lives. His belief was the nightmare of British Prime Minister Winston Churchill, who had dreamt of beaches drenched in blood.

The German High Command, in its indecision about the landing area — indecision helped along by carefully planned deception on the part of the Allies — had spread its forces along and behind the coast. It was ready to send them quickly to defeat the main thrust. Indecision about the main thrust, also helped along by clever Allied deception, would play a big part in what was to come. The planning staff for the invasion had seen to it that even if the Germans wanted to move their units forward to the beachhead quickly, they would have trouble doing so. Interdiction was the key.

L to R: 27th Sq Capts Conley Hayslip, Photo Lab; Charles Cassaday, Operations Officer; and Intelligence Officer Walter Hickey relax during busy days before D-day.

("Doc" Fritsche)

The chosen beachhead was in Normandy. Two great rivers formed a parenthesis almost enclosing a large area behind the beachhead. The Seine River ran from the coast at Le Havre north of the invasion area, passed through Paris, curving down southward and then toward the east. The Loire River, with its estuary on the eastern French Atlantic coast at the infamous home of U-boats, St. Nazaire, traced inland in a mostly easterly direction, coming just 100 kilometers short of the Seine. Within this area was a complex system of railroads, bridges, canals, and roads, all of which German reinforcements and supplies moving to the front would need.

The 7th Photo Group had covered the area for months. The bombers of the Eighth Air Force and Bomber Command pounded rail junctions, marshaling yards, and rail maintenance facilities during May trying to interrupt transportation and overload the Germans' capacity to make repairs. The airfields the photo squadrons had so dutifully covered were bombed in an effective "postholing" technique, which filled the runways with craters. This drove the Luftwaffe units deeper into France and away from the beaches. Heavy, medium, and fighter bombers struck at the bridges along the two big rivers. By the afternoon of 30 May all the bridges over the Seine between Elboeuf, near the coast, and Paris were down.

Loire River Bridges

The Interdiction Plan called for the general disruption of communications behind the beachhead. Bombers pounded all rail and road transport now bogged down in the chaos of destroyed junctions. The purpose was to seal off the area and immobilize everything within it. Most of the Seine River bridges had been destroyed or severely damaged. Now attention focused on the Loire River bridges. Accurate photographs must be obtained showing how much damage had been sustained and whether the bridges had to be attacked again.

On the morning of 2 June, Capt. Hubert Childress of the 27th Squadron and Lt. "Chick" Batson of the 13th prepared for a mission to supply this knowledge. Batson had been with the squadron much longer than his total of sorties indicated. Until 8 May he had been too ill to fly. He had a dashing look with his thin dark mustache but as he became better known it was not the mustache that singled him out as a character but his wild and crazy adventures. Both pilots (Childress sported a mustache as well) had other dashing qualities they would need this day.

Donning their usual warm jackets and fleece-lined boots, parachutes, and other flight gear, they checked out their F-5s with the crew chiefs and took off from Mount Farm. Flying to Wormingford near Colchester, England, they landed, refueled, and briefed the pilots of a 16-plane fighter escort from the 55th Fighter Group. Taking off at 1630 hours, the two photo pilots circled over the airfield waiting for the P-38s to join them, then headed out near Beachy Head at 15,000 feet. Leveling off, the formation set course for Chateaubriant, France, about 35 miles north of the Loire River town of Nantes. As they crossed in over the French coast near Caen, Childress and Batson flew in loose formation with the fighters about 1,000 feet higher, covering both sides.

The two F-5s and their escort dropped down on the deck to approach Nantes, their first target. Childress planned to use two waterways, the Canal de Brest and the connecting river, Erdre, to skim at tree top level for their approach to the Loire River on the outskirts of Nantes. On reaching the Loire they would turn left and fly up the river. He hoped this low-level approach would minimize the amount of resistance from the Nantes/LaBele Airfield which they had to pass. Racing above the water almost even with the treetops along the Erdre River they saw no one except some startled boaters, who had been enjoying the beautiful early summer day and were now flailing about in the water near their sailboats, overturned by the propwash. By this time the warm sunny day asserted itself on the two pilots who, dressed for their usual frigid high altitude flights, began heating up inside the cockpits. It was just about to get much warmer.

Childress, with Batson just behind and their escort covering them from above, pulled up over the edge of the town to reach the Loire. At 100 feet, tracers shot past them on all sides. Light flak opened up mixing with the tracers as they crossed the Loire. Unable to drop back down to a lower altitude because of some high-tension lines and towers, they had to fly at 50 feet. Batson flew about 200 yards directly behind and the escort fanned

Group Commander Lt Col Norris Hartwell, Jr. and Capt Hubert Childress of the 27th Sq. (Norris Hartwell)

Eyes of the Eighth

Bridge over the Loire River taken by Capt Childress on 2 June 1944. Shadow of his aircraft is in the foreground. (J. Byers)

out at 2,000 feet as they left Nantes for the next target up the river. Because the F-5s had not been fitted with the as-yet-unavailable forward facing nose cameras, their camera runs were parallel to the bridges using the oblique cameras. The two PR pilots worked their way up the river flying low until near a target, popping up to orient themselves then flying across the river alongside the bridge, cameras clicking. On the camera runs or on the approach and departure, Childress and Batson came under attack from all manner of guns, heavy flak batteries, light flak, small arms and machine guns. Shells burst around them and tracers followed every move. The two pilots felt they disturbed a hornet's nest at every bridge.

Somewhere along the flight Childress felt a sudden jolt, but thought he had clipped something on the ground. Looking back, he saw frayed metal over the top of the right boom. Nothing seemed wrong with his aircraft's handling and he continued on. Racing along, just above the water the two pilots continued their high speed snake-like path past the cities of Angers and Saumur.

As it had been at Nantes, resistance was heavy at Saumur and Tours. Tours presented a particularly difficult target. There were four bridges within the city and an airfield just north of the bridges. Back and forth the planes roared at rooftop level, scattering civilians and stirring up the angry gunners of the flak batteries. Tracers were everywhere, but the Tours flak seemed directed against the fighters who quickly disappeared to wait upstream for the photo planes.

When Childress reached the escort, they informed him that his left engine was smoking. "It looked to me like a vapor coming out of the turbo and there were several jagged holes in the center of the left wing. I concluded the vapor was ethylene glycol vapor and that I had lost my coolant supply. The left coolant shutter was wide open and the coolant temperature was pegged on 150 degrees." Childress feathered the engine's prop and with an escort of four fighters started for home leaving Batson to finish the sortie. Childress landed safely at Mount Farm at 2045 hours.

"Chick" Batson continued up the river with the rest of the escort. Sweeping back and forth across the Loire,

Lt "Chick" Batson of the 13th Sq. (John Weeks)

then skimming the water up the river, Batson covered six more bridges near Blois before returning to base with his photos. The two pilots covered 26 bridges in all. (For their achievement Childress and Batson each received the Silver Star.)

On the eve of the planned invasion, Eighth Air Force bombers attacked coastal defenses in the Pas de Calais, rail bridges near Paris, and Luftwaffe airfields. The 7th Group sent out 15 sorties over France. The weather began to deteriorate and stormy weather threatened the naval and airborne assault planned for the fifth of June. After consulting the senior weather officer, the Supreme Command delayed the invasion for one day on the forecast of a small period of calmer weather early on 6 June. Tides and the moon would still be acceptable then and seas might subside enough for the massive fleet of landing craft choking harbors along the English coast.

Suddenly, the 7th Group learned that Eighth Air Force had replaced the Group's C.O., Col. Norris Hartwell. The new commanding officer, Col. Clarence Shoop, had been flying with the 55th Fighter Group while in England reviewing and making modifications to Lockheed's P-38 aircraft. A test pilot for Lockheed, Shoop was on his way back to the States when he got orders to report to Eighth Air Force Headquarters. He reported to Eighth HQ on 5 June and learned that he was to take over the 7th PR Group.

At Mount Farm, trucks delivered cans of black and white paint along with secret orders that stripes had to be painted on all operational aircraft the afternoon and night of 5 June. No aircraft painted with this recognition design could take-off until further orders came through.

Capt Hubert Childress with F-5 damaged over Loire River on 2 June 1944. (Claude Murray)

This had to be a sign of imminent activity across the Channel. Line crews began painting the stripes on the F-5s, Spitfires, and any other aircraft possibly needed for operations.

Colonel Shoop drove from Headquarters to Mount Farm to take command of his unit. When he arrived at the field he saw a strange sight of men at one end of the field painting black and white stripes on the aircraft. Lt. Col. Norris Hartwell, now the Deputy Group Commander, told his new C.O. that the stripes were being put on all aircraft 24 hours before D-day. The orders had just been received. Shoop and Hartwell talked to Chapman, the Group Operations Officer, and alerted the Flight Line to get two F-5s ready for 0600 the next morning.

Late that evening, the new 7th Group C.O. settled in at his quarters and met some of the men he would

Col Clarence Shoop, new C.O. of 7th Group. (John Weeks)

Eyes of the Eighth

Mark XI Spitfire PL 767 of the 14th Sq painted with the invasion stripes. (J. Robison)

work with. Earlier, before dawn that same day, on the English coast at Southwick House overlooking Portsmouth, another group of men met. General Eisenhower and his SHAEF commanders had a decision to make. Rain beat against the windows and wind swirled around the grand house on the cliff. In the harbors below and all along the coast, tens of thousands of men suffered on pitching boats, trapped there for an extra day after the delay. Eisenhower's weather officer, Stagg, said there was a window and the seas would slacken for 24 hours. If the invasion did not go off that night, Stagg forecast at least two weeks before ideal conditions could occur again. The Supreme Commander's staff stated their opinions. "Ike" made the decision, "O.K., let's go." As the last syllable left his lips, his commanders cheered and rushed out to begin the greatest amphibious assault in history.

That night, glider infantry and paratroops waited on airfields to load onto their aircraft for landings in France at midnight. In the early hours after midnight, teletype machines began to chatter all over England sending yard after yard of type-filled paper into the hands of communications men. At Mount Farm, Warren Heraty and Julius Kindervater watched the orders spill out. They folded the long ribbons of paper over and over, stacking them to take to the C.O. over at the farm house. As orders for all aircraft activity for the day poured out of the machines on 6 June 1944, the communications men knew the invasion had begun.

Colonel Shoop had a bang-up beginning at his new command. He got up at 0445, had some coffee, and went straight over to Operations. As word spread that this was the big day, the base erupted in activity. Briefings for missions and planning at Operations and Intelligence set the tone for the day. Everyone who could get in the air wanted a sortie over the beaches. On the flight lines and in the dispersal areas, the strangely striped aircraft waited.

New to photo recon, Shoop had to be briefed on the operation of the cameras. He and Hartwell took off at 0600 as planned. Spotting a P-38 Fighter Group heading for the Channel, they tagged along. As soon as they crossed out over the coast they could see the Channel full of ships. Hartwell thought, "They were so close you could have walked almost from shore to shore on their decks." When they got to mid-Channel the fighters began circling a convoy and Shoop and Hartwell broke off to go over the beaches. Below them there were ships burning and geysers of water around from enemy shelling.

They could see that the overcast was too low for photos from high altitude. Flying back out over the Channel, the pilots dropped their two black and white striped F-5s down to 1,000 feet and flew in under the cloud layer where they ran into light rain at the

Camera Repair and Flight Crew prepare an F-5 for a mission. Black and white stripes seen over the right engine are identification marks for the invasion. (Norris Hartwell)

June 1944

Col Hartwell's F-5 on the right in the murky weather of D-day as he and Col Shoop, who took the photo, cover targets behind the invasion beachhead. (P.F. Keen)

coast near Le Havre. Their flight plan called for each pilot to fly along just behind the beachhead in several different areas. They flew down the coast to the point where they planned to turn inland. The weather worsened as they flew over their targets. Shoop thought that the ceiling seemed to be getting lower and the light was not good for pictures. They turned back to the coast. "Suddenly little red golf balls started floating by my wings — light caliber flak. I yelled at Hartwell and he turned one way and I turned the other. The air was pretty full of lead for a few seconds. I snapped a few pictures and discovered later that we had flown over Caen/Carpiquet Airport. I had turned right, which took me directly over the city of Caen and more flak came up but I got a few pictures of it while I was dodging."

They expected heavy flak but what there was according to Hartwell, "Was enthusiastic but wild. We had a grandstand seat for the show." Hartwell went down near Cherbourg then returned to the beaches. "There were Allied fighters everywhere, all sporting the black and white invasion stripes, but no enemy fighters." Hartwell could see troops moving inland and concentrations of tanks and vehicles in assembly areas. Behind the beaches, fires burned in the villages.

Rejoining their formation, they swept low along the beaches under the low clouds until Hartwell and Shoop found themselves too close to crossfire from the ships and shore batteries and got out of there in a hurry. They had exhausted their film anyway. As they turned back toward England they could see thousands of boats of all sizes scurrying back and forth with large naval ships hammering away at the shore defenses. They landed at

Col John Hoover, Eighth Reconnaissance Wing (Prov). (John Weeks)

Eyes of the Eighth

Large landing craft on the beaches of Normandy, 6 June 1944. (P.F. Keen)

Mount Farm shortly after 0900.

Camera Repair unloaded the magazines and the Photo Lab rushed to see what they had. The tree top flights over French villages produced pictures where you could read signs on buildings. The camera caught people startled by the low flying planes in various poses of as-tonishment. Hartwell's film magazines included pictures of an old lady kneeling in prayer in her garden.

Two Operation officers, the 7th's Maj. Carl Chapman and Wing's Lt. Col. John Hoover, took later flights over the beaches, bringing back more pictures of the invasion and in some areas, photos showing lines of vehicles mov-

June 1944

ing inland off the beachheads. (The Eighth Air Force awarded its new group commander, Lt. Col Clarence Shoop, the Distinguished Flying Cross.)

Riding the Rails

Rail traffic on all the lines within the interdiction area was important. The Interpretation section at RAF Benson set up a special railroad intelligence and interpretation unit to read only rail photos. This unit, which included a member of the 22nd Squadron, Sgt Paul Webb, viewed sortie after sortie flown over the extensive French rail system in and around Normandy. Two 22nd Squadron pilots, Lts. Irl Cosby and James Wicker, took the rail line between Chartres and Chateaudun. Flying at 2,000 feet, just under the cloud cover, they followed the tracks taking pictures of any activity on the line. Four other sorties tried to cover the same supply route without success earlier in the morning. Wicker, flying as Cosby's wing man, followed as close as he dared in the overcast between the coast of France and their target. Their briefing prepared them for the poor weather on the way but the weather officer thought they had a good chance finding just enough room below the overcast over the rail lines. The two pilots let down through the cloud. When they came out at 2,200 feet, they found that they and the weather officer were right on target. Off in the distance was the railroad.

From Chartres they followed the tracks toward Chateaudun where the rail lines ran through a large airfield. As they roared down the tracks across the field, cameras clicking, light flak began exploding around them. Cosby, leading the way, looked at his wing man just in time to see Wicker's *Bluebell 2* disappear in a burst of black smoke. Racing away from the field, Lieutenant Cosby climbed back up into the relative safety of the overcast and set course for Mount Farm. In spite of desperately wanting to know what had happened to his wing man, Cosby had pictures to deliver to Intelligence and another trip below would expose him to the same deadly fire. Reluctantly, he flew back across the Channel. His report of the incident and the failure of Lieutenant Wicker to return added another name to the Missing in Action list.

On D-day, the 7th Group scheduled 36 sorties. One pilot, Lieutenant Wicker, failed to return. Lt. John Blyth was recalled. Five pilots found too much cloud over their targets and Operations canceled three missions before they took-off. The 29 successful sorties flown that day were the result of hard-working men from all departments on the base.

Beachhead D Plus One

Most of the pilots wanted to fly over the invasion beaches to see the show but other targets had to be covered. Many pilots flew sorties along transportation routes, as Cosby and Wicker had, all a part of the interdiction intelligence needed to keep Supreme Command posted on German troop movements and reinforcements. General Eisenhower and his officers needed to know when and where the powerful panzer units were at all times. They could play havoc with troops on the tenuous beachheads.

Major Hartwell got an opportunity to see the beaches again on a flight after D-day. "There were still a lot of ships out in the bay unloading men and equipment. They had a terrific balloon barrage at various places. I was flying low and had to watch out pretty closely so as not to run into it. I saw one train burning from caboose to engine." The smoke from the fires began to drift across the battle. Hartwell flew over the enemy airfield at Caen/Carpiquet, a frequent target of the photo cameras. The anti-aircraft guns opened up on him. "I gave them a couple of bursts with my camera and went on my way. At several points I saw lots of red, green, and orange parachutes. I saw more gliders, too, than on the first day." Hartwell returned to Mount Farm with pictures of Lisieux, a beautiful French town burdened with the misfortune of tactical rail targets. Directives from Allied Headquarters tried to prevent too much damage to the non-military targets. The sortie covered another ancient and historically important city, Bayeaux, also burdened with tactical road junctions. The terrible destructive price of liberation had come to the Normandy countryside.

The invasion encompassed more than the immediate area around the beachheads and French countryside. Main supply routes and sources had to be watched to note any movement toward Normandy. Antwerp, Belgium, a thriving, efficient port, one of the largest in northwestern Europe, lay 55 miles up the Scheldt Estuary. When Belgium surrendered in 1940, the Germans took this major port intact. From here they supplied their forces in Belgium, Holland, and Northern France. Heavily defended with smoke screens, anti-aircraft batteries, and fighters stationed nearby, Antwerp's wharves, slips, and dry docks also serviced German naval and merchant ships.

Really Low Flying

Continued coverage of the rail lines and traffic all along the Western Front was the order of the day. On the second day of the invasion, two 13th Squadron pilots went to the Antwerp area covering possible troop train movements. Low-level cloud cover demanded even lower level flying to get the pictures and another hedge-hopping mission began for Lieutenant Batson, accompanied by Lt. Robert E. Moss. Going in at tree-top altitude they swept along the railways getting their photos. German light flak

Wicker

His F-5 roared across the Chateaudun Airfield, tracks of the railroad he followed, long silver blurs on the ground. His friend Irl Cosby led the way. The airfield's formidable defenses opened up and light flak burst all around. Suddenly, Lt. James Wicker and his F-5 were in a burst of smoke, rocked and shaken by direct hits.

As his leader vanished into the clouds, Jim Wicker had a problem on his hands. At less than 1,500 feet, his plane hit by flak and smoke filling the cockpit, he had no time and no choice. He bailed out, pulled the ripcord, and the big canopy of his parachute billowed out over his head in time to slow his fall. Wicker hit the ground in a hayfield. His crippled F-5 crashed on the field ahead of him. German soldiers from the airbase ran toward him. Wicker could see he had no chance to escape and afraid of being caught with a gun, the American threw his .45 sidearm away. In less than three minutes, soldiers surrounded the stunned pilot.

The Germans looked at the prize that had literally dropped into their lap and for a few minutes argued whether they had an American or an Englishman. They spoke to Wicker in German, which he did not understand, but he realized his mixture of RAF and USAAF clothing confused them. Like other pilots at Mount Farm, he sometimes wore an RAF jacket and flying suit. Many American aircrew thought the RAF clothing was warmer than their own. Wicker figured out one question relating to blood trickling from a small scratch and indicated that other than that, he was not injured.

The soldiers took him to the German police in Chateaudun, who locked him in a small closet with a tiny window high up in the wall. Left alone, Wicker tried to look out the window but it was too high. The only information he could discern from the window was whether it was day or night. Sounds from outside filtered in but otherwise he could learn nothing about his situation. That afternoon, still slightly stunned and groggy, Wicker thought to himself how strange it felt. "I was in England at 1:30 and at 3:30 I am a POW." Dozing through the remains of the long summer afternoon he awoke to hear footsteps up and down the street outside the window. Sirens blared warning of an air raid. Although the building did not come under direct attack, he could hear the "crump" of bombs in the distance. Lieutenant Wicker realized for the first time what it was like to be on the receiving end of a bomber attack.

He stayed four days in the tiny improvised prison cell, taken out only for necessary trips to the bathroom. Then guards put him in a small Volkswagen-type car and drove to an assembly point in Chartres. The Germans collected their prisoners from locations near the Normandy beaches and housed them on the fourth floor of a large building in the city. There, he became one of a large group of Allied soldiers waiting for transportation to prisoner of war camps. The other men had been captured, like himself, on D-day. Some were from the airborne forces and some from the infantry. Many were wounded. Wicker had never seen such badly wounded men before.

Allied air forces bombed objectives all through the area. While Wicker and the others waited at Chartres, low-flying medium bombers, attacked targets near their prison. From windows bigger and better situated than the one in Wicker's previous closet cell, they could see the bombers as they roared over the building. As the men on the fourth floor thrilled at the sight of, "their side getting in a lick," the mood quickly changed when they saw bomb bay doors opened and their building shook from near misses.

Four days after Wicker arrived at the collection point, the Germans took the prisoners to Paris in buses. Because Wicker was an airman, the Luftwaffe removed him from the group and sent him off separately with a guard. As a general rule, all Allied aircrew were the responsibility of the Luftwaffe not the Wehrmacht. The American lieutenant and his German guard took a train to Frankfurt and then traveled out to nearby *Auswertestelle West* interrogation center at Oberursel.

Placed in a tiny sparsely-furnished cell, Wicker began the same isolation and interrogation routine so familiar to all aircrew shuttled through the center. The Germans seemed to know almost as much about him as he did himself. Name, rank, and serial number. They had determined that by themselves. Whatever they wanted, Wicker would not give them. The routine was a prelude to his transfer to a prisoner of war camp and he just waited it out.

June 1944

Anderson's DFC

Low cloud continued to force photo pilots down to perilously low altitudes to cover their targets. On 10 June, Lt. John Anderson of the 13th Squadron flew his sortie near Breskins on the Scheldt at very low altitude in the face of intense anti-aircraft fire. With his aircraft struck by more than 100 fragments of flak, Anderson continued on in spite of losing his compass, hydraulic, and electrical systems. Like many low-level flights that often brought back more than photographs, Lieutenant Anderson collected 34 pieces of flak shrapnel. With photos of his targets his mission went on the board as successful. (Anderson received the Distinguished Flying Cross for his mission.)

Five pilots had to return to Mount farm without photos on the same day when cloud completely obscured their targets. Captain Nesselrode attempted to cover targets in Belgium although the weather was hazardous and worsening as the day went on. While trying to cover some targets Intelligence felt had to be photographed that day, Nesselrode caught heavy anti-aircraft fire. He pushed on to Antwerp to photograph the rail yards and activity which might indicate a reinforcement of the Normandy area from the north. He covered Terneuzen and Malines as well and a truck convoy on the autobahn south of Hulst. On his return he had to fly through a crossfire of flak. At Mount Farm, Intelligence confirmed that he had gotten the pictures, which it forwarded to the proper sections at Benson and Medmenham for further interpretation. (Nesselrode was awarded the Distinguished Flying Cross for his mission.)

Another sortie on the same day attempted to get tactical cover of the rail yards at Antwerp and the rail lines through Malines to north of Ghent. The pilot on this mission, Lt. Waldo Bruns of the 13th Squadron, again had to fly at extremely low altitude. As usual, the flak batteries tried to bring down another of these persistent zebra-striped Lightnings that continued storming along the railroads. Bruns maneuvered through the heavy fire and completely covered his targets in spite of the opposition. (Lieutenant Bruns received the Distinguished Flying Cross for his mission.)

Orders from Supreme Command meant sending sortie after sortie into the face of what would become infamous anti-aircraft fire after June. Continuous coverage of the supply and reinforcement lines had to be maintained. Military installations needed activity assessment. Many targets lay within a constricted area around Antwerp. Operations assigned frequent coverage in this dangerous area. They assigned targets in the area, at Capellen, to Lt. Jack Lewis Campbell of the 27th Squadron. Faced with withering ground fire on his approach to

Lt Robert E. Moss brought back twigs, bird, and copper ball from low-level sortie in France. (John Weeks)

batteries fired heavy barrages at them as they flashed by. Moss suddenly flew into a flock of birds and, with no latitude for maneuver, clipped a tree, more to the detriment of the tree than his aircraft. Moss managed to avoid more trees trying to get out of trouble but brushed the tip of a church steeple with the tail boom before getting enough altitude to fly in clear air. The F-5, a particularly sturdy aircraft, safely made it home battered but with excess baggage of Belgian twigs embedded in the wings, a bird in the radiator, and a small copper ball off the steeple top. Moss kept the copper ball as a souvenir. (Eighth Air Force Headquarters agreed with 7th Group recommendations and Lieutenant Moss received the Distinguished Flying Cross for this mission.)

On the same mission, during his entire photo run intensive ground fire followed Lieutenant Batson. With his plane full of holes and one engine knocked out, Batson returned to Mount Farm on the remaining engine, bringing with him a wild story about flying down the streets of Antwerp so low that he insisted he could see the tears in a pretty girl's eyes as he flew off. He also brought back his assigned photos. (Batson also received the Distinguished Flying Cross for his mission.)

Nelson and Cassaday Lost

Not all pilots sent on hazardous low-level missions were as fortunate as Batson and Moss. The next day, Capt. Robert P. Nelson of the 14th and Capt. Charles G. Cassaday, Operations Officer of the 27th, flew two more missions to the Antwerp area. Both pilots failed to return. Operations considered they might have been hit by the same flak that greeted every other plane in the area. The Group listed them both as missing in action then received word from Eighth Air Force Headquarters that both pilots had been confirmed killed.

Eyes of the Eighth

the target, he persisted, making three runs over the military installations before returning to base with his photographs. The developed photos proved the mission successful. (Campbell was awarded the Distinguished Flying Cross.)

Sommerkamp's Close Call
A 13th Squadron pilot, Lt. Frank Sommerkamp, set out to cover German airfields in France on 13 June. He photographed Cormeilles-en-Vexin and Beaumont-sur-Oise then began his run over Dreux. Six white-nosed FW-190s attacked him, firing 20mm cannon. Shells slammed into the aircraft and canopy, shards of Plexiglas grazed the pilot but both man and plane kept going. The Focke-Wulf pilots, determined to bring down the F-5, kept after him. Sommerkamp had other ideas and pushed everything to full power, twisted and turned through the fusillade escaping into some clouds. Momentarily hidden, the pilot dove toward the deck, leveling off at 1,000 feet. At this altitude he could not cross out over enemy batteries on the coast. When sure his six pursuers had broken off, Sommerkamp climbed to 10,000 feet. He crossed the coast and, two miles off shore, dove down to skim over the Channel headed for home.

When he landed at Mount Farm, the Flight Line marveled at his safe return when they saw the damage. The 190s shot holes in the wings and put one shell through a propeller blade. Amazingly, a 20mm shell had torn through the canopy behind the pilot's seat and smashed the radio, stopped only by the steel armor plate behind the pilot's seat. The armor did exactly what its designers planned. It saved a pilot's life.(The lieutenant was awarded the Distinguished Flying Cross for this mission as well as a Purple Heart for his wounds.)

Not every pilot had such harrowing flights. Another 13th Squadron pilot had better luck on his sortie over Cormeilles-en-Vexin on the same day. Flight Officer Ed Vassar took D/A photos of the airfield as well as Evreux/Fauville A/F. Better weather and need for other targets outside France sent six sorties into Germany but most flights covered French or Belgian targets.

The French town of Tours on the Loire River was the location of targets assigned to Lt. Adam P. Tymowicz of the 13th Squadron for a low level sortie on 13 June. From Childress' and Batson's sortie on 2 June, Operations knew that Tours had accurate and busy flak batteries especially covering the bridges assigned to Tymowicz for cover. Constricted by the city on the banks of the Loire River, his flight path would put him in range of even small-arms fire.

When Lieutenant Tymowicz failed to return from his mission the squadron listed him as missing in action. The men on the flight line and all who knew him waited as they had in the past for others. When he had not been reported safe at another field they knew eventually Headquarters would send further information and he might be a prisoner rather than dead.

First V-1
Demands for photo reconnaissance increased as the troops in the beachhead advanced inland. The 7th Group concentrated its attention toward targets in France, Belgium, and Holland. With Eighth Air Force bomb-

Col Elliott Roosevelt, C.O. of the Eighth Reconnaissance Wing (Prov), pins the DFC next to the Purple Heart on Lt Frank Sommerkamp's blouse. (John Weeks)

Capt Carl Fritsche, 27th Sq Flight Surgeon seeks camera information from Majs Lawrence McBee and Cecil T. Haugen, 14th Sq C.O. ("Doc" Fritsche)

130

June 1944

Adam Tymowicz

As soon as the F-5 got in range, light ack-ack and machine guns opened up on the F-5 and scored hits. One shell exploded in the left wheel-well knocking out the port engine, airspeed indicator, and hydraulic system. At only 800 feet altitude, Tymowicz feathered the prop on the burning engine. Trailing a long black plume of smoke with flames beginning to buckle the aircraft's skin, the lieutenant set his IFF equipment to detonate on impact. He then released the cord for the radio equipment, rolled down his right window, and jettisoned the canopy.

Tymowicz came out of the cockpit head first, thrown back by the slipstream which hurled him over the tail boom. His right leg struck something. He pulled the rip-cord, his parachute boomed open above him. Within seconds he hit the ground. A tell-tale column of smoke rose like a smoke signal from his crashed plane. Tymowicz tore off his flying suit, bundled it up under a nearby bush and took off in the opposite direction. He had to evade anyone drawn to the location by the smoke and searching for the pilot. With his severely bruised right leg he couldn't outrun the search parties but he didn't want to make it easy for them. A large barking dog quickly discovered him and gave noisy chase. Soon a civilian attracted by the dog's barking approached. Suspicious, Tymowicz hid in a wheat field before deciding he would ask for help.

The old man was friendly and kept repeating "Comrade, Comrade," gesturing for the pilot to follow him. They ran and walked several miles, the man gesturing with hand signs that they were going to a farm house. Near the house the man indicated Tymowicz should hide, which the lieutenant agreed to, while the old man went for help. After his helper disappeared Tymowicz changed his hiding place just to be safe. From his new one he could see anyone coming before thay saw him.

Tymowicz waited for what he hoped would be help. He thought the old man could be trusted but he wasn't taking any chances. At least a half an hour passed. Two men, neither of whom spoke English, arrived followed by a third who brought food, wine, and civilian clothes for the pilot. The third man spoke a little English and told the American that as soon as darkness fell they would get bicycles from the farmhouse. They would move him to another location and eventually join up with a resistance group.

They waited until dark to begin their journey. One particular man, who always accompanied Tymowicz, turned out to be a member of the resistance group. For three weeks he arranged everything. Then the organization discovered that another member was a traitor and the resistance group disbanded for security. Luckily, a second man with Tymowicz suggested that they go off on their own. He wanted to get out of German-controlled territory as much as Tymowicz to avoid labor detachment sweeps or, worse, capture and imprisonment. He said they could make their way to Allied lines using friendly locals for food, shelter, and information. The two men traveled only in the daylight to avoid breaking curfew laws. On 16 August Tymowicz and his French helper contacted an American advanced infantry outpost. After confirming his identity, Tymowicz found transport back to Mount Farm and arrived on 27 August where he told his story to eager listeners.

The day after he bailed out into France, his promotion to captain came through. Unfortunately the captain did not stay at his old base long having been assigned duty at Advanced Headquarters Ninth Air Force and then on detached service to the Office of Director of Intelligence. He was awarded a Purple Heart for the wounds he received when he bailed out on 13 June.

Eyes of the Eighth

ers restricted to tactical targets under the direction of the Supreme Command, its usual industrial and strategic targets in Germany escaped attention. Only poor bombing weather along the new Western Front in Normandy released the B-17s and B-24s to attack oil refineries in the campaign General Spaatz knew would cripple Germany's ability to wage effective war on all fronts. Oil was the Achilles heel and Spaatz meant to destroy German production. For the moment, his attention, and that of the photo recon effort, had to concentrate on other German threats.

The most frightening of these threats, particularly to England, became reality. The first of many flying bombs landed on London on 12 June. Although delayed by the bombing attacks through the spring months, the Germans completed enough of their launching sites to fire the first salvo of ten V-1 flying bombs against the capital city. Four crossed the Channel. Only one reached London, killing six civilians. With an information blackout on the location of the hits, the British hoped to prevent the Germans from refining their aiming. If they did not know exactly where each bomb fell they might fail in their terror attack against the war-weary citizens.

The night of 13 June the 7th Group's B-25 *Miss Nashville*, dressed in slick black paint and fitted with night photography equipment, covered targets behind the front lines. The 381st Service Squadron prepared the aircraft for the mission. Sgt Lonnie Milford loaded special flash bombs to illuminate the target area. Maj. John Hoover of the Eighth Reconnaissance Wing (Provisional) and the 7th's Operations Officer, Capt. Carl Chapman, along with engineer SSgt Mark Hicks of the 381st, flew the mission to photograph German activity in the Carentan area. This aircraft, the only B-25 in the Eighth Air Force, drew fire from Allied batteries on the invasion coast but escaped without damage. At 0130 on 14 June Hoover buzzed Mount Farm alerting the waiting 14th and 22nd Squadron night crews. Although they did not get photos of their target, they did cover other targets that interested Intelligence.

Hoover and Kendall to Russia

The first orders for shuttle flights out of Mount Farm in support of Operation Frantic, the Eastern Command in Poltava, Ukraine, finally came to 7th Group Headquarters. The Military Mission in Moscow and USSTAF Headquarters cut through all the red tape to send two photo planes to Russia. They completed arrangements for recognition signals and gained permission for the planes to enter Russian-controlled territory with precise times and routes. The 7th Group C.O., Col. Shoop expected to fly one of the first missions to Russia with the 8th Reconnaissance Wing Operations Officer, Major Hoover, but when the Russians reset the date, Shoop decided to take an earlier shuttle sortie to the Mediterranean. Operations notified Maj. John Hoover and Lt. Ralph D. Kendall of the 13th Squadron the night of 14 June that they would make the flight the next day.

Kendall took off first and flew toward Holland where he crossed in over enemy territory. Over the Zuider Zee he ran into heavy weather and went on instruments for the long flight toward Russia. Fifteen minutes behind Kendall, Major Hoover also had to fly on instruments in the dense cloud. Kendall reached the first break in the clouds near Brest-Litovsk, Poland, where his right engine's turbo went out and he had to reduce his speed.

After leaving the Brest-Litovsk area, the heavy overcast closed in again and Kendall began to think he might

B-25 Mitchell 253357, *Miss Nashville*, painted black for night mission using flash bombs to illuminate German targets in France. On the right, F-5 331 in invasion stripes.

not make Poltava on one good engine. He decided to land at the nearest Russian airfield. Radioing Major Hoover his decision, he let down through the cloud cover to 4,000 feet. Below, he found a river that he followed for 15 minutes. Unaware that the Germans still occupied the land below, he flew over a small village. Anti-aircraft shells burst around him.

Thinking the flak came from Russian batteries, Kendall flashed his recognition lights and waggled his wings in the prescribed manner for the day. Escaping without damage, he flew beyond range, searching for a place to land. Down to 1,000 feet altitude, he made a turn north and found an airfield and more flak. Wary but desperate, he decided to land in spite of the opposition, Kendall turned his F-5 and dropped down on the field. Convinced that the flak came from confused Russian gunners he wheeled his plane around at the end of the strip to prepare for a quick take-off in the event he had made a dreadful mistake. The pilot kept his F-5's engines running and he waited.

He did not wait long. Galloping horsemen raced toward him. Kendall saw their large black Russian caps just about the time he caught sight of an aircraft with a red star off to the side. When the soldiers learned that he was an American lieutenant they directed him to a dispersal area where they hid his F-5. With Kendall in tow, the officers called General Perminov, the senior Russian officer at Poltava, who confirmed Kendall's identity.

Kendall had landed near Vinnitza, at an advanced fighter base only ten miles from the front. The Russians found an English-speaking bomber gunner for an interpreter and made the pilot as comfortable as possible. Two Russian generals flew in to see what had happened. It seemed a minor thing to Lieutenant Kendall but to the Russians this was a major breach in the agreement. The Russian High Command did not like surprises and this event was an almost fatal one. Unknown to Kendall "all Hell was breaking loose" in Moscow where no Soviets wanted the Americans flying freely about the front under any circumstances. American and Soviet Russian officials had spent months of sensitive diplomatic discussions on just this problem.

Adding to the concern over Kendall's flight, Major Hoover did not get to Poltava either. Near Posen he saw a FW-190 but it did not attack. He got lost in the heavy weather and drew flak after crossing the front lines. Then three Russian Yak fighters intercepted and chased him for ten minutes. He found an airfield and landed in Russian territory at Ryechitsa.

Two days later, General Perminov and his staff gathered American commanders together for a conference at Escom (Eastern Command) in Poltava. A few previous incidents had made everyone wary. Now after this infraction and resulting questions, the Russians threatened to reconsider the agreement. Perminov informed the Americans that after interrogation of the two lost American pilots, the Russians believed that neither of them had been sufficiently briefed on Russian radio facilities, regulations, and other vital data forwarded to London. General Perminov also informed them that Major Hoover had the impression that he could land anywhere within Soviet territory. According to the report he, "was under no pressure to follow the flight plan as was submitted to the Soviets." Even worse, the two aircraft flying in from England bore strange stripes not the usual white star the Russians expected. Added just the week before, the invasion markings confused the Russian gunners and pilots who had come to expect just about anything from their enemy, the Germans. This event embarrassed both the Russians and Americans, especially the Mount Farm contingent. During June, three flights from the Fifteenth Air Force's 5th Photo Group in Italy had followed their corridors and timetables exactly and landed safely at Poltava on the minute.

After Perminov's two and a half hour conference, General Walsh, from the Military Mission in Moscow, informed USSTAF Headquarters that the Russians considered this problem of shooting down or injuring Americans paramount. Walsh relayed to General Doolittle at Eighth Air Force that General Deane, head of the Military Mission, had three protests from the Russians. Walsh noted in his message that he realized, "that you cannot prevent individuals from getting lost, however, every effort must be made to observe prescribed flight routes or an international incident highly prejudicial to the success of this project may result." The Russians required advance notice of each planned flight submitted far enough ahead of time for approval from Moscow. No aircraft would be allowed to enter until such approval came. Above all, the Soviets feared another incident.

Hoover refueled and managed to get to Poltava. A communication sent to London on 16 June read, "Glided into Poltava at 1000Z Hoover in F5 number 2682 plane and pilot okay." The ciphered messages in and out of Russia occasionally took on a strange and amusing syntax in translation. Hoover picked up his orders to continue on to Italy, 17 June. Kendall, after 11 days at the Russian base sampling Russian hospitality, including a Russian movie shown on a screen 12 inches square, flew on to Poltava.

Diderickson Lost

Good weather allowed maximum effort over the next two days of 14 and 15 June. Most sorties successfully cov-

ered targets in France, Belgium, Holland, and Germany. Major Smith took photos in the Leipzig area and strips of the Rhine to the Scheldt, near Antwerp. Lts. Cameron, Alley, and Floyd of the 27th Squadron covered multiple airfields in France.

On 15 June, 14th Squadron's Lt. Robert W. Diderickson took off in his Spitfire on a sortie to cover targets at Evere/Fauville and Coulommiers. His friend Verner "Dave" Davidson did not have a mission that day. Like Diderickson, he was one of the staff sergeant pilots commissioned in England as lieutenants. As Davidson walked toward the main gate he saw Sgt. John Neff who told him that "Deed" went down in the Paris area. Davidson declared he was going to, "tie one on," and with his friend Capt. George Epsom, "Sheriff" of the base who took him under his wing, the grieving pilot spent the rest of the day trying to deal with the loss.

Richards Goes to the Beach
Dieppe, damage assessment at Laval, and airfields at Le Mans made up the assignment for Lt. John Richards and his Spitfire on 17 June. After crossing out over the English coast and Channel, Richards lost one of his dual magnetos but his engine kept running. He informed the base about his trouble and told them he was going on and would finish the mission. He covered his targets and maintained as high altitude as possible. His engine continued to run but, "It would run awhile and then quit, then run again and quit. I called the base and told them my problem and what my altitude was." The other magneto finally cut out. Mount Farm told Richards he had enough altitude to glide across the Channel. Richards answered, "Hell, I can't even see the Channel."

The pilot nursed his Spit along, letting the engine cool off. "The points would open up and it would start running again. It was rough as hell. I would gain as much altitude as I could then the engine would cut out and I'd let it windmill." While roller coasting thousands of feet up and down on the way to the Channel, Richards spotted a flight of British Hurricane fighters. One broke formation and came to look at this peculiar performance. "They didn't know what the hell I was doing. I indicated I had an engine out. He waved and went back to his formation." With the Channel now in sight, Richards decided to forego the crossing and set his plane down on one of the temporary landing strips built along the invasion beaches. Searching the area he spotted aircraft taking off, stirring up a dusty cloud which must be hiding the strip. It was a front-line fighter strip in the British Zone. Having no radio contact with them Richards, "Just went in, made a straight in approach. It was perfect. I couldn't have done it better if I had power. But I just rolled past the runway and a guy came out of a little tent and told me to get off. I told him if they wanted it moved they would have to push it." Five RAF ground crew quickly pushed the Spit off right in front of the control tower. A British mechanic removed the cowling from the PR Spitfire and looked for a solution.

Forward landing strip on beachhead near Caen. British Horsa glider lies in field off the steel runway matting. (John Richards)

The RAF strip was on a part of Sword Beach north of Caen, held by the 2nd British Army. This was a hot area with heavy fighting as the British tried to capture the strategic city of Caen. That afternoon an RAF fighter came in for a belly-landing sustaining severe damage. It seemed the solution had just arrived.

The mechanic checked the crashed plane to see if the magnetos would fit. Fortunately they were the same model and he cannibalized the written-off fighter. It was too late to return and the hospitable British put Richards up for the night in a medic's tent. The arrangement inside the tent was unusual. Slit trenches had been dug out and stretcher cots laid down in them. They gave Richards a steel helmet and told him to put it on his head when he went to bed down in the slit trench. On querying this odd suggestion, he was told he might find out later. "Sure enough, the Germans came over with a couple of bombers and laid a stick of bombs alongside the runway. There was more flak than I had seen in my life. The sky was all lit up. The damn gun right alongside the tent would sound off and I liked to jump right out of there. The shrapnel from the flak rained down everywhere. The tent looked like a sieve. I knew why I had a helmet over my head."

The next morning Richards had some beans for breakfast and a cup of what he described to the Mount Farm boys as mud-like tea. Supper the night before had been a half a can of cold salmon. He did not recommend the cuisine or the accommodations but the mechanic got a nod of approval. When he got back to Mount Farm, Engineering had a Tech order already out to replace all magnetos of that particular model.

F-5 in invasion stripes. On the right in the distance on the other side of the Thames, is the dominant geological feature seen from Mount Farm. The hills are the wooded Wittenham Clumps and Sinodun Hills, where Celtic warriors built their fort (*dun* the Celtic word for fort). The Bronze Age hill fort dates from 1500 BC. (George Simmons)

SSgt Leroy Hatch of 13th Sq Supply Section. (George P. Simmons)

2,000

Back in the air again on 20 June, Lt John Richards flew his 19th sortie covering enemy airfields west and southwest of Paris without opposition. He returned to Mount Farm after an uneventful trip, completing the 2000th mission flown by the 7th Group. It was a big contrast to his flight three days earlier.

Maj Ray Mitchell, C.O. and Capt Frank Campbell, Engineering Officer of the 27th Sq. ("Doc" Fritsche)

Russian Roulette

Operations at Eastern Command continued in spite of the indigestion caused by the failure of the first two PR missions from Mount Farm. Diplomatic signals flashed back and forth between Moscow and London. Requests for new flights met delays of the usual Russian foot-dragging style compounded by the two errant sor-

ties. The Fifteenth Air Force flew the first shuttle bombing mission, code-named "Frantic Joe." On 2 June, led by the Fifteenth's commanding officer, Lt. Gen. Ira Eaker, the bombers attacked the Debrecen marshaling yards in Hungary and continued on to land at Poltava. After ceremonies, flowers, speeches, and press conferences — both Russian and American — the business end of base operations got back to work.

When the Frantic Joe planes landed, the lab processed 30 rolls of strike film taken during the raid. The small photo unit stationed at Poltava maintained a steady pace processing damage assessment photos from PR flights flown from Poltava as well as strike photos from the bombers. Two more shuttle missions by the Fifteenth Air Force in quick succession, on 6 and 11 June, kept the lab busy for two weeks before slacking off.

The men lived in the tent area next to the ruined hangers. The few Americans stationed on the base could not do all the work themselves. Soviet regulations prevented full manning of the base by American personnel. In the Photo Lab, Russians received superior "on the job training" working with Capt. Alan Buster's men. Staff Sergeant Rudnicki, who conveniently spoke Polish, could converse fairly well with the Russians on his printing crew, which included three Russian sergeants – two men and a woman – and a GI cook. This little band turned out 3,500 prints a day. Rudnicki borrowed his lab technicians on detached service from a Soviet lab on base. In every area, Russian soldiers filled jobs to supplement base units. Fewer than 400 Americans manned the base permanently. When aircrews from bomber missions arrived, either from England or Italy, the base population temporarily swelled by as many as 700 men.

The original arrangements with the Soviets, permitted only two PR flights into Poltava each day. Several F-5s and their pilots remained for short periods at the base for flights to and from Poltava covering targets for the Eighth and Fifteenth Air Forces. Surprisingly, the Russians shared information on weather and a very good system furnished excellent weather forecasts and conditions to Escom and thence to England. The exchange worked both ways. One thing that did not work as well was the defense of the three bases in Escom's command. Besides the bomber and PR base at Poltava, the command had bases at Piryatin and Mirgorod for fighters accompanying the bombers. From the beginning of negotiations for the bases, the Americans wanted to bring in their own anti-aircraft batteries and crews, as well as defensive fighter forces. The Soviets declared the defense of the bases was their responsibility and would not consider any other arrangement. As far as Moscow was concerned, the fewer foreigners in its country the better.

Not only did the Russians refuse to allow the U.S. its own anti-aircraft batteries for protection, they did not allow any inspection of forces, guns, or disposition of defenses at the bases either. Escom did know that the guns were not heavy anti-aircraft but 40mm medium guns. Where and how many, they did not know. The Photo Lab knew where one was, only a few hundred yards from its tents. The base did not have any effective camouflage, the concrete runways and perimeter track remained exposed. The lengthened steel mat runways had been painted green and grass grew through the open holes. Protection for the men at the base consisted of enough slit trenches for 300, dug about the base mainly near the tent areas.

The first PR shuttle flights from Mount Farm created great consternation, especially for the Soviet command, when they failed to land at the base. Major Hoover arrived within days but Lieutenant Kendall remained at the Russian base for more than ten days. As yet no bombing force had come from the Eighth but the premier photo flights had not gone well at all. On 19 June, Capt. Frank Carney left Poltava and flew to Bari, Italy, where he spent the night and flew on to Mount Farm on the 20th. Another 7th Group pilot, Lt. Everett Thies, also flying out of Bari, arrived safely in Poltava prompting one of the strangely deciphered messages, "Zoomed in at 0840 in F5126 did Lt. Theissiebbs." On the same day, a scheduled pair of sorties had to be canceled when the Soviets refused to accept the routes and timing. Capts. Hubert Childress and Frank Carney had expected to leave for Russia on 21 June. Many of the pilots flying sorties out of Poltava were the 7th Group men who had spent time with the 5th Photo Group at Bari. So far, most of the missions had been successful.

Finally, Eighth Air Force B-17s of the 3rd Bomb

Lt Ernie Johnston, 27th pilot, enjoys time off in Russia while awaiting word whether his wife has had their baby. He shares his copy of *Life* magazine with two Russian soldiers in the summer sun of the Ukraine. ("Doc" Fritsche)

Division hit the Ruhland/Schwartzheide Oil plant and continued east to Escom bases in the Soviet Union on 21 June. That night, the 7th Group men worked long hours in the lab processing film. At 1815 hours, a lone aircraft passed over the base and drew fire from some anti-aircraft guns. Near midnight, local Russian military authorities notified Escom Headquarters at Poltava that enemy planes had crossed the front and appeared headed toward Poltava. The Germans would have little trouble finding the big base, as they had occupied it only a few months before. Inside the photo lab, the Lab commander, Lt. Alan Buster, TSgt Dick Brown and MSgt Charlie Sands worked developing film. At first they did not hear any air raid warnings. A Russian soldier rushed in the door shouting *"Amerikanski, samelyote, Amerikanski, samelyote,"* which elicited an, "Okay Ivan," from the busy Americans who did not know that the *samelyote* he shouted about were German airplanes. Fifteen minutes later, they heard a commotion outside as Russian flak batteries opened up even before the first GAF bombers appeared over the base.

Searchlights stabbed into the darkness through exploding bursts of ineffective flak. The first Luftwaffe plane dropped a string of three magnesium flares that ignited at 5,000 feet lighting up the field below with white brilliance. More flares fell, illuminating the B-17s parked on the base. Then the first high explosive bombs began to fall. The men rushed from the lab to see tracers, flares, and ack-ack filling the sky. They jumped into the nearest slit trench. Sands and Brown thought it too shallow, raced back to the Lab, grabbed two Speed Graphic cameras and headed for the deep lab sump. From this less-crowded and much safer-seeming hole, they watched bombs rain down on the field. Bombers caught fire, ammunition exploding; fuel dumps went up. After the demolition bombs, the Germans dropped incendiaries that turned the damaged Fortresses into torches further lighting everything on the base with orange and red.

All around, with hell falling from above, men hid in the insufficient trenches, railroad ditches, behind brick walls, the ruins of hangers, anywhere that offered protection. From their shelter in the sump, the two photo men took picture after picture of the horror. The raid continued for over an hour, then after a short lull, bombers came back and dropped more bombs while others strafed. Some came so close as they swept the field that the burning B-17s lit the faces of the pilots. In the sump, Sands and Brown heard something flying past. Not the *whang* of bullets but softer sounds, *phewft, phewft*. After the raid ended, the men found the base covered with lethal anti-personnel bombs, large soup can looking things with wings.

Flares from Luftwaffe bombers light up their B-17 targets as Russian tracers streak the night sky during the raid on 20/21 June at Poltava. (R. Brown)

The Russians refused to allow Americans to clear the field fearing fatalities and further embarrassment after their failure to protect the base. Two Americans had been killed and several wounded, 50 aircraft (47 of them B-17s) lay damaged beyond repair, among them, one of the 7th Group's F-5s. Other damaged planes sat about the field among unexploded bombs and the deadly "butterfly" anti-personnel bombs. During the raid, Russians had rushed to shovel dirt on the burning planes in spite of falling bombs and exploding ammunition. In the morning light, the carnage amongst the Russians sickened the Americans. Soviet troops and civilians began clearing the field. Sappers found and destroyed over 30,000 anti-personnel mines, unexploded bombs, and "butterfly bombs", many of the latter removed by hand. Poltava airfield remained closed for 48 hours and then opened for limited operations. The heavy demolition bombs had

Poltava, Ukraine. After the raid. Bombed B-17 with oxygen bottles lying in the burned out wreckage. In the background, a B-17 of the 96BG lies with its back broken. (Sam Burns)

Eyes of the Eighth

cratered the runways, just as the Germans planned.

The raid underlined some major flaws in the layout of the Poltava base. The Soviets experimented with smoke screens for the base. Escom moved the hospital tents well away from the airfield. Although the lab suffered little damage, a few shrapnel holes in the tents and a knocked-out lighting system, Lieutenant Buster considered it prudent to move away from the field. For a few nights after the raid, the men slept in pup tents off base. Then the Photo Lab chose a location near the hospital's in an apple orchard which offered shelter and cover for its lab and living tents.

Rowe

One of the Bari pilots flying out of Poltava, Lt. David Rowe of the 22nd Squadron, had missed the big D-day activities when he flew mail down to Italy on 4 June. Since then he had been flying in the Mediterranean and now, after a flight to the Ukranian base, he took a sortie out of Poltava on 26 June to cover Bialystock and other targets. A bombing force left for the oil refinery at Drohobycz three hours later, drawing attention of both the Germans and the Russian fighters. Reports of a JU-88 Luftwaffe plane near there had the Soviets looking for intruders.

The weather was beautiful and clear except for a few broken clouds. Lieutenant Rowe kept a wary eye, looking in his rear view mirrors for enemy aircraft. Without the excellent warning system supplied by British tracking stations, pilots in Russian territory had to depend mainly on their eyes. The pilot had called base several times identifying himself with his *Highball* callsign. Over the headset he heard Russian and American chatter. In a slow climb he passed through 27,000, changed his power settings to level off at 28,000 feet. Rowe suddenly had a feeling that someone had put a hand on his shoulder. Two contrails appeared in his mirror and he thought they were bandits. They closed on him. He hit his mike button and told base he thought he was being hit. Rowe dropped his tanks and heard the staccato "*rap, rap, rap*" like a stick on a slat fence. Instinctively, he pushed his seat-jack lever. The seat thudded down dropping Rowe below the rear armor plate. Cannon shell exploded in his F-5's right engine. His windscreen was gone, the canopy shattered, and the throttle quadrant shot out.

Gray liquid streamed from the right nacelle. Coolant. His attackers passed over him. Rowe saw two red-starred Airacobras. His left engine on fire, he rolled into the gray stream. The gray turned to yellow, green, then orange flames. Gasoline. He was going down. Rowe went to his trim tabs to pull out of the clockwise spiral. His plane leveled off. The pilot saw metalwork around his feet changing color. Fire came through the wing tunnels. Rowe jettisoned the canopy, flames sucked up and around him. He tried to bail out to escape the stench and heat. Something hung for a moment. The next thing he knew he was ice cold. His chute opened. Fire had burned several panels and shrouds but the chute canopy held. His plane fell dragging a plume of smoke.

Rowe swung slowly back and forth; the two Airacobras circled. He could hear the odd sound of the Airacobra's planatary gears sounding like the old BT trainers. All he could think of was that Airacobras did not operate at 28,000 feet nor have cannon the size that hit him. Below, the Russian countryside looked like northern Colorado range land. From nowhere, peasants and workers came running toward him with pitchforks. Rowe landed hard. Twenty or more surrounded him. He struggled to get to his knees. They did not seem aggressive and he knew they had seen what had happened.

"*Amerikanski peelota, Amerikanski peelota,*" Rowe tried every language he knew to identify himself as a friend. One old woman understood and pressed her hands to her face crying, "*Amerikanetz.*" They helped the burned pilot into a truck and took him to get medical attention. After a rough and excruciatingly painful ride, Rowe arrived at the best hospital in Kiev where Russian doctors and nurses treated his burns.

Lt David K. Rowe and his F-5, *School-Boy Rowe*. Rowe survives Airacobra attack on 26 June 1944. (Bob Coyne)

The incident the Russian dreaded had happened, soft-

ened only by the fact that the pilot their fighters had shot down was alive and not fatally wounded. Cables and messages flashed back and forth. From England, queries about the pilot's safety and condition needed answers. An Air Transport Command pilot, Captain Specht, in Kiev for discussions about B-17 repairs, went to see Lieutenant Rowe in the hospital. He brought the first personal report to Cullen about the injured pilot. He told the colonel that the pilot's condition was good and that sunglasses, oxygen mask, and gloves prevented more extensive burns. Rowe's painful burns would heal and he could soon be sent to the hospital at Poltava.

Messages sent from General Doolittle in England to Eastern Command specified the time and routes for the next sorties, scheduled to be flown by Capts. Hubert Childress and Frank Carney, in great detail as that is what the Russians demanded in order to approve PR flights. One small private note made its way to an anxious father-to-be flying sorties out of Poltava. At the end of the proposed route and schedule for Captain Carney were three words: Johnson has girl.

As a result of the Rowe incident, as well as the usual delays, the Soviets canceled clearance for sorties into Poltava. Rescheduled for 26 June with a warning that the pilot must learn the recognition signal, the mission again failed approval from Moscow authorities who cited insufficient time. A communiqué about the Childress mission acknowledging the cancellation of the 27 June sortie, states that the pilot has been warned to memorize the Soviet signals of the day. Now scheduled for 28 June, the Russian refusal came after a concerned communiqué from Eastern Command wanted to know, "Did Childress take off for Eastern Command?" Moscow accepted the next date, 29 June.

Capt. Hubert Childress had his sortie cleared for landing at Poltava. He took off from Mount Farm and covered his targets at Konigsberg, Newhausen, Danzig, as well as Bialystok in Russia. He crossed the front lines without flak or fighter interference. In spite of scant detail on large-scale maps, Childress had little difficulty finding Poltava and landed there on time, the first sortie out of Mount Farm to do so. The first man to greet Captain Childress was a happy Colonel Cullen. This was a welcome happening for the suspicious Soviets and the nervous Americans. Eastern Command, with great relief, sent this message to General Doolittle, "Alighted at 1205Z Capt Childress in F5. Safe and sound."

Doodlebugs

Once the flying bombs began falling on southern England, the harried populace quickly found a new and innocuous name for the V-1s. The putt-putt of their pulse-

Col Paul T. Cullen, Escom Deputy Commander of Operations at his desk in Poltava. The view outside his executive office is of bombed-out buildings left from the German occupation of the field. (R. Brown)

jet motors made such an odd sound as the winged bomb ran out its fuel to drop unguided on the land below. One name, "Doodlebug," gained popularity almost as a way of down-playing its deadly intent. British defenses made every effort to bring them down before they reached populated areas. The PR units photographed reported and suspected sites to find operational launching ramps. The 27th Squadron sent out sorties between 22 and 24 June to try to photograph V-1 "Doodlebugs" in-flight. Only Lt. Max Alley succeeded in catching the elusive target on his film. When developed, the negative showed a tiny unidentifiable speck.

Haugen Killed

The 14th Squadron's commanding officer Maj. Cecil Haugen took off at 0615 for three damage assessment targets at airfields in the Paris area on 28 June. On his return to Mount Farm, he ran into bad weather and a low ceiling. He radioed the tower that he was having trouble with his instruments and that he was going to have to bail out. The tower heard nothing more from Haugen. North of Mount Farm, Major Haugen's Spitfire crashed onto Combe Farm in Oxfordshire. Investigation indicated that he had become disoriented in an unfamiliar aircraft and had misjudged his altitude. Haugen had been flying F-5s until taking over the 14th. Over 200 officers and enlisted men from the station attended his funeral at Brookwood American Cemetery. Major Kermit E. Bliss, previously a member of the 14th Squadron and veteran pilot with 22 missions, assumed command of the squadron transferring from 7th Group.

Shoop turns command over to Hartwell

Colonel Shoop left the base on 28 June. He had received orders on 26 June to return to the States to finish the

Eyes of the Eighth

P-38 evaluation originally assigned. Two days later he left in the Group's B-25 flying to another base where he transferred to an Air Transport Command flight to the States. Colonel Norris Hartwell assumed command of the Group in Shoop's absence.

High Praise from Doolittle
General Doolittle recognized the efforts of the 7th Group in a citation that described the contribution in "the seven day period prior to D-day, the 7th Photo Group was ordered by Supreme Headquarters, Allied Expeditionary Forces; Headquarters, U.S. Strategic Air Forces in Europe; Headquarters Eighth Air Force, and other ground and air force Allied units, to photograph targets of the highest priority in order to secure coverage of enemy activities and installations in areas occupied by the enemy which has direct bearing on pending operations. This was in addition to the regular coverage of Eighth Air Force heavy and fighter bombardment missions as well as coastal and inland targets and mapping projects regularly covered by the Group..."

Statistics for the period from D minus seven to D plus 24 the 7th Group sent out 474 missions: 426 accredited sorties and 342 or 80% considered successful.

Photo typical of low-level cover searching for V-weapon sites and transportation intelligence. This picture, taken by Lt John Richards of the 14th Sq shows road blocks on either end of a bridge over a swollen stream. Behind trees on the far side of the bridge is a man running from his car to escape the approaching aircraft. Open fields and pastures, upper center, are "planted" with tall glider-stopping poles nicknamed "Rommel's Asparagus."
(John Richards)

Chapter 10
July 1944

The battle in Normandy raged as the Allies fought to sustain, expand, and break out of the beachhead area. Tenacious German units fought to prevent loss of each foot of ground. The hedgerow country facing the American forces advancing from Omaha and Utah beaches had to be taken lane by lane, field by field. Behind the British and Canadian beaches, a D-day objective, the main transportation hub of the area, Caen, remained in the hands of the Germans. More open land allowed the massing of Panzer units against Gen. Bernard Montgomery's forces and in spite of horrific bombing the blasted city had not been taken. In 24 days the Allies had landed 920,000 men and 600,000 tons of supplies but they had suffered almost 62,000 killed and wounded.

Allied photo reconnaissance had more requests for cover than it could handle as commands of all types recognized the value of immediate photo cover. Camera Repair, the Photo Lab, Intelligence, the men on the line, everyone worked overtime to keep planes and pilots in the air. The weather remained the most restricting influence. Limited resources and unlimited requests kept all photo reconnaissance units in England busy. Eighth Air Force strikes on German oil targets increased whenever the bombers were not required on tactical targets. These needed damage assessment cover. The new threat of flying bombs increased low-level photography.

Operation Dilly

Headquarters USSTAF sent a request, code name Dilly, to Mount Farm for large scale cover of a list of 53 Noball sites in France. The scale of the existing cover was too small for such well-hidden targets. On 2 July 1944, the Eighth Reconnaissance Wing assigned the job to Maj. Kermit Bliss's 14th Squadron. A staff of three first phase interpreters headed by Capt. Trip Russell came from Medmenham to assist the program by interpreting and annotating the photos. Headquarters wanted the job done quickly. Bliss, his Operations Officer and Intelligence men organized the job and divided the target area into four sections. A flight of four planes would cover each section. As usual, all plans hinged on the weather which was unsatisfactory until, between 4 July and 17 July, 17 sorties produced excellent cover of all 53 sites. Pilots flying these sorties were: Lt. Col. Hartwell; Major Bliss; Capts. Dixon, Sheble, Nesselrode, Simon; and Lts. Adams, Davidson, Richards, Blyth, Graves, and Goffin. As the coverage came in, Headquarters requested additional sites, which the pilots covered and removed from the program.

The number of flying bombs falling on England increased. Before bombers could attack the launching sites, the photo pilots had to locate, pin-point, and photograph the target areas. Then interpreters searched the photographs for evidence of the well-hidden V-1 launching ramps and buildings. Heavy coverage of the Pas de Calais area by American and British PR flights kept them supplied with both vertical pictures from altitude and obliques taken from as low as 50 feet. The Germans located each site where it blended into existing surroundings, cleverly hiding them in small villages, farms, and wooded areas. Each site had two features that could reveal its location on vertical photographs. The 150 foot launching ramp always pointed toward England, in the case of the Pas de Calais sites – London. Hidden by trees or carefully camouflaged with greenery, on vertical photos the long straight ramps often resembled hedgerows or verdant fence lines. At extremely low altitudes, taken by oblique or forward-facing cameras, these inclined ramps looked more out of place. Perfectly aligned with the ramp was a square wooden building. The two features signified a site given the name Belhamelin after the first of its design discovered on the Cherbourg Peninsula.

The operational procedure explained the significance of the alignment. After assembly, the Luftwaffe crew moved the flying bomb into the square building, which contained nothing magnetic either in its construction or

Lt J. B. Matthews talks with Col Norris Hartwell on the flight line. Camera Repair men work on cameras in F-5 389.

Eyes of the Eighth

Annotated print of Belhamelin type V-1 launching site at Chateau Bernapre. The site is circled with dotted line. Arrow from letter P points to the launching ramp, which is marked at each end by a short straight line. Q indicates the square non-magnetic "compass swinging" building. This site has fired V-1s as indicated by the narrow scratch-like spray pattern beginning near the end of the ramp. The launching catapult's piston makes these marks when it fires out the end of the ramp's tube and lands in the fields. Craters from sticks of bombs dropped on the area stand out clearly in the neat fields. 7th Group sortie 2219 flown on 6 July 1944 in Spitfire PA 841 by Maj Kermit Bliss. (Kermit Bliss)

equipment. Here they performed a process called "swinging the compass." The Luftwaffe crew pointed the V-1 winged bomb in the direction of its target, hence the alignment of the square building with the ramp. No magnetic pull must cause any deviation in the compass needle to divert the bomb from the preset course. Inside the steel-shelled bomb, the compass used for guidance rested in a wooden ball that partially cushioned the compass from vibrations. With the course set and the bomb aligned toward its target, the men performed the "delicate" job of aligning the magnetic field of the steel bomb with the earth's magnetic field. They beat the bomb with wooden mallets.

The photos revealed more than just launching ramps. They located storage facilities for flying bombs from the vicinity of Compeigne to Beaumont-sur-Oise, in the Foret

July 1944

Noball site XI/A/187, Fresnoy. Arrow in lower left points to brush covered launching ramp. R1 points to the square "compass swinging" building also camouflaged with brush and hidden among trees. Low oblique photo taken on 7th Group sortie 2263 by Col Norris Hartwell in F-5 on 7 July 1944.

de Compeigne, the Foret de Chantilly, and Foret de Halatte. Near Vuillery, north of Soissons, photo interpreters spotted another storage area. The facilities were in wooded areas which offered easy camouflage. The Germans planned to take the bombs from storage, load them on trains and canal barges to transport to the launching sites. Not only photo cover but Ultra decrypts also revealed activity and damage resulting from attacks. The messages often instigated cover of certain areas, partly to confirm the location, and at other times simply to offer an explanation to suspicious German Intelligence when bombers attacked their previously unrecognized target.

Eyes of the Eighth

Low-level photo showing Fresnoy site with camouflaged ramp rising toward the road junction. This is several frames before the annotated photo.
(Paul Webb)

Fourth of July chase across English countryside by 7th Group pilots looking for V-1s pays off for Lt Wesley Schumacher of the 27th Sq who took this picture of a flying "Doodlebug". In the inset, the image is enlarged (and enhanced for 1944 publication in Britain).

The cat and mouse game of secrets continued on both sides. Through extraordinary care, the British kept secret that they could read many of the supposedly unreadable Enigma codes. On the German side, structures originally thought to be the main flying bomb launching areas had been abandoned yet remained on the target lists, not without satisfaction to the Germans.

Celebrating Independence Day, the 7th Group sent out 21 missions on 4 July 1944. Flights had been sent out before to try and photograph the V-1 Doodlebug,

144

also called the buzz-bomb. Max Alley had seen one, but its tiny image on film looked like an indistinguishable speck. On the fourth, Lieutenants Elston, from the 13th, Schumacher from the 27th, and McKinnon of the 22nd, went out to chase V-1s. Lt. Wesley Schumacher found one zipping across the English countryside being chased by RAF Spitfires. Schumacher got close enough to catch a good image on film. When the Photo Lab processed the film, they found a number of frames showing the bomb's progress across fields and hedgerows. The pictures became instant sensations. Censors released an enlarged photo with the image slightly enhanced for publication a few weeks later in the British papers.

Return from Russia
On his return from Poltava, Capt. Hubert Childress had none of the turmoil accompanying his first stage on 29 June. The cables and questions concerning his safety on his flight to Poltava resulted from the unfortunate incident when Russian Aircobras shot Lt. David Rowe down on the 26th. Childress set out on 3 July to return to Mount Farm by way of the Mediterranean, landing at Foggia, Italy, then on to Sardinia. From there he crossed France taking several targets along the way. When he landed at his home base he reported no difficulty with the Russians and thought they had been most hospitable. His care and adherence to the prescribed course and time had impressed them. Operations considered his mission very successful with almost 100% coverage of his assigned targets.

After a long absence, where he flew missions in Italy and Russia, Lt. R. D. Kendall of the 13th Squadron returned from his three way shuttle from Russia. His 4 July flight had started in Alghero, Sardinia. Flying over France he dodged heavy flak at Orange, just southeast of Lyons. He climbed until he could fly above the 10/10 cloud cover stretching all the way to England. When his time and distance calculation indicated he was within range, he radioed for direction and received a homing to Mount Farm. This trip was short but the journey had been long. Kendall told his listeners about the first leg of his shuttle flight to Russia. He said that after his 11 day stay at the Russian forward fighter base, he flew to Piryatin to refuel, flew to Poltava, picked up instructions and completed a five hour mission landing at the Eastern Command base. He had left Poltava on 30 June, covered Odessa, photographed targets in Romania, Bulgaria, and Yugoslavia before crossing the Adriatic to the Fifteenth Air Force base at San Severo. When he landed there he hit a ditch, twisting the tail booms. Repairs kept him at San Severo until 3 July when he flew to Sardinia, stopping at Bari, Italy, on the way. Bad luck plagued the pilot and trouble with a propeller forced him to remain overnight for repairs. Finally, the next day he made it back to Mount Farm. He had been gone since the 15th of June.

Military Police at Mount Farm
There was a change of command in the 1274th Military Police Company when the very popular "Sheriff" of Mount Farm, Capt. George Epsom, transferred to AAF Station 376 at Watton on 1 July 1944. Lt. Lloyd S. Snyder became Company Commander and Station Provost Marshall. The military police maintained order at the base and on occasion defused dangerous situations. One such event occurred on 5 July when a drunken soldier in one of the barracks started firing his carbine wildly, endangering others in the barracks. Sgt Jesse La Vier and Pfc Francis R. Calderwood disarmed the man before he injured anyone. Colonel Hartwell, 7th Group commander, sent the two MPs a written commendation for their coolness under fire.

The military police at Mount Farm maintained a good record of crime prevention, especially by the efforts of two investigators, Sgt Howard Fenn and Cpl Woodrow Breig. Although very few major problems came up, the unit had an excellent record of convictions and "Closed Cases" on those that did.

Record Numbers
The 7th Group completed the largest number of sorties to date when weather cleared over target areas on 6 July. One month to the day after the invasion, the weather bore no resemblance to D-day's murky low ceiling conditions. Operations had a long list of targets to cover and dispatched 54 missions. Of those, one had to be canceled and four were unsuccessful. The resulting record number of sorties covered France, particularly the Pas de Calais area; Belgium, Holland, and Germany. On their missions, German flak batteries fired at Major Smith, Lieutenants Sommerkamp, Gilmore, and Batson. Batson returned with five hits on his aircraft. The 14th Squadron flew 15 successful sorties, tying the 22nd for most flown. Major Bliss covered the Lutzkendorf oil plant, refueling at Bradwell Bay for the extra long flight. While over Ruklinghausen, he encountered 25 bursts of white flak. Lt. Charles J.J. Goffin, a Belgian pilot in the 14th Squadron, followed the railroad lines from Hasselt to Louvain. Operations and Intelligence briefed Goffin not to fly too low. On the Belgian's previous photos of gon-

Eyes of the Eighth

dolas, open-top railcars, taken at less than 50 feet, the focus blurred on the contents – the critical information for interpreters. On another transportation mission, Lt. John Richards recorded activity on railroads in the Ghent area. With so many targets to cover and good weather, many pilots flew two missions that day.

Recently, targets in Germany had lower priority than the more immediate tactical and flying bomb objectives. On this busy day, a few of the missions went to Germany after V-1 related industries. The 22nd Squadron's Lts. Alexander Kann and J. B. "Red" Mathews covered targets at Saarbrucken and Friedrichshafen. Lt. Louis Gilmore of the 13th took damage assessment photos of Kiel. Another of the 13th's pilots, Lt. Albert Clark, had assignments covering targets at Fallersleben and Wittenburg. Clark's subjects were factories manufacturing engines and components for V-1s.

Some of the larger constructions in the Pas de Calais area were too big to hide and made excellent targets for bombers. Unfortunately, as big and as exposed as they were, their massive poured concrete design, similar to reinforced sub pens, made them difficult to destroy. Even the largest bombs in the British arsenal could not pierce them. Suspected launching platforms or supply sites, they turned out to be dangerous subjects for low-level photography. Wizernes, Mimoyecques, Watten, St. Pol/Siracourt, all familiar names on the Noball target list. On 6 July, Lt. Gerald Adams of the 14th Squadron covered all four.

The next day, Operations sent Col. Norris Hartwell and Lt. John Richards to cover supposed launching and supply sites at Ferme du Forestel, Fresnoy, and St. Pol/Siracourt with low level obliques. In spite of intense flak and ground fire, the two men completed their assignments. Richard's aircraft suffered extensive damage on the fuselage and tail from the 100 flak shells directed at him. His right engine alone took 40 hits. The photographs exposed the sites in detail. Interpreters marked and indicated bomb damage and activity. Specialists in the Crossbow program and Intelligence continued to investigate the importance and purpose of the sites.

Redmond on Loan to Royal Navy
Whenever some outfit needed help or instruction in camera matters, it tapped the 14th Squadron's Camera Repair Department for the services of TSgt Larry Redmond. This time a British unit, the Fleet Air Arm of the Royal Naval Air Service, asked for someone to instruct its men in the maintenance of the K-17B, K-18 cameras and the B-2 and B-7 intervalometers. Instead of the usual aircraft seen by Camera Repair, these cameras were in F6F Hellcats. The Camera Repair crew chief had a talent explaining intricate camera mechanics and after five days the British had high praise for his instruction in the intricate mechanisms and installations. The Fleet Air Arm flew Redmond back to Mount Farm.

"Bernie" Proko and the Interrogator
One place no airman wanted to see was the Luftwaffe's Intelligence and Evaluation Center, *Auswertestelle West*, at Oberursel, a town outside Frankfurt. This location is often confused with Dulag Luft, (short for *Durtchgangslager* meaning "Through-going Camp"), which was a transit camp for Allied aircrew prisoners of war. Originally in the middle of Frankfurt, Dulag Luft moved to Wetzlar outside the city after air raids threatened the camp. Men on their way to various POW camps usually went through Dulag Luft.

Auswertestelle West was the main collection point for intelligence gathered from captured airmen and their aircraft. Any scrap of information found its way into a file about an aircraft, or unit, or person, or project. Nothing was too insignificant. The main part of *Auswertestelle West* an airman would see was the Interrogation Center. Here, specially trained men questioned captured airmen – even tried to trick some into answering through false Red Cross forms. According to the Geneva Convention, an airman was not required to answer any questions except those of name, rank, and serial number.

When guards escorted Lt. "Bernie" Proko into Room 47 at *Auswertestelle West*, a serious looking man with a small mustache greeted him as he greeted every POW walking through his door, "Come in please. I am your interrogator." Hanns-Joachim Scharff knew the man who now faced him across the desk. He had files at the Interrogation Center on almost every pilot in the 7th Group including its Wing commander, Col. Elliott Roosevelt. Scharff made a little welcoming speech to Proko explaining that he already knew *everything* but, nevertheless, needed to ask just one little question. Then he turned over a photo that had been face down on his desk and asked the pilot, "What is the name of that mechanic working on the Jeep?"

Proko looked down at the black and white image. An F-5 sat on the Flight Line at Mount Farm and there was a mechanic working on a Jeep in the background. Startled as he was, Proko gave no information to his interrogator. The same photo shocked other members of Group on their visit to the center. The photo came from leader frames, exposed while testing the oblique cameras be-

July 1944

Photo from film's leader strip exposed in trial of camera magazine feed before F-5 of 22nd Sq flies sortie on 28 May 1944. Line or camera repair crewmen stand at foot of platform used to service aircraft's camera bays. F-5 in background on 22nd Sq flight line. This type of picture, taken from a downed 7th Group aircraft, is what interrogator Scharff presented to Lt Bernie Proko at Dulag Luft, *Auswertestelle West* at Oberursel. (National Archives)

fore a mission, on the film in a magazine from a crashed F-5 from Mount Farm.

Courier Flights

The demand for cover, which it satisfied as quickly as weather allowed, created another job for the 7th Group. Ground forces in France needed swift delivery of photos. To shorten the time between coverage, interpretation, and acquisition, the 8th Reconnaissance Wing approved a courier service to the front-line commands. On 9 July, Lts. Robert N. Florine and Ira J. Purdy of the 27th Squadron began courier flights to the Normandy area carrying photos, messages, and data for ground forces. They used a noisy single-engine UC-64 Norseman for the first flight but almost any aircraft on the base could be utilized and was in the coming months. Florine and Purdy flew two round-trips that day with Lt. Max Alley flying a third, all in UC-64s.

The weather returned to its usual mixed cloud cover with a small number of missions carried out daily. A period of better weather lasting most of the month produced some heavy operational days beginning on 17 July. Operations canceled seven sorties and only one was unsuccessful out of the 49 assigned that day. Heavy mapping demands sent 13th Squadron pilots; Captain Kendall, Lieutenants Clark, Brink, and Wiebe to the Brest Peninsula. Later in the day, Major Smith, Lieutenants Schultz, Brink, and Clark went back to do more mapping in the area.

The Group's clerks spent a couple of busy days when Headquarters assigned four new pilots to the 13th: Lts. Robert Facer, Arthur Leatherwood, Gerald Budrevich, and Wilbur Bickford. Within a few days, the clerks recorded an exchange when Lts. Taylor Belt and Richard Brogan traded roster places with Lieutenants Gilmore and Leatherwood who wanted to fly Spitfires with the 14th Squadron.

Good weather continued in most areas the next day as well. Lieutenants Bruns and Moss covered targets in Berlin; Major Smith took airfields in the Hanover area. Lt. Donald Schultz flew a mission to Lille using special cameras equipped with color film designed to detect en-

147

Eyes of the Eighth

emy camouflage. Gilmore flew his first mission with the 14th Squadron and completed a mission with targets in Antwerp, Essechen, and Ghent-Terneuzen area.

Flight to the Beachhead
As the beachhead area expanded, more small airstrips became available for refueling and emergency landings. A few operational flights used the strips to leave film, reload cameras with fresh magazines, or refuel before covering more assignments. The courier flights bringing important photos to ground forces also brought a few personnel to perform their tasks right there on the beachhead airstrip. On 17 July, Lts. Bob Florine and W. G. White flew the UC-64 Norseman with men to service some flights in and out of the beachhead. Spending most of the afternoon at the strip, TSgt C.L. Myers, MSgts M. F. Comanitzky, B. Brown, Sgt G.E. Asplund, and Cpls L.J. Brown and W.J. Wolfer serviced aircraft from Mount Farm before returning in the Norseman.

On one of the flights to the beachhead area, the courier plane carried Maj. Lytton Doolittle, the grand old man of the 13th. An artillery officer in the last war, Major Doolittle paid particular attention to the heavy artillery the Americans had in Normandy. He inspected some of the gun emplacements and returned to Mount Farm with a high opinion of his old branch of the service.

New pilots and a replacement Spitfire added to the 14th Squadron's rosters. The new Spitfire arrived early in the month to replace the one destroyed in the crash, which killed the squadron's commanding officer, Major Haugen. Spitfires were in short supply. The RAF had priority but the British tried to keep up with the 7th Group's needs. The Engineering Department worked hard to keep up with the servicing of aircraft that had to fly as many sorties a day as the weather allowed. Captain Nelson assigned the new Mark XI to SSgt Willie Naylor who thought the engine sounded a little rough and made sure it ran perfectly before declaring it ready for a mission.

Major Bliss welcomed the new pilots into the squadron but made sure they understood they had work to do before flying off to face the enemy. The mechanics of Flight A had the most to say about the major's requirements for the new men. They had three flyable Spitfires. TSgts Nisoff and Miller, and Sgt Koskelo needed time and a half to keep them in the air as the new men followed their C.O.'s orders to get in 15 hours local flying time before qualifying for operations. Just like most of the pilots before them, they had bumpy landings, roller-coaster take-offs, and overheated engines as they learned to fly the Spits. The line men despaired. "They are just learning to fly and learning on our planes too."

Some of this chatter was justified by the unfamiliar controls and manner of the Spitfire, but these men were not learning to fly. The transfers had a different effect on squadron and group clerks as pilots moved about between squadrons. One lieutenant, Louis M. Gilmore, transferred from the 13th where he had flown seven missions while Lt. Bruce Fish had 150 hours civilian flying time before joining up. He immediately transferred to the 14th when assigned to the 27th. Arthur K. Leatherwood, the only first lieutenant, had been a flight instructor. Originally assigned to the 13th he preferred Spitfires. Whichever squadron they came from, these men were a cross section of experience. All were young, Leatherwood was the oldest at 23 and the youngest, Lt. Gerard A. Glaza was 20 that month. Paul A. Balogh, whose parents were Hungarian, joined the army in 1940 and rose to staff sergeant before entering flight training. Robert B. Hilborn worked at Lockheed as an electrical repairman and Irving L. Rawlings, also 20, was a bookkeeper. The only flight officer in the group was Fabian J. Egan who previously had served with the Airborne Engineers.

Dicing Noballs
Fair weather over the Pas de Calais allowed Operations to assign several pilots to more low-level sorties on Noball

Flight Officer Ed Vasser after returning from first mission is greeted by Capt Harry Witt. Both pilots served with the RAF.
(John Weeks)

sites. The V-1s continued to fall on England and interpreters needed continuing cover to locate new firing sites as well as evaluate damage to older ones. The low altitude flights, often called by the British term "dicing," often drew heavy opposition from ground batteries. Capt. R. L. Kendall took one sortie and returned with low level obliques in the Boulogne area without attracting flak.

Lieutenant Bruns diced Noball targets returning with good photos in spite of a heavy haze and enough opposition for several missions. Light flak batteries sent up 100 bursts. Bruns also had several hundred rounds of tracer machine gun fire directed his way and spotted four twin engine enemy aircraft when he regained some altitude. Three of them attempted to intercept him near Offrethun Airfield and he returned to treetop level under full power to escape. The fighters pursued him all the way to mid-Channel before he lost them.

Lt. Albert Clark and F/O Ed Vassar crossed the English coast on their way to get photos of airfields in central Germany. Clark sighted a convoy going NE out of Emden and immediately contacted British Communications control. Based on his report, the RAF sent out a flight of Beaufighters to attack the convoy, which they did with success. British papers gave the attack on the convoy good publicity. It was a very successful example of cooperation between allies and services.

Flight Officer Vassar completed his mission and returned to Mount Farm. As usual, like all photo pilots, he buzzed the field. Not since the record low level buzz of "Doc" Hughes had anyone misjudged his altitude to the detriment of an airfield structure. The control tower was Vassar's target. His F-5 clipped the tower, removed an antenna and several bricks. No one was hurt but the tower and aircraft needed repair. Men from the needed departments fixed the structure, the C.O. "counseled the pilot," and the 381st Air Service Squadron repaired the aircraft.

381st Air Service Squadron
The 381st took over the F-5. Under Crew Chief TSgt Willard Andrew's directions, TSgt Alvin Johnson, SSgts Edwin Moeller, and William Rudeck repaired the damage to tail, flaps, scoop, left nacelle, and leading edge. They completed all the work on number 616 and transferred it back to the 13th Squadron on the 28th of July. Three days later it went back into action when Lt. Taylor M. Belt flew a successful sortie mapping the Brest Peninsula in the aircraft.

Besides repair work on other squadron's aircraft, men from the 381st took care of some of their own needs in July. Volunteers spent hours working on a Squadron Day and Recreation Room, completing their work in five days. The Duty Room got a new look with the removal of a partition, which the Welding Shop replaced with a specially constructed roof truss. Men in the Carpenter Shop built a crap table. The new room took on a finished look with a new paint job, and major refurnishing by Special Services who supplied furniture, ping pong table, and a battery-powered radio. Electricians from the Electric Shop installed a new electrical system. In the Base Radio Shop, Sgts Daniel Nagler and Joe Bognar converted the radio to an electrical set. The 381st had a new place to enjoy leisure time when they could manage to find some.

During July, the 381st installed cameras in a B-26 for another unit. Four men, SSgt John V. Larkin, Sgts Robert J. Geyer, Jasper L. Fegette, and S.A Giada from the Sheet Metal Shop did the major overhaul. They had to remove the bomb bay tanks and auxiliary equipment to make the installation. After they finished their part of the work the 381st returned the B-26 to the depot on 30 July.

Under the direction of Crew Chief TSgt Robert E. Dout; SSgts Arthur Croteau, Naphtali Checkoway, and Lonnie Milford repaired electrical trouble, and changed an engine and turbo-charger in an F-5 of the 27th Squadron. The aircraft went back to the squadron on 25 July ready for operations.

A crew of three, SSgts Edwin P Moeller and William Rudeck, with Sgt Wallace Mitchell, under the direction of Crew Chief Bernard Hesemann, repaired the badly damaged F-5 flown by Lt. John Richards on the 7 July low level mission covering V-1 sites. They made major repairs to the nose door and its activating cylinder, right prop spinner, elevator, lower left rudder and stabilizer, left horizontal stabilizer lip, and elevator cables. The 381st sent number 67331 to the 27th Squadron on 16 July where Lieutenant Stamey checked it out with local flights before Capt. Hubert Childress flew sortie 2452 on a damage assessment mission on 24 July.

Mitchell Killed
A sortie to Strasbourg, Stuttgart, Munich, and other German targets ended in tragedy on 20 July 1944. Soon after Lt. Robert L. Mitchell of the 22nd Squadron took off to cover his targets he radioed the tower that he had mechanical problems and was returning to Mount Farm. Unable to reach the base, Mitchell died when his F-5 crashed two miles short of Mount Farm in an open field near Clifton Hampton.

Eyes of the Eighth

Durst Killed

The 22nd Squadron lost another pilot, one flying his first operational mission. Assigned to the squadron on the 17th, Lt. Edward W. Durst went on a sortie in formation with three other pilots, mapping in the St. Malo area of France on 24 July. Lt. James B. Mathews led the mission; Lt. Harold G. Wier flew left wing, Lieutenant Durst, the right wing with Lt. Alexander Kann flying immediately behind him. The four pilots crossed the Channel and flew down along the western side of the Cherbourg Peninsula. As they flew over Guernsey in the Channel Islands, the German anti-aircraft batteries fired heavy flak accurate for altitude but about 200 yards behind. No one was hit.

The four F-5s approached the French coast at 24,000 feet in clear weather. Durst seemed to fall behind. As they neared the St. Malo area, Durst made a wide sweep to the left. Mathews saw the F-5 pass over him and almost collide with Wier. Mathews tried to call Durst on the radio but there was no answer. The plane fell off in a steep dive. Lieutenant Durst did not answer their calls. Weir and Kann lost sight of his plane when it passed through 15,000 feet, but Mathews saw him fall another 12,000. Durst died instantly when his F-5 crashed next to a hanger on the edge of Ploubalay airfield near Plombiers, France. When the three pilots returned to Mount Farm, they told their story to Operations and said they thought that something had happened to his oxygen equipment and anoxia caused his crash rather than aircraft failure. In France, the Germans buried the American pilot in the Community Cemetery of Ploubalay.

Parsons MIA

The next day, another group from the 22nd Squadron took a mapping assignment over the Brest Peninsula. It

Lt Edward B. Parsons, surrounded by German captors on the beach at Parame near St Malo after being shot down and ditching in the bay on 24 July 1944. This film belonged to a German who left it in an office in Guernsey, Channel Islands, where Flt Lt B. Winspear of the RAF liberated it in May 1945.
(B. Winspear)

Sunday sightseers inspect Lt Parson's F-5 67116 *Katy*, on the beach after German barge raised plane from bay and hauled it onto the sand. (B. Winspear)

was the 35th mission, the end of a tour, for Lt. Edward B. Parsons. After photographing his area Parsons decided to make a low run along the coast past the island monastery, Mont St. Michel, toward St. Malo. German observers spotted Parsons' plane and reported his course to the flak batteries at the fortress port town of St. Malo. Less than 2,000 feet above the water, Parsons' F-5 dashed down the coast. The German batteries opened up firing tracers and light flak.

Parsons saw tracers coming up between his tail booms. Explosions rocked his F-5, knocking out one engine. Parsons knew he could not recover at this altitude and pancaked into the water along the waterfront near St. Malo. His plane sank into the bay; he struggled to get free from his harness, parachute, oxygen lines, anything tying him to the wreckage. Something held him in the cockpit. Water flooded in. His foot was wedged under a pedal and Parsons fought to free himself. He pulled his foot out and burst from the cockpit toward the surface. The pilot popped up to the surface gasping for breath. He treaded water, his Mae West holding him up. In the distance he saw a crowd gathering on the shore and a man in a kayak paddling toward him.

A German paddled alongside and ordered Parsons to swim to shore. When he protested the man threatened him with a pistol. In good high school German, the American protested but the German continued to wave the gun at him. With this encouragement, Parsons, who was a good swimmer, started toward the waiting crowd. He swam to shore under protest through what he thought might be a mine field. Germans in various uniforms, French civilians, adults, children, and dogs greeted his arrival. On this Monday in July he was the attraction of the day.

Taken prisoner and removed from the beach, he learned that a barge retrieved his plane and dragged it up on the beach. After the German authorities officially inspected it, the curious civilian crowds climbed all over it. At Mount Farm the mechanics on the 22nd Squadron Flight Line, Operations, everyone, waited in vain for the

150

Parsons

Lieutenant Parsons glared back at the German in the kayak and swam toward shore. He feared he was in a minefield. His protests brought only a wave of the pistol. Soon Parsons waded in waist deep water between the pyramids of iron stakes set to gut landing craft. He took off his Mae West and, in a last minute sign to any American aircraft that might fly over, he tore up his yellow dye marker packets and pushed them secretly into the water. Someone might see them and know he had survived. Parsons knew Walt Weitner and "Tubby" Carlgren had not followed him down but someone else might see the yellow stain and report it.

A colonel advanced toward him shouting German at Parsons as the pilot came dripping up the beach. "What kind of papers do you tear up?" When Parsons protested in his poor German, the angry colonel yelled, "You speak German. That's final proof. *Sie sind der Spion.*"

"No. *Nein*. I speak terrible German." After being called a spy, Parsons offered his dog tags as proof of his status but the angry officer said they could be faked. Then he shouted orders to all the men to get into the water and search for the "secret" papers torn up by the spy. Enlisted men and officers, some in summer dress uniforms, waded out and floundered in the bay looking in vain for bits of paper.

Fortunately, the volatile colonel calmed down and sent Parsons to a large house where they stripped him of his wet clothes and gave him a robe to wear. When his clothes had dried, they returned all but his underwear and socks, which they withheld in retribution for their dip in the sea. Parsons suspected they might be looking for laundry marks. One of his captors tried to intimidate Parsons who repeatedly invoked the Geneva Convention. With a Nazi caricature performance the German inferred, "Ve haf vayz to make you talk." This brought smothered smiles from the other Germans standing behind the interrogator and a half smile from Parsons. Betrayed by his companions, the tough talker turned and gave them a disgusted look. There were no more questions.

A Luftwaffe sergeant arrived and took his prisoner to the airbase at Rennes. Some of the pilots shared tea and cantaloupe with the American pilot. They wanted to know where he came from in America. He knew he should not say anything but Parsons told them he was from Chicago. One had an uncle there. Another said that Parsons' war was over for which he should be grateful. Ed Parsons had less-than-comforting thoughts about POW camps and felt that the German pilots were jerks not to know how awful it would be. Each new aggravation made Lieutenant Parsons testier and his ability to speak French and German meant he usually knew what his captors were saying. It also meant he could needle them in their own language.

His guard, Sergeant Geseler, then took him by car to the civilian jail in Laval to spend, with official apologies, the night with criminals. Parsons' nearest companion could talk to him through a drain gutter between the cells and identified himself as an Italian deserter. When Parsons said he was an American pilot, the Italian called him a murderer and they said no more.

The next morning, his sergeant escort took him by truck to the Collection Base at Chartres where the Germans held prisoners awaiting transport east in the chapel of a convent. There were four or five other Americans, some British, a few Poles, and two South Africans, all pilots. The convent was near a bridge that bombers attacked several times during Parsons' stay. He and the other prisoners watched the statues sway with the shock from nearby explosions. One very close hit blew open the heavy double chapel doors. They hit the young German standing guard, knocked his helmet down over his eyes, and almost made him drop his rifle. He was visibly shaken. About ten minutes after the raid he came over and asked if anyone spoke German. Parsons volunteered. The young soldier qualified his question saying that he knew they were not going to lose the war but just in case, "What are you going to do with us?" Parsons was the wrong man to ask. He looked around to see if anyone could overhear and whispered jokingly that he thought the Germans might be sent to the salt mines in Siberia.

Later, the guard changed and within minutes, an irate lieutenant came in waving a gun and wanting to know who said the Germans were going to Siberia. All the prisoners looked at Parsons. "Parsons, is that what you told him, you idiot?" The lieutenant continued to rant and rave waving his pistol at Parsons. When he calmed down, he began a lecture on Germany's holy crusade to save Christianity, Western Civilization, and the freedom of mankind from the Bolsheviks. He informed his captive audience that the Russians were savage barbarians. Parsons assured him his German was too poor to have told the young soldier about saltmines. During each exercise period, the lieutenant continued his lecture to Parsons on the crusade as they walked. Parsons was relieved when he left for his prison camp.

Eyes of the Eighth

return of Ed Parsons and his aircraft. When time ran out for his arrival, his squadron listed him as missing in action.

New C.O. for 27th Squadron
The 7th Group removed from flying status and transferred Maj. Ray Mitchell to Group Headquarters. It replaced him as C.O. of the 27th Squadron with Capt. Hubert Childress, a veteran pilot originally from the squadron and only recently added to the Group Headquarters' roster after his service at Eastern Base Command in Russia

One of the major jobs done by the Group, mapping of the Brest Peninsula, dominated assignments of the last few days of July. From the 24th of July through the 31st, all squadrons participated in this program.

An Uninvited Mosquito
Activities in the Communications department usually started winding down around five in the afternoon. One man hard at work on 31 July, SSgt William Black, manned the Direction Finding (DF) station. Long hours of daylight in the summer meant sorties leaving far later than usual. On this particular day, a huge mapping assignment over the Brest Peninsula sent over 30 aircraft up within one 30-minute period. Anyone out on the field could see them assembling overhead and pairing off for their assigned parts of the job. In the DF station, "Blackie" handled radio check calls that came in bunches. At one time he answered six pilots simultaneously. After they climbed out to head for France, business calmed down until the planes returned.

By dusk, all the planes had landed safely. The station was quiet. The sergeant received a call from an unknown ship. Its pilot wanted instructions for landing. Black gave him the information but the pilot radioed back that he could not find the proper runway. Even flares shot off to indicate the right one did not help and the pilot set his plane down on the wrong runway headed straight for Black's DF hut. As fast as he could, he turned on the lights, opened all the windows, and bolted out the door. Its two powerful Rolls Royce Merlin engines roaring, a lost Mosquito stopped 20 feet from Black's recently vacated station.

Operation Cobra
During July, 7th Group photographs recorded battle action below its PR aircraft. Photo pilots covered more and more tactical targets giving the pictures to Intelligence documenting ground forces' attempts to break through fierce enemy defenses. On the ground, the battle to liberate France cratered the beautiful Normandy countryside with bombs and artillery shells. The Americans captured St. Lo after fierce fighting on 18 July and pushed toward Coutances. Their objectives were a line between the two towns and a break out of the hedgerow country. The British, still shut out of Caen by heavy concentrations of German armor, planned a major assault on the German lines. Operation Goodwood, launched on 18 July and supported by massive air bombardment of the area in a technique called carpet bombing, failed to achieve the expected breakthrough. Photographs taken of the Caen area by Lt. John Richards showed pockmarked fields criss-crossed by thousands of tank tracks.

Originally scheduled to follow Goodwood, Operation Cobra, the Americans' attempt to break out in their sector, had to be delayed. Then poor weather, which prevented the necessary air support, delayed Cobra again. On 24 July, B-17s of the Eighth's 1st, 2nd, and 3rd Bomb Divisions bombed the Periers/St Lo area in support of Operation Cobra. The Ninth Tactical Air Command supplied heavy air support for the attack. Expected to begin early in the morning, ground haze caused cancellation of the operation, but a few of the Ninth's formations did not get the message an accidental release of bombs fell on American troops.

Finally on 25 July Cobra began with massive carpet bombing before the assault. Eighth Air Force B-17s and B-24s of 1st, 2nd, and 3rd Bomb Divisions again bombed the Periers/St Lo area. The attack by the US First Army under the command of Gen. Omar Bradley was aimed at smashing the German lines in France between Caumont and the sea in an offensive directed toward Avranches. Again, accidental bombing within Allied lines killed American ground troops. The worst fears of opponents of this type of close air support were realized. Lts. Max Alley and W.G. White of the 27th Squadron covered the area successfully bringing back photographs of the destruction below. By 28 July, Coutances, the first objective of Cobra, was captured. In one sense, the failure of the British breakout in Operation Goodwood achieved more success by attracting a large share of the German armor to the Caen area. By 30 July, Cobra forces captured the crossroads town Avranches and its vital bridge over the river See. Then on 31 July they captured the equally important crossing of the Selune at Pontaubault. American forces sealed off the Contentin Peninsula and Patton's Third Army armor rushed across the captured bridges pouring into French countryside more conducive to tank warfare than the Normandy hedgerows. These achievements opened the way for events in August.

August 1944

Chapter 11
August 1944

Operation Cobra effectively sealed off the Cotentin Peninsula. Forces on the ground in France exploited the breakthroughs at Avranches and Pontaubault. General Eisenhower had used his most audacious general successfully as commander of FUSAG, the fictitious army that "threatened" the Pas de Calais. Now Eisenhower wanted an aggressive army on the right flank of the Allied forces to drive the Germans out of Brittany. He assigned the job to Patton and the newly formed US Third Army. Patton struck south and westward toward his objectives in Brittany. His armor rushed across the bridge at Pontaubault and fanned out toward Rennes and St. Malo in terrain more conducive to Patton's brand of tank warfare than the Normandy hedgerow country.

Patton moved fast. All ground forces wanted swift photo coverage of their areas and maps for attacks. He wanted them immediately or sooner. His forces poured through the breech in the German lines. The mapping of the Brest Peninsula that had dominated so much of late July kept the army supplied, but detailed area maps around Lorient, Rennes, St. Malo, Vannes, and as far as Quimper, Brittany, filled the 7th Group photo assignments on the first day of August.

Patton's was not the only voice crying out for more cover. Requests came from other forces headed east toward the Seine River. Mapping sorties covered areas southwest of Paris in the Chartres region and another area north from Laon to the vicinity of Lille. The 7th Group sent mapping sorties to the Nancy-Verdun section from Liege south to Lyons, and the Nevers-Dijon region

Pilots go over maps and photos in ready room. (R. R. Smith)

from Bourges east to Besancon. Boxes traced on the master map of France at the Allied Combined Interpretation Unit began to fill in with cover bearing 7th Group sortie numbers.

Tactical targets continued as part of regular cover with photos of canals and railroads searched for enemy troop and supply movements. As fast as the ACIU noted concentrations of barges or railway cars, Eighth Air Force heavies or Ninth Air Force tactical bombers attacked the targets.

Operations designated areas of the Continent to different squadrons for primary cover. The 22nd Squadron's assigned area during the first 16 days of the month was bounded on the east by a line from Fecamp on the English Channel, to Marseilles on the Mediterranean; west to the Atlantic Ocean and south to the Spanish frontier. One of their clients was the Third Army. The squadron mapped areas immediately forward of the American Sector of the Allied lines. Included in the assignment was damage assessment of both tactical and strategic bombing. The 22nd's cover of rail lines immediately to the rear of the German Seventh Army revealed the movement of troops and supplies to this beleaguered force. By the middle of August the German Seventh would be in dire straights, all photographed by this squadron of the 7th Group.

Windsor Killed
The Operations Officer of the 22nd Squadron, Capt. D.A. Farley, along with Intelligence officers, planned the missions and assigned targets. On 1 August, Operations assigned mapping in the Vannes area to Lt. Robert D. Windsor. The pilot covered his targets, crossed the Channel on his return flight to base. He had not encountered any opposition. As he neared Mount Farm, Windsor had trouble with his F-5, and unable to control the aircraft, crashed at Culham. Killed in the crash, Lieutenant

Major Robert R. Smith discusses mission with Major McBee. He holds his maps and escape kit in his right hand. (R.R. Smith)

153

Eyes of the Eighth

Windsor became the first person from Mount Farm buried at the new American Cemetery at Madingley, near Cambridge.

Hot August weather caused a problem of tire blowouts with the very reliable Spitfire. Annoying on the ground, these blowouts were dangerous on landing and take-off. On 1 August, Lt. John Blyth's Spitfire blew a tire canceling his mission. The Engineering Officer, Captain Nelson and his crew chiefs decided the hot weather was only adding to an already bad condition with unsatisfactory wheels on landing gear of the older model Spitfires. Supplies for the British aircraft went first to the RAF. Just trying to find new wheels, which were in short supply, took a special sort of "scrounger." The 7th Group had just such a man, W/O "Pop" Porter. He had a reputation, just short of notorious, for his ability to disappear in one of the Group's utility planes with a shopping list of impossible requests. Captain Nelson told Porter what he needed. A pilot flew the warrant officer wherever he wanted to go and about 18 hours later Nelson had the parts in stock. Within a couple of days the crews had the wheel problem solved. When Engineering personnel found their wants supplied they did not ask where the pilot and his passenger had been. Rumor was that Porter could talk anyone, including tough British supply officers, out of anything. No one asked any questions; they just went about using the booty.

Komet

After diversion of the Eighth Air Force's bombers in support of the D-day preparations and interdiction campaign in France, strategic targets returned to the program in July. Back to the top of the target list for both bombers and photo planes went the oil refineries, storage depots, synthetic oil plants, and allied industries. All came under heavy attack. The fuel situation became critical for the Germans with an estimated half of their production cut by these raids. Assessment cover kept the special section at Medmenham able to offer to the targets committee valuable data of production losses. On 2 August, Lt. Gerald Adams, a recent transfer to the 27th Squadron, took the assignment for damage assessment of oil targets deep in Germany. Unable to bomb in Germany this day due to heavy cloud, the bombers hit targets in France. Operations had German targets on a priority list and decided, as it frequently did, that a photo plane should be sent out. The Weather Officer did not promise Adams any holes in the clouds but a few might appear and if they did — take pictures.

Adams took off from Mount Farm in his F-5 at 1740 hours. He flew through overcast into Germany and spotting some breaks below, Adams turned on his cameras. "I was way the Hell into Germany near Halberstadt when I saw what appeared to be an airplane, probably a German fighter, about five miles away to the east and above. I thought, 'no problem.'" Adams finished photographing through the hole and looked again to find the aircraft had cut the distance in half. Realizing he did have a problem, he turned westward toward England. The pilot pushed his RPMs to the maximum and trimmed his airplane. "I looked up again and he was back there firing at me."

Lieutenant Adams was about to meet an incredible new German aircraft, the Messerschmidt 163, which the Germans called the *Komet*. This was no ordinary plane. It was the world's first operational rocket fighter. The *Komet's* mission was as *Objektschutz-Jager* or target interceptor and this day its target was the lone F-5. The little fat bat-like planes were not operational as yet and encounters with Allied planes came during combat training. Now, one of the Luftwaffe pilots was about to practice on an unarmed 7th Group photo plane.

Astonished at an aircraft that could catch his F-5 so easily, Adams thought it was "a really weird looking airplane with little puffs of smoke coming out of its tail." Adams was at 33,000 feet when the *Komet* attacked. "I just went down, straight down, in a weaving kind of pattern." The *Komet* followed the F-5 down and Adams ran for cloud cover below him at about 12,000 feet. The rocket plane had tremendous speed but could not maneuver into firing position on the F-5's tail. "I kept going straight down, which is kind of exciting too, and it took me about 5,000 feet more to get straight and level. The cloud sort of tapered down and I came sailing out the other side heading for England with the windshield and canopy frosted. I was trying to rub this down and get squared away when here come the tracers again." Adams darted back into the clouds and stayed there as far as he could. With the *Komet's* extremely limited fuel supply, the Luftwaffe pilot had to break off and the strange little fighter was not there when Adams emerged from the cloud again.

The 27th Squadron pilot returned to Mount Farm at 2200 hours where Capt. T. "Trip" Russell and other intelligence officers debriefed him on the mission. Adams' account of the interception caught their interest. They questioned Adams much longer than usual and he felt they thought, "I had lost a little of my reason." The 14th Squadron's Intelligence Officer, Capt. Jim Mahoney, listened to Adams, previously with the 14th, give his description of the speedy stubby-winged fighter that puffed smoke rings out its tail. There had been rumors and there had been fuzzy photographs but this was the first encounter for these men.

August 1944

A few days later, his C.O. asked Adams if he "didn't want to go to the Red Cross Camp down south someplace?" It took only a moment for Adams to accept. "Hell yeah, I'll be glad to go." The *Komet* incident had been worth three days rest and recuperation.

On the same day as the *Komet* attack, Lt. Albert Clark of the 13th Squadron managed to photograph the Wetzlar Optical Plant and Giessen A/F in Germany before turning back with an oxygen regulator malfunction. Near Brussels at 29,000 feet, an enemy fighter intercepted him but he evaded by diving to 16,000. Ten minutes later, two more fighters attacked Clark who dove away and went down to 2,000. The pilot lost the fighters but ran into ten bursts of flak near Hesdin, France. The inaccurate flak missed his plane and he reached the French coast without damage, safely returning to Mount Farm with his photographs.

Aggressive enemy fighter action continued against another 13th Squadron pilot on his assignment to Brussels, Belgium, the same day. Flying just his third mission, Lt. Gerald Budrevich ran into two enemy aircraft between Brussels, Belgium, and Lille, France. He evaded his attackers and returned safely to Mount Farm. Budrevich had encountered his first enemy aircraft.

Not all sorties that day met opposition and in spite of the cloudy weather over the Continent, many brought back pictures. The pilots turned their cameras on over clear areas and took targets of opportunity or secondary targets when cloud or haze covered their primaries. Early in the morning, Lt. J.B. Matthew's flew an F-5 on a meteorological flight reporting back to the weather office and Intelligence. Lt. Glenn Wiebe, also of the 13th, covered Koblenz Marshaling Yard and Airfield as well as the Weisbaden RR Station, a factory in Russelhelm, and other targets in Germany. The Belgian pilot, Lt. Charles J.J. Goffin, of the 14th Squadron took his Spit XI and covered damage assessment of marshaling yards at Saarbrucken and Kons/Karthaus. Some pilots enjoyed the break from mapping in front of the ground troops.

Aphrodite

Not all missions covered regular bombing targets. On 4 August, Lieutenants Anderson, Batson, and Brink of the 13th Squadron were assigned to photograph a special Eighth Air Force mission in the Aphrodite project. Aphrodite was designed to attack difficult German targets such as heavy concrete sub-pens that had remained impervious to the heaviest bombs. The Eighth Air Force established a special unit equipped with war-weary B-17s stripped of all their armament and packed with 20,000 pounds of Torpex explosive. Two men, a pilot and an engineer, flew the B-17 drone off its home airfield climb-

Smoke billows from an oil refinery at Hamburg after 3rd Bomb Division B-17s' strike. Lt Robert N. Florine, 27th Sq covered target after 4 Aug 1944 raid. Towering cloud of smoke casts shadow across the shoreline on right. The main refinery is outlined in rectangular box. (J. Byers)

Capt George Nesselrode, 14th Sq, covered damaged assessment of the same refinery the following day. Smaller fires continue to burn, seen in upper right corner of enlargement of boxed area. Parallel lines of storage tanks in upper right corner of 5 Aug Photo can be seen in upper right corner of box on 4 Aug Photo. (J. Byers)

Eyes of the Eighth

ing to under 2,000 feet. While the pilot flew the plane in a box pattern, the engineer brought the onboard electronic double Azon guidance system under the contol of a "mother" ship flying above. When the B-17 "baby's" autopilot answered the double Azon controller in the "mother" ship, the crew set the detonating mechanism and bailed out. At this point the "baby" became a true drone. Aphrodite missions had fighter cover, extra aircraft used as observation by necessary personnel and interested parties, "mother" ships, and photo aircraft to record the flight and result. On this mission the three PR planes accompanied the control aircraft and drones out over the North Sea but something went wrong and the drones crashed into the sea without hitting the target. The mission failed but the 7th Group brought back excellent photographs of the flight.

A 27th Squadron pilot, Capt. Robert Floyd had a close call on 5 August when he returned from a mapping mission with one engine out. On his approach to the field he discovered that he could not lower one of his wheels. He circled the field for two hours but could not budge the jammed landing gear. Finally he made a perfect belly-landing without too much damage to his aircraft and none to himself.

Mapping returned to the 7th Group's program. Forward units of the ground forces swept across Brittany to the outskirts of St Malo and halfway to Brest by 3 August. Rennes fell on the fourth, and Laval on 6 August. The drive not only swept westward to clear Brittany but also eastward around the German flank toward Le Mans. Mapping ahead of the armies took on a frantic pace. The 13th had two groups of three aircraft mapping in the Paris area on 6 August. Two enemy aircraft bounced the first three, Lieutenants Clark, Elston, and Budrevich, near Rouen. Having completed most of their runs they beat it for home. Later in the day Lieutenants Batson, Bickford, and Schultz covered the Le Mans-Paris mapping job without interference.

Blyth's DFC
Operations assigned targets at Fallersleben, Brandenberg, Berlin, and other heavily defended targets in Germany to Lt. John Blyth on 6 August. He crossed in over enemy territory and made Berlin where he discovered only one third of his cameras were operating. Camera failure rarely occurred. Blyth, determined to cover his targets, figured out how he could change his route and time over target. He flew his photo runs using the only operating cameras, spending twice as long over the targets as originally planned but he covered them all. When the lieutenant's Spitfire stopped in the dispersal area his crew found only six gallons of fuel left in the tanks. Lieutenant Blyth received the DFC for his mission.

Sgt Carl Rosenberger of 13th Sq views negatives through light box. (Robert Jung)

Caen
Disappointing British ground attacks against the German lines near Caen failed to dislodge the Panzer forces preventing further advance in the British and Canadian sectors of Normandy. Heavy bombing just prior to an attack might stun the German forces allowing deeper penetration in the enemy lines. Bombers struck the front on 8 August

Capt Gordon L Puffer, 22 Sq; Lts John F. Orth, 55th Station Complement; and James F. Connors, 18th Weather Sq on balcony of Control Tower. (L. Exner)

August 1944

in a tactic known as "carpet bombing" prior to an advance by the Canadians. The controversial concentrated close support bombing near Allied troops, just as it had in some previous attacks, resulted in "friendly" casualties. Lt. John Ross of the 22nd Squadron followed the bombers to cover the attack and came back with his pictures filled with the smoke of battle, bomb bursts, and the bomber formations. The area south of Caen was pitted with craters and traced with tank tracks.

On 8 August 1944 the 13th Squadron's senior Intelligence Officer, Major Lytton W. "Pappy" Doolittle left Mount Farm for reassignment stateside. Doolittle was a fixture in the 7th Group and had earned his rest. Although he never received the Purple Heart everyone thought he deserved for plaster wounds in the Intelligence Room's tussle with "Doc" Hughes' F-5 propeller, he had the admiration and affection of all his comrades.

Shoop Returns
When Col. Clarence Shoop left Mount Farm and the 7th Group in Col. Norris Hartwell's capable hands to return to the United States, he envisioned spending his time working on solutions to P-38 problems. At each stop, whether the Pentagon, Wright Field, or Lockheed's Burbank plant, all anyone wanted to talk about was the invasion. This was not what he planned but after the initial excitement, he managed to get his work done. During his stay Stateside, while flying back and forth across the country reporting on aircraft performance and problems in the ETO, Colonel Shoop met, wooed, and wed the beautiful movie actress, Julie Bishop. Even the wedding did not go as planned. Rushing to get blood tests and a marriage license, the couple discovered the friend's house they planned to get married in was not in the same county as the issued license. Not to be deterred, the wedding party, Justice of the Peace, and guests grabbed the Champagne, hopped into cars and drove down to a small woods on the property but across the road in the correct county. Another change in plans, a snag at the Lockheed plant delayed the arrival of parts Shoop was taking back to England. This gave the newlyweds a few days together before the colonel had to return from leave. A quick round-trip to Lockheed's plant in California, a visit to the president's home at Hyde Park to pick up a few things Mrs. Roosevelt wanted to send over for her son Elliott, and Shoop headed for the relative calm of Mount Farm.

Colonel Shoop arrived at Mount Farm on 8 August and happily greeted his friends. They headed for the farm house Shoop called home. He opened the door and two pony-sized dogs almost knocked him over. With this collision, Shoop met *Blitz* and *Blaze*. The colonel discovered he no longer had top priority on his own base.

Bill, Tommy, Burr and *Blaze*. (Bill McGivern)

His Wing commander, Col. Elliott Roosevelt, staff, cook, and English Mastiffs had taken over the farm house. The president's son had taken over his bedroom as well. Eventually, this arrangement became less disrupting, especially when Shoop no longer had to go out in the cold dark mornings for breakfast.

Clark Killed in Action
By 9 August, Third Army units surrounded Brest and Lorient, pushed within a few miles of Nantes on the Loire River and captured Le Mans. There they began a two pronged attack, one toward the Normandy area to encircle the German troops still fighting there, the other toward Chartres and thence to Paris. Two 13th Squadron pilots, Lts. Albert Wesley Clark and Frank M. Sommerkamp took mapping assignments in the Tours-Paris area. Sommerkamp returned to base alone and reported to Intelligence about the mission. He and Clark completed mapping an area near Amboise, France, with Sommerkamp flying wing man and were on a course of approximately 340 degrees near Chartres. "We were at 21,000 feet, I was 100 yards behind and to the right of Lieutenant Clark when I spotted four unidentified aircraft at approximately the same altitude and at 4 o'clock."

Sommerkamp reported that he gave a radio warning to Clark and then started a diving turn. Clark also made a diving turn and called Sommerkamp. He asked how close the other aircraft were. Sommerkamp told him, "very close." Then Clark passed under his wing man

with his belly tank still on, diving and headed in the right direction for home. Sommerkamp thought Clark knew where the enemy aircraft were but a short time later he saw what he thought was an F-5 behind him at 7 o'clock, in a spin, trailing smoke with several aircraft around. Over his radio, Sommerkamp heard Clark call, "Sommerkamp, I'm on fire." He couldn't understand the rest but it sounded like Clark said, "I'm getting out." Continuing on his same course, Sommerkamp called but Clark did not answer. He returned to base and reported that the last communication he had with Clark was at 1345 hours. Later, Eighth Air Force Headquarters confirmed to 7th Group that Lieutenant Clark had been killed in action.

Hartwell Missing in Action
With Colonel Shoop back as Group C.O., Col. Norris Hartwell became Deputy Group Commander. Hartwell had flown occasional missions, several low-level sorties over Noball sites, while C.O. in Shoop's absence. On 12 August, he took an assignment over the dangerous V-1 sites again. When he did not return and no word came that he had landed elsewhere, the Group knew he had gone down and listed Hartwell as missing in action.

In France, south of the Normandy beaches, the German 7th Army's counter-attacks which began on 7 August and succeeded in capturing Mortain, now were being worn down. Ultra supplied warning to the Allies that the attack would take place. In spite of Hitler's refusal for a pull-back, events forced the Germans into a fighting withdrawal. Allied forces attempted to trap them near Falaise where remnants of the 7th Army managed to escape but paid a terrible price. All of the mapping done in the area by photo planes supplied ground forces with up-to-date cover and maps.

Two 14th Squadron pilots covered targets in Germany, Lieutenant Blyth in the Munich area and Lieutenant Gilmore targets along the Swiss border. Two German fighters bounced Gilmore and prevented him from turning towards England. He was forced to run from his attackers as far as Geneva before losing them and flying on to land in Sardinia. The Paris area drew three other pilots, Lts. Leatherwood, Rawlings and Fish, the latter two getting excellent cover. Leatherwood's targets were cloud covered but he returned with other photos of airfields east of Paris.

Targets deep in Germany were assigned to two of the 14th Squadron pilots sent out on 9 August. Captain Nesselrode covered oil targets and Captain Dixon, damage assessment targets in the Munich area. Lieutenant Davidson returned with cover of Strasbourg and Quesnay.

Kennedy Killed
One of the 7th Group's assignments in the late summer of 1944 required a photo recon plane to assist documentation of experimental use of drone aircraft. The first such mission had been on 4 August when Lieutenants Anderson, Batson, and Brink had covered the failed attempt by four drones to attack all four of the biggest V-weapon sites. The heaviest bombs presently available had not destroyed the thick concrete constructions in the Pas de Calais. These sites, which Colonel Hartwell and Lieutenant Richards covered in their low-level flights in July, (photograph of St. Pol/Siracourt appears on Part III page number 83) no longer remained on the regular bombing program after 22 July, but became test targets for the Aphrodite program.

Two more unsuccessful attempts on 6 August led to the abandonment of the Double Azon guidance equipment that had been used until more sophisticated systems arrived. At the same time, a United States Navy program being tested by a unit stationed at Dunkeswell, used a different drone control and detonation system. The drone aircraft, B-24 Liberators with the Navy designation PB4Y-1, used Lockheed Ventura "mother" ships. Isolated at the remote airfield at Fersfield in Norfolk, the volunteer crews had faith in their aircraft.

Two particular concerns worried the scientists and technicians responsible for Aphrodite. Were the Germans using radio signal "jamming" techniques to divert the drone aircraft? More important to the success of the next planned mission was the concern that the electrical detonation system used in the Navy drone might be unstable. Air force technicians thought the Navy system was unreliable in spite of apparently successful testing, which had not been in a loaded drone.

On 12 August, the target was Mimoyecques. The formation of ships gathered in the air near the airbase at Fersfield. The callsign of the day was *Zootsuit*. Two Ventura PVY-M "mother" ships; two observation and relay B-17s; two Mosquito aircraft from the 25th Bomb Group, one a weather plane, the other a photo ship; a P-38 observation plane flown by the base commander; and one F-5, all accompanied by four P-51 fighters flying cover, made up the entourage. Two other interested parties, Generals Partridge and Doolittle observed the whole operation from their individual fighters. An F-5 callsign *Zootsuit Orange*, flown by Lt. Fred Brink, was there to cover the mission for the 7th Group.

The drone or "baby," *Zootsuit Black*, in spite of its callsign, was highly visible gray-white. Special ordnance crews had loaded it with 20,570 lbs. of Torpex, an explosive over one and a half times as powerful as TNT. The load also included 600 lbs of TNT for detonation

August 1944

charges. Originally scheduled for 11 August, the mission to Mimoyecques was "on" for the afternoon of the 12th. The accompanying aircraft gathered above as *Zootsuit Black* waited on the runway. An air raid siren warned the base of the iminent take-off.

Lieutenant Kennedy and his radio man, Lt. W.J. Willy, took off at 1805 hours and began the prescribed flight plan to bring the drone under control of the guiding *Zootsuit Red* "mother" ship flown by Lieutenant Lyon. The first leg of the journey away from Fersfield toward Saxmundham went according to plan. The controller in *Zootsuit Red* received the signal "Spadeflush" from Kennedy and began to take control of the drone. Kennedy's plane made a perfect left turn and levelled off heading for the next checkpoint. Suddenly, at 1820 hours the Torpex laden drone disintegrated. Both crewmen died instantly. The 25th Bomb Group photo Mosquito flew through the center of the fireball and came out the other side badly damaged but flyable. Below, on Sir R.B.M. Blois' estate between Blytheburgh and Walberswick in Suffolk, the blast flattened a grove of trees and rained tiny fragments of wreckage on the land.

The largest pieces that investigators found from the explosion were chunks of the engine blocks. There were no clues but the electrical detonation system became the primary suspect. New arming wire and fuses in a safer system replaced the old one on new Navy equipment. Sensorship prevented full disclosure of the incident. The secret mission death of Lt. Joseph P. Kennedy, Jr., the eldest son of the former United States Ambassador to the United Kingdom, generated countless rumors about the event. The Aphrodite project would continue.

A Record Day

Whenever good weather combined with a long shopping list for photos from its customers, the 7th Group flew as many sorties as possible. Most of the requested cover on 14 August was mapping in two main areas; Beauvais, north of the Seine; and Paris. The Group flew 56 missions for the biggest day of the month. Working around the clock, the Photo Lab turned out 71,000 prints, 59,000 in 24 hours. The more targets covered the more Operations removed from the Group's programs. As before, many pilots flew two sorties. Line crew and men from Camera Repair kept their equipment ready to go. Even when so many successful missions removed jobs from the board, more requests kept coming in. The Group had routine cover in the event nothing special came in. That was rare if not unheard of.

Film magazines stack up outside Photo Lab as result of 56 successful missions flown on 14 Aug 1944. Within 24 hours they would turn out 59,000 prints. (Ross Garreth)

More film arrives for processing on 14 Aug. (Ross Garreth)

Bruns and Smith Fail to Return

The commanding general of the United States Strategic Air Forces in Europe, Carl Spaatz fervently believed that the destruction of Germany's oil industries would cripple its ability to wage war. Oil targets topped his priority list and only bad weather and commands from higher authority prevented his bombers from striking hard at Leuna, Lutzkendorf, Brux, Politz, and Ruhland. Photos taken as soon as possible to assess what damage had been done and whether production had been seriously affected meant high priority on these targets for the 7th Group as well. When SHAEF allowed the bombers that had been concentrating on tactical targets in July to begin the all-out assault on oil, the Germans recognized the danger. As always, they made aggressive attempts to protect their plants with heavy concentrations of anti-aircraft — the second most numerous flak batteries in Germany. Fighter aircraft stationed nearby had orders to protect these facilities from both bombs and cameras. Increased attacks on photo aircraft proved that the Germans knew how valuable PR

Lt Waldo Bruns on occasion of Air Medal presentation by CO Norris Hartwell earlier in year. (John Weeks)

intelligence was. Spaatz also believed that increased attacks on the air industries complemented those on oil. Cut the head *and* tail off the beast.

On 14 August, Lt. Waldo Bruns, operations officer of the 13th Squadron and his squadron commander, Maj. Robert Smith were in Operations looking at jobs on the board in their squadron's newly assigned area. Bruns pointed toward two names and said, "Bobby, the weather is good over Cottbus and Sorau. Let's go get 'em."

Bob Smith knew those targets had been on the board a long time. The previous squadron had been unable to remove them. Now they were in his 13th's "slice of the pie." He had told his people he wanted to get those targets off the board. He agreed to go. Cottbus and Sorau were in Silesia, east of Berlin. All the pilots knew Sorau even if they had not been there. The prisoner of war camp, Stalag Luft III, was at Sagan near Sorau, and they all had seen aerial photographs of the compound. They had friends there.

Bruns and Smith checked with the Weather Officer and laid out their flight plans. Smith took Cottbus; Bruns, Sorau. An oil plant at Ruhland and a POW camp at Muhlberg could be picked up on the way back. They suited up. Until they were on their way, the flying suits and fleece lined boots would be hot on this warm August afternoon. The two F-5s left Mount Farm and climbed out toward the Channel. Since Cottbus and Sorau lay less than 60 miles apart, the two pilots flew within sight of each other in clear skies all the way to the targets. After they made their runs, they would rendezvous for the flight back. Smith covered his target and Bruns photographed the Focke-Wulf plant at Sorau. Together they turned their F-5s into the sun toward home.

Ten minutes out from their targets, four Focke-Wulf 190s bounced them. Both pilots pushed the throttles to the firewall, pulled back on the sticks and climbed away from the Germans. The 190s disappeared. The two planes streaked across northern Germany. Below lay nothing but dark green forest. Out of the nothing came deadly clouds of heavy, Ruhr-type flak. Bruns and Smith racked their planes up and changed altitude in evasive moves. Neither pilot could see anything below but forest and it was sending up heavy flak.

Flak burst and hit Smith's right engine. As smoke seeped into the cockpit, he throttled back and put Waldo Bruns in the lead. Smith flew on his wing. For a few minutes Smith fought the smoke trying to keep his right engine running. His temperature gauges, oil, coolant, and engine were hot. Bruns radioed Smith, "Here they come again." Below they saw some cloud – the first they had seen all day. They dove down and flew through the gray shelter. It seemed to be about 2,000 feet thick and their cover lasted three or four minutes. When they came out the other side the 190s had disappeared again.

Smith's dive into the cloud layer had pushed his temperature to the peg and he had more smoke in his cockpit. "I had a tough time flying on Waldo and we went along for three or four minutes and here they came again. This time there were eight of them. The two flights of four started to scissor us – one from one direction and one from another so when we would break we'd be breaking away from one attack but into another." Smith lost his right engine. "It just went *clang bang whack* and stopped running. I trimmed the plane out and said to Waldo, 'Take off. I'm leaving you.'"

Major Smith put his plane into a dive. "It was the only thing I could do." He heard Bruns radio, "Good luck and goodbye," then saw the F-5 respond to full throttle and disappear toward the west. That was the last he saw of his wingman. The smoke was very acrid and burned Smith's eyes. He could barely see and didn't know how many planes followed Waldo and how many stayed with him. He guessed four.

Looking back Smith saw his four had broken up into two flights and kept up their scissor attacks. "I would see the other airplanes coming towards me and their guns blinking. When they shot out my cockpit and I took a slug across the knee, I decided this was a losing battle. I've got one engine, I can't keep my eyes open, I've got four guys firing at me and my cockpit instrument panel has disappeared." Smith jettisoned his canopy and stood up to bail-out. "I was in a hurry 'cause I didn't disconnect my oxygen feed or go onto my oxygen bail-out bottle and I did not undo my shoulder harness and safety belt. I say I stood up – about two inches."

Smith sat back down and undid the belts, pulled back on the stick, and as he went out of the cockpit, the edge of the parachute where it joins the dinghy caught on the

August 1944

Taking a few moments off are L to R: Johnny Connors, Ross Garreth (in doorway), Tommy Gillean and Charlie Hinchee (seated) Irv Carr, Bill Goetz. (Ross Garreth)

back rim of the canopy. "I hung there for what seemed like hours with the wind screaming through my ears thinking this was a helluva way to get caught up." Suddenly Smith fell free. He opened his chute and saw the ground a long way off. The pilot hung there swinging back and forth. It was quiet. In the distance he saw two fighters follow his smoking F-5 down until it crashed. A confirmed kill on their cameras. Then they turned and headed back toward Smith, little planes growing swiftly until their cowlings got bigger and bigger. Hanging there under his parachute Smith saw the gun ports grow. Would they shoot him? One 190 seemed to Smith determined to fly right through him but the pilot veered off at the last minute. "I thought I could see a smile on his face." His canopy was rolled back. "He saluted and I was so relieved I saluted back."

The FW-190s left their victim and disappeared. Bob Smith was about to make his first parachute landing. "I had no anticipation of how fast that last 30, 40, 50 feet would go." The impact came suddenly and sharply. Excrutiating pain shot through one ankle. Smith had made a hard landing in Germany.

In England, at Mount Farm Airfield, ground crews waited for two pilots. The crew chiefs knew when the fuel supply ran out. They had to wait for word from Headquarters if Bruns and Smith had made it to other fields. After the invasion there were fields on the Continent where a plane low on fuel or crippled could put down. Many pilots had used available strips before. After three days, they knew the news was bad. Two new names went on the list of the Group's missing in action: Lt. Waldo Bruns and his 13th Squadron commander Maj. Robert R. Smith.

Commendation

The Wing C.O. Col. Elliott Roosevelt issued a formal memorandum commending the 7th Group on behalf of the Eighth Air Force, its commanding officer General Doolittle, and Wing. In addition, the Group received a commendation from the Eighth through Doolittle citing the 7th Group for "extraordinary heroism, work, and accomplishments" during the 31 days between D-day minus 7 to D-day plus 24. During this period, the Group assigned a total of 474 missions, 42% of which were accredited and 342 were successful for 80% coverage of objectives.

The weather cooperated over much of the 7th Group's primary target areas on 15 August allowing 36 aircraft to attempt cover in France, Belgium, Holland, Luxembourg, and Germany. The next day, poor weather allowed PR coverage mainly in Germany and Holland. The night before, an old friend of Colonel Shoop's came to visit. Shoop and Lt. W.F Blackburn had been in flying school together but Blackburn had never flown a P-38 before. On the morning of the 16th, Shoop saw that he checked out in one of the F-5s and after a successful local flight, the C.O. arranged an operational sortie for the afternoon. He, Lieutenant Blackburn, Major Chapman, and Lt. J.L. Anderson took off to cover airfields in Holland and northern Germany. When the four returned to Mount Farm, the Group celebrated its 3,000th mission, which was flown by Lieutenant Anderson.

Lt John Anderson, 13th Sq, completes 7th Group's 3,000th sortie on 16 Aug on mission covering airfields in northern Germany. (John Weeks)

161

Robert R. Smith

A swarm of Germans came out of a building Smith had just floated over. On bicycles and on foot they rushed toward the American. Smith thought a nearby woods offered his only chance for escape if his injured ankle would hold up. He stood up, unbuckled his chute, and started to run. Pain shot through his body. He blacked out and collapsed on the ground.

Smith opened his eyes and stared into rifle barrels. Over him stood six angry home guards. "They had me cold." Poking him with their guns they made Smith get up and walk, each step on his ankle an agony. The American tried by gesture and pidgin English to tell his captors that he had sprained his ankle. Every step was hell. They jabbed him again. *"Mach schnell. Mach schnell."* He couldn't hurry up but they pushed and prodded him toward the village town hall of Geitheim.

A crowd collected. Inside, the villagers pushed forward to see the American *Luftverbrecher* in their midst. Civilians often killed the men they called air gangsters and this crowd had even more to be angry about. A man who spoke English said that the Allies had landed in the south of France that morning. Smith told him, "For you the war is over." He shouted, *"Ach! nein.* Oh no, Doctor Goebbels says now we go to all-out war." The people listened to the exchange. The air crackled with tension. Testily, the German told him that they had phoned the Luftwaffe and he was going to prison camp. Under the circumstance that seemed good news to Smith.

After dark, about nine o'clock, a touring car pulled up to the town hall. A Luftwaffe officer took charge of the prisoner and Major Robert Smith rode to the airbase at Altenborn between two enlisted men with drawn pistols. There they put him in a cell and had a doctor look at his wounds.

The German major spoke English. He dressed a wound on Smith's knee and looked at the bad ankle. "*Ya*, yes, it is broken and it's a bad break." He said they would have to take the American to another hospital to take care of the break. Then he looked up at Smith and told him, "You know there was another Lightning shot down this evening." Bob Smith felt a chill. He and Waldo had the only two Lightnings that deep in Germany that day. He asked, "What happened to the pilot?" The doctor said the pilot was killed.

When alone, "Smitty" thought about his lost friend. He had been so sure Bruns would outrun the 190s. It occurred to him that the Luftwaffe had tried very hard to bring down these two particular photo planes. Sadly, they had succeeded.

The next day, his captors sent him by train under guard to Leipzig-Wahren where Smith spent the night in a compound for British enlisted men. They had a Polish doctor, who, without facilities to set the break properly, put a temporary cast on his ankle. After another trip by train, Smith arrived at Frankfurt with a single armed guard. By now, he had been supplied with crutches and a small box of Red Cross items. Alighting from the railcar, the guard escorted Smith toward another platform. Hobbled by his injury, juggling crutches and the small but awkward box, Smith clumped along behind. After going a long way down the platform, the guard decided he had chosen the wrong route and retraced his steps. The major followed behind, stumbling and swearing at every painful step. Finally, they arrived at a small spur railway and boarded a tramcar.

For several miles, the tramcar rolled along toward the outskirts of Frankfurt toward the Taunus Mountains. Local passengers got on and off, all eyeing the American pilot and his Luftwaffe guard. Their interest ranged from curious through hostile but this was the regular route to Oberursel and they were used to seeing captured Allied airmen. The tramcar stopped outside the wire-encircled camp lying in a cleared part of the forest. This was *Auswertestelle West*. Technically The Luftwaffe Intelligence and Evaluation Center, to airmen it was better known for one department, the Interrogation Center.

Here, expert English-speaking Germans tried to gain valuable information about Allied air forces. In spite of the Geneva Convention's prohibition against such activities, the Germans used various ruses to get details airmen were forbidden to give. Name, rank, and serial number. That was all they had to say.

Bob Smith hobbled through the wire gates into the large compound. His guard handed him over to the Luftwaffe personnel who took him to a cell and locked him in. It was small. There was one window but the glass was opaque and Smith couldn't see out. He had a bucket in the corner, a narrow bed with a straw-stuffed paper-ticking mattress, a wooden stool, and a small table. Smith saw a light bulb hanging from the ceiling but no switch. The light, like the heater in the cell was controlled by the guards. He didn't know it yet but that light would burn all night. Instead of keeping him warm, the heater was either off in cold weather or turned to the maximum during hot. Crippled and in pain, Smith waited. For what, he knew not.

August 1944

Ninth Air Force to France

Neighbors at nearby Chalgrove airfield, the Ninth Air Force's 10th Photo Recon Group, a tactical outfit, began its move to France on 16 August 1944. Colonel Cleveland of the 325th Wing received a request from General Vandenburg of the Ninth for the 7th Group to cover assignments normally handled by the tactical unit, which he accepted on 18 August. Wing ordered the 7th Group to cover Ninth Air Force targets during the 10th PR Group's move to France. Added to other duties this new tactical cover increased sorties as much as personnel and weather would allow. The Photo Lab, with the required extra production, added new men to supplement its usual complement.

Another added job for the Lab was the processing of night photography flown out of Watton by members of the 25th Bomb Group, a member of the 325th Reconnaissance Wing. After completing the night sorties, the 25th's Mosquitoes landed at Mount Farm within a few hours after midnight and the crews turned the film magazines over to the Group's technicians. Camera repairmen had to learn how to remove and service the cameras from different aircraft than their usual F-5s, Spitfires, and the B-25.

The Ninth Air Force, which had drawn many of its staff from Eighth Air Force personnel and many of the photo recon men from the 7th Group, claimed another when Group Photo Officer Capt. Conley Hayslip transferred with the Ninth to France. Previously, Captain Neilson of the 22nd held that position until his assignment in Russia. Now, another 22nd Squadron man, Capt. Gordon Puffer took over the job. The new assignments, usually done by the tactical PR unit, meant extra work all around but coping with heavy work loads characterized all of the departments on the base. The recently established courier service added the new Ninth Air Force Headquarters field at Laval to its regular stops.

New 13th Squadron C.O.

On the morning of 17 August, Capt. George Nesselrode told the men of the 13th Squadron that he had been assigned to take over the squadron until "Smitty" came back. The weather over the Continent prevented any operational sorties but a few pilots made local flights while others went to airfields in England on various duties. Colonel Shoop's friend, Lieutenant Blackburn flew co-pilot with Lt. R.S. Quiggins in the British-made twin-engine Oxford to A-9, an airfield at Le Molay near Bayeux. This field was a regular stop on the courier flights, Lt. Benton Grayson having made a flight there earlier in the day.

New Aircraft

After suffering losses in July and early August, the 22nd Squadron increased its inventory of aircraft with the return of F-5C 42-67128, *Dot & Dash* from Russia. The aircraft went back to its previous crew chief, TSgt G.L. Mock. Engineering assigned two new F-5Es to crew chiefs SSgt J.C. Ginex and TSgt T.H. Schoenbeck. Along with the new F-5s, the squadron received a new and unusual plane, a P-38J assigned to SSgt R.J. Milligan. With a Plexiglas nose extension and room for extra equipment as well as a bombardier, the model acquired the nickname of "Droop Snoot" at the Operational Engineering Section at Bovingdon. Its major creator was Col. Cass Hough, an innovative experimenter and test pilot. Developed mainly as a fighter-bomber it usually carried a bomb sight and was used as the lead aircraft in fighter-bomber attacks. This particular "Droop Snoot" had another purpose and was intended for, among other things, radar emission searches.

DFCs and Bronze Stars

The 325th Wing Commander Colonel Roosevelt wanted to present awards and medals at ceremonies accompanying a big parade by the 7th Group. Planned for 19 August, the day came and the wonderful sunny weather turned gray and rainy. Everyone waited for a break in the weather but finally the Group canceled the parade and held the awards ceremony in a big hangar. Colonel Roosevelt presented the Distinguished Flying Cross to the new 13th Squadron C.O. Captain Nesselrode and pilots: Lts. J.L. Anderson, Robert Moss, and Frank Sommerkamp who also received a Purple Heart. The colonel awarded the DFC to two others, Maj. Robert Smith and Lt. Waldo Bruns, both missing in action.

Two 13th Squadron enlisted men, TSgt Edwin L. Wolcott and SSgt Delmar B. Harris had Bronze Stars awarded to them for their maintenance and service of the squadron's planes. Also on the line for Bronze Stars on 19 August were two 14th Squadron men, TSgts Sam W. Quindt and Earl E. Kinder, commended for outstanding mechanical skills in maintain-

British-made Airspeed Oxford from 381st Air Service Sq in flight. (Riggins)

163

SSgt Delmar Harris, Crew Chief for Lt Frank Sommerkamp's F-5, stands with hands in pockets. Harris received a Bronze Star for maintenance and service of the 13th Sq Aircraft.

ing and servicing aircraft under their care. The 22nd Squadron had two men awarded Bronze Stars for outstanding maintenance work: MSgt Evan A. Price for excellent work as Flight Chief of Flight B and TSgt Philip O'Donnell for amassing 60 missions with his F-5 114.

Good work and ingenuity in all departments was a hallmark of the 7th Group. Men from all types of work experience and background saw problems and solved them without the red tape of official form requests if possible. Sending an idea for a solution to Wright Field for it to be digested and filed for reports did not get much done over on the flight line, or in the photo lab or camera repair. A 22nd Squadron Camera Repair man, MSgt Edgar C. Erwin, worked out a solution to sticking shutters in the K-22 camera. He figured out that the shutters jammed because there was too much heat in the camera compartments. A simple solution solved the problem and prevented further jamming.

Innovations by men of the different squadrons helped solve problems in more than mechanical and technical fields. Something as ordinary as the inconvenient location of an Orderly Room could cause dislocation within a squadron. The 14th Squadron headquarters building was separated from the enlisted mens' billeting area during the squadron's first year at Mount Farm. There was little opportunity for the officers to have much contact with the enlisted men under their command. Their C.O., Maj. Cecil Haugen had suggested that a new Orderly Room be built in the billeting area. Haugen and Captain Kendricks had met with squadron carpenters, SSgt Raymond Heath and Sgt Ross Franklin, to plan the project. They recruited Sgt Ed Douttiel from the Chemical Warfare Department and went to work on a design. Heath planned and supervised the construction using Captain Kendrick's idea of utilizing empty glider crates for siding. Using the crate size, Heath laid out the plans. Sergeant Harkrader hauled two glider crates to the site from the Base Carpenter Shop. There, they dismantled the crates, cleaned the lumber, removed and straightened the nails for reuse. Nails were a scarce commodity on the airbase.

During the construction, Major Haugen died in the crash of his Spitfire north of the base. The new commanding officer Major Bliss heartily endorsed the idea and work continued. Without proper supplies, the three men improvised making roof trusses from ribs of old drop-tank crates. Until they found some tar paper for the roof, Heath and his crew used old aircraft tarpaulins. Some parts appeared from unknown sources but usually the three enthusiastic builders begged and scrounged what they needed. Finally it came time for the squadron telephone man SSgt Bob Arnott to connect the new Orderly Room to the rest of the base via two telephone lines. Major Bliss moved in with congratulations to all.

Summer in Russia

At the Eastern Command in Poltava, PR shuttle flights between Italy, England, and the Russian bases covered targets unfamiliar to interpreters and plotters. The Photo Intelligence Section, originally located in the Headquarters building, moved after the air raid to a location in an apple orchard. One Photo Interpreter officer and an enlisted man interpreter operated the section. A Russian non-commissioned officer photo interpreter worked with the Americans. After 10 August four more P.I.s arrived from the Mediterranean Allied Photo Reconnaissance Wing (MAPRW) in Italy to assist in the large volume of cover. By late August, 90 PR sorties had been flown into Poltava and interpreted by the American section. The Russian interpreter helped identify new and unfamiliar targets. One major problem could not be overcome by relocation or the assistance of a Russian P.I. Moscow

August 1944

Russians watch as one American waits his turn while two Red Army women barbers — out of uniform — work in an orchard. Having their hair cut L: Bill Litowa. R: Dick Brown of the Photo Lab at Poltava. (R. Brown)

often refused permission for aerial photography in certain restricted areas no matter how much it interfered with American bombing plans. The Russian Photo Interpretation Officer at Poltava, in contrast to his Moscow superiors, helped out in any way he could.

Not only the Interpretation Section moved to the orchard after the bombing. The hospital and the Photo Lab also set up their sections there. The Lab worked whatever hours they had to when PR sorties or bombers arrived with film. On occasions, the work load could be handled quickly leaving a few hours off for recreation or necessary non-photo related jobs such as supplementing the early food rations. When they first arrived at Poltava, the 7th Group contingent ate Russian food served on china plates set on white linen tablecloths with silver flatware. Unfortunately, the food consisted mainly of greasy pork and boiled cabbage. After this unappetizing fare, American rations were familiar and welcome. Food was always a subject for conversation and complaint. A correspondent wrote that when visiting the Russian bases he saw "hundreds of GIs eating vast quantities of American canned food – Spam, baked beans, and applesauce – drinking gallons of good coffee, making passes at the giggling Ukraine Canteen waitresses..." To supplement the canned Spam, powdered eggs, and such, the men of the Photo Lab sneaked out at night and harvested their own supply of roasting ears of corn and cucumbers for dill pickles.

Foraging was not limited to nearby fields. There were plenty of ruined buildings in the area to furnish bits and pieces to improve facilities in and around the 7th Group's contingent in the orchard. After moving there, the Lab men set up two parameter tents, one inside the other to get as dark a space as possible. Then they painted the canvas with whatever dark paint they could scrounge. From bombed out areas they gathered bathtubs and pipes to get water to the lab.

Operations in the apple orchard became more sophisticated. The Russian photo technicians worked well with the Americans and received the best on the job training possible. The Americans processed the film for First and Second Phase Interpretation and the Russians did the printing. The two groups worked well together except for one problem having nothing to do with language. During the hot summer, the newly painted and closed tents became unbearably hot. The Photo Lab men from the cooler English climate had to learn to work in the closed area with Russian soldiers who had not bathed in a week and had eaten garlic sausage for breakfast.

Nothing like your own dill pickles. Three 7th Group photo lab men at Eastern Command adding variety to their meals. L to R: Dick Brown, Doug Cumbers, and Bill Rudnicki. (R. Brown)

Dick Brown and Bill Litowa copy a photograph in an improvised outdoor lab using the bright Russian sun for lighting. (R. Brown)

Eyes of the Eighth

Dick Brown and Sam Burns with film magazine and camera installation from an F-5 in front of one of the Photo Lab tents at their base in Poltava. (Larry Redmond)

When the work day was over, the Americans turned on Radio Berlin to listen to Tommy Dorsey and other good bands. Dick Brown noticed how much the average Russians liked American things but he also noted that their superiors did not want them corrupted by capitalist ideas and materials. Each little group of Russian technicians had its advisor who made their men leave rather than be seduced by Tommy Dorsey. These same men did not keep the Russians from stealing anything that was not nailed down.

At first the Americans had few luxuries. Small necessities such as hair oil and combs were non-existent and the men substituted glycerin for their hair and used a community comb. This prompted them to begin a barter system by unloading the 12" camera from the nose of a shuttle F-5 and sending the plane back to Mount Farm with bottles of vodka and champagne along with a "want" list. When an F-5 flew back to Poltava, any spare space might be filled with necessary items as well as magazines and special treats. One plane arrived with assorted "wants" including a case of Mail Pouch Chewing Tobacco for Bill Rudnicki.

One night after finishing their regular work, the Photo Lab men were running movie film preparing it for showing to the base. Film that came in from Tehran usually needed repair and splicing before it could be shown. Lieutenant Buster's men took care of this job after work. This evening, Dick Brown was in the group working on the film when they heard a commotion in the bushes. Russians from a nearby anti-aircraft battery had sneaked into the 7th Group's area and stolen a number of things including Bill Rudnicki's case of chewing tobacco.

The Lab men raced after the robbers to recover what they could and found themselves under small arms fire from the battery's revetments. The non-combatant photo specialists dropped to the ground and crawled on their bellies firing back with their side arms. During the lively firefight, the voice of the Lab Chief Lt. Alan Buster sounded out, "Damn it fellows, someone's likely to get hurt." Fortunately, no one was. The Russians dropped most of what they had stolen and Bill Rudnicki recovered his tobacco. From then on, the Americans posted a guard at night.

Not all Russians stole. Some were particularly gracious and generous. They risked punishment because their commanders frowned on friendships with the Americans. The crew chief of General Permanoff's personal plane, was very friendly with the photo men. The chief, who was equal to a U.S. master sergeant, invited Dick Brown and Doug Cumbers to meet him in town and he would show them around. When they arrived at the appointed place, the Russian greeted each of them with a large bouquet of freshly picked flowers and then took

Lt Everett Thies, on the right, with TSgt Daniel Noble, his crew chief on *Dot & Dash* in Poltova, Russia. Thies flew sorties in *Dot & Dash* out of Bari, Italy, to Poltava beginning in June. At the end of August, Thies completed his tour and flew *Dot & Dash* back to Mount Farm where its former crew chief, TSgt Guy Mock took over maintenance. Noble remained in Russia servicing other 7th Group aircraft. (Christy/Ethell/USAF)

Cumbers and Brown on a tour. After hearing how much the Americans missed fresh milk, the crew chief later crawled on his belly from his area to bring his GI comrades vodka bottles filled with fresh milk. No one knew who informers were and the political superiors tried to prevent fraternization.

Pilots from the 7th Group flew sorties in and out of Poltava from Italy and Mount Farm. Some would stay in Poltava for a short time, flying missions in and out of the base. Then they would return either to England or Italy and begin shuttle flights again. Most schedules depended entirely on Russian permission that came from Moscow. It was not always forthcoming in time for requests but that was the Russian way. After the shooting down of Lieutenant Rowe in June, the Russians increased their intervention under the guise of safety.

Fortunately, the American pilot was recovering. For part of his recuperation, Lt. David Rowe stayed at the hospital set up in the orchard. The 325th Wing removed him from the active duty list and, when he could travel, assigned Rowe to the Casual Pool of 12th Replacement Control Depot where he waited return to the United States. For his injuries suffered when shot down by the Russian Airacobras he received the Purple Heart.

Night Photos
During August, the 25th Bomb Group flew 7th Group's B-25 Miss Nashville out of Mount Farm and Watten on more night photo sorties over France. Operations included Dilly, the photo reconnaissance of V-weapon sites with the assistance of night flash bombs and Joker, similar night flash photography of other targets including transportation choke points on road and rail. These flights hoped to reveal movements made by German forces under cover of darkness. Harried during the day by fighter bombers, the Germans tried to move troops and supplies by night. The 25th Bomb Group used *Miss Nashville* early in August when Major Hoover of Wing flew three missions out of Mount Farm on the nights of the 3rd, 4th, and 5th. The targets were in France. Anti-aircraft batteries opened up on the black painted B-25 as it passed over Allied lines. It was Allied flak. Several hits on the plane convinced Operations at the 25th Bomb Group that flight courses might better come in beyond Allied lines rather than over them. *Miss Nashville* flew three Dilly flights on 11, 12, and 13 August with three Joker flights following on the 16th and 17th.

In France, the Germans withdrew rapidly toward the Belgian border ahead of advancing British and Canadian forces. American ground and air forces pursued the retreating Germans toward Paris as well as southeast France. The massive withdrawal was so rapid that the liberation armies overran many of 7th Group's assignments before sorties could be dispatched. It also set up the situation that led to planning for airborne landings in Holland in September.

One of the 13th Squadron pilots flew a sortie into Germany on 19 August to cover Halberstadt and Hopsten Airfields, as well as an aircraft factory at Magdeburg. Realizing he was near his father's birthplace, Lt. Fred Brink flew over the little town of Hovelhof, near Paderborn. Brink covered 20 additional routine airfields and towns to complete a very successful sortie.

Wiebe Killed
The Luftwaffe protected any area vital to Germany's synthetic oil production vigorously. The Brux area of Czechoslovakia, along with the refinery-thick Leipzig-Merseberg-Leuna area of Germany had particularly heavy fighter and flak defenses. Both Smith and Bruns had been lost on missions over such heavily defended areas. On 23 August another pilot went on a sortie to one of the hottest areas of Germany: Merseburg, Bohlen, and Rasitz near Leipzig. Promoted to first lieutenant just the day before, Lt. Glen Wiebe failed to return. The Group officially listed him as missing. Then further word received from Headquarters confirmed that he had been killed in action near Freiburg, Germany.

Paris Free?
The front lines marched swiftly across the maps in Intelligence and the pilots' Briefing Room. On 23 August 1944 a bulletin broadcast on the BBC proclaiming that Paris was free prompted someone in Operations to mark the city with a notation "liberated." Excitement grew when CBS broadcast a radio message from American correspondent Charles Collingswood describing the liberation of the city. The 7th Group C.O. Colonel Shoop, scheduled for a photo mission in France, heard the good news. He and two other pilots, Group Operations Officer Maj. Carl Chapman and C.O. of the 27th Squadron Capt. Hubert Childress, decided to fly over the French capital during their mission. Public Relations men wanted first photographs of the most famous city free of the Nazis. Shoop intended to furnish them the pictures.

The swiftly advancing Allied ground forces reached the Seine River northwest and southeast of Paris on 19 August. Natural defensive positions along the Seine River running through the city were formidable. Paris had been laid out with broad avenues and central commanding points for military reasons as well as esthetics. Old fortresses, which appeared in their star-like symmetry on aerial photos, ringed the city. A dug-in defender could cause havoc on attacking troops as well as count-

Eyes of the Eighth

less miseries to the civilian population. For these reasons, General Eisenhower and the SHAEF staff were reluctant to attack Paris. Haunted by the specter of destructive street by street warfare in this jewel of history and architecture, they planned to bypass the city.

Another war within the city concerned the leader of the Free French Forces, Gen. Charles DeGaulle. He knew that a powerful and ruthless Communist organization that had offered strong resistance against the Germans planned to take over the city at the first sign of German weakness. As the front lines inched closer on three sides of the city, the non-Communist underground had its own plans to prevent that takeover.

General DeGaulle understood the aims of the Communists to take over France, as well as Paris, using arms dropped to them by the Allies. The general realized that he would have to act alone. DeGaulle went behind everyone's back in London and sent orders halting arms drops in the Paris area where the Communists outnumbered all the other resistance organizations. He also advised General LeClerc that he must be ready to make a run for Paris when the time came. Then DeGaulle would install his own government.

On the night of 18 August the Communists tried to surprise the other resistance organizations. They did not succeed. The anti-Communists moved first and took over a most important objective, the Prefecture of Police. Thus began the fighting in the city of Paris. It was a four-sided battle between DeGaulle's followers, Communists, revenge-driven citizens, and the German occupiers.

Hitler had a new tough commander in Paris. Maj. Gen. Dietrich von Cholitz had orders to make it a fortress and front line city. The short, fat, monocled Prussian brought a brutal reputation to his job. Behind him lay the ruins of Rotterdam and Sevastapol. "It has been my fate to cover the retreat of our armies and to destroy the cities behind them," he said. When von Cholitz took command of Paris on 10 August he had just returned from a meeting with Hitler. In the Wolf's Lair, von Cholitz had seen the madness in his Fuhrer. The general's confidence was shaken.

Fighting ebbed and flowed. Parisians saw the mining of their beloved city's most beautiful and historic buildings and bridges. Again they answered the call to man the barricades. Pressure on Eisenhower increased for the Allied armies to aid the insurrection and save the city. Inside Paris, Charles Collingswood of CBS feared that disrupted communications would prevent his timely dispatch describing the city's liberation. He recorded one in advance and sent it to CBS in London for release at the right time. On the morning of the 23rd, Hitler ordered von Cholitz to reduce Paris to, "a field of ruins."

In London, a French officer deliberately released a false bulletin to the BBC hoping to force the Allies' hand. The BBC broadcast the bulletin and CBS followed with Collingswood's account. Celebrations began in England. Paris is Free! Unaware of the violent fighting in the city, someone at Mount Farm pasted a note next to Paris on the Intelligence Room map, "Liberated!"

Just after three in the afternoon, Shoop, Chapman, and Childress, took off to cover Loire River bridges from Blois to Cosne. Poor weather sent them north to Paris. They sighted the city and dropped down to 5,000 feet to make some "tourist" runs up the Parisian boulevards. Over the center of the city, a fierce barrage of flak blossomed all around them. The pilots took evasive action and broke off either to seek altitude or get "on the deck." They met up again over the English Channel and returned to Mount Farm undamaged but in less than good humor. All three stomped into the Intelligence Room for the mission debriefing. On the way out, one of them scrawled "nearly" next to "Liberated" on the map next to Paris.

That night in Paris, the Germans prepared the Eiffel Tower for destruction and Parisians "prepared to go to sleep on mattresses of dynamite..." The next day, the French Second Armored Division moved on the city. Late that night, the first three tanks broke into Paris. On the 25th, the rest of the division's armor entered the city. After fierce fighting they raised the *Tricolore* on the Eiffel Tower. Unable to destroy the city in a losing cause, von Cholitz surrendered. At four thirty in the afternoon, General DeGaulle returned to Paris and established his primacy as leader of the new French Republic.

Intelligence still needed cover in the heavily defended area of Ruhland, Brux, and Leipzig. Operations sent three 14th Squadron pilots into the area on 24 August. Capt. Walter J. Simon went first with targets at Brux and Paderborn. Half an hour later, Lt. John S. Blyth left to cover Ruhland and Freihal. Maj Kermit E. Bliss' targets included Merseburg and Bohlen. An ME-109 bounced Blyth at Dresden. In his attempts at evasion, he ended up over Brux where fires burned from bombing attacks. He covered Brux and went on to Ruhland.

All the way in to his targets, Blyth thought of Glen Wiebe who had been lost near Freiburg the day before. Blyth and Wiebe discovered in conversation one day that they had both started the first grade together in the small town of Dallas, Oregon. The extraordinary coincidence, considering that they were two in a class of only 25 and had not seen each other since, kept coming to mind. Now, all Blyth could think of as he was flying into the "hot" targets was, "What if two boys from the same little town

August 1944

Paris. F-5s flying up the Seine River within days of the liberation of the city. Aircraft in circle flies past Eiffel Tower on right. In the distance just to the left of the tower are the white domes of Sacre Coeur on Montmartre.

got it in the same damn place." Fortunately, Lieutenant Blyth returned safely to Mount Farm with his pictures.

The 13th Squadron gained five new pilots on 24 August with the arrival of Capt. John G. Austin, Lts. Donald B. Bayne, Ross Madden, Charles B. Finley, and Stanley V. Hazlett. At the same time, the 13th's intelligence officer, Lt. John J. Shatinski transferred to the 22nd.

On 26 August, the 13th's pilots received two new jobs, mapping the Siegfried Line and the Rhine Valley. Operations assigned these sorties to Lieutenants Schultz, Brogan, Elston, and Belt, as well as, Capt. Dale Shade and Lt. Hector Gonzalez. The latter two pilots had returned to the squadron on 21 August from leave in the United States. Rapid advances had the ground forces running off the maps as fast as they could be produced. Everyone hoped the Allied armies would continue to run off the new maps and bring a swift end to the war.

The Ninth Air Force's tactical targets of the fighting just south of Paris needed cover. While the Ninth's PR group settled in to its new bases in France, the 7th Group continued to cover many of the unit's damage assessment targets. On 27 August, Lieutenant Brink and Flight Officer Vassar of the 13th Squadron successfully covered the tactical assignments.

The next day, the 7th Group covered more Ninth Air Force tactical targets. Lieutenant Bickford of the 13th took the assignment for damage assessment of three targets in the Rouen area and three in Brest. He successfully completed the job, the only sortie for the

Eyes of the Eighth

Brux Synthetic Oil Plant in northwest Sudetenland of Czechoslavkia. Capt Walter Simon and Lt John Blyth of 14th Sq took off at noon to cover strikes by 3rd Bomb Division B-17s on the plant. Blyth also covered other oil targets bombed that day at Ruhland and Freital. Simon covered the 1st Bomb Division target at Kolleda Airfield.

Refineries for crude oil, either from Germany or imported, supplied 26% of all finished oil products but 90% of lubricating oils. Synthetic oil plants produced oil from from bituminous and brown coal, which was plentiful in Germany. Of the two processes, Fischer-Tropsch and Bergius hydrongenation, the latter was the most important. These installations supplied almost 50% of all oil products. More importantly, Bergius hydrogenation comprised nearly 100% of aviation fuel. Three of the largest Bergius plants were Leuna, Politz, and Brux. In this photograph taken on 24 Aug. (A) the most critical location and aiming point, the gas plant, lies under heavy smoke. (B) Smoke rises from the Tar Plant. (C) Cooling Towers. (D) Refinery. (E) Hydrogenation stalls.

(J. Byers)

August 1944

day. The weather closed in on the Continent and the Group managed only two more sorties during the month, both on 31 August.

During a month with record days for operations, maintenance got special notice. The F-5 67114 *Maxine*, flown by Capt. Malcolm D. Hughes, became the first 7th Group aircraft to finish 50 missions. A record all the more remarkable because it was *Maxine* that Hughes flew into the roof of the Intelligence Building. No mechanical failure ever caused this 22nd Squadron aircraft to turn back from an operational mission.

By the end of the month the 7th Group had amassed a total of 583 sorties presenting the Photo Lab with 221,760 feet of film which was turned into 504,792 prints.

During July, most photo reconnaissance aircraft had the conspicuous black and white invasion stripes on the upper surfaces of the F-5s and Spitfires removed or painted over. PR units felt these stripes made their aircraft particularly vulnerable from above. SHAEF left this decision up to the individual units until Autumn when they issued such an order. At 1415 hours on 25 Aug, two 22nd Sq Pilots took off to cover the Seine-Marne Canal. While over the English Channel, Lt M.E. McKinnon caught Lt E.S. Williams' F-5 in his vertical camera. The remaining stripes are no longer visible from above. (A. Leatherwood)

Eyes of the Eighth

Chapter 12
September 1944

Canadians and British under newly promoted Field Marshal Montgomery pursued the retreating German forces toward the Belgian frontier. On the first day of September, units of Patton's Third Army had captured Verdun and pushed through the Argonne into Lorraine. The remnants of the German army that escaped from the Falaise Gap raced for defensive positions along the river systems in Holland. The two forces, American and British competed for limited supplies, which still had to be brought in across the beaches in Normandy. Until they captured a major port that had not been destroyed and blocked by the retreating Germans, they could not sustain two spearheads. Montgomery assigned some of his Canadian forces to lay siege to the Channel ports, which Hitler demanded his units hold until death. Photo reconnaissance had watched each port diligently recording the placing of demolition charges and sinking of block ships. Even when their defenders surrendered, the ports would be useless until cleared. Armies need food, ammunition, fuel. Patton knew that he could push the Germans to the Rhine and into the Ruhr. Over the phone he told Twelfth Army Group Commander General Omar Bradley, "My men can eat their belts but my tanks have gotta have gas." Montgomery thought he had a better chance of forcing a crossing of the Rhine into Germany through Holland with his Twenty-first Army Group. Montgomery had the key to his own plan within sight — the great port of Antwerp.

The British entered Brussels on 3 September. The next day, led by members of the Belgian resistance, advance forces of the British 11th Armoured Division entered Antwerp and rushed to the port. It was intact. The Belgians had prevented the Germans from carrying out either demolition or blocking. One of the greatest ports in the world was in Allied hands. Exhausted and at the end of an increasingly strained supply line, the British stopped their advance without crossing the Scheldt River leading into the port. During the next weeks, German

Antwerp, Belgium. The huge port shows clearly on this photo taken by the 13th Sq in May 1943. The wide Scheldt River bend points east. On the right, the densely built city lies within ancient fortifications punctuated with distinct V-shaped fortifications. Leading away from the city toward the upper right corner is a narrow waterway, the Albert Canal. By 5 Sept 1944 German forces held a line just north of the city and along the north side of the Albert Canal. (J. Byers)

September 1944

forces held a pocket at Breskins along the Leopold Canal on the south side of the Scheldt. During poor weather and under the dark of night, they ferried men and what equipment they had salvaged from Normandy across the Scheldt. The heavily defended Scheldt Estuary could not be used by the Allies, nor could the port of Antwerp, until this force was defeated. Then the 54 miles leading to the sea could be cleared of mines and critical shipping begin to supply British forces.

In England a gathering of airborne forces, the U.S. 82nd and 101st, and 1st British Airborne Division, formed the new First Allied Airborne Army. Created to drop behind the German divisions, the new army is continually frustrated as its dropzones fall to advancing ground forces. SHAEF HQ canceled Operations Linnet, Linnet II, and Comet just hours before the landings. One of the early objectives of the First Allied Airborne Army was Courtrai, Belgium. At the beginning of September, that area was part of the 7th Group's mapping assignment in advance of the Allied forces.

As Montgomery's forces overrun the V-1 launching sites in the Pas de Calais area, the Germans move their operations north. Prime Minister Churchill knows the civilian population in the south of England is at the breaking point. Air raid sirens wail at all hours of the day and night as V-1s approach the coast. Three, four, five or more warnings a night keep people on edge. Intelligence reveals to the prime minister that the Germans have begun launching flying bombs from aircraft against the eastern coast of England. Worse yet, they have a new weapon in the assault against Britain. With this one, there will be no warning.

German batteries launched the first V-2 rocket against England from The Hague, Holland, on 8 September. In the London village of Chiswick people were used to the wailing sirens, the putt-putt of the Doodlebug, then the silence before it fell and exploded. The danger quickly over, they went on about their lives. On this rainy Friday afternoon, there was no siren. At 6:34 PM, without warning, the V-2 silently streaked down and exploded in the middle of Stavely Road. To keep the new terror weapon secret, cover stories of mysterious gas explosions became common. In the Intelligence rooms of the 7th Group and the RAF PRU, photo interpreters searched their pictures for launching sites.

Weather as usual played its part in September's operations. Fast damage assessment coverage of bomber targets became unusual and almost impossible. Clouds often inhibited photo planes from following the heavies for weeks after a raid. The weather men predicted there would be holes but as the cloud built up and lay in layers over the Continent a joke arose that good cover would be possible if all the holes in the three cloud layers all lined up over the target.

The danger of heavy flak concentrations remained around Leipzig, Berlin, and the Ruhr, as well as St.

Night Photo taken on 5/6 Sept by a 25th Bomb Group B-26. The French city below is illuminated by a flash bomb developed especially for night aerial photography. (J. Byers)

173

Nazaire and Lorient, two ports held by the Germans until 1945. The Luftwaffe, although badly hurt, still sent up ME-109s, FW-190s, the rocket-powered ME-163 *Komet*, and the ME-262 jet. They especially went after the lone photo planes acknowledging their importance by the tenacity and persistence of the attacks. More low-level coverage of V-weapon sites, tactical targets, and the heavily defended railroads, canals, and bridges in Holland, protected ferociously by a retreating but not beaten German army, resulted in losses for the 7th Group.

Spitfire Misfire
The most dependable of aircraft and the easiest to maintain, the Spitfire experienced unusual troubles with engine cut-out at altitude early in September. The 14th Squadron Flight Line had trouble keeping enough aircraft available for operational flying. The trouble first appeared in Henry Novak's Spitfire 892 and moved along the flight line until only five Spitfires remained trouble free and available. Engineering called in Rolls Royce technical representatives and the RAF for advice. The problems continued even after crews followed every suggestion. Captain Nelson met with his crew chiefs in the engineering office where they thrashed out a solution. One of the men felt the recent spell of hot weather might be the culprit. He thought that the fuel sitting in the tanks overheated. When the pilot took the Spitfire up and climbed rapidly, sudden change of altitude caused the already overheated fuel to boil in the lines and cause vapor-lock. They decided to test the theory. Captain Nelson told the pilot flying the test hop to remain at low altitude for about 30 minutes after takeoff giving the overheated gasoline in the tanks time to cool off before the Spitfire climbed to higher altitude. The test proved the theory correct.

New Cameras
The 7th Group added a new nose camera to the arsenal of photo equipment. The forward facing camera, installed in F-5s, allowed a new type of photo cover use by bomber crews. These "run-up" photos provided a bomber pilot perspective in his approach to the target. Obtaining these photos required the nose camera, precise navigation, and good weather. The first two conditions were controllable, the third, was not. The Photos had to be taken from exact pin points and from the correct approach angle. The pilot sighted the nose camera in much the same manner as a fighter pilot sights his guns. Lining up with the correct points, he dropped down in altitude and made the

Mechanics work on F-5 *International Geog* (Geog: Geographic — a play on *National Geographic* magazine) in 381st Air Service Sq area. The nose camera port is clearly seen in front of the large oblique port.

same long approach runs to the target a bomber would follow. Much of the danger came from the time required to stay in the area, which increased chances for interception.

Hilborn Missing
The 14th Squadron was unable to fly any missions in its assigned area until 5 September when Lt. Robert B. Hilborn took off in Sgt Al McLaughlin's Spitfire after noon to cover Eighth Air Force strikes flown that morning against Stuttgart, Ludwigshaven, and Karlsruhe. Near Stuttgart Hilborn encountered two ME-262 jet fighters. His Spitfire damaged, Hilborn bailed out. When he failed to return to Mount Farm, he was listed as missing. Eighth Air Force Headquarters later notified 7th Group that the Germans had captured Hilborn 500 meters north of the town border of Stuttgart-Feuerbach. Another pilot from the Group entered a prisoner of war camp in Germany.

Sgt Harry Novak's Spitfire Mark IX PA 892, *Dorothy*, in flight. (K. Bettin)

September 1944

Belgian pilot, Lt Charles J.J. Goffin (14th Sq) with Capt Hubert Childress (27th Sq) on wing of F-5. (F. Gaccione)

Now that much of France had been liberated, the damage to the railroads during the attacks on transportation targets had to be evaluated. Army engineers needed coverage of rail lines and requested photo cover of certain sections. Capt. Dale Shade of the 13th Squadron, flew a railroad damage assessment mission on 6 September to determine the extent of necessary repairs on the Paris-St. Quentin line. His primary job done, he covered a few airfields and marshaling yards.

Goffin lost

On the morning of 8 September, six 14th Squadron pilots, Capts. Robert Dixon, and Willard Graves, with Lts. Louis Gilmore, Charles Goffin, James Tostevin, and F/O Fabian Egan went on a mapping sweep of the Siegfried Line. Five pilots returned with photos. On the 14th Squadron line, Sgt Archie Graveson waited in vain for his Spitfire MB 952 and Lt. Charles J.J. Goffin to return. The squadron listed its pilot as missing in action.

Anticipations

The 7th Group received an urgent request for mapping the Rhine Valley. Rapidly advancing units of Patton's Third Army pushed toward Luxembourg and the Saar. The apparent collapse of the German armies in front of Bradley's Twelfth Army Group and Montgomery's Twenty-first Army Group in Belgium led many overly optimistic planners to assume that a general German collapse was imminent. Plans for crossing the Rhine and striking for Berlin occupied Field Marshal Montgomery's mind as well as Patton's. Anticipation of an urgent need for mapping the Rhine prompted a request, which sent through channels, arrived at 7th Group. Operations assigned the job on 9 September to the 13th, 22nd, and 27th Squadrons. The 13th sent a group out to cover part of the area from Cologne to Basle, Switzerland. Lts. Charles Batson, W. F. Bickford, Taylor Belt, Frank Sommerkamp, Donald Bayne, and D. A. Schultz took off for Germany. A call came through relieving the Group of this assignment after the aircraft had been out about an hour. Communications men attempted to recall the pilots. They reached Sommerkamp, Bayne, and Schultz who returned to base but the others did not get the recall and continued on, getting good results with their photos. Although no longer needed for the assignment, the pictures did not go to waste. Not long after, the photos filled a later request for the same cover.

Parker missing in action

On the same mapping assignment, a group of 27th Squadron pilots mapped the Rhine Valley in the Mulhouse, Strasbourg, Hagenau area. Capt. Robert Floyd along with Lts. W.H. McDonald, R.W. Harmon, Irv Wigton, Ira Purdy, J.W. Saxton, and G.P. Parker covered their area with Saxton adding the Swiss Alps. Between Strasbourg and Hagenau, Lieutenant McDonald received about ten bursts of fairly accurate flak. All of the pilots except Lt. Grover P. Parker returned safely to Mount Farm.

Brogan and Elston overdue

After strikes on 10 September by Eighth Air Force bombers on airfields and aircraft plants at Worms, Giebelstadt, Furth, and Nurnburg, Lts. Allan V. Elston and Richard W. Brogan of the 13th Squadron followed the bombers to get strike photos of the targets. When they failed to return to Mount Farm, the squadron feared they might be missing but hoped they had landed at another field. Lts. Donald Schultz and Charles Crane had been covering airfields in the Frankfurt area and overheard conver-

Archie Graveson's Spitfire Mark IX MB 952 lost with Lt Charles J.J. Goffin on 5 Sept 1944.

The Belgian

Lt. Charles Jean Joseph Goffin appeared at Mount Farm one day with an assignment to the 14th Squadron. He was a Belgian pilot who spoke marginal English. His new comrades thought he had a mysterious background, most probably because of the language barrier. Debriefing officers had difficulty understanding him, some comparing the routine to, "retracing a Chinese fire drill." Even though others thought his flying "usually on the edge," he completed most of his missions successfully. He flew his first sortie on 26 March 1944. Goffin failed to return from his 33rd.

Born on 7 March 1919 in Graide, Belgium, in the province of Namur, Charles J. J. Goffin entered military school in 1933 and received his commission as a second lieutenant of Cavalry in 1935. Goffin trained as an observer and a pilot in 1937. He saw action in Belgium from September 1939 until going to France with his unit in May 1940. In his first engagement he was one of two Belgian fighters against 15 ME-109s. He shot down one ME-109 and continued to attack his targets, two Dornier 17s, even after the Germans shot down the other Belgian. A windshield covered with oil prevented him from pressing the attack. His second kill came while flying in a formation of three Fiat 42s. Challenged by nine ME-109s, Goffin shot one down before his guns jammed. On an interception mission at Chartres, France, he singly attacked a formation of 15 German bombers, killing the rear gunner of a Dornier 15 and seriously damaging the bomber but again his guns jammed and he had to break off his attack.

When Goffin returned to Belgium in August, the Germans immediately arrested him and put him in prison. Freed in October, he escaped occupied Belgium in January of 1941 only to be interned in France at the Mauzat Prison until October. Freed from Mauzat he escaped to Spain where the Spanish authorities interned him from November 1941 until they released him in March 1942.

Determined to fight against the Germans, Lieutenant Goffin made his way from Spain to England in May 1942 where he joined the Free Belgian Forces and received a commission as a second lieutenant in the 6th Fighter Wing of the USAAF. After realizing his new outfit would not let him fly, Goffin returned to London in September assuming the Belgian grade of Captain of Aviation. Undefeated, the Belgian searched for a combat assignment, Those who thought they understood Goffin believe he had powerful friends in high places and he found a home with the 14th Squadron, again as lieutenant in the USAAF.

His friends knew that he used to fly near his village in the Belgian Ardennes and buzz his home whenever he could. He flew some of his low level sorties at such low altitude that photo interpreters warned him that his pictures of pieces of coal in an open rail car were not as useful as pictures of the car itself. With his limited English, his apparent recklessness might have come from misunderstanding. On the line, some of the line crew thought he had little regard for the aircraft itself. Taking a Spitfire up for a test flight after the crew chief's American expression to, "Take her up for a spin, Lieutenant," Goffin took the invitation literally and, to the astonishment of the ground crew, put the Spitfire into a spin. Fortunately, he successfully pulled it out as well and landed safely.

On 8 September, the mapping sweep over the Siegfried Line was near Goffin's home. At 1100 hours in the village of Reckange-les-Mersch, Grand Duchy of Luxembourg, the acting *Burgomeister* N. Kugener saw an aircraft flying low over the village. Outside the town the Spitfire crashed, exploding on impact. Later in the day the local road mender told Kugener that a British reconnaissance plane or fighter had crashed in flames between Hingerhaff farm and Enelter Chapel. The pilot had been found dead. A carpenter, Jean Muller, and Tony Kugener placed the body in a coffin after removing one of the identity disks. The townspeople buried Lt. Charles J. J. Goffin in Mersch on 9 September and hid the site from the Germans. He was only 80 kilometers from Graide, Belgium.

After the war, Kermit Bliss went to Graide to present Goffin's medals to his parents. In March 1946 Goffin's body was moved from Mersch to the military cemetery in Hamm, Luxembourg, and in September of the same year, Lt. Charles J. J. Goffin finally returned to Graide to be buried in his family's plot.

September 1944

14th Sq Camera Repair men wait for return of their aircraft. L to R: Shelton M. Gingerich, Ellis A. Warren, Charles Wald, Edward S. Vasileski, and Wallace Arnold. (Allan Cassidy)

sation at 1630 between the two pilots about heavy flak. Later Schultz picked up part of another conversation when Brogan and Elston talked about returning to base. During their debriefing back at Mount Farm, Schultz and Crane related all the overheard bits and pieces to Intelligence.

The next day, Lieutenants Brogan and Elston flew back in to Mount Farm much to the relief of all. They told their Intelligence debriefers that after leaving their target, the jet airfield at Giebelstadt, they turned for home. After a short time headed westward, they sighted three single-engine aircraft at their altitude on a course to intercept them. Both pilots turned south and pushed their throttles to the maximum. They held that course for ten minutes. Below lay solid cloud. Without a visual pin-point, they figured they might be near the Swiss border. They had lost their pursuers so the two pilots changed course to bring them out over the Channel. Breaks in the cloud revealed fires on the ground and they changed course again to take photographs. Over the target, which turned out to be near Saareburg, Brogan reported a malfunction in his oxygen system. With their fuel supply getting low, the two decided to land at a strip near Paris. Intending to take-off after refueling, Brogan learned his aircraft needed repairs to the oil system that could not be completed before nightfall. Both pilots stayed overnight and returned to Mount Farm together with good photographs of their assignments as well as the target of opportunity at Saareburg.

Dolle Dinsdag

After the collapse in France, the retreating German armies moved north toward Holland. In Berlin, the *OKW (Oberkommando der Wehrmacht)*, the German Armed Forces High Command, moved quickly to bolster thin defenses in the path of Montgomery's British Twenty-first Army Group and Bradley's Twelfth Army Group. The *OKW* saw that the Twenty-first's route toward Germany across the Rhine in the north through Holland lay open. Except for battered remnants of the Fifteenth Army, weak forces manned the defensive line. Disparagingly known as "stomach battalions," outfits made up of men unable to serve in front line units due to various ailments could not be expected to slow the rush of the Allies. Quickly, the *OKW* sent reinforcements into the area north of the Lower Rhine at Arnhem and alerted two SS Panzer Divisions refitting there.

Behind the front lines, the Dutch witnessed an incredible sight. On the first of September, their hated ruler during Nazi occupation, *Reichkommisar* Dr. Seyss-Inquart, ordered German civilians evacuated from Holland. The despised occupiers began to leave by every conceivable conveyance. The flood increased when the leader of the Dutch Nazi Party ordered his party members to leave and led the way himself. Streams of retreating soldiers joined the tide running toward Germany. During their frantic flight, the Nazis did not go without their "spoils of war." They carried with them Champagne, double beds, even mistresses. The Dutch people reveled in the sight and celebrated in the streets shouting that the war was over. At the news of the fall of Antwerp, salvation seemed a breath away. On 5 September the excitement reached such a pitch that the day was remembered as *Dolle Dinsdag*, Mad Tuesday.

In the midst of the madness, an ominous sign escaped the attention of most of the joyous Dutch. Members of the Dutch resistance noticed that German soldiers had stopped running and were digging in. The forces the *OKW* had put in motion in Germany began to arrive bolstering defenses. In the face of imminent defeat, resistance stiffened as two experienced officers showed the German army's remarkable ability to reorganize. Field Marshal Walter Model had overall command of Army Group B, to which the *OKW* promoted and assigned its legendary airborne officer, General Kurt Student and his First Parachute Army. Now the Dutch learned that the Allied advance had stopped on the northern edge of Antwerp and on the *south* side of the Albert Canal. Hopes of a quick end to the occupation were shattered.

Continued flights into Holland covered targets in advance of the Twenty-first Army Group, possible launching sites of V-2 rockets, railroad traffic, and airfields where Ultra and Dutch resistance reported HE-111s equipped to launch V-1s from the air against London from seaward. Pilots from the 7th Group knew the sting of defenses from an area always dangerous for either low-level or flights at altitude. On 11 September, three 27th Squadron pilots, Lieutenants Florine and Ward, as well as Captain Carney covered rail and airfield targets in the

Rare failure of Spitfire landing gear forces Lt Blyth to land wheels-up on the grass at Mount Farm on 12 Sept 1944. (J. Blyth)

Arnhem, Nijmegan, Rotterdam, and Venlo area. All three returned safely. The day before, in response to appeals from Montgomery to use the First Allied Airborne Army, Eisenhower accepted Montgomery's plan for an airborne and ground assault on the bridges over three rivers in Holland to open the way into Germany in the north. On 12 September, 1st British Airborne Division's Intelligence Officer Maj. Brian Urquhart added low-level obliques of the wooded areas near Arnhem to an RAF PR flight from Benson. The uneasy Urquhart believed that heavy armor lay in the dropzones of the British paratroopers at Arnhem. The photographs proved him to be correct and verified word from the Dutch underground. What was perceived as a small annoying ant hill was, in fact, a large hornet's nest.

On 12 September, 7th Group Headquarters received requests for low level oblique cover of nine points in the Eindhoven, Holland, area. Two 13th Squadron pilots Captain Shade and Lt. G. J. Budrevich covered landing areas and bridges for the planned airborne drop completing the job on the day it was issued.

The same day, Lt. John Blyth encountered no opposition mapping in the Eisenach area. He returned to Mount Farm and as he made his approach, discovered his wheels would not come down. As this was a very unusual thing with a very reliable aircraft, engineering officers and mechanics radioed all manner of ideas as Blyth circled the field. Maj. Kermit Bliss and Capt. Robert Dixon added their expertise. Blyth tried each idea but after circling the field for over an hour the wheels still refused to come down. Fuel was the problem now and the tower informed the pilot he had to make a belly landing. When he could stay airborne no longer he made a beautiful low approach and aimed his Spitfire for a smooth grassy stretch near the main runway. Blyth gently let the Spitfire down onto the slick grass and slid to a stop. The landing caused damage mainly to the wood composition propeller blades, which shredded off at the ends.

Later that day the men on the 22nd Squadron Flight Line waited anxious hours for the return of Lt. John H. Ross from his 16th sortie. He had gone out to cover targets at Bremen, Hamburg, and Kiel. No word arrived and as night fell, the squadron wondered whether they had lost another pilot.

Lt John Blyth talks to Maj Kermit Bliss and Capt Robert Dixon after bringing his Spitfire in for belly landing on grassy area at Mount Farm. The frayed ends illustrate non-metal composition used for Spitfire propellers. (J. Blyth)

September 1944

Ross at Sea

While the men back at Mount Farm wondered, their overdue pilot knew he was in trouble. His gas tanks were almost empty. After covering his targets at Bremen and Hamburg, Lt. John Ross had flown his F-5 toward Kiel. Heavy cloud prevented Ross from lining up the target. Trying to pin-point his objective, he located the Kaiser Wilhelm Canal on his left and Fehmarn Island on his right figuring Kiel at mid-center between those two points. He made one run over the area. On his second run, black mushrooms of lethal flak surrounded and boxed him in. The F-5 rocked with the explosions. A red fuel lamp flashed on the panel; Ross knew the fuel tanks had been hit. The indicator needle on the gas gauge began to fall. At 26,000 feet he turned his plane toward home. Over Hamburg, anti-aircraft batteries sent up more flak that burst around him. Racing for the coast, Ross watched the needle drop. He crossed out of enemy territory over the Dutch coast at Den Helder. Only 15 gallons remained in his tanks.

Ross decided to risk the sea rather then certain capture if he turned back toward land. He kept the nose of his F-5 pointed toward England. In a matter of minutes his engines would quit. At 1720 hours he called for a vector, position, and course. Flying that course, he scanned ahead looking for land, getting closer every minute but not enough minutes were left. The pilot called for a vector and told the station he was hitting the silk. He was 55 miles northeast of Lowestoft, England. The voice in his earphones told him what course to steer and added, "Am sending a ship. Good luck." That was all.

It was late and getting dark. Could the ship find him in the dark? Jettisoning the canopy Ross tried to crawl out on the wing but the wind pressed him into the cockpit. He took over the controls again and with the last bit of fuel nosed the plane down then pulled back on the stick. The F-5 swooped up throwing Ross out. The terrific suction pulled him from the cockpit and hurled him back over the tail boom. He cleared the plane and pulled the rip cord. His chute billowed out over his head. For a moment Ross thought his plane was going to loop back into him but it nosed over and plunged into the ocean.

Ross floated downward. To prevent getting tangled in the shrouds, he released his parachute harness just before hitting the water. He dropped into the cold North Sea. The parachute blew away and the pilot inflated his Mae West. Bobbing on the surface, Lieutenant Ross knew he had to get into his dinghy as quickly as possible. All the survival lectures stressed the dangers of the bone-chilling water's effect on a man. He flipped the valve to inflate the dinghy, which popped open next to him. He crawled in. All the equipment was there: three flares, a packet of food, fish hooks and lines, plugs to fill any holes the dinghy might develop, a bellows pump, a small collapsible bailing bucket, a sack to act as a sea anchor, a cover to fasten himself in the dinghy, sea marker, two small paddles, a bright red triangular sail, and a telescoping mast.

Lieutenant Ross set up his mast, attached the sail, set the course the radio had given him, sailed slowly toward England, and waited for rescue. Whenever a ship or plane appeared in the distance he waved his red sail frantically but they passed by without seeing him. As dusk fell, his hopes for immediate rescue faded.

Darkness was not the only problem. The weather was stormy. Seasickness overwhelmed Ross and huge waves tossed his dinghy violently, throwing Ross out into the cold water which would revive his strength enough to clamber back into his craft. Without the cord attaching the bucking dinghy to his Mae West, Ross would have lost his reluctant companion on the first toss. The dinghy climbed up the shoulder of the wave to the crest until almost vertical and it could go no further. Over Ross went into the sea and the bright yellow dinghy followed like an obedient dog on a leash. Ross climbed back in. He bailed water and rode the tossing craft as the dinghy topped a huge wave, tossed him out and down into the trough again. The routine repeated itself over and over. During the night he heard German sounding voices coming from a boat within hailing distance and Ross kept very quiet. They might be looking for him. The boat came within only a couple of waves of the pilot before it went away. Nothing else interrupted his acrobatic float, flip, swim, float, routine.

Slightly calmer seas came with the dawn. Exhausted, Ross knew that many of his supplies had gone overboard in the night. His dinghy, so tiny in the great expanse of water, gleamed bright yellow in the morning light and raised his hopes that he would be seen. Again, ships and planes that seemed so close passed by in spite of more frantic waving. The constant dunking had wet the flares and as daylight faded on his second day so did his hopes. One more ship appeared on the horizon heading straight toward him. Ross waved his red sail wildly. The ship came on. It had to see him but it too passed him by. The Canadian minesweeper was not looking for a downed pilot but a lookout spotted the waving red sail and notified the captain. The ship turned back toward the bobbing dinghy. After some desperately hopeless minutes Ross saw the ship returning.

In a few minutes the minesweeper slowed down alongside the dinghy. The crew threw a line to Ross then hauled the wet and cold, half drowned pilot on board. They carried him to the sick bay where two husky British sailors

rubbed him briskly from head to toe with Turkish towels. Then they gave him a hot bath, dried him off, and put him in a bed warmed with hot water-bottles. The Navy medics gave Ross three large bowls of hot soup and a glass of brandy. Seamen knew what it took to resurrect a victim of rough and cold waters.

The captain showed the lieutenant around his ship, a new minesweeper just out of the Brooklyn Shipyards, built for duty in the Pacific and just coming down from Scotland. He insisted Ross sleep in his quarters. They docked in England the next day and the captain dropped Ross off near London. From there someone from Mount Farm picked the pilot up to return him to the airfield. Ross, none the worse for the experience, told his friends about the wonderful treatment he had received. He said he could not praise his rescuers too highly. "They treated me like a king."

Kann Killed
The Group had assignments for cover of jet aircraft centers in Germany as well as aircraft factories in Stuttgart and targets at Ludwigshaven on 13 September. Poor weather in the 22nd Squadron's sector allowed only four sorties. In spite of heavy clouds, Lts. Harold Weir and M.E. McKinnon managed to cover some targets in Germany. The same targets had been assigned to Lts. Robert Carlgren and Alexander Kann as well but Lieutenant Kann's F-5 developed trouble with one propeller while the two pilots were on their way to a fighter base to pick up P-51 escorts. Kann brought the F-5 back to Mount Farm on one engine. While coming in for a landing he overshot the field. The pilot attempted to go around again for another approach but lost control and crashed within sight and just to the north of the airfield. Lieutenant Kann died in the crash.

Camera Repair technicians work on F-5's cameras while pilot, Lt Robert "Tubby" Carlgren talks to Maj Walt Weitner.
(Edward Murdock)

Carlgren Intercepted
The Baltic coast had gained the reputation as a "hot" area with its vital installations and increasingly aggressive jet protection. Within this area lay some of the 300 Luftwaffe airfields that the 7th Group routinely covered to check for activity and the movements of the German Air Force. Intelligence used this cover in conjunction with information gathered from reading the GAF Enigma coded messages listed as Ultra, information gleaned from captured soldiers, and human resources on the ground. Some of the airfields were next to experimental stations where the Luftwaffe tested new equipment and aircraft. Photo interpreters at base and Medmenham kept a close watch for new developments at these airfields. One of the signs of the presence of new jet aircraft was the pair of tell-tale scorch marks made by exhaust from the ME-262's two Jumo jet engines when they fired up and again upon acceleration for take-off. These marks showed clearly on photos. As soon as photo interpreters spotted the ominous marks where they had never been seen before, they notified the intelligence sections of any unit that might send aircraft into the area.

After Lieutenant Kann aborted his mission to return to Mount Farm, Lt. Robert F. Carlgren landed at the fighter base and briefed his escort on the mission. His assignments lay in the zone where jet aircraft had been located. Also on his list of targets was one of the main development factories and test airfields: Rechlin. Operations, both at Mount Farm and the fighter base, warned the pilots to look out for the jets. The seven P-51s and one F-5 took off at 1530 with Carlgren leading the formation and crossed in over the enemy coast at Cuxhaven. Carlgren's first target at Brunsbuttel was open. The flak batteries threw up about 100 bursts of accurate flak but failed to hit any of the planes. The formation survived more flak at Neumunster and Kiel. Carlgren made runs over his primary assignment at Schwerin and flying north to Wismar, picked up his second and third listed targets as well.

The photo ship flew at the center of the formation with two flights of fighters arranged on either side. Suddenly from below, two ME-262 jet fighters attacked the P-51 just behind Carlgren. The Mustang began to smoke. The fighters broke away and engaged the jets. Carlgren found himself alone. With the formation broken and the jets seemly not interested in him, Carlgren decided to go on to his next target, Parow Airfield. Near Rostock, he was in the middle of more flak but again, suffered no damage. Over Parow he turned on his cameras then headed toward Griefswalde where he made three runs before heading to his next target, the oil plant at Politz.

September 1944

A familiar sight of the bridge over the Thames at Abingdon. The nearby river offered swimming and boating during the hot summer of '44. (Mysliwczyk)

In spite of a flak barrage bigger than all the rest, Carlgren completed one run over Politz. He continued on covering a routine airfield at Prenzlau, then Rechlin Airfield and factory. He made two runs over Rechlin. Carlgren could barely see the ground as increasing industrial haze spread below him. Another routine airfield was on his course and he covered that in case the PIs could see something on the film. His target list completed and time and fuel at their limits, Carlgren returned to the fighter base in England at 2030 hours. The field was almost completely dark and the control tower turned on the sodium flare path to light his way in after the five hour mission.

Carlgren's cover of six of the eight assigned targets on 13 September, was good enough to remove them from the program. The other two targets, taken through the haze, were not clear enough to remove them. Additional photos of three airfields, one seaplane base, and the port of Travemunde were all of good quality. Lieutenant Carlgren's tenacity and enterprise had produced a very successful mission.

The First Allied Airborne pressed on with its plans for Market Garden. They needed more cover from photo reconnaissance. On 14 September, the 7th Group received requests for low level obliques of five more points in Holland. Again the 13th Squadron took the job and Lieu-

Not all photography took place in studios or from PR planes. Harold Fox and Fleming Vigorito of 13th Sq setting up a camera for informal photography next to Fox's barracks.
(Harold Fox)

One of many ground personnel working to keep 7th Group operating successfully. Mess Sergeant MSgt Henry Mosier gets help sorting through burlap bags full of cabbages.
(George Simmons)

Oxford, *Ramblin' Wreck*, J. Riggins (381st) first plane as a Crew Chief. Standing with Riggins is J. Blackmon of the 22nd Squadron. (Riggins)

181

tenants Brink and Bickford flew successful sorties the next day.

Their targets were bridges in the Scheldt area. The land north of Antwerp was low-lying and laced with great river estuaries. Through the countryside and across the proposed path of the ground attack planned for Market Garden, lay the Upper Rhine, the Maas, the Waal, and an extensive canal system. The particular bridges assigned to the 13th Squadron pilots were at Ooltgensplaat and Willemstad, Willemsdorf, Gertruidenburg, and 'S-Hertogenbosch. Lieutenant Brink, with Bickford as his wing man, photographed the target bridges with a nose camera. Neither plane sustained damage from the flak sent up from each target. Both planes took damage assessment photos at Arnemuiden.

Parker Returns
The 27th Squadron welcomed home one of its pilots on 15 September when Lt. Grover P. Parker returned to Mount Farm from France. Intelligence debriefed Parker about his mission on 9 September when he failed to return to base. Parker told them that he was ten miles south of Strasbourg at 18,000 feet when two single-engine enemy aircraft jumped him. Diving away from their tracers, he headed north at 10,000 feet to escape. Over the Strasbourg area, a heavy flak barrage caught him and damaged his aircraft and instruments. The pursuing enemy aircraft broke off when the flak came up and Parker headed for the coast. He nursed his fuel supply and cleared the coast near the mouth of the Gironde Estuary. Parker turned north and flew about half an hour before he realized he had no hope of reaching England. The pilot managed to reach land and crossed back into France near Bordeaux where he made a belly-landing in a field.

Parker quickly began the routine to destroy his F-5 but was prevented from doing so by the sudden arrival of French resistance men of the FFI. They took Parker to their headquarters and questioned him. Then, after word of approaching enemy in the neighborhood, they allowed Parker to destroy his photo plane. Parker told Intelligence that men who looked like paratroopers put him in a jeep fitted with mounted machine guns and took him across Allied lines to Orleans. From there he returned to England in a Flying Fortress.

Bayne Lost
Operations assigned cover of Mainz, Germany, a recent target of the Eighth's bombers, to Lieutenants Bayne, Elston, Madden, and Sommerkamp of the 13th Squadron on 16 September. When they returned from the mission they reported to Operations and Intelligence that while making runs over the target they saw Bayne's F-5

Lt Donald B. Bayne of the 13th Sq failed to return from a flight to Mainz, Germany on 16 Sept 1944.

pass under one plane of the formation just as they flew into a cloud. They did not see him reappear but observed a white trail that spiraled up almost vertically to an estimated 40,000 feet and then leveled off. The formation left the area without seeing the F-5 again. When Lt. Donald Bayne failed to return to base the Group listed him as missing in action.

That same day, oil plants at Ruhland and Leipzig, an area of some of the heaviest concentrations of flak in Germany, were on the target list for two 27th Squadron pilots, Capt. Gerry Adams and Lt. W.G. White. Flak batteries at both targets responded ferociously toward the two PR planes with heavy and accurate barrages damaging the wings on Adam's F-5 and shooting out Lieutenant White's right engine. In spite of the damage, both aircraft returned to Mount Farm. Neither pilot suffered injury.

The following day, requests from the Engineers for rail lines damage assessment to estimate repairs and construction needed on the line made up the assignment for two 13th Squadron pilots. Lieutenants Brogan and Moss covered the potential supply lines east from Paris to the front. Moss used an F-5 equipped with a nose camera.

September 1944

Both covered the targets successfully with particularly good coverage from Moss's camera.

Operation Market Garden

The First Allied Airborne Army began its combined airborne and ground attack to capture the bridges at Nijmegen, Eindhoven, Graves, and the Lower Rhine Bridge at Arnhem on 17 September. The flak batteries, so deadly to the low flying aircraft of the 7th Group in the recent past, came under massive bomber attack just before the airborne assault. The U.S. 101st Airborne's targets were Eindhoven and the bridges over the Wilhelmina and Willems Canals. The U.S. 82nd Airborne was to take the bridges over the Maas at Graves and the Waal at Nijmegan. The main objective, a crossing of the Rhine at Arnhem, was assigned to the British 1st Airborne. The British dropped on the north side of the river and had long marches to the bridge where they secured the northern end. The Polish 1st Parachute Brigade, ideally dropped simultaneously on the south bank to secure that end of the bridge, could not be brought over on 17 September due to a shortage of transport aircraft in the first and second lifts. Fog postponed the Poles' arrival until the third lift of the operation by which time the Germans were waiting. The airborne landings of Market, were to open the way for Garden, the armored attack north from the Meuse-Escaut Canal by British XXX Corps. Just as 1st British Airborne's Intelligence Officer Maj. Brian Urquhart tried to point out with his reports and aerial photographs, two units of II SS Panzer Corps, 9th SS Panzer *Hohenstauffen* Division, and 10th SS Panzer *Frundsberg* Division had relocated near Arnhem to refit and rest. German Field Marshal Walter Model's Army Group B headquarters, also reported to the First Airborne commander, was near the Arnhem drop zones. British forces' inability to continue the attack northward after the capture of Antwerp allowed the Germans to stiffen their defenses for the expected attack during the short time before Market Garden began. The resiliency and re-organization leadership of German troops in the area soon became apparent. Field Marshal Montgomery's assault toward a bridgehead over the Rhine, instead of attacking weak "stomach battalions" and defeated soldiers, struck against veteran panzer forces, into the heart of a hornet's nest.

Already prepared for heavy opposition in the area, the 7th Group dispatched sorties at the request of various

A 7th Group photo plane catches aircraft and their shadows on the water as C-47s tow gliders to the landing zones in Holland on 17 Sept 1944 for Operation Market Garden. (J. Byers)

Eyes of the Eighth

commands that needed to keep an eye on the Airborne troops and their opposition. Because of the re-assignment of target areas for the various squadrons, the Market Garden missions would now be flown by 27th Squadron pilots. On the 17th of September, Lieutenants Parker, Harmon, and Gonzalez of the 27th flew sorties over the airborne landing areas in the Arnhem area just after the landings. On their way across the Channel they flew over serials of tugs and their gliders heading for landing zones. When the pilots reached the target areas they saw parachutes and gliders strewn across the fields. Smoke rose from the landing zones where very accurate anti-aircraft fire brought down Allied aircraft. In spite of strikes by bomber forces against the batteries, they still remained a formidable and deadly element. With these sorties, the American share of the photo reconnaissance watch had begun on Operation Market Garden.

The Group continued its coverage of transportation targets for the Engineers. On the same day as Market Garden the 13th Squadron sent three F-5s to cover the railroad lines east from Paris to forward lines. Lt. R.E. Moss, who had the most experience at low level rail

7th Group pilots covered RR lines east from Paris toward the front lines on 17 Sept for the Engineers to estimate damage and repairs. The photograph reveals a direct hit over the entrance and the huge crater caused by one of the large British bombs used to attack thick-roofed targets. This type of bomb, properly placed, caused internal collapse in tunnels or similar structures such as entrances to underground factories. (J. Byers)

The concrete and steel three-span highway bridge over the Lower Rhine at Arnhem on 18 Sept 1944, which was the main objective of Operation Market Garden. Smoke rises from houses on either side of the northern bridge approach in the town of Arnhem where elements of 1st British Airborne Division hold positions. Wreckage of the 9th SS Panzer Reconnaissance Battalions' armored attack across the bridge lies between the houses blocking the road. Photo taken by 27th Sq on one of seven PR flights in the area that day. (J. Byers)

coverage, flew an F-5 equipped with a nose camera "on the deck." Maj. O.G. Johnson and Lt. R.W. Brogan accompanied Moss covering their targets along the same lines. All returned safely with photos.

The next day, six 27th Squadron pilots covered the various landing zones in Holland and other critical targets in the general area. Lieutenants Purdy, Florine, Wigton, Johnston, Ricetti, and Saxton returned safely and brought back photos with important information on the progress of both airborne and ground forces for Intelligence. What bridges had been taken; which had been blown by the Germans? Were there German forces gathering for counterattacks and where? Another pilot, from the 13th Squadron, flew into that area on 18 September. Lt. Fred Brink took his F-5 over Rotterdam and the Scheldt area for meteorological information. Flak batteries tracked him and fired a few barrages but he returned to Mount Farm without damage. The only other sortie flown by the 7th that day was a damage assessment mission to Kiel by Capt. Dan Burrows of the 22nd Squadron.

Better weather on 19 September allowed PR planes to cover targets in Germany again and the 13th Squadron sent eight aircraft into the Darmstadt area for damage assessment. Captain Shade also covered Mainz and the Trier area as well. Lieutenants Elston, Facer, and Sommerkamp added Ludwigshaven and Mannheim. Several 14th Squadron pilots, Lieutenants Glaza, Leatherwood, and Fish took sorties near the Belgian-German border. Fish returned from his first attempt but went out later in the day to cover his targets.

On the 19th the Germans counterattacked against the U.S. 101st Airborne near Eindhoven while the British 1st Airborne and Polish forces felt the strength of the two panzer forces at Arnhem. Slow progress by XXX Corps fighting along the corridor toward Arnhem concentrated all German forces in the area against attack from any quarter. On this day, the fact was underlined that the Germans considered unarmed reconnaissance aircraft a dangerous threat — an attacking force.

Balogh, Stamey, and Parker Missing
One 14th Squadron pilot, Lt. Paul A. Balogh, had targets at Bitche, Zweibruken, and St. Wendoz, which took him over the Market Garden area of Holland. At Mount Farm, as time passed, Sgt Carl Norsten waited in vain for the return of his pilot and the veteran Spitfire *Lease Fleece*. Word finally came to 7th Group that Balogh had been killed in the crash of his Spitfire after being shot down near Langkamp.

The 27th Squadron assigned six sorties on the 19th but weather prevented Captain Childress and Lieutenants Blackburn and Rickey from completing their missions. Lieutenant White flew a successful mission over Arnhem and Nijmegan. Later in the day, Lt. Irwin J. Rickey went out again. Lt. Earl K. Stamey, flying his F-5 *No Nuthin*, went with Rickey to the same area. At 20,500 feet, ten miles south of Utrecht, Holland, a black FW-190 passed 300 feet below them. The fighter was less than a quarter of a mile off to their right. Rickey dropped his tanks and started a steep climbing turn to the left to get on a heading back to Mount Farm. While climbing, Rickey saw Stamey continue on an easterly course at the same altitude. Just north of their target area, a bank of clouds offered Stamey some cover and Rickey saw his friend turn toward it. When Rickey felt he had lost the Focke-Wulf, he looked in the area for Stamey until he had to return to base. He never saw Stamey again. When he returned to Mount Farm, he reported the action to Operations and Intelligence. When Stamey failed to return, the Group listed him as missing in action, learning later that he had been killed.

Another pilot from the 27th Squadron failed to return that same day. Lt Grover P. Parker had assignments in the Arnhem-Nijmegan-Graves area covering the paratroops' and glider landing zones. Parker had flown just one mission, also over the Market Garden area, since his return from France after escaping from behind German lines near Bordeaux. Again, his ground crew waited in vain for his return. The 27th added his name to the missing in action and waited for additional information from headquarters. The 7th Group had lost three pilots on 19 September, two from the same squadron.

Operation Market Garden demanded more coverage every day as attacks and counterattacks increased in the fight for the river crossings. A request for daily coverage of six new dropping areas came to the 7th Group on 20 September. Lieutenants Ness and Ward covered the targets. New areas came over the teletype again on 21 and 22 September. Two 27th Squadron pilots, Lts. D. A. Ness and Hector Gonzalez, took missions to the Arnhem and Nijmegan area, returning with coverage of the targets. A request for cover of the five bridges at Arnhem and Nijmegen arrived on the 23rd. In spite of poor weather preventing other cover, Lt. Ira Purdy completed a sortie

B-24s of the 2nd Bomb Division caught on film by the vertical camera in Lt Taylor Belt's F-5 on 22 Sept 1944 after raid on Henschel Works at Kassel, Germany.

over the bridge at Graves over the Maas River in the 82nd Airborne's area.

McDonald and Johnston Killed

With increasing confidence, Field Marshal Model's forces attacked all along the corridor where the airborne armies held bridges over the waterways for XXX Corps' armor to advance to Arnhem. Particularly heavy fighting against the 101st Airborne's section, a 15 mile stretch that Gen. Maxwell Taylor called "Hell's Highway," at the Veghal crossing of the South Willems Canal cut the corridor temporarily. This action concentrated even more of the infamous 88s in the battlefield in Holland. The 88 not only could be operated as a regular and efficient field artillery weapon against armor, but also as a deadly anti-aircraft gun when elevated.

The fluid battlelines needed frequent cover. At some points along the corridor, the front lines literally were the sides of the road. An especially ominous development early in the morning on 24 September, the arrival of 45 Tiger tanks to reinforce Model's army, caused increasing concern to Allied Intelligence. Headquarters, First Allied Airborne Army knew that the Arnhem bridgehead had not been re-supplied and was on the verge of collapse after eight days fighting. In spite of weather preventing all other air operations, Intelligence asked for cover of the battlezone.

The rotating assignment of geographical sections to individual squadrons sent the same pilots back again and again to the same areas. During Market Garden, the 27th Squadron took most of the missions for that cover. Because of the losses in the active battlezone in Holland, any sortie assigned targets in the area now brought more than the usual apprehension from ground personnel as well as pilots. Reports from units trying to airdrop supplies in Holland reinforced the information 7th Group had from its own pilots' debriefings about murderous ground fire from small arms up to 88s. The request for cover of the Arnhem bridges and area caused concern among all the Intelligence Officers when it came in on the 24th. The high priority of the request, considered vital by First Allied Airborne's commander who knew that his forces at Arnhem must be evacuated that night, took precedence over the weather and risk.

Group Operations assigned the mission to the 27th Squadron and the two pilots chosen for the task, Lts. Warren M. McDonald and Ernest E. Johnston, prepared for their sorties. Operations Officer for the squadron, Captain Floyd, and the new assistant Ops Officer appointed just that day, Lt. Max Alley, conferred with weather officers and Intelligence Officers, Capt. Walter Hickey of the 27th and Lt. Howard Jeske of the 22nd Squadron. They knew the weather was not marginal, it was below that. Rain and fog covered most of the Continent. The Eighth Air Force had not one other operational mission scheduled on the 24th. The men went over strip photographs and maps of the routes over Holland with the pilots and laid out the best course and pinpoints to identify the requested targets. Whether the two pilots could find and photograph them bothered those left behind at Mount Farm. On the flight line, Camera Repair men completed their work on the nose cameras for the low-level photographs.

"Red" McDonald and Johnston left to get in the Jeep taking them to their planes. McDonald turned back and stuck his head in the door, "Tell my date I won't be in town until 9:30." It was now four o'clock. After the two F-5s took off that afternoon, the long wait began. When they left Mount Farm the pilots had 6/10ths cloud at 2,000 feet and 15 miles visibility. The wind was 27 mph from the northwest. Weather reported much less favorably about Holland, predicting, at most, a ceiling of 600 feet at Arnhem. Time seemed to stop at Mount Farm. This sortie was not one of the long four or five hour flights deep into Germany. Operations estimated McDonald's and Johnston's return at 1839 hours.

Apprehension permeated Operations and Intelligence. The 27th Flight Line was quiet as the ground crews for the two aircraft waited. By 2000 hours, word had come

Lt Ernie Johnston, one of the 27th Sq pilots who flew shuttle flights between Russia, Italy, and England for Operation Frantic. Killed in action on 24 Sept 1944 over Holland during Operation Market Garden. ("Doc" Fritsche)

September 1944

Grover P. Parker

In Holland, dropzones of the various elements of the First Allied Airborne Army lay scattered along the corridor leading toward Arnhem. Lt. Grover P. Parker covered his targets at Arnhem, Nijmegan, and Graves as well as the port of Flushing on the north bank of the Scheldt Estuary. The heavy and accurate German flak caught his low flying F-5 and as he approached the coast after crossing the Scheldt he knew he would not make it to Allied territory.

Ahead lay a stretch of beach near Knocke, just over the Belgian border. Parker kept his landing gear retracted and slid along the sand coming to a stop between the sea and a high seawall. Realizing that he was uninjured, he jumped from his plane prepared to set it on fire before discovery. It was already too late. German soldiers came down from the top of the seawall from where they had seen the crash-landing. Unlike the last time, Parker could not escape imminent capture.

They took him back toward the Scheldt where his captors left him at a Field Command Post at Breskens. After interrogation he spent the night under guard. The next morning, Parker recrossed the Scheldt and spent the next four nights at Flushing on Walcheren Island. From there the Germans took Parker off Walcheren to the town of Goes where he spent another four nights. His route to a prisoner of war camp now took him along the narrow isthmus connecting Zuid Beveland with mainland Holland just above Antwerp. He was so close to Allied lines and headed toward the Market Garden battlezone but unable to do anything about it. After another night even closer still at Breda, they moved him away from the front to Dordrecht just southeast of Rotterdam and across the Maas River.

Parker took stock of his situation. His temporary prison was a collection point in a warehouse surrounded by a stockade. Determined to escape, Parker watched the guards' routine and walked about near the stockade as much as possible during the morning to let the guards become familiar with his routine. In the afternoon he continued his walks and was at the rear of the compound when a new group of prisoners arrived. As the stockade gates opened to let new men and their escorts in, the stockade guards looked away. This was all the break he wanted and Parker ducked into an abandoned blacksmith shop that stood next to the stockade wire.

Parker swiftly made his way over the wire, through and over buildings until he sat on the roof of an apartment house. Below he saw an elderly couple. Parker thought he was far enough away from the stockade to seek help. He climbed down and tried to speak to the Dutch man and his wife who thought he was a German. They left him there while they went for an interpreter, a school teacher. Taking Parker inside the couple's house, the teacher gave Parker an old suit of civilian clothes and a hat. After the pilot shaved and changed, he started out the door to continue his escape but they called him back when they learned the Germans were looking for him. Parker ducked back inside.

The little group argued about the best place to hide the American pilot but Parker had other ideas. He wanted to escape and insisted they put him in touch with the resistance or someone who could get him out of Holland. Parker won the argument. Several days later the men from the underground came to get him out. They took him just outside of Gertruidenburg where another man waited for similar help. Robert Carson was an RAF pilot also shot down over Holland. Both men wanted to return to England but the new battlelines made this more dangerous than ever. They agreed to stay in Holland with the resistance for the time being. In their new situation the two pilots took new identities, Carson would be "Steve" and Parker became "Dutch."

Their new home was an old houseboat, the *Ganzenest*, which was moored deep in the reed beds of the Lijnoorden. This was part of a much larger area of osier (reed) beds in the low-lying land between the Maas and Waal known as the Biesbosch. Along with the house boat, the group known as Biesbosch North had an old coal motor-barge *Martha Jacoba* that they used to house Germans captured during various forays along the edges of the osier beds and canals. Within these dense islands of tall reeds, "Dutch" and "Steve" helped their Dutch companions guarding prisoners and foraging for food. Armed and ready for action, they participated in several raids adding to the total of Germans held by the group now stronger through the addition of the Biesbosch South organization. *Grote Jan*, commander of the group, now had a motley collection of prisoners and feeding them took help from local farmers and supporters.

On one occasion they had to abandon the prisoners to evade an attack by some SS troops but when they returned their prisoners were still there. As the Allies drove the Germans out of the coastal areas of Holland and crossed the maze of waterways and canals below Gertruidenburg, Allied artillery began falling near the barges' location. The Biesbosch Group left their reed beds and turned 75 German prisoners over to the Allies. The two pilots crossed the British lines and returned by air transport to England.

Eyes of the Eighth

in that Air Controllers had reported no contact with either pilot and no trace of their aircraft. The Group Operations Officer quietly left the Operations Room followed later by the 27th Squadron's C.O. Capt. Hubert Childress. Within an hour, Captains Hickey and Floyd, as well as the remaining officers left, turning off the main overhead lights. The Duty Pilot and a telephone operator sat at their desks under the only lights in the darkened room. The big wall maps faded in the dim light that diminished the bright red pins along the Market Garden corridor. The 27th Squadron alone had lost four pilots in one week, all in the same area. Eighth Air Force Headquarters would confirm both McDonald and Johnston killed in action but without details.

Poor weather over the Continent prevented missions in all sectors of the front lines from Holland to the south of France. Germany lay under cloud preventing photo reconnaissance and damage assessment of the few bombing missions completed since the 21st. Operations concentrated its attention to requests covering the battles along the Market Garden corridor. British armor of XXX Corps failed to break through to the 1st Airborne in Arnhem and by the 25th orders went to the survivors north of the Arnhem bridge to evacuate what forces they could across the Rhine. The 7th Group received more requests for cover on 25 September of two new areas near Graves for further landing zone information. Drop zones to re-supply the paratroopers and glider forces already on the ground had to be photographed often. Unfortunately, weather prevented almost all photo coverage at this critical time.

An urgent call for cover of Nijmegen on a priority one request came on 25 September. In two days, only five missions had been attempted and two pilots had been lost. Operations assigned this new request to Lt. Benton C. Grayson of the 22nd Squadron. Threatening weather had grounded all other 7th Group operational missions. Operations briefed Lieutenant Grayson. In spite of the weather and the fact that the area was the same one where Johnston and McDonald had been lost the day before, the importance of the intelligence required that a mission be attempted.

Grayson took off for Nijmegen in the afternoon. He flew across the Channel to Brussels at 2,000 feet, just below the cloud base. From Brussels to Nijmegan, he varied his altitude from 50 to 1,500 feet flying his F-5 in poor visibility through rain showers. At some points, Grayson could see as far ahead as four miles but the weather was worsening. His assignment was for low-level obliques. When he reached the target area, the river landmark given to him at Mount Farm did not seem to have the amount of water he had been told to expect. Grayson flew up and down the river several times to pin point his target before making three photo runs at 50 feet altitude. Then Grayson turned for home and stayed at tree top level until he reached the Channel. He turned his cameras on and photographed allied gliders and part of Brussels. Even with the terrible weather and rain, Grayson's photographs covered the assignment and satisfied the request.

Action along the eastern front lines in Lorraine had taken a back seat for photo reconnaissance by the 7th Group during the bad weather of the previous week. With better weather on 28 September, Lt. Irv Rawlings of the 14th flew to the front line areas in the Third Army sector for damage assessment of Ninth Air Force tactical strikes at St. Wendel and Thionville. Two ME-109s bounced him as he approached his target but Rawlings evaded them and returned to base with his pictures. The next day, another 14th Squadron pilot, Lt. Louis Gilmore had better luck and saw no opposition. Gilmore managed to photograph in the Thionville and Metz area for tactical Ninth Air Force damage assessment.

Lieutenant Way Killed on Courier Flight
The 22nd, as did the other three squadrons, furnished pilots for courier missions to deliver important new photos and maps to the army at the front lines. The 381st Air Service Squadron maintained the various transport aircraft for most courier flights but when the need was urgent and the load small Intelligence used an F-5 to carry the package. On 30 September, Lt. Ian P. Way of the 22nd took off for France to make a courier run in an F-5.

14th Sq technicians taking a break on a slow day in the Photo Lab. Back row L to R: Tommy Gillean, George Lehman, and Irv Carr. Front Row L to R: Jim Robertson, Dick Post (piano player in base band), Fred Whitehead, and Joe Conrath.
(Ross Garreth)

188

September 1944

While serving as engineer on a courier flight to France, SSgt Lonnie C. Milford is issued a pass on half a post card by Capt George Nesselrode. (L. Milford)

On his return to Mount Farm, Lieutenant Way ran into the bad weather that had limited operational missions. Ground forces in France reported that his F-5 had crashed near Lefrety, killing the pilot.

The 7th Group made frequent requests for new replacement aircraft and the losses during September made a critical shortage of operational F-5s possible in the coming months. Some replacements arrived at Mount Farm and three F-5s went to the 22nd Squadron, assigned to TSgts James R. Pyle and Herbert C. Driver, and SSgt Willie Esque. The 27th Squadron received five new F-5Es.

Mustang

Occasionally, new equipment and the men ordered to modify it got off on the wrong foot. This was true about a very fine aircraft which arrived without fanfare at Mount Farm. The Station Engineering Officer notified the 14th Squadron Maintenance Department on 1 September 1944 that a P-51 had just arrived on the field and been assigned to them for maintenance. The oldest mechanic in the outfit, totally familiar with F-5s and Spitfires did not know how to tow a P-51 much less maintain it. The 14th's Line Chief, MSgt "Crash" Mayden, figured out how to get the aircraft to the area and appointed TSgt Clarence M. Bean as crew chief. He began an acceptance check. The inspection was not routine because P-51 tech orders were not easily found on a F-5/Spitfire base. In spite of the unfamiliar aircraft, his crew finished the check in five days. Major Chapman took the Mustang up on a local test hop and gave a favorable report. Every time the crew made a modification to the plane, test flights evaluated the changes. General Spaatz and Colonel Roosevelt had discussed the replacement of F-5s with P-51s (F-6s) as early as April and Col. George Goddard, the photo wizard of the air force, began work on camera installations in a P-51's wings at Langford Lodge, Ireland, in May, 1944. The various generals and colonels interested in improving photo reconnaissance thought that the Mustang would make a very good PR plane. It needed many changes to outfit it as one and the aircraft's swiftness seemed the overriding recommendation. The PR men at Mount Farm thought otherwise but set out to do the assigned job.

After the maintenance crew made their modifications, they sent the Mustang to Camera Repair for outfitting with aerial cameras. While converting this fighter to a satisfactory camera platform, Camera Repair ran into various difficulties fitting it with K-22, 24" focal length cameras. These had to be mounted horizontally in the wings with their lenses facing outboard and mirrors set at an angle facing downward. Excessive vibrations in the cameras showed up during tests of the installations. The 7th Group never used the camera equipped P-51 operationally and sent the Mustang on detached service to a depot that was better able to maintain the aircraft. There were mixed emotions at its departure from the 14th Squadron maintenance section where many of the men hoped it would be the last P-51 to invade the photo field.

The Ninth Air Force used P-51s, designated as F-6s and equipped with oblique cameras, successfully on medium and low-level tactical photo reconnaissance. They never became the premier photo ship of strategic PR units.

Glenn Miller

One of the highlights of September had nothing to do with missions, flak or interceptions. On 25 September, Maj. Glenn Miller and his "Supreme Band of the Allied Command" played in one of the hangers to over 1,500 men. Special Services Officer, Capt. John Anderson had

Colonel Shoop talks to band leader Glenn Miller.
(Ross Garreth)

Eyes of the Eighth

a big job keeping the men of the 7th Group entertained but wonderful talent from Hollywood and the USO toured bases putting on shows. Movies were regularly shown at the base and different films made the rounds of the Eighth Air Force airbases. Anderson received a special request from his newly-wed group commander, when Colonel Shoop asked him to get a particular couple of movies sent to the base. Both featured his wife. It was no surprise that the C.O. watched "Northern Pursuit" and "Action on the North Atlantic" more than once even though Shoop took a ribbing about Humphrey Bogart and Errol Flynn chasing his wife, Julie Bishop.

Lt John S. Richards of the 14th Sq.

September ended with reduced operations by both bombers and photo recon units of the Eighth Air Force. After 12 successful PR missions on the 28th, bad weather on the 29th grounded the bombers and limited the 7th Group to six sorties. The 13th and 14th Squadrons flew three each. There were no bombing missions. Most operations from Mount Farm consisted of courier flights and local tests. Lieutenant Richards took Captain Dixon up in a modified version of a P-38J, which had acquired an odd name, Droop Snoot, as well as a longer nose. The extra space made room for a second man, an observer, to ride below and forward of the pilot. Dixon rode in the nose compartment, the observer's position on operational missions. The two 14th Squadron pilots stayed up for 45 minutes with Dixon getting a ride he would give to others on future missions.

Eighth Air Force bombers from all three bomb divisions attacked targets in Germany on the last day of September. The main tonnage fell on the primary targets of marshaling yards at Bielefeld and Hamm. The B-17s of 1BD had to drop most of their bombs on a target of opportunity at Munster but did deliver 145 tons to their primaries of the Munster/Handorf Airfield and Munster Marshaling Yards. As usual, weather was a determining factor.

Pilots from all four squadrons flew sorties to Germany on the 30th but in limited force. Only five aircraft, four F-5s and one Spitfire, left Mount Farm on operational missions. Lieutenants Shade, Leatherwood, and Carlgren from the 13th, 14th, and 22nd Squadrons respectively, covered open targets. The 27th Squadron managed to get two pilots, Lieutenants Florine and Floyd, over Germany for photo coverage.

Because of incomplete information and delayed discovery and notification, the 7th Group's losses for the month of September could not have been calculated accurately at the time. Losses were heavy. Thirteen pilots did not return to Mount Farm from 12 photo reconnaissance sorties and one courier flight. Some pilots originally listed as missing in action returned to base as did Lt. John Ross after his ditching and rescue at sea. One man was listed twice; Lt. Grover P. Parker managed to return from France after evading capture but was on the MIA list at the end of the month from his last sortie over Holland.

Crashing just short of the airfield, Lt. Alexander Kann, Jr., died within sight of Mount Farm removing any doubt of his fate. The infantry found Lieutenant Way's body and notified authorities who quickly informed Mount Farm that the courier pilot had been killed. At the end of the month, Colonel Hartwell remained on the MIA list as well as Lieutenants Hilborn and Parker, all three eventually either being identified as prisoners or returning. Lieutenants Balogh, Bayne, Goffin, Johnston, McDonald, and Stamey stayed on the missing list until eventual confirmation of their deaths.

This ominous increase in interception and opposition to photo reconnaissance aircraft, coupled with deteriorating fall weather both over the Continent and England foretold a developing trend that would effect future Group operations.

Chapter 13

October 1944

Bad weather prevented any 7th Group operational sorties on the first day of October. The next day, Eighth Air Force bombers found satisfactory weather over targets in Germany using their bombing aids to attack industrial targets. The 7th Group flew four successful sorties that day. Lt. Hector Gonzalez of the 27th Squadron covered the strike against the Cologne/Ford Motorworks as well as targets at Mulheim, Euskirchen, and Ghent. Another of his targets, Dillenberg, had been attacked on 19 September but poor weather prevented cover until now. A pilot from the 22nd, Capt. D.A. Farley, had his targets, including airfields in the Bremen area, obscured by heavy cloud. With better weather in Holland, he obtained the much wanted photos of the Arnhem Bridge, now securely in the hands of the Germans, as well as barge yards in Rotterdam, and the airfields of Plantlunne and Hopsten.

Smoke and Deception

It was not cloud cover that prevented 22nd Squadron pilot, Lt. J.B. "Red" Matthews from covering his main target that day. After raids on industrial targets at Kassel by Eighth Air Force bombers, Matthews tried to get photographs for damage assessment but could not due to smoke covering the target area. The smoke was not from the bombing but came from an artificial and controlled

The city of Nijmegan is at the top left of the picture. Its two bridges over the River Waal are clearly seen. The upper double-span RR bridge is partially destroyed but the single span road bridge, captured by the 82nd Airborne during Operation Market Garden is intact. The river bank on the right side is clearly seen as it bends to the right. The left bank is barely visible where very low-lying land has been flooded leaving the higher ground as a temporary bank. The real river bank is seen in the lower half of the photo, outlined by the active smokescreen sites lining the dykes. The smoke streams across the River Waal at this point. Scattered puffy clouds cast shadows across flooded land and river.
(J. Byers)

source. Many of the heavily defended installations in Germany used various types of chemically produced smoke screens, which they activated at the approach of PR aircraft. On inland targets such as Kassel, the Germans easily could place protective smoke generators in strategic locations to foil aerial cameras. On rivers and in harbors, they installed the chemical smoke pots on barges to take advantage of prevailing winds. These smoke screens could be quite effective and on this day, the smoke hindered Matthews' cover of the target.

Another means of deception used by the Germans consisted of decoys to draw attacks from real targets and dummy installations to mislead intelligence gatherers. Photo interpreters began to notice more devices on their aerial pictures as oil and air industries suffered increasing attacks. Near Wilhelmshaven, the Germans built a decoy installation used for daylight deception with smoke screens as well as dummy chimneys that could make smoke to deceive either bombers or photo planes. When bombers neared the real targets, the chimneys could be set smoking to indicate a working plant and the smoke screen compounded the illusion and prevented revealing photography. Evidence of fire sites used to divert RAF night bombers appeared on PR film and allowed Operations to alert aircrews where such deception could be found.

Costs and Commendation

Operation Market Garden, the battle for the crossing over the Rhine, failed to achieve its major objective. The partial success of the airborne forces left a front line projecting narrowly into Holland as far as the south side of the Rhine River near Arnhem. The 38 missions scheduled and dispatched by the 7th Group to cover the airborne operations resulted in the loss of four pilots, a rate of loss four times greater than normal. The high cost to both aircrew and soldiers who fought on the ground marred the limited success of the airborne forces during the operation.

In recognition of its contribution, the 7th Group received commendations from two commanding generals. The American commander of First Allied Airborne Army Lt. Gen. L.N. Brereton commended the 7th Group for executing the requests for cover successfully in the face of danger from flak and interception. The Group received another commendation from Lt. Gen. Omar Bradley, commanding general of the Twelfth Army Group, who thanked the 7th Group for their hard work in spite of considerable losses flying hazardous missions filling Twelfth Army Group requests.

Field Marshal Montgomery, his attempt to break though into Germany across the Lower Rhine thwarted, turned his attention toward the most important objective in his area, the opening of the port of Antwerp. Finally forced to clear German forces from the approaches to Antwerp by orders from Eisenhower, Montgomery directed the First Canadian Army to begin the operation on 2 October to clear the Schledt Estuary. Suddenly, the Dutch saw their hopes of liberation dashed. Ever since the wild celebrations of *Dolle Dinsdag* early in September, followed by the Market Garden advances, a violent battle had raged on their land. Many Dutch resistance members came out of hiding to fight and the people, after four years occupation, carried out reprisals on collaborators. After the defeat of the British 1st Airborne at Arnhem, the shifting of attention to the Scheldt in Belgium assured them of another bitter winter under Nazi rule. Resisters went back into hiding. German reinforcements strengthened defensive positions. The high cost to the Dutch people of Market Garden's failure began to add up.

The concentration of action in a small area increased the incidents of interception. Luftwaffe fighters were more active than ever against photo planes particularly over Holland and the battleground of the Scheldt area on the Belgian-Holland border. A circle of airfields protected the German homeland that lay only a few miles to the east of the front lines. The whole of northwestern Germany was a hot area for interception and 7th Group pilots swiveled their heads watching for the tiny speck or contrail to warn them of fighters.

On 5 October, three 22nd Squadron pilots ran into strong opposition. Over Munster, 12 ME-109s intercepted Lt. Willie Williams who escaped by rapidly climbing to

During a Flying Fortress attack, a smokescreen is in operation and two fake chimneys (indicated by arrows) begin to issue smoke that differs in color from the smokescreen. The chimneys are used to imitate an operating factory not to augment the screen. (J. Byers)

October 1944

Confidence of Allied air superiority over Luftwaffe incursions into French air space is indicated by aircraft lined up on the recently captured Brussels/Evere airfield in Belgium. Photo taken by Lt Charles Batson (13th Sq) on 5 Oct.

36,500 feet. On the same day, 12 enemy fighters chased Lt. Byron Waldram out over the North Sea as he attempted to reach his targets at Hamm, Munster, Soest, and Bielefeld. Waldram managed to get other targets. By ducking into heavy clouds, Lt. J.H. Ross shook off 12 ME-109s and got alternate targets covered on his film. All three pilots evaded their interceptors and returned safely to Mount Farm although Lieutenant Waldram cut it pretty close with only seven gallons of gas remaining in his tanks.

Lieutenant Waldram's sortie was his third successful operational mission. Like other new pilots, he flew as many local flights as possible preparing for these. When poor weather prevented operational sorties over the Continent, many pilots flew aircraft to various depots to pick up parts, and deliver papers or photographs to other units. They kept up their flying time testing newly accepted aircraft and planes modified or repaired by squadron flight line crews or the 381st Air Service Squadron. Good weather at Mount Farm meant opportunities to hone flying skills. To add a little fun to routine local flying, pilots chased each other around in their F-5s and Spitfires, practicing combat maneuvers in a game they called "rat-racing."

Often, replacement pilots like Lts. Robert Hall, Claude Murray, and Byron Lee Waldram, only on the base a few weeks and without time to form new friendships with the "old-timers," stuck together. The three 22nd Squadron pilots frequently flew together "rat-racing" in mock combat about the English skies. With youthful exuberance they altered their innocuous callsign *Baylo* to a more irreverent, *Bat Crap* as they prepared for real operations over enemy territory. Their first missions followed the usual milk run routine. With so much of France liberated, these amounted to railroad repair studies. Several times in September, Hall, Murray, and Waldram covered rail lines from Paris to

Three friends, Lts Robert W. Hall, Byron Lee Waldram, and Claude C. Murray pose in front of an F-5 before taking off to fly around the Mount Farm area engaging in "rat-racing," good practice for combat flying. (C. Murray)

Patton's Third Army front-lines near Metz returning with film of their assignments.

Murray Missing in Action

The targets on 6 October for Lieutenants Hall and Murray were in enemy territory in Holland as well as Hamm, Bielefeld, Lippstadt, Soest, and Paderborn in Germany. Neither pilot had his own specific aircraft but flew squadron F-5s assigned to them. Recently, Hall had flown a mission in Lt. Everett Thies' F-5 *Dot & Dash*, which had returned to Mount Farm and Crew Chief SSgt Guy Mock's charge from Russia where it had been crewed by TSgt Daniel Noble in Poltava. Aircraft were in too short supply to sit idle when their regular pilot had no mission for the day. On 6 October, Operations assigned *Dot & Dash* to Lieutenant Murray.

With their targets so close together, the two pilots took off at the same time and headed for Holland keeping about a mile apart within sight and radio contact of each other. They planned to travel together through the areas of heavy enemy fighter activity as far as Munster but with each mile the degree of separation increased. The weather was clear but slightly hazy. As they crossed in over the coast of Holland at 27,000 feet they had drifted about three miles apart. Radio chatter was forbidden but near Arnhem, when Hall thought Murray was on the wrong heading too far to the left, he called to his friend, "*Bat Crap*, you're off course." Murray, really *Baylo 28,* told Hall, "No, *Bat Crap*, you're off course."

Hall checked his map and figures to make sure. Suddenly from nowhere an enemy fighter jumped him from 500 feet. He shouted over the radio, "Murray, bogies, bogies." Hall turned away from the twin-engine fighter

Eyes of the Eighth

as it turned in on him and escaped. He looked for his friend but couldn't see him. Radioing that he was returning to base, Hall turned back toward England. During his debriefing, Hall reported the interception by the fast twin-engine fighter and his warning to Murray. Intelligence confirmed that the plane was a jet-propelled ME-262. When Lieutenant Murray did not return, 7th Group reported him missing in action. His friends hoped that he had been able to land in friendly territory.

Olympic Gold
The Rheinmetal Borsig A.G. plant, Berlin's Tegel Airfield, the Spandau Military Depot, and an Ordnance Depot on the west side of Berlin were the targets of the Eighth Air Force bombers on 6 October 1944. Capts. George Nesselrode and Robert Dixon, commanding officers of the 13th and 14th Squadrons respectively, followed the bombers out for the damage assessment photos. They saw fires burning throughout the target area. Both pilots made several runs over the city then photographed Templehof Airdrome as well.

After finishing their runs, Nesselrode radioed Dixon to wait a minute and he would be right back. Dixon was uncomfortably puzzled for Berlin was still a hot area for interception and flak but he stooged around over the city waiting for his friend. When Nesselrode reappeared, Dixon was naturally curious. Nesselrode told Dixon that he had flown over the Olympic Stadium and photographed the adjacent swimming stadium where their friend and former 14th Squadron commander, Marshall Wayne, had won his 1936 Berlin Olympic gold medal. Returning safely to Mount Farm, the two men had the photo printed and they delivered it to Wayne, now with the Ninth Air Force. (After the war, Wayne hung the photo in his home where it remains today.)

The weather cleared on 7 October and the 7th Group sent out sorties to every quarter to try and catch up on pending requests. Jobs had accumulated; many were considered first priority especially by the units requesting them. The Engineers held one of the highest priority jobs, mapping for the ground forces. The areas were from Frankfurt to the vicinity of Hanover, Germany.

The 13th Squadron assigned six aircraft in two flights of three each to an area near Giessen. Lts. Bickford, Budrevich, Schultz, Sommerkamp, Madden and Facer formed the two flights. Just after crossing in over the Continent, Lt. Ross Madden's right engine threw a connecting rod and he had to return to base. The others secured the coverage requested and returned safely.

Another 13th Squadron pilot, Lt. John Anderson flew a sortie to the Scheldt area where the First Cana-

Breached dykes on Walcheren Island at Westkapelle after 3 October raid by RAF in preparation for operations to clear the Scheldt Estuary. (J. Byers)

Two low-level obliques of flooded land at Flushing on Walcheren Island after the breaching of the dykes. (J. Byers)

dian Army had begun a wet and muddy campaign against heavy and determined opposition. At the entrance to the Scheldt Estuary, the most prominent feature was Walcheren Island. Partially surrounded by sand dunes and dykes to hold out the North Sea, most of Walcheren Island lay three or four feet below sea level. The German occupiers held strong defensive positions with heavy artillery on the high ground. An assault against the island would be suicide unless the Germans could be isolated. The British considered their options carefully as any bombing and flooding would cause their Dutch allies terrible harm. Finally, they decided that the dykes had to be breached to flood Walcheren making passage of German armor and heavy guns impossible. Before the air strikes, RAF bombers dropped leaflets warning the Dutch population of the danger. Then on 3 October, the RAF bombed the dykes creating large openings for the North Sea to rush in. Anderson returned with good cover of the breech and the resulting flood.

October 1944

Claude Murray

"Bogies. Bogies." Bob Hall's shouted warning came too late. *Whoomp*. Canon shells slammed into the F-5. *Dot & Dash* shuddered. The violent jolt stunned Murray. Instinctively, he dropped his auxillary tanks, pushed the throttles to the fire-wall and dove into a right-hand spiral. *Jets*. You didn't see jets the way you saw the 109s and 190s. His props began windmilling as the engines quit. He had forgotten to switch from the drop-tanks. His right engine caught fire. Murray switched back to his main tanks and started the left engine. He couldn't blow the fire out on his right one. Pulling out of the spiral at 6,000 feet, Murray pointed the F-5 toward England holding hard left rudder to fly straight and level. Smoke poured into the cockpit. He would not make it home.

"*Mayday. Mayday.*" The pilot popped the canopy. Wind sucked his helmet, goggles, and mask off. Could he get out safely? He knew the drill. Murray held the left rudder hard. Would he get hung up with all his gear? He remembered P-38 bailout horror stories. It seemed impossible. Smoke meant fire and he had to try. He reached up to pull himself out; wind almost broke his arm. The pilot prayed and took his foot off the rudder pedal. *Dot & Dash* flipped over, Split-S'd, and threw him out.

Lieutenant Murray blacked out. As before, training and instinct made him react correctly. When he came to he was swinging under the white canopy of his parachute. He couldn't remember pulling the D-ring rip cord. Below lay water. *Dot & Dash* had disappeared. He managed to release all but one chute harness buckle before dropping into the cold sea. Inflating his Mae West, Murray bobbed to the surface and shed his parachute. The CO-2 cylinder pumped up the dinghy that hung from the vest. Crawling into his tiny raft, Murray found only the sea anchor and bail out bucket. No paddles, no sail and mast, he set the sea anchor and began to drift.

The afternoon faded and at nightfall Murray still had not seen land. The sea anchor kept his little vessel steady and following the current. Bitter cold enveloped him. The dinghy had an orange flap to use as a cover and although he huddled under it, the only respite from the cold came when he relieved himself, the warm liquid running down his legs. He drifted on. The night was clear. A shape appeared on the horizon. Murray paddled with his hands towards the object. The shape grew larger; it was land. Exhausted and cold, Murray crawled ashore; pulled his dinghy up and deflated it. He found a bush, lay down under it and fell into a deep sleep.

At dawn, Murray awoke and began looking about. He crept quietly, wary of being discovered. His refuge was a small island, a fort of some kind. He didn't have to creep about. He was alone. He shouted but no one was there to hear him. The fortress had thick concrete walls and a moat of some sort that he realized he might have fallen into if he had moved about in the night. A sign declared *Verboten*, forbidding entry, but there was no one else to warn off. Murray could explore the whole island fort. It was old, disintegrating, and abandoned. There were all sorts of rooms and corridors. In one area Murray found enough debris to start a fire at the bottom of the empty moat with matches from his escape kit. His GI high-top shoes were wet. He took them off and set them by the fire to dry. Pulling his flying boots back on, the pilot climbed up out of the moat to look around.

The Zuiderzee. Murray decided he must be there, but where? The superstructure of the fortress had long ago crumbled but what was left gave him a view over the water. In the distance, about two miles away, he saw a small town. Off to one side he could make out what he thought might be a factory, smoke coming from some chimneys. Someone might be watching if he could attract their attention.

From the dinghy he tore the orange flap, hung it on a stick and waved it wildly from the highest point. Then he found everything that would burn, piled it together into a bonfire. Surely, someone would see *that*. He could see boats out there. Why couldn't they see him? Murray tried his piercing whistle with his fingers; he shouted; he waved the orange flap. Nothing.

By mid-afternoon, his shoes ruined from overheating, hungry, wanting a cigarette and someone to talk to, Claude Murray made his decision. If he got back into the damned dinghy – as much as he did not want to get wet again – he would paddle toward the town. He might get ashore near enough for the factory workers to see him. If they didn't he would start walking. Somehow, the pilot got the dinghy inflated and with a couple of boards for paddles, he set out.

Murray had not gotten far when he spotted people in a small fishing boat. Three Dutch boys saw him, pulled alongside, and hauled the pilot into their boat. They deflated his dinghy and hid it under their fishing nets. Murray pointed to the Eighth Air Force insignia on his B-10 flight jacket. "I am an American." They spoke no English and Murray spoke no Dutch but as a German patrol boat passed by, the boys shoved the American under the nets and rowed to the side of a stone-faced dyke. One climbed up the dyke and disappeared. Murray took no chances and ordered the other two to row back out into the water. Who would the young fisherman bring? The Germans?

Eyes of the Eighth

Photographs taken by 27th Sq pilot Lt Donald A. Farley (enlargment of Muiden see insert). Arrow A indicates Fort Pampus (see insert) where Lt Claude Murray, shot down on 6 Oct 1944, landed after drifting in his liferaft. B: Where the boys in the fishing boat landed on the dyke after picking Murray up. C: Rozendaal's house in Muiden (see insert). D: Road to Naarden. E: Gys Regtuyt's farm on the Vecht River. F: Weesp. G: Amsterdam-Rhine Canal. (P. Keen/USAF)

October 1944

Claude Murray's Evasion

Lieutenant Murray felt he could trust the boys in the boat. Hadn't they hidden his dinghy and avoided the German patrol boat? Jan Dobber and Gosse Bijl kept watch over the man with the U.S. Air Force insignia on his jacket. Dobber's brother Jacob had gone to get help, to "*haul zyn vader*." Murray hoped what sounded like, "haul his fodder," meant he had gone for his father.

Jacob returned with an older man on a bicycle. A civilian. The boys told the man what had happened. Years of occupation taught the Dutch to be suspicious of strangers. The older man was not going to take this American at face value. He peddled off to get expert help. The three boys and Murray waited.

The man returned with another man. Murray recognized that the new man was in control. He gestured asking if Murray could ride a bicycle. The pilot nodded yes and they rode to a nearby house. A woman gave Murray civilian clothes to put over his flying suit. They took away his escape kit and maps.

After dark they rode to a plain brick two-story house in a village. Men from the local underground sat around the dining room table. Spread out on the table was everything from the escape kit. Murray recognized that Johannis (Joh) Rozendaal, the man who had brought him there, was in charge. The young men from Joh's resistance group needed to know if Murray was a German spy. An English-speaking minister, Dominee Douma would translate.

With his crewcut, dirty face, and a shadowy stubble of a beard, Murray could very well be a German plant. The Dutchmen waited until he had some warm food, a bath, and a shave before they questioned their "prisoner." Murray relayed his story through Dominee Douma. Joh and his men listened. When he finished they let him go to bed where the exhausted Murray slept through the night.

The next day a new interrogator, Daan Spoor (Swen) presented him with a written list of questions. Spoor spoke fluent English. He wanted details. Murray had given his name, rank, and serial number but now he had to trust these people enough to tell them other things he would not tell the Germans. Who was his flight surgeon? He told them. They asked the usual questions about American things, baseball, slang, and other non-military information. There were no more questions after Spoor left.

Murray waited. In a few days Daan Spoor returned. He had contacted British Intelligence. This former Dutch military officer confirmed that Murray was who he said he was. He brought instructions for Murray. "We have orders that you are not to try to escape and we are dedicated to helping you evade capture. We will hide and protect you but we can't help you to escape."

Murray did not know at the time that this man was well-schooled in evading Germans. He was what the Dutch called an *onderduiker*, someone forced to "dive under." He never went home nor slept in the same place twice. Spoor changed his identity, traveled constantly, keeping on the move to escape the Gestapo who vigorously searched for him. Now he would change Murray's identity and see that the Germans did not find the American either. Spoor told Murray, "We have orders to make you a Dutch civilian for the time being."

They took his picture and put it on a *Persoonsbewijs* with Murray's fingerprints. With this personal permit, Murray became Jan Pieter Smit, a *doofstom*, and a salesman from Edam. Unable to understand or speak Dutch, the designation as deaf and dumb would come in handy. Murray turned over his dogtags, uniform, and anything that could reveal his true identity. Now, the underground had to find a new safe home for Jan Smit.

Eyes of the Eighth

During a visit to Mount Farm, Bing Crosby enjoys a fried chicken wing prepared by Col Elliott Roosevelt's cook. L to R. Colonel Shoop, Maj D. Brooks, Crosby, Roosevelt. (Ross Garreth)

Bing Crosby

On Saturday afternoon, one week after Glenn Miller's appearance, Bing Crosby and his troupe of entertainers, put on a show in the same hanger. Everyone who could crowd in did so and enjoyed the diversion. Crosby was at the end of a tour entertaining and made a special trip to Mount Farm for his friends, Colonels Roosevelt and Shoop. As a treat and way of saying thank you, Roosevelt's cook fried chicken at the farmhouse for the Hollywood star who had to leave after his performance.

Aphrodite Target Heligoland

The Aphrodite drone aircraft campaign against difficult concrete constructions impervious to regular bombing proceeded in spite of the tragic failure of the U.S. Navy's mission on 12 August. By early September, the ground forces had overrun the large V-weapon sites targeted for Aphrodite and new targets chosen included the thick concrete U-boat pens at Heligoland, one of two small strategic islands in the North Sea off the northwest coast of Germany. The last Navy mission using its drones had been against Heligoland but the mission failed when the controller mistook the smaller neighboring island of Dune for the target and destroyed a few houses. One other attack against Heligoland, on 11 September by the USAAF unit at Fersfield, began tragically when the drone's pilot, Lt. R. W. Lindahl was killed bailing out. The mission proceeded but flak hit the drone ten seconds from the target and it crashed into the sea 200 yards short. Two drones targeted an oil refinery complex at Hemmingstadt on 14 September but poor weather over the target prevented both accurate direction and photo reconnaissance.

The next Aphrodite attack came on 15 October against the U-boat pens at Heligoland. Prior to the mission, the 25th Bomb Group sent several Mosquito aircraft on weather reconnaissance in the area. The 7th's Assistant Group Operations Officer Capt. J.D. Campbell and Lt. Richard W. Brogan of the 13th Squadron took the assignment with Brogan flying an F-5B, 42-68265, equipped with a nose camera. They flew to East Anglia where they picked up the formation of 16 P-51s escorting nine B-17s, two of which were "war-weary" Fortress drones guided by Castor directional equipment. Castor utilized a television camera in the nose of the drone "baby" and a receiver in the "mother" B-17. The operator "saw" how to guide the drone through the camera and flew his "baby" from the "mother" ship. Two drones, painted bright chrome yellow for easier tracking, had the usual complement of observation aircraft including the two photo ships from Mount Farm. Brogan photographed all phases of the mission successfully including the crash of one of the drones into the sea after it was hit by flak before reaching the target.

Grayson

The same day, on return from a mission over Eisenach, Lt. Benton Grayson's F-5 took six bursts of flak over Cologne and caught fire. Grayson struggled with the canopy, got it open but could not get out of the cockpit. The pilot tried again and rolled his plane over on its back, fell out, and lost consciousness just as he pulled the ripcord of his parachute. That was the last thing he remembered until he awoke on the ground being injected with morphine by an Allied medic. Grayson learned he had landed near Rheims and had broken one leg in three places and fractured both arms.

British Air Controllers informed the 7th Group that they last heard from Lieutenant Grayson over the Pas de Calais, France. The Group listed him as missing in action but soon learned that the injured pilot had been

TSgt Ed Hoffman photographs two other members of 381st Air Service Sq, SSgts Lonnie Milford and Daryl Nooner posing on Luftwaffe wreckage at A-97 airfield in Luxembourg. These flight engineers crewed many courier flights. (D. Nooner)

taken to the 108th General Hospital. When he recovered enough to travel, Grayson transferred to a hospital near Oxford.

Courier Service

Poor October weather prevented most cover of targets on the Continent after the first week in October. The only big day had been on the 7th when the Group flew 28 sorties. On days when a few aircraft could go out many returned with reports of cloud covered targets. Only 19 missions had been dispatched between the 7th and 15th of October with only 11 successful. The courier service, instigated shortly after D-day, continued flying vital maps, mosaics, and photos to air strips next to various army headquarters and forward bases. More aircraft allowed the 7th to fly more courier flights. The 7th Group's inventory increased with the addition of three C-47s, an AT-23B, and a C-53 to the original C-64, two B-26s, and the B-25 *Miss Nashville*. The AT-23B was a faster, lighter, and easier to handle version of the B-26B built for target towing, which ended up in various Eighth and Ninth Air Forces units when the No. 3 CCRC closed its station at Toome in September. The assignments for these assorted non-combatant aircraft took them from Mount Farm to Ireland at one end of the European theater, down into the southern theater of operations in the Mediterranean.

Sgt Mark Hicks of the 381st Air Service Squadron with Tony.
(D. Nooner)

The four combat squadrons alternated the responsibility of supplying pilots for flying the courier runs. Each squadron flew one day out of four. The 381st Air Service Squadron maintained all the aircraft except the F-5s from individual squadrons and furnished the engineers on aircraft requiring crew. Among the men serving as flight engineers were SSgts Mark Hicks, L.C. Milford, D.W. Nooner, TSgt E.C. Hoffman and Cpl A. Lucyk.

The airfields used by the courier flights ranged from temporary forward fields quickly scraped out and laid with steel matting to airfields formerly used by the Germans and frequently bombed by the Eighth Air Force until their capture and repair by Allied forces. The Ninth Air Force occupied many of the fields and some were emergency landing strips for combat aircraft returning from operations over Germany. The forward strips, by necessity and title, were very close to the front lines. By October part of this line in the east was near the Luxembourg-German border. A landing strip near Hamm, just outside Luxembourg City, served Patton's Third Army and was only eight to ten miles from the front lines. There was little margin for error in this hilly country. In the poor weather common to the area at this time of year, a ceiling below 600 feet was not unusual. Letting down for a landing under these conditions often caused miscalculations and overshoots. In a direct line with the runway lay the German occupied city of Liege on the Moselle River. Pilots flying into the field near Hamm had been briefed that overshooting the strip would bring them quickly over front lines where ground troops from both sides would fire at them.

No operational sorties left Mount Farm on 17 October. In the morning 27th Squadron C.O. Captain Childress with Lt. Robert Florine flying co-pilot and SSgt Lonnie Milford as engineer took the Group's AT-23B to A-70 at Laon/Couvron on a courier flight. They returned to Manston in the afternoon. At the same time, *Miss Nashville* left Mount Farm with Capt. J. L. Campbell at the controls and its regular engineer, SSgt Mark Hicks as crew. After a flight to Villacoublay Airfield outside Paris, they also returned to Manston.

Later in the morning, Lt. E.S. Williams of the 22nd Squadron, after flying 17 missions, flew an F-5 on a courier run to Luxembourg. From the coast of France, Williams flew in 10/10 cloud and frequent severe rainstorms. At first Williams could drop down to below the cloud base around 3,000 feet but as he neared Luxembourg that base lowered to 100 feet. Unable to see the ground, he overshot the field at Hamm and without realizing it crossed the front lines. The cloudy weather hiding the field prevented the gunners on the ground from seeing him as well and no one fired at him. Below, Williams found the Moselle River. Unaware that he was over enemy territory, he headed north, keeping a close watch for the landing strip.

Suddenly tracers and small arms fire erupted around him. With little air space to work with, Williams racked his aircraft down to the left. Ahead lay a small valley between high hills. The pilot sought refuge below the

Lt E.S. "Willie" Williams stands in front of his F-5. He is wearing dark glasses, necessary items above the clouds where the sun shines in a pilot's eyes either on the way over in the morning or on afternoon return flights from the Continent. He has his parachute harness on but the dinghy seat pack lies on the wing in front of the ground crewman. (E. Williams)

hills but Germans on the heights fired at him as he dashed past. Through the valley bullets came from all sides, below, and above. Williams flew through the hailstorm of lead until he reached the farthest hill and went over and down the other side.

He left the firing behind and without bullets to worry about, Lieutenant Williams looked again for the little airfield. Looking up and around for enemy aircraft, Williams found what he did not want to. Above him and a couple of miles to his left, he saw a twin-engine fighter. As it peeled off to attack, Williams recognized a ME-210. Above him, the cloud base was at 1,000 feet and he climbed toward it to escape. Flying blind in unfamiliar hilly territory, Williams slowly let down below the clouds and no longer saw the ME-210. He saw a small town and circled it several times but found no airfield. At his altitude, Williams could see people on the ground and flew over two unconcerned British soldiers smoking their pipes and watching him. He circled several more times still unable to see the airfield. A large paved road below might have to substitute for a landing strip. Just as he decided to set down, a rare spot of sunlight flashed on the wing of a distant plane. It was a P-47 on the field he was looking for. Williams landed on the runway. As soon as he stopped on the hardstand he climbed out to see how much damage his F-5 had taken in the charge up the valley. The pilot discovered in amazement that his plane, miraculously, was untouched. He returned to Mount Farm the next day.

ELINT and the Droop Snoot

An interesting type of aircraft entered the 7th Group's inventory early in August. At the Operational Engineering unit at Bovingdon, Col. Cass Hough, one of the most innovative engineers in the Eighth Air Force, worked on the development of a fighter that could be equipped with space for a bombardier and bomb sight. Fighter-bombers could attack certain targets more effectively than medium or heavy bombers. A way had to be found to make such strikes more accurate. The logical fighter was the P-38. Work began at Bovingdon in January on the concept and design with major work finished at Langford Lodge in Ireland. The engineers cut the nose off a P-38J, prompting someone to remark about the "droop snooted" plane, removed armament, added space and a hatch for the bombardier, as well as a Plexiglas nose. This new configuration accentuated the droop of the nose and the name Droop Snoot stuck. Used operationally for the first time in April, the new aircraft led many bombing missions with both P-38s and P-47s.

In late summer, a directive came in to Operational Engineering to equip four Droop Snoots with electronics to monitor enemy radar defenses on ELINT operations. ELINT, ELectronic INTelligence, consisted of the gathering of information by electronic means. One of the jobs involved mapping the enemy's radar defenses by locating and recording the source of the radar beams. Both the British and Germans laid out their patterns of radar stations, known as chains, to cover vulnerable areas. Some of the lesser known operations of the RAF and USAAF dealt with the discovery of these chains and the continuing development of radar types and methods to confound them. One such unit was the RAF's 192 Squadron based at Foulsham in Norfolk. Under the larger title of Radio Countermeasures (RCM), other squadrons worked to discover, subvert, block, and jam enemy electronic signals of all kinds. The 192nd was in the RCM unit, the 100th Group, whose motto was Confound and Destroy. American detachments worked with the RAF at different stations in support of RAF and Eighth Air Force bomber operations.

The four P-38J Droop Snoots equipped for ELINT assigned to the 7th Group were numbers 43-28479, 44-23156, 44-23501, and 44-23515. The 14th Squadron Flight Line acquired number 501. Engineering Of-

Col Clarence Shoop pins Air Medal on Capt Fred Brink.
(J.Weeks)

ficer, Captain Nelson, assigned the Droop Snoot to TSgt Gene Nissoff who had the most P-38J experience. Nissoff pulled an acceptance check on the aircraft immediately getting it ready for secret operations from another base. Each squadron prepared the Droop Snoot assigned to it. Pilots chosen to fly these new planes made a few local flights for familiarization. Then the aircraft's crew chief and pilot went on short periods of detached service with RAF 192 Squadron to Norfolk.

The 27th Squadron's Lt. Max Alley took his Droop Snoot, 156, to Foulsham where he flew his first mission on 1 September carrying out a patrol searching for radar signals in an area within the Dutch coast between Delft and West Scheldt. His electronic equipment operator, Lt. W.H. Zeidler, flew inside the lower compartment. These specially trained operators came from the 36th Bomb Squadron at Cheddington. Capt. H. Kasch supervised the small detachment at Foulsham for these ELINT missions.

Joining Alley, Lt. John Richards with his crew chief Nissoff brought the 14th Squadron's P-38J 501 to Foulsham. On 3 September, Richards and his observer Lt. T.C. Holt covered a Navy Aphrodite attack on Heligoland. During September, F/O Ed Vassar of the 13th Squadron flew Droop Snoot 515 on missions with either Holt or another operator, Lt. Francis Kunze. In mid September, Lieutenant Alley returned to Foulsham with crew chief, Sgt Rodger H. Carnes, and alternated with Vassar after Richards returned to Mount Farm. Most of the missions were in Holland in the area south of the Zuiderzee.

For the first ten days of October, Lieutenants Alley and Richards flew missions whenever weather allowed. Richards had one occasion when he had to return to Foulsham due to failure of the electronic equipment. Repairs finished within an hour, Richards and his observer, Lt. W.B. Stallcup took off again and completed a four hour patrol. On 6 October, again flying with Stallcup, Lieutenant Richards flew the last of his 14 ELINT missions in a Droop Snoot. He returned to Mount Farm and nine days later flew to Coltishall, then on to cover targets at Politz, Stettin, and Stargaard. Richards saw one enemy aircraft climbing over Rechlin before he returned to Mount Farm by way of Coltishall. He was away from base over six hours and successfully completed his mission. This was Richards' 51st and last operational sortie.

On 8 October, Capt. Fred Brink of the 13th Squadron, accompanied by SSgt Garth M. Thomas and Sgt Edward H. Yonkers, went on detached service for an indefinite period to RAF Foulsham. His first Droop Snoot mission was on 9 October with a signals search along the Zuiderzee, Lieutenant Kunze as observer. In good weather, the detachment flew one morning and one afternoon mission but the heavy rains, fog, and cloudy weather in October often prevented this schedule. On the 10th, the 27th's Capt. Gerry Adams and Lieutenant Zeidler took number 156 out in the morning with Brink and Holt flying 515 in the afternoon. The next day, bad weather grounded the planes but on the 11th, Brink and Stallcup managed to fly over four and a half hours in the Zuiderzee area but could not land at Foulsham and stayed overnight at Manston, returning the next day. Another pilot, Capt. Robert Dixon, along with TSgt Eugene Nissoff and Sgt Arnold Koskela, arrived on 14 October. For the next two weeks, Captains Dixon, Adams, and Brink rotated assignments.

Photo taken from 25,000 feet showing smoke columns erupting above solid overcast after Eighth Air Force bombers strike oil plants at Hamburg on 25 Oct 1944. Targeting aids allow B-17s to bomb through heavy clouds that prevent photo cover.
(J. Byers)

Eyes of the Eighth

B-26 43-34193, Colonel Shoop's favorite aircraft while C.O. of 7th Group. (J. Riggins)

Shoop Transfers Command to Humbrecht

The 7th Group's commanding officer Col. Clarence Shoop received orders to return to the States where Lockheed and the War Department wanted him to consult on the possible development of Lockheed's new jet aircraft for use in photo reconnaissance. The colonel eagerly looked forward to his return to California where he had seen one of the first flights of the jet at Muroc Flight Test Base.

On 25 October, Colonel Shoop climbed into his favorite B-26 and flew to Prestwick, Scotland, with Major Chapman as his co-pilot, to catch an ATS flight to his new assignment. Along with the B-26's engineer, Cpl A. Lucyk, Capt. Willard Graves went along to fly in the right-hand seat when they brought the aircraft back to Mount Farm. Shoop's successor as C.O. of the 7th Group, Maj. George W. Humbrecht took over command the next day and began the usual changeover and adjustments.

Brink Lost

On 26 October, Capt. Fred B. Brink, Jr., flew a sortie out of Foulsham with his observer Lt. Francis Kunze on a routine signal check near the coast of Holland. Brink, a veteran P-38 pilot had flown in the Mediterranean Theater before coming to the 13th Squadron at Mount Farm. While on service in that theater, he had broken his back when forced to crash-land his crippled P-38. Fully recovered, he had been flying regular F-5 sorties out of Mount Farm.

The Assistant S-3 at Mount Farm, Lt. John L. Anderson, received a telephone call at 1530 hours from Captain Kasch at Foulsham reporting that Capt. Fred Brink had gone down at 1345 hours approximately 40 miles east of Orfordness in the North Sea as a result of engine failure. Slowly, more details came in to 7th Group. The Royal Air Force's 11th Group had contacted Brink, who reported one engine had cut out at 1321 hours at 30,000 feet altitude. Brink's Droop Snoot dropped to 22,000 feet, the other engine cutting out two minutes after the first. British controllers gave fixes to Brink at 11,000 and 8,000 feet. A fix from a station at Leiston reported Brink's aircraft still in the air at 1334 hours. Then at approximately 1343 hours they made their last contact with Brink. His reported altitude – 250 feet. Brink said, "Both engines are gone, I'm going into the sea in one minute." According to Captain Kasch there was no word whether the observer was still with the ship or had bailed out.

A Royal Air Force search unit received a report at 1343 that an aircraft was ditching about 60 miles off the Norfolk coast. They sent out two Mosquitoes and two Halifaxes to find the lost P-38. One of the Halifaxes lost an engine and had to return early but the others continued the search for three hours. Later in the evening, another call reported that Air Sea Rescue had picked up the following articles and equipment: 1 black dinghy, 1 leather flying helmet, 1 aircraft wheel, 1 fuel tank, several pieces of radio equipment, and a log book belonging to a Lieutenant Holt.

The RAF reported the two men, Holt and Capt. Fred Brink of the 7th Group, missing in action and presumed dead. By a strange twist of fate, the observer listed as killed in action was not in the aircraft. Lt. Francis I. Kunze, not Holt, accompanied Brink. For some unexplained reason, he took Holt's log book with him. At Foulsham, it became obvious immediately that Holt was still alive but the paper work to clear up the mistake did not come through until mid-December.

The new C.O. Major Humbrecht was not a stranger to Mount Farm. During the past six weeks, while Colonel Shoop had been away from the base on the Continent with the 325th Wing commander, Humbrecht had filled in as acting C.O. Just one month before, he had flown an operational sortie and had been learning the routine at the PR base. This familiarity with the area and responsibilities became important as word from Captain Kasch came in from Foulsham. At 1600 hours, he and Lt. J.B. Matthews flew to Foulsham to investigate Brink's loss. They took one of the Group's Douglas C-53s, a version of the C-47, just received from the 325th Wing earlier that month for courier duties. Humbrecht and Matthews returned to Mount Farm the next day.

Brink's death raised questions. Some men thought that the observer's small escape hatch could not be used to bail out in flight. John Richards knew that Fred Brink's doctor had told him that bailing out could be fatal. He

October 1944

said he would rather try to land or ditch. Perhaps the pilot would not leave his observer Kunze and they agreed to ditch. The questions remained unanswered. The Eighth Air Force added both men's names to the growing list of missing in action.

Miss Nashville

Word came over the teletype to the Group on 27 October that its B-25 *Miss Nashville* had crashed in France. The day before, Lt. Robert Kraft left in the Mitchell on a courier mission to Luxembourg. *Miss Nashville* was unique. It was the only B-25 in the Eighth Air Force. During the early days of the Eighth, the air war plans called for a medium bomber force. The Third Bomb Wing transferred to England in September 1942 with plans to use both the B-25 and the B-26. The North African invasion changed plans leaving the 26's in England and sending the 25's to North Africa. Number 42-53357 went to Morocco in January of 1943 but was back in England the next month as part of the Eighth. Early in June, the Eighth, in a decision to concentrate on heavy bombers, sent the Third Bomb Wing and its units to Air Support Command. *Miss Nashville* went along, soon to be sent to Burtonwood. There it sat on a hardstand, seemingly unattached, until one day when two pilots from Mount Farm came in to the depot to get much needed parts for operations at Mount Farm. Major Marshall Wayne spotted the racy Mitchell and told Capt. Kermit Bliss that they could use just such a plane in the 7th Group. Wayne had the B-25 assigned to his outfit and, sending their Jeep back to base with the driver, the two pilots flew their acquisition to Mount Farm where they turned it over to the 381st Air Service Squadron for maintenance. Sgt Mark Hicks became the engineer and named the sleek bomber *Miss Nashville*. One of the base artists painted a voluptuous pin-up girl on the nose.

B-25 *Miss Nashville* and Sgt Mark Hicks with typical World War II nose art of voluptuous young women. (J. Bognar)

In August, the B-25 had to return to Burtonwood for extensive repairs on one damaged engine. While the Mitchell was there, an attentive crew chief noticed some unusual interest in the aircraft by senior officers. He notified 7th Group about rumors that the plane was to be outfitted for General Doolittle. On 22 August, Major Wayne and Captain Weitner of the 14th Squadron, along with TSgt Ed Hoffman of the 381st, flew to Burtonwood and had the crew chief at the depot sign off on a receipt, "Received, one B-25 #42-53357," saying in essence that *they* were accountable for it. Then the three knights flew off with the rescued lady and brought her home. "We arrived about dusk," Weitner related, "and didn't clear the barbed wire fence at the end of the runway by more than a few inches." When they stopped in the 381st dispersal area, Weitner checked the tires for nicks and cuts but found none. A few days later, an engineering officer at Burtonwood called Captain Bliss about the B-25 they had up there but Bliss assured him that the 7th Group's B-25 was at Mount Farm, in fact he could see it out on the flight line.

Used by the Group as an auxiliary aircraft, *Miss Nashville* drew the attention of the provisional PR Wing for use at Watton by the 25th Bomb Group for night

Miss Nashville, **Number 42-53357 in slick black paint for night photo work.** (J. Bognar)

photography. Col. George Goddard, chief photographic technical advisor for the Eighth, worked with technicians to fit photographic equipment in the bomb bay of the now slick black bomber. To illuminate the target area they used fused magnesium flash bombs dropped to explode and trigger the camera by light exposure. The better method, still being refined by its inventor Dr. Harold Edgerton, was a powerful strobe-type lamp named after its inventor. The Edgerton Lamp was much more reliable than a flash bomb. Colonel Roosevelt used his influence as the president's son and his friendship with both Goddard and Edgerton to promote night photography for both the Eighth and Ninth Air Forces' photo recon efforts.

Intelligence, particularly tactical intelligence,

needed a way to expose enemy movements usually hidden by the cover of darkness. Night photography allowed pictures of critical road junctions and chokepoints after the invasion of the Continent. In one instance, night photography revealed that the Germans had built a section of bridge across a narrow waterway to replace the one bombed by the Allies. During the day, the span was lowered beneath the water level and did not show on aerial photographs but signs of vehicle traffic on the road approaches did. Night photography revealed the bridge section in use and the tactical bombers took it out again. Thereafter, the crossing received regular coverage.

Miss Nashville had been busy as a courier aircraft in October. Early in the month, Maj. Lawrence McBee and Lt. Hector Gonzalez, with SSgt Mark Hicks as engineer, went to Rome returning with passengers by way of Naples and Grosseto on 7 October. Between the 17th and 25th different pilots took the aircraft to Villacoublay and Lille, France, as well as Luxembourg on courier duty. On the morning of 26 October, in spite of very bad weather in eastern Belgium, Operations assigned Lt. Robert Kraft of the 14th Squadron to fly photographs needed immediately at advanced headquarters in Luxembourg. Kraft had the most instrument time in a B-25, having flown Mitchells out of Bluie West One in Greenland before his transfer to the 7th Group. As crew on the flight, Kraft had Lt. Ross Madden, 13th Squadron, as co-pilot and *Miss Nashville's* regular crew chief and engineer SSgt Mark Hicks of the 381st Air Service Squadron.

Besides the crew, the B-25 carried one passenger. This was not unusual and due to the fact that the 7th Group's parent organization was under the command of President Franklin D. Roosevelt's son who lived on base, many important and famous people hitched rides in the Group's planes. On this particular day, Lorelle Hearst, a good friend of Colonel Roosevelt's and wife of William Randolph Hearst of the newspaper empire, caught the flight to go as far as Paris where she was to cover the recently liberated French capital as a correspondent for her husband's papers.

Lieutenant Kraft and crew delivered Lorelle Hearst and photographs to Paris and then headed for the forward field A-97 at Hamm, four miles outside Luxembourg City where they delivered the bundle of vital intelligence photos. The next leg of the trip would take them back toward Paris to deliver more photos at another field, A-80 at Mourmelon-le-Grande, near Chalons-sur-Marne. The weather was marginal on the eastern front. The B-25 took off and because of the low ceiling, did not turn westward soon enough, quickly passing over the front lines and the occupied city of Trier. Anti-aircraft guns erupted below. Flak hit the Mitchell toward the tail. The B-25 still answered the controls. Nothing seemed to be critically damaged and the pilots decided to go on to A-80, which was not far away and much better considering the weather in Luxembourg.

During the short flight, fire took hold in the rear of the plane and by the time the plane reached the airstrip it had burned into the rudder cables. When Kraft lowered the landing gear, flames shot up into the cabin. The pilot put *Miss Nashville* down on a field short of the strip. As it touched down, the rudder cables gave way. The plane skidded across the slick grass toward an anti-aircraft battery, slammed into a tree knocking the left engine loose and into the cockpit pinning Kraft in his seat. Hicks and Kraft died instantly but Madden, although badly burned, was thrown clear. Thinking Kraft still alive, he repeatedly tried to pull his pilot out of the flames. Members of the gun crew, who saw that neither pilot nor engineer could be saved, had to pull Madden out and hold him back while the wreckage of *Miss Nashville* burned. An ambulance rushed Lieutenant Madden to the hospital.

When word reached Mount Farm about the crash, confusion created stories about a mysterious woman being killed and that all the crew had perished but within two days the Group learned the correct details. Major Kermit Bliss, Group Engineering Officer and accident investigator, flew with Lt. J. B. Matthews in the AT-23B to Mourmelon-le-Grande. Cpl A. Lucyk flew as engineer. The 13th Squadron's Medical Officer Capt. E.H. Heller, as well as Maj. W.A. Hart, went along to check on Madden's condition as well as investigate the crash. They found Lieutenant Madden in the 40th Field Hospital swathed in brilliant red bandages left behind by German medical personnel when they evacuated the

The Eighth Air Force's only B-25 in bare metal finish. Hit by AA fire over Liege while on courier flight from Luxembourg, *Miss Nashville* crashed and burned at Mourmelon-le-Grande, France on 26 October 1944, killing pilot, Lt Robert Kraft and flight engineer Sgt Mark Hicks. Co-pilot Lt Ross Madden survived.
(J. Bognar)

area. Madden gave his report to the officers who left him in the hospital to continue healing from his burns. Heller and Bliss brought back word to the Group that it had lost both Lt. Robert Kraft and SSgt Mark Hicks but that Madden would recover. They also reported that no one else had died in the crash.

Schultz and Crane meet a V-2

Poor weather since 7 October had limited sorties in all squadrons' areas but most of all in the 13th's. Bomber strikes continued whenever possible with bombing aids but cover of the damage could not be accomplished until better conditions over the Continent. The weather broke on 29 October. Operations dispatched 16 sorties. Lts. D.A. Schultz and Charles M. Crane, Jr., had targets at Mannheim, Ludwigshafen, Schweinfurt, and Giebelstadt. Lieutenant Crane's F-5 had a nose camera designed for low level work but this was a high altitude mission. He told his crew chief that he would not be needing that one and flipped off its switch. Each camera in the F-5 had an on-off switch, which when in the on position allowed automatic triggering of all cameras into continuous operation by a single switch.

Schultz and Crane took off and headed for Germany climbing to 30,000 feet. After crossing in over the French coast they flew toward the Rhine, approaching Trier on the Moselle River. On the ground, near St. Goar, Germany, a mobile battery made the final preparations for the launch of an A-4 rocket, known to the Allies as a V-2 and code named Big Ben. Temporarily driven out of Holland by Operation Market Garden and denied the use of the heavy concrete launching sites in the Pas de Calais now in liberated France, SS *Gruppenfuhrer* Hans Kammler made use of an ingenious transport and launching system almost as remarkable as the rocket itself. The *Meillerwagen* was a type of flat bed truck that hauled the 46 foot rocket to the launching site, hydraulically raised it to a vertical firing position on to a metal plate shaped like a cone, which the British referred to as a "lemon-squeezer." The *Meillerwagen* then lowered to the horizontal position and moved away to await its next load. General Walter Dornberger, the developer of the V-2, preferred this type of temporary and easily disguised mobile launching system that made site location difficult for aerial photography even when other intelligence suggested a location. The *Meillerwagen* was long gone before bombers could attack. Hitler, with his love of massive structures formed with tons of concrete, had pushed for the now useless sites in France. In this battle, Dornberger had won but he lost the war of control of the V-2s to Kammler. The public knew almost nothing about the V-2 due to the secrecy surrounding even the

Ground crew waiting for return of 22nd Sq aircraft. L to R. Charles A. Burleson, Evan A. Price, James A. "Little John" Mazilly, and George "PeWee" Newberg.

strikes against London. There was no defense, no advance warning, and no acknowledgment by the British government that such attacks were taking place. Exploding gas mains still remained the explanation for the "unexplainable."

Even though 7th Group pilots knew general locations where they might see rocket trails no one had seen the rocket itself. As Schultz and Crane flew overhead, the *Meillerwagen* moved away and the firing sequence began. The blast-off from the "lemon-squeezer" platform went perfectly and another Big Ben roared up toward the stratosphere and, ultimately, its unsuspecting target. Within seconds, the giant rocket hurtled less than 100 yards just ahead and almost between Schultz and Crane. "I'll get it," yelled Crane aiming his F-5 at the rocket and flipping on the runaway operation switch. Cameras began clicking and rewinding as fast as they could, all cameras that is except the nose camera which was not "on." As the V-2 soared through their altitude with incredible speed toward 40,000 feet, Crane remembered that his nose camera was not operating. Rolling his F-5 over, he aimed at the fiery object with the vertical camera in the F-5's belly. Crane flipped his ship wildly this way and that trying to get the rocket on film but all that remained was the vapor trail.

After the excitement was over, the two pilots continued their mission without incident and returned to base. Intelligence listened intently to their animated de-briefing knowing that the lid was still on information about the rockets. The Photo Lab processed the film and found a few frames where vapor trails recorded the

Eyes of the Eighth

unique moment. What Public Relations would have considered a dream story had to stay under wraps for the time being.

Williams Lost
Taking advantage of the good weather over parts of Germany, the 22nd Squadron sent out Captain Burrows, Lts. R.W Hall, J.B. "Red" Matthews, and E.S. Williams to Minden, Hanover, Genabruch, and targets in Holland near Terneuzen and Apeldoorn. Matthews' sortie was his 45th and he removed five targets from the program. Captain Burrows, on his 31st mission spotted a rocket trail in the distance at 40,000 feet over the Ruhr. Lt. Robert Hall removed seven requests from his squadron's program in a very successful mission. Two enemy aircraft, revealed by their contrails above him, dove toward Hall but disappeared to the west so quickly he thought they were probably jets. Hall returned to Mount Farm from only his seventh sortie without further encounters. One pilot, "Willie" Williams failed to return. The squadron waited to hear that he had landed away as he had before but when no such word came, his name went on the board as missing in action.

Besides Schultz and Crane, other pilots from the 13th Squadron tried to cover as many targets on their program as possible. Captains Nesselrode and Shade, with Lieutenants Batson, Elston, Budrevich, Facer, Sommerkamp, and Flight Officer Vassar photographed Saarbrucken, Karlsruhe, Stuttgart, Kaiserslautern, Schweinfurt, Koblenz, and other targets recently hit by Eighth Air Force bombers. Shade and Sommerkamp found too much cloud for successful coverage but the others returned with good pictures.

Only two 14th Squadron pilots, Lts. J.F. Tostevin and J.H. Roberts, took missions on the 29th. They refueled at Bradwell Bay on the way to their targets at Hamburg, Neumunster, Heligoland, Bremen, and Oldenburg. Both returned with cover of their assignments.

After the loss of Brink in the Droop Snoot out of Foulsham anyone thinking the flights looking for radio waves and electronic signals were milk runs had second thoughts. The pilots knew they had a chance to bail out but it was a sobering thought that the observer had only a small access panel and might be trapped in the belly

After the PR planes return, Camera Repair removes the cameras and the Photo Lab processes the film. On the right, Marshall Williams of the 14th Sq fills tanks used to wash the large rolls of film from the aerial cameras. (M. Williams)

October 1944

Individual prints being processed in developing trays in the Photo Lab. (M. Williams)

of the aircraft. For men who were comfortable with, and preferred, flying alone this was an added responsibility they were not used to. During the month, one pilot, Lieutenant Kraft, who had transferred from bombers to fly solo in Spitfires, ironically died flying with a crew in the B-25 on a courier mission.

The flights from Foulsham continued and each pilot from 7th Group squadrons dealt with this new realization. On 30 October, Capt. Willard Graves joined the little group of photo pilots serving at Foulsham. He took with him ground crew mechanics, TSgt Eugene Nissoff and Sgt Samuel C. McKinney.

The same day, 22nd Squadron's Lt. John Ross followed two Aphrodite drones aimed again at the submarine pens at Heligoland. One of the drones crashed into the sea short of the target and the other failed to respond to radio signals flying on another 325 miles to crash onto a farm in Sweden. Fortunately, no one was hurt in the explosion, which the Swedes reported as the crash of a crippled American bomber whose crew had abandoned ship over Denmark.

New aircraft, all F-5Es, arrived at the 22nd Squadron flight line as replacements for ones lost during the month. TSgt Guy Mock, was crew chief for number 704 until a bad knee sidelined him and Sgt Bob Coyne took over. SSgts J.G. Ginex and A.H. Kirby, TSgt H.C. Driver, and Sgt Willy Esque handled the other new F-5s. The squadron transferred out only one aircraft, the veteran F-5C 42-67108 with 197 hours and 55 minutes recorded flying time, but lost three when Murray, Grayson, and Williams failed to return. Of those F-5s, Murray's was the veteran; *Dot & Dash* had accumulated 209 hours and ten minutes. The 381st Air Service Squadron sent them another veteran F-5B with almost as much time as the one lost, 190 hours and 55 minutes. The 27th transferred its Droop Snoot P-38J 156, which had amassed almost 104 hours, to the 22nd. Engineering had not only new aircraft to prepare but also regular maintenance and seven engine changes during October. New plans in the offing would effect the flight line in the 22nd as well as the other squadrons.

Operating Changes

The new commanding officer of the Group, Colonel Humbrecht had been associated with the 7th long enough to know what it needed to continue operating successfully under changing circumstances. He felt that the squadrons would operate better as individual units rather than in the pooled arrangement in effect in the Group. As of the 31st of October, all sections would operate independently except one, Camera Repair. Operations, which had been a combined function in the Group Operations Building would now move to squadron areas and be separated. Humbrecht thought that this move would create better camaraderie and morale within the squadrons as well as competitive spirit between the units.

There were other reasons prompting this move. In

spite of the failure of Market Garden, the general belief that the war was almost over in Europe permeated much of the higher command. Eyes began to turn toward the Pacific and future plans for air forces. Individual squadrons might be separated from their parent organizations in the near future and they should be prepared to operate independently.

Do svidaniya Russia

At Eastern Base Command in Russia, things had not worked out exactly as planned for the War Department. The Russians became increasingly obstructionist and there was no hope for cooperation in the Far East with advanced American bases. The 7th Group men serving at Poltava noticed increased harassment and stealing. In the very small photo unit, relations with the Russian photo technicians remained pleasant but the Soviets refused to let the men socialize with the Americans. The limited need of further operations from a Russian base became obvious as the western front pressed closer to the borders of Germany at all points. Bases established farther north in Italy brought once distant targets closer for heavy bombers.

The men received the news of the removal of the photo reconnaissance unit from Poltava with joy. No one welcomed a Russian winter in the Ukraine. They were happy to say, "*Do svidaniya*, good-bye Russia." Unfortunately, a few men would stay behind to keep watch over what was left of the American presence. In the Photo Lab, two men flipped a coin to see who would stay behind. Sam Burns lost to Dick Brown, the only original 7th Group Operation Frantic member other than Colonel Cullen. Brown and his companions prepared to return to England. This time they would go together by the southern route. In mid-October, they began the journey by train out of Poltava toward Tabriz, Iran. The devastation along the route and even the stay in the destroyed city of Poltava did not prepare the men for one sight along the way. Early one morning, when they looked out the train window they saw several hundred naked bodies stacked like cord wood. No one knew who they were or why they were there.

At Tabriz, they boarded trucks of the 3925 QM Truck Co. for the ride through the desert, which was more comfortable than the first time. This time they had only 12 men to a truck and the better 10-in-1 instead of C rations for lunch. Added to the better conditions was the knowledge that they were going "home." On the way to Poltava they had used the British camps and their facilities but on this return trip, the detachment had to pitch tents in the rocky desert in spite of the fact that the camps used previously were empty. The 7th Group men could not understand why their Allies added to this discomfort by forbidding the Americans to use the Canteens, NAFFIs (Naval, Army, and Air Forces Institute-- similar to the American Red Cross Service Club centers), or anything else British. Whose side were they on anyway? Their dismay, disappointment, and anger increased when they arrived at Camp Huckstep, the American base. There they found the British free to use any of the camp's facilities, theaters, service clubs and all. At Cairo, the men of the 7th's detachment eagerly awaited a ship for the return to England and their more familiar home away from home, Mount Farm.

Chapter 14
November December 1944

November 1944

Poor weather over the Continent restricted sorties by the 7th Group. Whenever there was a chance of photography in a squadron's assigned area Squadron Operations tried to cover as many requests as possible. On the first day of November, Lts. Robert Facer and Richard W. Brogan of the 13th flew from target to cloud-covered target until they found an opening over Hamburg for a little footage. Both pilots managed to photograph some shipping. Brogan covered the large naval anchorage in the Schilling Roads and Facer, a section of the Elbe River. These were the only two sorties sent out by the 7th Group.

The 13th's new assigned area was north of a line from Amsterdam, Holland, to Breslau, Germany. Within this area lay some very difficult targets including the oil installations at Magdeburg, Stargaard, Stettin, and Politz; ordnance plants, aircraft assembly plants, and other installations around Berlin. The area also included airfield coverage along the Baltic as well as more oil and armaments targets at Kiel and Hamburg. Considered hot targets were installations at Heligoland and the Frisian Islands off Germany's North Sea Coast along with Fallersleben, Minden, Hanover, Rheine, and Osnabruck. The squadron program maintained routine cover of all airfields in the assigned area. At this time of year, the major limiting factor for swift and complete photographic target cover was bad weather. Fog and freezing rain were common with heavy cloud, low ceilings, and poor visibility. It was in such conditions over northern Europe during the winter months, that experience in instrument flying and navigation paid off with successful missions and safe returns.

With every passing month, opposition to photo reconnaissance aircraft grew. The Germans increased protection against photo cover of their vulnerable and critical industries with more anti-aircraft batteries and jet interceptors. As German-held territory contracted from battle losses on the ground, air defenses became more concentrated. Previously lightly defended areas became filled with intense flak barrages. Often forced by winter weather from their usual high altitude above anti-aircraft range, photo recon pilots became more exposed to the Germans' flak and fighters.

The Luftwaffe had been seriously effected by heavy bomber strikes against oil targets that drastically reduced production of all fuel but especially the higher grade aviation gasoline. The shortage restricted not only operations but also training. In spite of German Minister Albert Speer's record production of fighters during 1944, there was not enough fuel to train new pilots thoroughly. The attacks against the air industry not only interrupted production but destroyed aircraft sent up to defend targets, one of the objectives of Operation Pointblank. Veteran Luftwaffe pilots lost in these attacks could not be replaced. The newcomers lacked experience, hours in the air, and much hope for survival.

The combined tactical and strategic bomber assault to cripple transportation added to the Germans' difficulties getting what armaments they produced to the front. In an added benefit, the destruction of rail transport restricted delivery of V-weapons and supplies to the launching site targets of the Crossbow campaign that were so difficult to destroy by air attack. Each part of the strategic bombing plan had begun to meld together into a whole that would destroy Germany's ability to conduct war. The "broad front" strategy of the Supreme Allied Commander General Eisenhower much maligned by many Allied generals and planners, engaged the enemy all along Germany's western border. RAF Bomber Command and the U.S. Eighth and Ninth Air Forces attacked night and day deep in the heart of the Third Reich. Other American air forces, the Twelfth and Fifteenth, carried out attacks from Italy in the south. In the east, the Russian offensive pushed toward Prussia and Silesia. As the campaign continued the 7th Group worked to supply all of its "customers."

22nd Sq Photo Interpreter, Lt William "Pappy" Noll.

Eyes of the Eighth

The 325th Wing transferred more photo interpreters into the various squadrons of the 7th Group when the reassignment to individual squadrons of previously combined sections demanded extra manpower, especially in Intelligence, Photo Interpretation and plotting. Now, the responsibility for viewing and evaluation of coverage of assigned targets belonged to the individual squadron. Each had its own personnel who worked on the squadron's sorties and wrote reports on the information. In many ways this new arrangement allowed each squadron to concentrate on its particular area from operations through interpretation. Working in the 22nd's photo interpretation section in November were Lts. Richard B. Nelson, "Pappy" Noll, Charles L. Keller, Abraham Scharf, Warren Syverud, and Sgt Joseph F. Gaghan.

Rocket Trails
The rocket campaign against the English capital gained momentum and during the last week of October 26 V-2s had hit in London, with only eight falling elsewhere. Hitler's special commissioner for the A-4 (V-2) program, SS *Gruppenfuhrer* Kammler had achieved an astonishing accuracy of 76 per cent. In the next week, 12 more landed inside London and 15 outside but two of the V-2s struck within a mile or so of what was suspected as Kammler's aiming point, the Tower Bridge area. With this increased activity against England alone (V-2s were aimed at Allied occupied territory on the Continent as well) it was not surprising when photo pilots saw more vapor trail traces of the weapon.

The famous Tower Bridge over the Thames River, named for the nearby Tower of London. In the area targeted by Kammler's V-2 rockets lie the financial heart of the City and the vast docklands of East London.

Bad weather prevented missions until 5 November when the Group sent out four sorties including three from the 22nd Squadron. Lt. B.L. Waldram, on his fifth mission, flew a sortie over Central Germany where 10/10 cloud prevented photos. Near Saarguemines, Waldram sighted two V-2 rocket trails rising vertically to a great height. Over Dortmund and Koblenz he managed to find a few holes in the cloud cover and turned his cameras on for a few frames. While near Koblenz he saw a third rocket trail in the distance.

On the same day, Lt. Irl Cosby saw rocket trails on his sortie over Germany when he covered the airfield at Kitzengen, a suspected jet training base. The photo interpreters did not find any jet aircraft when they looked at the processed photos. They did see lengthening of the dispersals, which they would keep an eye on in future cover. Cosby also covered Wiesbaden and Frankfurt but his other targets at Neunkirchen and Ludwigshaven were cloud covered.

Lt. Robert F. Carlgren went to an area near Munich known for its jet aircraft activity but was not intercepted. He managed to remove one of his targets from the program but only partially covered others due to the weather. Just as Cosby and Waldram had, he also sighted rocket trails. When interpreters examined Lieutenant Carlgren's photos of Lechfeld's experimental and training airfield, they found about 40 aircraft on the field, ten of which were ME-262s jet fighters. On the only other sortie, Lt. Irv Rawlings of the 14th Squadron tried to get damage assessment cover in the Ruhr but all his targets were cloud-covered. He returned with photos of Maastricht and Aplerbeck, Holland.

Weather improved enough on 6 November for the 13th Squadron to send out seven sorties with one abort when Lt. Wilber Bickford returned to base early due to engine trouble. Another mission was unsuccessful when, while making a run over the island of Heligoland, four ME-109s jumped Lt. Taylor M. Belt. He dropped his auxillary fuel tanks, made a diving turn for the deck to pick up speed and dashed southward across the North Sea to circle back toward England. His attackers did not follow but as Belt gained enough altitude to clear the sandy dunes of one of the Frisian Islands along the German coast, the flak batteries on Langeroog opened up. He cleared the islands and turned away from Germany toward home. Belt returned safely to Mount Farm and amazingly found no damage to his aircraft. During his de-briefing Belt told the intelligence officers that the attacking planes seemed to emit black smoke from some sort of fuel injection system.

Budrevich Fails to Return
Without interference, another 13th Squadron pilot, Lt. Allan V. Elston, managed to get photos of the few assigned targets he found free of cloud. That same day, two others were not so lucky. Squadron Operations assigned Lt. Gerald Budrevich and F/O Ed Vassar routine cover of airfields in northwestern Germany and Holland.

November December 1944

Vassar and Budrevich had to cross another of the Frisian Islands, Wangerooge, before entering air space over Germany proper. They were at a high enough altitude that the batteries did not fire on them as they had on Taylor Belt but that changed at their targets. As they flew their photo runs over Bremerhaven, Borkum, Oldenburg, and Broidzetel airfields every flak battery fired at them.

Over Oldenburg at 1330 hours Flight Officer Vassar reported an aircraft making a pass from above at six o'clock, passing approximately 100 feet over him but not firing. He thought it was a jet and called Budrevich, flying wide on his right wing, to warn him. Then he released his drop-tanks and dived gaining speed to evade. Vassar last saw the jet making a sweeping turn.

Ed Vassar reported to the interrogating officers in Intelligence back at Mount Farm that Budrevich did not respond to his call and that he had not seen his wing man after spotting the jet. Lieutenant Budrevich failed to return to base. Budrevich, first listed as missing in action, was later confirmed by Eighth Air Force Headquarters as killed in action.

Brogan Lost

The last three missions scheduled for 6 November were not the usual type of high altitude operation most common to 7th Group. Group Operations Officer, Major Johnson, and 13th Squadron pilots Lts. Richard W. Brogan and "Chick" Batson flew missions to test the effectiveness of various camera types at low altitude. Their targets were seven airfields due for routine cover in an area just west of Cologne. They approached Blankenheim, their first target, at 1,500 feet altitude and made several runs going full out. The pilots varied their altitude on the runs from 1,500 to 8,000 feet. Intense ground fire from machine guns and flak batteries scored hits on their F-5s. On the run over the last target near Aachen, Lieutenant Brogan's aircraft began trailing smoke. Johnson and Batson thought it began to burn, saw a parachute open, and the F-5 crash and explode near a road two miles southeast of Aachen. Upon their return to Mount Farm, the two pilots reported that although they did not see Brogan leave the crippled plane they felt the parachute they saw had to be his and that he was probably captured. The 13th listed Brogan as missing until informed that indeed he had been captured and was in a POW camp.

The 14th Squadron attempted four sorties on 6 November, Lt. Robert E. Sanford removed a mapping assignment of Appeldorn, Holland, from the program. Lt. Gerald Glaza successfully covered targets south of Cologne in the Bonn area. Cloud prevented both Maj. Kermit Bliss from covering his Ruhr targets and Lt. Louis Gilmore from his at Munster and Hamm.

Crane on BBC

When Lts. Donald Schultz and Charles Crane, Jr., saw the V-2 in flight near St. Goar on 29 October and Crane brought back pictures of the rocket's trail, Public Relations had one of the best stories of the war. Unfortunately, neither the Germans nor the British had yet publicly admitted the rocket attacks. The "exploding gas mains" explanation given by the British government had worn thin with the public who knew something unusual was happening.

By 8 November, 150 rocket hits had been listed leaving 235 people dead and another 711 injured. Prime Minister Churchill and his Cabinet knew there was worse to come and that there was no warning and no defense. This ominous knowledge influenced their reluctance to make any announcements about the weapon. In spite of a "leak" appearing in the *New York Times* as early as 6 October about rocket attacks on the UK, no one picked it up and there was silence from both London and Berlin. All this changed when the German High Command announced that, "the V-1 bombardment of the Greater London area... has been supplemented for the last few weeks by another and far more effective explosive missile, the V-2."

Lt Gerald Budrevich of the 13th Sq listed killed in action on 5 November 1944.

Churchill, his hand forced, made a sober announcement to the House of Commons on 10 November and the still barely secret word was out. Some form of censorship remained to prevent timely information reaching the Germans about the location of hits and casualties. Hyperbole and propaganda poured from the Germans, in one instance referring to the "liar on the Thames" keeping the information away from his people. One line from Germany held more truth than Churchill wished. "A period of horrible and silent death has begun for Great Britain."

Press and radio clamored for interviews and eye witness accounts. Just before the official announcement about the rocket, 7th Group Public Relations arranged for movie star Lt. Col. Ben Lyons to extensively interview Maj. Turney Braund, Camera Repair Officer, on the BBC. Braund described to the Army Hour radio audience how his department worked and how it contributed to the war. The many secrets, including that of the V-2 rocket could not be discussed. Within a few days, the restriction on details of the V-2 changed. Later in the month, Chester Morrison of NBC New York taped an interview with Lieutenant Crane at the BBC. Crane told the radio audience the exciting story of his and Schultz' encounter. His photos of the spiraling trail appeared in some British papers. After word of the terrible new weapon came out into the open, unlike the V-1 flying bomb, which gained nicknames like Doodle Bug and buzz bomb, the British people neither gave it a name nor made jokes about it. The more details they learned the more horrified they became. Norman Longmate, in his book *Hitler's Rockets* quotes a woman, "No buildup. Just bang, or oblivion."

Eighth Air Force bombers continued their attack on Germany's oil production. Even though results of persistent attacks had effected their war effort, the Germans had shown an extraordinary ability to repair, move, or reorganize their industries. On 8 November the target was one of the major synthetic oil refineries in the Leipzig area, Merseburg/Leuna. Damage assessment to plan further raids had been hampered by poor weather and without proper analysis, Eighth Air Force commanders were reluctant to send air crews into this flak saturated area. The 7th Group received an urgent request for cover from the JPRC (Joint Photographic Reconnaissance Committee). Weather prevented cover until 14 November.

The 14th Squadron assigned two pilots, Lts. Bruce B. Fish and Fabian J. Egan to cover the targets. Eight green and yellow checkerboard-nosed P-51s of the 55th Fighter Group from Wormingford flew escort for the Spit-

14th Sq Ground crew lie across the rear fuselage and tail of a Spitfire while the engine is run up to power. If not held down, the light aircraft would lift off the tail wheel and damage the propeller. A regular operation, even when no mission is planned, this maneuver almost caused Sgt Patsy Piscatelli to lose his recently collected pay from his pocket in the blast from the windstream as he draped himself over a Spitfire.

fires. With ever-increasing attacks by Luftwaffe jets, more 7th Group photo missions needed fighter escort as protection. Fish and Egan flew over heavy cloud most of the way in to the target area where they found an opening in the overcast near Leipzig. Below lay the flat open countryside filled with clusters of anti-aircraft batteries encircling the concentration of synthetic oil refineries near the city. As they neared Merseburg/Leuna, the deadly 88's opened up as expected. Lieutenant Fish described the flak in terms that had become a cliché in the ETO, "You could get out and walk on it." Egan followed Fish over the huge complex at Merseburg as they made their photo runs. In spite of the flak they returned to Mount Farm with photos good enough for the Photo Interpreters and Intelligence to judge the effectiveness of the 8 November raid. Lieutenant Fish's Spitfire escaped damage but shrapnel had damaged the right wing, horizontal stabilizer, and propeller on Egan's ship. (After reviewing the photographs, the JPRC kept the refinery on the target schedule for attack. The Eighth Air Force hit Merseburg/Leuna again on 21 and 25 November.)

Haughton's Direct Promotion

In the 22nd Squadron, the squadron's Adjutant, Lt. Robert E. McManus swore in CWO Perry Haughton of Camera Repair as a second lieutenant on 8 November. The chief warrant officer, a veteran Army man since 1921, received his promotion because of his outstanding ability and advanced technical knowledge of camera repair. He was the first officer in the squadron to receive a direct commission in the ETO.

November December 1944

Spitfire PA842 being loaded with film magazines prior to a mission. Ground Crew and Camera Repair technicians swarm over aircraft preparing it for a mission.

Combined Operations

For months, various rumors about new plans for the 7th Group floated around the base. Ever since the detachment went to Attlebridge early in the year to determine the feasibility of independent operations away from the home base, all sorts of ideas had been circulated through the upper echelons of planners in London and Washington. Most ideas addressed improved photo coverage for the Eighth Air Force. After the invasion, scuttlebutt circulated that one squadron would move to the Continent. As time passed that rumor joined the ones about a squadron being equipped with Mosquitoes. That never materialized because there were not enough of the "Wooden Wonders" to go to any but RAF units needing them. Each rumor had a nugget of truth such as word that the 325th Wing wanted to transfer some of the pilots from the 7th Group to the 25th Bomb Group (Rcn), at Watton. It was true that the 25BG was short of experienced pilots but operations of the two units were decidedly different. The 25th BG flew many weather missions over the Atlantic and to the Azores in addition to some photo flights. Because bad weather limited the sorties out of Mount Farm, perhaps it appeared on paper that the 7th had too many pilots but it took every pilot in the 7th Group to fill the job requests when the weather was clear. Heavy losses of experienced 7th Group pilots during the fall also weighed against such a move.

When Col. Elliott Roosevelt took over the command of photo reconnaissance in the Eighth Air Force with the formation of the 8th PR Wing early in 1944, he envisioned a large multi-force operation similar to his 90th Wing in the Mediterranean. His idea to join all PR operations under one command never materialized as the British, quite rightly so, felt their organization had pioneered present methods of operation and that the RAF needed its own units under British command. Because of a difference in terminology, the idea of combining two groups under the larger wing sounded practical but, in fact, an RAF group, like 106 Group at Benson, was comparable to an American wing like the 325th Wing.

One idea that continued to surface was a plan to send one squadron to the Continent. The reasons for

Before the separation of Photo Interpretation into squadron sections, men from different squadrons worked together in the large Group Interpretation Room. At the table, L to R: Lts Arthur Radke (27Sq), Malcolm Fenter (14Sq), Bernard Green (27Sq), and Capt Thomas "Trip" Russell. Seated at the desk is Capt Gerald T. Cunningham (7th Gp P.I. Officer). In the background at one of the maps are Sgts Earl W. Henry and Arnold M. Gidley (27Sq).

such a move were sound. As the front lines moved ever eastward, airfields in France could be used by strategic as well as tactical units. With the possibility of clear weather at a field closer to the photo targets when Mount Farm might be fogged in kept the idea of a transfer alive. After the new group C.O. Major Humbrecht removed Operations, Intelligence, and general sections of the individual squadrons from a combined group operation, the way became clear to send a squadron across the English Channel.

The 27th Squadron Moves to France
The men of the 27th Squadron learned in October that the latrine rumor about a squadron moving to France was true and they were it. In mid-October, the 7th Group sent a detachment from the 27th led by Lt. Edward V. Shipley to an air strip, A-70 at Laon/Couvron, France. The advanced detail for the squadron's move included, MSgt Charles Pongracz, SSgts I.M. Davis, Don Petty; Sgts B.L. Kwiatek, W.M. Rogers, A.A. Strucke, and A.C. Zinny; and Cpl E.W. Keel. The squadron commander Captain Childress with Lt. Robert Florine as co-pilot and SSgt Lonnie Milford of the 381st as engineer flew an AT-23B over to the field on the morning of 17 October returning late in the afternoon. The move to France had begun.

Laon/Couvron, 130 kilometers north northeast of Paris, was a target covered many times by the 7th Group when it was occupied by the Luftwaffe. Now it was occupied by the Ninth Air Force and it quickly became obvious to Childress and Shipley that for various reasons this field was unsuitable for the 27th Squadron. Before the rest of the squadron followed, the 325th Wing decided that the field was too far from the front. Named for its neighboring villages, Denain/Prouvy, A-83 was 100 kilometers farther north near Valenciennes, France. Close to the Belgian border, this was a better location for the 27th Squadron's operations.

On 1 November, Lieutenant Shipley and his men drove a jeep and equipment trailer up to Denain/Prouvy from Laon/Couvron. They passed through countryside recently fought over by the retreating Germans and advancing British and Canadians. Except for the most heavily bombed areas of London, the destruction was on a scale that they had not seen before. The scene when the men arrived at their new airfield was one of a war zone — a target, a target hit many times by American and British bombs.

At the time of their arrival, the VIII Service Command used A-83 as an emergency field for damaged aircraft unable to reach bases farther to the rear. Some fighters operated from the field but as front lines advanced they moved to more forward bases. Heavy air traffic used the field including supply planes landing at Denain/Prouvy with fuel for the Army's Red Ball Express, the well-known trucking operation carrying fuel and supplies to the front lines.

The airfield was pockmarked by bomb craters. The runways and necessary taxi-ways had been repaired by the Engineers but the rest waited for attention. When the men from the 27th arrived some took it for granted and many hoped that the Engineers also had cleared all the unexploded ordnance. Bombed buildings lay in ruins. The 27th's pioneers chose one of the large bombed out German hangers as home and they pitched the regulation, center-hole-square-peg tents for shelter.

Lieutenant Shipley and his advance party expected Air Transport Command C-47s to bring the remainder of the squadron and its equipment to France as quickly as weather and availability of aircraft allowed. The squadron surgeon Capt. Carl Fritchie, Lt. Victor Gras, and eight enlisted men arrived on 8 November in the group's C-53 flown by Lts. "Chick" Batson and W.E. Bickford as pilot and co-pilot. Sgt S.E. Owen and Cpl D.M. Magers made up the crew. The new men took up residence in the "hanger tent city" set up by Shipley's men. Conditions were primitive and democratic with the ranking officer "Doc" Fritchie bunking next to SSgt Ike Davis.

A motor convoy set out on 9 November led by Lts. Robert Weber and Robert S. Korsvick with 43 enlisted men. The next day Captain Adams and Lieutenants White and Alley ferried another 37 EMs under Capt. Frank Campbell's command in the group's C-47 and C-53. On the following day, Lt. William H. Teague, Jr., arrived at A-83 with a plane load of cargo. As transports landed, the men already at the airfield stopped the flurry of shelter building and tent raising to unload the aircraft before getting back to the chores of providing for the new arrivals. For days, this hectic scramble continued. When cargo planes arrived, men dutifully unloaded and stored or erected equipment. When personnel arrived they had to bed down temporarily where ever they could find a dry spot. When they were not unloading other aircraft they set up their required shelters and the circle started all over again with the landing of the next flight.

There was a shortage of everything except mud. Fall rains had turned the churned field into a quagmire of black, deep, boot-sucking mud. There were no warm barracks, no Nissen or Quonset huts, only tents. Damp and miserable, this was the 27th's new home. Rations, water, everything, had to be hauled in. There was no salt, no coffee. Men worked to improve the tent area and repair the big hanger but the location proved unsat-

November December 1944

isfactory and all the work wasted as everything had to be moved to the edge of the field near some houses and a cemetery. The new area was also muddy. Any location on the base would be muddy. They abandoned the hanger completely. Desperate men found solutions to some of their housing problems. They pulled down and unbolted some of the old German hanger doors constructed with tongue and groove boards to make sidewalls and floors in the tents. Everyone pitched in to get ready for the day when the planes and pilots would fly in from England to start operations. There was one bright spot. The unfilled bomb craters turned out to be excellent garbage dumps, which when full could be covered with dirt by a bulldozer.

Doolittle Inspects the Group
The commander of the 325th Recon Wing Col. Elliott Roosevelt welcomed the Eighth Air Force commander Lt. Gen. Jimmy Doolittle to Mount Farm for an inspection of the 7th Group's base on 12 November. The Group Intelligence Officer Maj. William Lanham and other S-2 officers conducted a tour through the Intelligence Department on the base. The three remaining squadrons' S-2 Sections gathered in the 7th Group offices. Colonel Roosevelt and Major Lanham gave the general a good overview of the group's operations.

Major Lanham explained the importance of coordination between Intelligence, Operations, and Photo Interpretation. Once a request came through channels, it was the responsibility of various departments of the group to prepare the pilots. Then, after a successful mission,

L to R. Colonel Roosevelt listens as Group Intelligence Officer (G2) Maj William E. Lanham explains some of the section's work to General Doolittle. Majors Humbrecht, Group CO and Carl Chapman, Group Ops Officer, look on.

properly identify and report the information in interpretation reports of varying detail and interest. On 6 November, Lt. Allan Elston flew a sortie over Northern Germany and found most of his assigned targets covered by cloud. While going over the photos that Elston managed to bring back, photo interpreters found some interesting objects on a harbor quay. A detailed examination revealed a new type of German U-boat the interpreters had been looking for. These were not small 45 foot midget subs. Although shorter than the typical combat submarine, what really distinguished these U-boats was the speed with which they could be assembled from pre-fabricated parts and launched ready for operations.

In issuing the interpretation report, Intelligence makes a note to photo interpreters that these pre-fabricated subs, "Have been seen at Ecken Forde, Borkum, Wilhelmshaven and are likely to be seen operating in the near future from the Frisian Islands against Allied shipping entering the Helgoland Bight." Special attention, by use of all upper case type, is drawn to instructions for interpreters to look carefully for these at all seaplane stations in the Frisian Islands and at places where they have been located previously. It is stressed that photo interpreters should make sure that they give the length of any similar craft to differentiate between the pre-fab U-boats, which are 100 feet or more, and the much smaller midget submarines, the former being a much more dangerous threat to shipping.

With each squadron doing its own interpretation, more men worked in squadron Intelligence sections. In the 22nd Squadron, Capt. Howard L. Jeske, ran the section

Capt "Trip" Russell shows General Doolittle some of the P.I. department's work. Captain Cunningham listens in the background.

215

Prefabricated U BOATS

Two types--originated in Danzig where they are now on working out trials
having been built also at Hamburg and other German shipbuilding
yards. *do not confuse 740 ton with this 250' p.f.*
1. 250' TYPE--very streamlined conning tower
2. 110' TYPE--ordinary conning tower as on the conventional 250'er.
(silhouettes to be received shortly)

Will be seen now on trials in the Baltic----
Expected into the Atlantic on operations from Norwegian ports----
They are extremely fast underwater speed 15 knots
Navy particularly interested in these craft and their movements.
CALL THESE PREFABRICATED U/B'S AND NOT MIDGETS

Midget U BOATS

30' in length see US/3559 print 3082 —see
Appearance very like the V-2 which is 45' in length

Third phase interpretation report on German pre-fabricated U-boats discovered on photo taken by Lt A. Elston of the 13th Sq on 6 November sortie 3559. A notation at the bottom of the report alerts photo interpreters that these small subs, "have been seen at Ecken Forde, Borkum, and Wilhelmshaven and are likely to be operating in the near future from the Frisian Islands against Allied shipping in the Heligoland Bight." Also included is the extra alert that P.I.s should, "look carefully at all seaplane stations in the Frisian Islands and at places already located (Ports, etc) as these craft are known to be launched on trolleys down seaplane slipways." The instruction stresses the importance of indicating the length to prevent the wrong identification as a much smaller Midget Sub.

November December 1944

with Lt. John J. Shatynski, TSgt Paul J. Webb, SSgt Robert E. Johnson, Sgts Marion G. Miles, William C. Mason, Ray W. Perkins, James S. Hix, Cpls Milton J. Greenberg and Arthur A. Davis. Before pilots left on their sorties, Jeske and Shatynski briefed them on their mission.

The sections worked in shifts, the work load depending on weather conditions and amount of cover obtained when pilots could fly sorties. Sergeant Miles was in charge of the enlisted men's shifts, which ranged around the clock alternating days to nights on a weekly basis. Webb, Hix, and Greenberg handled routine administrative duties during a regular day shift. Sergeant Johnson and Corporal Davis worked primarily in the plotting section. There they compared a pilot's route to the photos he had taken. All photos carried a number indicating the camera as well as the sequence in which they were taken. When the men laid out the numbered photos in order the photos formed a "foot print" of the flight. They plotted all this information on the map that accompanied films from a particular sortie. With the military grid system on the maps, any co-ordinate could be located quickly and used as reference for the correct photo or in reverse, any photo could be located on the map by its number. Sergeants Miles, Mason, and Perkins worked one shift handling the routine sortie details on operational days, doing plotting and other duties keeping files and information up to date. The section classified and compiled photos according to target category then bound them into volumes that squadron intelligence officers used to brief the pilots.

Weather cleared enough in the 22nd Squadron's target area on 16 November for Operations to send out six sorties. Due to the increased fighter opposition, mainly by jet aircraft, pilots now paired up on missions to help prevent surprise attacks. Increasingly aggressive against photo planes, the Luftwaffe's jets closed at such an alarming rate surprise was more common even for the wariest of lone pilots. On his 21st sortie, Lt. Harold G. Wier flew with another veteran, Lt. M.E. McKinnon, who had completed 26. They were not intercepted but returned from central Germany without photos as all their targets were obscured by cloud.

The second pair, Lts. R.E. Quiggins and Robert W. Hall, had targets assigned in areas of Germany known for heavy jet activity. They got as far as the fighter base where they were to pick up an escort. While circling overhead waiting for the escort to take off, the fickle English weather closed in on the field and the mission had to be canceled.

A newcomer, Lt. Richard E. Brown had an experienced pilot, Lt. John H. Ross flying his 20th mission, for his leader. They had a damage assessment target just northeast of Aachen, Germany, which had been bombed first by the Eighth Air Force's heavies. Later in the day the Ninth Air Force medium bombers followed with their attack on a target also hit by RAF heavy bombers. The two pilots had to slip in between the Americans and British to get their photos. Ross and Brown returned safely with photos good enough to remove part of the job from the flying program.

L to R: Buster A Giada, George J. Murray, Carl Olsen, John V. Larkin, Nicholas D Mollitor, and *Red Dog* in front of F-5 in 381st Air Service Sq hanger. (Ed Hoffman)

Pets

The airbase at Mount Farm had its share of wildlife. Not only were there game birds roaming the hedgerows and the usual wild birds found in the English countryside but also pets adopted from various sources. The most common were dogs of varying size and pedi-

L to R: Unid, Clarence W. Robinson, Harold Davidson, Robert G Rosenbaum, Winfield A. Romig, *Rags*, and Unid in front of Spitfire, 381st Air Service Sq. (Ed Hoffman)

217

Eyes of the Eighth

Lt Bert Sears, Intelligence Officer, at home in quarters with his dog Lady. (H. Gonzalez)

gree. The Wing commander Colonel Roosevelt had his two English Bull Mastiffs, *Blitz* and *Blaze*, by far the largest dogs on the base. Several part-this and part-that mutts found a home around the 381st Air Service Squadron. *Red Dog* was a spaniel and *Rags*, at least part Airedale. When Lt. Ed Parsons failed to return in July, his big yellow Chow-mix *Shavetail* ended up with someone in the 381st.

Interned in Sweden

Weather officers in the 13th Squadron Ops room pre-

Robert R. Smith, now prisoner of war, and Allan Elston, internee in Sweden, shown here upon completion of Elston's first combat mission earlier in 1944. (John Weeks)

dicted which areas were worth sending sorties over on 22 November. They estimated openings around Stettin, Politz, and the coast in north Germany. Operations assigned Lieutenants Elston and Sommerkamp these targets. Very soon after Sommerkamp took off, he had trouble with his radio and returned to the field. Technicians solved the problem in minutes; he got back in the air and on his way again. Elston had continued on and began covering his targets.

Flying through bad weather all the way, Lieutenant Sommerkamp could not see Elston. Over Stettin, while making a run across his target through bursts of flak, he heard Elston call him on the radio that he had one engine out. Even though the signal was very strong Sommerkamp still could not see the other F-5. When Allan Elston then told him that he did not think he could make it back, Sommerkamp told him to fly north to Sweden. There was no reply. Sommerkamp called once more to warn Elston about enemy aircraft in the area but, again, heard no reply. He reported this information to the interrogators at Intelligence where he added that Elston might have lost an engine to flak at Stettin and probably did fly to Sweden. (Lt. Allan V. Elston landed safely in the neutral country where authorities interned him for the remainder of the war along with many other Allied airmen.)

Sears

Members of the 13th Squadron and others from Mount Farm attended a funeral at the American Cemetery at Maddingley near Cambridge on 24 November for Lt. Bert Sears. Sears died when his Jeep rolled over returning from Oxford. He had been a pilot with the 13th Squadron before becoming an Intelligence Officer. Just as they had for Lieutenant Parson's dog *Shavetail*, friends found a new home for Sear's little black spaniel *Lady*.

A new 22nd pilot had a rude introduction to operational missions on 25 November. The usual coastal targets used to get a new pilot familiar with photo sorties over enemy territory had long ago been repatriated by the ground forces. Enemy enclaves held out along the French coast and it was here Operations sent Lt. E.B. Edwards for his baptism. Headquarters wanted photos of the German defenses at Lorient and St. Nazaire. Their isolation had done nothing to dull the sting in their anti-aircraft batteries, which had brought down other 7th Group planes in the past. Edwards covered Lorient sufficiently on three runs to remove it from the program but cloud prevented full coverage of St. Nazaire. He returned safely from his first mission.

Even more than flak, bad weather could cause the

most experienced pilots grief. The best of navigators could get into trouble when Europe's winter weather caught them out. Sometimes a pilot saw nothing but cloud all the way over and all the way back. Depending on the height of the cloud cover, he could fly above all the murky weather below him but when the cloud tops were above his plane's limit he had to go though. Before leaving base, a pilot figured all the information available about winds aloft, their direction, his speed and time, plotting routes to and from the targets. With this plotting he established his estimated time of arrival (ETA) over a particular point. If his navigation was wrong or if the winds were different from what the weather officer predicted he could find himself in dire straits. On 26 November, Lt. Robert Moss of the 13th Squadron had assigned targets at Heligoland, Neumunster, and Hamburg. Moss crossed out over the English coast in thick cloud on a direct course for the island of Heligoland.

Moss flew on instruments until his ETA over Heligoland. There, he found himself still in cloud. He finally broke out over water but land was on the wrong side and what he could make out was unfamiliar. He turned his cameras on as he flew over an island. His fuel indicators registered just enough to return to base and he began the long flight home. Moss decided that the plotters could figure out where he had been.

After landing he turned his plane over to the mechanics and technicians who had their jobs to do. The Photo Lab took the film magazines from Camera Repair and developed his pictures. The plotters checked their maps with the general area Moss had been over and matched the island, water, and land. Intelligence informed Moss that he had flown over Laaland, South Nykobing, near Denmark. The winds had been stronger than predicted. If he had not broken out of the clouds when he did Moss probably would have joined Lieutenant Elston interned in Sweden.

The next day, another 22nd Squadron pilot, Lt. Alf Carstens flew his first combat sortie. Again the targets were locations in the Lorient area. He completed his task allowing Intelligence and Operations to remove this job from the program as well.

Two 13th Squadron pilots, Capt. Dale Shade and Lt. Raymond Hakkila covered Moss's target Heligoland on 29 November. Due to the usual cause of mission failure, omnipresent cloud, they were unable to cover their other targets.

The 13th Squadron welcomed back Lt. Ross Madden on 30 November from the Fortieth Field Hospital in France where he had been recuperating from injuries suffered in the crash of the B-25 *Miss Nashville* in October. Scars from the burns covered Madden's hands

Lt Raymond Hakkila, 13th Sq. (John Weeks)

and part of his body. Because of the new skin on his hands he had to wear silk gloves to protect them. Madden told his friends that in spite of being moved eight times he had good treatment in each of the hospitals. He was in good spirits but ready for doctors to release him for good and expected to get back on flying status as soon as possible.

Electronic Transmissions

During October and November, pilots from 7th Group continued to fly special ELINT sorties out of RAF Foulsham on detached service to 192 Squadron. The pilots and crew chiefs for the P-38 "Droop Snoot," rotated on this service. On 30 November Lt. Bruce Fish of the 14th Squadron and Lt. Richard Quiggins of the 22nd flew sorties out of Foulsham. Quiggins and his observer Lieutenant Stallcup took off from Foulsham at 0958 on flight "A." Their aircraft, P-38J 156, was equipped with a S.27U Modified Receiver, PSO, Monitor Type 32. Both the equipment and observer had to crowd into a fuselage lengthened by a special Plexiglas nose resembling the nose on a B-17.

They patrolled over Belgium and Holland between Brussels and Schiermonnikoog searching the 30 to 70 megacycles band, paying particular attention to pulse transmissions. Stallcup logged certain signals for all transmissions. Flight "B" covered the same area in the after-

noon. Lt. Bruce Fish and Stallcup used the similarly equipped P-38J 501 and took off at 1309 hours.

Specialists analyzed the records of the signals, which were given repeated searches or registered as "friendly." A particularly important part of these searches was the location and mapping of Radar installations in an area heavily traveled by bombers on their way to German targets. Just the day before, the same two pilots, Quiggins with Lieutenant Holt as observer and Fish with Lieutenant Zeidler, flew searches for any pulse signals in the band used by a particular type of German Radar. Intelligence believed these were being used by the Germans for long range plotting as allied aircraft approached the enemy coast. That same Radar then swung around and plotted the flight inland.

On 30 November Flight "A" recorded signals that seemed to originate from the same Radar transmitter, a type called a *Freya*. By analyzing the reception of 0 in the Antwerp, Belgium, area; 0.8 in the Zwolle, Holland, area; and 2.8 near Leeuwarden, Holland; Intelligence and electronic specialists thought the source could be found on islands off the Dutch coast. By narrowing the location, they knew Headquarthers could destroy the installations or reroute the bombers.

27th Squadron Operations from Denain/Prouvy

Since their arrival in France, squadron personnel had one objective, to prepare for operations. By 26 November, Operations expected good enough weather to schedule some flights for the next day. All departments involved getting a mission ready completed their preparations.

Station A-83 Denain/Prouvy was a large airfield frequently used for emergency landings by damaged aircraft unable to make their home base. Set in a partly rural, partly industrialized region, factories as well as farms, fields, and villages surrounded the airbase. The local French who lived and worked near the base occasionally broke regulations to cut across the grass and fields on the perimeter near the 27th Squadron's dispersal area.

Civilian Casualties

On the line in the Camera Repair area, technicians serviced one of the planes scheduled to fly on the 27th. Arthur K. Young was one of the men working on the cameras in the F-5. He saw a woman and two children take a shortcut across a nearby potato field.

Not far from the airbase, *Terry's Tiger* struggled to stay airborne. Crippled by flak over Altenbeken, Germany, the 91st Bomb Group B-17 approached Denain/Prouvy. Unable to lower his landing gear, the pilot bellied in. *Terry's Tiger* skidded along the strip and across the potato field striking the French civilians. The smoking Fortress stopped short of the 27th's area. The fuselage and tail split apart, oxygen hoses breaking and hissing. There was no fire. The camera men rushed to the site. Remarkably, the crew crawled out of the bomber uninjured. They and the men from the 27th tried to help the civilians. One boy was dead, the mother and the younger child critically hurt. Captain Fritchie, 27th Squadron Surgeon, rushed to the scene but could not save the child. Stunned, the men of Camera Repair and the crew of the B-17 felt helpless.

Officials immediately removed the most secret piece of equipment, the Norden bomb sight. Air Force investigators declared the B-17 Category E, unrepairable, and left it where it had stopped. The wreckage remained next to the squadron area. It became a supply source. For months, men from the 27th cannibalized the carcass of *Terry's Tiger* to use its salvaged parts for all manner of jobs.

The day after the crash, on 27 November the squadron flew its first missions from Denain/Prouvy. Operations dispatched four sorties. With a new numbering system assigned by the Allied Central Interpretation Unit at Medmenham, the sorties took the suffix A to distinguish them from those flown out of Mount Farm by the other three squadrons still in England. Mapping in the Stuttgart-Ulm area took Lt. Irvin Rickey over Germany for Sortie 1A. Three of the four were successful including Lt. Robert Florine's 25th mission, which also covered targets in Germany. One aircraft, Lieutenant Rickey's, failed to return. The 27th had suffered its first loss in France. Headquarters waited to hear of the pilot's fate.

Only two of the four sorties sent out on 29 November were successful. Operations assigned Lt. Hector Gonzalez an area north of the Ruhr and he returned with photos of his targets. Poor weather prevented any more sorties until December.

On 30 November there were changes in personnel. Captains Floyd and Adams transferred to AAF Station 594 at Stone in Staffordshire to await transportation back to the United States for an indefinite period. On the same day, the 27th Squadron acquired six officers and 25 enlisted men attached from the 654th Bomb Squadron, 25th Bomb Group of the 325th Wing. The detachment brought some B-26s for use in night photography.

December at Mount Farm

The 7th Group's base in England suffered the same miserable weather in early December as it had the previous month. Both on the Continent and at home, weather lim-

November December 1944

Rickey Lost

Rickey's new base Denain/Prouvy was near Valenciennes in northern France just south of the Belgian border. On this mission, Lt. Irvin Rickey flew southeast across recently liberated France. After passing Verdun and Metz, he approached Patton's forward lines along the Saar River and Germany's West Wall. Here the famous German defenses ran mainly eastward to the Rhine where they turned sharply south to follow the formidable river through Alsace to Strasbourg and on to Switzerland. Along the Saar River, the West Wall pointed directly toward Rickey's target area. Until he crossed the Rhine he would be over friendly territory.

Before reaching his target, heavy cloud threatened his mission. Beyond the Rhine, Rickey crossed the northern end of the Black Forest and in less than 60 miles came to the target area of Stuttgart on the Neckar River and Ulm on the Danube. A forested ridge ran between the two cities. At Stuttgart, amongst the vineyards and fruit orchards were factories including the huge Daimler Benz works responsible for fine engines as well as cars. Here, just as the weather officers had predicted, Rickey found the area open and completed the runs for his mapping assignment. He turned westward away from Stuttgart and flew back into 10/10 cloud cover for the short run to friendly territory.

Suddenly, a burst of flak under the cockpit jarred his plane. An engine caught fire; intense heat filled the cockpit. Rickey unbuckled his straps and gear. He flicked the release switch; the wind tore the canopy away and sucked him out of his burning plane.

Rickey fell through the grayness. He pulled his ripcord and tumbled downward through the thick clouds. After an eternity of silence, to his great relief he heard the muffled pop of his canopy as it opened above him; the jolt and clutch of his harness stopping his free-fall. As he looked upward at the billowing silk, relief turned to anxiety. Directly off center, the chute had a huge hole and three completely severed shrouds.

In spite of the damage, the parachute held and Rickey drifted safely to earth. He landed in a field, a prisoner under the guns of elderly German men of the Home Guard. The American learned he was about eight miles southeast of the town of Calw, Germany, less than 35 miles from the Rhine. The old men marched their prisoner into a town to a hayloft where they completely stripped and searched him. They tied his clothes in a bundle except for his thin flying suit, which they let him put back on. Then, the Home Guard escort marched him off in the freezing weather with his clothing bundle tied on his back and his hands behind his head. The old men never took their guns off of him.

For eight miles Rickey got colder and angrier, his fingers becoming numb from the cold and lack of circulation. When they reached the next town, his civilian captors turned him over to military control. Now in the hands of the Luftwaffe, Rickey began his trip straight to a prisoner of war camp instead of the usual interrogation center at Oberursel. Along with 27 other prisoners, he was crowded into a boxcar with a guard. The captured men had half the space and the guard the rest. For days the boxcar traveled northward as part of different trains until, after much shunting and waiting on sidings, it reached Barth on the Baltic coast near Stettin.

There the men entered their new home, Stalag Luft I, a grim forbidding place surrounded by sandy dunes and rugged pine forests. Nearby, buildings of a Luftwaffe anti-aircraft school broke the monotonous landscape. The rows of wooden barracks in the various compounds stretched across the flat land. Where the woods ended, low marshy ground reached toward the sea. Winter darkness came early here and added to the gloom. For weeks, Rickey's fingers remained numb. Feeling returned along with pain in the awakened nerves. Although he knew he had been lucky not to have been killed by the civilians, the once mild Rickey nursed a bitter hatred toward the Germans that, unlike the pain in his fingers, would take much longer to lose. Rickey believed that the Allies would win the war. He would wait. He wanted to see the Germans pay.

Lt Irvin Rickey

Waiting out the weather at Mount Farm.

ited flying during the month except for two breaks, one on the 5th and the other on the 23rd of December. On those two days, the Group flew 40 percent of December's total sorties. The 7th Group now had a squadron in France in hopes that the new base could put men in the air when the Mount Farm field was closed in. The airfield A-83 at Denain/Prouvy also put the 27th's F-5s closer to the fast moving front lines.

By December the ground forces had cleared most of France. For the pilots, there was less German occupied territory to cross before entering the most dangerous zones but this did not lessen the opposition to lone PR aircraft. Continued activity against the photo planes by the Luftwaffe, particularly its ME-262 jet, put cover of deep penetration targets in jeopardy. Whenever possible these sorties had P-51 escorts from various fighter units of the Eighth Air Force.

Across the Western Front the Allied armies advanced toward Germany. They met stiff resistance everywhere as the Germans now fought on their homeland or very close to it. In the north, the advance through Holland stalled. The slogging battle by the Canadians and British against the German forces holding the Scheldt finally cleared both sides of the estuary. It took until the end of November to clear mines from the channels. The first ship into the port of Antwerp arrived on the 28th. Antwerp was now a new anchor of the lifeline of supplies needed by armies in the north. In spite of, or probably because of the tremendous amount of territory freed since D-day, the Allied armies were exhausted. Short of supplies and replacements, the forces needed a winter lull, a short period to rest, resupply, and regroup.

After the victorious dash across France and Belgium, many of the allies felt that the Germans were through. It was just a matter of time before they would be overwhelmed. Their line would break for the final Allied dash to Berlin. In particular, two very different men wanted to lead that dash to victory. In the north, Field Marshal Montgomery had tried to assure his progress by the bold Market Garden assault on the bridges over the Lower Rhine, which he believed would open the northern route to Berlin. Coupled with terrain unsuited to armor, another miscalculation led to the failure of the ground forces to join their airborne advance groups. Headquarters underestimated the fighting will, the strength of the German forces around Arnhem, and the ability of the Germans to regroup. Montgomery, in his push to cross the Rhine, did not appear to recognize the significance the huge port of Antwerp would hold for his resupply. By the time the port opened, his forces had bogged down in Holland.

General George Patton's Third Army charged out of the hedgerow country in Normandy. He battled Montgomery for supplies and the Germans for territory. The Supreme Commander General Eisenhower's broad front tactic had the defeat of all the German forces as a goal. He chose Patton to head Third Army for his lightning armored thrusts and swift advances. With a major port in the north available to the field marshal once he cleared its approaches, Patton used his armor to the limit of the fuel he could beg, borrow, or steal to advance across France. If his army was poised and positioned to break through into Germany he would be ready. Eisenhower would be unable to deny him. After fighting its way across the Moselle and taking Metz the Third Army stood along the Saar River facing the West Wall.

On the Eastern Front, Russian forces drove the Germans out of Latvia and Estonia, conquering parts of Lithuania and pressing toward East Prussia. Everywhere the smell of early victory permeated the Allied camps. One place impervious to the alluring scent was Hitler's headquarters. There he planned a surprise for the Americans and British. Another miscalculation by the Allies set the scene for what was considered impossible, a German winter offensive.

The 13th Squadron scheduled the only sorties for 1 December. Operations assigned two F-5s to follow a bombing raid in Germany. Both sorties had to be cancelled when the bombers could not take off from their bases. The Maritime climate of England displayed its rapidly changing quality as a series of fronts moved over En-

gland and on to the Continent from the first until the fifth of December.

Return from Russia

After a long and arduous journey, men from the 7th Group returned to Mount Farm after serving with the Eastern Base Command at Poltava. Officially they had been on detached service to the Command as part of Detachment 5, SAC, USSTAF. Their trip back was an almost perfect reverse of the journey out except they were met at Tabriz by American transport, which took them all the way to Cairo with only one stop-over at Jerusalem. The 22nd Squadron's Major Gordon Neilson, MSgt Charles S. Sands, TSgt William Litton, and Sgt Douglas E. Cumbers arrived at Mount Farm on 2 December. Master Sergeant Sands brought back a Bronze Star awarded while he was in Russia for his accomplishments and untiring response to duty. Four men from the group, which left in March, did not return to the base. Two men, Staff Sergeants Burns and Bight stayed in Russia while Tech Sergeants Michael and Noble remained in a replacement center unable to get transferred back to the 22nd.

The 22nd Squadron sent Lt. William R. Buck on his first mission and the squadron's first operational flight of December on the 4th. His assigned targets in Holland were cloud covered. The next day the weather cleared over parts of the Continent allowing the 7th Group to dispatch 19 sorties. The increased attacks by jets against lone photo reconnaissance aircraft had forced the Group to send its pilots in pairs. This extra pair of eyes gave a better sense of security against the fast-closing jets. The ideal formation included escort fighters but VIII Fighter Command did not have enough numerical strength to cover both bombers and the many PR planes, which often went to numerous and different targets.

The 22nd Squadron sent two pilots together on a mission to cover Osnabruck, Minden, damage assessment of the Misburg Oil Plant, the railroad between Bad Oeynhausen and Wissingen, as well as mapping in that area. Weather prevented Lt. Robert Carlgren and Lt. Donald G. Pipes, who was on his first mission, from covering their targets. Carlgren did manage to get a strip of Lingen and the Achmer Airfield.

From the same squadron, Lts. Harold G. Weir and John H. Ross attempted to cover oil industries at Hamburg, an important target for bombers. Another assignment, the airfield at Neumunster had a high priority due to its strategic position in relation to the Kiel Canal, the Baltic ports, and Hamburg. These targets required frequent cover, which was difficult in the poor winter weather. Heavily defended, this area always made 7th Group pilots wary. On this day, just as the pilots crossed in from the North Sea over Wangeroog Island, they saw a jet aircraft. The ME-262 came in from the starboard side about 500 yards away. At 22,000 feet, Weir and Ross dropped their auxiliary tanks and dove into convenient cloud cover. They lost their pursuer. Low on fuel and already over water, they had to return to Mount Farm without photos, even of targets of opportunity. Both pilots reported to Intelligence that they had seen condensation trails of V-2 rockets fired from northern Holland.

November December 1944

Lt Jackson Byers, 13th Sq photo interpreter, uses special magnifying glass over a stereo pair of photos.

Intelligence liked to get targets of opportunity even when pilots had covered assigned targets. Photo Interpreters found surprises on some. They used new cover of previously unphotographed areas for comparison in future cover. Whether a pilot could tell exactly where he was clicking on his cameras was not as important as it might seem. The plotters and PIs could recognize almost any town, airfield, port, river, lake, forest, coast line, and land irregularity by its distinct shapes and features. You take it and we'll find it might have been their motto. Photo Interpreters found impromptu coverage of airfields particularly interesting and productive.

Two other 22nd pilots, Lts. Byron L. Waldram and Richard E. Brown went off to cover targets in the Zwolle and Lingen areas as well as the Brussels landing ground.

Eyes of the Eighth

Spitfires waiting on the 14th Sq flight line for better weather over the Continent. In the foreground, the Mark IX *Little Gremlin* has 57 sortie badges painted on its fuselage.

(Ross Garreth)

Brown had to turn back with engine trouble just after crossing in over the Dutch coast. Waldram managed to take a few photos through small breaks in the cloud over his assigned targets. Then, on his way home he turned on the cameras over Plantlunne and Hopsten Airfields. The Photo Interpreters considered this valuable cover when they found 12 aircraft including fighters and one Ju-88 at Plantlunne. The Hopsten pictures were even more important revealing 23 aircraft, 13 of which were ME-262 jets.

Captain Dixon watched for a break in the weather in his 14th Squadron's new operating section of Germany. "Socked in" until the fifth, area cover had to wait. With a good weather prediction for the day, Robert Dixon took off to cover damage assessment targets near Nurnburg. Soon after crossing into enemy territory, his Spitfire's engine started acting up. Much to his dismay, Dixon had to abort a mission for the first time in 58 sorties. He returned safely to Mount Farm and handed over his faltering craft to the disappointed linecrew. Spitfire failure was rare.

Other members of the 14th squadron managed to get their targets on 5 December. Both Lts. James Gilmore and Jack Roberts covered their assignments in Germany over Karlsruhe, the Rhine-Ludwigshaven area, Cochem, and Koblenz.

Aphrodite/Castor

Not all of the Continent was free of cloud. On 5 December two 13th Squadron pilots, Captain Ralph D. Kendall and Lt. Donald Schultz flew to East Anglia to pick up an Aphrodite mission. Earlier, such missions flew out of Fersfield in Norfolk. In November, the 3rd Bomb Division decided to move the operation to the base at Knettishall, also in Norfolk. The war-weary B-17s had new and improved radio-control equipment code named Castor. These planes took the new name but the overall USSTAF guided missile program retained the title Aphrodite.

Kendall and Schultz joined a force that included two B-17 Castor drones each loaded with 20,000 lbs of Torpex explosive, three B-17 control and observation aircraft, P-38 and Mosquito observation planes, 17 P-51 fighter escorts, and their two F-5s. The target was the marshaling yard at Herford in northern Germany.

Above Knettishall, the two pilots waited as the heavily laden bombers took off to join their waiting entourage. After reaching the prescribed altitude, the Castor drones flew precise box patterns allowing the "mother" ships to take control. Then Lts. T. H. Barton and F.E. Bruno bailed out of their old Fortress. The second Castor "baby" came under the control of its "mother" and Lts. R.F. Butler and K.T. Waters left the ex-96th Bomb Group's *Ten Knights in a Bar Room*.

Mission number 739 was underway. Lieutenant Schultz had mechanical trouble when a reduction gear housing broke up in one engine and he had to return to base. Captain Kendall continued on with the bombers. Worsening weather along the route threatened to abort the mission. When the leading ships could not find Herford through the clouds, they decided to find some breaks and hit a target of opportunity. The breaks came near Dummer Lake. Dropping down through the opening, Haldorf appeared as a likely target and the control ship sent the first "baby" toward the town. It fell short and exploded south of its target.

The second Castor drone began to lose power. The controllers suspected carburetor icing, a frequent problem. They could not prevent the old B-17 from slowly sinking toward the ground. Instead of crashing, the "baby" slowly settled down and mushed into a plowed field. There was no explosion. Observation aircraft reported that it appeared to be intact. Neither light nor cloud conditions were favorable for photographs from altitude. The mission commander instructed Kendall to get what photos he could of the location. Then he sent the fighter escorts to strafe the downed plane, which they did cautiously expecting a tremendous explosion. There was none. With the weather closing in and fuel getting low, the remaining aircraft turned back for England. The Castor drone sat on the field with all the secret electronic guidance and detonation equipment on board. Still there was no explosion.

Eighth Air Force commanders feared that the drone had fallen into enemy hands intact. They made further attempts to find and destroy the aircraft for days afterward but no one could locate a B-17 in a plowed field in

the reported area. A few fighter pilots bristled when their navigational abilities were questioned. On the reports turned in by the searchers after the loss of the drone, some of the pilots mentioned a gravel pit in the location where the B-17 was supposed to be. (One explanation surfaced after the war that ground troops stationed in the neighborhood "captured" the unmanned bomber. When there was no response to their demands for the crew to step out and surrender, they broke in the door and entered the ship. Peasants on a nearby farm heard an explosion and ran to the field. They found a smoldering rock pit 12 feet deep. German records do not mention a drone attack on that day and the plane may have been mistaken for an ordinary bomb-laden B-17 when it exploded.)

The Group managed four sorties over Holland on 6 December before weather closed down operations over the Continent for photo reconnaissance until the 11th. On that day, the Eighth dispatched the largest force of bombers, 1,586 B-17s and B-24s, in one operation. Assisted by various bombing aids, 1,473 successfully attacked targets including Frankfurt, Karlsruhe, Giessen, Euskirchen, Koblenz, Mannheim, and Hanau.

Two pilots from the 13th Squadron, Lieutenants Schultz and Hakkila tried to cover airfields and power plants in the Ruhr on the 11th managing a few photos through breaks in the cloud.

The next day, five 13th Squadron aircraft went to St. Nazaire to map coastal defenses. A force of 20,000 German troops still held out in this port alone. Allied armies simply by-passed many of the German coastal strongholds in France isolating them rather than using large forces to capture them. Unless the area constituted a major threat, Supreme Command preferred to use just enough force to sustain pressure on the enclave. Their maintenance posed a supply problem for Germany. At some point the effectiveness of the U-boat bases and harbors would dwindle. At this time, the primary Allied objective lay in the east at the borders of Germany. These heavily defended areas with their notorious flak posed real danger for PR aircraft. No one wanted to be the next victim of St. Nazaire's batteries. All five F-5s returned safely with photos. On a similar mission, two 14th Squadron Spitfires successfully covered the other U-boat stronghold at Lorient as well as St Nazaire.

A Near Miss
Visibility at Mount Farm was poor on 13 December. Operations scheduled seven sorties for the day. Two pilots from the 14th Squadron, Capt. Willard Graves and Lt. Irving Rawlings had their missions canceled before they took off. Five sorties managed to get in the air. Operations assigned Lts. M.E. McKinnon and R.S. Quiggins of the 22nd Squadron to follow bomber strikes at Rheine, Osnabruck, the railroad between Bad Oeynhausen and Wissingen, as well as the town and aqueduct at Minden. Bad weather on the Continent forced the cancellation of the bomber mission. Mount Farm's control tower recalled the photo planes.

Captain Dixon decided to take his Spitfire to Germany in hopes of covering targets in central Germany. A heavy mist covered the field and lowering clouds threatened to close down further operations. Dixon accelerated down the runway and lifted off toward the low overcast. Above the field, "Red" McKinnon had trouble finding the runway through the murky cloud. Visibility was almost nil. McKinnon let down cautiously on his approach. Through a rare mix-up with clearance, neither pilot knew the other was there. Dixon, with little altitude under him, saw McKinnon first. He racked his Spitfire up on one wing. McKinnon pulled his wheels up. The Spitfire and F-5 narrowly missed colliding. Unable to lower his gear in time, McKinnon made a belly landing with his drop tanks still on. There was no fire. Both pilots were lucky to be alive.

Dixon decided to continue on his mission. He flew in cloud and fog until crossing into enemy territory where he found an opening over Trier. Through the breaks, he took pictures of one of the Mosel bridges and the city before returning to base. The next day, fog closed the field.

On 15 December, poor visibility in England and over the Continent limited Eighth Air Force operations. Two 7th Group pilots tried to cover assigned targets. Lt. Robert Facer of the 13th Squadron found his targets weathered in but he brought back a few photos from breaks over the Ruhr.

The only other mission from Mount Farm that day ran into more than bad weather. The 22nd Squadron's commanding officer, Capt. Daniel Burrows had targets at Hanover, where bombers had hit the marshaling yards

22nd Sq C.O. Capt Dan Burrows gives an A/P war correspondent a ride wedged into a "piggy-back" version of the P-38.
(D Burrows)

Eyes of the Eighth

Puzzled British faces at 8th Recon Wing baseball game played at Eton on 14 July. Trying to understand the American version of "rounders" seems to be a serious business.
(Paul Campbell)

"All Work and No Play..."

Most Americans love sports. The men of the 7th Group were no exception. From the earliest days at Mount Farm Special Services kept them supplied with all the gear necessary to play football, baseball, softball, basketball, and volleyball. The first Special Services Officer Lt. Edward M. Shepherd, 13th Squadron, began a program of entertainment and sports for the men. His replacement, Lt. Gordon L. Puffer continued to equip the men and arrange competitions with other service groups.

In July 1943, Lt. John G. Anderson, 22nd Squadron, took over the job. During the warm summer months 7th Group swimmers and divers competed against RAF Benson and later took second place in the Eighth Air Force Championship meet in London on 14 August 1943. Anderson hurriedly organized a track team to compete against Eighth Bomber Command track team on Labor Day at High Wycombe. The bomber boys were too powerful and the Group lost.

Squadron teams organized on base competed in softball and baseball with the 14th Squadron winning the Station baseball title. The 22nd was victorious in softball. The Station baseball team won eight of its nine games. A very successful Station softball team went all the way to the semi-finals of the Eighth Air Force Championship Tournament with 18 wins and only three losses.

Touch football games broke out on the perimeter near squadron areas whenever the men had spare time. Lieutenant Anderson helped organize squadron teams and one to represent Mount Farm. The first competition between the squadrons was won by the newly arrived 27th Squadron. During the winter of 1943/44 the Mount Farm "Photo Lightnings" won the Eighth Air Force title with three straight shutout victories before losing the ETO crown 20-0 to the formidable 29th Infantry "Blues" in March 1944.

The captain and coach of the champion "Photo Lightnings," Capt. Franklyn Carney organized a new team when the 1944 football season rolled around. He recruited many of the former members to play again for Mount Farm and the 7th Group. A heavier schedule promised good competition for the team and entertainment for the spectators. The "Photo Lightnings" found cold and muddy conditions at almost every venue. With the tremendous buildup of men in the ETO, competition was keener than ever.

They played their first game in Oxford on 1 October, a defensive scoreless battle against the Colchester "Mustangs." Over 6500 people watched the game played for the benefit of the Oxford Orphanage Fund. The next three games all ended with the same score – 18-0. Unfortunately, the "Lightnings" were on the wrong end of the score at the game in Warrington against the "Bearcats."

On 12 November, the "Lightnings" beat the 61st General Hospital "Panthers" 12-0. Lt. David G. "Dusty" Rhodes, a California "Aggies" star, scored the first touchdown on a 26 yard double-lateral run. Razzle-dazzle play continued as quarterback Pvt. Chester Janick passed to Pvt James Frazier from the place-kick position to score the second. Two more games ended with the Mount Farm team on the short end. Enthusiasm never waned and the team won more games but came up short of the title.

On the sidelines trying to stay warm. Capt J.R. "Doc" Savage, 14th Sq Flight Surgeon, bandages hand of player. Paul Campbell of 14th Sq huddles under blanket on right.
(Paul Campbell)

November December 1944

PHOTO LIGHTNINGS

8TH AIR FORCE CHAMPS

1943-44

earlier. His assignments also included Osnabruck as well as the Minden aqueduct and Canal. While on his way in he saw two rocket trails. Clouds covered Burrows' first two targets. He flew on toward his Minden targets where he found some clear bright sky. Just north of Minden, Burrows spotted four single-engine aircraft northeast of his F-5 at about 20,000 feet. They looked like ME-109s. The group split to attack his photo plane from either side and closed in. Burrows turned south and climbed into the sun. When he no longer saw the fighters, he made some photo runs over the German front in Holland from Nijmegen to Zaltbommel, then returned safely to base.

The 27th Squadron at Denain/Prouvy
Denain/Prouvy was a busy field when the 27th Squadron arrived. The VIII Service Command operated the field as an emergency airstrip and supply field. It performed all manner of duties that were not appreciated by the 27th at the time. When the command moved out and left A-83 to the 27th Squadron there was more than extra space left behind. Now the squadron had to become more than it bargained for, a photo outfit, as well as service and guard squadron. The men spread the extra load around but it strained the limited manpower. In November the 27th had experienced an emergency landing practically in their camera repair area when a B-17 crash-landed killing several French civilians. Damaged aircraft continued to use the field. Now the 27th had "guests" almost every day in almost every condition.

The physical situation at the airfield caused problems. Winter weather with its cold persistent rain made the living area a muddy quagmire. The enlisted men did what they could to improve their situation but beyond laying wooden walks and making their tents as secure as possible, there was little they could do. Denain/Prouvy was a cold, wet, and muddy field. The tents and their small stoves did little to improve miserable conditions. The men were used to Nissen huts and barracks. Some jokingly compared their present situation to a winter bivouac without the Rockies.

This was not Colorado Springs nor Mount Farm but France. That fact offered some benefits to living in the rough. Here at Denain/Prouvy French cooks and KP workers took that duty off the squadron's list. Transports flew rations in from England when weather allowed. Short winter days and bad weather limited the supply trips causing shortages. Just across the road outside the field there were a few French cafes. The men would adjust.

The advantage of having a squadron on the Continent paid off on 3 December when the Eighth could not send sorties out from England. The 27th managed to get two sorties to targets in Germany. They covered Koblenz, Cologne and Duren. On the 5th seven aircraft covered targets in the Ruhr, Munich, Wurzburg, and Frankfurt areas. All returned with photos of their assignments. With their home field closer to Germany, the pilots had less flying time to their targets and could cover more areas if needed.

Denain/Prouvy had been a target for Allied bombers during the German occupation creating ruins of bombed out hangers and buildings full of useless objects. With a chronic shortage of about everything, the useless could be turned into useful things by clever hands. There were some old droptanks on the field. Three men thought they could make reservoirs out of them. If they could rig the tanks overhead in one of the bombed out hangers they could build showers for the enlisted men. On the 6th, two sergeants, Carl Olsen and Herbert J. Miller, worked with Cpl Wm. E. McKinley to prepare the tanks. McKinley began welding. Suddenly the tank exploded blinding McKinley in one eye. Olsen and Miller, although burned, recovered without permanent injury.

The squadron commander Capt. Hubert Childress received his promotion to major on 11 December. His squadron flew missions when weather permitted. By the 11th, the 27th Squadron had been able to fly only 17 sorties.

The problem was the same in France as it was in England. Weather, always the weather. Eighth Air Force bombers went out on 11 December putting the largest force in the air to date. Able to use bombing aids 777 B-17s and B-24s hit rail targets in Western Germany including the Koblenz Marshaling Yard and Mannheim bridges. Four 27th pilots attempted to cover targets that day but only two succeeded bringing back photos of areas near Burg and south of Cologne.

Again on the 12th, the bombers hit rail targets and the synthetic oil refinery at Merseburg/Leuna. Neither the 7th in England nor the 27th in France could cover the targets. The next opportunity for photography came on the 13th when the 27th sent out four sorties. Three successfully covered areas near Homberg and Frankfurt. Then the weather again shut down operations at Denain/Prouvy.

The Ardennes
A blanket of impenetrable fog and mist covered the rugged hills, deep gorges, and forests of the Schnee Eifel region of the Ardennes. Just such weather common to this time of year was what Hitler counted on to hide a counter offensive against American forces in the Ardennes. He disguised his plan under the defensive cover name *Wacht am Rein* (Watch on the Rhine). His

commanders appropriately referred to the operation as *Herbstnebel* (autumn mist). This plan was so secret that any breach of secrecy was punishable by death. Hitler protected it with a vengeance allowing no direct mention on radio transmitted messages thereby limiting Enigma coded transmissions.

Soon after the collapse of his Normandy front, Hitler envisioned a way to delay, divide, and stop the advance toward Germany. Part of his plan was in force — the holding of all possible harbors on the Channel and Atlantic coasts. The only usable major northern port in Allied hands was Antwerp and by holding the Scheldt so long he had denied the Allies quick use of it. His troops had held the line along the rivers in Holland and turned back the Market Garden attack at Arnhem. Behind the lines he cannibalized other forces to form 25 new Volksgrenadier divisions and gathered together much of his remaining fuel supplies. He would drive a wedge into the weakest point of the Allied lines. Armor would move forward swiftly as it had in the past, cross the Meuse River and retake Antwerp. He would divide the Allies. After such a stunning blow, his enemies in London and Washington might want to talk. Just as Hitler misjudged the Allies, they also misjudged him.

December days were short. Under cover of the early, long lasting darkness of winter, troops and armor moved up behind the front. They muffled sound by covering the winding mountain roads with straw. Luftwaffe fighters flew parallel to the front, a tactic which mystified American troops in the line. The sound of the aircraft's engines masked sounds of armor and motor transport. Where a dim daylight did not appear until eight and was gone by four, all was protected from the eyes of cameras by the Ardennes fog and mist.

The general attitude at Allied Headquarters added to the success of Hitler's plan. They knew the Germans were short of men, short of reserves, short of fuel, and aircraft. By all military logic the German commander in the area, von Rundstedt, was unlikely to make a winter attack under those conditions. The Germans would not risk their forces on the Western Front while being pounded on the east by the advancing Russians. There were clues, hints, a few Ultra transcripts, prisoner talk, some photo intelligence, and a ferocity of resistance by the Germans in certain areas of the line but all the puzzle pieces did not fit the overall picture projected by Headquarters. Field Marshall Montgomery spoke on 15 December to colleagues about the defensive campaign the Germans were fighting on all fronts and stated that, "his (Hitler's) situation is such that he cannot stage any major offensive operations." All along the front in their positions from Monschau in the north to Echternach in the south, the troops of the U.S. First Army would probably have agreed. This was the quiet front. The action would be in the north against the Roer River or in the south with Patton.

At 5:30 AM on Sunday, 16 December 1944, German artillery opened up on American forces. Armor poured into gaps created in the lines by the surprise attack against lightly held positions. Hitler's Ardennes counteroffensive Operation *Herbstnebel* had begun.

With the German attack along the U.S. First Army front in the Ardennes, the 27th Squadron found itself in a more forward position than planned. Early reports did not reflect the magnitude of the attack. As later word came down from headquarters, the squadron doubled the guard and ordered everyone at the airfield to wear a helmet and carry his rifle at all times. Curfew was at 2100 hours. Squadron Headquarters restricted any social life to the cafes across the street from the field.

On the 17th the Eighth had no operations due to bad weather and the 7th could not send out any flights from Mount Farm. From France, the 27th Squadron sent ten sorties to targets in Germany including Wurzburg,

Difficult outdoor working conditions for the men during the snow and freezing weather in England.

Frozen fog covers bicycles at 381st Air Service Sq area and everything else at Mount Farm.

Eyes of the Eighth

Ludwigshaven, and the airfield at Trier. Lieutenant Gonzalez covered airfields at Furth, Ansbach, and Nurnberg as well as the Nurnberg-Mannheim and Hamburg-Erlangen areas. Of the ten sorties, only one was unsatisfactory and that was due to cloud.

The 7th Group Faces Increased Opposition
Forced by weather to sit on the ground the 7th Group had to wait until 18 December before sending out five sorties. Captain Shade of the 13th Squadron flew one of them. The weather was poor everywhere. Shade had targets at Cologne and Koblenz. Intelligence wanted as much area cover of the German breakthrough near Euskirchen as possible. Due to heavy cloud cover, Shade crossed into enemy territory at only 10,000 feet and flew into the Ardennes battle area. Over Euskirchen two ME-109s intercepted the F-5. Without releasing his droptanks, the pilot did a fast Split-S. The two 109s followed him down. Shade pulled every maneuver he could think of to lose them, ducking in and out of clouds, eventually ending up on the deck. Light flak and machine gun fire reached up toward him. He was over the battlelines. Shade evaded the fighters and escaped without any damage from ground fire. Four FW-190s appeared in the distance but did not engage. Whether they saw him or not, Shade didn't care as long as he got away. He landed safely at Mount Farm with his photos.

Newly promoted Capt. Arthur Leatherwood of the 14th Squadron flew another of the Group's sorties. Operations assigned him to cover the day's bomber strikes in the Koblenz-Cologne area. The heavies attacked German communications targets in Western Germany using bombing aids when necessary. They also bombed tactical targets in the area of the breakthrough. Over 600 U.S. fighters protected the forces and made sweeps in the area. Leatherwood's assignments were in that busy air space. When he found them covered by cloud he looked for other targets in the clear but 12 persistent P-51's on patrol ran him off in spite of the captain's repeated attempts to identify himself. Finally, Leatherwood returned to Mount Farm without much success.

The Ardennes battle made tactical targets a priority. Bombers from both the Eighth and Ninth Air Forces hit communications centers, marshaling yards, road chokepoints, and other tactical targets to blunt the attack and prevent re-supply. On the 19th, a small force of bombers struck Ehrang and Koblenz. Then weather grounded all of the Eighth's bombers, fighters, and photo reconnaissance planes until the 23rd.

Hitler's ability to attack in force with the refitted and reinforced 6th SS and 5th Panzer Armies surprised the Supreme Command but Eisenhower reacted swiftly.

He ordered the 101st Airborne to Bastogne, a vital road and transportation junction. The U.S. 7th Armored held another key junction at St. Vith. All along the front small elements used the advantage of terrain to delay the German advance. In spite of confusion and disruption, most American forces bent but did not break as the tanks rolled into the forested Ardennes intent on reaching open country beyond and their objective of the Meuse River and port of Antwerp.

Encircled and the target of constant attack, Bastogne held. By the 22nd, Patton had turned his Third Army north and begun the march from Arlon toward the relief of the 101st Airborne. Allied units counterattacked all along the German advance. Without the help of vital air support St. Vith on the northern flank of the German attack had to be abandoned on the 23rd. On that same day, the German forces ran out of fuel. They had counted on a surprise lightning strike and the capture of a huge Allied fuel dump. They achieved the former but failed to take the latter. Their advance had pushed a deep bulge into the American lines but fierce fighting forced delays that crippled the attack.

On 23 December the weather improved enough for 7th Group to launch 15 sorties. Only two returned without pictures. On a sortie to Kaiserslautern, 14th Squadron's Lt. Jack Roberts slowly let his Spitfire down to get below the overcast and found himself 1,000 feet to the left of a formation of B-24s at 26,000 feet. He climbed away from the bombers but ran into 12 ME-109s. Two split out of the formation to go after him. Roberts ducked back into the overcast again to escape and returned to base safely.

A single engine enemy fighter attacked Lt. Richard Brunell of the 22nd over Osnabruck on his mission to Staaken, Berlin, Genshaven, and Erkner. He dropped his auxiliary tanks to evade the fighter and had to return to Mount Farm without covering his targets. Just before crossing out over the coast he saw three rocket trails rising into the stratosphere from near The Hague, a prime launching area for V-2s.

When Lt. Marcus Vaughn, 14th Squadron, attempted to get his tactical targets following the bomber strikes on communication centers near Ehrang four ME-109s bounced him near Stenay, Germany. Vaughn released his droptanks, pushed his boost to maximum, and climbed to 38,000 feet. He lost the fighters. With little fuel left he photographed a short strip along the front lines and returned to Mount Farm.

The 14th sent Lt. Robert Sanford to targets in the Koblenz area. West of Koblenz Sanford saw seven P-51s drop their tanks and turn toward him. Taking no chances, he turned into the sun, climbed to 38,000 feet and evaded

November December 1944

the "friendly" fighters. Then, unable to pin point his target, he photographed Luxembourg City and a strip east of the city. Another 14th pilot, Lt. James Fellwock also ran into Allied fighter patrols and could not reach his target at Frankfurt. He photographed a power station at Knapsack and returned safely. The 14th Squadron pilots wanted fighter escorts but none were available. Most fighters were out on patrol or bomber escort and in some cases intercepting 7th Group planes.

The 27th Squadron at the Front

By the time of the German counterattack in the Ardennes, the 27th Squadron had made its home at the Denain/Prouvy Airfield as comfortable as possible under extremely cold and difficult conditions. Some of the undamaged buildings served as a mess hall and supply room. The men set up the Orderly Room in a double tent.

The squadron found a large chateau in Valenciennes to serve as headquarters with living space for the officers and pilots. The basement made a perfect location for the Lt. William Teague's photo lab as it had a water supply and was warm and dry. There was room for Capt. Walter Hickey's Intelligence Room, Captain Floyd's Operations section and whatever other offices had to be near headquarters.

The Chateau Regie sat in a spacious garden park across the street from a large hospital. As soon as the

Entrance to the 27th Squadron's new headquarters at Chateau Regie in Valenciennes, France. (H. Gonzalez)

squadron moved in, Lt. Frank Heidelbach's communications men had to establish contact between the airfield and the Chateau. Sgt. Elbert Keel strung wire, ran lines between the two, and quickly solved that problem. Unable to get direct lines to Mount Farm, under a temporary arrangement the 27th managed to set up communications with Mount Farm through a nearby fighter base. This radio contact had to be abandoned when the 27th squadron's radio frequency was taken away. The squadron needed more landlines and teletype machines. Until enough landlines could be installed, the 18th Sq. Weather Officer Lt. Tony Pircio had to make daily courier runs by Jeep to maintain the squadron's contact with the weather station at Mons, Belgium.

Dangerous Travels

With planes grounded by fog and freezing rain, film for Twelfth Army Group had to be delivered over muddy roads. Although Valenciennes was in gently rolling open land, the destination for important film lay in the Ardennes at Luxembourg City forcing any courier runs to eventually travel narrow winding roads through the forests. The route lay below the southern flank of the German army's advance. Most supply to the forward areas was by road. Truck convoys forged ahead toward the front day and night. Couriers often drove with the convoys.

The shooting war came close to two 27th Squadron men one night. Two transportation men, Cpl Bernard F. Cain and Pvt William H. Cook had film to deliver to Luxembourg. They joined a group of trucks heading southeast through the night toward the Ardennes. The convoys had to move as fast as possible and with weather usually protecting them from attack from above, they ran with lights on. This night an enemy aircraft strafed the road. Cain and Cook turned off their lights just as shells and tracers hit the truck behind them. No one was hurt and they continued on. Near Verdun, as they started to stop for gas and to switch drivers, German paratroopers opened up on them with machine guns. The two air force drivers made a hasty departure. Again no one was hurt. After delivering the film, they returned to Denain/Prouvy with stories of combat at the "front" to tell their friends in the "rear."

Schumacher Missing

Lt. Wesley Schumacher took an F-5 up for a high altitude test flight check on the afternoon of 21 December and failed to return to base. The weather closed in after he took off on his local flight. There were no operational sorties that day. Many of the men wondered if he had strayed over the front lines, which were much closer since the beginning of the Ardennes battle. The squadron heard nothing from him and listed him as missing until further investigation.

Unexpected Guests

Necessary re-inforcements for ground troops fighting in the Ardennes began arriving from rear areas on the Continent and from England. To supplement forces already stretched to the limit, the army pulled men out of

non-combat positions. Supreme Headquarters took men from kitchens, offices, supply units, and any unit that could supply them to rush new men forward to stop the German advance. The 27th Squadron received a message over its teletype one morning to expect RAF transports in the afternoon bringing U.S. Army re-inforcements to Denain/Prouvy in transit to the front lines. The squadron would have to find billets for the air crews and enlisted men to stay overnight near the base. Major Childress set his headquarters staff to making arrangements to find housing for the men, all 2,000 of them. He called the mayor of Valenciennes who offered a school for the troops. The first RAF plane came in under a low overcast with less than a 600 foot ceiling. The C-47 taxied to the end of the runway and unloaded portable equipment to guide the rest of the transports in through the cloud. The C-47s began to land one after the other, unloading their cargo of infantry into the hands of the 27th Squadron.

The 27th found room for the air crews in the halls of the Chateau. Special Services Officer Lt. Hector Gonzalez added a little extra welcome when he asked his squadron if they would let the Army watch the movie planned for that night. In the morning, the men assembled and boarded trucks of the "Red Ball Express," which took them to the front lines. The RAF C-47s left Denain/Prouvy and the field returned to normal operations.

Behind the Ardennes counteroffensive lay the supply lines of the Middle Rhine section of the German rail system. The line ran from Julich in the north to Konz/Karthus in the south between the Rhine River and the Belgian and Luxembourg borders. Feeding in from Germany, other lines brought supplies forward to the armies in the bulge. Duren had the biggest junction, where five lines met. Farther south, four lines passed through Euskirchen then down to Junkerath, Bitburg, Trier, and Ehrang. Feeding supplies in from the southeast, rail traffic passed through Kaiserslautern. On 23 December the 1st Bomb Division hit the marshaling yards at Ehrang. The 2nd Division bombed communications centers at Junkerath, Ahrweiler, and Dahlem. Kaiserslautern was one of the targets of the 3rd Division.

Damage assessment dominated the sorties on 24 December. Lt. Gerald Glaza, 14th Squadron, brought back photos of Konz/Karthus revealing to photo interpreters heavy loading in the southwest sidings and 50 empty flat cars. The line toward the Moselle River had been repaired. Photos of Ehrang showed severe damage in the marshaling yards with all the lines cut. Also from the 14th and flying a Spitfire, Lt. Fabian Egan covered targets from other attacks as well as Bitburg, which had only one line open and considerable damage in the sidings.

As long as the eyes of photo reconnaissance cameras could bring back the information, the heavies could concentrate on transportation hubs and bridges still in operation. Allied bombers kept up the attacks to overload the German repair units' ability to quickly replace damaged track and sidings to reopen routes of supply. The proximity of major river and rail facilities along the Rhine made German supply lines short but vulnerable. Cooperation between strategic and tactical air forces during this emergency played a large part in the sealing off of the front.

The 13th Squadron Commander Captain Nesselrode headed for his targets at Cologne and Frankfurt on the 24th. As he crossed the Rhine below Koblenz, a flight of ME-109s bounced him. He hit the deck and poured power to his F-5. When he returned to Mount Farm he told the Intelligence officers that he had seen some very unusual flak. As he crossed into enemy territory, four bursts of flak appeared in front of his aircraft. It looked like a ball of flame dropping down from his altitude. As the flame went out, the ball exploded and filled the air with hundreds of black objects but none damaged his plane.

Of the 13 sorties Operations sent out from Mount Farm that day, five were intercepted. The 22nd Squadron Operations Officer Lt. James "Red" Matthews had targets at Harburg, Hamburg, Stettin, Stargard, Stralsund, and Klutz, an area plagued by jet aircraft,. On his way in, near Bremen, two ME-262s attacked his F-5. "Red" turned into and under the jets. As they flashed by he noticed that their jet engine nacelles were black. Losing the jets, Matthews went on to Harburg and Hamburg, successfully completing his runs there. He managed two runs over Minden before having to turn back. Near Munster he made a turn at 23,000 feet unaware of four ME-109s who were just as unaware of him. As he turned toward the startled Germans they released their drop tanks and took off after the "opportunity" that had come their way. Matthews fire-walled his throttles and beat a hasty retreat to the coast. In spite of his troubles, "Red" Matthews removed seven of his assigned targets from the program.

Carlgren
Three P-51s escorted two 22nd Squadron pilots flying together to Magdeburg, Fallersleben, Hanover, and Minden. Lts. R.W. Hall and R.F. Carlgren made two runs over Magdeburg. Just as they left for the next target, six ME-262s jumped the formation. Suddenly there were aircraft everywhere. Three of the ME-262s blocked the fighters while one jet attacked Hall and Carlgren.

November December 1944

The two other jets flew above the melee. The attacking jet made passes from right to left firing its cannon. Lieutenant Hall turned sharply under the jet and evaded without damage. Carlgren, however, was not as lucky. The shells hit Carlgren's right engine, which exploded. Hall saw the F-5 fall off into a spin. The plane disappeared but the fighter escort reported the F-5 had flipped over on its back. They also saw a parachute open a little later.

The fight lasted about ten minutes. The jets broke off after the successful kill and attacks by one of the P-51s. Lieutenant Hall and the three escorts went on to cover Hanover where a black FW-190 dove on Hall. The P-51s turned on the attacker who broke off and flew away. When Bob Hall returned to Mount Farm he reported the incident. With the description from the fighters, the squadron assumed Carlgren had bailed out successfully. This was the best they could hope for on this Christmas Eve. They would wait for word from Headquarters.

The mission was partly successful with photos of Magdeburg and Fallersleben good enough to remove those targets from the program. Hall had more to tell Intelligence. The ME-262s were painted white below and light blue above, not the usual mottled green and brown typical of so many Luftwaffe aircraft.

Christmas at Mount Farm

The next day the 7th Group sent six aircraft out on sorties to Germany where there was clear weather over some of the targets in the zone of interdiction behind the Ardennes battle area. Lieutenants Vaughn, Facer, and Belt from the 13th Squadron along with Lieutenants Fellwock, Glaza, and Sanford from the 14th covered over 40 targets including Giessen, Euskirchen, Dahlem, Arhweiler, Kaiserslautern, and Bitburg. Before they returned to base, a cold mist and heavy fog descended upon Mount Farm closing the field. All six pilots had to land at Bradwell Bay on their return.

In spite of extremely cold weather and foggy mist again freezing on everything, four sorties managed to take off on the 26th. The men who had to work outside had the hardest job keeping aircraft ready for operations. Visibility was very poor at best. Lieutenants Gilmore and Roberts of the 14th Squadron covered more targets behind the Ardennes front. The 13th sent Lts. Evan Mecham and David T. Davidson to the Cologne area. They both returned with their assignments. Mecham also took photos of the northern end of the Ardennes front at Monschau, which was still in Allied hands. After the four planes returned the field closed until New Year's Eve.

Christmas in France

At Denain/Prouvy on 24 December, the 27th Squadron sent eight sorties to Germany. The weather report for its area of operation was good enough for photography and the airfield itself was clear. Preparation for the Christmas party in Valenciennes was well in hand. Almost everyone on base planned to go to the Grand Hotel in town to celebrate. The squadron's cooks and the hotel's chefs had turkeys supplied by the Quartermaster Corps to roast in the hotel ovens. The hotel's staff would do most of the work and the men of the 27th would do all the feasting. Guards and a small staff would remain behind to man the airfield when the time came. For now, it was business as usual in the air.

Captain McGuire and Lieutenants Purdy, White, Hanson, Florine, Saxton, Nolan, and Crowell headed for Germany. Capt. T.B. McGuire and Lt. J.W. Saxton had damage assessment targets. Each took 12 of the 13 jobs and covered all but one. With the overlap of coverage, each pilot taking one the other had missed, they completed all the assignments. Lieutenants Nolan and White also covered their targets successfully.

When "Willie" White returned, he reported that an enemy fighter attacked Lt. Jeryl Crowell while they were in the vicinity of Stavelot, Belgium, a hot spot in the Ardennes area. White heard Crowell had radioed that he was hit; then White heard nothing else. When Crowell failed to return, the squadron listed him as missing in action until further notice.

Lieutenants Purdy and Florine were mapping near Nurnburg, when Bob Florine spotted a jet and called a warning to Ira Purdy. The ME-262 attacked Purdy from behind before he could evade. Shells ripped into his left engine, the propeller, and all along the trailing edge of the wing between the two booms.

Unarmed but determined to come to the aid of his friend, Florine turned his F-5 into the jet and attacked

The holiday season keeps Al Ambrose of the 381st Air Service Sq busy using his talents as an artist to customize cards for the men to send home. (J. Bognar)

233

Eyes of the Eighth

Smoking wreckage of Lt Ira Purdy's F-5 on Christmas Eve at Denain/Prouvy, France.

until he drove the German away from the crippled aircraft. Uninjured, Purdy began to nurse his F-5 toward Denain/Prouvy. On his single engine he used the highest settings he could get. He saw all his coolant boiling and evaporating away on the way back. Barely able to keep the plane up to flying speed on the one engine, he fought the controls all the way from Germany. Having successfully driven the jet off, Florine flew cover as they headed home.

Ahead lay the wide expanse of Denain/Prouvy where so many crippled Fortresses and Liberators had sought a safe landing. Now it was Purdy's turn. Exhausted from holding the rudder and trim tab to keep his plane in level flight, Purdy used his last bit of strength to set the smoking F-5 down. He aimed toward the grassy middle of the airfield. Wheels up and on one engine, the F-5 touched down, sliding and bouncing across the rutted field.

From the side of the field men watched the plane come to a smoldering halt. They raced toward the column of smoke to help. Purdy tore free from his straps and scrambled out of the cockpit. The plane burst into flames. He ran a few yards and his legs gave way. He got to his feet and ran a few more yards before dropping again. He couldn't run any farther. Help arrived and hands grabbed the pilot pulling him away to safety as his plane burned on the field.

"Doc" Fritchie checked Purdy out and found him shaken but unhurt. Relief flooded the rest of the squadron as they already knew that Crowell had not returned. "Doc" offered him the usual ration of two ounces of whiskey when a pilot returned to base after a mission. Most refused, as did Purdy, and "Doc" kept the ration in a bottle for safe keeping.

Soon he had another patient, the headliner for the coming party. Major Childress planned a bang-up party for Christmas and had arranged for the glamorous Marlene Dietrich to perform. She had been touring some of the army bases but now was back in Paris. Childress sent one of the 25th Bomb Group detachment's B-26s to Paris to pick Marlene and her accordionist up. Not long after Purdy's fiery arrival on the field, the B-26 approached and landed alongside the still smoking wreckage.

Refusing to stay in the hotel, she insisted upon spending the night at the Chateau. She arrived homesick for Paris and nursing a cold. The C.O. told Vern Farrow and his roommate to put clean sheets on their beds and turn the room over to the women. They could bunk in with someone else. Marlene wanted to see the doctor to get something for her cold. "Doc" did what he could for her. Then she had to call her current boyfriend in Paris and tell him how miserable she was and how much she missed him. It was not a good beginning.

After she went to her room, Fritchie brought out the bottles of whiskey and gave each pilot the one marked with his name to celebrate Christmas and all who had returned safely. They had more than Purdy's scary return to celebrate, the night before the 27th Squadron came close to losing another pilot, the same Vern Farrow who had just been booted out of his room for Marlene.

Lieutenant Farrow had been on a local flight late in the afternoon when he had trouble lowering his landing gear. He pumped furiously to get it down but to no avail. Running out of gas, he attempted a wheels up landing in a plowed field out in the countryside. The F-5 nosed over and sank into the mud upside down. Farrow, suspended head down in the cockpit, discovered that he had not been injured except for a few minor scratches. Cushioned — almost buried — in the awful, sticky French mud he knew he had to get out somehow as menacing wisps of smoke curled from one engine. He was trapped. Soon some Frenchmen who had seen his crash came and dug at the earth entombing the anxious pilot. It took a hairy 25 minutes to get Farrow out.

November December 1944

Back at the airfield they knew they had a plane down. The 27th's Intelligence Officer Captain Hickey, who spoke French, wasn't there and they needed someone to go and find Farrow. At dusk, while eating his dinner in the field mess tent, one of the S-2 staff, Harry Kaplowitz heard his name called over the loudspeaker. He reported to Operations. Told of the situation, Kaplowitz gathered a group to search for Farrow. They loaded into a weapons carrier and started off on a country road in the general direction of the likely crash site. Armed with .45s the little group drove into a cold black night.

At each farmhouse they stopped and asked about a plane going down nearby. The French families happily greeted the men but until they reached the eighth farm, no one had seen or heard anything. Then a young boy about ten years old leaped about excitedly drowning Kaplowitz in frantic French until the American understood, "I saw it. I saw it fall." *Maman* let the men take her son with them to show the way. They drove for miles with directions of "*la droite*" to turn right and "*a gouche*" for a left. Suddenly the headlights caught a wildly waving Vern Farrow and jumping up and down in the middle of the road.

Purdy, Farrow, and the rest of the pilots finished the whiskey "Doc" had given them. They switched to Cham-

27th Sq CO Major Hubert Childress with Marlene Dietrich, 25 Dec 1944. (H. Gonzalez)

pagne. Soon they had an overwhelming desire to serenade the lovely Marlene. Unfortunately the lovely Marlene, suffering from her head cold, refused to open the door. Undeterered, the happy pilots sang several choruses of White Christmas in the hall outside her door.

The Christmas day party in the festively decorated Grand Ballroom of the hotel in Valenciennes was a huge success. The chefs produced turkey and all the trimmings with ice cream for dessert. Then the guest of honor, known for her glamorous legs and sultry voice, put on the evening's show. For these few hours, the squadron's recent losses and difficulties temporarily retreated into the background.

A Crash in Luxembourg

Advanced units of Patton's Third Army fought through the German encirclement at Bastogne on the 26th to relieve the stubborn 101st Airborne. Farther west, the U.S Second Armored Division stopped the tanks of the 2nd Panzer Division on a winding ravine road at Celles. The German advance had come within ten miles of the Meuse River at Dinant.

The 7th Group had photo cover of the fluid front to rush forward by courier plane. Weather stopped all operational flights from Mount Farm on the 27th but C-53 number 42-15549 managed to reach the airfield at Luxembourg. The next day, Lts. Fabian John Egan and Jack H. Roberts of the 14th Squadron loaded up in the early afternoon to bring passengers back to England. The C-53, because it lacked the wide cargo doors of its better known configuration the C-47, was used more as a transport. The 325th Wing had five of the few remaining C-53s in the Eighth Air Force most of which flew out of Mount Farm. Maintained by the 381st Air Service Squadron, these aircraft had crews made up of pilots from various squadrons and engineers from the 381st.

On this trip, Egan's crew included SSgt Daryl Nooner as engineer and two other men, SSgts Lloyd S. Snyder and B.J Deriacomo of the 1274th Military Police Com-

Marlene Dietrich entertains at the 27th Sq Christmas dinner. (H. Gonzalez)

pany. Their passenger manifest listed captured German officers including a colonel and a Luftwaffe pilot, both of whom Supreme Headquarters Intelligence wished to interrogate.

As the crew prepared and loaded its aircraft, the weather worsened. Wind drove sleet across the field. Egan watched conditions deteriorate and the C-53's wings begin to collect snow and a hint of ice. They rushed to get away before A-97 closed. The pilot taxied to the end of the runway and powered up the two engines. Releasing the brakes, Egan pushed the throttles forward and sped down the strip. Releasing the brakes, Egan pushed the throttles forward and sped down the strip. The C-53 bounced on the rough runway, lifted off and slowly climbed to clear the woods at the edge of the airfield. Without warning one engine quit. The transport plowed into the tops of the trees. Limbs crashed into the cockpit striking the pilot on the leg. The crippled plane dropped toward a field. Egan and Roberts struggled to keep the plane level as it slammed into the ground and slid to a stop.

Shaken but still alive, crew and passengers all walked away from the crash, all that is except John Egan who limped on his injured leg. The group made sure the prisoners were accounted for and returned to the airfield. Other transportation could be arranged when the weather cleared. Lieutenant Egan spent the night recuperating in a comfortable bed at the hotel in Luxembourg City while his crew looked for a way home.

On the 29th, everyone gathered at the airfield and the 7th Group men discovered that they were not high on the priority list. The Germans were. With their guards, the prisoners took the first flight out. The others scrounged flights back to England the best way they could.

The last day of 1944 came and weather still governed the sorties sent out by the Group. Bombers had better weather over their strategic targets and made major strikes against the oil industry. The communications and transportation targets in the Ardennes sector still held a high priority and the 1st Bomb Division made heavy attacks in the area. Operations planned nine missions but canceled one of three 22nd Squadron sorties, Lt. William Buck's, before takeoff. Two others, flown by Lieutenant Sarber and Pipes had better success. Sarber covered St. Nazaire and Pipes, Ijmuiden in Holland.

Lt. Carter E. Hitt of the 13th Squadron flew to his targets in the Cologne area at Dusseldorf, Neuss, and Krefeld, the latter two just after the bomber strikes. Hitt made one run over each target. When he started a second run over Krefeld the flak batteries opened up forcing Hitt to leave that area. He returned to Dusseldorf and then Neuss where he lost an engine. Just as he left the target three FW-190s jumped him. On one engine pulling maximum boost he headed for the deck and cloud cover. Hitt flew toward safety within the gray mantle for a long time losing altitude all the while. Then his remaining engine faltered. Flying blind and his engine no longer able to keep the F-5 going, Hitt broke out of the clouds only a few hundred feet off the ground. Just ahead lay an airfield. With little time or altitude to spare, Hitt discovered trouble with his hydraulic lines. He managed to get his wheels down but could not operate the flaps. The F-5 barely cleared the trees on the edge of the airfield and landed safely at A-81 in France. The VIII Service Command gave him a ride back to England where Lieutenant Hitt completed his journey to Mount Farm by Jeep.

Two other pilots, Capt. Robert Dixon and Lt. Bruce Fish of the 14th also had assignments to follow the bombers. Heavy cloud covered some of the targets but Dixon saw smoke rising from the bomber strikes on the marshaling yards at Neuss and photographed the burning city. Fish covered a strip from Junkerath through Trier and Bingen to Nuenkirchen.

14th Sq CO Maj Robert J. Dixon and MSgt John Mates.

Closing Out 1944 in France

The 27th Squadron could not fly any sorties on 31 December. Since the beginning of its operations at Denain/Prouvy the 27th had flown 35 missions. The year ended with an unusual event. Late that New Year's Eve a single enemy aircraft buzzed and strafed south of the field and dropped several bombs near a factory. It did little real damage. The 27th did not know how lucky it was until reports came in the next day. With forces mustered to support the counteroffensive, the Luftwaffe mounted its last major offensive and attacked Allied airfields in Belgium. At a terrible price they could not afford, the Germans destroyed 156 aircraft on the ground. Denain/Prouvy had lost none.

Part IV

CHAPTER 15

January 1945
New Year's Day began with clearing skies all along the Western Front from the Baltic Sea in the north to Strasbourg, France, on the Rhine River in the south. In unexpected strength, German fighters strafed and bombed airfields in France, Belgium, and Holland. They caught a large number of parked Allied aircraft, previously grounded by bad weather, before they could return to their home fields. American bombers and fighters at Brussels/Melsbroek Airfield in particular took a beating. This last major effort by the Luftwaffe to seriously challenge Allied air supremacy damaged or destroyed almost 200 aircraft on the ground. Except for the single plane raid during the night, the 27th Squadron, the only unit of the 7th Group on the Continent, escaped attack. Although the Luftwaffe caught the Allies by surprise, it paid a price it could not afford. It lost over 300 replaceable planes but 253 irreplaceable pilots.

Even without such losses the Luftwaffe's dispatch of such a force used precious fuel, which was the most critical shortage plaguing the entire German war effort. The counteroffensive in the Ardennes nearly bled Germany's scant oil reserves dry. Repeated Allied air strikes at Germany's oil industry had paid off. Now, the emergency need for all the air forces to attack tactical targets interrupted this effort.

The Eighth Air Force began the new year with a redesignation of its bomber forces. As of the first of January, the old bomb divisions became known as air divisions. For the time being, their chief assignments were tactical in support of ground troops reducing the Germans' penetration into the Allied lines. Germany's Ardennes counteroffensive had pushed a deep bulge in the American sector, a bulge pointing toward Hitler's main objective, Antwerp. The name "Battle of the Bulge" caught the imagination of the press and public throughout the Allied world.

Up until 31 December, two weeks had passed without bomber attacks on strategic targets. Following heavy strikes on the last day of 1944, the Eighth started 1945 with more hits on General Spaatz' preferred targets in the oil industry. Seventy-nine B-17s from both the 1st and 3rd Air Divisions attacked oil targets at Derben, Magdeburg, Dolbergen, and Ehmen.

The same clear weather that worked to the Luftwaffe's advantage allowed over 700 Eighth Air Force bombers out of Britain to attack rail bridges at Koblenz and Remagen; marshaling yards at Kassel, Gottingen, and Koblenz. The heaviest concentration of bombs fell on the yards at Kassel/Henschel where 292 B-17s of the 1st Air Division dropped 687.8 tons of explosives.

Tactical targets required damage assessment as quickly as weather would allow. Using any break in the weather at either their airfields in Britain and France or their targets areas, squadrons of the 7th attempted to get damage assessment of the Eighth's bomber attacks, both tactical and strategic. Very few good days of flying weather in January restricted operations. Regardless of the weather, if the aircraft could get off from the base, they took off to search for openings over the targets. Operations assigned many pilots to fly their sorties in pairs for protection from the Luftwaffe. Although the German fuel shortage reduced enemy air opposition throughout the area from its high point during the preceding months it was still formidable. Escorts of P-51 fighters went on the long trips to the vicinity of Munich because of known jet activity in the area.

During January, the 13th Squadron covered an area bounded by a line across Walcheren Island in the Scheldt to Munich, Germany, and south to the Swiss border. Within this area lay the Ardennes, the Bulge battlefield, where the heavies targeted every possible road and rail junction, communications center, and supply point. This gave photo reconnaissance a very large number of targets to cover for assessing damage in an area containing many of the main tactical targets.

On 1 January, 13th Squadron Operations Officer Lt. Robert Facer assigned five sorties. Lts. Donald A. Schultz and John Weeks attempted to cover targets in the tactical area from Euskirchen to Trier. Weeks had trouble with his aircraft and could not take off, leaving Lieutenant Schultz to go out alone. Weather prevented Schultz from returning to Mount Farm and he landed at an airfield on the coast of England.

Lt John Weeks, 13th Squadron. (J. Weeks)

January 1945

Lts. Taylor Belt and Thomas D. Vaughn had 29 targets in the tactical area from Euskirchen to Koblenz to Trier. Airborne at 1111A hours, they met no opposition but found the area partly cloud covered. Lieutenant Belt photographed bridges at Remagen, Engers, Cochem, Sinzig, and Irlich as well as targets at Koblenz and Euskirchen. With especially good cover of Koblenz, he returned to Mount Farm before weather closed the field. Lieutenant Vaughn had to land at Bradwell Bay where he spent the night.

Capt. Dale Shade, along with Lt. Ellis B. Edwards of the 22nd Squadron, covered an Aphrodite drone attack against a power station at Oldenburg, Germany, on New Year's Day. Two Castor equipped B-17s, the war-weary *Darlin' Dolly* from the 95BG and *Stump Jumper* from the 397BG, headed for their target accompanied by the attendant guiding ships and observers. Flak struck the drones on their approach to the target bringing them down. Both ships crashed outside Oldenburg but only the second B-17 exploded on contact. The other broke up without detonation. (From salvage of the crash site the Luftwaffe retrieved and analyzed the Castor equipment but there were no other Aphrodite/Castor missions. The use of unmanned delivery of high explosives and, in fact, the bombing of heavily populated areas came under reassessment by American and British governments.) After successfully covering the mission, Shade and Edwards returned to England. Weather had closed Mount Farm forcing them to stay overnight at another base. They returned the next day.

Earlier the same day, Lt. Carter Hitt flew the squadron's P-38J Droop Snoot to Creil Airfield in France. He picked up the film left there the day before when forced to land his F-5 after flak over Neuss and Krefeld damaged one engine. When Hitt prepared to land at Mount Farm on his return, his landing gear did not lock and he had to belly-in on the grass. Hitt was not injured and delivered the film in spite of a run of bad luck.

Ed Douttiel resting atop a pile of coal, an important but grimy commodity in winter. (E. Douttiel)

P-51 Fighters for the 7th

Luftwaffe fighter opposition to photo recon aircraft increased steadily in 1944. With the addition of jet aircraft to its forces, the German Air Force toll of lone photo aircraft multiplied until 7th Group losses surged in the fall of the year. Eighth Fighter Command furnished escort whenever possible, particularly on the deep penetrations and to areas known for jet activity.

The usual routine for a photo sortie flown with escort required the PR pilot to fly to the assigned fighter base where the pilot landed and briefed the escort pilots on the mission. Used to covering slower bomber forces, the fighters now had a much faster aircraft to cover. Unless throttled back, the lighter faster PR aircraft climbed away from its armed escort. When the formation arrived over the targets, the photo pilot had to maintain a steady prescribed course, often over heavily flak-protected areas. There, the escort usually maintained high cover as German fighters were unlikely to attack in a flak zone. On low-level "dicing" missions similar to the 2 June 1944 cover of the Loire River bridges, the fighters maintained medium and high cover over their hedge-hopping charges.

Most attacks came during approaches to targets and cover had to be all around. The fighter pilots provided many pairs of eyes to search for the enemy from whatever quarter he came. With the F-5, the most vulnerable area was behind and below. The German's ME262 jet was the most deadly adversary from that angle. With great speed and rate of climb it could approach and attack from this position before the PR pilot realized the danger. Pilots increased their vigilance and some began to see enemy aircraft even when they weren't there. As his eyes swept the view behind him in his rearview mirrors, one pilot momentarily reacted to a speck in the distance until he realized it was the rudder trim tab on the tail of his Spitfire.

Beginning in late 1944, the 7th Group began sending many of its sorties in pairs but they needed fighters, which were also needed elsewhere to protect growing bomber formations. When fighters were not available some missions either had to be scrubbed or if the cover was considered critical, flown with the extra risk.

Headquarters of both Eighth Air Force and 325th Reconnaissance Wing knew that changes had to be made to keep up the coverage needed for tactical and strategic demands. The mounting jet assaults reached a critical level just before Christmas with the ME262 attacks against Carlgren, Hall, and Matthews. The rate of loss neared unacceptable levels. Earlier in December, Headquarters, Eighth Air Force, set in motion a plan to equip the Group with its own P-51 Mustang fighters for es-

corts. Late in December orders came to the Group to send aircraft technicians from each combat squadron as well as the 381st Air Service Squadron on 30 December to fighter bases for seven days. Half of the enlisted men went to Station 122, home of the 355th Fighter Group at Steeple Morden. The remainder traveled to Station 356, Debden, and the 4th Fighter Group. There they would receive instruction in maintenance of the P-51s.

This new arrangement should establish better coordination between the photo pilots flying the missions and the escort. Both could be briefed at the same time for a thorough understanding of the assigned task. From the squadrons up through Headquarters, Eighth Air Force, this new development in photo reconnaissance was welcomed as a major advancement.

Pilots flying the new Mustangs came from the photo recon ranks. Already familiar with PR procedure, they needed training in fighter and escort tactics. On 2 January six pilots flew to Warton Base Air Depot, Lancashire, in the Group's B-26. They were checked out in P-51s and flew the first consignment of fighters back to Mount Farm.

The next day another six planes arrived followed by two more on 4 January. The Group now had 14 new escort fighters for its own use. The Eighth Air Force sent number 181 P-51 Mobile Training Unit to Mount Farm to help pilots and mechanics learn about Mustangs.

Many of the older pilots who had seen their share of FW-190s, ME-109s, and ME262s were eager to have the chance to shoot more than pictures. The Group sent 15 pilots on one week's detached service for P-51 gunnery practice. In order to train the new escort pilots in fighter tactics, Fighter Command sent four pilots on detached service to Mount Farm. They came from four different groups: Capt. D.M. Williams from the 20th Fighter Group, Kingscliffe; Capt. L.J. Dizette from the 355th Fighter Group, Steeple Morden; Lt. R.G. Goldsworth from 357th Fighter Group, Leiston; and Lt. E.L. Gimbel from the 4th Fighter Group, Debden. The inclusion of a 4th Group pilot was important. In October 1944, the RAF's first jet unit, equipped with Gloster Meteors, practiced with fighters of the 4th at Debden. By using its own jets, the British worked with RAF and USAAF fighter groups to develop combat tactics involving jet versus conventional aircraft.

The 22nd Squadron received four of the P-51s. Trained at Debden, TSgts Philip C. O'Donnell, Adolph J. Pesicka, Theodore H. Schoenbeck, and Sgt Ben H. Roberts took over maintenance of the Mustangs. In order to bring in armorers to prepare and service the guns, the Group had to change the Table of Organization for all the squadrons. Armorers Pvt Robert C. Dutcher, Cpl Joseph B. Moser, Cpl Taurina S. Macias, Pfc Andrew J. Cronlotac, Pvt George F. Eyerman, Pvt Martin Mayer, and Pvt Roy E. Hester arrived on 10 January to prepare the 22nd's fighters. The squadron added three more men, Sgt Joseph T. Kurylo, Cpl William D. Callan, and Pvt George J. Tappero over the next few days.

The significance of these new escort fighters was not lost on Lt. Irving Rawlings of the 14th Squadron. On the first day of the year, Operations assigned him to photograph the results of Eighth bomber strikes made against oil targets at Misburg on 31 December. The mission had to be canceled when the promised fighter

New additions to the 7th Group. Four P-51 Mustang fighters in formation. (E. Murdock)

escort could not accompany the PR plane. Rawlings looked forward to the day when his own squadron would be able to furnish cover on future sorties.

The addition of fighters to the inventory of the 7th Group precipitated changes in many of the units on base. The armament section of the 1787 Ordnance S&M Co. (Avn) would be responsible for Third Echelon (major) maintenance of the guns on the new P-51s. The company's commanding officer Capt. Edward J. Litvin sent four men to the RAF Armament Schools at Kirkham. Two men, SSgt Francis B. Doherty and Pfc George A. Simonds learned about the K-14 Computing Sight now being installed in P-51s. Based on the British Gyro Computing Sights, the American version, the K-14, was very accurate in deflection shooting.

To refresh their knowledge about the weapons themselves, T3 Ralph Mackowiak and Pfc Carl W. Cicetti attended P-51 Armament School at Kirkham. Fire power for the Mustang came from six .50 inch Caliber Browning machine guns mounted in the wings. The new fighter pilots would learn that their maximum effective range for penetration of the target would be 3500 feet. Rate of fire varied according to conditions but was about 750 rounds per minute.

The 27th Trains for P-51s

Stationed in France, the 27th had to transfer some men to receive training in flying and maintaining its expected assignment of Mustangs. Temporarily attached to the other squadrons until their return to France, Lts. Robert N. Florine and Ira J. Purdy joined the 13th Squadron. The 22nd took Lts. Walter B. Ward and Willie G. White. Six linemen also joined squadrons in England for their training in maintenance of the new P-51s. The 13th Squadron received TSgts Mark A. Bullock, Harold M. Green, and Edgar R. Garrett with TSgt Robert O. Niehus, SSgt Clifford F. Pavlowich, and Sgt Kurt H. Wegman going to the 22nd.

The need for escort was not lost on Lt. Richard Quiggins of the 22nd Squadron when he tried to complete a mission scheduled for New Year's Day and postponed until the 2nd. He and another pilot from his squadron, Lt. William R. Buck who was flying only his second mission, flew together as far as Giessen. Lieutenant Quiggins went after his targets, most of which were cloud covered. He found Eisenbach clear enough to attempt photos. Suddenly he spotted four agressive FW-190s in the distance and headed for home to avoid interception. Quiggins wished for a P-51's guns to give the Germans a surprise but his was an unarmed F-5. Flak bracketed Quiggins' F-5 over Altenkirchen. Neither the ship nor pilot suffered any damage and landed safely at Mount Farm.

Lieutenant Buck had better luck when he found neither fighters nor flak at his targets at the Fulda Marshaling Yards and the Kirch/Kons, Widna, and Ettinghausen Airfields but cloud prevented any photographs and he retured to base without incident.

Two other 22nd pilots had missions assigned to cover tactical targets. Bomber strikes were on Lt. Alf Carstens list but he had to cancel when his ship's compass went out before he took off. On only his second mission, F/O Michael Dembkowski had bomber strikes at Engers, Remagen, Koblenz, Irlich, and Andernach to cover. Fighters from the Eighth Fighter Command accompanied Dembkowski but they lost contact over Aachen and the PR pilot continued on alone. He found all his assigned targets covered by 10/10 cloud but flew on along the Rhine photographing Mainz, Bingen, Boppard, Weisbaden, and Bad Kreuznach.

On the third, 22nd Squadron pilots tried to cover tactical targets in the Cologne area. The tables were turned when Lieutenant Carstens took off successfully but Lt. John W. Brabham had compass trouble and had his mission canceled. Carstens found his targets cloud covered and brought back no photos but he had another strange type of flak near Cologne to report to Intelligence. He related how the flak trailed smoke just before bursting at the same altitude as his F-5. If such a thing existed, he thought the three bursts of flak looked like rocket flak.

Captain Dixon of the 14th and Lieutenants Facer and Riley of the 13th attempted sorties but none could find clear targets. They had escorts from the fighter groups but suffered no interception.

Bad weather prevented any missions on 4 January but two squadrons, the 14th and 22nd, scheduled nine sorties the next day. The most successful was flown by the 22nd's Lt. John Ross who started out with Lieutenant Brabham. The latter had to return to base when his F-5 developed engine trouble but Ross went on alone. He found most of his assigned targets cloud covered but determined to bring back some cover he ran strips over Duisburg, Osterfeld, and Dusseldorf. His photos were good enough to remove the Krefeld job from the 7th Group's program and eight British jobs from the RAF's program. This successful mission was the 23rd for Ross.

A far more eventful sortie occurred when Lt. D.R Sherman went to St. Nazaire on only his second mission. The request was for area cover to analyze defenses around the German-held Atlantic coast port. Notorious for its accurate and intense flak, St. Nazaire did not disappoint Lieutenant Sherman. He made three runs over the area without opposition. On the fourth, the batteries opened up with six shell bursts. On the fifth run flak hit

the wheel housing on his F-5. Sherman continued to make three more runs over the target and the batteries fired what the pilot estimated as 21 to 25 bursts that were not accurate. Only a lack of film made Sherman turn back toward England. Because he had spent almost an hour and a half over the St. Nazaire area Sherman put down at a English coastal base to refuel before returning to Mount Farm. His cover combined with previous photos completed 80 per cent of the job successfully.

DFCs

Captain Daniel Burrows, C.O. of the 22nd awarded three Distinguished Flying Crosses to members of his squadron on 7 January 1945. Two of the recipients were awarded their decorations in absentia. Capt. Donald A. Farley and Lt. Everett Thies had returned to the States earlier. He presented the third medal in person to Capt. Benton C. Grayson at the 97th General Hospital, where Grayson was recovering from injuries.

Gentille Killed

The next day, the 22nd Squadron lost another pilot when F/O Albert L. Gentille's aircraft developed engine trouble near the base while on a local flight. He radioed that he was bailing out. The F-5 crashed within a mile of the field. Emergency crew rushed to the scene and found Gentille near the wreckage with his chute unopened leading the investigators to conclude that as he bailed out he may have hit a part of the aircraft before he could pull the rip cord.

New 22nd C.O.

The 22nd Squadron had a multiple change of command in January 1945. Major Oscar G. Johnson, Assistant Group Operations Officer assumed command of the squadron on 11 January when Headquarters transferred Capt. Daniel W. Burrows to the 7th Group in preparation for his return to the States. While awaiting his papers he served as Assistant Group Operations Officer. On 21 January, Headquarters recalled Captain Troy McGuire from the 27th Squadron at A-83, Denain/Prouvy, France, to assume command of the 22nd Squadron.

First Escort

Anxious to put the new escort tactics for his 7th Group into action, the Group Commanding Officer Lt. Col. George Humbrecht took the first escorted mission out on 13 January. Flying four P-51 escorts were 22nd Squadron C.O. Maj. Oscar G. Johnson, Capt. Robert Moss of the 13th, and two of the fighter liaison pilots, Capts. D.M. Williams and L.J. Dizette. Humbrecht planned to cover tactical targets of troop concentrations, communication centers, and strong points in the area of the Western Front south of Koblenz. The Group C.O. covered four damage assessment jobs near the towns of Speicher, Lunebach, Bitburg, and Ehrang successfully enough for Intelligence to remove them from the program. Although the formation did not see any enemy fighters it did experience flak including a strange new type near Birresborne. Colonel Humbrecht and the escort pilots told Intelligence about strange small glass-like spheres floating about.

Third Air Division B-17s bombed the 1060 foot long cantilevered Dusseldorf-Neuss Autobahn Bridge over the Rhine River on 10 Jan 1945. Continued attacks brought down both the road bridge and the rail bridge. This photo taken later in the year shows a pontoon bridge built between the two.

January 1945

None of the planes suffered any damage. Major Johnson reported two rocket trails east of Trier. The Group's first escort mission went on the records as successful.

That same day, Lts. Max McKinnon and Donald Pipes of the 22nd Squadron covered targets in Germany. The bridges over the Rhine River at Cologne continued to be targets of the Eighth's bombers and in need of damage assessment by the 7th Group. Clouds covered some of the targets but McKinnon managed to photograph a few before sighting four unidentified single engine aircraft. He left the area to avoid interception.

Pipes also covered what bridges he could as well as the Cologne Marshaling Yards. Cover of one bridge and part of the marshaling yards was good enough to remove part of the job from the program.

Another 22nd Squadron pilot, Lt. Robert B. Gillick went out on his first sortie. Operations assigned him three airfields in the Brussels area for his maiden mission. Between Mount Farm and Brussels, clouds interfered with Gillick's visual navigation. By the time he reached what he supposed to be the target area, clouds and haze prevented any pin-point location but Gillick continued on. To the west lay water so he flew eastward looking for an opening in the clouds. Within a few minutes he crossed Belgium and found some openings over the Rhine near Cologne. Gillick turned his cameras on. He got good cover of parts of Cologne and Opladen. When he returned to Mount Farm, Intelligence found that his Cologne photos were good enough to remove the jobs from the program, but the other sorties of the day had already covered the same targets. Gillick did succeed in removing a railroad yard and shops portion of a British requirement at Opladen. Even though he never saw his targets at Brussels, Gillick completed a successful first operational mission.

Beautiful weather in almost all the target areas on 14 January resulted in 16 sorties, which covered 80 targets. Many were in the tactical area where Eighth Air Force bombers attacked targets in support of the Allied troops along the front. The day before, the Eighth had hit rail bridges over the Rhine at Rudesheim, Worms, Mainz, Germersheim, and Mannheim. They also attacked marshaling yards at Kaiserslautern and Bischofsheim. On the 14th the heavies added the three main Rhine highway bridges at Cologne to the target list as well as the Osnabruck Marshaling Yard. Combined with targets from previous raids obscured by cloud until now, the campaign against tactical targets required extra damage assessment cover by 7th Group. These demands crowded each sortie with high priority jobs.

The 22nd Squadron flew six sorties on the 14th, all considered successful. They covered targets along the Rhine and in the Cologne area. One pilot, Lt. Ellis Edwards, on his fourth mission went with Lt. Richard E. Brown who was flying his third. They covered their targets without interference but spotted two unidentified aircraft near Siegburg. The two pilots headed for Mount Farm. On the way, Lieutenant Edwards' plane developed engine trouble and he landed at Bradwell Bay.

Rodenkirchen Autobahn Bridge over Rhine at Cologne bombed by First Air Division B-17s on 14 Jan 1945 was destroyed after repeated attacks. In this photograph taken later, the 1834 foot three-span suspension bridge is under water.

Eyes of the Eighth

The Hohenzollern Road and Rail Bridge crossing the Rhine at Cologne under attack on 14 Jan 1945 by B-17s of the First Air Division. Although bombed frequently by both USAAF and RAF bombers, the bridge remained standing until blown by the retreating Germans.

Brown returned to base alone. At Bradwell Bay, technicians removed the film magazines from Edwards' F-5 and a courier took them to Mount Farm by auto. The Photo Lab processed the film, photo interpreters looked it over and Intelligence saw that Edwards' sortie had removed eight jobs from the program; all accomplished before the pilot returned the next day.

Two more 22nd pilots, each on his third operational sortie, covered Eighth bomber strikes against the Rhine bridges at Cologne. They started out with a planned escort of four P-51s from a fighter group. Two of the fighters failed to take off from their field and the remaining two aborted their mission while crossing the Channel. The two PR pilots, Lts. David F. Thomas and Denver R. Sherman continued on. They made a run together over the Cologne bridges before splitting up to cover other targets. Proceeding alone Thomas looked about ever on alert for enemy aircraft, especially now without the planned-for fighter cover. In the distance he noticed a smoky trail spiraling down and exploding in a ball of flame. Sherman. Could it be Sherman? He looked around but did not see the other F-5. He called on the radio but the receiver was silent. It must have been Sherman.

After completing his photo runs, Lieutenant Thomas returned to Mount Farm and reported his observations to Intelligence. Word that the 22nd might have lost another pilot spread through the squadron area. When more time passed without Sherman's return, everyone was sure the fireball had been his plane.

When Lieutenant Sherman split away from Thomas to cover different targets, he found good weather over several areas and photographed airfields at Giessen and Kirch/Kons. Then he photographed the Siegen Marshaling Yards, Siegburg, and Troisdorf. Satisfied that he had gotten as much cover as possible he turned back from Germany and headed for Mount Farm. When he landed, men ran out cheering and shouting. Sherman could not imagine why he was greeted with such an ovation until he heard about Thomas' fearful belief that he had been shot down. Neither pilot learned who had gone down but Headquarters, Eighth Air Force, reported heavy enemy action on the 14th which resulted in the loss of 11 fighter aircraft alone. The combined success of the two pilots removed nine jobs from the program.

Encouraged by the better weather on the 14th, the 7th Group was disappointed on the 15th and Operations succeeded in dispatching only four sorties. Two 13th Squadron pilots, Lts. William V. Malone and R.W. Riley successfully covered damage assessment targets at Sindelfingen outside Frankfurt, Echterdingen, Nalbach, and Kaiserslautern. The 14th Squadron hoped to get both Lts. James Tostevin and Irving Rawlings to targets in Germany but Rawlings ran off the runway at Kingscliffe where he landed to pick up some fighter cover.

Tostevin Lost

On 15 January, 14th Squadron Operations assigned Lt. James Tostevin targets in Berlin and Misburg. He left Mount Farm with a fighter escort and completed his photo runs. On his return he radioed that he was low on gas and would land on the Continent. His escort continued on to England and reported that when they last spoke to the PR pilot near Lille, France, he told them he was going down to look for a place to land and refuel. When Tostevin did not return to Mount Farm, his squadron assumed that he had stayed overnight in France. The squadron looked for him the next day but could not find any reported landing of a Spitfire from the 7th Group. The 14th added his name to its list of men missing in action and began the wait for more information from Eighth Air Force Headquarters.

Shoop Visits

The former commanding officer of the 7th Group, Col. Clarence Shoop dropped by Mount Farm on 16 January. He was on his way back to the States and took time off to visit the base and his friends still serving there. Shoop went to all the departments to see how everything was going and to tell the men good-bye. His good friend,

244

Major Chapman, who had returned from the States on 2 January with Colonel Roosevelt and Lt. Col. John Hoover, flew the colonel to Prestwick, Scotland, later in the day where ATC would take him across the Atlantic.

Crowded Air Space
Group Operations sent 14th Squadron C.O. Capt. Robert Dixon out on the only operational sortie flown 16 January. Bad weather over the Continent and fickle changing conditions at Mount Farm limited flying to a few local flights. The 13th Squadron Operations Officer Lt. Robert Facer was on a local flight with typical mixed weather conditions. Heavy cloud settled in around the area and forced Facer to fly with extremely limited visibility. At times he had to rely primarily on his instruments. For a moment the thick cloud lightened into gray streamers that rushed past the cockpit. Suddenly, he saw a C-47 dead ahead. Facer pulled back on the yoke and racked his F-5 up into a steep climb. His Lightning responded quickly and barely missed the slow-moving transport. The violent evasion sent the needles on the instrument panel spinning and swinging wildly. Most importantly, the maneuver tumbled the gyro.

It took a tremendous force to tumble an aircraft's gyroscope. The very reliable balanced instrument told the aircraft and its pilot which way was up. When the F-5's gyro tumbled out of balance, it no longer "knew" up from down and left Facer flying blind. His last maneuver had been up in a steep climb to avoid the C-47. Now without the gyro he flew blindly through the clouds until he broke out into clear air. He was 1,000 feet above the ground and headed straight for it. Facer pulled back on the yoke and dropped the flaps to bring his plane on a fairly level course just above some woods. The F-5 lost airspeed and mushed into the trees, bouncing along the tops. The pilot pushed both engines to full throttle. Skipping and bouncing across the treetops until gaining enough air speed to clear the woods, Facer climbed away from disaster and returned to Mount Farm. After making an uneventful landing, he told everyone, in an understatement more British than American that it was, "One of the closest calls I've had."

The weather that almost conquered Bob Facer closed Mount Farm before the only operational sortie of the day could return. Captain Dixon had flown into Germany to cover targets at Hanover, Magdeburg, and Berlin. After runs over Hanover, Ehmen, Magdeburg, and a target east of Berlin, he found his other assignments covered by cloud. Seeing extremely bad weather ahead of him on his return trip, he radioed for instructions and was diverted to a strip near Mereville, France. He would stay there until weather cleared enough to return to England.

Usually, a pilot found a spare bunk at the airfield and considered himself lucky to have a place to lay down his head. Dixon found much better accommodations when the town mayor took him to his home for the evening. His host, a former French Army captain and local leader of the FFI, insisted that the captain join him in a few beers before dinner. The camaraderie between the two veterans increased through the evening as they moved on to a few bottles of Champagne. After dinner they shared their war experiences over Cognac before the mayor insisted the captain spend the night. Ending a long and busy day, the 14th Squadron's C.O. settled down into a warm, soft featherbed.

The next day the weather prevented operational flying from Mount Farm but was good enough to allow Dixon to return. When he landed and briefed Intelligence about the sortie, he regaled everyone about his overnight stay in France. Of all the extras offered, the Cognac, Champagne, beer, hospitality, and good fellowship, the thing he appreciated the most was the feather bed.

A Visit From Top Brass
In January, during Col. Elliot Roosevelt's temporary absence, the 325th Wing had a different commanding officer, Brig. Gen. Charles F. Banfill. He took over on 17 January and inspected the 7th Group on the 19th. During his visit to Mount Farm he learned from the various departments not only how the 7th Group operated but also the variety of its assignments. Roosevelt resumed command of the wing on 22 January 1945.

On the left, Group Intelligence Officer Maj Lanham listens as his Group CO Col Humbrecht, on the far right, tells Gen Banfill and Col Roosevelt about the operation of the photo group.

Eyes of the Eighth

**13th
Photographic Reconnaissance
Squadron**

**14th
Photographic Reconnaissance
Squadron**

**27th
Photographic Reconnaissance
Squadron**

**22nd
Photographic Reconnaissance
Squadron**

246

January 1945

Limited Operations

The worst winter in 50 years enveloped England and the Continent in fog, mist, snowstorms, and blizzards. On some days there was little air activity anywhere. Poor visibility restricted photo reconnaissance more than any other air operations keeping 7th Group planes grounded both at Mount Farm and Denain/Prouvy, France. The squadron in England most effected was the 14th. Assigned much of the deep cover into Germany, fighter interference and weather prevented continuing operations. Captain Dixon's sortie on the 16th turned out to be the last mission flown by the squadron in January. The most active squadron, the 13th had most of the tactical targets in its area and attempted cover if weather charts showed any signs of openings. Targets along the Rhine dominated the assignments of the 22nd Squadron, which also added cover of the German-held French Atlantic ports to its schedule.

Group Operations managed only three sorties on 20 January. The 22nd Squadron's Lt. Byron Waldram, flying alone, followed Eighth Air Force 1AD and 3AD B-17s to cover their strikes on the Sterkrade/Holsten synthetic oil refinery just north of Duisberg. Clouds prevented Waldram from photographing the strikes, which the bombers made with the assistance of the blind bombing aid H2X. Waldram found breaks in the cloud cover over Holland and successfully covered Nijmegan and an area between Antwerp and the Rhine River. Also in the Rhine area, Lieutenants Facer and Wigton of the 13th successfully covered a few damage assessment targets including the Hohenzollern and Rodenkirchen road and rail bridges at Cologne.

The next day, the 13th sent Lieutenants Parker, Madden, Hitt, and Hakkila to targets in the western part of Germany and the French Atlantic coast at St. Nazaire and Lorient. All four pilots returned safely with limited cover of their targets.

Eighth Air Force Headquarters tried a new tactic on 21 January to increase photo cover of its strikes. The heavy losses and mounting load of assignments requested of RAF and USAAF photo reconnaissance units during restrictive weather increased high level talks aimed at alleviating the situation. There were several schools of thought. One idea on the table considered arming photo reconnaissance aircraft. Another had been ordered but was, as yet, in its early stages — armed escorts assigned to individual photo squadrons. Tactical photo recon was in effect by the Ninth Air Force's 10th Photo Group but did not cover strategic targets and mapping. The most immediate concern was quick assessment of bombing strikes. Headquarters ordered a few P-51s fitted with K-25 cameras behind the pilot's seat for oblique photos. On the 21st, Capt. Noble Peterson led three camera-equipped Mustangs of the 355th Fighter Group's 358th Squadron and three escort fighters near the Baltic coast to cover the Politz oil refinery. In spite of intense flak and interception by ME262s, the latter dealt with by the armed aircraft, the experiment resulted in photographs

Vital marshaling yard and rail junction at Ehrang, Germany, behind the Ardennes front lines. Newly fallen snow softens bomb craters from repeated bombing to cut Germany's supplies to the front. (J. Byers)

Eyes of the Eighth

good enough to prevent an unnecessary bomber strike on the heavily defended target. This addition to intelligence gathering in support of Eighth Air Force operations added another dimension to the discussions on armed photo reconnaissance aircraft.

When 7th Group aircraft could find openings in the winter cloud and overcast they found a landscape covered in snow. Above the clouds their flight might be in the low sun of a northern winter but as soon as they dropped down through the cloud layers, a grayness blurred edges and details on the snow blanketed scene. A break in the clouds or a rare sunny day revealed a panorama of hills and valleys, towns and villages softened by gleaming whiteness. In the tactical area of the Battle of the Bulge, the snowy land was pitted with shell and bomb craters. New damage lay in gray and black smudges but fresh snow and ice softened old battle signs. Behind the lines, rail and road junctions showed tremendous damage, its age revealed by the difference in white, gray, or black. The high altitude photo pilot always flew in frigid conditions but his pictures now revealed the bitter conditions of the foot soldier below.

After five days of inactivity, the 22nd Squadron sent three aircraft up on 26 January. Lieutenants Carstens and Dembkowski covered the St. Nazaire and Lorient areas. The gun battery on Coubre Point at the mouth of the Gironde River was Lieutenant Brabham's target. Intelligence needed cover to assess activity at this important German defense on the French Atlantic coast. Brabham's sortie produced good enough photographs to satisfy the request.

Bombers of 1AD and 3AD struck targets in Germany on 28 January, including bridges at Cologne, the Hohenbudberg Marshaling Yards, and Duisburg. Assigned to cover the attacks, Lt. John Ross of the 22nd Squadron flew alone and covered his targets as well as damage assessment of the Dortmund Coking Plant. Finding enough clear weather in the area he also covered the Sterkrade Oil Plant and Wanne/Eichel Marshaling Yards to successfully complete his 24th combat mission. Intelligence found that the Sterkrade cover was enough to remove that job from the Group's program.

Winter cloud interfered with the last January sorties flown by the 7th Group on the 28th. Lieutenants Weir and Hall of the 22nd managed a few pictures near Cologne but cloud covered all their assigned targets as it had so many of the others during the month. In spite of this, the squadron flew more sorties than any other squadron. The number of missions dispatched from Mount Farm by the three squadrons was 103, more than in December but a restricted program nevertheless.

▶ **Opposite Page: Center photo taken by Capt John Ross as he swept by the spires of Cologne Cathedral prompted an Intelligence Officer to scrawl across the back, "Hey Ross you are out of focus at less than 50' let's get closer next time. Hickey"**

(J. Ross)

Long winter shadows over the snow at the important rail and road junction town of Bitburg. Freshly fallen snow masks most of the damage but dark rectangles reveal roofless buildings. (J. Byers)

249

During January, the 7th Group Operations Officer Maj. Carl Chapman took over temporary command during the absence of Lt. Col. George Humbrecht between the 19th and 28th of the month. The smooth operation of the squadrons continued although restricted by poor weather. Clerks and staff in Headquarters wrote up daily reports and the special orders sending men to training as fighter pilots, or gun sight technicians to support the new escort missions. Signed by Group Adjutant Capt. John Rees, the orders for that period carried Major Chapman as C.O. of the Group. The usual flow of men into the 7th increased on 25 January with the addition of a special group of officers and enlisted men from another unit of the 325th Wing.

Increased Courier Service
The 381st Air Service Squadron opened a new Operations Office in January. From the small courier service used mainly to transport film to forward bases, the 325th Wing developed a much larger operation to transport all authorized personnel and freight to and from the Continent. Originally, pilots from combat squadrons flew the 381st's transports crewed with the service squadron's engineers on the courier runs. To operate a much more extensive courier service, Wing assigned six pilots, three navigators, and three radio operators from Watton to the 7th Group to be attached to the 381st Air Service Squadron. The crews had been flying meteorological missions with the 25th Bomb Group scouting and reporting weather conditions in the Atlantic and over the Continent. The combined operation of the older service along with the newly activated and enlarged section accounted for 25 courier trips to the Continent in January. It ferried 89 passengers and 49,000 lbs. of freight.

A Desperate Fight in the Ardennes
When 1945 began, German forces continued on the offensive around Bastogne in the Ardennes. Patton's forces had battled snow and Germans in their push through from Arlon in the south to relieve the encircled 101st Airborne. Fierce resistance by American forces at vital bridges, road junctions, and passes delayed the swift advance by the Panzers. The Airborne's stubborn stand at Bastogne disrupted Hitler's plan for a lightning strike to the Meuse River. Patton's armored units reached Bastogne on 26 December. They brought reinforcements and supplies through the narrow corridor described as only wide enough to spit across. Without delay these Third Army units helped turn back German attacks and went on the offensive to enlarge the gouge they had made in the German flank. North of the Bulge, for command simplifications in the emergency, Eisenhower had placed American forces temporarily under Field Marshal Montgomery's overall command in December. He patiently waited while Montgomery made his usual meticulous but cautious plans for attack. Patton's aggressive and extraordinary thrust northward offered an opportunity to encircle and trap thousands of German men and equipment by a corresponding assault from the north.

In spite of a smaller offensive by Hitler in Alsace on 1 January, the main American attacks remained against the snow-covered Bulge battlefield. On the northern flank of the Bulge, Montgomery finally ordered Lt. Gen. Courtney Hodges' U.S. First Army, temporarily under his command, to attack southward on 3 January. Exasperated by the delay but thankful for the attack Eisenhower declared, "Praise God from whom all blessings flow."

The battle to recover territory lost in late December raged through the first weeks of January 1945. Icy roads made hazardous going for armor and transport. Infantry struggled to advance through snowstorms and blizzards, bitter cold, and waist-deep drifts. Artillery from both sides pounded day and night filling the air with muzzle flashes, lightning-like brilliance flashed in the night reflected in the ever-present clouds, fog, and mists. Wailing banshee shrieks of the Germans' rocket launcher, the *Nebelwerfer*, jangled nerves and confirmed the nickname "Screamin' Meemies." Added to the explosions and heavy *crump* of regular artillery, the noise of battle took its toll on the troops. Both Germans and Americans took heavy losses.

Infantry Recruits
SHAEF Headquarters sent out a call to reinforce the Ardennes front with men from every area. Infantry divisions were short of replacements. Attrition in the Battle of the Bulge created a critical need for ground and support soldiers from already strained resources. The Army combed rear units for men suitable to serve at the front. Clerks and cooks, barbers and bakers, anyone who could carry a rifle was plucked from rear area troops and sent to reinforcement training units. Many men eager to serve with front line soldiers volunteered to transfer but they could not make up the need for thousands. To spread the load as evenly as possible SHAEF set quotas based on non-essential personnel available from individual units. The air forces had to supply their share. Volunteers could supplement men chosen to fill those quotas.

At the end of the January, 43 men from the 7th Group's units went to fill the gap when they were ordered to the 12th Reinforcement Depot, Reinforcement Command, European Theater of Operations. Quite a few were eager to get into action unconvinced that they were

contributing to the war effort in a photo recon outfit. The very much underrated and misunderstood role of the photo reconnaissance operation wasn't their idea of fighting. Whether they wanted to slog it out on the front in snow and slush was another matter but they all were soldiers.

January 1945 and the 27th Squadron at Denain/Prouvy

The winter in France was bitter cold and wet. When the Germans launched their counterattack through the Ardennes the airfield became a front line field with its attendant perils. With the 27th's move to the Continent, the squadron was sure to fly more sorties than ever, being much closer to the target areas than the Mount Farm squadrons. Circumstances in January proved that a false hope. Weather and increased enemy fighter activity kept the 27th's planes on the ground most of the month. It became clear that until the squadron received its own P-51s to fly escort, it would have to curtail operations. In order to be prepared for this new type of flying, Lieutenants Purdy, White, Ward, and Florine went back to Mount farm on 3 January for fighter training.

The field remained a refuge for damaged aircraft returning from bombing raids. On 13 January, a crippled 91BG B-17 crash-landed at Denain/Prouvy, unable to make the return flight all the way to its base at Bassingbourn. Several members of the crew had been on the B-17 that had crash-landed at the field on 26 November 1944. They remembered seeing someone from the 27th Squadron's Camera Repair unit taking pictures that day. Now they had a chance to look for him to see if he had pictures of the wrecked Fortress.

In order to protect evidence and the wreckage itself, the air force assigned a military guard for any aircraft that crashed or was forced down on Allied-held territory. Such locations on or near Denain/Prouvy came under the jurisdiction of the 27th Squadron, which furnished armed men for the duty. One guard, Ottaw E. Fulton, had the misfortune to be on duty during one of the snowstorms that swept the area in January. Fulton remained on guard alone for 18 hours, stranded at his post guarding a wrecked B-17, until relieved.

Bitter cold weather with snow, sleet, and freezing fog made everything difficult, especially courier runs. Whether they delivered photos to forward bases at the front or made daily trips to Mons for weather information, these runs posed heavy risks for the drivers. Edward W. Bock of the motor pool made courier runs during the Battle of the Bulge risking attack by Germans along the fluid and confused battlelines. In December two 27th couriers had a scary moment on the road to Luxembourg.

Weather information still came from Mons, collected

Ed Murdock, Al Hanson, and Ike Davis of the 27th Sq during the snowy, cold winter in France. (E. Murdock)

in person by daily drives to and from the Belgian city. Increasingly poor weather for flying rolled across the base and target areas for 27th Squadron assignments. Under these conditions, Lt. Tony Pircio, the 18th Weather Squadron's representative to the 27th, needed immediate and constant weather updates. Denain/Prouvy had to establish teletype lines as soon as possible. This would offer up-to-date weather forecasts and better general communications with both Continental commands and those in England.

From the squadron's first days at Denain/Prouvy, Communications Officer Lt. Frank Heidelbach worked to solve the many problems facing an isolated photo recon outfit on the Continent. Due to the its unusual situation, a single squadron separated from its parent group and not attached directly to a larger working unit, the 27th was truly isolated. Other than the miles of telephone lines strung to join the airfield at Denain/Prouvy with the squadron headquarters in Valenciennes, all communication had to be made overland by motor transport. Transport aircraft brought in supplies from Mount Farm when weather permitted but this was a tenuous connection at best.

Eyes of the Eighth

At Mount Farm Lieutenant Heidelbach also served as Group Cryptographic Officer and ran the teleprinter room. With all four squadron's pooling their men in most offices, the 27th's move to France left holes in various departments. The cryptographic duty went to a new officer at Mount Farm, Lt. Charles H. Dengrove of the 22nd and Cpl F. Smith filled Sgt Martin H. Comen's job as the group's communication clerk.

The 7th Group intended to maintain radio communications with the 27th by radio. A SCR-399 radio truck would furnish the necessary means. Unfortunately, the whole unit could not be sent over in one piece and in spite of careful disassembly, packing, and transport by air, the reconstructed radio equipment never worked satisfactorily. Partly due to faulty internal parts, the radio continued to confound the best technicians. Burned out tubes, shorted-out coaxial cable in the antenna, all glitches found and solved one by one failed to obtain an operating unit. Finally, the men found a defective tube socket. Replacing this just might get the radio in operation but there was no replacement available. With no local supply source the socket had to be carved by hand.

Each problem solved revealed another. The lack of a supply source frustrated solutions even in the simplest of situations. Before electrical equipment could be used it had to be properly grounded. Insufficient grounding caused too much loss of output. When this was discovered, the men ran ground leads to a central waterpipe plus two other ground points. They drove stakes with farming wires attached into the ground then connected these grounds not only to the normal ground leads from the transmitter but also to two other points on the truck chassis. The antennas had been erected. Now all that was needed was a connection from the truck to the base of the antennas. Under normal circumstances the radiomen would pick up the right kind and length of coaxial wire at Group Supply and make the connection. Tech Sergeant Norman A. Sommers couldn't do that. He had several short lengths when he needed long ones. Carefully he worked at the tedious job and created his own spliced cable long enough to connect the antennas to the radio truck.

In addition to Heidelbach and Sommers, SSgts Anthony A. Waraske and James Galloway worked for a week, sometimes 15 hours a day, to set up and get the radio operating. While the technicians worked on the equipment, SSgt Casimir S. Kostrzewski trained several radio mechanics in operating procedure in anticipation of the day when radio contact began with Mount Farm. His men were ready and began operations when all the wiring problems succumbed to Lieutenant Heidelbach's attention and the station opened. Three days later orders came from higher headquarters not to use the radio. The 27th had lost its assigned frequency and was again without direct radio contact with Mount Farm.

With radio communications again in limbo, Heidelbach continued his efforts to get teletype facilities and lines to service the 27th. Coordinating his efforts with the French was difficult enough but Heidelbach was frustrated by not knowing with whom the 27th needed to establish communications. He consulted with VIII Service Command, the outfit running operations at Denain/Prouvy when the 27th arrived but they had left the field to the PR squadron. After dealings with Headquarters of both the Eighth and Ninth Air Forces, USSTAF, and the RAF through the 72nd Signals Wing, he found help at VIII Fighter Command Headquarters in Charleroi, Belgium. The communications department established telephone and teletype lines to that base through which the 27th could contact the 7th Group at Mount Farm as well as all the other commands on the Continent.

Heidelbach, promoted to captain on the first of January, finally saw his efforts bear fruit when the 27th Squadron's own teletype channels began operating on 9 January 1945. The achievement was all the more valorous considering that the base at Denain/Prouvy could not count on continuous commercial electric power from local sources. In fact, most of the time the squadron depended on its own power units, which required constant and expert service. The man responsible for the job, Sgt Howard Devault, helped other sections on the base when needed and serviced every power unit in the squadron including the radio trucks.

Legacy

Constant reliable power had to be sufficient for the VHF/DF station added to the squadron in early January. The 27th needed a directional station at A-83 for efficient and safe operations. At Mount Farm, Group Communications Officer Capt. Dennis V. Neill requisitioned the equipment and sent it to France with technicians Sgts Tevis G. Burns and Willard W. Black; Cpls Julius P. Hibo, Walter B. Madrela, and Julian P. Williams. Captain Heidelbach added SSgts Wareske and Joseph A. Cadorette to the team that would set up and operate the equipment. Three other men from 27th Squadron Communications filled out the new section, Sgts Gerard F. Donovan and Oakley C. Curtis; and Cpl Sandy Jones. Within a few days they completed the job and A-83's VHF/DF began operations under the call-sign *Legacy*.

Without a supply base on the Continent, the 27th Squadron struggled to maintain its aircraft, camera and photo

January 1945

Parsons' Travels

Ed Parsons left Chartres on the next leg of his trek the first week of August. Parsons and the other pilot prisoners traveled to Paris in a truck powered by charcoal burned in a strange barrel contraption mounted on top. On big hills, the sweating prisoners had to get out and push. At the railway station in Paris, the guards kept the original 19 officers in a small room for two days and nights. New captives arrived until they gathered over 40 men. In the station, Parsons had the audacity to bum a cigarette off a passing SS officer only after Parsons allayed his suspicion that he was not a *Jabo*. Other pilots asked for cigarettes, each swearing he also was not a dreaded *Jaegerbomber*. The pilots figured out that fighter-bombers must be attacking the Germans, causing heavy casualties. It was a thought each quietly celebrated.

Fleeing Vichy French Nazi sympathizers and collaborators jammed the Frankfurt train, a sign that the Allies must be sweeping toward Paris. An hour out of Frankfurt, one guard warned the prisoners that a similar group had made the mistake of crowing over destruction at the rail station and nearby apartments still burning after a recent bombing. On the opposite platform over a thousand German civilians awaited evacuation by train. Incensed, they charged across the tracks, dragged the prisoners out into the streets and hanged them from lampposts. The guard said that they were few and would not fire on any mob of other Germans. The POWs took the hint and without expression looked straight ahead as they walked to the tram that took them to their next stop.

Parsons spent one day at the Interrogation Center — his birthday, August 6th. He was 22. Refusing to answer any questions from his interrogator, Parsons was returned to the little cell with the painted-over window where he waited alone for what came next. What came was a guard who took the surprised pilot by train to Stalag Luft III at Sagan, about 65 miles southeast of Berlin in Lower Silesia. Lieutenant Parsons had reached his POW camp.

Sagan, as it was known, had been a small prison camp for RAF aircrew. The first USAAF airman to arrive at Stalag Luft III was a tall thin redheaded lieutenant colonel from the 31st Fighter Group. Albert P. Clark's Spitfire had been shot down on 26 July 1942. He became the first Senior American Officer (SAO). As the air war increased in intensity, other higher ranking officers arrived to take that designation.

More and more downed airmen filled up the available space in the two existing compounds. The Luftwaffe added another. When the Germans finished the large new North Compound, they transferred most of the British, Commonwealth, and some American prisoners there. As Americans arrived in greater numbers, the Germans separated the nationalities. There was no room with the Americans when Parsons arrived and they placed him and about a dozen others in the mainly British North Compound.

As soon as the well-established security committee vetted him he learned more about his companions. Some had been prisoners for years having been shot down early in the war. Many came from Stalag Luft I at Barth up on the northern coast where they became experienced tunnel diggers even in sandy, wet soil. Here at Sagan they had much better ground to tunnel through. An official prisoner escape committee continually planned escapes and dug tunnels that extended under the wire. From these the prisoners might reach the nearby forest. Earlier, on the night of 24 March 1944, 200 prisoners waited to escape from *Harry*. Only 80 men got through the tunnel before the Germans discovered the attempt. Of those, 76 escaped the camp area. Only three made it to England. Of the remaining men captured by the Germans, none returned to Sagan alive. On 6 April, the camp commandant announced that the Gestapo had shot 50 re-captured prisoners.

This announcement stunned the POWs who nevertheless continued to dig other tunnels from the North Compound. Not long after learning the fate of their comrades, in June 1944 senior men of the escape committee began *George* from under the compound's large prisoner-built theater. Properly vetted and considered reliable, the newly arrived Lieutenant Parsons joined the amateur theater company. One of the jobs assigned trusted POWs was that of lookout or "stooge." These men kept track of every German in the compound particularly the "ferrets" (Anti-escape personnel). New prisoners not included in such secret activities were told that they must not pay any attention to anything odd or unusual going on in the compound.

With the digging of *George* underway beneath the theater, any German "ferret" or "goon" (guard) inside the wire had someone with him or watching at all times. One day, the "stooge" supposed to knock on the theater door to announce a "ferret's" arrival missed the signal. Parsons engaged the German in conversation about George Bernard Shaw's plays while *George's* excavation continued below. Undiscovered, the tunnel lost its importance that winter when, as the Germans described it, "the Bolshevik hordes from the steppes of Asia crossed into the sacred soil of the Fatherland." By late January, Russian guns thundered less than 40 miles away.

Eyes of the Eighth

Veteran Spitfire Mark IX MB950 of the 14th Sq in the original RAF photo recon color known as PRU Blue. The aircraft number is in small letters on the fuselage in front of the tail assembly. MB950 was returned to the RAF in March 1945.
(R. Astrella)

Spitfire Mark IX PA842 of the 14th Sq taking off from Mount Farm is in bare metal finish. Colors were standardized in early 1945 identifying 7th Group aircraft with a broad red stripe on cowling and dark blue spinners. The green rudder indicates a 14th Sq aircraft. PA842 now in larger yellow letters on tail.
(R. Astrella)

January 1945

Unpainted F-5E 44-24225 with dark blue spinner and red stripe of the Group. The last three aircraft numbers are in black under the stripe on the cowling. The white rudder identifies a 22nd Sq plane, which is being loaded with a K-17 camera. (R. Astrella)

Mid-summer 1944 photo of a new F-5E 43-28333 in PRU Blue with red spinners of the 13th Sq. Spinner colors identifying squadrons were placed on rudder from late 1944 and replaced by dark blue spinners of Group. This F-5 has original invasion stripes for D-day invasion of Europe. (R. Astrella)

Eyes of the Eighth

C-47B 43-48871 of 381st Air Service Sq. Part of the supply life-line for 27th Sq in France. (J. Riggins)

departments, communications equipment, transportation, and base maintenance. Almost everything needed by the squadron had to be shipped by air from Mount Farm. Improvisation and the manufacture of certain parts helped keep the squadron operating but not every necessity could be replaced or rebuilt. Weather that grounded operational aircraft also grounded the transports with their valuable cargo. The flight from Mount Farm with rations for the base was impossible when everything was shut down. Only the most vital parts and provisions made it into the limited cargo space on the transports that did take off. Scheduled for weekly re-supply by courier plane, the PX had to close during the worst winter weather. After a three week hiatus without the little extras, the men swarmed in to load up on cigarettes and candy when a courier flight brought Sgt Richard Mack enough supplies to reopen.

Good news from the near-by front cheered the men. Elements of Patton's Third and Hodges' U.S. First Army closed their pincer move at Houffalize. Slowed by weather and fierce German resistance the number of captured enemy was less than wanted. Hitler, in response to Stalin's 12 January major offensive on the Eastern Front, began pulling out the Sixth Panzer Army to reinforce his troops in Russia. The immediate effect was a faster pull-out of all German forces toward the defenses of the West Wall. Eisenhower removed the no longer isolated First Army from Montgomery's command and rejoined it to Gen. Omar Bradley's 12th Army Group. Patton feared the escape of the remaining enemy forces and sent forces across the icy Sauer River in assault boats under falling snow. This attack against the base of the remaining bulge accelerated the Germans' withdrawal but they fought fiercely for every scrap of ground.

Even after the army stopped the ominous advance by the German Panzers in the Ardennes the dangers of a forward base remained. Denain/Prouvy had been a very active enemy airfield. The Germans had not abandoned it without leaving a little something behind. An explosion reminded the men of hidden dangers when four FFI men were killed by a German booby trap just across from the airfield.

Under Arctic conditions, mechanics on the line kept the squadron's F-5s ready for any let-up in the weather. Through optimistic word from weather forecasting sources, Lieutenant Pircio informed Operations that there was a small possibility of breaks in cloud cover on 19 January. Requests from the Eighth and Ninth Air Forces, Wing, and 12th Army Group for damage assessment and photo intelligence remained on the squadron's program. In an attempt to cover targets in the Euskirchen-Cologne area, Lt. R.W. Harmon and F/O John Ricetti took off and flew toward the Rhine River. They found clouds that covered the area between the great river and the Ardennes. Below the cloud cover a blizzard raged in the Eifel Mountain region. The hoped-for openings over their target area were not there. At 29,500 feet over Mullenbeck, five FW-190s intercepted the two F-5s. Lieutenant Harmon climbed away to evade. Ricetti pushed the yoke forward and dove steeply away from the German fighters. Both pilots lost the pursuers and returned to Denain/Prouvy safely.

Two days later, the 27th Squadron received a package from Maj. Gen. Lawton Collins VIII Corps Headquarters. It contained Lt. Jeryl D. Crowell's dog tags and an identification plate from his F-5. When soldiers from Collins' command pushed south into the northern shoulder of the Bulge toward the Ourthe River they found the snow-covered wreckage just east of the village of Somme Leuze, Belgium. Crowell had died when his aircraft crashed and burned on 24 December 1944 at about 1730 hours according to the local people.

Another opportunity for sorties out of A-83 came on 22 January when weather cleared in the battle area. The Ninth Air Force and VIII Fighter Command sent aircraft after retreating enemy forces trying to cross the Our River. Narrow roads and limited bridges across the winding river concentrated enemy transport and armor into an enticing target area. Like a swarm of angry hornets, Allied fighter-bombers, the dreaded *Jabos* attacked.

One of the Eighth's fighters' targets was the hard-fought-over road junction town of St. Vith. Operations assigned Capt. Hector Gonzalez cover of St. Vith, Prum, Frankfurt, Hanau, and Mannheim. Increased air activity brought out more Luftwaffe fighters. Over Daun, just east of Prum, three enemy fighters intercepted Gonzalez and forced him to return without photos. On the only other 27th sortie that day, one engine of Lt. J.W. Saxton's F-5 began running roughly before he reached his target. Unable to continue his mission he

256

January 1945

returned to Denain/Prouvy without photos.

By the end of January, most of the territory lost in the German counteroffensive of 16 December had been regained. Again, American forces stood along the Our River poised to attack into Germany. Heavy losses on both sides required replacements. Among the men making up Headquarter's infantry replacement quota were two important Communications men from the 27th Squadron who were accepted for officer's training. Both Sgts John U. Nattkemper and Oakley C. Curtis would be hard to replace. Nattkemper had been in charge of all teletype machines on base. Curtis was a VHF/DF operator. The Group transferred Cpl Jay C. Fresh to the squadron for duty in the teletype office. To replace Curtis, it sent VHF/DF operator Sgt Sidney Stutman on detached service to the 27th.

The squadron ended a frustrating and disappointing January with only two more sorties. On 29 January, the squadron C.O. Maj. Hubert Childress and Lt. Howell R. Hanson, Jr. tried to cover damage assessment targets in the Koblenz-Frankfurt area. They found openings between Frankfurt and Bad Kreuznach but cloud obscured the remaining targets. Both pilots returned safely to Denain/Prouvy with partial cover of the assignment. Childress knew that better weather and the new fighter escorts would improve the squadron's operational record in the coming months. It galled him that the 27th had been able to fly only six sorties in January.

Mount Farm and the Poet
The first month of 1945 ended with promise. The fierce fighting in the Ardennes had brought the ground forces near the borders of Germany. The Group's 27th Squadron now had communications established between the Continent and England. Fighters continued to arrive at the base swelling the number of escort aircraft to over 30. During the month not all events were combat related. Parties for officers and enlisted men cheered everyone in spite of winter gloom. An illustrious area resident once quite angry at the audacity and bad manners of his new American neighbors visited the base to read from his works. John Masefield, Poet Laurette of England, came to the Aero Club on 15 January. The club director Miss Lida Brown and the Group's Executive Officer Lt. Col. Edward O. Gwynn introduced Mr. Masefield who read from his poem *The Fox*. Set in the local area, many of the references were familiar to the men. Masefield entertained his listeners with added comments and personal remarks about the locale.

18th Weather Squadron
Cruel and miserable for fighting men on the ground, bad weather was the most limiting factor for airmen. Through its influence on air warfare bad weather affected modern ground battles by removing an intelligence element army commanders had come to rely on — eyes in the sky. Just before Christmas, General George Patton, a man known to believe in the value of prayer, expressed his frustration during the bitter weather slowing his march to relieve the 101st Airborne at Bastogne. He offered a prayer for better weather, "Sir, this is Patton talking. The last fourteen days have been straight hell. Rain, snow, more rain, more snow..." The general's prayer continued, "Sir, I have never been an unreasonable man, I am not going to ask you for the impossible. I do not even insist upon a miracle... Give me four clear days so that my planes can fly..."

The fog and mists that Hitler had used for his counteroffensive succumbed to a "Russian High" that swept clear cold weather into the Ardennes on the 24th. Christmas day dawned clear and cold. The good flying weather lasted until 27 December. Forecasters had seen signs of the change in the east and although they were not always right, they had an excellent record under trying circumstances.

When the Eighth Air Force first came to England, the RAF meteorological service furnished weather forecasts and information to the Americans. After the 13th Squadron's arrival at Mount Farm, it used the facilities of the British Met Service through its satellite of the main RAF PRU field at Benson.

A hydrogen balloon is released and timed to obtain wind velocity.
(J. Bognar)

257

Eyes of the Eighth

In Washington, the USAAF activated the 18th Weather Squadron at Bolling Air Force Base to serve its needs in the European Theater of Operations. Detachments of the 18th would operate from all active airbases in England. On 8 March 1943 TSgt Howard Chestnut, forecaster and Station Chief, brought a detachment to Mount Farm. Known as 18th Weather Squadron, Detachment 234, the unit had two weather observers, Cpl John Ghiardi and Pvt Paul L Bredeman. Chestnut received more help when two more forecasters, SSgts Kenneth H. Dieter and James J. Dunn, arrived on 27 April. To carry the heavier work load as the 13th Squadron began operations, four more observers Sgts Robert P. Deune and Paul B. Dubrueil, Jr.; Cpls Richard V. Thayer and Manuel D. Young joined the small group.

The RAF loaned Sergeant Chestnut one of its Met Officers, Pilot Officer George Cowling, to instruct the new American personnel in the British codes, plotting methods and any other different procedures they might encounter. At the end of April, Lt. Arthur J. Breslin reported as Weather Officer but left on 1 July to be replaced by Lt. Alexander J. Lapis, Jr.

When new squadrons arrived at Mount Farm, their staff weather officers joined the work rotation of the round-the-clock schedule of the weather station. The 14th Squadron's Lt. William Parchman, Jr. was soon joined by Lt. Lawrence J. Exner of the 22nd. In October, Lt. James M. Conners took on the assignment as Assistant Weather Officer. Shortly thereafter, the arrival of the last combat squadron, the 27th, added Lt. Nathan S. Waldrop to the roster. Additional observers and forecasters supplemented the small force as operations increased. In April 1944 Lieutenants Exner, Parchman, and Waldrop transferred to the 18th Weather Squadron.

The first weather office squeezed into a one-room addition to the Control Tower with a small office and teleprinter room attached. Late in 1943, it took over the ground floor of the tower to use as the office of Forecasting and Restricted Operations. This left the original room for an observers' workroom and a space where weather officers could meet with pilots. Cooperation between pilots and the weather office went both ways. The weather officer advised pilots what to expect and returning pilots gave them valuable observations from areas recently flown over.

Originally a satellite field of RAF Benson, Mount Farm had direct teleprinter lines to the British Teleprinter System by relay through the RAF's PRU weather station. The squadron added two American teleprinter machines in early 1944 connecting to the American Met System. Even though the unit was part of the Eighth Air Force's operations, Detachment 234 was not a regular "reporting station" on the American system, its weather information needs vastly different from bomber and fighter groups.

Outside the station, which was equipped with the original RAF weather instruments, the 18th maintained the usual Stevenson Screen with Wet Bulb, Dry Bulb, Maximum and Minimum Thermometers and also the Hydrograph and Thermograph. To measure wind, the squadron used an American wind-instrument mast with anemometer and wind vane in place of the British wind vane. These instruments connected to an ML-117 '9-light Indicator mounted in the Observers Room. Indoors instruments included a *Negretti and Zambra* Kew Pattern Barometer and a *Short and Mason* Microbarograph. To keep current, the squadron made hourly readings. In rapidly changing inclement weather the men made readings even more frequently.

With these instruments for local conditions and teletype information from the British and American Met Services, the men of the weather station performed their main function — forecasting for photo reconnaissance flights. Lieutenant Conners explains the difference in PR weather men's forecasting in a report. "Their primary interest was visibility and cloud amounts, especially at high altitudes. Where most forecasting stations and the operations for which they forecast were not too concerned with cirrus cloud, that same cirrus is just as important as low cloud to the Photographic Unit pilots, and to the Weather Officer at a PRU station." (Wispy Cirrus clouds frequently made up of icy crystals are found above an altitude of 20,000 feet.) "These pilots and Met-men are also greatly interested in the forecasting of contrail levels, and in forecasting of winds up to 40,000 feet."

Forecasters took on the heavy responsibility of making critical calls on something as changeable as the weather. Eisenhower had trusted the word of SHAEF's Weather Officer when the Supreme Commander decided to delay the start of the invasion of Europe from 5 June until the 6th. He based his decision on a forecast of a narrow window of better weather. In spite of a raging storm outside at the time, Eisenhower gambled that the forecasted window would be there. It was and the invasion went forward successfully.

Good weather over target areas and at Mount Farm meant weather officers worked all day to brief pilots who could fly from first until last light. Each sortie had a separate briefing. The pilot had to be briefed for almost any part of enemy territory within a plane's range. This meant forecasting weather elements affecting photography for most of Europe, to the North German coasts,

east to Poland, south to Italy and Sardinia. The recovery of formerly German-held territory did not lessen this necessity as the photo planes still passed over the same geography on the way to enemy targets. Mapping assignments in recently liberated countries also required accurate weather forecasting.

When miserable weather rolled across target areas day after day, weather forecasters at photo recon bases looked for "windows" or openings in the cloud cover that could be exploited by a photo plane at the right place at the right time. Conners expressed the sense of responsibility in his report, "The Weather Officer, with the Operations Officer, must balance weather hazards against picture-taking requirements as long as there is a chance for successful missions. ...a job of high priority may find the photo pilot going out on any possible chance of getting a shot at his target. 'Any *possible* chance' — no one wants to send out a pilot in his defenseless photo plane, unless there is some chance of getting the picture in return for the risk of his trip."

The accuracy of the weather forecasters and the tenacity of a photo reconnnaissance pilot could capitalize on an otherwise marginal opportunity. Not only did the need for cover put photo pilots in jeopardy, but also bomber and fighter escort pilots. When weather prevented damage assessment and activity cover by the PR pilot, Eighth Air Force Operations had to risk its bombers and escorts over a target not knowing if the strike was necessary.

Just such a situation developed in late 1944. Bombers had been hitting critical oil targets. Through photo recon damage assessment and other intelligence sources, planners projected that oil production had been drastically cut at most of the regular and synthetic oil refineries. Without up-to-date information they had a mission against heavily defended plants near Brux, Czechoslovakia, on the schedule. If the particular refinery had been sufficiently damaged the raid could wait. Bad weather prevented cover of this deep penetration objective. At such a distant target an unarmed PR pilot had many miles to cover where enemy jets prowled on the lookout for vulnerable lone aircraft.

The 7th Group had a high priority request for cover at Brux. Days of bad weather moved the called-for photo cover into the critical period when the raid must go on without the best and latest information. Spitfires usually covered the most distant targets and the 14th sent three pilots out an hour apart to take advantage of a weather forecast of possible openings over Brux. The last pilot to leave Mount Farm, Lt. Bruce Fish, stopped to refuel before crossing out of England and climbed up to 30,000 feet in heavy cloud.

Lieutenant Fish crossed France and most of Germany, all hidden below the dense clouds. He heard the two pilots ahead of him radio that they had turned back without finding any openings in the weather. For a moment, Fish thought he would return also but then decided to fly a little farther on his planned route. His fuel supply was sufficient and he pressed on.

After about 15 minutes he thought he saw a break in the clouds ahead. As he got closer the sky lightened and he saw three layers of clouds. Fish rolled his Spitfire up to look below. "I could see a small area of a city with a railroad track making a distinct 'U' turn about our designated town." Comparing this feature with the map on his lap he thought, "There it was, the city and exact rail pattern he was supposed to find. Amazingly right on course." Now to find the oil refinery.

More breaks appeared in the clouds. He got closer to the target area and, "the weather broke wide open. Perfect timing. The other recon people had just been too early." The weather officer had been right about this hole in the clouds. It opened just as Fish arrived.

After making two runs each over his three assigned targets with only light inaccurate flak, Fish turned toward home, a long 400 miles away. The only enemy aircraft he saw was a slow flight of JU-52s far below near Brux. Frustrated that he didn't have guns to pick off a juicy target, Fish returned to Mount Farm where his "got the pictures" buzz alerted very happy Intelligence, Operations, and Weather sections.

Weather officers knew there were many more weeks of winter weather to come. Unless an unforeseen climatic change occurred, weather would limit February's operations as it had January's. The most anyone could hope for was an occasional clear day and a modest supply of those perfect breaks.

CHAPTER 16
February March 1945

After beating back the German counter offensive in the Ardennes, Allied commanders again turned their eyes toward the Rhine. German forces on the Western Front, crippled by the vicious winter fighting and the transfer of vital units to the Russian Front, defended the Homeland with only three army groups. Eisenhower's broad front plan called for Montgomery to clear the Lower Rhine, its approaches, and Holland with eventual crossing over the river in a northern strike. In the Middle Rhine area, Bradley's First and Third Armies would clear the Eifel region and attack toward the Ruhr River. The last and most southern assault would clear the Moselle and the Saar Basin.

To support this overall plan the Eighth and Ninth Air Forces' primary target became the crippling of the German transportation system. The areas covered by the 7th Group ranged from the Baltic Sea in the north, south to Lake Constance on the Swiss-German-Austrian border, and along the Western Front eastward to Berlin.

Target selection committees chose railroads, marshaling yards, road and rail bridges just behind the Western Front for destruction. Tactical and strategic targets merged in the attempt to disrupt the Germans' ability to supply their troops, move freely near the front, or to retreat without obstruction. It was a plan of interdiction similar to the one used during the Normandy invasion. To assess damage and eliminate targets, photo aircraft of the 7th Group, RAF PRU, and the Ninth's 10th Photo Group covered the targets. Under direction from SHAEF, the 325th Wing produced a book of both oblique and vertical photos taken of bridges and rail junctions to be destroyed or taken. These were distributed to ground forces and tactical air units.

As usual weather confounded operations for both bombers, fighters, and especially photo aircraft. On the last day of January, the Eighth had to recall most of its missions because of expected bad weather for returning bombers. The 7th had not attempted any sorties. An inauspicious first day of February frustrated Group Operations when bad weather over the target area allowed bombers using bombing aids to attack targets but prevented any photo cover. Only two photo aircraft operated in the St. Nazaire area with four P-51s for escort.

Gun Packages

Allied Intelligence officers were not the only people who understood how critical photo reconnaissance was. The Germans knew. Their persistent targeting of the Spitfires and F-5s of the 7th Group exposed how important photo sorties were. Anxious communiqués passed back and forth between Generals Arnold, Spaatz, and Doolittle. How could they solve the problem?

The decision to equip 7th Group squadrons with their own P-51 escorts was implemented in early January. There was an ongoing debate whether photo planes should carry guns. The present aircraft in use had been stripped of armor to add speed and room for cameras. How to accomplish the re-arming of the planes and other relevant problems delayed any action on that theme. Neither the Spitfire nor the F-5 could use regular gun installations and still carry the usual cameras. Tactical armed photographic P-51s, designated F-6s, operated with the Ninth Air Force but their mission was different. The F-6 did not work for high altitude PR and mapping presently performed by the 7th Group.

An under-wing gun package might give the F-5 enough fire-power to fight off Luftwaffe attacks. The main argument against this theory was that photo planes when attacked had to evade and avoid dog fights not be equipped to mix it up with superior numbers of enemy fighters. The photo pilot's responsibility was to get his pictures home safely not chalk up kills. Gun packages might encourage the wrong behavior.

Pressure to try arming PR planes persisted. The 7th delivered one of the 22nd Squadron's F-5s to Bovingdon's Maintenance and Technical Section in January to be fitted with a gun package under each wing outboard of the engines. When the aircraft returned to Mount Farm, pilots found the awkward installations cut the F-5's speed too much and were not very effective. This fact alone could have scuttled the program but the final word came from senior officers who prevailed in the argument against arming PR aircraft.

General Spaatz knew that a high percentage of interceptions were by German jets. Impressed by the British Gloster Meteor jets, he and 325th Wing C.O. Col. Elliott Roosevelt pressed for the new American jet aircraft developed by Lockheed, the P-80. On 21 January 1945, Spaatz asked for diversion of early production of the P-80 for modification into a photographic version, the F-14. He added, "We are very anxious to obtain F-14s at earliest possible date."

Two of the jets had been shipped to Bovingdon for testing in the northern European climate. They still carried the experimental designation YP-80. The first test flight in England was on 27 January when YP-80 44-83026 flew easy passes for 35 minutes over the airfield. The next day during its second test, a failure in the YP-80's tail pipe released the full exhaust into the aft fuselage blowing the tail off. The jet slammed into the ground

February March 1945

F-5E 43-28577 with experimental under-wing gun packages after nosing over on the airfield at Mount Farm. (Pat Keen)

killing the pilot instantly. This fatal crash put an end to the high command's hopes to equip the 7th Group with American jets. Until other means were found, the P-51 escorts would continue to protect the Spitfires and F-5s.

After another day grounded in England, the 7th Group's pilots finally got a chance to take assignments that had piled up in every squadron's area. Weather officers forecast mixed conditions over Germany on 3 February and Operations dispatched 16 aircraft. Eight found cloud over their targets and returned without photos. Three 14th Squadron pilots, Lts. Jack H. Roberts, Roger L. Wilcox, and Louis Gilmore accompanied by P-51s attempted cover of a heavy Eighth Air Force raid on Berlin. Gilmore found his assigned area covered by cloud and ran some strips from east of Berlin to Hanover before turning back to England. On his way home he evaded a jet and landed safely at base.

Lieutenants Wilcox and Roberts returned without photos after encountering what Roberts described to Intelligence as a Heinkel 280 jet fighter. This was the first time anyone from the 7th Group had reported seeing this aircraft in operation as its production had been halted in 1943 in favor of Messerschmidt's 262. The jet made three passes at Roberts who took evasive action with his Spitfire and escaped. Both pilots returned without suffering any damage.

Two more 14th Squadron Spitfires headed for the Ruhr on damage assessment missions. Lieutenants Fellwock and Vaughn accompanied by 14th Squadron P-51s photographed bridges over the Rhine at Wesel. Then Fellwock, after getting separated from the escort, covered Duisberg before returning to Mount Farm. Both missions were successful.

From the first of February through the first of March, the 13th Squadron's area of responsibility lay north of a line extending from just below Rotterdam, Holland, to a point approximately mid-way between Magdeburg and Merseburg near Leipzig. This area covered all of north and northwest Germany and extended east to the Russian lines. The main targets in the area were rail interdiction targets, synthetic oil plants, oil storage, and armament works. Berlin fell in that area as well Hamburg and other Baltic ports.

After the 3 February raid on Berlin, the 13th attempted to get damage assessment cover several times. As usual, weather interfered and Operations persisted in this important job. Another obstacle to aerial photography of vital targets was interception. Enemy air opposition, especially by jet aircraft increased during February. Most missions penetrating into Germany deeper than the Hanover area at best spotted enemy aircraft or at worst were attacked by the German fighters. To protect its aircraft, 7th Group made it standard procedure to provide fighter escort for any mission going beyond 10 degrees eastward.

The four P-51s accompanying Lt. John G. Weeks on a trip to Berlin had the 13th Squadron escort's first encounter with enemy aircraft. Two ME262 jets bounced the group on

The railroad bridge at Germersheim, a prime target of the Eighth's bombers. This set of pictures seen through a stereoscope viewer gave the photo interpreter a three dimensional look that more easily revealed damage assessment information than a single photograph. The small cloud can be seen to have moved in the two exposures. (J. Byers)

Eyes of the Eighth

its homeward leg of the mission. One jet made two passes at Weeks' F-5. Two of the escorts engaged the jet; the pilots firing for the first time. Although they didn't score a kill they prevented the German from hitting Weeks and the jet broke off. All five 13th Squadron planes returned successfully. The squadron's first encounter had ended in a draw.

The Hunger Winter
Photographs brought back by pilots from the 13th from parts of Occupied-Holland revealed vital activity information to intelligence officers. Photo interpreters usually looked at photos for particular signs of damage, or the lack thereof, at a target on the bombers' schedule. They also looked for any activity at a harbor, airfield, military installation, or transportation target.

When the British looked for any signs of the rumored flying bomb late in 1943, an experienced interpreter, Constance Babington-Smith, found a tiny cruciform object on a photo of Pennemunde. She was so familiar with the area and its features that anything new, or changed in any way, caught her eye. Some of her colleagues said that she knew every rooftop in Germany. It was this familiarity combined with frequent photo cover, translated by the interpreter, that painted the picture Intelligence needed.

Ominous signs began to appear on photographs taken in German-held Holland. Winter snow covered the land. The canals and waterways stood out black against the white landscape. During winter, leafless trees appeared in spidery rows along the canals and roads and like clusters of tangled thread in parks and woodland. In cities like Amsterdam where tree-lined waterways delineated the city in great arcs, the photo interpreters gradually began to see less of the spidery lines. The trees were disappearing.

Through other intelligence sources the British and American governments knew that the Dutch people had run out of fuel and food. In this particularly harsh winter they could do nothing else but cut their trees down for firewood. City dwellers attacked any damaged building, tearing out all the parts that would burn until in some cases the unsupported brickwork collapsed. All supplies going into Holland were for the occupiers. People trekked out into the countryside to barter and trade for what food the farmers would sacrifice. Starvation and death invaded the cities of Rotterdam and Amsterdam. Many died on the streets and froze by the side of the road, abandoned. There was no wood for coffins and the ground was frozen. As February — this terrible winter — dragged on and the Allied armies didn't come, the Dutch began to call it the Hunger Winter.

Low-level photograph of two freight barges anchored in a Belgian canal during the foggy winter. Their funnels fold down to let them pass under low bridges as they travel. (J. Byers)

Operations for the 22nd Squadron had been slow to begin in February. Captain James B. Matthews left the squadron to return to the States and Lt. John Ross took over as Operations Officer. So far, he had been unable to send many sorties out. On the first he assigned Lts. Sam Purlia and William C. Goodison for defense-study cover of St. Nazaire. Just to get experience for pilots who had never flown escort missions, he and three other pilots from the squadron flew their P-51s along.

The weather cooperated on the third and Ross assigned three pairs of pilots to missions. Targets at Aschaffenburg, Hanau, and Marzhausen made up the list for Lts. Donald A. Pipes and Ellis B. Edwards. Four P-51s, piloted by the squadron's Lts. Taylor Belt and Stanley J. Reilly, as well as the 13th's David T. Davidson and Frank Sommerkamp provided escort. Only Edwards found any cloud-free area to cover with a strip from Brussels to Lille.

February March 1945

Hiding Jan Pieter Smit

Second Lieutenant Claude C. Murray had ceased to exist. Now, a deaf and dumb Dutch salesman from Edam, Jan Pieter Smit waited to go into hiding, to become an *onderduiker*. Several days after acquiring his new identity and papers, Smit answered yes to Daan Spoor's question if Murray, now Jan Smit, could ride a bicycle at least ten kilometers. Two days later, a young man about Smit's age, Jan van Etten came for him with a bicycle. He told his charge that they were going to ride to another town and Smit must ride about ten yards behind. "If I get stopped," van Etten told Smit, "You stop and turn around."

From Rozendaal's house(C) in Muiden they rode eastward(D) to the village of Naarden where they stopped at a tidy two story brick house. Like so many houses in the neighborhood it had a high peaked roof with several dormers. In this house on Paulus Potterlaan lived Mevrouw Dietz, a widow with two teenage sons, Jaap and Peter. She would hide Jan Smit. The Underground gave trusted brave Dutch who hid *onderduikers* extra food stamps for their charges. The widow would get extra stamps for Jan Smit as she had for another man hiding in her house, Ted Cohen, a Jewish boy. If the Germans found either of these men they would execute the men, the widow, and perhaps her sons.

Cohen and Smit shared a front corner room on the second floor with a window that looked out onto the street. Like all Dutch homes, the windows had sheer or lace curtains that let light in and allowed those inside to see out, but blocked those outside seeing in. At night Cohen and Smit must close heavy curtains and keep any light inside to a minimum. They could move around in the house but could not go outside. When they spoke, it was softly. No one outside must hear strange voices. All the family and Cohen spoke English and talked *to* their secret American. When they talked *about* him they spoke Dutch.

Since his arrival in mid October, Smit had not seen anyone other than the family and Cohen. He felt boxed-in and longed to go outside. Mevrouw Dietz let him walk in the garden one night but as the days passed, Smit became more restless. Daan Spoor came to see him and brought a rare and precious gift — a pint of bourbon. When he made other visits they each had a jigger, the familiar amber liquid easing Smit's stress. He might be Jan Smit on the outside but the man who was Claude Murray inside longed to move to a less confined hiding place.

Time passed slowly, increased tension and Smit's restlessness. Outside the tiny world of the Dietz house, the determined Germans sought able-bodied Dutch for forced labor in Germany. They set quotas and issued orders for each district; in Naarden's area it was 1,500 men. The order demanded, "Come down to the railroad station at six o'clock in the morning...Anyone between the ages of eighteen and forty. This is an order." Many complied. Not the *onderduikers*. They and the men hiding in the house on Paulus Potterlaan knew the Germans and their Dutch police units would follow soon after with a house by house search — a *razzia*.

On the Dietz' house third floor, there was a hiding place behind a bookcase. When books were in place on the shelves no one could tell that the top shelf folded down exposing a secret entrance into the attic. With the *razzia* expected the next morning, twelve Dutch boys sneaked in darkness to the Dietz house and went up into the attic to hide. The boys did not know Jan Smit was really an American pilot. They all crowded into the tiny space with Smit and Ted Cohen. There they stayed through the next morning when the Germans came down the streets with a loudspeaker ordering everyone outside. The little group in the attic smothered any sound and each secretly wished himself small and invisible. More than just the American shook with fear. The Dutch faced labor camp in Germany but Cohen and the pilot faced immediate execution along with the Dietz family. Each followed the sound of the boots tramping through the house. Where were they now? Will they find the bookcase entrance? It took an unnerving and seemingly endless time. Then the little group heard the front door slam as the Germans left the house. Another long wait until someone from the Underground decided it was safe to let them out.

In December, a trusted Catholic priest came to ask Mevrouw Dietz if she could take in some refugees. After two months confined in the house, Smit asked if there was a way he could escape. The priest raised his hopes that he might be able to get him out of occupied Holland. The pilot would have to have his uniform, flight suit, and dog tags. Word delivered to the Rozendaal's brought Joh's wife on her bicycle to Naarden. She talked to the widow and although she had brought the clothes and tags with her, Mother Rozendaal, as Smit now called her, rode back to Muiden taking his things with her.

Daan Spoor returned the next day and explained that it was too dangerous to try the escape plan. "You haven't got a fifty-fifty chance of making it out. We don't want you to try it. We've got another place for you." He sternly warned the pilot, "We have orders not to allow you to try to escape." Spoor then rode back to Muiden with the deaf and dumb salesman from Edam bicycling along behind to "another place."

Note: See map on page 196 for locations indicated by letters C and D.

Eyes of the Eighth

The next pair, Lts. Max McKinnon and James W. Flowers tried to cover a bridge at Ludwigshaven and Kaiserslautern. They would try to get other targets at Mannheim but only 22 minutes into the flight Flowers' oxygen mask failed and McKinnon went on alone but found cloud over all the targets.

One of the pilots in the last pair, Lt. Charles B. Sarber, on only his second sortie, managed to get a small strip near Monschau, the tiny town that had been the northern most point of the Bulge. The other pilot had trouble with one of his engines. While flying over the Siegburg area at 25,000 feet, Lt. Robert B. Gillick noticed that his right engine began to run roughly and the instruments fluctuated wildly. He increased his RPMs from 2300 to 2600. Now drawing 42 inches of pressure instead of 35, the engine ran smoothly. When he cut back to 2300 and 35, it ran rough. Gillick flew with the higher setting as far as Liege on the return flight where everything seemed satisfactory and he landed at Mount Farm safely.

After five days of inactivity, Ross had the 22nd back in operation on 8 February with seven sorties taking off. His squadron C.O. Captain Troy B. McGuire had targets at Hanau, Aschaffenburg, Koblenz, Niederbresig, and Merzhausen to cover. To fill in a job for ground troops in the area, McGuire also planned to map near Frankfurt. He took an escort with him made up of his Operations Officer Ross and Lieutenants Reilly and McKinnon from his own squadron. Two 13th Squadron P-51s flown by Capt. Dale Shade and Lieutenant Sommerkamp added their fire power. Koblenz was the only assigned target taken but McGuire did get photos of Cologne's bridges and other targets in the area.

Further mapping cover of Frankfurt was the program for Lts. William R. Buck, J.W. Flowers, Richard E. Brown, and Byron L. Waldram. Bad weather over Frankfurt prevented any photo coverage and similar conditions at Mount Farm forced all four aircraft to land instead at Watton.

Three fighters from the 364th Fighter Group at Honington escorted three photo pilots on 9 February when the 22nd sent F/O Michael Dembkowski and Lt Alf Carstens to cover targets in the Koblenz and Frankfurt areas. The Group Operations Officer Major Carl Chapman led the flight. When they neared the front lines, the right engine of Dembkowski's F-5 developed a problem that forced his return to Mount Farm. Chapman and Carstens found 10/10s cloud with a few breaks to the south. There they covered Karlsruhe, Pforsheim, and Stuttgart before returning to base.

Still attempting to cover the Frankfurt job, Ross assigned Lts. Denver R. Sherman and David F. Thomas to fly the missions while he, his C.O. Captain McGuire, Lieutenant Reilly, and Captain Shade from the 13th escorted the mission in their P-51s. Sherman never got off the ground when his F-5's brakes locked up but Thomas and his escort flew to Frankfurt. Again, cloud foiled the attempt. They all returned safely but without any photos.

The 14th Squadron flew two missions on the 9th, one out of Denain/Prouvy. The day before, fearing that deteriorating weather would prevent pilots from returning to Mount Farm, 14th Squadron Operations arranged to have its pilots land at A-83 after their missions. The squadron flew men from Intelligence and Photo Interpretation over to France to support the added flights into the 27th's airbase. Capt. John L. Robison, Lts. Thomas S. Cornwell and Harry O. Guss arrived at Denain/Prouvy in a C-53 from the 381st Air Service Squadron.

One of the sorties, damage assessment at Gotha and Ohrdruf, was Lt. Jack H. Roberts' assignment but he did not cross out and was directed to land at Watton. Five other pilots had targets in the Ruhr and Cologne areas. Captain Dixon attempted to cover high priority targets in the heavily defended Leipzig area but like the other 14th Squadron pilots out that day his targets were covered by persistent cloud. Only Lt. Donald W. Werner found an opening and photographed a strip from Bruhl to Lechenich.

The next day, Lt. Ian Feltham left A-83 and flew to the Bielefeld area before returning to Mount Farm. Again the mission was unsuccessful. None of the other pilots that had flown the day before had missions because the weather officers predicted solid overcast in the squadron's target areas. The only other sortie by the 14th, Lt. Fabian Egan's attempt to cover Dortmund, also failed due to cloud.

Disney Rocket Bombs

Throughout World War II, Britain, like its allies and enemies, created and invented hundreds of weapons and defenses. Some were imaginative and worked to perfection. Some were imaginative and failed miserably. One particular invention was imaginative but came into operation too late to affect the outcome. From the very beginning of its war with Germany, Britain feared the most difficult enemy to defeat, the U-boat. Experiences in World War I added to the concern. Frustrated by Hitler's concrete monster constructions protecting Germany's U-boat pens, British scientists searched for the weapon that could destroy them under their thick reinforced concrete roofs.

They had experience with similar constructions attacked during the campaign against the concrete V-weapon sites early in 1944. The RAF had two ex-

February March 1945

tremely large bombs that they used to reasonably good effect. The 12,000 lb. *Tall Boy* could penetrate 9 feet into reinforced concrete and had modest results within the structure in what the scientists called "scabbing," where the concussion damaged the interior ceiling. In a race of "can you top this," scientists on both sides made development moves and countermoves. While the British experimented with bigger bombs, the Germans reinforced and experimented with thicker protection.

German scientists, familiar with rockets and results of high speed impact, developed a defensive theory. It would take a 27,000 lb. bomb striking the target at the speed of sound (Mach 1) to penetrate 23 feet of heavily reinforced concrete. German intelligence knew that the RAF did not have a bomber to carry this approximately 12 ton bomb. The 23 foot thickness became the construction criteria. Hitler, already a lover of giant concrete constructions, developed an obsession with the figure. He

Oblique view of Ijmuiden E/R pens after 10 February raid by 92BG with *Disney* Rocket Bomb. Target is in lower right corner. (J. Byers)

Vertical photo of Ijmuiden pens pock-marked by huge craters from previous bombings. Arrow marks small entry hole made in roof at the entry point of the *Disney* Rocket Bomb (A). (J. Byers)

now insisted that any bomb-proof concrete structure must have a 23 foot thick reinforced roof. If his U-boat pens did not conform then they must be reinforced to do so.

Photo reconnaissance by PR units of both the RAF and the Eighth supplied picture after picture to the section at Medmenham that studied these facilities. Interpreters and scientists evaluated damage inflicted by every kind of ordnance available. Some structures failed under the onslaught but the U-boat pens seemed to survive although pockmarked by direct hits. Soon RAF bombers tried even heavier bombs, the 22,000 lb. *Grandslam,* which penetrated 12 feet with a much greater "scabbing" affect. Still, the interior remained relatively undamaged.

Without a bomb able to penetrate into the interior of the structures, attacks against the U-boat pens would continue to fail. To do the most damage, the explosives must be delivered into the target rather than onto it. One such attempt was the Aphrodite/Castor project, which planned to fly the unmanned drone into the entrance of the submarine pen. The failure of Aphrodite and Castor to do the job and political influences terminated that experiment. There was something new in the works.

Most concerned by the U-boats' heavy toll in its domain, the sea, the Royal Navy developed a weapon to penetrate thick concrete before exploding. They produced a 4,500 lb. bomb that fell in free-fall to 5,000 feet altitude. There, a rocket motor ignited and drove the long slender bomb into its target at 2,400 feet per second. They named the new weapon the *Disney* Rocket Bomb after a similar futuristic weapon in a thirties animated movie by the famous studio. In tests the new weapon penetrated 22 feet of concrete before detonation.

At the time, due to its 14 foot length, British aircraft could not deliver the bomb. The Royal Navy approached USSTAF to equip a B-17G to carry two bombs externally on bomb racks. On 10 February, the 92nd Bomb Group made a visual attack against the Ijmuiden U-boat pens (old E/R boat pens) on the North Sea coast of Holland. Observers flew along to see the strikes. Instead of the violent explosions made by the big bombs visible from above, the *Disney* Bomb made a small hole in the roof of the target and exploded inside causing an already weakened roof section to collapse.

On a sortie to Hamburg, the 13th's Lt. Charles H. Cole covered the Ijmuiden strike on 10 February adding to the before and after damage assessment photos taken of this new weapon's effectiveness. When he returned to Mount Farm he also brought pictures of three large U-boats running on the surface, passing from the Baltic into the Elbe River. Based on evidence from photo reconnaissance and other intelligence, the Eighth equipped aircraft of the 305th and 306th Bomb Groups to drop the *Disney* Bomb. Plans to add it to the 94BG's arsenal and the need for more attacks were overtaken by events that removed further major U-boat threats.

Bennett and Brabham

Seven P-51 fighters accompanied two 14th Squadron pilots, Lts. Harold Weir and John W. Brabham across the Channel on 11 February. Lts. Richard M. Bennett, Bruce Fish, and Louis Gilmore of the 22nd joined Captain McGuire, Lieutenants Ross, Moorehouse, and Reilly of the 14th. The two F-5s and their Mustang escort flew toward the Continent. Weather was marginal with heavy cloud layers that extended up to 25,000 feet. After ten minutes they separated into two flights, one F-5 going with only three P-51s. Both groups continued toward their targets in the Koblenz and Frankfurt area.

Bennett began having engine trouble just after his group of four broke out of the heavy clouds over the Continent. His Mustang's engine lost coolant and began hammering and pounding; gray smoke pouring out. At 29,000 feet he lost all power. Calling for assistance he got a fix from the homing station *Nuthouse* and instructions to stay with the plane. If he continued on his heading for one more minute he would be over friendly territory. Losing altitude rapidly, Bennett waited for the longest minute in his life. At 11,000 feet his Mustang's engine began to burn. The pilot disconnected his oxygen tubes, radio lines, and dinghy. He wouldn't need that over land. Bennett was still in overcast at 7,500 feet when he had to bail out. His parachute blossomed above him in the gray cloud. He couldn't see the ground at first. Had he flown far enough? As he cleared the overcast, Bennett saw his P-51 hit the ground in a fiery explosion.

Bennett floated down toward a small village. As he hit the ground, a weapons carrier, tank, and Jeep rolled up. American infantry surrounded him until he identified himself. They told the pilot that he was less than two miles from the front in Elliz, 24 miles north of Luxembourg. The soldiers took him to a field hospital at their headquarters where doctors treated burns on his face and neck. After spending two days in Luxembourg City, he caught a ride back to Mount Farm on one of the 381st Air Service Squadron's C-47 courier flights.

Brabham and Weir, still flying with their escorts in separate groups, made several runs over the assigned area and turned back toward England. Weir and his escorts had not seen the other group since they separated and they flew back to Mount Farm without ever rejoining them. Bad weather made any rendezvous improbable.

The second group left the Frankfurt area and re-

February March 1945

entered heavy cloud for the trip home. The weather had worsened. While crossing out over France, Lieutenant Brabham thought he would look for better conditions on the deck. He dropped down to only 400 feet while flying over the Channel. When he reached the English coast he climbed up through cloud to 2,500 feet and headed toward Mount Farm.

Unknown to the pilot, something had gone wrong in his plane's instrument panel. The artificial horizon indicator went out. Brabham was flying in a layer of cloud above a ceiling at about 1,000 feet below. Within seconds the pilot hung suspended in his safety straps. He was upside down. Brabham quickly rolled his plane over to what he thought was close to a level course. He had not known that his artificial horizon had failed. After trying to fly by reading the needle and ball indicator he found himself upside down again. There must be trouble with more than the one instrument. Under the circumstances the lieutenant made a decision. He did another half roll and began to climb. When his altimeter read 4,000 feet, he opened the canopy, jumped clear of the ship and pulled the D-ring on his chute.

All of the rolling and climbing had brought Brabham somewhere over southern England but how far had he flown? Was he on course to Mount Farm or had he strayed while trying to level his plane? Cloud swirled all around him. As he broke out he saw houses and trees spread out before him. Brabham was going to land in a residential area of London. He could see his F-5's wreckage burning on the ground just before he skimmed over some trees and landed in the backyard of a house. Brabham estimated that the crash site was about four blocks away.

From the house, the pilot telephoned the police and an ambulance before going over to the crash site. The F-5 had buried itself in the ground only four feet from the back wall of a house. Fortunately no one had been hurt but the wall suffered some damage. Local police took him to their headquarters where Brabham called the base to report what had happened. He then returned to Mount Farm in a jeep bringing Intelligence a souvenir — a roll of burned and blackened film.

Merseburg/Leuna, A Deadly Target
Oil targets remained on the board in Intelligence. Although badly crippled, the German synthetic oil industry

Low-level view of the Merseburg/Leuna Synthetic Oil Refinery near Leipzig. Photo taken after German surrender. (Dixon)

Eyes of the Eighth

managed to keep up limited production through intensive repair. Photo interpreters watched the plants on as frequent cover as the Eighth and RAF PR units could provide. When such intelligence and other sources indicated a return to production, any increase or added capacity, the target moved to the top of the priority list. New strikes scheduled to bomb the indicated location only waited for appropriate weather. Most oil targets had heavy protection by fighters and concentrations of anti-aircraft batteries. The Ruhr, facetiously known as "happy valley" to bomber crews, had large numbers of flak positions. Another group of targets dreaded by bomber crews was around the city of Leipzig. By early 1945, the heaviest concentration of flak batteries in Germany spread in a belt across the approach to these targets. They protected clusters of synthetic oil refineries and related industrial plants — nitrogen, hydrogen, synthetic rubber, and explosives — that sprawled over the plain. In May of 1944, aware that their fate depended on the industries in the area, the Germans began developing the belt in an arc extending from Bitterfeld, northeast of Halle, southwestward to encompass Halle, Merseburg, and Weissenfels on the Saale River, then southeastward to Zeitz.

By the spring of 1945 flak guns in batteries of 12 to 36 guns, usually the dreaded '88s, were grouped along the arc. A particularly heavily defended target was Leuna, near Merseburg. Leuna contained a large hydrogen plant, Germany's largest synthetic rubber plant, and the second largest synthetic oil refinery. Bomber groups and photo recon units had maps on which all the positions were plotted from information gained by cameras from on high and secret ground sources. They knew where they were but neither the bombers nor the PR aircraft could stop them from sending up murderous flak.

Eighth Air Force Intelligence needed up-to-date cover of the plants near Merseburg. Weather good enough for photos had been rare. Without recent cover, Intelligence could not be certain if the synthetic oil plant at Leuna was in production again. The weathermen promised good bombing weather on 15 February in the Merseburg area. Without cover proving that a raid was not needed, the Eighth's high command would have to risk heavy losses of aircrew and planes. Intelligence knew the 7th Group had a flight scheduled to cover the area on 14 February. They waited for the results.

Dixon

Commanding officer of the 14th Squadron Capt. Robert J. Dixon took the critical targets listed for cover on Valentine's Day, 14 February. The mission listed targets in Gotha, Weimar, Erfurt, Lutzkendorf, Merseburg, Leipzig, Zeitz, and Gross/Kanya. He also planned to fol-

Maj Kermit Bliss discusses mission with Capt Robert Dixon.
(Dixon)

low the bombers and cover strikes at Dresden and Chemnitz. The 55th Fighter Group furnished four P-51's. One aborted its mission early and Dixon went with three escorts, Flight leader Lt. Richard Ozinga, Lts. Francis R. Sharp and Thomas M. Love of the 343rd Squadron.

The Spitfire and its three fighters crossed into Germany in less than satisfactory weather for photography. Cloud threatened to defeat any attempt at cover of the targets. As the group approached Leipzig, Dixon saw a break in the clouds off to the west toward the Merseburg refineries. Through haze common to all industrial areas of Europe he thought he could just make out the big complex Intelligence wanted most. He would divert from the Leipzig job long enough to make a few runs over the target and get the precious photos.

With his fighter cover above him he flew over to his new target. At 35,000 feet the haze was too heavy. Dixon always preached a cardinal rule to new photo pilots — never go down. No target is worth the loss of the plane or the pilot. There will always be another day. Now, he had a decision to make. Because he was the 14th's commanding officer, he knew about the plans to bomb the complex the following day. Dixon thought the target was worth his risk this time and he broke his own rule. After instructing his escort to stay at altitude, he went down after the pictures.

At 12,000 feet Dixon made three runs over the plant without opposition. The big guns remained silent. On the fourth run the flak batteries let loose with highly accurate fire. Shells burst all around. Fragments hit his engine and one piece came up through the floor between his legs, which the captain found very personally threatening. He still had his drop tank on and the shell ignited the gas that remained in it. The shrapnel broke the stick off in his hand and knocked off the Spitfire's canopy.

268

His pants caught on fire; he slapped the flames out. Dixon called his escort, "My ship is on fire — don't follow me in — the flak is heavy." Then he gave a visual picture of the plant and described to Flight Leader Ozinga and the other fighter pilots circling above that the plant appeared inoperative and wasn't worth bombing. He told them that there was, "smoke coming from only one of the chimneys." They must get the message to Intelligence. His escort saw the smoking Spitfire roll over and the pilot drop out at 10,000 feet. As the parachute opened, the flight leader dipped his wings and the P-51s turned for home. Dixon slowly drifted toward earth. The Spitfire crashed and burned in the distance.

At Eighth Air Force Intelligence, Maj. John Leggett called Mount Farm to see if Dixon had gotten any cover from the Merseburg area. He was shocked to hear that the 14th Squadron C.O.'s Spitfire was overdue and presumed lost. The aircrew of VIII Bomber Command would have to go the next morning. While they were looking at their options the intelligence officers learned with surprise that there was a telephone call from Fighter Command with a message to pass along from one of its bases. Leggett picked up the paper and read the message. "We arrived over Leuna." The fighter escort described what had happened and said that Dixon had told them to stay up above while he tried to get the photos. The message continued, "He gradually worked down into the cloud and then we heard him again. He still could not see the target." The message reported that Dixon told the escort that he was going lower. They said that the next word from Dixon was after he was hit. Dixon's visual sighting and appraisal of the Leuna plant relayed by the fighter pilots gave Intelligence enough information to call off the raid. (Capt. Robert J. Dixon was awarded the Distinguished Service Cross.)

Without knowing what had happened, the crew on the line in the 14th's dispersal area waited for the distinctive sound of the Merlin engine. One by one, all the other pilots landed safely after their sorties. It became obvious that the squadron C.O. was overdue. The control tower personnel made the usual calls but Dixon had not been reported as landing at any of the other airfields. Finally, the squadron learned that the captain had been shot down on his 65th mission. Word that his fighter escort reported seeing a parachute open eased their sadness but the men felt a terrible loss. Eventually word came down from Headquarters that Bob Dixon had been shot down over Merseburg/Leuna. He was presumed to be a prisoner of war. The squadron listed him as MIA until notified otherwise. Who would take over command?

Twenty-one sorties, many with escorts, covered long requested targets on 14 February. The 22nd Squadron covered the Frankfurt area assignment successfully with four aircraft. The long delayed cover for damage assessment in the area around Hanau, Aschaffenburg, and Marzhausen arrived courtesy of the 22nd at the Photo Lab, which had one of its biggest days in months.

A promise of good operating weather on the following day did not materialize. Operations assigned 18 sorties but canceled four before they took off. The 14th Squadron's Lt. Fabian Egan planned to cover targets from Captain Dixon's mission of the previous day but Operations recalled him due to weather. Those missions that did make it to the Continent for photo cover had to land at other bases due to bad weather at Mount Farm. One pilot, the 13th Squadron's Lt. Ross Madden failed to return and became another missing in action entry for his squadron. Ironically, Madden was scheduled to receive the Soldier's Medal in two days. He had been badly burned trying to rescue his pilot, Lt. Bob Kraft in the crash of their B-25 in France on 26 October 1944.

Adams New C.O. of the 14th Squadron

A new commanding officer for the 14th Squadron arrived at Mount Farm from France on the 16th. The 7th Group transferred veteran pilot, Capt. Gerald M. "Jerry" Adams, from the 27th Squadron to take over the 14th. Adams had come overseas with the squadron and was an experienced Spitfire pilot. He now returned as commanding officer.

Crew Chief Carl Nordsten and Capt Gerald Adams in front of 14th Sq P-51. (J. Mates)

Dixon's Capture

Captain Dixon's chute seemed to take forever to open. In the distance smoke rose from the wreckage of his Spitfire. Everything was quiet. A cold February wind blew through the canopy's shrouds and pushed the man hanging in the harness swiftly across the sky. The P-51s no longer circled above where they had stayed as ordered. He hoped they would get back safely and deliver the message about the refinery. It had almost looked deserted with only the one chimney smoking. The pilot thought of all the men who could be lost bombing a useless target. Maybe he had done the right thing after all. Anyway, he was still alive but headed for certain capture.

The closer he got to the ground, the more Dixon realized just how fast the wind was blowing him across the countryside. Ahead lay a plowed field. He hit the ground hard and lost consciousness as he crashed into a frozen manure pile. His chute filled like a sail in the wind and dragged him across the field. He came to, bumping and pounding across the ice-hard furrows. Dixon was not alone. Chasing behind the chute and its passenger were some elderly farmers trying to catch up with him but the wind outdistanced the struggling men. Then he crashed into a fence where they caught up with him.

These were angry men. They came from the small villages around the big targets and their homes had taken heavy damage from bombs that missed the target. Captain Dixon was the first enemy they had seen face to face and they were a wrathful lot. After disentangling the pilot from the chute and shrouds the old men searched their captured *Luftgangster*. Dixon had borrowed a flying suit that morning. It was badly scorched and his legs were burned. He wondered what the Germans would think about his RAF flying jacket under the suit. More importantly he wondered what they would do when they found the .45 sewn into the pocket of the suit. The old man who dug it out was some kind of Landsguardsman but waved the gun menacingly about as if he didn't know how to handle it.

They marched their prisoner into the village center. All along the way hostile people came out to watch. The pilot almost smiled at the little blond children along the road. They were so beautiful, such cute little kids until they started throwing rocks at him. They shouted insults and pelted him with stones. He was the carnival come to town and the center of attraction until it got dark. Then the old men locked him in a cold stable. Dixon asked for something to eat and a blanket but the owner refused and the American crawled into a horse trough and fell into exhausted sleep.

The next day the civilians marched him to another town where they paraded him in front of more villagers hurling stones and curses. An old man came down from a porch. He had tears in his eyes. For a moment the captive thought someone felt some compassion for him until the man struck him with all the strength he could muster. The blow stunned Dixon who made no reaction and, with tears of rage, the old man struck the pilot again.

Dixon's captors locked him in the cellar of a house at the end of a long and painful day. Again a hostile owner left him without food or a blanket. It was bitter cold. Dixon curled up in a corner of the cellar and slept fitfully. Sometime after midnight he heard footsteps on the cellar steps as the owner of the house crept down to the makeshift prison. Apprehensive, Dixon watched the man approach. Without the earlier hostility, the man motioned for the pilot to follow him upstairs. It was warm in the kitchen. The room was cozy; windows closed against the cold and curtained to keep light from leaking out. The German fed the pilot the hot food, the first real meal he had eaten since leaving Mount Farm. Then he gave him a light blanket. He warned Dixon that no one must know what he had done and he took the American back down into the cellar. Bob Dixon wrapped the banket around himself, curled up in the corner, and with a full stomach fell into a deep sleep. In the morning the kind man's overt hostility returned for all the village to see.

After two days of tramping from village to village, the target of desperate civilians' vengeance, Dixon was picked up by German soldiers. He spent the next eight days with two soldier guards as they traveled by train from Merseburg to the interrogation center outside of Frankfurt. Now the prisoner faced a new threat. Train travel by this stage of the war exposed passengers to attacks from the air as the bombing and strafing campaign against German transportation increased. Fighter bombers or fighters on strafing raids shot up anything that moved, raking trains from one end to the other in hopes of blowing up an ammunition car or striking the boiler of the engine. Those great eruptions of steam and exploding flame and debris looked great on combat action film back at headquarters. His experiences with the civilians alerted Dixon that an attack on their train might trigger reprisals against any supposed *Terrorflieger* caught in the aftermath. He didn't believe they would accept his explanation that he only shot at them with cameras. Cautiously, Dixon kept a low profile, spoke little, and hoped no one would take him for a terror-flyer.

February March 1945

Other changes in the 14th during this period included the promotion of the squadron's Sergeant Major John Mates to First Sergeant Mates. He replaced former First Sergeant Edgar Knight who moved to the Engineering Section as a mechanic. To replace Mates, Sgt James Conway took over as sergeant major.

Of the eight scheduled missions on the 16th, only six crossed out and covered targets on the Continent. The 13th picked up more cover in the Frankfurt area. With bomber strikes at Dortmund, Lieutenants Feltham and Fellwock covered those targets and many others along the Rhine River.

Awards Given at Formal Review

Half of the sorties scheduled for 17 February had to be canceled due to bad weather over the targets. Two 22nd Squadron pilots had to land away, Lieutenants Buck at Manston and Thomas at Bradwell Bay. A formal review by the Group's commanding officer Lt. Col. George Humbrecht was the biggest event of the day. He had a long list of various awards and decorations to pin on his men's blouses. Three recipients were missing. Humbrecht announced the award, in absentia, of an Oak Leaf Cluster to the Air Medal for James F. Tostevin, missing in action since the middle of January. The new commanding officer of the 14th Squadron Capt. Gerald Adams, himself holder of the Distingushed Flying Cross since December, stood at the head of his men. He had taken over the squadron after the loss of Capt. Robert Dixon. Captain Dixon, shot down over Merseburg/Leuna on the 14th and Lt. Ross Madden, reported missing only the day before, had their medals awarded in absentia as well.

Colonel Humbrecht spoke eloquently to the assembled men about Captain Dixon's loss, telling much of the story for the first time. He awarded the captain another Oak Leaf Cluster to his Air Medal. Humbrecht read that the award of the Soldier's Medal to Lieutenant Madden was in recognition for heroism in the crash of the B-25 in France.

The highest decoration pinned on a blouse that day was the Distinguished Flying Cross awarded to Maj. Hubert M. Childress "for extraordinary achievement in accomplishing with distinction two photographic reconnaissance missions over Europe on 4 and 15 August 1944."

Childress, C.O. of the 27th Squadron stationed at Denain/Prouvy, France, flew over for the ceremony. At

Section of Mittelland Canal at Gravenhorst obliterated by RAF and Eighth Air Force bombs.

Eyes of the Eighth

the time of the missions he had been a captain and still flying out of Mount Farm. On the 4 August mission, Operations had assigned Childress to photograph targets immediately after attack for damage assessment. Only a few minutes behind the bombers, Captain Childress found a heavy pall of smoke over the area. He knew that the enemy would still be on high alert but made repeated runs over the target from every angle. He then covered other targets returning to base with excellent photographs. On his mission of 15 August, after covering his assigned targets, Childress flew on to cover seven important airfields. Again, he returned to Mount Farm with excellent results.

Many recipients of multiple Oak Leaf Clusters to their Air Medals were veteran pilots from the 7th Group: Capt. Franklyn K. Carney, Lts. Richard H. Brunell, Max E. McKinnon, Richard S. Quiggins, Harold G. Weir, Fabian J. Egan, Taylor M. Belt, John D. Nolan, Robert N. Florine, and Arthur K. Leatherwood.

Humbrecht pinned on many other Oak Leaf Clusters to Air Medals worn by new members to the 7th Group's 381st Air Service Squadron. These men were pilots, navigators and radio operators who had earned their decorations while flying weather reconnaissance with the 25th Bomb Group at Watton. Many of the men assembled that day had never heard the names Colonel Humbrecht read out nor recognized the men that stepped forward to receive their medals. The new and expanded courier service had not been on the base long. Clusters went to Lts. William F. Dittrich, John H. Satterfield, Alfred Collins, Ben Curry, Jr., Leon G. Megginson, Byron H. Pollitt, Albert H. Schlenger, Jr., Herbert S. Feinsheimer; TSgts James D. Copen and Victor A. DeSimone.

Master Sergeant Richard M. Brown, 13th Squadron Photo Lab, received a Bronze Star for "meritorious technical work in action against the enemy . . ." in Poltava, Russia. Brown accompanied all the photo lab equipment shipped to Russia by convoy to Murmansk. Under special orders, he could not return directly to his squadron when the other members of the detachment traveled back to Mount Farm. The sergeant had to go to a replacement center and arrange for a transfer to the 7th Group.

Frustrated by poor weather, Operations questioned weather officers looking for any opportunity to get cover for damage assessment of recent bomb strikes against German transportation targets. The Eighth's heavies struck the marshaling yards and stations in Nurnburg on the 20th and 21st. During the first raid, 860 B-17s and B-24s dropped almost 2,177 tons of explosives on Nurnburg's rail facilities. Newly-promoted Capt. John Ross covered the strikes on the only successful one of six planned sorties for the entire group, including the detached squadron in France.

The next day, the Eighth's bombers hit Nurnburg again when a force of 1,219 bombers dropped 2,890 tons. Better weather allowed Operations to send many more planes over the Continent. The 14th Squadron covered oil targets near Leipzig and other targets that had been on Captain Dixon's list when he was shot down. Several pilots brought back long wanted cover for damage assessment at Paderborn, Duisberg, and Gelsenkirchen. The 22nd Squadron concentrated in the Cologne, Frankfurt, and Siegen areas. Targets under the cameras of the 13th included Berlin and Magdeburg.

One pilot flying into northern Germany that day was Lt. Grover P. Parker, formerly of the 27th Squadron. Parker had been shot down twice, once in France and once in Holland. His escape from the Germans and subsequent hiding by the Dutch Underground should have prevented him from flying combat missions. It was the policy of the Eighth Air Force, and other air forces as well, that any man shot down and hidden by underground groups could not fly operational sorties when he returned to Allied territory. This rule protected the helpers in German-occupied Europe.

Pilots hidden and returned through secret channels to Allied control could expose these underground groups if the pilot was shot down and captured again. Most men who escaped and evaded capture were given a choice of station and duty as long as it did not expose them to capture and subsequent interrogation. The Luftwaffe's system of tracking aircrew was excellent and the reappearance of anyone previously reported shot down would put the pilot and his previous helpers in jeopardy.

When Parker returned from Holland in late 1944 he had been debriefed and given a choice of duty and station. He asked to go back to the 7th Group on operational status. Sent to a replacement center in northern England, he persuaded the staff that he had not been with any group that remained in business as an escape route for Allied personnel. He explained that all the territory he had been in was now in Allied hands. Convincing them that he posed no threat to anyone, he managed to get a transfer back to the 7th Group, this time assigned to the 13th Squadron.

On 21 February, Lieutenant Parker flew to Martlesham Heath to pick up two P-51 escorts from the 356th Fighter Group. Lts. Harold E. Whitmore and Russell H. Webb would accompany Parker to the heavily defended area of the north coast of Germany. The little group crossed in at 14,000 feet over Den Helder. They climbed toward their target at Stettin. Parker began fly-

ing his pattern over the city at 20,000 feet. Whitmore, the escort leader flew cover at 22,000 feet to the right and about 1000 yards behind. He spotted an ME262 climbing from behind. The swiftly closing jet had made no forewarning contrails and would be on them quickly. Parker was turning right when Lieutenant Whitmore called over the radio to break away. Whitmore chopped throttle, nosed down, and attacked the jet from 5 o'clock high at 800 yards.

The jet fired at Parker hitting the right engine and left wing outside the boom. Flames burst from the F-5's engine. Lieutenant Webb chopped throttle about the same time, slid high to the outside and fired a short burst that just missed the jet as the German turned to the left. Whitmore attacked again with long and short bursts that scored hits over the whole surface of the jet. The ME262 burst into flames and exploded.

The action over, the two fighter pilots looked for the photo plane. Parker had not replied when Whitmore told him to break. Webb last saw the F-5 flying straight and level on a course of 100 degrees heading for the Eastern Front about 30 to 40 miles away. Only a small fire remained in the right engine. Now neither of the escort pilots could see Parker. When they returned to their base they reported the incident to Intelligence and noted that the PR pilot might have made the Russian lines safely. This report went to 7th Group. The 13th added Lt. Grover P. Parker to the missing in action list until further notice.

Operation Clarion

Weather forecasters had good news for air forces in Europe. After weeks of heavy cloud and adverse conditions, a few bright days lay ahead. Important for photo reconnaissance, clear skies meant Operation Clarion could get underway. SHAEF wanted German communications disrupted by extensive bombing. The air forces had targeted the Rhine bridges and marshaling yards in towns and cities directly behind the front supporting the December and January battles to drive the Germans back from their advance through the Ardennes. Ahead of Allied ground forces lay the boundaries of Germany itself with the great natural barrier of the Rhine. One by one the bridges fell to bombing or destruction by retreating Germans. The Supreme Commander planned to bring all forces up to the Rhine for the final assault.

Eighth Air Force targets in Operation Clarion lay in north and central Germany; some never bombed previously. Many were small and difficult to hit especially without excessive danger to civilians. Bombing must be as precise as possible. To achieve this accuracy, the Eighth's bombers flew at much lower altitudes than usual, some bombing from as low as 10,000 feet. On 22 February 1,411 B-17s and B-24s headed for Germany. Used to large formations hitting targets en masse, the Germans did not realize these bombers would strike in small groups at low altitude. The bombers dispersed widely across the area, hit their targets, and headed home before Luftwaffe fighters could respond to the new tactics in force. Fears of heavy losses failed to materialize and all but one bomber returned safely.

The 7th Group sent its photo planes after the bombers. All of the 13th Squadron's four sorties returned with over 15 successfully covered targets each. From Heligoland to Berlin, where two aircraft covered Berlin's Tempelhof airfield, the F-5s photographed marshaling yards and airfields for damage assessment. Only one of the 14th's five Spitfires failed to get cover of targets near Gelsenkirchen, Paderborn, and Hamm.

Bridges and rail facilities along the Rhine at Cologne, Remagen, Frankfurt, Wiesbaden, and mapping at Limburg filled the 22nd's pilots' assignments. Operations assigned bomber strikes at Kitzingen, Bamberg, and Saalfeld. Lieutenants Carstens and Flowers also tried to cover targets at Nurnburg. They had five P-51s from the squadron as escort flown by Captain McGuire, and Lieutenants Quiggins, Reilly, Pipes, and McKinnon. Carstens and Flowers found too much cloud over their targets but ran a strip north of Frankfurt to bring back to base. Lieutenants Buck, Thomas, Purlia, and F/O M. Dembkowski successfully mapped Limburg. On his second run over the target, Lieutenant Buck saw two unidentified aircraft turn in toward him. The pilot dipped a wing to show his F-5's distinctive profile, identifying himself as a USAAF plane if the others were friendly but they kept coming. Buck turned away and headed home.

Dembkowski also saw a plane he could not identify. While flying over the Aachen area, the flight officer saw a black aircraft, which looked like a Spitfire. It turned in and approached the F-5 intending to get on the PR pilot's tail. Demkowski evaded and soon lost the dark pursuer.

The next day, another fine weather day for bombers, the Eighth hit Clarion objectives again with 1,193

24 Feb 1945. On mission to Germany, 94 BG B-17s fly over clouds that frustrate photo recon. (J. Byers)

Parsons' Overland March

Snow covered the ground at Stalag Luft III. In the distance the men could hear Russian artillery getting closer with each passing day. After four months on half rations, the prisoners received a supply of Red Cross parcels in mid-January. The senior officers put the men back on full rations. They must be ready for whatever might happen. Many exercised and walked the perimeter of their compounds to build up lost strength. It was hard to keep one's mind on everyday things when refugees streamed westward past the camp and the amazing ME262 frequently flew over the camp. At first, rumors persisted that Sagan would be evacuated.

Ed Parsons, like the other prisoners, spent his days making preparations to leave the camp, packing what he could carry out especially the precious cigarettes so useful for barter and bribery with the Germans. Word came from Berlin that the prisoners would remain in the camp. The men continued to play sports, read, exercise, and put on their theater productions while they waited. Everyone noticed the German guards were uneasy. The ferrets in their blue overalls rarely crawled about under the buildings looking for signs of escape tunnels.

The night of 27 January was cold. Snow fell intermittently. Word from Berlin seemed to confirm that the Luftwaffe would not evacuate the camp. In the North Compound theater, Parsons watched the rehearsal of *The Wind and the Rain*. The Americans in South Compound watched a play in their theater. The Senior American Officer in the compound, Col. Charles G. Goodrich, stepped on the stage and announced, "The goons have just come and given us thirty minutes to be at the front gate."

Announcements went out to all the compounds setting times for departure. The prisoners rushed about madly packing and discarding what they couldn't carry. They destroyed everything they had built for their comfort to keep the Germans — or the Russians — from getting it. Bonfires lit up the wire-enclosed sections; the men burned their cabinets and lockers. They left behind all the sports equipment and books supplied by the YMCA.

After South's departure, each compound followed in turn. The men marched past the Red Cross storage area and picked up extra rations, especially cigarettes. Cans opened for just one or two critical items littered the road. Many men had made sleds, which they dragged along with their possessions. Ed Parsons marched out at 0345 hours on 28 January. No one knew where they were headed except that it was away from the advancing Russian guns.

North Compound walked for hours through the snow, a long column of men bundled against the freezing cold under the eyes of their elderly guards. Wind whipped little blizzards about them and made it seem even colder that it was. A few times they stopped to rest but there was no shelter. Few thought of escape. The BBC had sent messages over the camp's clandestine radios that the men should stay together.

The first planned stop was 16 miles away but when North reached Halbau, German guards said there was no room and they must move another four miles to Friedwaldau. Parsons and his companions trudged on through the snow and reached the town at noon. Again there was not enough room but German civilians took some of the men into their houses. As soon as they found out, SS and German police went about the streets ordering the prisoners back out onto the road and berating the citizens for taking in the *Luftgangsters*.

Pushed out into the cold the men from North marched on another four miles to the village of Lieppe. Lieppe had a very large barn that would house the men out of the weather but when they reached their refuge it also was not big enough for all. Fifty of the men bedded down outside on straw piled up in the lee of a barn wall. That night temperatures dropped below zero.

After another shorter march, North Compound reached Muskau where they would rest for several days before moving on. By now, the columns straggled along the road. Parsons watched as men discarded extra provisions. One man, a watch maker, had collected, bartered, and made tools to repair prisoners' watches in camp. Now his small tool box was too heavy to haul any longer, he heaved it off into the bushes along the road. Some men could not go on and the Germans picked them up in wagons and returned them to Sagan where a small medical staff remained with prisoners too ill to evacuate. No one was shot for falling behind. Parsons saw strange sights of prisoners helping the guards as they struggled through the snow. One POW carried the exhausted gaurd's rifle while another supported the old man. Everyone had only one thought in mind — survival.

Muskau offered more shelter for the men. The luckiest found places in a large brick factory where heat coursed through high flat platforms to kilns and drying rooms. The brick was warm and as many as

February March 1945

possible crawled on top to sleep. Other factories and any shelter available gave protection from the cold. Here the men from North Compound rested for three days. Other groups straggled in from Sagan mixing with those from previous columns as the German timetable suffered.

At Muskau, the bureaucratic Germans carefully separated the 500 or so Americans from their British comrades from North Compound. They still had different camps for different nationalities even under such extreme circumstances. British and Commonwealth prisoners left for another destination, the camp at Marlag-Milag near Tarmstedt. The Americans joined others from different compounds and marched on to Spremburg. American's from South and Center Compounds went south to a camp at Moosburg near Munich.

When his column arrived at Spremburg, guards loaded prisoners onto cattle or box cars as trains hauled them up to the sidings. Ed Parsons crowded into a cattle car. The guards pushed more and more men in until 40 or 50 men jammed the space left over after two guards marked off a third of the car for themselves. It was obvious there would be no room to lie down. No one knew where they were going nor how long they would be shut up in the car.

Conditions went from bad to worse. Too many men jammed into too small a space without food, water, or sanitary facilities. Only the strongest failed to get ill from the stench of such foul conditions. The train stopped frequently but the men never got out. Cold air came through cracks in the car and gave a little relief. Parsons could tell by the sounds outside and from the little German filtering through that their low priority train often waited on sidings in marshaling yards. How many damage assessment sorties had he flown covering strikes of French marshaling yards before he was shot down? He had seen the pictures and the thought sent chills along his spine.

The trains hauling prisoners south and away from the Russians carried no marks distinguishing them from regular freight, ammunition, or troop trains. Pilots more recently captured knew that fighters and fighter-bombers often strafed these trains. Now they were targets for their own airmen. Still they did not know where they were headed. They talked about the frightening rumor that POWs were being put in city centers to stop the bombing.

Parsons realized when they reached their destination, Nurnburg, that the big prison camp lay just outside the city, within sight of marshaling yards and the big stadium where Hitler held his Nazi torchlit parades and rallies, the Zepplin Weis. They might as well be in the city center.

Prisoners crowded into the new camp already overrun by rats and crawling with lice. A loud speaker played light operetta and popular music. Parsons translated for other POWs the intermittent messages broadcast over the radio to German citizens – Nazi slogans, heroic myths and folklore, inspirations for war-weary people. Bulletins assured the citizens there were no battle squadrons over the Reich's territory, *Uber dem Reichsgebeit Befindet sich kein Feinlicher Kampfverband.* Ominous words that a large battle formation was headed for Berlin, *Starker Kampfverband mit Spitze auf Berlin* brought secret joy to the POWs. After they learned the opening phrase, they listened at night for *auf Nürnberg* with dread. The RAF came in the night, sometimes without warning, sudden shocks of fright as RAF Mosquitoes pounced. Bombs exploded. Neighboring rail sidings took the blow; the prison camp shook and the sound of twin merlins faded away.

One night Parsons and his companions, many of them bomber crews, heard "Imminent Attack" sirens. Searchlights split the darkness. Flak burst in the air, shrapnel raining down. A shout, "Markers down." Red and green flares fell closer and closer, marking a target too near those watching below. Flame and explosions blasted into the air. Parsons felt the shaking from tons of bombs falling nearby. The POWs' senior officers had demanded slit trenches; the Germans said men outside would be shot. This time the prisoners ran and threw themselves into the freezing holes.

A red glow spread up heavy columns of smoke. Somewhere a great fire burned. It was the Fourth of July but this was no celebration. It was horror up close. The men crept inside shaking with fear and cold.

The Germans crowded more prisoners into the camp. Senior officers filed complaints about conditions and the dangerous site of the camp; both defying the Geneva Convention's prescribed treatment of the POWs. Allied ground forces approached. The Germans, unable to supply enough food through their crippled transport system decided to move the prisoners again. On 4 April the men from Stalag Luft III began the march south to Moosburg. The next day, the Eighth made its last great raid on Nurnburg's rail targets. Parsons and his companions were on the road again.

heavies spread over a large area of multiple targets. Unfortunately, it was not a good day for photography and the 7th sent no aircraft from Mount Farm. Better conditions returned on 24 February. The bombers attacked oil refineries at Misburg and Hamburg as well as U-boat yards at Bremen.

Koblenz was the assigned target for three 22nd Squadron sorties. Clouds prevented all but a small area of cover. The squadron's operation officer Captain Ross had similar weather over his targets at Siegen and Jungenthal. He and Lt. Robert Hall also had rail lines between Nordheim and Orlenbach. Hall's F-5 developed a leak in the aircraft's oil cooler as the pilots crossed in over the French Coast forcing him to turn back to Mount Farm. Ross continued on but 10/10 cloud frustrated his attempts at cover. He returned with photos north of Frankfurt in an area being mapped by the 7th Group.

Lieutenant William C. Smith flew another 22nd Squadron sortie to photograph the St. Nazaire area for defense activity. This was Smith's first mission. He flew down across the Brest Peninsula and found cloud covering everything in the target area except one of the tiny islands just off the coast. Rather than come back without exposed film, he made several runs over the island and brought those back to his base.

Pilots from the 14th Squadron had targets at Hanover, Gelsenkirchen, and on the Rhine at Wesel. The rail bridge at Wesel was one of the Eighth's targets for the day. Lieutenant Sanford covered targets in the Leipzig area. All four sorties were partially successful.

Lt. Jack H. Roberts of 14th Sq.

The 4000th Sortie

A 7th Group and public relations milestone arrived on 24 February as the number 4000 rolled up on Operations' sortie board. For days, squadron C.O.s watched the numbers climb toward the magic number. Who would be at the top of the list when 3999 had been assigned? Squadron operations officers met to sort it out and all said that their squadron should fly the mission. They used every argument in the books trying to justify why their squadron deserved the 4000th. The only way to solve the problem was a time-honored one. They would draw names from a hat. The 14th won.

Again came another decision. Who would fly the mission. The chosen man, his name high on the alert list, was Lt. Jack H. Roberts. His Spitfire would make the run deep into the hot Leipzig area. Just a few days before he had to abort his mission because his oxygen mask failed. This one had to be perfect. Roberts returned after getting pictures at Leipzig and the Mulhausen area to be greeted by his Group C.O. Colonel Humbrecht and the new 14th commanding officer Capt. Gerald Adams. Congratulations from all and a few pictures before he went into Operations for the usual debriefing, ending a safe and successful sortie for the books.

Targets for bombing on 25 February included tank factories at Friedrichshafen, rail, oil, and jet airfields. The weather cooperated for the bombers but cloud covered most squadrons' assigned areas. The 22nd sent out two pilots, Captain McGuire and Lieutenant Gillick to get damage assessment photos of the strikes. Four P-51s from a fighter base accompanied them. The PR planes made runs over their first target. On the way to the next one they came under attack near Tuttlingen. Four unidentified enemy aircraft tried to get at the two F-5s. During the attack, the photo planes and their escorts became separated. McGuire and Gillick went on alone to cover other targets well enough for Intelligence to remove them from the 7th Group's program. Other unidentified aircraft appeared on the return trip but McGuire and Gillick hid in some convenient cloud layers. Running low on fuel they landed at Manston to refuel before returning to base.

The same day, the group commander Lt. Col. George Humbrecht and Lt. Robert Hall took off to cover important assignments. Fighter escort from the 22nd Squadron composed of P-51s flown by Lieutenants Waldram, Reilly, Weir, and Quiggins accompanied them. On the way in, flying eastward at 21,000 feet toward Aschaffenburg, the pilots spotted 18 FW-190s coming in from the east at 10,000 feet. The German fighters made an 180 degree turn and began to climb rapidly toward the PR group. Within three minutes, the Folke Wulfs

reached 20,000 feet. Two of the enemy fighters managed to separate unnoticed from the others and suddenly appeared inside the 22nd's formation, one closing on Hall's F-5. Shells struck his left engine and Hall fell off into a steep dive. Humbrecht called but Hall did not answer and disappeared from sight.

The P-51 escorts engaged 12 of the 190s. Six Germans went after Colonel Humbrecht who managed to evade them. Quiggins, from his position on the right of the formation, turned after the German who had attacked Hall. He fired two short bursts and scored hits on the FW-190. The pilot bailed out leaving his fighter spiraling downward. Two enemy fighters set upon Quiggins firing and hitting the P-51 along the top of the fuselage and tail.

His plane battered but still flying, Lieutenant Quiggins nursed his rough-engined Mustang, with its shot-up tail toward the safety of Allied lines. He found a field near Lille, France, and landed. A courier plane returned the escort pilot to Mount Farm. All of the others arrived at the base and told their story of the action. Colonel Humbrecht reported that he could not confirm that Hall had bailed out and the 22nd Squadron listed Lt. Robert W. Hall as missing in action.

No one flew on the 26th; the field was socked in. Headquarters at 7th Group received word that from 27 February all sorties would carry a different numbering system. The detached squadron in France used an A suffix when it began operations with number 1A as the first sortie out of Denain/Prouvy. Now the other squadrons fell under the same numbering system, each with its new suffix. The 13th Squadron began using B after its sortie number now starting again at 1B. The 14th picked up C; the 22nd, D. After reaching the magic number of 4000 on the 24th, the 7th Group began numbering again at 1. The last number of the old system was 4016, the sortie ending with the loss of Lieutenant Hall.

This new designation had been requested by the main interpretation center as a way to distinguish individual squadron sorties. Through developments under consideration at the highest levels in the 325th Wing and Eighth Air Force Headquarters, the photo squadrons became more independent of each other within the group.

Combat Crew Rest Homes
Senior officers recognized that aircrew needed more than just a few days leave to recuperate from the stress and rigor of combat flying. Long hours in frigid conditions at high altitudes frequently punctuated by fighter attacks and bursting flak pushed men to exhaustion. To give men a place to relax, VIII Air Force Service Command acquired a number of country homes and mansions to furnish restful places for recuperation.

The 7th Group gained access to these Combat Crew Rest Homes for its pilots in November 1944. Few homes had room at any one time for more than 40 officers, or enlisted men. Usually, two men went to the rest home where they found a country hotel atmosphere with opportunity for sports and amusements. Service was on the level of a good hotel's. The men did not have to remain on the property all the time but were free to travel about; they only had to return by midnight.

In late February, Lts. Richard E. Brown and William R. Buck took seven day's leave to stay at Stanbridge Earls in Romsey, Hampshire, a few miles north of Southampton. Romsey lay in the wide valley of the salmon-rich Test River. Water meadows and reed beds lined the banks as the river ran through low chalk hills and spread out with many channels. Several large buildings, most notably Broadlands, the Mountbatten estate, and the 12th Century Abbey contrasted with modest thatched cottages. Stanbridge Earls had room for 30 officers and was the first rest home opened for American aircrew. Brown and Buck found the many-chimneyed house in a woodland with a lawn and back garden sloping down to a tranquil pond. Even though spring had not arrived this early in 1945, the pilots enjoyed the break and, as others before them, brought back high praise to their comrades at Mount Farm.

February at Denain/Prouvy with the 27th
The advantages of being on the Continent did not pay off in January with terrible weather both over targets and the airfield at Denain/Prouvy. The danger of the German counteroffensive in the Ardennes passed with front lines back where they were in mid-December. Nevertheless, the 27th Squadron maintained heavy security at the sprawling airfield where boundaries were irregular, some abutting large industrial buildings. Along one edge of the field lay a village and its cemetery.

Patrolling the dispersal areas offered the guards an opportunity to get away from the cold wind by cautiously climbing into the cockpit of a parked F-5. Cozy and seated up high, the guards could see all around and stay warm during the long night hours. They mustn't fall asleep or get caught as either was a serious offense. Enlisted men from various departments took their turn walking the beat and guarding the area. Except for the winter weather the worst part for many was the patrol next to the little cemetery. Late at night many a guard felt that creepy feeling so well portrayed in the Saturday matinees of their youth. There was just something about a dark graveyard when wind moaned and whistled about a man's head.

Now that possible German paratroops no longer threatened the field and spirits failed to materialize from

Eyes of the Eighth

27th Sq C.O. Major Hubert Childress discusses first fighter escort mission on the flight line at Denain/Prouvy.

the graves, a different danger appeared on the base quite unexpectedly. It happened only once but that was enough to startle one 27th Squadron veteran. Frank Gaccione had taken his turn walking sentry duty near the cemetery and had not been challenged by the unknown. On this day he faced a different threat while walking near the flight line. Gaccione heard a terrible ripping *brrrrrrrrrrrp* as guns on one of the new P-51s fired. Shells arced high enough to miss hitting anything and fell spent into the open field. An armorer working on one of the new P-51 escort Mustangs discovered a faulty trigger mechanism in his ship. It was the first and only time that a P-51 fired accidentally on the base.

The fighters had been needed badly during January when German jets, along with the bad weather, restricted operation. Now, the 27th had pilots trained to fly escort and they anxiously questioned Lieutenant Pircio's weather staff for a clear day to fly the first escorted mission from Denain/Prouvy. Operations cleared three missions for 3 February. The new escorts would go with Lt. John W. Saxton to cover rail and bridge targets near the Rhine. Intelligence also wanted pictures of Duisburg targets long hidden by cloud since the attack by the Eighth's bombers on 28 January.

The squadron C.O. Maj. Hubert Childress and Capt. Robert N. Florine went over the mission with the photo pilot and planned their course. Then they climbed into the shiny P-51s that sported the group's red stripe on the cowling and the distinctive blue rudder of the squadron. Armed and ready, the little group took off and headed for Germany. As much as they would have liked to tangle with the Luftwaffe, the escorts covered their charge while Saxton photographed his assignments and all three returned to Denain/Prouvy. Two of the three missions assigned on 3 February brought back pictures.

Three days later, planes from the 27th out of France flew the only sorties for the 7th Group. Capt. Hector

Gonzalez covered Munster's marshaling yards, hit by bombers on 29 January, and long awaited damage assessment of targets at Dortmund. Only one other sortie brought back pictures that day, more damage assessment of Cologne.

Good news on the 7th that the C.O. had been awarded the Distinguished Flying Cross lessened the disappointment that weather would not improve at the field or in the squadron's target area at least until the next day. How many sorties would find good weather over the targets was still a gamble. Lieutenant Pircio insisted that it looked good for the 8th.

True to his word and prediction, the 18th Weather Squadron's man in France laid out the weather maps and Operations assigned eight sorties. Some targets, bombed on the first of the month would be clear of cloud. The photo pilots had a long list of targets at Mannheim, Kassel, Hildesheim, Magdeburg, Brunswick, Ludwigshaven, and Karlsruhe. All but two sorties brought back photos. All returned safely.

By the 9th of February, the 27th Squadron had flown twice as many successful sorties than in all of January. More promised good weather materialized and the squadron sent off seven sorties. One 14th Squadron Spitfire flown by Lt. Ian Feltham, forced to land at Denain/Prouvy the night before, also flew out of the airfield that day but returned to Mount Farm. The 27th's pilots brought back photos of strike targets at Bielefeld, Dortmund, and Paderborn. Some had assignments covering strips near Frankfurt, Freiburg, and Saarbourg. All were successful.

The squadron's new activity added up to new totals for its veteran pilots. By the second week in February, Capt. Max Alley had completed his 55th mission. Captains Gonzalez and Florine had 30 each. Two other veteran officers returned from leave in the States. Capts. Robert Floyd and Gerald Adams joined their squadron ready for action. For the next few days, bad weather frustrated their wishes with only three missions assigned and one of those recalled.

Finally on the 14th, Operations sent out ten PR planes to Mainz, Frankfurt, Hanau and transportation targets along the Rhine. Capt. Hector Gonzalez found clear skies over the Koblenz marshaling yards and the Siegen area. Within two more days he would have a 35 mission total. The numbers rose fast under clear skies. Only one sortie on the 14th failed to get cover.

All three pilots flying on 15 February returned with photographs. Bradley's First and Third Armies needed cover of the small area of the Bulge that still remained in German hands near Luxembourg. Just northwest of Trier, an important road junction had to be taken. The village of Vianden was in the deep winding valley of the Our

February March 1945

River, a few miles north of where the heavily fortified West Wall (Siegfried Line) lay adjacent to the east bank of the river itself. The main drive to push through the defenses toward the city of Trier had to go through Vianden. Clearing the Eifel Mountain area was the assignment of Bradley's First Army while the Third under Patton would clear the Moselle River to Trier. New cover of this objective dominated the 27th Squadron's immediate program. The three sorties brought back important strips in the Trier-Frankfurt area.

Captain Gonzalez flew one of only two sorties on the 16th, covering a factory and airfield in Mannheim, and targets in Mainz and Frankfurt. He also brought back area cover between Wurzburg and Nurnburg. Poor weather prevented cover in other areas except for a partially successful sortie in the Eifel region near St. Vith and the area of Wiesbaden on the Rhine River.

Nurnburg was cloud-free on the 17th allowing cover by four 27th Squadron pilots. The squadron's commanding officer Major Childress flew to Mount Farm to receive his DFC where he saw the recently transferred new commander of the 14th Squadron Captain Adams. Within two days the squadron added a familiar name to its roster when Lt. Tony Pircio, the 18th Weather Squadron's representative to the 27th, transferred into the squadron becoming Squadron Weather Officer. Grounded by bad weather until the 20th, the squadron attempted two sorties but both pilots failed to find any openings. The next day Operations successfully sent out one meteoroligical flight and one photo sortie.

Better conditions finally arrived on 22 February and Operations loaded assignments needed for its area of coverage into eight missions all of which returned with photos. After very slow days, interpreters had cover of the Frankfurt-Cologne area, Wiesbaden, Euskirchen, airfields at Wiesbaden and Limburg, Rhine bridges including the Ludendorff rail bridge at Remagen, marshaling yards and airfields, as well as other targets along the Rhine. Only two sorties in the Wurzburg area the next day seemed to re-establish the bad weather pattern so prevalent the first two months of the year.

False hope that better operational days were on hand surfaced on the 24th. Three of seven sorties dispatched came back without pictures. One very important strip did get coverage, much needed new photos of the Roer River to Duren. The day before, in the early hours of the 23rd, 2,000 guns of Lt. Gen. William Simpson's Ninth Army thundered for 45 minutes. Every gun that could fire poured steel down upon the German defenders across the river. Operation Grenade had begun. German destruction of the Roer dams turned a Spring-swollen river into a flood and delayed the attack into the heart of the

Denain/Prouvy graveyard for crashed aircraft. P-51D 44-63261 "Hellion" damaged beyond repair in crash-landing 5 Feb 1945. Usable parts will be cannibalized from the wrecks.
(V. Farrow)

industrial Ruhr area originally planned for early February. Previous photo reconnaissance to plan the attack had shown General Simpson where the weakness in the German lines lay and he would exploit it to the fullest once his army crossed the Roer.

Then came three more idle days for the pilots. Only two sorties made it into the air on the last day of the month picking up damage assessment at the Trautlingen Marshaling Yards and Bamberg. During February, the 27th flew 66 photo and 62 fighter escort sorties without combat loss. One P-51 ended up in the aircraft junkyard at Denain/Prouvy after F/O John Ricetti crash-landed "Hellion" on 5 February.

Closing Out February at Mount Farm

The first operations using new sortie numbering left Mount Farm on 27 February. The 14th Squadron's C.O. Captain Adams flew sortie 1C returning with strips of the Rhine near Wesel. Here, the Lower Rhine was wide and ran through flat open farm land. Wesel was the place where Field Marshal Montgomery planned to cross the Rhine. His Twenty-First Army Group began the push to the river in early February. Capt. Arthur Leatherwood, also of the 14th, bought back area cover between Arnhem and Deventer, Holland.

Weather officers predicted that most of the Continent would be under 10/10 cloud on the 27th. Two 22nd Squadron pilots took assignments in an area where there might be some openings. Accompanied by eight P-51 escorts, Lts. Richard E. Brown and John A. Gauss flew above complete overcast as far as the Rhine River. Breaks appeared in the cloud and they turned their cameras on at Crailsheim, Ulm, Schwabisch-Hall, and

279

Tibingen. Schwabish-Hall was a Luftwaffe jet fighter base and the eight escorts kept alert watch over the two photo planes.

Six of the P-51s, flown by Captain Ross, Lieutenants Reilly, Weir, Pipes, Waldram, and Edwards came from the 22nd Squadron. Two 13th Squadron pilots, Captain Kendall and Lieutenant Batson, made up the rest of the formation. The photo planes covered some targets but after finding others covered by heavy cloud, the group headed for Mount Farm. Near Kaiserslautern, Waldram had to drop down to 12,000 feet when his oxygen mask failed. His wing man Pipes went down with him. They saw six enemy aircraft about 6,000 feet below, which started climbing toward the Mustangs as soon as they spotted the two American fighters.

Pipes and Waldram pushed the throttles forward and tried to evade but the enemy fighters continued to climb, closing up behind to 1,200 yards within four minutes. As the Germans closed, the P-51 pilots saw some handy cloud and dove down to 5,000 feet seeking the gray cover. As the cloud swallowed Pipes and Waldram they saw that the Germans were 200 yards to their rear. They raced toward England and lost their pursuers. The photo planes and escorts all returned safely. Lieutenant Gauss had to land at Manston to refuel before reaching Mount Farm. The mission was extremely successful in spite of the cloud and allowed Intelligence to remove five targets from the program. The 22nd marked up sorties 1 and 2D in the new numbering system.

The last day of February proved short on good photo weather. The 22nd sent Lts. Alf Carstens and James Flowers with eight P51s on the only missions for the squadron. Again, four pilots from the squadron, Lieutenants Weir, Pipes, Waldram, and Reilly, were joined by 51s from the 13th Squadron. Captain Kendall led their contingent accompanied by Lieutenants Belt, Schultz, and Davidson. Flowers had turned back with manifold pressure problems when something whizzed past him coming out of the sun. It flashed by so quickly and disappeared, the pilot thought it must have been a jet. There had been no attack and Flowers returned to Mount Farm without further incident.

Lieutenant Carstens found some of his targets under cloud but had good enough conditions over three to remove them from the program. He also brought back photos of Lechfield, Leiphem, Furstenfeldbruck, and airfields at Neuberg. A valuable strip from Karlsruhe to the Moselle River added to his total.

February's weather proved only generally better than January's. This was not true in all squadrons' assigned areas. The 13th found more weather obstruction to good cover than the other squadrons. This situation left the squadron with few sorties to escort and resulted in the use of 13th Squadron P-51s as escort for some 22nd Squadron missions.

The Group dispatched a total of 240 sorties, but did not credit 17 due to failure of aircraft. Losses were heavy. Captain Dixon, Lieutenants Madden, Parker, and Hall were listed as missing in action. Two pilots had bailed out and returned safely, Brabham over London and Bennett near Luxembourg.

March 1945

The Move That Didn't Happen

The three combat squadrons at Mount Farm spent much of February expecting a move to the Continent. As a result of the proposed changes in the 325th Wing, preparations began within the squadrons. Sections accumulated equipment, packed, and did necessary paperwork. Word finally came through that final plans agreed to by SHAEF and the 325th Wing left the 7th Group at Mount Farm. By the first of March the men knew they would not be going to France.

Marshaling yards in Germany, the transportation targets of Operation Clarion, synthetic oil refineries and their companion industries, remained high priorities on the bombing list of both the Eighth and the RAF. The continued menace of the ME262 jet directed strikes at any production facility, even when it only made parts for the aircraft. Bombers hit the jet assembly plants to delay if not stop production. As fast as the Germans produced

Magdelene College Tower and Bridge in Oxford, a familiar sight to 7th Group men in familiar cold and foggy weather.
(V. Farrow)

them the jets went into action in newly created units. Intelligence played a never ending search for new locations. Various channels confirmed that the Germans were moving their factories underground and locating new dispersal areas near forests and highway bridges. There the ME262s could be hidden from cameras, bombers, or strafing fighters. All three photo groups from the RAF, Eighth, and Ninth Air Forces searched for these targets.

As land forces closed on the Rhine River all along the front, photo reconnaissance kept frequent cover available to the British Twenty-first and U.S. 12th Army Groups. One by one the bridges over the Rhine succumbed to Allied bombardment or destruction by the retreating German armies. On 1 March, Lt. David F. Thomas of the 22nd Squadron, accompanied by three squadron P-51s, tried to cover oil installations at Misburg, the marshaling yards at Wilhelmshaven, and a bridge and factory at Bremen but found all under 10/10s cloud.

Operations took advantage of improved weather over Germany the next day. All squadrons put aircraft in the air. The 13th Squadron, after a long period of inactivity, sent one veteran, Lt. Wilbur Bickford over Bielefeld and Cologne for damage assessment. Two pilots, Lt. William J. Harkins and F/O Bernard Q. Springer covered St. Nazaire for defense activity at the German enclave on the French Atlantic coast. Squadron P-51s flew escort with added aircraft from fighter groups. One Spitfire from the 14th, flown by F/O Sam Silliman, made the trip to St. Nazaire. Other Spitfires covered Kassel and Cologne with Lt. Louis Gilmore flying to oil targets around Leipzig, including Halle and Leuna.

Bombers struck oil targets at Bohlen and Rothensee on 2 March with planned strikes the next day at Misburg and Ruhland. Berlin and Misburg were Lt. Denver R. Sherman's primary targets on 2 March but he found too much cloud and photographed secondary targets. On his way home, while flying near Dummer Lake, Sherman saw two enemy aircraft rising to attack. His escort turned into them and the German pilots broke off. Sherman returned to base completing his eighth mission.

The 325th Reconnaissance Wing
Brigadier General Elliott Roosevelt threw a party at Mount Farm on 3 March 1945 to celebrate the first birthday of the 325th Reconnaissance Wing. In January 1944, General Spaatz, commander of USSAF, called Colonel Roosevelt to England for discussions about future reconnaissance needs of the expanding air forces in the ETO. Roosevelt, commander of the Mediterranean Allied Photo Reconnaissance Command (MAPRC), brought members of the 90th Photo Wing to assist him in the planning. They recommended the establishment of a reconnaissance command in the Eighth Air Force.

To plan operations, the high command needed the best information about the enemy, terrain, and weather. The initial assignment involved the invasion of Europe, an invasion planned on a scale never attempted before. This involved not only the strategic interests of the Eighth Air Force but also tactical interests of units with different but vital roles. The 7th Group was the existing American photo recon unit in the Eighth at this time. On 18 Feb 1944 the Eighth Air Force established the 8th Reconnaissance Wing (Provisional) at Chedington and assigned to it the existing 7th Group and its units.

In order to manage the organization and transfer of all necessary men and services, the new Wing utilized various unused units to bring together its complement. As usual the established military Tables of Organization did not fit the requirements to handle a rapidly developing Wing charged with many tasks. The 325th improvised through transfers and redesignations. General Spaatz' directive, with the Eighth's future role in the Pacific in mind, wanted the Wing to be independent and self-contained if it needed to make a major move in the future.

The Americans must work closely with the RAF and Air Ministry to avoid duplication and conflict. They had done so from the beginning. Soon after his 14th Squadron arrived in England, Tom Johnson worked as the liaison representative from Mount Farm to RAF Benson, the primary British photo recon base. Johnson relayed information, sent to Benson from Whitehall in London, to 7th Group Operations. This daily schedule of daylight flights to the Continent allowed Group Operations to plan and plot mission routes away from fighter and bomber activities if necessary.

In March, Wing established subordinate provisional units: 8th Weather Reconnaissance Squadron (H), 8th Weather Reconnaissance Squadron (L) and the 8th Courier Reconnaissance Squadron. The 325th moved to a permanent location at Station 101, known as Pinetree, at High Wycombe, Buckinghamshire, in April. Wycombe Abbey Lodge on Dawes Hill had been VIII Bomber Command Headquarters then Headquarters, Eighth Air Force. The High Wycombe complex contained Camp Lynn, underground facilities and headquarters, as well as the burgeoning lab area under development by the 325th Wing.

As Wing established its command structure and necessary individual units, many of the original detachments changed designations. Specialists to perform the Wing's assignments came from many new units. Early in 1944, the tactical Ninth Air Force's 10th PR Group was stationed at Chalgrove near Mount Farm. Throughout '44

and '45, men from Wing and its components passed through Chalgrove, High Wycombe, Mount Farm, and then Chalgrove again. Eric Hawkinson worked in intelligence, operations, and as a courier with the 325th, beginning at Chalgrove and returning there with the 27th Squadron. Ottaw E. Fulton came to England with the 2nd Photo Tech (redesignated 8th Photo Tech along with 1stPTS), served at Chalgrove with the Ninth Air Force, and worked as an 8th Photo Tech technician in the world's largest photo lab at High Wycombe. He went to Denain/Prouvy and also returned with the 27th to Chalgrove.

In a confusing "march and countermarch" of assignments, the Wing gathered together various units including the 3rd and 8th Combat Camera Units, 1st and 19th Photographic Intelligence Detachments, the 55th Engineering Topographic Company (Avn), 1st Photo Laboratory Section, and the 1st and 2nd Photo Technical Squadrons (PTS). It utilized existing U.S. and British organizations to train its men. Required to train photo interpreters for the Ninth Air Force destined for tactical use on the Continent, Wing sent men to the British PI school at Nuneham Park, a satellite of Medmenham.

Part of General Spaatz' March directive required the Wing to operate day and night photo reconnaissance units; weather reconnaissance and H2X photographic units; prepare target charts, maps, folders, mosaics, enlargements and models; and provide for film processing, production of prints, and preparation of interpretation reports. The 8th Reconnaissance Squadron (Sp) (P) produced prints from H2X radar scope film. The H2X, a blind bombing aid, made radar images of the outline of targets areas. Operations used the photos for target recognition. Technicians of the 942nd Engineering Aviation Topo Battalion prepared target charts, maps, folders, and mosaics. The Photo Technical Squadrons staffed the Photo Laboratory, processing film and producing prints.

The 1st and 19th Photo Intelligence Detachments (PIDs) studied data from various sources and prepared interpretation reports evaluating damage. To improve target recognition and evaluation, the PI detachments established a model makers section. Glenn E. Johnson, 19th PID, worked not only on targets but also made a three dimensional model of the ME163. Based on silhouettes and descriptions from the earliest encounters with the rocket interceptor, Johnson's models were used by General Doolittle and his staff in briefings about the ME163.

Swift development of the Wing soon brought its redesignation and activation from a provisional unit to the 325th Photographic Wing (Reconnaissance) on 9 August 1944. As expected the Wing was assigned to the Eighth Air Force with Col. Elliott Roosevelt in command.

Daws Hill Lodge, High Wycombe.

Previously a bomb group commander, Col. William H. Cleveland became Chief of Staff. The A-1 (Personnel) Officer Maj. George W. Dow handled administrative problems with Capt. Walter H. Scott and Lt. John B. Larkin as Assistant A-1 Officers. Maj. Arthur Powers joined the 325th Wing after service in North Africa and the Italian Campaign and became Liaison Officer at RAF Benson to insure maximum efficiency and prevent duplication of effort. A large complement of WAACs worked with Wing.

General Spaatz' original directive also ordered the 325th to organize and maintain a photo center including a library for films and prints on all aerial photography produced by the Eighth and Ninth Air Force. Wing established the film library in conjunction with its Photo Lab. The directive made Wing responsible for meeting the requirements of the Army Engineers on mapping the continent of Europe. The 7th Photo Group carried out this program in addition to photographing its assigned targets. The 325th maintained direct liaison with the U.S. Army Engineers who plotted the results of the missions.

Weather reports indicated clearing skies over Germany on 3 March. Unfortunately, Lts. J.W. Brabham and R.B. Gillick of the 22nd and their escort of two P-51s did not find clear sky over their targets in the Frankfurt and Siegen areas. On their return they found some clear patches and photographed Neuss and Neuwied. Another area caught on film interested Intelligence as it showed the large Ludendorff rail bridge over the Rhine at Remagen still standing.

The usual target for first sorties, St. Nazaire, had seen its share of new pilots. Four more made the trip on 3 March and flew their 14th Squadron's Spitfires south

February March 1945

across the Channel and Brest Peninsula. Two were flight officers and two, lieutenants. Both F/Os William M. Clark and Alfred Walker brought back photos of the infamous U-boat haven at the entrance to the Loire River. Photo interpreters found ship activity of interest to Intelligence on their films. Lts. Archie N. Nix and Jerome Goebel also completed their first missions successfully.

To cover immediate damage assessment, 13th Squadron Operations assigned Lt. Raymond Hakkila an Eighth Air Force strike scheduled on the Ruhland Oil Refinery. He left Mount Farm and picked up his escort of four P-51 fighters from the 355th Fighter Group at Steeple Morden. Hakkila covered targets on the way in and found open sky over Ruhland. He made two successful runs over the target before the anti-aircraft batteries sent up flak accurate for altitude. The pilot made a diving turn to escape the salvo. Another target at Lauta was covered by cloud. With his escort low on fuel, they returned to England. Hakkila landed at Mount Farm at 1931 hours.

Poor weather for the next three days limited operations from Mount Farm. Bombers continued to hit oil targets at Harburg, Chemical industries at Chemnitz, Plauen, and Fulda as conditions permitted but on 6 March no strategic forces crossed the Channel. Only one aircraft, a 22nd Squadron F-5 represented the 7th Group. Lt. Ellis Edwards covered damage assessment targets at Hamburg and Ludwigslust. March was proving as difficult and as discouraging as the previous two months.

After three days of limited activity the 7th Group tried six sorties on 7 March. The 14th Squadron assigned Lt. Jack Roberts targets in the Leipzig area escorted by three P-51s from his squadron flown by F/O Thomas M. McFatter, Lts. James A. Baird and John Moorehouse. The 13th Squadron sent one of their fighters along flown by Lt. Evan Mecham. Roberts could not find an opening in the clouds and the group turned back for home. Lieutenant Mecham failed to return when enemy action brought down the P-51 and the pilot had to bail out over Germany. His squadron listed him as missing in action.

Partial Quarantine
An unusual directive came down from Wing on 7 March. Orders restricted 7th Group personnel from an area within a radius of two miles from two farms in the neighborhood unless the men used hard roads. Mount Farm was a working farm within an active airfield. It had dispersal areas and runways next to farm buildings, cultivated fields, and pastures. A deadly and devastating enemy had entered this rural area. Hoof and Mouth Disease was a highly infectious, incurable disease affecting cloven-hoofed livestock. It spread easily on men's shoes and boots; truck, car, and bicycle tires; as well as through the animals themselves. Quarantine and destruction of infected animals by burning was the only effective treatment. It was a serious matter, which any farm-raised member of the 7th Group understood well. Headquarters' warning was severe. Wing was determined that no American would carry the disease, even unknowingly, and spread it around the beautiful farmland they were borrowing for the duration.

Crossing the Rhine
North of Cologne, Simpson's Ninth Army closed to the Rhine. By 2 March, aerial photographs showed all bridges across the river destroyed either by Allied bombing or the retreating Germans. All, that is, except the massive Ludendorff Rail Bridge at Remagen. South of Cologne, Hodges' First Army advanced toward the river through hilly terrain. Ahead of the U.S. forces, German refugees, troops, and armor retreated out of the Eifel region across the Rhine. General van Zangen pushed the remnants of his Fifteenth Army toward the homeland behind the great river barrier. At the last minute, charges already in place would bring down the last path to safety.

On 7 March 1945, a detachment of the American 9th Armored Division drove out of the Eifel Woods and reached a high ridge above the river. Ahead, spanning the rushing water lay the Ludendorff Bridge, crowded with streams of people heading east. Without waiting for reinforcements the Americans attacked and overpowered German positions on the west bank in a short sharp fight. Expecting to have the bridge go up underneath them, the men raced across the span. On the opposite bank sheltered in the rail tunnel, the Germans detonated the demolition charges. A small explosion shook the bridge but it held. American troops crossed the Rhine into Germany and quickly established a small bridgehead.

Engineers began removing explosives from the bridge supports and found that a shell had shattered the main line to the demolition charges. Armor and more troops poured across the Rhine to hold the position and enlarge the bridgehead. Headlines shouted, "Americans Cross Rhine." The news elated the staff at SHAEF, charged the ground troops with new confidence, and sent panic through the Germans. Immediately, U.S. Engineers started a pontoon bridge next to the badly damaged steel span and the Germans attacked both from the air with V-2 rockets, jets, and bombers.

Intelligence and damage assessment cover told target planners that the Germans' synthetic oil refineries could not supply all of the country's fuel needs. The lost capacity limited all German forces. Oil was the Achilles'

Eyes of the Eighth

heel General Spaatz had believed it was. Even though badly crippled, factories within Germany continued to turn out tanks and planes but without fuel to run them their numbers meant nothing. Attrition took its toll. Secret intelligence sources kept the highest Allied authorities informed about German intentions. The Germans would not quit.

The bombers continued pounding oil and transportation targets. Sorties brought back damage assessment, pre-strike photos, ground force activity, and cover of areas rumored to hide underground factories and jet assembly plants. They flew strips of highways for photo interpreters to search for signs of use as jet runways. Sometimes the pilots saw trails of rising V-2 rockets now aimed at the port of Antwerp and the newly captured bridge at Remagen. The Luftwaffe still attacked photo flights even when they had escorts.

In the north near Wesel, British and Canadian forces pushed the Germans back across the Rhine forcing them to abandon the west bank of the river. As before, the retreating army destroyed the bridges behind it. Both the RAF and U.S. photo recon covered the Wesel area where Montgomery planned to cross the Rhine utilizing airborne troops. On 13 March Lieutenant Hakkila of the 13th Squadron flew a low-level sortie to get obliques of the paratroops' proposed dropping zones. Low clouds and haze marred most of his negatives of Wesel. While in the area he ran low altitude passes over what was left of the heavily bombed city of Cologne captured by American forces on 5 March. Hakkila returned on 14 March and again covered the Wesel target area bringing back excellent low level obliques to complete his assignment. He returned on 19 March to run a strip from Rees to Wesel covering the Rhine crossing area for Operation Plunder.

Moving to Chalgrove

After preparing in February for the move that never came, the men of the 7th Group continued performing tasks that indicated a big change. Squadron supply officers diligently checked and rechecked inventory, replaced necessary equipment and directed packing and crating of all U.S. property.

Several new F-5s for the 14th Squadron arrived at the other squadrons' flight lines for inspection. Rumors flew. Was it true that the 14th would no longer fly the British planes and this was in preparation for their return to the RAF? Many men figured they were off to the Pacific. By mid-March the word came down that they were moving but it was only a five mile trip. The high command had decided to move the 7th Group over to the larger airbase at Chalgrove. Scheduled to be the first, the 22nd Squadron increased preparations to move by the end of the month. Until then, operations continued as usual.

Fighters from the 357th Fighter Group at Leiston escorted Lt. William Buck when 22nd Squadron Operations gave him a request for photos of the Zossen *Wehrmacht* HQ near Berlin. Weather officers predicted good weather for the sortie on 22 March. Buck got Zossen and other targets in the Berlin area.

That day, Patton's Third Army crossed the Rhine at Oppenheim beating his rival Montgomery's forces across the river. One day later, Montgomery's Twenty-first Army Group began Operation Plunder. Thirteen hours after the initial assault, 14,000 airborne troops landed across the Rhine River behind the German lines on the east bank in Operation Varsity. This assault targeted gun emplacements overlooking the Rhine from high ground north of Wesel as well as enlarged the bridgehead.

On 24 March three pilots from 7th Group flew over the battlefield. The 325th Wing Commander General Roosevelt, Col. John Hoover from Wing, and the 13th Squadron's Capt. Robert Facer covered the landing areas. Facer's F-5 had a forward facing camera in the nose for low level photos. Flying below haze and cloud, Facer brought back excellent photos while the photos

Photo taken from bomber attack on Tegel Airfield in Berlin is marked to show target area. The smoke within the box illustrates how difficult it is to get good damage assessment photos at the time of the strike.

284

taken from the higher flying planes were too hazy for good cover.

A special priority request came to the Group on 27 March for important target information in the Paderborn area where American forces fought to encircle the Ruhr. The 13th Squadron sent Lieutenant Hakkila who had to fly under low cloud in order to complete the job. The RAF sent 268 Lancasters and eight Mosquitoes to attack Paderborn. Although the target was covered by cloud, the British bombers carried out the raid with such accuracy that within 15 minutes they leveled the old town.

Losing the Spitfires
For advance planners, the end of the war seemed near. After a German defeat plans called for American forces including the Eighth Air Force to transfer to the Pacific Theater. All equipment must be American in a predominately American theater to facilitate operations. The 14th Squadron's Spitfires came under this order. The Group C.O. Colonel Humbrecht presided over a meeting on 29 March, where the 14th Squadron learned that the rumored loss of its Spitfires was true. All Spitfires must be returned to the RAF and off the station by the end of the week.

March at Denain/Prouvy
Veteran 27th Squadron pilots added more missions as

Low level cover of airborne landing at Wesel on 24 March 1945 as British cross the Rhine. (J. Ross)

better flying weather developed over the Continent during March. With its base nearer targets, the 27th often took damage assessment missions on short notice. Quickly changing weather was a factor but less flying time to the target often made the difference.

On 1 March the 27th dispatched seven sorties to targets in Germany covering Mannheim, Bamberg, Kaiserslautern, and Germersheim successfully. Good cover of strikes by Eighth Air Force bombers at Bruchsal and damage assessment of Wurzburg, Kitzingen, and the Schweinfurt marshaling yards completed a successful day. Ten missions left Denain/Prouvy the next day but three found too much cloud over the targets and returned without photos. Most assignments were for damage assessment at Aschaffenburg, Nurnburg, Ingolstadt, as well as the marshaling yards at Ulm, Munich, Freiburg, and Augsburg. Lieutenants Purdy and Florine now had completed 40 missions each.

Better Living Conditions
Through diligent work and ingenuity the 27th's enlisted men improved their rough living conditions. They did what they could to make their tents warm and dry. In just 30 days the French built them a red brick building equipped with six showers and other bath facilities. Showers and baths waited a few days while the the men repaired a leaking boiler. Then, hot showers restored morale.

Escorts for photo planes proved successful, either preventing interception or driving off approaching enemy aircraft. On 3 March, the threesome that flew the first escorted mission in February, went out together to cover targets in Germany. Lieutenant Saxton flew one of three successful sorties. Major Childress and Lieutenant Florine furnished his escort. One sortie of the four dispatched found too much cloud over the targets and returned without photos. More cloud on 5 March prevented Lt. Walter B. Ward from successfully completing his 30th mission. Bad weather over the 27th Squadron's area prevented any missions until 9 March when Operations assigned five, all successfully completed. Pilots covered targets in the Ruhr area, Wesel, Duisburg, and Mainz with Captain Gonzalez bringing back damage assessment of marshaling yards at Schweinfurt, Nurnburg, and Lichtenfels.

While coming in for a landing on 12 March, Lt. Floyd R. Clark, Jr., overshot the runway, cleared some warehouses along a canal bordering the airfield and crashed into the water. Cranes hauled his F-5 out. Clark luckily suffered only small cuts on his hands and face.

Not until 13 March did the squadron find enough clear sky to send more than one or two sorties. Two of the ten missions on the 13th were meteorological flights

Eyes of the Eighth

Clark's F-5 pulled from the canal bordering Denain/Prouvy Airfield, France. (H. Gonzalez)

sent ahead to scout conditions for the bombers. They reported the target areas cloud covered and the Eighth Air Force canceled the strike for that day. The other seven sorties brought back photos with heavy coverage taken of the Giessen-Frankfurt-Rhine River area where bombers had concentrated strikes the previous week. A ME163 Komet rocket interceptor attacked Lt. Ronald W. Harmon but failed to do any damage.

After the Rhine crossing on 7 March, 27th Squadron Intelligence received requests for new cover where ground forces were clearing the Germans out of the land between the Moselle and Rhine Rivers. Good weather on 14 March allowed Operations to send 19 aircraft for new photos for one part of the job. In this section, between the Main and Rhine Rivers, were the cities of Frankfurt, Heidelburg, Mainz, and Aschaffenburg. Eighteen sorties were successfull

The 27th flew eight successful sorties on 15 March before another period of limited operations until the 19th when only one of seven was successful. Most of these flights deep into Germany had escort fighters. Lts. John Moorehouse, Melvin G. Owen, James G. Fellwock, and Walter C. Davis of the 14th Squadron flew four P-51s over to escort a 27th Squadron sortie to Fulda and Giessen. Fortunately, on most of these days flak was light and no one suffered damage.

At Denain/Prouvy, 27th Squadron mechanics added to the escort inventory by building a P-51 from salvage. This field still claimed a stray and wounded plane from action over Germany. When good parts remained on a scrapped wreck the mechanics didn't see why they should waste them. They built a perfectly good fighter even if it had a mongrel background.

On 22 March the squadron celebrated the return of all five sorties, which covered multiple targets on their assignments with no damage or losses. The main cause

for celebration was squadron C.O. Major Childress' completion of the 200th mission from Denain/Prouvy. He also had completed 200 operational flying hours. The squadron succeeded with all eleven of its missions flown on 25 March and brought some big numbers to total missions. With a few days of good weather, the roll stood at Captain Floyd, 50; Captain Gonzalez, 45; Lieutenants White and Ward, 45 each; Lieutenant Harmon and Saxton, 35 each; Lieutenants Ness, 30 and Farrow, 20. March ended with two successful sorties on each of the last two days. The squadron flew 114 photo and 103 escort sorties without a single combat loss.

High 7th Group Numbers for March

Prior to March 1945, the largest monthly total of 7th Group operational flights was in August 1944. In March 1945, 31 flying days enabled the Group to dispatch at least one aircraft, and on some days more than 20 each day amassing a total of 781 accredited sorties, 363 photo missions and 418 fighter missions. The photo missions had an 86% success rate, a figure identical to August 1944 when they dispatched 546 missions, with 484 successful. Ninety percent of the fighter escorts were effective thereby giving due tribute to the maintenance section of the Group.

Fighter escort enabled many photo missions to succeed where they might have failed before. The fighters kept down losses which had been particularly heavy in the month of August 1944, which is used in comparison. The one loss to the Group was from one of these escorts when the Germans shot down Lt. Evan Mecham's P-51. Flying hours for March 1945 exceeded those of August by 1,557 hours in spite of preparations for the move to Chalgrove.

Hildesheim Metal Works before and after 8AF raids. PR cover by Capt Hector Gonzalez of the 27th Sq. (H. Gonzalez)

286

CHAPTER 17

April May 1945

Targets marked on Intelligence wall maps changed every day. Colored pins marked their priority. As each day passed all the subjects for photography clustered ever increasingly in the heart of Germany. By the beginning of April 1945 Allied troops were across the Rhine all along the front. The U.S Seventh Army captured Schweinfurt on the 8th. On the Eastern Front Russians massed for the attack on Berlin. The Germans fought ferociously, battered by RAF Bomber Command, the Eighth Air Force heavies and tactical air forces. Supreme Commander General Eisenhower's aim: The destruction of German forces and their ability to resist.

Major changes affected the 7th Group in April. The move to nearby Chalgrove, Station 465, continued. Wing's decision to put all of the group on one station required a much larger one than Mount Farm. Chalgrove was a base built for an American unit. This move would return to the RAF its much needed satellite field to Benson. Two combat squadrons from the 7th Group were operating from Chalgrove by early April. The 22nd Squadron moved on 24 March. The 14th Squadron, no longer equipped with Spitfires, completed its transfer to the new base on 2 April 1945 with its new F-5s. Group Operations arrived on 4 April and all squadrons continued flying missions during the move, aircraft flying from both fields for a short time.

In the middle of a squadron move, a pilot might take off from Mount Farm and land at Chalgrove. Part of this success was due to the smooth move of the Group's VHF/DF Station, considered one of the best in the United Kingdom. The Group Communications Department moved the DF system without loss of any operational time. This pleased the 14th Squadron's Communication Section, as they made a large portion of that move. While operations continued during the transfer, Flying Control operated two stations for almost a month. Their watch at Mount Farm closed at 1700 hours 8 April 1945.

When necessary, squadrons helped each other out. The 14th's Photo Lab had a building assigned to them that was not appropriate for a lab. They quickly remodeled it. While the work was in process the 22nd's lab, which was already in operation, processed the 14th's film. Even though the new base was very large and spread out, headquarters, group operations, teletype, plotting, the message center, and photo interpretation offices were centrally located.

General Roosevelt received a special letter at 325th Wing Headquarters. General Jimmy Doolittle, commanding general of the Eighth Air Force, wrote in appreciation of photo reconnaissance efforts in support of Ninth U.S. Army, First Canadian Army, Second British Army, and First Allied Airborne Army operations in their crossing of the Rhine at Wesel, Germany. The letter made a particular point about recon that supplied the exact position of high tension power lines in the Wesel area, which constituted a major operational hazard to the re-supply aircraft. Roosevelt added his own thanks before posting the commendation.

Weather officers predicted breaks in the clouds over the 22nd Squadron's area on 2 April and they dispatched five sorties. Capt. John Ross and Lt. Richard E. Brown with four P-51 escorts attempted cover of Grottingen and Aschersleben-Halle areas. The predicted holes in the cloud did not appear and except for a strip run near Munster, they returned without photos. Flak activity on the Goedereede Peninsula of Overflakee Island, the northern island of the Scheldt group was Lt. W. R. Buck's assignment. Although some photos had cloud over part of the area, the photos removed the job from the squadron program.

Flying an F-5, 14th Squadron pilot Lt. Richard Vanderpool took the only mission on the third, photographing targets in the Kiel area. The next day, both the 14th and 22nd assigned sorties. The 22nd Squadron had good results with four dispatched. Lts. Robert R. Gillick and Sam L. Purlia, escorted by four P-51s, found 10/10s cloud at their targets. They flew eastward looking for breaks in the cloud layers and photographed a town and airstrip in Russian-occupied Poland. Fortunately the Russians, who did not like such over-flights, did not fire on the intruders. The two pilots also brought back photos of Potsdam/Werder airfield and the Magdeburg/Buchau marshaling yards.

In spite of expected cloud, the 13th's Lt. R. W. Riley flew to the Leipzig-Plauen and Kassel areas. Five P-51s flown by Captain Batson, Lts. David T. Davidson, William V. Malone, Charles H. Cole, and Irving L. Rawlings furnished escort. The predicted cloud offered no openings at Leipzig and the formation returned on a course for Kassel where Riley found some small breaks over the airfield and marshaling yards. On a second attempt to get the same targets, Lt. Carter Hitt tried the next day, escorted by six Mustangs flown by Captains Shade and Kendall, along with Lieutenants Davidson, Goodison, Hakkila, and Malone. Just before reaching the Rhine, William Goodison had supercharger trouble and returned to base. None of the targets were open and they turned back. When the formation crossed out over Dunkirk, the German flak batteries fired several rounds at them reminding the pilots that there were enclaves along the

Eyes of the Eighth

Lt William C. Goodison, 13th Sq, and his P-51 Minnechacha.
(J. Weeks)

French coast where an accurate flak battery could catch an unwary pilot. One burst hit Captain Kendall's P-51 in the engine and it lost oil pressure. He had to land at RAF Biggin Hill. From there Kendall caught a ride home in an A-20 medium bomber.

Four 22nd Squadron P-51s flown by Capt. Stanley Reilly, Lts. Alf Carstens, John A. Gauss, and Charles A. Sarber escorted Capt. John H. Ross to the Leipzig area to cover bomber strikes but solid cloud extended up to 30,000 feet. They returned without photos. Gauss had engine trouble with his P-51 and had to belly in at Chalgrove damaging the gear and propeller. Operations assigned other strikes at Unterschlauers/Bach Airfield, Furth, Ingolstadt, Regensburg, and the Nurnburg marshaling yards to Lt. John W. Brabham. Again, cloud covered the targets where bombers could use the bombing aid H2X. Brabham only found a small break at Regensburg where he could just cover the marshaling yard.

Sarber

In spite of a discouraging forecast on 6 April, the 22nd's C.O. Capt. Troy McGuire tried to get damage assessment cover after bomber strikes at Halle and Brunswick. His escorts were Capt. Harold Weir, Lts. Alf Carstens, Charles Sarber, and David F. Thomas. Clouds covered most of his targets. The bombers used H2X in the Leipzig area but the only break in the clouds pictures came in the Munster and Scheldt areas.

Over Munster, after leaving the last target at Brunswick, Lieutenant Sarber's P-51 developed a coolant leak that soon covered his canopy. Sarber was at 23,000 feet and could not see out of the cockpit. As he lost altitude, he called his formation and reported his problem. Then he called an American radar station that told him his present course would take him over friendly territory. He continued to let down flying westward on instruments through heavy cloud. Smoke filled his cockpit. He could no longer see the instruments he depended on. Sarber opened a ventilator to get rid of some of the smoke and made another call to the radar station. Informed that on his present course, air speed, and rate of descent he could land at Munster.

Sarber didn't think so and radioed to report a small break in the clouds. He had to land now. Red flames shot out of the exhausts. The pilot increased the throttle, cut the gas mixture leaner and the flames stopped. Sarber circled down and looked through the side of the canopy. He picked out a field and leveled off about ten feet above the ground. Sarber saw his indicated air speed at 140 miles per hour then everything went blank. He came to, climbing out of the cockpit. White plaster and cement dust was everywhere. The pilot brushed at his clothes and helmet, dust flying. He seemed to be in a pile of rubble.

A man rushed to help him. Sarber didn't recognize the language but the man was friendly and concerned. His rescuer took him to a nearby farmhouse where the American became the center of attention. He learned the man was Yugoslavian. A German civilian doctor cleaned Sarber up and washed some bleeding cuts on the pilot's forehead and hand. He couldn't bandage them as there were no dressings.

The Yugoslavian sent for help. Men arrived in two jeeps and went to look at the crash site. They told Lieutenant Sarber that he had flown his P-51 into an unoccupied brick farmhouse. The plane had gone almost all the way through and demolished the house. Only the Mustang's cockpit was left. Everyone agreed that Sarber was one lucky fellow. The men took him to Munster. At a First Aid Station, the medic gave him a tetanus shot. Aches and pains began to develop from the impact. Later in the evening he traveled 30 miles by truck to a field hospital where doctors examined and X-rayed him. The final accounting was a broken tooth, a slight cut on the back of the hand, a cut lip, and a swollen jaw.

He spent the night in the hospital, was cleared by the medics, and went by ambulance to an air evacuation strip where he caught a ride back to England. Sarber phoned Chalgrove as soon as he landed. A 381st Squadron C-47 picked him up and returned the lieutenant just 36 hours after he had taken off setting a record for a crash landing in Germany and return home.

Better weather encouraged 13th Squadron Operations to try the targets near Leipzig again. Persistence paid off and they got cover on 7 April. In the same area, General Roosevelt and his Chief of Staff Col. John Hoover of the 325th Wing flew 22nd Squadron damage assessment sorties of targets at Halle, and Eisleben. Lieu-

April May 1945

tenants Waldram, Pipes, Flowers, and Gauss flew escort. Large clear breaks in cloud layers over the targets allowed good cover of all the targets except Brunswick and removed five from the flying program. The formation sighted four P-51s chasing two ME163 rocket planes at 8,000 feet southwest of Brunswick. They saw another ME163 climbing through 23,000 feet near Halberstadt but it showed no interest in them.

While flying a sortie with a fighter escort over Leipzig on 8 April, the 13th's Lieutenant Hitt saw three ME109s. They followed him over his target courses until he approached Weimar on the return. Two were black, the other either white or silver. He spotted a third flying off his left wing. None of the aircraft attempted to make a pass at him or his escort. At Chalgrove Intelligence listened to Hitt's description of the aircraft he had seen. One sounded like the Rechlin-66, an experimental aircraft recently seen on photos of Rechlin Airfield from another sortie in the same area. Rechlin was a major experimental facility of the Luftwaffe and where photo interpreters first saw the aircraft, hence the name.

The next day, Intelligence learned more new information from Lt. Wilbur Bickford when the 13th Squadron pilot returned from a sortie with word that he could see Allied ground troops very close to his objectives in the Plauen area. The pilot said that he saw small fires burning in many of the communications centers throughout the Saalfield-Plauen area. He reported that the smoke pall over Saalfield rose to around 5,000 feet and the Germans had their smoke screen at Saalburg Dam operating. Lieutenants Weeks, Clark, Harkins and Flight Officer Springer returned from mapping between Chemnitz and Dresden with similar information describing how fires marked both the Eastern and Western Front lines.

Two powerful forces squeezed Germany ever tighter. Russians advanced from the east; American, British, and French armies drove toward them from the west. The Eighth's bombing list and the 7th's photo subjects fell to Allied troops every day. There were not many places left where heavy bombing could continue without endangering ground forces. The danger from flak continued but on a smaller scale and in a smaller area except for concentrations in the Berlin and Leipzig areas. Jets still went after unarmed photo ships. Only with escort could single PR planes penetrate what was left of the Nazi Reich.

Mapping took on more importance. SHAEF requested mapping in the Eisleben area, which Lieutenants Purlia and Gillick covered on 9 April before completing another mapping assignment in the Leipzig area. Two other 22nd Squadron pilots, Lieutenants Brabham and Brunell had similar mapping strips on their flight plan.

The four F-5s picked up P-51 escorts from the 349th Fighter Group at Foulmere. The photo planes split into two elements after crossing the Channel, each with two checkerboard nosed '51s for protection.

Brabham covered parts of the Eisleben strip. Over the target his two escorts peeled off to join Lt. Brunell's escort. Just as Brunell reached the Halle area two ME262s came up after him, one directly under and the other from the right. He did a Split-S to 15,000 feet. One jet followed but as Brunell pulled out he lost the German. As he evaded, his escort, joined by Brabham's, attacked the jets damaging one and bringing down the other. Everyone returned to base safely; the photo planes with good cover.

Only one incident marred mapping sorties on the 10th. Lt. Carter Hitt, 13th Squadron, lost an engine on his first run while flying in a group assigned to finish mapping from Chemnitz east to the Elbe River. He feathered the engine and completed two more runs then turned back. All the other pilots and escorts returned to base safely. Hitt had to land at an airfield in France when his other engine became too rough. He stayed there overnight and a C-47 brought him back to Chalgrove Airfield the next day.

President Franklin D. Roosevelt died on 12 April 1945, at Warm Springs, Georgia. The word of his death stunned the world as it swept across the airwaves. At Chalgrove it was a far more personal loss because the 325th Wing Commander Brig. Gen. Elliott Roosevelt had lived in one of the farmhouses at Mount Farm. Flags flew at half-staff, the Group canceled all social functions at Chalgrove for a one week period of mourning in respect for the late President and General Roosevelt. The Group planned memorial services to be held at 1700 hours on 15 April.

After noisy days with large groups of planes taking off, Chalgrove grew much quieter on 12 and 13 April when weather over the Continent deteriorated. Marginal conditions limited missions although Eighth Air Force heavies bombed the German garrisons in the Gironde on 15 April hitting gun emplacements, strong points, and flak batteries in support of French ground forces attempting to free Bordeaux. Lieutenant Harry B. Cate of the 13th Squadron had approximately 19 small pin points to cover. The lieutenant arrived over the targets during the bombing and had a grandstand seat. He got good photos of the strikes marred only by smoke from the bombs, which obscured some portions of the targets. The 14th Squadron's Lt. Ira Comstock filled in the cover on 16 April when the smoke had cleared.

The 14th lost a P-51 pilot on the 16th. Flight Officer Willard H. Watkins and Lt. Richard M. Bennett took off

Eyes of the Eighth

as escorts for Lt. Gerald Glaza to run damage assessment strips to Straubing and Daggendorf. Glaza also covered the Eighth's bomber strikes on rail and communications targets. Over Ingolstadt the engine of Watkins' Mustang quit and the pilot had to bail out. Fortunately he was over friendly territory.

Another 14th Squadron escort ran into trouble the same day. This P-51 pilot came from the 13th Squadron. Flying as escort for Lieutenant Vanderpool, Lt. David T. Davidson radioed Vanderpool over the first target just south of Munich that he was having trouble with his engine. He said he was returning to base. Fifteen minutes later, Vanderpool called him, learned that Davidson's engine had just quit but that he had gotten it started again after losing quite a bit of altitude. The radio contact was faint and Vanderpool could not raise Davidson again. Vanderpool successfully covered his targets, returned to base, and reported the incident. The squadron waited for more information.

April at Denain/Prouvy
Operations began slowly in April for the 27th Squadron. The squadron's new area of cover encompassed Leipzig, Dresden, and Lake Constance in Germany; Linz, Salzburg, Innsbruck, in Austria; and Prague, Czechoslovakia. Spring weather slowly improved but cloud often covered both the airfield and targets. Four airfields in Prague made up the target list on the first sortie of the month on the 4th, the only one of the day. Two out of three failed to get pictures on the 6th but on one of three successful sorties flown the 7th, C. O. of the 27th Major Childress completed his 55th mission. The squadron attempted 11 sorties on 8 April, three returned without

Capt Hector Gonzalez, Lt Howell Hanson, Capt Robert Floyd, and Lt James Coleman enjoy a sunny Spring day on the Chateau Regie steps in Valenciennes, France. (J. Farrow)

photos due to clouds over the targets, and eight pilots successfully covered targets in the Plauen-Leipzig area and Friedrichshafen.

Capt. Hector Gonzalez photographed targets at Ingolstadt on the bombers' schedule the next day. His flight took him to Nurnburg and beyond the city where steams of refugees moved south along the roads. Intelligence wanted reports of these movements. SHAEF knew that Allied prisoners of war were moving within these columns. Five more sorties covered the Karlsbad-Prague area on the 10th. Bombers continued to pound the remaining targets inside Germany requiring damage assessment by the 27th. Captain Gonzalez covered Bayreuth following the 11th with a mission deep into what remained of enemy territory. His 50th sortie covered targets at Pilsen and Brux, Czechoslovakia.

Within the 27th Squadron's area lay secret industries of the Reich. Heavy bombing drove industry south to rugged regions where factories and assembly facilities operated in tunnels burrowed deep into mountains. The Germans moved much of their rocket development and construction into these locations. Intelligence directed toward German V-1, V-2, and other rocket programs needed new information about rumored sites deep in Germany and parts of Czechoslovakia. The committee directing countermeasures against this threat requested 7th Group to get cover of an area where they suspected three tunnels, code named Richard I, II, and III. The 27th flew one sortie over the area on 9 April and two more on the 11th. All three missions brought back excellent photos revealing entrances to tunnels in the east flank of Bidnice Hill near Leitmeritz (Litomerice), Czechoslovakia.

Photos showed two entrances to Richard I, a dispersal area for V weapons hidden deep in galleries cut into the hill. Intelligence made the tunnel a high priority target when it believed operations there began in December 1944 and included production of a new "panzer wagon." Further intelligence indicated that Richard II had begun production of precision instruments for V-1, V-2, and V-3s on 1 March 1945. Richard III remained a more secret site, even though photos revealed its entrance and the same company occupying Richard II was believed to occupy III as well. Intelligence produced a lengthy report based on information gained from the 27th's photos.

Better weather allowed the squadron to send more missions out regularly. The 7th Group requested two missions outside the 27th's usual area to augment cover by two Chalgrove based squadrons. On 14 and 15 April, Eighth Air Force bombers targeted batteries and gun emplacements, flak batteries, and strong points in the

290

April May 1945

Moving day at the Chateau Regie for 27th Sq Hq.
(E. Murdock)

Gironde Estuary on the French Atlantic coast. The attacks were near Royan, Pointe Grave, and Point Coubre in support of French troops attempting to clear the German enclaves in the area. A sortie on the 15th brought back photos of the targets but one escort, Lt. Allen E. Barnes' Mustang crashed and burned on takeoff. Barnes escaped injury.

That same day, the 27th lost another P-51. While on instruments in bad weather over Meiningen, Germany, Lt. Shirley Tubbs' Mustang broke up in turbulence. The plane, minus the part of its left wing and tail, fell off into a spin. Tubbs bailed out and landed safely in Allied territory The pilot hitch-hiked back to base, and picked up some souvenirs along the way. When he arrived at Denain/Prouvy two days later he had a large Nazi Eagle plaque. Another souvenir collector, Pfc C.H. Brooks, was not as lucky as Tubbs. He lost two fingers when some ordnance he had collected on base exploded.

Orders came on 16 April for the 27th to prepare immediately for its return to England. The move to the new airfield at Chalgrove would begin in two days. Every department worked to get ready. The squadron set up a shuttle of C-64s and C-47s to move all the men and equipment that could be moved by air. Pilots would fly their aircraft back. Except for the final closing up at Denain/Prouvy the squadron had 11 days to complete the move. The first flight carried one officer and three enlisted men on 18 April 1945, as an advanced detail. Sgt Edward R. Murdock of Photo Supply was assigned to set up the Photo Lab. He had been the last man to leave England and would be the first to return. The second flight carried only two enlisted men accompanying equipment. From then on, daily flights ferried most of the men and equipment to their new base. Operations continued unabated during the move until the planes returned to England on 20 April.

Ward Lost
The day before the scheduled move to Chalgrove, 19 April, Operations assigned five targets in Germany to Captain Gonzalez. As escorts for the flight to cover Straubing, Passau, Freising, Memmingen, and Berchtesgaden, Gonzalez had Lts. Ray Workman and Walter B. Ward, the latter one of the more experienced escort pilots in the 27th. The previous month, Ward amassed a total of 64 hours on 19 escort missions flying P-51s. Captain Gonzalez made his photo runs and the formation started back to Denain/Prouvy flying westward toward Frankfurt. As soon as they reached friendly territory they let down from their operational altitude to fly down the Rhine River at low level for a few miles.

All the territory between them and their home base securely in Allied hands, the three pilots considered the river safe for lower altitude flying. Gonzalez led the way following the Rhine toward Bingen where the river turns sharply north. The flight would leave the river at Bingen and continue west toward northern France and Denain/Prouvy. As the planes flew up the Rhine between Wiesbaden and Mainz, the river was wide and looked benign in the late afternoon sun. Workman flew on the left about a mile off and behind Gonzalez with Ward on the right in about the same position. As they approached Bingen the Rhine ran between hills that rose gradually until the river turned sharply north and rushed through a narrow passage called the *Binger Loch*. The picturesque legendary Mouse Tower fortress built on an island in the middle of the Rhine guarded the entrance.

The F-5 and two P-51s flew 100 feet above the water and closed tighter as the river narrowed and hills rose sharply on either side. Gonzalez flew the lead as they approached the Mouse Tower, his escort close behind and now only about 50 feet away on either side. Ahead lay 12 to 15 heavy copper communication wires strung by the Signal Corps from one side of the river to the other. Anchored in the middle of the river on the Mouse Tower, the wires sagged toward the water on either side. There were no markers or warning streamers.

Tearing down 27th Sq tent city at Denain/Prouvy before return to England.
(E. Murdock)

Eyes of the Eighth

Gonzalez radioed his escort and glanced over to check their position in such close formation. He turned back to follow the river. Below the hills in the shadows of late afternoon Gonzalez could not see the wires until he was on them. He caught a glint just in front of him and tried to pull up. The F-5 shuddered as the propellers cut the wires and whipped them into the air. The tough, heavy F-5's air speed dropped. Gonzalez saw no obvious damage and pushed his engines to full power to maintain altitude. The pilot called his escort. Ray Workman told Gonzalez that Ward's Mustang hit the wires and crashed into the Rhine, exploding on impact. Workman was sure Ward had been killed instantly.

Gonzalez tried to radio the base to notify his C.O. He could talk to Workman but the wires had ripped off his antenna and he could not raise the airfield at Denain/Prouvy. He told Workman to radio and have Major Childress meet the planes when they returned. Childress was there when they landed and listened to the report. Then he and Lt. Robert Florine flew back to Bingen. Searchers found only one drop tank in the swift river, the wreckage carried away by the Rhine. They stayed overnight and learned that other aircraft had tangled with the wires. Eventually, the Signal Corps hung warning streamers. Bulletins sent out to units flying in the area warned of possible dangers there and at other crossings. A Board of Inquiry declared it an accident with no blame attached to any of the pilots. Gonzalez took the loss particularly hard. He and Ward, both over 30, were the two oldest pilots in the squadron, but Ward was married with a family.

Six sorties flew out of Denain/Prouvy on the last day of operations from France on 20 April. The planes completed their missions and landed at Station 465, Chalgrove, England. Captain Gonzalez took one of the sorties and covered Chemnitz and Dresden before flying back to England.

Lt Walter B. Ward sitting in cockpit of his P-51. Ward later killed at Bingen on the Rhine River. (Doc Fritsche)

Lt E. Bruce Edwards flew signal detection missions in this P-38J Droop Snoot. The extended nose contained space for electronic equipment and an operator. (E. B. Edwards)

Wandering Gypsies

Not everyone accompanied the 27th Squadron to Chalgrove. Temporary duty on another airfield at Etain, France, claimed 16 men. Six men from the Mobile Homing Unit, Walter Medrela's "Wandering Gypsies," stayed behind. Only attached and never assigned to the 27th, the nomadic unit filled a transient position that led to the nickname.

Medrela arrived in England with a P-47 unit, the 359th Fighter Group. He then went to Bovington where he worked on the P-38J Droop Snoot with one of the top test pilots in the Eighth, Col. Cass Hough, and Tony LeVier, a Lockheed civilian test pilot. During its testing period as a precision fighter bomber and electronic countermeasures aircraft, Medrela flew in the Plexigas nose. Pilots from the 7th flew Droop Snoots on electronic search missions out of Foulsham and Alconbury.

Just before the 27th moved to France, Medrela and his six "Gypsies" were attached to the 27th. The unit ran the homing station at Denain/Prouvy, as long as the squadron operated from the field. From Denain/Prouvy the unit moved to an emergency landing strip in Briey, France. After serving that field they checked into 7th Group with their equipment, were assigned to the 361st Fighter Squadron in Ipswich for passage home.

Cold weather and many changes greeted the 27th Squadron at Chalgrove. Many of the veterans had over 40 missions, some over 50. Five replacement pilots transferred into the squadron on the 23rd, Lts. John M. Bowen, Edward F. Block, Jr., Shelby F. Boggess, Jr., John B. Kirkpatrick, and LaVerne S. Carlson. Enemy territory shrank leaving less combat sorties for the pilots. After its return to England, the 27th Squadron flew only two operational sorties from Chalgrove on 25 April. Both were unsatisfactory with cloud over the target. No other operational flights were made during the month. During April the squadron flew 84 photo sorties and 77 escort missions.

Major Changes

Through the latter part of 1944 and into February 1945, the 325th Wing grew rapidly and expanded its facilities to handle increased responsibilities. Different organizations fulfilled the enormous task assigned to it. Various commands using Wing's talents needed different types of photography, not all by photo recon squadrons. Duties of the 8th Combat Camera Unit, made up of camera crewmen and photographic technicians, covered a broad spectrum. Photographers flew on bombing missions gathering images of targets, bomb fall patterns, whatever was needed to improve attacks on Germany. The 3rd CCU filmed the Glenn Miller concert at High Wycombe. On an August 1944 Aphrodite mission, SSgt Augie Kurjack caught the premature explosion of the drone on his movie film. It was this diversity and Spaatz' directive that encouraged Wing to seek more independence.

General Roosevelt sought to develop an entirely separate and independent U.S. photo and intelligence organization. In January, Wing opened the 325th Reproduction and Interpretation Center on the Continent at Virton, Belgium. There, Wing maintained a central film library and a facility to handle photographic and interpretation reports for the Ninth Air Force serving the Twelfth Army Group. Roosevelt wanted to take most of the Wing's operations to the Continent independent of the long established British photo interpretation and intelligence service in England. Through discussions and conferences, both British and American interests agreed that duplication of the two services was not in the best interest of either. Instead, Wing would reorganize and consolidate. This decision moved the 27th Squadron back to England and the 7th Group to Chalgrove.

More than the new Chalgrove base greeted the 27th on its return to England. Changes in the organization of 7th Group and the 325th Wing affected all the units on the field. In a efficiency move on 15 April, the veteran 381st Air Service Squadron became the nucleus of the newly activated 451st Service Group, Lt. Col. John R. Whitson commanding. Planned to utilize a new Table of Organization, the 451st absorbed units and men from the 55th Station Complement, Fire Fighting Platoon, and Military Police. Also activated the same day, the 681st Air Material Squadron gathered staff from all units on the base. The Air Corps Supply transferred intact as did the Quartermaster Squadron. Although the new group was intended to improve and concentrate all the services necessary on the base except operations, the men soon realized that its Table of Organization also fell short of the needs and everyone was doing more than ever before.

As the 7th Group pilots photographed the shrinking Reich during April, many of their fellow pilots held prisoner by the Germans were on the move. The Luftwaffe moved most of its aircrew prisoners of war away from the advancing Russians.

The Eighth flew its last operational bombing mission on 25 April over Czechoslovakia and Germany. The 7th Group flew 14 missions that day, all but one successfully. At the end of the day the heavies stood down. Preparations for transfer to the Pacific began. The 7th still had work to do in the ETO and its future was less clear.

The 13th Squadron fittingly flew the Group's last three operational sorties. Lieutenant Bickford covered Berlin and saw great columns of smoke rising from the Tiergarten district of the city. Lieutenant Vaughn covered the Salzburg airfield, the Berchtesgaden area, and Muhldorf. Lieutenant Weeks photographed Karlsbad and airfields at Prague. While over Prague/Ruzyne airfield he watched several ME262s take off. A short time later he sighted one ME262 trying for position to attack, but he was able to evade him and returned to base safely.

That same day, 25 April, elements of the US First Army met elements of Konev's Third Ukraine Front on the Elbe River at Torgau. Farther north, Zhukov's and Konev's forces completed the encirclement of Berlin. In the south, Patton's Third Army crossed the Danube near Regensburg.

The Group's flying program was reduced to a request for mapping coverage of areas in Germany, which it had not covered, principally eastern and southeastern Germany, Czechoslovakia, and part of Austria. The weather closed in and before the area's skies cleared the mapping was transferred to a heavy bomb group for coverage.

The End of the Road

During April, as the Russians advanced from the east, streams of captured Allied prisoners wound along roads toward safer camps. The men evacuated from Nurnburg traveled south toward Munich. Several pilots from the 7th Group straggled along toward another wire-enclosed prison. Few thought of escape. Where would they go? Their own aircraft strafed the moving columns, POWs indistinguishable from retreating Germans and refugees. Guards merged with the throng and many prisoners wandered off to barter cigarettes for a little food from German civilians.

Ed Parsons had come a long way from Stalag Luft III at Sagan. He had survived the bombing raids at Nurnburg and some strafing American fighters on this trek. What lay ahead, neither he nor any of his companions knew. He wandered along the side roads looking

for food to augment the spare rations. Occasionally an SS officer threatened to shoot men who left the main road but Parsons had not heard of any reprisals. He found a farm house across a field and went to ask for food in exchange for precious American cigarettes. The farmwife invited him in. He sat at the kitchen table as she prepared an extraordinary treat, a pork chop. Parsons savored the delicious meat. A woman came into the kitchen who the farmwife introduced as an American. Parsons tried to make friendly conversation. Bitterly, the American woman told the pilot she had been married to a German. Allied bombs had made her a widow and she had nothing but hatred for Parsons. He quietly finished eating, thanked the farm woman, and rejoined the migration toward Moosburg.

Dix and Smitty
After his rescue from the angry citizens near Merseburg, Captain Dixon escaped imminent danger for only a short time until his train from Leipzig to Frankfurt came under the guns of strafing American planes. Fighter-bombers attacked everything rolling on Germans rails. Dixon had two guards who could not have protected him and he feared the wrath of German civilians during these attacks. After his bailout, bashing across a frozen field on landing, and beatings in the villages, the American was a miserable looking creature. He was sure his battered condition made him look less of a threat and he arrived safely at Frankfurt. From there, Dixon went to the interrogation center for the usual questioning with fake Red Cross forms and tricks, none of which fooled the captain. Weeks of questioning gained the Germans nothing and they sent their prisoner to Nurnburg. Again the train was attacked, the nearby flak cars the targets. Packed into boxcars, the men were vulnerable. A shell striking through the top or side would hit eight or ten men. Again, Dixon escaped injury.

Soon after reaching Nurnburg, Captain Dixon moved south with the streams of men. His destination Stalag VIIA at Moosburg, a huge camp swollen with prisoners of all nationalities. Tents augmented crowded barracks. Food and water were scarce and conditions as bad if not worse than at Nurnburg. The Germans sent groups of men outside the wire on work details, sometimes collecting wood for stoves. Dixon went with one of the details. When he passed by other compounds, Dixon would ask the other *Kriegies*, "Hey, you got a guy in there named Bob Smith?"

Bob Smith left the Luftwaffe's interrogation center after days of questioning and no treatment for his injured ankle. The only concession was crutches for him to use as he hobbled to and from interrogation rooms or the latrine. That trip came only once a day with a bucket in the corner serving as a toilet. With meals of bread, thin soup, and water Smith quickly lost weight. To entice him to talk, they sent him up the hill to the Hohemark Hospital where he had a hot bath and shave for the first time since his capture three weeks before. He shared a room with three other men. Each had a comfortable bed. After a dinner of hot roast beef, mashed potatoes, gravy, and cake his captors asked if he had enjoyed his meal. Admitting, "I sure as hell did," Smith said he still would not tell them anything but name, rank, and serial number. The Germans were furious and sent the other men out. One berated Smith about not cooperating and making the other men lose their room. The American snapped back, "You're a bunch of bastards as far as I'm concerned and I'm not telling you anything but name, rank, and serial number." The German stomped out. Smith never saw him again.

After four days, the hospital collected enough wounded prisoners at Hohemark to make up a section of a hospital train. The Germans put Major Smith, as the senior Allied officer, in charge of the section subject to a German *Feldwebel* (staff sergeant) for the trip to the hospital and convalescent home at Meiningen. For two months, Smith received treatment for his leg and regained strength. Then the Luftwaffe sent him in one of the crowded trains packed with prisoners for Stalag Luft III. Sagan was a relief after the appalling conditions in the box cars. His travels not over, Bob Smith joined the winter march to Spremburg where trains waited to take them south again in horrible boxcars to Moosburg.

Moosburg
The sprawling prison camp near the small town of Moosburg swelled as new prisoners arrived daily. Thousands upon thousands, they crowded into every shelter. Food was scarce and sanitation deplorable in spite of attempts to improve conditions. Men of the 7th Group, Herschel Turner, Bob Kinsell, Tip Byington, Ed Parsons, Jack Emerson, and Bob Smith began to find each other. One day, another prisoner called to Bob Smith, "There's a guy over the fence wants to talk to you." Smith walked over to the wire. There was his friend Bob Dixon. "Dix, what took you so long?"

Smitty figured out how Dix could move in to Smith's barracks. Together they gathered wood for their stoves and used what water they could save to wash and keep the lice off. Rumors spread through camp that the Germans were moving them into the mountains or to a city, perhaps as hostages. Senior officers demanded that no one in the camp be sent anywhere. American forces were close. Their soldiers were coming. Armored ve-

April May 1945

Another Place to Hide

Jan van Etten led Jan Smit along the road from Naarden back to Muiden(D). They crossed the Vecht River, turned south and rode out of the village. Smit followed along behind and watched as his guide cycled unchallenged across a small bridge past a guard. The road paralleled the Vecht River. Less than a kilometer out of Muiden, van Etten turned into a lane leading toward the river. Farm and pasture land lay on both sides; a neat red brick Dutch farmhouse straight ahead(E).

A tall powerfully-built man greeted van Etten and took him and Smit inside across the black and white tile into a neat parlor with a polished wooden floor. Gysbertus (Gys) Regtuyt was not much older than the American pilot. An active member of the Underground, Gys lived on his dairy farm with his wife Willie, their little boy Eppie, and baby girl Tina. This family would risk reprisals and offer Jan Smit another place to hide.

They showed Smit a cosy place in the attic. There he could sleep near a trap door to a hiding place between the floor and the room below in case Germans or the dreaded Nazi Green Police, *Groen Politie* came looking. Smit dressed in work clothes and wooden shoes worn over heavy wool socks. Inside he took off the *klompen* and walked around in socks like everyone else. He would wear them outside. *Outside.* Now, Smit could walk around outside.

That evening, Gys showed Smit where he would live and work. The dairy barn connected to the house. During winter, the dairy cows stayed in the barn where they could be milked twice a day without the farmer or his wife going outside. The Dutchman was proud of his farm and its herd. He began Jan Smit's lessons in Dutch. Pointing to himself, *boer*, a farmer. His dairy farm, a *boerderij*. He then pointed to a horse and said, "*Paard. Versta Je?*" The American shook his head. He didn't understand but he was learning. "*Koe. Versta Je?*" No. But he learned cow just as he learned horse.

Two other men lived and worked on the farm, Pete Samplonius and Jan Grondella. Smit joined them working wherever he was needed. Up early in the morning dressed in his overalls and wooden shoes, he went to the barn where the cows waited, lowing until their full udders were emptied. He learned to balance on a one legged stool, tie the cow's tail to her leg, clean off the udder, and milk. The milk, butter, and cheese produced on the farm gave the family and the three men a far better diet than less fortunate Dutch living in cities and non-farming areas. Meals were simple. In the morning the family ate bread and cheese with cups of milk. At mid-morning they drank a coffee drink made with herbs. Potatoes dominated the main meal at noon, sometimes with white or red cabbage, sometimes Brussels sprouts. The only sweet was *Pap*, a grain based gruel with syrup.

The terrible winter dragged on. Snow blanketed the land, barely disguising the misery in occupied Holland. The rivers and canals froze solid. A few times Smit went skating on the frozen Vecht behind the farm using borrowed skates, literally blades strapped onto shoes. Out in the country, farmers saw more and more hungry people bartering — begging for food. Sometimes people like the guard from the little bridge on the Muiden to Weesp road came to the farm to buy a litre of milk. He was a Pole conscripted by the Germans. The Regtuyts never allowed any German nor anyone they could not trust to see Jan Smit. The Dutch knew if a German headed down the road. They warned the farm and if the men were in the fields, Jan Smit ran as fast as he could and hid in a cave in the river bank.

Gys hired a young woman to work one day a week and help Willie with the housework. They suspected that she fraternized with the Germans and could not be trusted. On her work day, Jan van Etten took Smit back into Muiden to spend the day with the Rozendaals. Smit tried his Dutch out on the three children using a small word-book. There was always news to learn from a forbidden radio set fitted with earphones. Some days, trusted English-speaking people came to visit. Smit learned about the horrible conditions in Amsterdam, Rotterdam, and other cities where central kitchens dispensed hot thin soup to the starving people. The American felt lucky to be hidden where he was.

In March, the Germans broke dykes and flooded great areas of occupied Holland to slow down the Canadian advance northward. German troops appeared in the Weesp area(F), then Muiden. Gys moved Jan Smit back to the Rozendaal's house. Again he would have to stay inside. One day the Rozendaals told Smit that the Germans had taken over the dairy farm. Soldiers moved in. They threw straw all over Willie's polished parlor floor and scratched the black and white tile in the entrance with their boots. Gun emplacements went up all along the river bank.

Jan Smit waited. In late April word came to the Rozendaal Resistance Group that Canadian forces were close and the Group must be ready to take control when the Germans left.

Note: See map on page 196 for locations indicated by letters D, E, and F.

Eyes of the Eighth

hicles arrived but only SS troops got out and set up defensive positions beyond the camp perimeter along a railroad embankment 300 yards away.

During the night, negotiations between the Germans and American forces failed to reach agreement. The Germans wanted to trade the safety of the camp and its prisoners for safe passage across the nearby river. The Americans refused. Sunday, 29 April dawned bright. Prisoners saw a P-51 fly low over the camp, so close they could see fresh mud on the wings. It must have come from a forward strip close to the camp. A guard in one watch tower fired at the Mustang. Gracefully, the fighter rose in a chandelle, swept back firing at the offending tower and shattered it. Mortars began to fall in the town and bullets whizzed into the compounds. The POWs dove under cover.

American tanks came over the hill and began firing. The SS fought back but were overcome. One tank kept coming and ran right over the wire into the compound. Within seconds it disappeared under a blanket of joyous humanity. Dixon, Smith and the other 7th Group pilots were free. From Stalag VIIA they could see the Stars and Stripes flying over the town of Moosburg.

May 1945

Berlin Falls
Russian artillery pounded Berlin. At terrible cost, Russian soldiers fought their way through the city, house by house and cellar by cellar. They had orders to raise the Red Victory Banner over the Old Reichstag before the first of May, a politically significant birthday for Communists. After fighting up through the battered building from one floor to the next, they raised the red flag on the last day of April. Less than a mile away, deep in his *Führer* Bunker under the Reich chancellery, Adolph Hitler committed suicide. On 1 May 1945, Hamburg radio announced that Hitler had died fighting for Germany in Berlin.

At Chalgrove men listened to the BBC, trying to sort scuttlebutt and rumors. No 7th planes had been dispatched. The Eighth flew a mission dropping food and supplies to The Hague and Rotterdam. Life went on within the squadrons. On 1 May 1945 the 55th Station Complement Squadron was dissolved and Flying Control personnel transferred to the 451st HQ and Base Service Squadron. The 451st T/O called for eight control tower operators and six radio operators but none of the other personnel required to run a tower. Later the radio and tower operators were struck from the T/O.

Major Hubert Childress left the 27th to become Deputy Group Commander on 2 May. The 14th Squadron's Maj. Kermit Bliss took over the 27th. Also, from the 27th, Squadron Capt. Carl J. Fritsche, Flight Surgeon, became Group Surgeon, relieving Capt. James R. Savage.

Although beaten, the Germans continued fighting, trying to get as many people away from the Russians as possible. Berlin fell; Grand Admiral Doenitz ordered all German forces in Holland, Denmark, and northwestern Germany to lay down their arms on 5 May 1945 honoring the surrender signed the day before. Holland was finally free.

The Taking of Stalag Luft I
Among the men imprisoned in Stalag Luft I at Barth was Lt. Col. Norris Hartwell, the former commanding officer of the 7th Group. Hartwell became a *Kriegesgefangener*, a war prisoner, when he returned to those V-weapon sites in northern France on 12 August 1944. During his travels from prison to prison and through the interrogation center he had plenty of time to remember that day. Long before he began his low-level runs he anticipated the fierce anti-aircraft fire thrown up at him on his last trip. The flak batteries opened up again as he flew over his first target. No hits. Hartwell flashed at treetop level to the next launching site and into a barrage of steel. Shrapnel hit his left engine; the plane began to burn. Smoke filled the cockpit. He wouldn't make it home and undid his straps to bail out.

Too low to roll and drop out, the pilot popped the canopy, forced his body upright into the wind, and pulled the ripcord. His parachute billowed out into the slipstream snatching Hartwell out of the F-5. For an instant the dinghy pack caught on the cockpit then tore open and released the pilot from the burning plane. The Lightning roared away. Hartwell drifted down in silence, the bright yellow dinghy flapping below him. He saw that he was not alone. Armed men from a flak battery rushed to where he would land, surrounding him as he hit the ground. His crashed plane burned in the distance.

The Germans put the colonel in an underground dungeon-like prison with damp stone walls and a vaulted ceiling. His cell was bare, no windows, and only a board to lie on. After several miserable days, Hartwell was relieved to leave for Brussels on his way to a real POW camp. On the way he had to walk through the streets where Belgians, behind the Germans' backs, secretly smiled and gave him the V for Victory sign. Hartwell's morale rose.

Norris Hartwell experienced a similar voyage as others before; angry Germans, crowded trains, bombing and strafing raids. His travels ended in northern Germany on the Baltic coast at Stalag Luft I, a wind-swept camp on a sandy, pine scrub peninsula. After sparse meals of bread,

296

thin soup, and water, Hartwell found better food in this windy and cold prison. Here, the *Kriegies*, as POWs were called, had an aggressive Senior Allied Officer who knew how to take advantage of the German's realization that they were losing the war. A P-47 fighter ace from the 56th Fighter Group, Col. Hub Zemke had been commanding officer of the newer 479FG when he took a last mission in late October 1944 before moving to a staff job behind a desk. Downed by a thunderstorm, which tore a wing off his P-51, Zemke arrived at Barth in mid-December.

Able to speak a little German, the new Senior Officer at the camp dealt with his captors and made sure that Red Cross packages stored in Sweden were delivered to the camp. A *Kriegie* organization named Provisional Wing X was already in existence when Zemke arrived. The Germans believed it was to insure good military discipline but it was far more. The *Kriegies* called Wing X's headquarters the Head Shed. From this office came instructions and plans to protect the prisoners as conditions worsened.

Many prisoners had been in German hands for years. Hartwell was a newcomer. He saw how some of the men taunted the Germans in the popular occupation, goon baiting. Twice a day at 0645 and 1630 hours, rain or snow, the Germans held *Appell*, a roll call outside the barracks. As the Russians moved closer from the east and the British and Americans advanced from the west, the prisoners taunted the Germans. When dismissed from *Appells*, they would turn toward the east and chant "Come on Joe, come on Joe." The chant toward the west was, "Come on Ike."

The nearness of defeat made Athe Germans more respectful of Colonel Zemke. In late April, the Germans said they had to march everyone away from the advancing Red Army. Zemke and his staff refused. With the Russians only a few miles away, the *Kommandant* approached Zemke on the last night of April and made arrangements to turn the camp over to Provisional Wing X in exchange for a quiet departure of all Germans in the dark of night. Zemke agreed. *Appell* went as usual. The guards locked the barracks' doors and closed the shutters for the night. Only a few officers, the Head Shed, knew what was happening. The *Kriegies* went to bed, lights out. Silence settled over the camp. No barking Dobermans and Shepherds patrolled the wire. As arranged, a few chosen *Kriegies* took over the watch towers and began their own patrols with arms left by the Germans. Silently, with only a few flashlights and the hooded beams of vehicle headlights visible, the Germans left Stalag Luft I.

Colonel Zemke was now responsible for over 9,000 men. He set up patrols and guards to try and keep the men from leaving the relative safety of the camp for an unknown world outside. The guards were there to keep civilians from trying to take refuge with the prisoners. The patrols tried to seal off the peninsula. Few got in but many made their way out. Colonel Hartwell was one who decided not to stay put.

He and another American sneaked out through a hole in the fence. They walked into Barth where they met two Polish boys who had a horse and wagon. The four set off toward the west. They found a farm house where some women, who were terrified of the Russians, let them in, fed them well, and let them stay the night. Hartwell slept in a feather bed. The next morning the little band moved on westward.

Soon they ran into a band of Russians, some on horseback. A few rode with the foursome and were happy comrades until one pulled a gun and stole the other American's watch. That ended the camaraderie and the Russians left. At the next farm, the foursome traded up, their horse and wagon for a better horse and carriage with a canopy. The two Polish boys sat up front and drove with the Americans "chauffeured" in the back until they rounded a corner and ran into more Russians. "*Amerikanski*," the Russians recognized them but still traded their nag and dilapidated cart at gun point.

Onward in less style, the little party came upon an Opel sedan by the side of the road. It had a full tank of gas. The foursome split up; the boys went off in the cart and the two Americans took the car. Driving into Rostock, they found the city deserted. An abandoned sporting goods store furnished the pair a small arsenal. They found a machine gun on the street and picked that up. Well-armed the two Americans continued their adventures until a few days later they ran into an American lieutenant and sergeant in a Jeep. The lieutenant leveled a shaky .45 at them and ordered them out of the Opel. Suspected as German spies, the two ex-*Kriegies* were escorted to 7th Army Division Headquarters near Luneburg. Prisoners again. A few answers to a colonel clarified the situation. They got their car and guns back and headed off again. Almost five days after leaving Barth, Hartwell and his companion found an American airfield in Holland and caught a ride back to a transit camp in France.

When the Russians arrived at Barth they ruthlessly took charge of the German town and surrounding area. If the prisoners behind the wire wanted to take revenge, the Russians gave a good measure of it in their place. Fingers still painfully numb from his treatment, Capt. Irwin Rickey was one who had waited for retribution. At Stalag Luft I, now in Russian territory, Colonel Zemke arranged

Eyes of the Eighth

to get the thousands of men out. Even when they cooperated, the Russians' bureaucracy resulted in reams of paper work for clearance as well as safe air corridors. It took until 11 May. Eighth Air Force B-17s landed at the nearby airstrip. On 13 May, the Fortresses began flying the men out. The wounded left in C-46s. A few days later, all non-Russian personnel had left Stalag Luft I.

In Holland, one 7th Group pilot was a prisoner for less than a month. When Lt. Richard E. Brown crash-landed his F-5 next to the Waal River on 20 April he thought he was on the Allied side. The first people to reach him were German soldiers. They took Brown to the nearby town of Dordrecht where they kept him for two days, then transferred him to Utrecht. There he joined a group of prisoners, mostly British, and traveled to Den Helder at the tip of northern Holland. Their new prison was a fortress, a situation not allowed by the Geneva Convention. The men protested long and loud until their German captors relented and took them by boat to Terschelling, one of the Frisian Islands off the west coast of Holland. Brown and his fellow prisoners stayed there until the war ended. When British and Canadian troops arrived in northern Holland, they sent the men over to the mainland. The British arranged transportation to a camp at St. Valery-en-Caux near Le Havre where repatriated prisoners went through processing before shipping home.

Liberation

Holland was free. The Germans' surrender in the north to Montgomery on 4 May 1945 gave Holland back to the Dutch. Underground and resistance groups took over control, dug hidden weapons up, and picked up collaborators and black marketeers. The *onderduikers* reappeared as well as all the airmen hidden by the Dutch. Jan Smit changed into the long-hidden uniform and walked back out onto the streets as Lt. Claude C. Murray. Crowds gathered in Muiden and celebrated, threw flowers, and sang. They hoisted their hero on their shoulders and cheered, "We had this pilot, Jan Smit, here for seven months, hiding from the Germans, and nobody knew it." Lieutenant Murray thought they were the heroes.

Murray said his good-byes and rode on the back of Jan van Etten's motorcycle to Blaricum where other pilots waited to go out together. They hitch-hiked and found some Canadian troops who took them to Almelo for interrogation. Then they traveled to Paris by plane and on to St. Valery-en-Caux and the huge transit camp named Lucky Strike. Murray ran into other pilots from the 7th Group, Dick Brown, "Tubby" Carlgren, and Irvin Rickey. He had been at Mount Farm such a short time, he didn't know them all.

Rumors flew. The Germans were surrendering but stalling diplomatically as well. General Eisenhower gave them an ultimatum. They had no choice but to accept. At 0200 hours on 7 May 1945, *Generaloberst* Alfred Jodl, German Chief of Staff, and a German delegation entered the second floor operations room of General Eisenhower's Headquarters in a schoolhouse in Rheims, France. Maps lined the walls from ceiling to floor. Rings of colored pins and arrows choked the fractured Reich. This may have been the first time the German representatives, and Jodl himself, really understood how thorough was Germany's defeat. The protocol of signing the unconditional surrender of all German forces to the Allies took only 30 minutes. General Eisenhower waited in his office. Staff brought Jodl in at 0241 hours. Eisenhower made sure that the general understood all Allied conditions of surrender and would see that the Germans complied. Jodl agreed and offered his hand. Eisenhower did not take it.

Jan Van Etten and Claude Murray ready to leave for Blaricum. (C. Murray)

Liberation! American pilot, Lt Claude Murray hidden by the Dutch for months as Jan Smit, celebrates freedom with Dutch villagers in May 1945. (C. Murray)

April May 1945

Celebrating VE day with a Beer Bust at Chalgrove.

VE Day

On 7 May, at Chalgrove, indeed all over England, everyone knew something was happening. As each hour passed, anticipation grew. Finally, Prime Minister Churchill broadcast over the BBC at 7:40 PM that 8 May 1945, would be celebrated as VE, Victory in Europe Day. Both the 8th and 9th would be national holidays.

Weeks before, the high command decided to restrict all American troops in England to their bases during the two days of British celebrations. With the surrender announcement, men on leave immediately returned to base. At Chalgrove the squadrons planned their own celebrations. For a short time, Americans put aside thoughts of transfer to the Pacific. The Eighth was going there. News of the battles for Iwo Jima and Okinawa during the Spring of 1945 reminded U.S. forces in Europe that the assault on the islands of the Japanese homeland lay ahead.

Although combat operations in the European Theater of Operations ceased, the 7th Group had sorties to fly. Unlike previous ones, these were unopposed and carried the designation LIB or LOC. Numbering began again at LOC1 with each squadron's suffix. These photo missions sought to answer questions for various headquarters previously using photo reconnaissance and for requests from new organizations as well.

On 7 May, the day of the German surrender, Lt. Marcus Vaughn and Capt. Arthur Leatherwood of the 14th Squadron flew low-level damage assessment runs over targets in one of the hottest spots of Germany. Leatherwood described flying only a few hundred feet over the deserted and silent flak batteries near Leipzig as a funny, eerie feeling. Below lay the ruined oil facilities, bombed towns and villages. Everything was quiet — peaceful. It was an experience neither pilot would forget.

At the airfield everyone planned parties for 9 May. The 13th Squadron officers took up a collection and supplied six barrels of beer. "Beer Busts" were the choice in all the squadron areas during the afternoon. To make room for an enlisted men's dance, the men rolled planes out of one of the big hangers and brought a bandstand in. Notice was short but they arranged invitations and transportation for hundreds of girls. The party lasted until midnight.

Bombing reduced Lutzkendorf oil refinery production to zero.

299

Eyes of the Eighth

Low level photo of camp holding thousands of German soldiers after surrender. (V. Farrow)

POWS—Ours and Theirs

Most operational flights were for either courier runs or damage assessment. Requests came in for photos of bomb damage and targets of special interest to one department or another. Not only was the efficacy of bombing under study but also the requirements to restore basic services to the devastated areas of Europe. Several low-level assignments covered huge camps overflowing with German soldiers. Many were sparsely wired and guarded fields — holding facilities with only meager makeshift shelter where men could be fed, treated medically if necessary, and identified. No one could have prepared for the tens of thousands of German prisoners. Pilots who flew over the camps were stunned at the enormous numbers.

Special forces processed them as swiftly as possible. Various Allied authorities checked for SS, Gestapo, or other Nazis suspected of war crimes. They removed these prisoners from the general collection of military flotsam and jetsam and isolated them either in prisons or other specialized camps. One of these, for prisoners of mid-level importance, was given the appropriate code name Ashcan.

Kriegies and RAMPS

A different kind of processing took place at camps organized to get Repatriated Allied Prisoners of War (RAMPS) on their way back home or returned to bases. By the thousands, Allied air crew and ground soldiers came from German POW camps. From the German bureaucratic morass of being a *Kriegie* the men passed into friendly hands as RAMPS and an Allied morass of bureaucracy. Air force transports picked up the released *Kriegies* at airfields near their Stalags and flew them back to transit camps in France. There they waited in endless lines to be processed, given any medical treatment needed, issued uniforms and partial pay.

Lucky Strike was one of the largest and most active repatriation camps. Not all 7th Group pilots had been *Kriegies*, but almost all came to Lucky Strike. After the camp at Moosburg had been liberated, Bob Smith and Bob Dixon wasted no time and set off into the countryside to scrounge up some decent food. They found a field kitchen and a willing Army cook who gave them plates of American chow. After wolfing down as much as they could eat, both men got violently ill. Their stomachs had some adjusting to do. A transport brought the two buddies from Moosburg to Lucky Strike where they began the interminable waiting in line for everything.

In this big sprawling camp, they lined up for what seemed like hours to get a card punched or a box checked before they could return to their base. Smith and Dixon had a better idea. Refused permission to telephone England, the two adventurers waited until after dark, sneaked into an office, and while one stood lookout the other managed to work his way through the switchboards until he had a connection to Chalgrove. Remarkably, the man on duty recognized the voice and said one of the Group's C-47s would come the next day and land at the nearby airfield. The pilot would wait for them if they could get to the field.

Just as promised, a C-47 circled Lucky Strike the next day. Smith and Dixon were ready with a small group of fellow RAMPS. They made their way to the airstrip and found Capt. Arthur Leatherwood lying in the shade under a wing waiting for them. The happy repatriates climbed on board and took off for "home." It was not the only trip Leatherwood would make to return men to England.

The sheer size of the camp prevented all of the 7th Group's men from joining together. Some who passed through Lucky Strike, Lieutenants Emerson, Byington, Kinsell, and Parsons shipped home directly from France. Lieutenant Mecham needed hospitalization after his release from prison camp for injuries suffered when he bailed out of his burning P-51 over Ruhland.

Captain Rickey, Lieutenants Carlgren, Brown, and Murray begged for a ride back to England from a Group pilot who came to Lucky Strike to drop off aerial photos of the camp. The next day, Capt. James "Red" Matthew's flew in a C-47 and picked them up. Before the month ended, Colonel Hartwell, Lieutenants Hilborn, Madden, Williams, and Van Wart, as well as Flight Officer Watkins had made it back to Chalgrove to share their stories. Ross Madden told about getting shot down over Paderborn, hiding and running a few days, being

April May 1945

captured and ending up back at Paderborn before his trip to prison camp. The re-united men wondered what had happened to friends shot down before they were. There was joy at word of survival and sadness for those lost.

One man came back a different route. When his escort last saw him, Lt. Grover P. Parker had been hit by an ME262 and was heading for the Russian lines. When he could no longer stay with his F-5, Parker bailed out into a forested area. His parachute hung up in a tree and when he cut himself loose, he fell and broke an ankle. After several days, Parker knew he would have to go looking for help. He made himself a crutch from a sapling and with only puddles of rain water to drink, began to hobble toward, he hoped, the Russians. Parker could hear sounds of battle all around him but not close enough to see any soldiers. Finally, after four days a group of Russian soldiers found him and took him to their headquarters. There he learned that he had been in a no man's land between attacks and counter attacks. The Russians moved him through their processing system for Allied personnel and sent him to Odessa on the Black Sea where someone from the 7th Group flew down, picked Parker up and returned him to England for the third time.

Repatriated prisoners returned to England in twos and threes, most arriving at Chalgrove for the first time. They were thinner and a few had suffered injuries when shot down. One of the most seriously hurt was Lt. E. S. "Willie" Williams. On 29 October, Williams had targets at Minden and Osnabruck. While flying near Minden at 30,000 feet, the pilot saw three contrails and suspected enemy aircraft but saw none. He headed toward Osnabruck. Williams racked his F-5 up to get a better view behind just as a jet began firing at him from 50 feet. He pushed the yoke forward and dove to escape. Below he spotted another ME262 and kept his plane in a steep dive. The altimeter wound down alarmingly. At 12,000 feet Williams tried to bring his plunging F-5 under control but could not pull out.

With no other choice, Williams unbuckled his seat belt and opened the canopy. The wind screamed in his ears and snatched the stunned pilot out of the cockpit. He looked up. Strange bits of cloth floated above him but no canopy. On the edge of consciousness, Williams tried to pull the ripcord. His arms seemed useless. As much as he tried he could not reach the D-ring.

Once more he tried to move his arms. His left hand flopped near his head and he grabbed his face. Then his collar, his jacket until he worked his hand along to the rip-cord. Williams grabbed it and pulled. The chute streamed out and caught the wind popping the canopy open just before Williams hit the ground. He lay there, flat on his back on the edge of consciousness. A crowd gathered. Williams couldn't move his arms. His shoes were gone, his trouser legs half-missing. Shreds of his Mae West lay on his chest; the dingy, his helmet and gloves were gone. He thought those must have been the missing bits floating above him when the wind tore him from the plane.

The civilians seemed to think he was German, chattered to him and gave him a Heil Hitler salute. In a daze, the pilot weakly tried to return the salute. He had no idea why. Three SS troops came and took him prisoner, forced the badly injured pilot to his feet, pushed and punched Williams toward the town. The civilians turned on him. Children ran their bicycles into him and threw sticks and stones. To them it was a big joke. Williams was defenseless.

Two SS officers picked him up in a car and took him to their headquarters. They allowed him to wash up. While they searched his clothes they stole Williams' fountain pen, escape kit, and pilot's rating card. Then they took him to a hospital where doctors found Williams' left arm broken in four places and his right arm, dislocated. Within a few days the pilot went from hospital to a Luftwaffe prison and the interrogation center at Oberursel. Nine days in solitary and repeated questioning gained the Germans nothing. All the while, Williams' arms remained paralyzed. The Germans gave him no treatment and only basic help during the day.

On the move again, the prisoner passed through hospitals and prison camps to reach Stalag Luft I at Sagan. Unable to take care of himself, Williams remained in the prison hospital after the other Kriegies left on their winter march. On 7 February, the guards put all the patients on a train for Nurnburg. In the new prison camp conditions were miserable, overcrowded, filthy, and cold. Poor food, without the supplements from Red Cross parcels, weakened the men further. By 3 April, prison authorities knew they had to move their captives again. They put the wounded on another train headed for Moosburg through Munich. Mustang fighters accidentally strafed the train but Williams and the other patients survived without injury.

Moosburg was better than Nurnburg, crowded but more food and the welcome Red Cross parcels were distributed again. Only water was impossible. The one faucet in Williams' area had to serve over 600 men and it was turned off most of the time. After the Americans liberated the camp, Williams waited until 8 May before evacuation to a hospital at Rheims, France. Two weeks later the 22nd Squadron pilot was sent to Cherbourg, no longer confined to a hospital. Early in the year he had

301

begun to regain the use of his arms. Now that he could take care of himself, he hitch-hiked back to England and turned up at Chalgrove the third week in May.

Lost Aircraft
Events moved rapidly at Chalgrove. The airbase went on garrison duty schedule, reveille at 0545 hours five days a week with Saturdays and Sundays off. Regulations required four hours work and four hours education or athletics each weekday. The Group offered educational programs in various technical fields and liberal arts classes.

Engineering began checks to determine which aircraft fit into the new classifications. Some would stay at Chalgrove for use on the remaining photo assignments. Others were transferred for decommission or use in other areas. Between 12 and 14 May, all P-51s left the Group, which resulted in the transfer of the armorers. Photo aircraft did not escape reduction and all four squadron began to lose F-5s as well.

On 17 May 1945, Colonel Whitson took over as commanding officer of the 451st Service Squadron. Capt. Jacob B. Wilcox became Group S-4. The 13th Squadron changed commanders on 18 May when Lt. Col. Benjamin F. Kendig relieved Major Walter D. Shade as C.O. Major Shade served as 13th Squadron C.O. after Capt. George Nesselrode left in March. The major returned to Group Operations as Assistant Operations Officer.

Rain kept most aircraft grounded until it let up enough for some local training flights. On 25 May Lts. Alf Carstens and D. R. Sherman of the 22nd Squadron were flying in formation near Bovington at 3,000 feet. Carstens' right engine caught fire. He lost altitude as he tried to control the fire but it flared into the cockpit forcing the pilot to bailout. At only 300 feet, Carstens' managed to get out and open his chute just before hitting the ground. People rushed to his aid. Sherman circled above. He saw the F-5 crash and explode nearby and that Carstens was away from the plane and talking to his rescuers. They took the burned pilot to a hospital near Bovington for treatment.

Hitler's Hidden Treasure
Toward the end of the war, as conditions deteriorated in the Third Reich and bombers destroyed city after city, the Germans sought safe storage for valuable items. In the mountains of Bavaria and Austria lay deep salt mines and tunnels. Many had been used as factories and assembly plants. Others became vaults for Nazi treasure, stolen art, intelligence files, gold, and assorted records including a large cache of photographs of Russia. The USSR restricted all photography within its borders and these pictures came from German archives. As soon as they fell into American hands, military intelligence wanted them.

Headquarters asked the 7th Group to run courier missions to pick up the photos and intelligence files in the Bavarian Alps. Hundreds of thousands of photos were stored near Hitler's mountain house at Berchtesgaden near Obersalzburg. Major Bliss organized three C-47s and a B-17 to make the trip. The men flew into Salzburg and drove through the mountains to Berchtesgaden where they stayed overnight at the Post Hotel. Photo Interpreters, Lts. Jackson Byers, and James E. Ward flew along on one of the three trips necessary to haul the large crates back.

A totally different service operated out of Chalgrove in May 1945. Using C-47s, pilots took turns carrying non-flying personnel on tours over the battle-scarred cities of Germany. These flights gave the men a chance to see first hand what the bombers had done and the PR men had photographed.

During May, Statistical Control produced the first detailed summary of the operations of the 7th Group in the ETO. It calculated that the Group dispatched 4,589 aircraft on missions for a total of 13,263 operational hours. Operational losses were 69 aircraft and 54 men. Seventeen of the 54 had been repatriated.

A few mysteries remained. Because so many of the 7th Group's pilots flew alone, their fate was often unknown. One particular casualty was a legendary RAF photo recon pilot posted to the 7th Group in April 1944 as a liaison officer. Wing Commander Adrian Warburton went on a mission with the 7th Group's Operations Officer Maj. Carl Chapman on 12 April 1944. After the two F-5s separated to fly to different targets, Warburton disappeared without a trace. Even at the end of the war, no conclusive report could be issued. (The most complete study of Wing Commander Warburton and his final flight is Tony Spooner's book, *Warburton's War*.)

April May 1945

Low-level photograph of the harbor at Bremen taken after the German surrender. The port, established on the Weser River in the tenth century and the oldest in Germany, lies in ruins after massive bombing by the RAF and Eighth Air Force. Two ships have sunk alongside the wharf, one still upright and the other on its side. (J. Byers)

Eyes of the Eighth

EUROPE 1939-45

Chapter 18
Deactivation June-November 1945

June 1945

At bases all over England units of the Eighth Air Force prepared to ship personnel home to the States. Processing of transfers continued at a frantic pace. War Department directives decided who stayed, who went home, and who went to the Pacific. Points based on various criteria added up to levels of priority. Unless a man was in a vital occupation, his lowest total for a chance to go home was 85 points. In June, transfers in and out of the Group increased. Clerks from Group and the squadrons worked overtime counting points, writing transfers, and processing the eventual breakup of the organization, for that was what it was.

The transition from operational status markedly changed the makeup and activities of the squadrons. Engineering departments rushed to dispose of aircraft and excess supplies. In all squadrons, aircraft having less than 100 hours were transferred for re-deployment. By the end of June most aircraft having less than 200 hours were grounded. To keep a modest level of operational aircraft, Engineering had to transfer F-5s between the squadrons.

In spite of fewer planes, the Group managed to fill most of its assignments particularly the damage assessment coverage ordered for a survey being conducted to assess the efficacy of strategic bombing. This massive task, the United States Strategic Bombing Survey, USSBS, commonly called "Usbus," required low level oblique photos as well as some cover from altitude. The 27th Squadron flew 14 photo missions, many of them at low altitude, of targets in the Ruhr, Kassel, Frankfurt, Nurnburg, Stuttgart, Saarbrucken, and the Munich area. They covered other priority targets with low obliques of the Rhine River bridges from Ludwigshafen to Wesel. Not only did the 27th Squadron supply the photos but they also supplied SSgt Carl F. Heinrich, Sgts John C. Budd, and Harry H. Kaplowitz to work in London on the project. The 22nd Squadron sent Cpl Joseph P. O'Bryan to work on the same project in Germany.

Two officers received high honors at the end of the war. Maj. Kermit Bliss received a DFC in May. The British bestowed their Distinguished Flying Cross on Maj. Gerald Adams for low-level photography of V-weapon sites and his encounter with the ME163. The Group had many highly decorated pilots but none more than Capt. Charles "Chick" Batson. He held awards of the Silver Star, Distinguished Flying Cross, Air Medal with five Oak Leaf Clusters, the British Distinguished Flying Cross, and the French Croix de Guerre with Star.

On 8 June, the 13th Squadron lost two men during a routine training flight near the field. Capt. Charles "Chick" Batson and Lt. Robert J. Howard collided in mid-air. Both F-5s crashed in the area of Didcot, Oxfordshire, killing the two pilots. Batson, the 13th Squadron's Operations Officer had flown 65 combat missions in photo ships and fighter escorts.

Less than two weeks later, on 19 June, Lt. Raymond Hakkila and F/O Clarence Diggs had completed damage assessment photos in the Brunswick-Magdeburg area. Flying in close formation on their return, one of Diggs' engines cut out and his F-5 dipped into the tail of Hakkila's ship. Both planes crippled, the pilots bailed out. Neither suffered any injuries and after three days of hitch-hiking, they were picked up in Luxembourg by one of the Group's C-47s.

On 19 June, Colonel Humbrecht left the 7th Group to take over command of the 325th Reconnaissance Wing replacing Col. Leon W. Gray. Colonel Gray had become wing commander when General Roosevelt returned to the United States on 13 April upon the death of his father, President Franklin D. Roosevelt. Humbrecht's deputy, Maj. Hubert Childress took over command of the 7th Group.

Transfers flooded through the organization. Squadron Intelligence sections had been reduced to skeleton staffs. In the 13th Squadron's Photo Intelligence Department, Lt. Jackson Byers, Lt. David G. "Dusty" Rhoades, and Lt. Ralph R. Swartz remained on duty but as members of the 8th Photo Tech Squadron.

In order to move men quickly, the War Department used existing units regardless of occupations. The Tables of Organization (T/O) had slots for just so many enlisted men and officers and they filled those accordingly. The 451st Air Service Group was one unit taking men from the various squadrons getting ready for deployment to the Pacific. To fill the roster, men were transferred into the 651st Air Material Squadron and the 827th Air Engineering Squadron. Personnel arrived from other air units and the infantry, using the T/Os of the various squadrons to transfer men for assignment. By the end of June there were fewer familiar faces in all units of the 7th. June was just a preview of the months to come and the rapid change of the 7th Group's makeup.

July 1945

The wide expansive base at Chalgrove temporarily took on an empty look. Those veteran Group men who remained saw changes daily. Simply by paper transfer on 16 July 1945, the Eighth Air Force moved sans men, equipment, and combat elements to Okinawa. Released

Eyes of the Eighth

from the Mighty Eighth on 20 July, the 7th Photo Recon Group was assigned to VIII Fighter Command, which had remained headquartered at High Wycombe.

The Pacific Theater claimed most of the bombers and combat troops; all shipped back to the States for reassignment or to the other combat units by any available transport. Fighter Command collected orphaned squadrons during the upheaval. The disbanding of the old 7th Photo Recon Group gained momentum.

Squadron clerks had difficulty keeping up with the mountains of paper work involved in moving so many men. Points had to be computed. They added five points each to every man's total for three more Battle Stars, awarded for the Rhineland, Ardennes, and Central Europe Campaigns. Each added point increased chances of going home soon. Men from all squadrons moved to various other units, some going to the 70th Replacement Depot to await shipment to the Zone of the Interior, Stateside. Many of the camera repair and photo lab personnel from all four squadrons who lacked 85 points went to the Second Photo Tech at Pinetree. This organization was scheduled for re-deployment to the States in preparation for operation in the Pacific.

Service outfits became classified in categories indicating personnel with high point totals. This expedited the return of whole units. The planned closing of Chalgrove concentrated men with 85 points or better into a 7th Group unit, the 356th Air Service Squadron, as the holding party for the base. Men transferred to the 356th, left their squadrons, but remained on the base. Many of the enlisted men married to English girls were in this transfer as they wanted to remain in Chalgrove as long as possible.

The first semester of the educational program finished on 20 July. Lt. Ray Hynds, the officer in charge, reported an attendance of approximately 4,000 students. This impressive figure brought a publicity team to Chalgrove from the Continent to interview the staff and photograph the classes. Personnel remaining in England had opportunities for many types of education. Two men from the 22nd Squadron, Sgt John C. Lindahl and SSgt Rogers W. Johnson, wanted to take advantage of this program and take university courses on the Continent. Although the service stressed education, the 22nd Squadron's category was too low to qualify for their particular request. There were ways of getting around red tape. By transferring to the 7th Group the two men moved to a high category outfit that allowed them to continue their education.

Some photo jobs still remained on the squadrons' programs and, limited by lack of aircraft, they worked to reduce the jobs. So few were left near the end of the month that the remaining jobs were transferred to the Ninth Air Force. This effectively canceled the program of targets for the 7th Group. More aircraft transferred out leaving an average of only six F-5s per squadron, barely enough to keep up pilots' flying time. Worsening of an already inadequate supply of spare parts kept many of the aircraft grounded. Once the men finished the necessary engine changes and maintenance to prepare aircraft for transfer on the flight line, less aircraft meant less work. By the end of July the 14th squadron had only five F-5s to maintain, the 13th, only four.

Some semblance of past routines remained with Aero Club dances on Mondays and officers parties on Saturdays. "Liberty Runs" into Oxford and neighboring villages continued. During a stretch of very warm weather the men enjoyed softball games and swimming in the Thames. All four squadrons completed their photo record books begun in April. They planned to distribute them in early August as soon as binding was completed. Personnel also received the 7th Photo Group book, *Now It Can Be Told*.

August September 1945

At the end of July, Allied leaders met in Potsdam outside of Berlin. Truman, Churchill, and Stalin discussed peace in Europe and the end of the war in the Pacific. On 26 July they issued a proclamation demanding the unconditional surrender of Japan. Not to do so, Japan was informed, would bring "complete destruction." Already under massive bombardment from the air, the Japanese military continued to press for all out defense of the Japanese homeland. Intelligence sources knew that any attempt to land forces on the islands could cost hundreds of thousands of American casualties. This knowledge influenced President Harry Truman to use an awesome new weapon developed by a small group of scientists working in Tennessee, New Mexico, and Nevada.

At 0930, 6 August 1945, the B-29 *Enola Gay* dropped the first atomic bomb on the Japanese city of Hiroshima. On 8 August the USSR declared war on Japan. Another B-29, *Great Artist*, dropped a second atomic bomb on Nagasaki on 9 August. In Britain an announcement on the one o'clock news said that the Japanese had asked for an armistice. The terms of unconditional surrender were repeated. Finally, news of the Japanese surrender came at 11:45 PM on Tuesday 14 August. The BBC warned its listeners to stand by for a special announcement. At midnight the new Prime Minister, Clement Attlee, spoke to the people, "Japan today surrendered." In Washington, President Harry Truman announced Japan's unconditional surrender over the radio at 7:00 PM Eastern time, 14 August 1945.

June-November 1945

Victory over Japan, VJ Day had arrived. On 15 August, Cpl Marshall Williams was in Oxford. Thousands celebrated in the streets. They danced and sang and cheered at the end of a very long war. At the main road junction, Carfax, a giant bonfire lit up the sky. Williams thought it big enough to burn down the neighboring buildings. Fortunately, he was wrong.

The war was over. Preparations to move personnel accelerated. Only skeleton staffs remained in two squadrons when the big transfers began on 29 August. The 13th squadron moved most of its remaining men to the 27th Squadron while the 14th moved its men to the 22nd Squadron, which had been depleted by transfers over the last two months. The organizations kept only enough men to hold the units on the USAAF rolls or until the War Department used their Tables of Organization to relocate personnel from other disbanding units. Men came from ground forces as well as air units. This was the military way of moving men in a hurry. Keep the unit and move the men or move the unit and transfer the men. Whether it made much sense to the veterans of the 7th Group or not, it was happening to them. Chalgrove became a busy transit camp.

When the 13th Squadron combined with the remainder of the 27th Squadron, Maj. Walter D. Shade, who replaced Colonel Kendig as C.O., was left with three other officers and eight enlisted men. On 11 September Major Shade took command of the 27th Squadron leaving Lt. John Weeks as C.O. of the 13th. For months Major Shade had been the only remaining member of the original 13th Squadron, which came to England in November 1942. By the end of September, Lieutenant Weeks and SSgt Leon A. Janota made up the entire 13th Squadron.

For months the squadrons had divested themselves of men, equipment, aircraft, ledgers, everything not needed to maintain a unit, and now existed only as a number and a minimum staff. In each squadron each and every piece of inventory acquired by the squadron over the years had to be accounted for. Most squadrons had some missing bits but Lieutenant Weeks discovered during the deactivation of the 13th that the largest single item unaccounted for was a C-47 twin engine transport.

During August the 22nd Squadron lost most of its men through transfer to other units. Sgt Paul J. McGarry and SSgt Donald M. Archambeau both transferred to

New York City skyline welcomes GIs returning on the well-named ship Le Grand Victory. (A. Cassidy)

the 7th Group in order to attend one of the Army universities in Europe. Then on 29 August the roster swelled to full strength with the transfer in of the men from the 14th Squadron.

After the loss of most personnel, Major Adams commanded a 14th Squadron reduced to a few officers and enlisted men. In September the last of the enlisted men transferred out for their trip home. Major Adams went on temporary duty (TDY) to the States to attend Command and Staff School at Fort Leavenworth, Kansas, leaving Lt. Richard Vanderpool as Executive Officer. Captain Marcus Vaughn transferred in from the 22nd Squadron to assume command.

All during September the personnel from the 22nd transferred out, some going home and others to Occupation Forces in Germany. At the end of the month all remaining men except the 22nds' C.O. Capt. Donald Pipes and the Orderly Room Clerk Sergeant Sleeper, were placed in the 27th Squadron and the 8th Photo Tech Squadron. Captain Pipes assumed command of the 27th Squadron on 24 September when the squadron C.O. Maj. Troy McGuire flew to Paris on TDY. From there he planned to fly home and attend the Air Staff Course at Fort Leavenworth, Kansas. On 28 September Major McGuire transferred from the 27th Squadron. Not only men but aircraft moved off the airfield. Only a C-47 and an AT6 under the 7th Group remained. Everything else had been transferred to a depot in northern England for disposition.

The 27th Squadron remained as the only relatively active squadron on the base and suffered its last casualty when Lt. Xenophon S. Eugenedes' plane crashed in Aberporth, Wales on 11 September 1945, killing the pilot instantly. His was the last death recorded in the 7th Photo Group.

October November 1945
Transfers continued to deplete the squadrons until in October all units were transferred from Chalgrove. Their parent unit, a much pared down VIII Fighter Command, moved from High Wycombe on 14 October to Honington, taking all its remaining groups with it. The 7th moved to Hitcham (Wattisham Depot) where it remained until 21 November, when it was inactivated in England.

One officer and one enlisted man, Lt. John Weeks and SSgt Leon A. Janota, were all that remained of the 13th Squadron. The 13th moved to London/Grove Airfield where the squadron remained until 23 November when it returned to Camp Kilmer, New Jersey, to be inactivated 1 December 1945.

The 14th squadron transferred to Villacoublay, France on 13 October along with what remained of the 22nd Squadron. The 22nd left from France on 5 December for Camp Kilmer, New Jersey, where it was inactivated on 16 December. The 14th left France 12 December for Camp Kilmer, New Jersey, to be inactivated 21 December 1945.

The 27th Squadron, reduced to two officers and two enlisted men, left Chalgrove on 14 October for Frankfurt, Germany, where it was assigned to the 51st Troop Carrier Wing. Reduced to one officer and one enlisted man, the 27th moved to Poix, France, on the 15th where it was assigned to the 466th Air Service Group. By 31 October the squadron strength was nine officers and 420 enlisted men transferred in from the 466th and 708th Air Material Squadron.

The use of a paper unit to move the men from unrelated units is illustrated by the fate of the 27th Squadron. Further changes reshaped the squadron until on 30 November, the squadron strength was 64 officers and 435 enlisted men with Maj. Herbert W. Rydstom, commanding. The organization now returned to the United States on the transport, Stephen P. Douglas, arriving 10 December 1945. The 27th Squadron was disbanded at Camp Kilmer, New Jersey, on 21 December.

These were just familiar names by now and not the units remembered by the men of the 7th Photo Group. By using the Tables of Organization to move personnel about after the war, hundreds of men passed through 7th Group and its squadrons. The 325th Wing, inactivated 20 October 1945 and the 7th Photographic Reconnaissance Group preceded its combat squadrons into mothballs. For them their war was truly over.

Wrap Up
The 7th Group began its service in July 1943 as the 7th Photographic Reconnaissance and Mapping Group. In November, its name changed to 7th Photographic Group (Reconnaissance). In June 1945, it became the 7th Reconnaissance Group. Several estimates were made regarding the number of missions flown but no details were given for the basis. Therefore, completely different totals are given in the various lists. In June 1945, a separate estimate set the numbers at 5,693 operational missions and 17,570 operational hours. The 7th Group pilots flew many missions not directly listed in many of the existing records. It is this confusion as well as incomplete sortie records that muddies the numbers. What is important is the contribution by the men of the 7th Group to the air war in Europe. The numbers are only statistics.

Epilogue

Two years after the end of the war in Europe, the War Department in Washington, D.C., awarded the Distinguished Service Cross, the United States' second highest military combat decoration, to Lt. John R. Richards. The Distinguished Service Cross is awarded for extraordinary heroism against an armed enemy. At the end of World War II, only 220 of the Eighth Air Force's men had received DSC's. This decoration recognized Richards' bravery while flying 51 missions in unarmed photographic reconnaissance F-5 and Spitfire aircraft, as well as the ELINT P-38 Droop Snoot, against an armed and aggressive enemy. Many of Richards missions were at extremely high altitude, while some were flown at tree-top level covering well-camouflaged V-weapon sites. All exposed the pilot to light and heavy flak and interception by regular or jet aircraft. Richards, a native of Tacoma, Washington, was a mechanic and welder before he enlisted in the Army Air Corps in March 1942. He served in both the 13th and 14th Squadrons. His DSC was only the second award of this decoration to a member of the 7th Group.

THE UNITED STATES OF AMERICA

TO ALL WHO SHALL SEE THESE PRESENTS, GREETING:

THIS IS TO CERTIFY THAT
THE PRESIDENT OF THE UNITED STATES OF AMERICA
AUTHORIZED BY ACT OF CONGRESS, JULY 9, 1918, HAS
AWARDED

THE DISTINGUISHED SERVICE CROSS

TO

First Lieutenant John R. Richards, A.S.N. 0736366

FOR EXTRAORDINARY HEROISM
IN CONNECTION WITH MILITARY OPERATIONS
AGAINST AN ARMED ENEMY

European Theater of Operations, 21 January 1944 – 6 October 1944
GIVEN UNDER MY HAND IN THE CITY OF WASHINGTON
THIS 24th DAY OF July 1947

Eyes of the Eighth

SOURCES

Searching for the records of the 7th Photographic Reconnaissance Group revealed that there is no one location where a comprehensive source is available. Records on various events and organizations are scattered in widely separated places. One complication is the lack of records on two of the four squadrons. To further complicate the search, many source locations have changed, moved, or closed. The National Archives have moved the Records Center from Suitland, to College Park, Maryland. The main building is still in Washington, D.C. where general information is located at the Modern Military Branch. Microfilm copies and the original records of air force units are held at the Air Force Historical Research Center, Maxwell Air Force Base, Montgomery, Alabama. The library at the Office of Air Force History, Bolling Air Force Base, Washington, D.C., has a large collection of books as well as copies of the microfilm records held at Maxwell.

In London, England, the Imperial War Museum has an excellent reference library open by appointment only. The Public Record Office at Kew contains thousands of records both of Eighth Air Force operations as well as those of the Royal Air Force. Invaluable photo reconnaissance information is in varied files especially those of the Allied Central Interpretation Unit. The enormous photo library from Medmenham is now located at the Air Photo Library, Dept. of Geography, Keele University, Staffordshire, England.

This is a partial list of sources in both the United States and England, which give a foundation for research into the 7th Group.

At the National Records Center, College Park, Maryland, the important group designation is Group 18, Boxes 689, 699, 904, 908, 909 for some records of the 7th Group, 14th Sq., and 22nd Sq. There are no listings for either the 13th or 27th Squadrons. In the catalog there are two log books listed for the 7th Group. Unfortunately, only one is in the boxes. In the same Group 18, Box 1182 has material on the 325th Wing. The Air Force Historical Research Center, Maxwell Air Force Base, Montgomery, Alabama, has original paper records of the Group microfilmed on reels listed as BO 753, BO 754, and BO 771. The squadron records are listed as AO 873, AO 878, AO 879, AO 882.

The Special Collections Room of the U.S. Air Force Academy Library in Colorado has three particularly interesting sources in the Harvey Brown Collection, Albert P. Clark Collection, and Brig. Gen. George C. McDonald Papers. In England the Public Record Office, Kew, has two particularly valuable groups, Air 29 and 40.

BIBLIOGRAPHY

Ambrose, Stephen E. *Eisenhower.* Vol. 1. New York: Simon and Schuster, 1983.

_____ *The Supreme Commander.* Garden City, New York: Doubleday & Co. Ltd. 1969.

Bennett, Ralph. *Ultra in the West: The Normandy Campaign, 1944-45.* New York: Charles Scribner's Sons, 1980.

Blumenson, Martin. *Breakout and Pursuit.* 1961 Reprint. Washington, D.C.: Center of Military History, 1984.

Brown, Anthony Cave. *Bodyguard of Lies.* Toronto: Fitzhenry and Whiteside, 1975.

Calvocoressi, Peter. *Top Secret Ultra.* New York: Pantheon Books, 1980.

Davis, Richard G. *Carl A. Spaatz and the Air War in Europe.* Washington, D.C.: Smithsonian Institution Press, 1992

Freeman, Roger A. *The Mighty Eighth.* London: Jane's Publishing Co. Ltd., 1970, 1986.

_____ *Mighty Eighth War Diary.* London: Jane's Publshing Co. Ltd. 1981.

_____ *Mighty Eighth War Manual.* London: Jane's Publshing Co. Ltd. 1984.

Hinsley, F. H. *British Intelligence in World War II.* Vol II, III (Part 1, 2). London: Her Majesty's Stationery Office 1981, 1984, 1988.

Kahn, David. *The Codebreakers: The Story of Secret Writing.* New York: Macmillan, 1967.

_____ *Hitler's Spies: German Military Intelligence in World War II.* New York: Macmillan, 1983.

Lee, Bruce. *Marching Orders.* New York: Crown Publishers, Inc. 1995.

Lewin, Ronald. *Ultra Goes to War.* New York: McGraw Hill, 1978.

Pogue, Forrest C. *The Supreme Command.* Washington, D.C.: Office of the Chief of Military History, 1954.

Putney, Diane T., ed. *Ultra and the Army Air Forces in World War II.* Washington, D.C.: Office of Air Force History, 1987.

Stanley, Col. Roy M. *World War II Photo Intelligence.* New York: Charles Scribner's Sons, 1981

Weinberg, Gerhard L. *A World at Arms.* Cambridge: Cambridge University Press, 1994.

West, Nigel. *The SIGINT Secrets: The Signals Intelligence War, 1900 to Today* New York, William Morrow, 1988.

Whiting, Charles. *Ardennes: The Secret War.* New York: Stein and Day, 1973.

Sortie List 1943

A Guide to the 7th Group Sortie List

This sortie list has been developed from information gathered from many sources. Lists of 7th Group sorties are not in squadron or group histories on microfilm at the Air Force Historical Research Center, Maxwell Air Force Base, Montgomery, Alabama. This list has been reduced from a much more extensive one to fit in the available space. Codes and abbreviations are used to indicate interesting and important information. These are indicated below. The numbering system for sorties changes several times and is explained where it happens. The list contains date, sortie number, pilot, squadron, aircraft, targets covered, and any incidents. Where there is only some evidence of a piece of information, it is marked with a ?(question mark). If no reliable information is available the space is left blank. Some pieces of information fell into place by process of elimination. Conflicting records prevent conclusions on others. Lack of records for the 13th and 27th Squadrons comparable to those available for the 14th and 22nd Squadrons resulted in the largest gaps in squadron and pilot lists. The only 7th Group logs available are for a short period from May through December 1944.

Sources: Squadron and Group Microfilm records, Air Force HRC, Maxwell AFB, Alabama; Squadron, Group, and Missing Air Crew Reports (MACR), at the National Archives and Records Administration, College Park, Maryland (This department used to be in Suitland, Maryland, but is now at the new facility.); individual pilot's records; Friskets (the identifying strip on the bottom of photos, not always left on photos in private collections); the Medmenham photo collection at the Air Photo Library, Department of Geography, University of Keele, Staffordshire, England; Allied Central Interpretation Unit records at the Public Record Office, Kew Gardens, London, England.

Complex target data, particularly airfields, have been coded to avoid repetition. Many airfields are identified by the combined names of two neighboring towns or cities. If there is more than one location with the same first name and one or more other names, the string uses the first name once then substitutes a hyphen for the name before the slash mark. For example Boulogne/Nord,-/Sud,-/Est A/Fs. The same device is utilized for Boulogne Town & M/Ys;-/Nord,-/Sud,-/Est A/Fs. This indicates that there is photo cover of the city of Boulogne, its marshaling yards and three airfields North, South, East. Laon/Couvron,-/Athies A/Fs are two airfields near the town of Laon.

Target Key:
- A/C = Aircraft
- A/F = airfield
- Br = Bridge
- D/A = Damage assessment
- Dcy = Decoy
- Dum = Dummy
- FB = Flak or Anti-aircraft batteries.
- FW = Form White a target declared by pilot.
- GB = Gun batteries
- HB = Highway bridge
- I = Industry as in Aircraft Industry
- LG = Landing ground, usually temporary or grass field.
- M/Y = Marshaling yard
- NB = Noball (V-weapon sites)
- OI = Oil Industry
- OR = Oil Refinery
- RB = Railway bridge
- RR = Railroad
- Riv = River
- SD = Sidings as with Railroad or Marshaling Yard

- Strip = Long continuous series of photos between places.
- TAC = Tactical targets
- U/B = U-boat
- U/Y = U-boat yard
- W/T = Wireless transmitter or tower
- W/W = Waterway or canal

Incidents

NOTE: MIA is used where a pilot is reported missing in action with subsequent information listed second. Example: MIA-KIA, MIA-POW, MIA-EE.

Where u/s indicates unsatisfactory the cause follows if known. Example: u/s Cloud, u/s Eng trbl.

Incidents Key:
- Canc = Canceled
- C/F = Camera failure
- CL = Crash-landing
- Con = Contrails
- CR = crashed
- E/A = Enemy aircraft
- Eng trbl = Engine trouble
- EE = Escape and/or evasion
- Esc = Escorted
- FD = Film destroyed
- Ins = Instrument as in instrument failure
- Intc = Intercepted
- KIA = Killed in action
- Ld = Landed
- Met = Meteorological
- MIA = Missing in action
- O/F = Oxygen trouble or failure
- POW = Prisoner of war
- Rec = Recalled
- Ref = Refueled
- Rd = Returned
- RT = Radio transmitter
- u/s = unsatisfactory

DATE	SORTIE	PILOT	SQ	A/C	TARGETS	INCIDENTS
1943						
MAR						
28	AA1	Hall, Maj James	13	F-5A	Le Treport	
APR						
3	AA2	Wright, Cpt James	13	F-5A	Boulogne	
	AA3	Parsons, Lt Hershell	13	F-5A	Calais	
	AA4	Mitchel, Lt Ray	13	F-5A	Ostende	
4	AA5	Campbell, Lt Jack	13	F-5A	Antwerp	MIA
	AA6	Brogan, Lt Robert	13	F-5A	Boulogne	
	AA7	Luber, Lt Vernon	13	F-5A	Cherbourg	u/s
5	AA8	Luber, Lt Vernon	13	F-5A	Cherbourg	
	AA9	Kinsell, Lt Robert C	13	F-5A	Boulogne, Le Havre	
	AA10	Shaffer, Lt John	13	F-5A	Calais	
	AA11	O'Bannon, Lt Thomas B	13	F-5A	Rouen, Dieppe	
	AA12	Nielson, Lt Howard R	13	F-5A	Boulogne	
8	AA13	Shade, Lt Walter D	13	F-5A	Cherbourg	
12	AA14	Owen, Lt George	13	F-5A	Chateaubriant	
13	AA15	Byington, Lt Telford	13	F-5A	Dieppe	
	AA16	Beckley, Lt Raymond	13	F-5 42-12969	Le Havre	
	AA17	Clark, Lt Robert	13	F-5A	Cherbourg	
14	AA18	Mazurek, Lt Raymond	13	F-5A	Triqueville	MIA-KIA
15	AA19	Watts, Lt John Harvey	13	F-5A	Cherbourg	
	AA20	Turner, Lt Herschel	13	F-5A	Dieppe	
	AA21	Tooke, Lt Walter	13	F-5A	Le Havre, Fecamp	
	AA22	Hall, Maj James	13	F-5A	Brittany Coast	Operation Bertie
	AA23		13			Canc Weather
	AA24		13			Canc Weather

311

Eyes of the Eighth

DATE	SORTIE	PILOT	SQ	A/C	TARGETS	INCIDENTS
16	AA25	Wright, Cpt James	13	F-5 42-12969	Lorient	Ref St Eval, Eng Trbl, Ld St Eval
	AA26	Parsons, Lt Hershell	13	F-5A	Brest	Ref St Eval
17	AA27	Wright, Capt James	13	F-5A	Lorient	Ref St Eval, Intercepted
20	AA28	Mitchell, Lt Ray C	13	F-5A	Lorient, Kerlin/Bastard A/F	Ref St Eval, 1st rprtd Flak
	AA29		13	F-5A	Brest Pen	
	AA30		13	F-5A	Brest Pen	
	AA31		13	F-5A	Brest Pen	
21	AA32		13	F-5A	Cherbourg	Cloud
28	AA33		13	F-5A	Cherbourg	Cloud
	AA34		13	F-5A	Dieppe	Cloud
MAY						
1	AA35		13	F-5A	Dieppe	u/s Mec trbl
	AA36		13	F-5A	Le Havre	u/s Cloud
4	AA37		13	F-5A	Dieppe,-/St Aubin A/F, St Valery-en-Caux A/F, FeCamp	
	AA38		13	F-5A	Le Havre, Caen/Carpiquet A/F	
	AA39		13	F-5A	Cherbourg,-/Maupertus A/F (FW)	
7	AA40		13	F-5A	Dieppe	
	AA41		13			u/s Eng trbl
11	AA42		13			u/s Cloud
	AA43		13			u/s Cloud
	AA44		13			u/s Cloud
12	AA45	Mitchell, Lt Raymond	13	F-5A	St Nazaire, St Brieuc/Pordic Dum A/F, Maltot ELG (6")	
	AA46		13	F-5A	Antwerp,-/Leverve, Bruges/St Croix, Ostend/Middelkirk, Maldeghem, St Trond/Brusthem A/Fs, strip Bruges to Ostende,-/Breeding SPB, Bruges	
	AA47		13	F-5A	Boulogne,-/Outreau M/Y, French A/Fs	
	AA48		13	F-5A	Achiet, Abbeville/Drucat, French A/Fs	
	AA49		13	F-5A	Laon/Couvron,-/Athies, French A/Fs	
	AA50		13	F-5A	Lille/Vendreville, French A/Fs	
	AA51		13	F-5A	Conches, Beaumont-le-Roger, French A/Fs	
	AA52	O'Bannon, Lt Thomas	13	F-5A	Amiens/Glisy, St Dizier/Robinson, Fr A/Fs	
	AA53		13	F-5A	Antwerp, Ostende, Belgian A/Fs	
	AA54		13	F-5A	Caen/Carpiquet, Rennes/St Jacques, French A/Fs	
15	AA55		13	F-5A	Courtrai M/Y, Boulogne, French A/Fs	
	AA56		13	F-5A	Vannes/Meucon A/F	
16	AA57		13	F-5A		Canc Weather
	AA58		13	F-5A	Ile Vierge area	
	AA59		13	F-5A	Paimbol to Perros/Guires	
	AA60		13	F-5A	Belgian A/Fs	u/s Cloud
	AA61	Byington, Lt Telford	13	F-5A-3 42-12769		MIA-POW
	AA62		13	F-5A	Poix/Nord, Montdidier, French A/Fs	
	AA63		13	F-5A	Chartres, FeCamp RR/St/SD, French A/Fs	
17	AA64		13	F-5A	Dunkirk, Clastres, Denain/Prouvy, Fren. & Belgian A/Fs	
	AA65		13	F-5A	Le Culot, Liege/Bierset, Chievres, Fr & Belgian A/Fs	
	AA66		13	F-5A	Ile Vierge to Pte de Corsen (FW)	
	AA67		13	F-5A	Perros/Guires, Paimpol area (FW)	
	AA68		13	F-5A		u/s Cloud
	AA69		13	F-5A	Lorient & Keroman D/A, Ouistreham, Kerlin/Bastard, Caen, French A/Fs	
18	AA70		13	F-5A	Heligoland,-/Dune A/F	
	AA71	O'Bannon, Lt Thomas	13	F-5A	Orleans,-/Bricy, Tours,-/Parcay, French A/Fs, Chateaudun, Bourges (FW)	
	AA72		13	F-5A	Quimper/Pluguffan, Brest A/Fs	
	AA73		13	F-5A		u/s Cam failure
	AA74		13	F-5A		u/s Cloud
	AA75		13	F-5A	Beauvais/Tille, Beaumont-sur-Oise, Le Treport, Courmeilles-en-Vexin A/Fs	

Sortie List
1943

DATE	SORTIE	PILOT	SQ	A/C	TARGETS	INCIDENTS
19	AA76	Hall, Maj James	13	F-5A		Recalled
	AA77	Hall, Maj James	13	F-5A	Paris, Le Bourget, Guyancourt/Caudron, Buc Ftry A/F, Versailles	
	AA78	Parsons, Lt Hershell	13	F-5A	Flensburg, Kiel, Erkenforde U/B YD, Heligoland,-/Dune, Westerland A/F	1st sortie over Germany
	AA79	Mitchell, Lt Raymond	13	F-5A	Haarlem, Ijmuiden, Bergin/Almaar, Amsterdam,-/Schipol	
23	AA80		13	F-5A		u/s Cloud
28	AA81		13	F-5A		u/s Cloud
	AA82		13	F-5A		u/s Eng trbl
	AA83		13	F-5A	Emden D/A, Borkum A/F U/B Y/D	
	AA84		13	F-5A	Antwerp,-/Deurne A/F (FW)	
	AA85		13	F-5A	Wilhelmshaven D/A, A/Fs at Jever, Wangerooge, U/B Y/D	
29	AA86		13	F-5A		u/s Haze
	AA87		13	F-5A		Canc
JUNE						
3	AA87		13	F-5A	Targets in France	
	AA88		13	F-5A		u/s
6	AA89		13	F-5A		u/s
10	AA90		13	F-5A		u/s Weather
	AA91		13	F-5A		u/s Weather
11	AA92	Turner, Lt Herschel	13	F-5A-3 42-12777	Germany (Vegesack)	MIA-POW
	AA93		13	F-5A	Sedan area, Coast s of Hardelot, W/T 1	
13	AA94		13	F-5A	Wilhelmshaven D/A, U/B Y/D 2	
	AA95		13	F-5A	Melun/Villeroche, Etampes/Bellevue A/Fs	
	AA96		13	F-5A		Canc Weather
	AA97		13	F-5A		u/s Cloud
	AA98		13	F-5A	Cuxhaven, Heligoland,-/Dune A/F Germany	
14	AA99		13	F-5A	St Malo (FW)	
18	AA100		13			u/s Weather
	AA101		13			u/s Weather
20	AA102		13			u/s
	AA103		13			u/s E/A
	AA104	Kinsell, Lt Robert	13	F-5A	Paris, Billancourt, Paris A/Fs, Buc A/F Issy-le-Moulineaux A/F, French A/Fs	
	AA105		13	F-5A	Flensburg, Lutzenholm A/Fs, Kiel Port: U/B Y/Ds 16, 17, 18, 19 Germany	
	AA106	Brogan, Lt Robert C.	13	F-5A-3 42-12779		MIA-KIA
22	AA107		13	F-5A		
	AA108		13	F-5A		Recalled
	AA109		13	F-5A	Rennes D/A,-/St Jacques A/F, Vitre, Nantes/Chateau Bougon, French A/Fs	
	AA110		13	F-5A		
23	AA111		13	F-5A		
	AA112		13	F-5A		Canc.
24	AA113		13	F-5A		u/s
	AA114		13	F-5A		
	AA115		13	F-5A		
	AA116	Lawson, Cpt George	22	F-5A 42-12969	Cap Gris Nez	1st 22sq sortie
	AA117		13	F-5A	Sedan area, Meault, Vitry-en-Artois A/F	
25	AA118		13	F-5A	Lannion, A/F,-/Kerbrigent, Ile Grande Dum/A/F	
	AA119		13	F-5A		u/s Recall E/A
	AA120		13	F-5A		u/s Cloud
	AA121		13	F-5A		
26	AA122			F-5	Nantes area	
	AA123			F-5	Paris area, Melun, Montargis/Vimory ELG	
	AA124			F-5	Orleans area, betw Dieppe & LeTreport	

313

Eyes of the Eighth

DATE	SORTIE	PILOT	SQ	A/C	TARGETS	INCIDENTS
26	AA125			F-5		u/s Weather
	AA126	Campbell, Cpt James	14	F-5	Cap Gris Nez, Boulogne,-/Alprech A/F	
	AA127			F-5	Cherbourg	
	AA128			F-5	LeTouquet to LeHavre	
	AA129			F-5	Paris area	
	AA130	Hartwell, Lt Norris	22	F-5 42-12969	Boulogne, LeTouquet/Etaples, LeTouquet to Cap Gris Nez, W/Ts 1,7,11; RDF 8	
	AA131					Canc Weather
27	AA132		13	F-5	Triqueville A/F, Rennes area, Rennes/St Jacques A/F	
	AA133	Smith, Lt Robert R	22	F-5 42-12969	Cap Gris Nez, W/T 7	
	AA134			F-5	Laval area, St Malo	
28	AA135			F-5		u/s Eng trbl
	AA136		13	F-5	Paris area, Villacoublay A/F D/A, Buc A/F, Rouen, Poissy D/A	
	AA137			F-5		u/s Cam fail
29	AA138	?Kinsell, Lt Robert	13	F-5A-3 42-12773	(St Nazaire)	MIA-POW
	AA139	Shaffer, Lt John	13	F-5A-3 42-12768	(St Nazaire)	Ref St Eval, MIA-KIA
JULY						
1	AA140	Lawson, Cpt George	22	F-5A-3 42-12781	Fecamp area	
3	AA141	Campbell, Cpt James	14	F-5A	Beaumont-le-Roger A/F D/A, Boulogne, Rouen obliques	
	AA142	Black, Lt Vernon	22	F-5A 42-12786	LeTouquet A/F,Breck-sur-Mer A/F, W/Ts 1,7,8,10; Cap Gris Nez to Cayeaux, Boulogne,-/Alprech LG, -/Harbor 5,-/Outreau M/Y	
4	AA143	Hartwell, Lt Norris	22	F-5 42-12770		u/s Eng failure
	AA144	Scott, Lt Steven	22	F-5 42-12780	Dieppe,-/Derchigny A/F, LeHavre/Octeville A/F, LeTreport, Fecamp/Eletot, -/St Helene A/F	
	AA145	Hughes, F/O Malcolm D	22	F-5 42-12979	Cherbourg,-/Maupertus,-/Querqueville,-/Chanterayne S/S, Quettou S/S, W/Ts E,F.	
	AA146	Hairston, F/O Richard	22	F-5 42-12979	Abbeville D/A, -/Drucat, Poix A/F D/A,-/Nord, LeHavre,-/Octeville St Valery-en-Caux, Dieppe/St Aubin	
	AA166			F-5	Boulogne, Dunkirk,-/Mardyck, Calais,-/Cocquelles, Coxyde/Furnes, A/Fs in France	
17	AA167	Haight, Lt Edward L	13	F-5-3 42-12780	(Huls, Germany; A/Fs in Holland)	Intc Scheldts area, MIA-KIA
	AA168	Campbell, Cpt James	14		Zeebruge, Ostende, Bruges/St Croix Belgium; A/Fs in France	
	AA169	Chapman, Lt Carl	22	F-5 42-13078	Crecy-en-Ponthieu LG, W/T 3,4.	
23	AA170	Smith, Lt Robert R	22	F-5 42-13099		Visual Met Flight
24	AA171	Chapman, Lt Carl	22	F-5 42-12981		Visual Met Flight
25	AA172				Boulogne area, Calais, A/Fs in France	
	AA173	Lawson, Maj George	22	F-5 42-13078	Fecamp, Dieppe area	
26	AA174			F-5	Amiens/Glissy A/F D/A, Albert/Meaulte, Mezieres-en-Santerre	
	AA175	Hartwell, Cpt Norris	22	F-5	Strip Calais -east, A/Fs in France	
	AA176			F-5		u/s
	AA177			F-5		u/s
27	AA178	Campbell, Cpt James	14	F-5	Ghent area D/A, Coxyde/Furnes A/F	
	AA179	Hairston, F/O Richard	22	F-5 42-12786	St Omer/Ft Rouge, A/F D/A, Boulogne, A/Fs in France	
	AA180	Hughes, F/O Malcolm D	22	F-5 42-12981		u/s cam failure
	AA181	Smith, Lt Robert R	22	F-5 42-13078		Canceled,
28	AA181	Smith, Lt Robert R	22	F-5 42-13078		u/s Lost canopy
	AA182	Scott, Lt Steven	22	F-5 42-13099		
	AA183	Smith, Lt Robert R	22	F-5 42-12981		Recalled
	AA184	Smith, Lt Robert R	22	F-5 42-12981	Cherbourg, -/Querqueville A/F, W/Ts A,B,C,D,E,F,G; A/Fs in France	
	AA185	Black, Lt Vernon	22	F-5 42-12786	Boulogne A/Fs, Breck-sur-Mer, Hardelot area, A/Fs in France	
	AA186					
	AA187	Chapman, Lt Carl	22	F-5 42-12981	Boulogne/Outreau M/Y, Watten area, A/Fs in France	
	AA188					u/s
	AA189				Zeebruge, Bruges, Mouth of Scheldt, Belgium	
29	AA190					u/s Eng trbl
	AA191					
	AA192					
	AA193					
	AA194					

314

Sortie List
1943

DATE	SORTIE	PILOT	SQ	A/C	TARGETS	INCIDENTS
30	AA195					
	AA196					
	AA197					
	AA198	Hughes, F/O Malcolm	22	F-5 42-12969		
	AA199	Hairston, F/O Richard	22	F-5 42-13099		
31	AA200					
AUG						
7	AA201					Canc
	AA202					Canc
8	AA203					u/s Eng trbl
	AA204					u/s Eng trbl
	AA205				St Brieuc/La Plaine A/F	
	AA206					u/s Eng trbl
12	AA207				Morlaix, -/Plouigneau Dum A/F, Knocke/Le Zoute A/F, Lannion, Morlaix/Ploujean, Roscoff, Strip Lannion to Pleubian, Ile Grande	
15	AA208					
	AA209					
	AA210	Lawson, Maj George	22	F-5A-10 42-13099	Marquise area, Calais,-/Coquelles A/F, St Omer/Longuenesse,-/Ft Rouge, Merville	
	AA211				Le Trait, Strip to E of Dieppe, Caudebec-en-Caux	
	AA212				St Omer/La Meppe A/F, Morlaix/Ploujean A/F, Douarnenez area, Brittany area	
	AA213					u/s E/A
	AA214	Scott, Lt Steven	22	F-5A-10 42-13311		u/s Cloud
16	AA215				Abbeville/Drucat A/F D/A, Amiens/Glissy A/F D/A -/Longueau M/Y, Poix A/F D/A	
	AA216	Campbell. Capt James	14	F-5A-10 42-13313	Flushing, Vlissingen A/F Holland	
	AA217	Smith, Lt Robert R	22	F-5A-10 42-13099	Valkenburg A/F, Ypenburg A/F D/A, Langerveld A/F, Ockenburg A/F Holland	
	AA218				Guernsey, Jersey (Channel Islands); Brittany area, Lannion A/F, Ile Grande Dum A/F France	
	AA219				Brest/Guypavas A/F, Languedoc/Poulmic A/F	
	AA220					u/s
	AA221	Black, Lt Vernon	22	F-5A-10 42-13316	Amiens/Glissy A/F D/A, -/Longueau M/Y, Poix A/F, D/A, Amiens/Gentelles Dum A/F	
	AA222	Chapman, Lt Carl	22	F-5A-10 42-1332	Merville A/F, St Omer/Ft Rouge A/F, St Omer/La Borne Decoy A/F	
	AA223				St Valery-en-Caux, Conches A/F, Dreux A/F, Villacoublay, Le Bourget A/Fs, Beaumont-sur-Oise, Dieppe, Beauvais/Tille, -/Nivillers A/F	
	AA224				Area SW of Paris, Strip Chateaudun to St Valery	
	AA225				St Malo, Dinard/Pleurtuit A/F	
	AA226					Canc resched 17/8/43
17	AA226					u/s Cloud
	AA287					Canc
	AA298				Saumer area, Strip N of Le Mans, Strip E of St Malo	
	AA229	Hartwell, Capt Norris	22	F-5A-10 42-13320	Lille/Vendeville A/F D/A, Vitry-en-Artois D/A, Lille/Ronchin A/F, Douai. La Brayville A/F	
	AA230	Hairston, F/O Richard	22	F-5A-10 42-13099	Abbeville/Drucat A/F D/A, Le Treport, Le Touquet,-/Etaples A/F	
18	AA231					u/s Weather
	AA232	Hughes, F/O Malcolm D	22	F-5A-10 42-13099		u/s Weather
	AA233					Canc
	AA234	Wayne, Maj Marshall	14	F-5A-10 42-13312		u/s Weather
	AA235				St Brieuc,-/La Plaine A/F, Lamballe	
19	AA236					u/s Weather
	AA237					Canc
	AA238	Hartwell, Capt Norris	22	F-5A-10 42-13320		u/s Cloud
	AA239	Lawson, Maj George	22	F-5A-10 42-13316		u/s Cloud
	AA240	Nesselrode, Capt George	14		Cap Gris Nez to Calais Obl	
	AA241	Weitner, Capt Walter	14		Cap Gris Nez to Calais Obl	
	AA242	Burrows, Lt Daniel	22	F-5A-10 42-13315	Gravelines, Calais	
	AA243	Hawes, F/O Clark	22	F-5A-10 42-13316	Coast Le Touquet to Boulogne Obl	
20	AA244					Canc
SEPT						
3	AA245	Hughes, Lt Malcolm D	22		Targets in France	

315

Eyes of the Eighth

DATE	SORTIE	PILOT	SQ	A/C	TARGETS	INCIDENTS
3	AA246				Le Treport, Dieppe, Poix A/F D/A, Issy Les Moulineux	
	AA247					u/s Cloud
	AA248	Scott, Capt Steven	22	F-5A-10 42-13312		u/s Cloud
	AA249					Canc
4	AA250	Scott, Capt Steven	22	F-5A-10 42-13311	Lille/Nord,-/Ronchin,-/Vendreville,-/Seclin A/Fs, Mazingarbe, Le Touquet	
	AA251				A/Fs Caen/Carpiquet, Beaumont-le-Roger	
	AA252	Smith, Capt Robert R	22	F-5A-10 42-13315	Dieppe, St Andre/LaFaville Dum A/F, A/Fs in France	
	AA253					
	AA254	Chapman, Lt Carl	22	F-5A-10 42-13319	Valkenburg/Katwcjk A/F, Utrecht M/Y Hol.	U/s Eng trbl
	AA255	Simon, Capt Walter	14		Obliques Barfleur to Cap de la Hague, France to Holland	
6	AA256				Lille/Nord A/F, -/La Deliverance M/Y D/A, Mazingarbe D/A, Boulogne, W/Ts 4&5	
	AA257				Dieppe,-/St Aubin,-/Derchigny A/Fs	
	AA258	Nesselrode, Capt George	14		Caen/Carpiquet A/F D/A, Plumetot A/F	
	AA259	Black, Lt. Vernon	22	F-5A-10 42-13322	Dunkirk, Calais, Merville A/F, Hazebrouck, St Omer/Ft Rouge	
	AA260	Hughes, Lt Malcolm D	22	F-5A-10 42-13320	Ostende, Ghent D/A,-/Maritime,-/Meirelberke M/Ys, Middelkirk, Bel & Hol	
	AA261					
	AA262	Burrows, Lt Daniel	22	F-5A-10 42-13325	St Pol M/Y D/A, Boulogne,-/Elprech A/F Monchy/Breton A/F, LeTouquet,-/Etaples.	
	AA263	Hairston, Lt Richard	22	F-5A-10 42-13279	Deelen A/F, Soesterberg A/F, Ijmuiden, Holland	
7	AA264					u/s Weather
	AA265					u/s
	AA266					u/s Cloud
	AA267	Campbell, Capt James	14	F-5A-10 42-13078	A/Fs St Omer/Longuenesse,-/Ft Rouge, -/Laborne Dum A/F, Watten area	
	AA268				Brussels/Evere A/F	
8	AA269	Hartwell, Capt Norris	22	F-5A-10 42-13320	A/Fs Deelen, Soesterberg, Holland	
	AA270	Wayne, Maj Marshall	14		Caen/Carpiquet A/F D/A, Crepon, Plumetot A/Fs,	
	AA271	Lawson, Maj George	22	F-5A-10 42-13311		u/s Recalled
9	AA272					u/s Weather
	AA273	Weitner, Capt Walter	14		Thelus Decoy, Beauvois Dum A/Fs, Nunc A/Fs at LeTouquet, Lille/Vendeville A/F	
	AA274	Scott, Capt Steven	22	F-5A-10 42-13315	Beauvois/Tille A/F D/A,-/M/Y, Meulan-les-Mureaux D/A	
	AA275					u/s Cloud
	AA276					u/s
	AA277					u/s Weather
	AA278					Canc
	AA279	Sheble, Lt Richard	14			Canc Weather
	AA280					Canc
11	AA279					Canc
	AA280					Canc
15	AA281	Bliss, Capt Kermit	14		Cherbourg Pen 6" Obliques	
	AA282	Snyder, Lt Eugene	22	F-5A-10 42-12981		u/s Weather
	AA283	Fricke, Lt Harlan,	14			u/s Cloud
	AA284	Aubrey, Lt Lawrence	22	F-5A-10 42-13311		u/s Cloud
	AA285	Blyth, Lt John S	22	F-5A-10 42-13325		u/s Cloud
	AA286	Alston, Lt Robert C	14			u/s Cloud
	AA287	Nelson, Lt Robert R	14			Canc
16	AA287	Nelson, Lt Robert R	14			u/s
	AA288	Nelson, Lt Robert R	14		Breck-sur-Mer	
	AA289	Beckley, Lt Raymond E	13			u/s
	AA290	Sears, Lt Bert	22	F-5A-10 42-13325		
	AA291				Le Treport, A/Fs at Cormielles-en-Vexin, Beaumont-sur-Oise, Serqueux M/Y	
	AA292	Smith, Capt Robert R	22	F-5A-10 42-13315	Antwerp, A/Fs at Brussels/Evere,-/Melsbroek, Ghent Belgium	
	AA293	Chapman, Lt Carl	22	F-5A-10 42-13316	Antwerp, Calais, A/Fs at Brussels/Melsbroek, St Omer/Longuenesse	
	AA294	Wayne, Maj Marshall	14			
	AA295	Simon, Capt Walter J	14		Doullens area, Abbeville/Drucat A/F, Beauvoir A/F	
	AA296	Nesselrode, Capt George	14	F-5A-10 42-13312	St Omer/Longuenesse,-/LaBorne A/F, St Nicholas area, Gravelines Port	
	AA297	Eaton, Lt Wilbur B	14			u/s
18	AA298					u/s
	AA299				Nantes,-/Gare de L'Etat M/Y Chateau Bougon A/F	

316

Sortie List
1943

DATE	SORTIE	PILOT	SQ	A/C	TARGETS	INCIDENTS
19	AA300					u/s Cloud
	AA301	Wayne, Maj Marshall	14		Lille area, Lille/Seclin LG.-/Phalemnin LG, Dunkirk,-Petrol SD, Boulogne,-/A/Fs	
21	AA302	Black, Lt Vernon	22	F-5A-10 42-13315		
22	AA303	Hartwell, Capt Norris	22	F-5A-10 42-12979		Met visual only
	AA304	Campbell, Capt James	14			Canc
23	AA304	Campbell, Capt James	14		Nantes, D/A Coveron, Le Pellerin, Canal Maritime, Nantes/Chateau Bougon A/F	
	AA305	Aubrey, Lt Lawrence	22	F-5A-10 42-13315	Boulogne, B/Harbor S/PB, Lille/Nord, -/Vendeville A/Fs D/A, Vitry-en-Artois D/A, Wimereux M/Y, W/T 11	
	AA306	Weitner, Capt Walter	14		Vitry-en-Artious, Mazingarbe, Fresne/LesMonthuban A/F	
	AA307				Rouen, Fecamp, Conches A/F, D/A,	
	AA308	Hairston, Lt Richard	22	F-5A-10 42-13322	Dieppe,-/Derchigny A/F, Serqueux	
	AA309				Vannes/Meucon, Kerlin/Bastard A/Fs D/A	
	AA310				Nantes, Ile Noirmoutier, Le Pellerin, Nantes/Chateau Bougon A/F, Canal Maritime	
	AA311				Chateaubriant area	
	AA312	Hughes, Lt Malcolm D	22	F-5A-10 42-13320	Beauvais/Tille A/F D/A, W/Ts A,B,D,E,F.	
24	AA313					Canc
	AA314				Nantes D/A, -/Chateau Bougon A/F	
	AA315					u/s
	AA316	Adams, Lt Gerald	14		Cherbourg 6" Obliques	
	AA317	Wayne, Maj Marshall	14		Strip Coast NE of Cherbourg Pen	
	AA318	Blickensderfer, Lt Wendell	22	F-5A-10 42-12981	Dunkirk, Gravelines, Calais 6" Obl, Calais/Marck, Coxyde/Furnes, A/Fs	
	AA319	Diderickson, Lt Robert	14		Le Touquet to Breck-sur-Mer Obl, Le Touquet A/Fs 6" Obl.	
	AA320	Hartwell, Capt Norris	22	F-5A-10 42-13322	Cormeilles-en-Vixen, Romilly A/Fs, Romilly	
	AA321	Davidson, Lt Verner	14		N Coast Cherbourg Pen Obl.	
26	AA322	Lawson, Maj George	22	F-5A-10 42-13303		u/s Cloud
27	AA323				Harderwijk, Harlingen, Holland	
	AA324	Burrows, Lt Daniel	22	F-5A-10 42-13322		u/s Cloud
	AA325	Chapman, Lt Carl	22	F-5A-10 42-13313	Rennes/St Jacques A/F D/A	
OCT						
2	AA326					u/s Cloud
3	AA327	Black, Capt Vernon	22	F-5A-10 42-13315	Dieppe, St Valery-en-Caux, Evreau/Fauville D/A-/Hurst Dum Beauvais/Tille D/A-/Nivilliers	
	AA328					u/s
	AA329	Scott, Capt Steven	22	F-5A-10 42-13312	Boulogne A/Fs, Amiens/Glissy, Rheims/Champagne D/A	
8	AA330	Aubrey, Lt Lawrence	22	F-5A-10 42-13320	Nantes,-/Chateau Bougon A/F, -/Orleans M/Y-/Chantenay M/Y, -/Gare de-Etat M/Y	
	AA331				Coast W of Calais, A/Fs St Inglevert, Breslau/Gandau Decoy,-/Schogarten,-/Gandau	
	AA332				Vlissingen, Woensdrecht A/F D/A Flushing, Breskins, Antwerp	
	AA333					Canc
	AA334	Sheble, Lt Richard	14		Met flt Lille/Vendeville,-/Nord	
9	AA335	Smith, Capt Robert R.	22	F-5A-10 42-13316	Ijmuiden, Amsterdam/Schipol D/A	
	AA336	Simon, Capt Walter	22		Le Havre,-/Octeville	
	AA337					u/s Cloud
	AA338	Wayne, Maj Marshall	14		Met flight	Eng trble
	AA339	Fricke, Lt Harlan	14		Gravelines/Oye LG (FW)	
	AA340	Nesselrode, Capt George	14		Visual Met flight	
	AA341				A/Fs in France Caen/Carpiquet, Valkenburg/Katwijk	
	AA342	Burrows, Lt Daniel	22	F-5A-10 42-13315		u/s
16	AA343	Sheble, Lt Richard	14		Schipol Met flight	
17	AA344	Graves, Lt Willard	14		Obliques of N Coast Cherbourg Pen	
18	AA345	Weitner, Capt Walter	14			u/s Eng trbl
	AA346	Alston, Lt Robert C	14		Bergues to Neufchatel, Coxyde/Furnes, A/F, Nieuport	
	AA347	?Waldron, Lt Arthur	13			u/s Eng trbl
	AA348	Snyder, Lt Eugene	22	F-5A-10 42-13316	Abbeville/Drucat A/F, LeTreport	
	AA349				Area SW of Paris	

317

Eyes of the Eighth

DATE	SORTIE	PILOT	SQ	A/C	TARGETS	INCIDENTS
18	AA350	Burrows, Lt Daniel	22	F-5A-10 42-13315	Coastline Zeebruge to Flushing	
	AA351				Coastline Calais to Dunkirk	
	AA352					u/s
	AA353	Hughes, Lt Malcolm	22	F-5A-10 42-13078		u/s
20	AA354	Weitner, Capt Walter	14		Beauvais/Tille A/F D/A, -/Nivilliers A/F, Crecy-en-Ponthieu A/F Poix/Nord, -/Movencourt	
	AA355	Simon, Capt Walter	14	F-5A-10 42-12979		Eng threw rod Scheldts, u/s weather, Ld Framlingham, rd to MF 22/10 by B-25
	AA356					Canc
	AA357	Lawson, Maj George	22	F-5A-10 42-13316	Lille/Vendeville A/F, Coast Calais to Ostend, Dunkirk, Calais/Marck A/F	
21	AA358	Wayne, Maj Marshall	14			Met
	AA359	Scott, Capt Steven	22	F-5A-10 42-13078	Rotterdam,-/Waalhaven A/F, B/Yds 36-40, Dordrecht	
	AA360	Hartwell, Capt Norris	22	F-5A-10 42-13316		u/s cloud
22	AA361	Fricke, Lt Harlan	14		Cabourg & area, Le Treport area	
24	AA362	Blickensderfer, Lt Wendell	22	F-5A-10 42-13320		
	AA363	Sheble, Lt Richard	14	F-5A-10 42-12979	Woensdrecht D/A, Convoy, Bergen-op-zoom, Thulen Holland	
	AA364	Sears, Lt Bert	22	F-5 42-13322	Noire Bernes area, Wissant/Inghen area, Boulogne/Outreau French A/Fs	
	AA365	Nesselrode, Capt George	14			u/s recalled
	AA366					u/s weather
	AA367	Aubrey, Lt Lawrence	22	F-5A-10 42-13316		
	AA368	Eaton, Lt Wilbur B	14		W/Ts 4, Samur/Wierre aux Bois A/F, Desvres A/F	
27	AA369					u/s cloud
	AA370	Snyder, Lt Eugene	22	F-5A-10 42-13320	Pois A/F, Brombos, Beauvais/Nivilliers-/Tille, Grandvilliers	
	AA371	Black, Capt Vernon	22	F-5 42-13322		u/s cloud
	AA372					Canc
30	AA373	Gonzalez, Lt Hector	13		A/Fs Evereux/Fauville, St Andre de L'Eure, Illiers/L'Eveque,	
	AA374	Sears, Lt Bert	22	F-5A-10 42-13320	Etaples area, Le Touquet, -/Etaples A/F	
	AA375					u/s
	AA376					Canc
	AA377	Burrows, Lt Daniel	22	F-5A-10 42-13316	Le Treport, Rouen, Poix A/F, Issy/Les Moulineaux A/F, Paris to Rouen. Paris to Fecamp, Le Treport area.	
	AA378					Canc
NOV						
3	AA379	Wayne, Maj Marshall	14	Spit XI MB-945		u/s
	AA380	Weitner, Capt Walter	14	F-5A-10 42-13312	Middleburg town, Holland	
	AA381	Hairston, Lt Richard	22	F-5A-10 42-13316		
	AA382				Rouen/Boos, Dieppe/St Aubin A/Fs	
	AA383	Blickensderfer, Lt Wendell	22	F-5A-10 42-13320	Abbeville/Drucat, Yvrench, Le Crotoy, Estres les Crecy, Evereux/Fauville A/Fs	
	AA384	Nelson, Lt Robert R	14		Montdidier A/F D/A, Beauvais/Nivilliers A/F D/A, -/Tille	
	AA385	Alston, Lt Robert	14		Domleger Lannoy A/F, Yvrench,-/Conteville, Amiens/Glissy A/F, Amiens area,	
5	AA386	Smith, Capt Robert R	22	F-5A-10 42-13320	Harlingen, Leeuwarden A/F, Texel A/F, strip Leeuwardern-Harlingen, Hol.	
	AA387	Nesselrode, Capt George	14			u/s cloud
	AA388					u/s weather
	AA389	Hartwell, Capt Norris	22	F-5A 42-12778		u/s
	AA390	Simon, Capt Walter	14	F-5A-10 42-13319	Calais area D/A, Wimereux, Marquise A/F, -/Mimoyecques, A/Fs in France	
	AA391	Hartwell, Capt Norris	22	F-5A-10 42-13316	Amsterdam/Schipol, Twente/Enschede A/Fs Holland	
7	AA392	Sheble, Lt Richard	14		Triqueville A/F D/A, St Andre de L'Eure A/F D/A, Illiers l'Eveque, Dreux	
	AA393	Chapman, Capt Carl	22	F-5 42-13320	Verneuil LG	
	AA394	Davidson, Lt Verner	14		Boulogne Port & M/Y	
	AA395				Tricqueville A/F D/A, Chateaudun	
9	AA396	Fricke, Lt Harlan	14			Met
	AA397	Bliss, Capt Kermit	14			Met
	AA398	Adams, Lt Gerald	14			Met
10	AA399	Weitner, Capt Walter	14			Met
	AA400	Blyth, Lt John S	22	F-5 42-13320	Met flight to Lille	Met
	AA401	Sear, Lt Bert	22	F-5 42-13320		u/s cloud

318

Sortie List 1943

DATE	SORTIE	PILOT	SQ	A/C	TARGETS	INCIDENTS
10	AA402	Aubrey, Lt Lawrence	22	F-5 42-13316	Nieuport/Fontes A/F	
16	AA403	Snyder, Lt Eugene	22	F-5 42-13316		u/s cloud
17	AA404					Canc
18	AA405	Hartwell, Capt Norris	22	Spit XI MB-948	Marquise/Mimoyecques, Guines/La Place, A/Fs in France	
23	AA406	Wayne, Maj Marshall	14	Spit XI MB-948	Wizernes, Bois D' Esquerdes, St Omer/Ft Rouge A/F, Lille-Calais areas	
	AA407	Blickensderfer, Lt Wendell	22	F-5 42-13289		u/s cloud
	AA408					u/s Recalled
	AA409					u/s cloud
24	AA410	Burrows, Lt Daniel	22	F-5 42-13320	Strip S of Ostende	
25	AA411	Weitner, Capt Walter	14		Cherbourg,-/Maupertus A/F, Martinvaast D/A,	
	AA412	Parker, Lt Charles F	13		Calais, St Omer/Longuenesse A/Fs, Lille-Calais areas	
	AA413	Hughes, Lt Malcolm D	22	Spit XI MB 950		
	AA414					u/s Eng trbl
	AA415	Sears, Lt Bert	22	F-5 42-13320		u/s Contrails
	AA416				Amiens/Glissy, Creil, Clastres, Roye/Amy, Beaumont-sur-Oise A/Fs	
	AA417	Bliss, Capt Kermit	14	F-5A-10 42-13312	Vitry-en-Artois, Merville, A/Fs in France	
	AA418	Graves, Lt Willard	14		Breck-sur-Mer A/F D/A	
	AA419				Montdidier A/F, area N of Amiens	
	AA420	Scott, Capt Steven	22	F-5 42-13322	Paris-Nantes area	
26	AA421	Chapman, Capt Carl	22	Spit XI MB-948	Wesel D/A, Huls	
	AA422	Simon, Capt Walter J	14	F-5A-10 42-13312	Martinvaast D/A	
	AA423					u/s
	AA424	Smith, Capt Robert R	22	Spit XI MB-952	Duren D/A, Brussels	
	AA425	Diderickson, ?Lt Robert	14		Boulogne, St Inglevert A/F, Audinghen D/A	
	AA426	Snyder, Lt Eugene	22	F-5A-10 42-13322		u/s cloud, intercepted
?	AA427					
	AA428	Hughes, Lt Malcolm D	22	Spit XI MB-948		
29	AA429	Alston, Lt Robert	14			Cloud
	AA430	Smith, Capt Robert R	22	Spit XI MB-950		
	AA431	Kingham, Lt LLoyd	22	Spit XI MB-952		
	AA432	Nelson, Lt Robert R				
30	AA433	Davidson, Lt Verner	22	F-5A-10 42-12979		
	AA434	Adams, Lt Gerald	14	F-5A-10 42-13312	Met flight Lille/Nord, Chievres	
	AA435	Blyth, Lt John S	22	F-5A-10 42-13311		Cloud
	AA436	Sears, Lt Bert	22	F-5A-10 42-13315		
	AA437					
	AA438					
DEC						
1	AA439	Blickensderfer, Lt Wendell	22	F-5A 10 42-13316	Nantes	Intc, Ld away Northweald
3	AA439	Blickensderfer, Lt Wendell	22		Strips E of Le Mans, W of Blois, N of Manchenoir	
	AA440	Fricke, Lt Harlan	14			Canc
4	AA441	Parker, Lt Charles F	13	Spit XI	Strip Den Helder to Haarlem, Ijmuiden, Utrecht, Coast S of The Hague	
	AA442	Nesselrode, Capt George	14		Volkel, A/Fs in Holland, Hook of Holland, Strip of The Hague	
	AA443					Canc
5	AA444	Diderickson, Lt Robert	14		Pas de Calais, W/Ts, Boulogne,-/Alprech A/F,-/Outreau M/Y	
11	AA445	Eaton, Lt Wilbur	14	F-5A-10 42-13312	Met Flight	False homing
	AA446	Blyth, Lt John S	22	F-5A-10 42-13316		u/s Cloud
	AA447	Fricke, Lt Harlan	14	F-5A-10 42-13312		KIA
	AA448					u/s
12	AA449	Graves, Lt Willard	14		Met flight	
	AA450				Met flight	

319

Eyes of the Eighth

DATE	SORTIE	PILOT	SQ	A/C	TARGETS	INCIDENTS
12	AA451	Hughes, Lt Malcolm D	22	Spit XI PA-851		u/s
	AA452	Hughes, Lt Malcolm D	22	Spit XI PA-851	Met flight	
20	AA453	Alston, Lt Robert	14			u/s
	AA454	Sheble, Capt Robert	14			u/s Intc
	AA455				Strips inland Cap Gris Nez & Boulogne, Bois de Belevil, W/Ts	
	AA456	Hartwell, Capt Norris	22	Spit XI MB-950	Kiel D/A,-/Holtenau A/F, Bremen D/A, U/Ys 16,17,18,30.	
	AA457				Area SW of Paris	
	AA458	Hawes, Lt Clark	22	F-5A-10 42-13322	Amsterdam,-/Schipol A/F, Scheldt area	
	AA459	Aubrey, Lt Lawrence	22	F-5A-10 42-13311	Area SW of Paris	
	AA460	Bliss, Capt Kermit	14			u/s
	AA461	Lawson, Maj George	22	Spit XI MB-955	Coast of Cap Gris Nez, Etelay LG, Boulogne, Denain/Prouvy	
	AA462					u/s
	AA463	Weitner, Capt Walter	14			u/s
	AA464	Bliss, Capt Kermit	14		LeHavre, Etretat, Montvillier former LG	
	AA465	Haugen, Capt Cecil T	27		Coast Calais to Dunkirk	
22	AA466	Nelson, Lt Robert R	14		Lille/Vendeville A/F D/A, Achiet A/F, Beauvoir A/F (FW)	
	AA467	Gonzalez, Lt Hector	13		Denain/Prouvy, Lille/Vendeville	
	AA468	Blyth, Lt John S	22		Area SW of Paris, Rennes/St Jacques A/F	
	AA469	Sears, Lt Bert	22		Area SW of Paris, ChateaudunA/F	
	AA470					u/s
	AA471	Wayne, Maj Marshall	14			u/s
	AA472				Cherbourg(FW),-/Querqueville A/F, Cap Levy area	
	AA473	Snyder, Lt Eugene	22	F-5A-10 42-13315		u/s Eng failure
23	AA474	Scott, Capt Steven	22	Spit XI PA-851		MIA-KIA
	AA475	Chapman, Capt Carl	22	Spit XI MB-950	Quackenbruck A/F (FW)	
	AA476	Simon, Capt Walter	14	Spit XI MB-956	Barmen, Sterkrade, Wanne/Eickel Kamen area	Ran out of gas, CL pasture 2m N of Salcombe,Corn
24	AA477	Kingham, Lt Lloyd	22	Spit XI MB-955	Lostebarne/Andres-Cocove-Heuringhem areas, W/T 9,10	
	AA478	Hairston, Lt Richard	22	Spit XI MB-952	Forest D'Hesdin, Siracourt, Bois Renpre, Bois de Renty	
	AA479	Parker, Lt Charles	13	Spit XI	Desrves/Bourthes Dum, Bellevue, Samur/Wierre-aux-Bois A/F	
	AA480	Alston, Lt Robert	14		Gueschart, Maison Ponthieu, Compagne les Hesdin	
30	AA481	Dixon, Lt Robert	14		Petit Bois Tillencourt, Yvrench Abbeville/Drucat A/Fs	
	AA482	Burrows, Capt Daniel	22	Spit XI MB-955	Rotterdam, Dunkirk Coastal area	
	AA483				Coastal strips Rotterdam area, strip Brussels to coast	
	AA484	Nesselrode, Capt George	14			u/s
	AA485	Skiff, Lt Earl V	22	F-5A-10 42-13316	Boulogne,-/Alprech, Breck A/F (FW), LeTouquet/Etaples A/F	
	AA486	Hairston, Lt Richard	22	Spit XI MB-945		u/s
	AA487	Davidson, Lt Verner	14		Cap Gris Nez to Lille, W/T 4,7, 8, St Omer/Ft Rouge,-/Longuenesse,-/Clairmarais A/F,	
	AA488	Nesselrode, Capt George	14	Spit XI MB-952		u/s Weather, LD Lypne, low fuel
	AA489				Cherbourg,-/Querqueville A/F Barfleur	
31	AA490	Eaton, Lt Wilbur	14			u/s Intc
	AA491				Ruhr area	
	AA492	Sears, Lt Bert	22	F-5A-10 42-13320		u/s
	AA493	Blyth, Lt John	22	F-5A-10 42-13316	Brussels area	
	AA494	Blickensderfer, Lt Wendell	22	F-5A-10 42-13303	Norrent/Fontes, St Omer/Ft Rouge,-/Longeunesse A/F Dunkirk	
	AA495	Hughes, Lt Malcolm D	22	Spit XI PA-892	Hulls	
	AA496	Bliss, Capt Kermit	14			
	AA497					u/s RT failure
	AA498	Snyder, Lt Eugene	22	F-5A-10 42-13320	Calais (FW)	
	AA499	Chapman, Capt Carl	22	F-5 42 67332		u/s Cloud
	AA500	Wayne, Maj Marshall	14			u/s
	AA501	?Waldron, Lt Arthur	13			
	AA502					u/s Prop failure
	AA503	Graves, Lt Willard	14		Dieppe,Orly/ Villeneuve A/F Bois Colombes, Issy-les-Moulineau	
	AA504					u/s RT failure
	AA505					u/s Eng Trbl
1944						
Jan						
2	AA506	Hawes, Lt Clark	22	F-5 42-67322		u/s Cloud
	AA507	Diderickson, Lt Robert	14			u/s Cloud

320

Sortie List 1944

DATE	SORTIE	PILOT	SQ	A/C	TARGETS	INCIDENTS
4	AA508				Strip SE Boulogne, Dunkirk, Nunca A/F, Pas de Calais area	
	AA509	Parsons, Lt Edward B	22	F-5 42-13316	Dunkirk,-/Mardyck A/F, Calais,-/Marck A/F,-/Fontinettes M/Y	
	AA510	Smith, Lt Robert R	22	Spit XI PA 842	Emden, U/Y 1, Wilhelmshaven	
	AA511	Adams, Lt Gerald	14	F-5B 67362	Boulogne, Monchy/Breton A/F, Bryas/Sud A/F(FW), Eclimeux	
	AA512	Blyth, Lt John S	22	F-5 42-67331	Strips Berneval-Mantes-Paris, & St Denis-Rouen-Fecamp	Part sucess Eng trbl
	AA513	Sheble, Capt Richard	14			u/s Eng Trbl
	AA514	Blickensderfer, Lt Wendell	22	F-5 42-67322	Strip W of Ostende-NE Lille to S of Ghent-Bruges to W of Zeebrugge, Coxyde/Furness A/F	
	AA515	?Gonzalez, Lt Hector	13		Oolfgenplat, Numansdorf, vicinity of Flushing, Hol.	
	AA516	Nelson, Lt Robert R	14			u/s
	AA517	Haugen, Capt Cecil T	27		SW of Arras, A/F in Arras area	
	AA518	Diderickson, Lt Robert	14	F-5B 37361	Paris-Orleans area Chartres A/F, Chartres A/F(6"), LeHavre	
	AA519				Paris-Orleans area, LeHavre,-/Octeville A/F, Rouen, LeTrait	
5	AA520	Sheble, Capt Robert N	14	Spit XI MB 945		u/s Eng trbl
	AA521	Nelson, Lt Robert R	14		Dieppe-Tours area	
	AA522	Hawes, Lt Clark	22	F-5 42-13316		u/s
	AA523	Hartwell, Maj Norris	22	Spit XI PA 892	A/Fs Caen/Carpiquet, Cognac/ Ch Bernard, Tours/Parcay, St Jean D'Angely, Landes de Bussas	
	AA524	Skiff, Lt Earl	22	F-5 42-67322	Boulogne, Arras area, Vitry-en-Artois A/F	
	AA525	Blyth, Lt John S	22	F-5 42 67331		u/s ice Eng trbl?
	AA526				Boulogne (FW)	
	AA527	Weitner, Capt Walter	14		Tours/Parcay, Chateaudun A/Fs Strips Dieppe-Tours area	
	AA528				Coast near Cap Gris Nez	
	AA529	Hughes, Lt Malcolm	14		Calais (FW),-/Marck A/F	
	AA530					Canc
	AA531				Boulogne (FW), and coast to Cap Gris Nez	
6	AA532	Blyth, Lt John S	22	F-5 42-67361	Meulan Les Mulineaux A/F (FW)	
	AA533	Blickensderfer, Lt Wendell	22	F-5 42 67345		u/s
	AA534	Graves, Lt Willard	14			u/s
	AA535	Snyder, Lt Eugene	22	F-5 42-67378	Le Mans area, Trouville	
	AA536				Nantes (FW)	
	AA537	Parker, Lt Charles F	13	Spit XI	Strip W of Mannheim	
	AA538	Bliss, Capt Kermit	14		Caen/Carpiquet A/F (FW)	
	AA539				Cherbourg,-/Maupertus A/F,-/Querqueville A/F (FW)	
	AA540	Davidson, Lt Verner	14	F-5A 42-13303		u/s
	AA541	?Gonzalez, Lt Hector	13		Poulmic,-/Guipavas, Strip near Landerneau-Dirinon area, Laval, Morlaix/Ploujean, Brest (FW)	Flak
	AA542	Hughes, Lt Malcolm D	22	F-5 42-67345		u/s
	AA543	Hawes, Lt Clark	22	F-5 42-67336	Lorient area, St Brieuc/La Plaine LG	
	AA544	Adams, Lt Gerald	14	F-5A 42-13289		u/s lost canopy
	AA545	Parsons, Lt Edward B	22	F-5 42-12778		u/s
	AA546	Alston, Lt Robert	14			
	AA547	Davidson, Lt Verner	14		Strip W of Rennes, Gael A/F	
	AA548	Sheble, Capt Richard	14	Spit XI MB 955		u/s Eng trbl
	AA549	Adams, Lt Gerald	14	F-5B 67362	Morlaix-Lorient area	
7	AA550	Aubrey, Lt Lawrence	22	F-5 42-37361	Caen, Quistreham	
	AA551	Blickensderfer, Lt Wendell	22	Spit XI MB 950	Paris/Ivry, Strip E of Rouen to E of Dieppe	
	AA552				St Valery-en-Caux,& A/F, Fecamp	
	AA553				St Nazaire u/y,-/Escoublac A/F, Rennes M/Y,-/St Jacques A/F, Donges, Paimboeuf	
	AA554	Nesselrode, Capt George	14		Nantes,-/Chateau Bougon A/F, Caen/Carpiquet, Rennes/St Jacques A/Fs	
	AA555	Lawson, Maj George	22	F-5 42-67322		u/s
	AA556				Pointe de Raz & Strip east, Bayeaux	
	AA557	Haugen, Capt Cecil T	27			u/s Eng trbl
	AA558	Skiff, Lt Earl	22	F-5 42-67378	Coast near Honfleur, LeHavre (6")	
	AA559	Diderickson, Lt Robert	14		LeHavre,-/Octeville A/F, Tours area, Chateaudun A/F	
	AA560	Nelson, Lt Robert	14			u/s
	AA561					
	AA562	Burrows, Capt Daniel	22	F-5 42-12979	LeHavre,-/Octeville A/F (FW)	
	AA563				LeHavre,-/Octeville A/F, St Valery & Yvetot areas	
	AA564	Hairston, Lt Richard	22	F-5 42-13316		u/s
	AA565					
8	AA566	Hawes, Lt Clark	22	F-5 42-37361	Strips Le Mans area, Caen/Carpiquet A/F	
14	AA567					u/s Weather

321

Eyes of the Eighth

DATE	SORTIE	PILOT	SQ	A/C	TARGETS	INCIDENTS
14	AA568				Calais to Ostende (Obliques)	
	AA569				Coast Cap Gris Nez to Cayeux	
	AA570				LeHavre,-/Octeville A/F	
	AA571				Rouen area, Le Treport	
	AA572	Dixon, Lt Robert	14	Spit XI MB 950	Foret D'Hesdin, Embry Bois de Pottier, Fruges/Bois de Coupelle, Audingthun	
	AA573	Van Wart, Lt Franklyn	13	Spit XI	Quoeux, Vacquerie-le-Boucq, Bonnieres, Maison Pontes III D/A, Le Meillard	
	AA574	Eaton, Lt Wilbur B	14	Spit XI MB 892	Bonniers, Quoeux, Guescart, Gorenflos, Yvrench/Bois Carre	
	AA575	Nelson, Lt Robert	14	Spit XI MB 945	Pas de Calais	
	AA576	Davidson, Lt Verner	14	Spit XI MB 948	St Pierre-des-Jonquiemes, Le Petit Bois Robert Grand Parc, Belmesnil, Ecalles-sur-Buchy D/As	
20	AA577				Strip on W. Coast of Cherbourg	
	AA578	Bruns, Lt Waldo	22	F-5 42-67331	Cherbourg area through cloud	
	AA579				Dordrecht & Nijmegan area	
	AA580	?Gonzalez, Lt Hector	13		Woensdrecht A/F(FW) Zeebrugge, Flushing, Antwerp/Deurne A/F, Vlissingen A/F, Hoboken	
21	AA581	Bruns, Lt Waldo	22	F-5 42-12981	Ypres area, Wreck nr Cap Blanc Nez(Munsterland) Aubrice, Notre Dame Ferme, Watten, W/T 10	
	AA582				Tilberg area, Gilze/Rijen, Volkel A/Fs, Woensdrecht	
	AA583	Parsons, Lt Edward B	22	F-5 42-13320	Coxyde/Furnes A/F(FW), Ghent area, Shipping	
	AA584	Richards, Lt John R	13	F-5A	Cherbourg	
	AA585					u/s Eng trbl
	AA586				Lille-Brussels area, Cap Gris Nez, Brussels, Lille/Nord A/F, Shipping	
	AA587	Alston, Lt Robert	14	Spit XI	Munster D/A, Osnabruck D/A, Handorf, Munster A/F,-/Loddenheide A/F	
	AA588				Boulogne/Outreau M/Y, Dunkirk D/A, Gravelines, Nieuport, Ostende, Coxyde/Furnes A/Fs, Calais,-/Pontinctte M/Y	
	AA589	Bliss, Capt Kermit	14	Spit XI	Heuringhen area	
	AA590	Weitner, Capt Walter	14	Spit XI	Le Meillard area, W/T 1&2, Boulogne/Alprech A/F, Crecy-en-Porthieu A/F, Abbeville/Drucat A/F	
	AA591	Van Wart, Lt Franklyn	14	Spit XI	Pommfreval area	
	AA592	Sheble, Capt Richard	14	Spit XI	Cap Gris Nez to SE of Boulogne	
	AA593	Diderickson, Lt Robert	14	Spit XI	Ecalles sur Buchy area	
	AA594	Graves, Lt Willard	14	Spit XI	La Glacerie area	
	AA595	Hawes, Lt Clark	22	F-5 42-67362		u/s
	AA596					u/s
25	AA597	Rowe, Lt David	22	F-5 42-13320		u/s
	AA598	Bruns, Lt Waldo	22	F-5 42-12786	Coxyde/Furnes A/F(FW), Ghent & Antwerp area	
	AA599	Haugen, Capt Cecil T	27		Rotterdam(FW),-/Walhaven A/F, Scheldt area	
	AA600					u/s
	AA601	Snyder, Lt Eugene	22	F-5 42-67331		u/s Cloud
	AA602	Richards, Lt John R	13	F-5B		u/s Recalled
26	AA603	Hartwell, Maj Norris	22	F-5 42-67336	Dicing strip Liege area to Channel, Neuss D/A, Huls area, strip Cologne-Neuss	
29	AA604	Hartwell, Maj Norris	22	F-5 42-67332	Dijon area, A/F on E coast of Corsica, Coulommiers/Voisins A/F	1st Shuttle
	AA605	Sears, Lt Bert	22	F-5 42-67130	Chartres A/F(FW), Orleans area	
	AA606	Nesselrode, Capt George	22			u/s Cloud
	AA607	Chapman, Capt Carl	14	Spit MB 946	Tours-Nantes-Rennes-St Lo Area	
	AA608	Hairston, Lt Richard	22	F-5 42-67566	Caen area	
	AA609				Nantes,-M/Y, La Rochelle,-/Laleu A/F	
	AA610	Parsons, Lt Edward B	22	F-5 42-67382	St Malo area	
30	AA611				Fecamp area(FW), Bayeux area, St Valery-en-Caux A/F	
	AA612				St Helier(FW)	
	AA613					u/s Cloud
	AA614	Davidson, Lt Verner	14	Spit XI	Nantes area, St Brieuc/La Plaine A/F	
	AA615	Van Wart, Lt Franklyn	14	Spit XI	Strip Poix area	
	AA616					u/s Eng trbl
31	AA617	Hartwell, Maj Norris	22	F-5 42-67332	Dijon area	Rd Shuttle
FEB						
4	AA618	Adams, Lt Gerald	14	Spit XI	Nesle Normandeuse	
	AA619	Bliss, Capt Kermit	14	Spit XI		Canc
	AA620	Thies, Lt Everett	22	F-5 42-67566	Caen, Le Havre, Trouville(FW)	
	AA621				Strip Boulogne(FW) to Breck-sur-Mer, W/T 11	

322

Sortie List
1944

DATE	SORTIE	PILOT	SQ	A/C	TARGETS	INCIDENTS
4	AA622	?Proko, Lt Bernard	13		Cherbourg	
	AA623				Meulan/Les Mureaux A/F, St Andre de L'Eure A/F	
	AA624	McGlynn, Lt John	13		Calais, Boulogne(FW),-/Outreau M/Y SD,-/Loco Depot, Calais/Fontinettes	
	AA625				W of Dunkirk, W/T 1 & 11	
	AA626	Dixon, Lt Robert	14	Spit XI	Poix Viaduct, Bonniers, Beauvoir	
5	AA627	Smith, Capt Robert R	22	F-5 42-67115		u/s FD
	AA628	Parker, Lt Charles F	14	Spit XI MB 842	Emden, Wesermunde(FW)m Bremerhaven U/Y 1 & 3	
	AA629					u/s
	AA630	?Gonzalez, Lt Hector	13		Tours/Parcay A/F, Chateauroux/Le Martinerie A/F,	Ld away Beachy Head
	AA631	Hughes, Lt Malcolm D	22	F-5 42-67114		u/s O/F
	AA632				Coast btw Fecamp-Le Havre	
6	AA633	Bliss, Capt Kermit	14	Spit XI		u/s
	AA634	Hughes, Lt Malcolm D	22	F-5 42-67109	Meppen D/A, Lingen	
	AA635	Nelson, Lt Robert R	14	Spit XI MB 841	Hamburg D/A, Wilhelmshaven D/A, Harburg, U/Ys 2,11,14	
	AA636				Chateaudun A/F, Orleans/Bricy A/F (FW)	
	AA637					u/s Cloud
	AA638	Hawes, Lt Clark	22	F-5 42-67131	Coxyde/Furnes A/F, Nieuport(FW)	
	AA639	Weitner, Capt Walter	14	Spit XI	Osnabruck area, Twente/Enschede A/F (FW)	
	AA640					u/s
	AA641	Bliss, Capt Kermit	14	Spit XI	Frankfurt	
	AA642					u/s
	AA643					u/s
8	AA644	Diderickson, Lt Robert	14	Spit XI	Wilhelmshaven D/A, strip nr Emden	
	AA645				St Omer-Watten Woods area	
	AA646	Sheble, Capt Richard	14	Spit XI	St Pol to St Omer,& E of St Pol, Boulogne area	
	AA647				Areas of Evereux/Fauville & St Andre de L'Eure	
	AA648	Graves, Lt Willard	14	Spit XI	Leeuwarden A/F D/A, Zuider Zee Causeway	
	AA649	Bruns, Lt Waldo	22	F-5 42-67114	Villacoublay A/F D/A, Rouen,-/Sotteville M/Y	
	AA650	Rowe, Lt David	22	F-5 42-67131		u/s Eng trbl
	AA651	Snyder, Lt Eugene	22	F-5 42-67115	Gilze/Rijen A/F, Duisberg, Rotterdam,-/Waalhaven A/F	
	AA652				Coast nr Berck-sur-Mer	
	AA653					u/s
	AA654	Davidson, Lt Verner	14	Spit XI	St Pol area & to Cap Gris Nez	
9	AA655	Aubrey, Lt Lawrence	22	F-5 42-67121	SW of Rouen, Rouen, Fecamp, Le Trait	
	AA656					u/s FD
	AA657				Chateaudun A/F, Conches A/F(FW), Triqueville A/F	
	AA658	Richards, Lt John R	13	F-5B	Tours/Parcay A/F, Caen/Carpiquet A/F (FW)	
	AA659					u/s
11	AA660	Van Wart, Lt Franklyn	14	Spit XI	Abbeville/Drucat A/F, Bonnieres-Hambures area, Agenvillers, Bois Coquerel	
13	AA661				St Phillipsland, Gilze/Rijen A/F, Scheldt area, Rhine area E of Rotterdam, -/Waachaven A/F	Ld away
	AA662	Dixon, Lt Robert	14	Spit MB 955	Vicinity Rotterdam, Deyden	Ld away
	AA663	Rowe, Lt David	22	F-5 42-67128	Den Helder, Vic of Harlingen, Texel, Conches A/F, Bernay St Martin A/F	Ld away
	AA664				Abbeville,-/Drucat A/F	Ld away
	AA665	Parsons, Lt Edward B	22	F-5 42-67566	Evereux/Fauville D/A, strip W of Rouen, Coast of Ouistreham	Ld away ?Attleb
	AA666				Strip Chateauroux to Coast, Orleans M/Y,-/Bricy A/F, Avord A/F D/A, Chateauroux A/F	Ld away?Attleb
	AA667	Burrows, Capt Daniel	22	F-5 42-67112	Coxyde/Furnes A/F	Ld away
	AA668	Parker, Lt Charles	14	Spit XI	Calais,-/Fontinettes M/Y, Pas de Calais, Boulogne,-/Outreau M/Y,-/Loco Depot	
14	AA669	Hairston, Lt Richard	22	F-5 42-67109		Canc
	AA670	Nelson, Lt Robert	14		Boulogne(FW), Area NE Paris	
	AA671	Hairston, Lt Richard	22	F-5 42-67109	Caen, Bernay area	
	AA672	Smith, Capt Robert R	22	F-5 42-67115	LeMans area, S of Caen-Saumer, Caen,-/Carpiquet A/F (6")	
	AA673	McGlynn,				MIA
	AA674	Chapman, Capt Carl	22	F-5 42 67348	St Pol Area	
	AA675	Graves, Lt Willard	14	Spit XI	Abbeville-Dieppe area	
	AA676				Le Crotoy-Hamm, Cambrai-Boulogne, Abbeville/Drucat	
	AA677	Bliss, Capt Kermit	14	Spit XI	Calais-Doullens-Dieppe area, Boulogne,-/Outreau M/Y, W/T 3	
15	AA678				Le Havre (FW)	
	AA679	Aubrey, Lt Lawrence	22	F-5 42-67116	Caen/Carpiquet A/F D/A(FW) Caen area	

Eyes of the Eighth

DATE	SORTIE	PILOT	SQ	A/C	TARGETS	INCIDENTS
15	AA680	Smith, Capt Robert R	22	F-5 42-67112	Bordeaux area	
	AA681				Brest area	
	AA682				St Brieuc, Lorient area	
	AA683				Vannes area	
	AA684	Van Wart, Lt Franklyn	14	Spit XI	Nantes,-/Chat Bougon, St Malo (FW), A/Fs at Rennes, St Jean D'Angely	
	AA685	Thies, Lt Everett	22	F-5 42-67116		u/s
	AA686				Bernay area, Rouen, Le Havre,-/Octeville A/F	
	AA687	Dixon, Lt Robert	14	Spit XI	N of Hesdin Forest, N of Poix to Le Treport	
	AA688					u/s
17	AA689	Smith, Capt Robert R	22	F-5 42-67112	Toulous-Marseilles, Montelimar-St Evenne, NW of Paris to SE of Ron	
NOTE	BB	New numbering added		The BB prefix indicates sorties flown by the detachment at Attlebridge		
20	AA690	Sears, Lt Bert	22	F-5 42-67112		u/s Intc
	BB1	Snyder, Lt Eugene	22	F-5 42 67121	Leeuwarden A/F	
21	AA691	Graves, Lt Willard	14	Spit XI		u/s Weather
	AA692	Richards, Lt John	13	F-5B	Clermont	
22	AA693				Frankfurt,-/Eschborn A/F, Wiesbaden/Erbenheim A/F, Strip Ruhr to Gravelines	
	AA694	Parker, Lt Charles F	14	Spit XI PA 841	Huls	
	AA695	Nelson, Lt Robert	14	Spit XI	Rotterdam, The Hook, Maldeghem A/F (FW)	
	AA696	Davidson, Lt Verner	14	Spit XI		u/s
	AA697	Blyth, Lt John S	22	F-5 42-67112	Ruhr	FD Haze
	AA698					u/s Intc
	AA699	Bliss, Capt Kermit	14	Spit XI	Frankfurt D/A, Wiesbaden D/A	
	AA700				Amsterdam(FW), Lippstadt, Werl, Zwolle-Lippstadt-Tilburg area	
	AA701	Rowe, Lt David	22	F-5 42-67132	Ruhr	FD
	AA702				Doullens-Peronne Amiens area	
	AA703				Poix-Le Treport area	
	AA704				Villacoublay A/F, Toussus Buc A/F, Dieppe,-/St Aubin A/F, Beauvais/Tille A/F, Paris area	
	AA705	Thies, Lt Everett	22	F-5 42-67128	Alencon area	
	AA706	Dixon, Lt Robert	14	Spit XI PA 842	Bielefeld D/A, Halberstadt, Oschersleben D/A, Denventer, Strip N of Den Hague	
	AA707					Canc
	AA708	Van Wart, Lt Franklyn	14	Spit XI		Canc at Ref base
	AA709				Den Helder area, S of Leeuwarden, Bergen/Alkmaar A/F	
	BB2	Hughes, Lt Malcolm D	22	F-5 42-67114		u/s
23	AA710	Van Wart, Lt Franklyn	14	Spit XI		u/s Intc Ld away
	AA711				Flushing, Bruges, Vlissingen A/F, Oddorp/W Diunen A/F, Knock-le-Zoute A/F, Blackenburg	
	AA712	Sheble, Capt Richard	14	Spit XI		u/s Weather
	AA713				Venlo, Neuss D/A	
	AA714				Cambrai/Epinoy,-/Niergnies, Douai/Dechy A/Fs	
	AA715	Burrows, Capt Daniel	22	F-5 42-67111	Strip Dunkirk to S of Ostende, Coxyde/Furnes A/F	
	AA716				Calais/Fontinettes M/Y, Bryas/Sud A/F, Nunce A/F, Strip Scheldt area to Rheims & Calais	
	AA717				Beauvais/Tille, Montdidier A/Fs Poix & A/F, Le Treport & Strip to Compiegne, Abbeville/Drucat	
	AA718	?Crane, Lt Charles	13		Ouistreham (FW), Mezidon, Cabourg	
	BB3	Hawes, Lt Clark	22		Ijmuiden	
	BB4	Parsons, Lt Edward B	22		A/Fs Ahlhorn, Leeuwarden D/A	
24	AA719	Hairston, Lt Richard	22	F-5 42-67115		u/s
	AA720	Haugen, Capt Cecil	27		Run Schouven-Scheldt, Haamstede A/F	
	AA721	Aubrey, Lt Lawrence	22	F-5 42-67116		u/s
	AA722	Alston, Capt Robert	14	Spit XI	Ludwigshaven D/A, Mannheim	
	AA723					u/s
	AA724	Sears, Lt Bert	22	F-5 42-67128	Rouen area	
	AA725	Richards, Lt John R	13	F-5B	Arras, Cherbourg, St Lo, Coutances	
	AA726				Brest, / Lanveoc A/F, Morlaix,-/Ploujean(FW)	
	AA727	Sheble, Capt Richard	14	Spit XI		u/s Intc
	AA728	Adams, Lt Gerald	14	Spit XI	Brunswick,-/Broitzen A/F, Valkenburg A/F	
	AA729	Smith, Capt Robert R	22	F-5 42-67115	Le Havre,-/Octeville A/F, Dreux Vermouillet, Conches, Beaumont-le-Roger, Chartres, Le Mans	
	AA730	Aubrey, Lt Lawrence	22	F-5 42-67116	Strips Boulogne-Arras, St Quentin-Compiegne-Le Crotoy, Achiet, Monchy Breton A/Fs	

324

Sortie List
1944

DATE	SORTIE	PILOT	SQ	A/C	TARGETS	INCIDENTS
24	AA731					Canc
	AA732	Thies, Lt Everett	22	F-5 42-67106	Alencon area, Strip Cabourg to Alencon	
	AA733					u/s Con
	AA734	Hartwell, Maj Norris	22	F-5 42-13289	Caen/Carpiquet, Romilly area, Cherbourg Port, Romilly-sur-Seine, Cormeilles-en-Vexin	
	AA735	Simon, Capt Walter	14	Spit XI	Schweinfurt, Eisenach	
	AA736	Weitner, Maj Walter	14	Spit XI PA 842	Ruhr area	
	AA737	Gonzalez, Lt Hector	13		Vannes area, Cherbourg, Romilly A/F, Caen/Carpiquet A/F	
	AA738				Ostende,-/Middlekerk,-/Steene A/Fs, Dunkirk (FW)	
	AA739				Sedan area, Rheims, Poix Viaduct, Martue area	
	AA740	Nesselrode, Capt George	14		Angers-La Rochelle area, Strip Cabourg to Niort	
	AA741				Caen area	
	AA742				Lorient A/Fs, Kerlin/Bastard, Lannion(FW), St Brieuc area,-/La Plaine A/F	
	AA743					u/s
	AA744	Smith, Capt Robert R	22	F-5 42-67111	Rotterdam, Amsterdam/Schipol,-/Waalhaven, Soesterburg, Deelen A/Fs	
	AA745	Burrows, Capt Daniel	22	F-5 42-67115	Areas Le Treport, Compeigne, Troyes, Dieppe, Beauvais/Tille A/F	
	AA746				Gilze/Rijen A/F	
	BB5	Snyder, Lt Eugene	22	F-5 42-67121	A/Fs Achmer,-/Bramsche, Hesepe, Ijmuiden, Vorden, Rheine; Strip btw Rheine-Amsterdam	
	BB6	Hughes, Lt Malcolm D	22	F-5 42-67114	A/Fs Diepholz, Ahlhorn & new A/F Ahlhorn, Strip Ahlhorn to Emden	
25	AA747	Haugen, Capt Cecil T	27		Antwerp,-/Deurne A/F(FW) Ruhr	
	AA748				Boulogne(FW), Le Touquet, Strip Le Crotoy to Laon area, W/T 1	
	AA749				A/Fs Volkel, Woensdrecht, Venlo, Ruhr area	
	AA750	Diderickson, Lt Robert	14	Spit XI PA 841	Leipzig, Gotha, Eisenach, Wenigenlupnitz	
	AA751	Blyth, Lt John S	22	F-5 42-67112	St Pol-Chalons-Marne-Troyes area	
	AA752					u/s
	AA753				Neuss & Ruhr area	
	AA754				St Lo & Vire area	
	AA755	Thies, Lt Everett	22	F-5 42-67128	Rheims-Troyes area, Romilly-sur-Seine	
	AA756	Sears, Lt Bert	22	F-5 42-67119	Dieppe(FW),-/St Aubin,-/Caupe Cote A/Fs, Rouen area	
	AA757	Burrows, Capt Daniel	22	F-5 42-67116	Dieppe area	
	AA758				Abbeville/Drucat, Le Crotoy to Amiens,	
	AA759	Chapman, Capt Carl	22	Spit XI MB 946	Paris-Bourges-Tours-Angers, Tours/Parcay Meslay A/F	
	AA760				Cabourg	
	AA761				Brussels area,-/Evere A/F	
	AA762				Monterfil, St Nazaire area	
	BB7	Parsons, Lt Edward B	22	F-5 42-67132	Emmerich	
	BB8	Hawes, Lt Clark	22	F-5 42-67131	Bielefeld-Den Hague	
26	AA763	Smith, Capt Robert R	22			Canc
28	AA764	Graves, Lt Willard	14	Spit XI MB 950	Stuttgart area, Strip S of Brussels to SW of Ostende	
	AA765				Dieppe area	
	AA766	Richards, Lt John	13	F-5	Dieppe area	
	AA767				Strips Calais to Dunkirk, Desures to Boulogne	
	AA768				Dieppe area	
	BB9	Snyder, Lt Eugene	22	F-5 42-67121	Leeuwarden, Gelsenkirchen area	
	BB10	Hughes, Lt Malcolm D	22	F-5 42-67114		u/s
	BB11	Parsons, Lt Edward B	22			Canc
29	AA769	Sheble, Capt Richard	14			Canc
	AA770				Dieppe area	
	AA771					
	BB12	Hawes, Lt Clark	22	F-5 42-67131		u/s Intc
	BB13	Parsons, Lt Edward B	22	F-5 42-67132	Strip N of Alkmaar	
MAR						
1	AA772	Davidson, Lt Verner	14	Spit XI PA 852	S of Magdeburg	
	AA773	Van Wart, Lt Franklyn	14	Spit XI MB 945	(Aschersleben, Brunswick)	MIA-POW
	BB14					Canc
	BB15					Canc
2	AA774				Pas de Calais-Abbeville area, Bois Carre	
	AA775				Montrevil-Fontaine, Desures-Boulogne areas	
	AA776				Pas de Calais area	
	AA777	Bliss, Capt Kermit	14		Parts of Frankfurt	
	AA778	Parker, Lt Charles F	14	Spit XI PA 841	Schweinfurt D/A, Frankfurt D/A	

325

Eyes of the Eighth

DATE	SORTIE	PILOT	SQ	A/C	TARGETS	INCIDENTS
2	AA779				Pas de Calais, Boulogne raea	
	AA780	Bruns, Lt Waldo	22	F-5 42-67111	Paris area	
	AA781					u/s
	AA782				St Josse-au-Bois area	
3	AA783	Smith, Capt Robert R	22	F-5 42-67112	Chartres A/F D/A, Dreux A/F, St Andre-de-L'Eure A/F(FW), Evere/Fauville A/F	
	AA784	Nelson, Lt Robert R	14	Spit XI MB 955		
	AA785	?Gonzalez, Lt Hector	13			u/s Eng trbl
	AA786					u/s Eng trbl
	AA787	Chapman, Capt Carl	22			u/s Eng trbl
	AA788	Thies, Lt Everett	22			Canc
	AA789	Thies, Lt Everett	22	F-5 42-67115	Pas de Calais D/A	
	AA790				Pas de Calais D/A	
	AA791	Dixon, Lt Robert	14		Rosieres-en-Santerre A/F, Achiet A/F(FW), St Quentin area	
4	AA792	Smith, Capt Robert R	22	F-5 42-67108	Boulogne-St Pol-Le Crotoy area	
	AA793	Nesselrode, Capt George	14			Canc
	AA794				Photos through break in clouds	
	AA795	Nesselrode, Capt George	14	Spit XI MB 952	Duren area	
	AA796				Tours/Parcay A/F(FW)	
	AA797	Hartwell, Maj Norris	22	F-5 42-13289	Twente/Enschede A/F(FW)	
	AA798	Weitner, Maj Walter	14			u/s Rec
5	AA799				Quackenbruck A/F, A/F in Uffeln vicinity	
	AA800					u/s
	AA801	Simon, Capt Walter	14	Spit XI	Amsterdam, /Schellingwoude, Brunswick,-/Waggum A/F	
	AA802				Terneuzen, Knocke/Le Zoute A/F(FW), Scheldts	
	AA803	Diderickson, Lt Robert W	14	Spit XI MB 948	Schweinfurt, Dunkirk	
	AA804	Adams, Lt Gerald	14	Spit XI	Ostend(FW), Ghent-Brussels area	
	AA805					Canc
	AA806				Dieppe area	
6	AA807	Parsons, Lt Edward B	22	F-5 42-67107	Amiens-Boulogne area, Crecy-en-Ponthieu A/F, Berck-sur-Mer A/F	
	AA808					u/s Mechanical
	AA809	Sheble, Capt Richard	14		Angers area	u/s Cloud
	AA810	Haugen, Maj Cecil T	27		Tours/Parcay A/F(FW), Tours-Bourges area, Tours A/F	
	AA811	Davidson, Lt David	14	Spit XI MB 950		Canc,Ld Brad Bay
	AA812	Bruns, Lt Waldo	22	F-5 42-67108	Montdidier A/F(FW), Rheims-Paris area	
	AA813	Davidson, Lt David	14			Canc
	AA814				Convoy off Heligoland(FW)	
	AA815					u/s Mechanical
	AA816	Blyth, Lt John S	22	F-5 42-67107		u/s Cloud
	AA817	Weitner, Maj Walter	14	Spit XI PA 892	Berlin, Hannover	
	AA818	Smith, Capt Robert R	22			Canc
	AA819				Brest area	
	AA820				N Paris area	
7	AA821	Davidson, Lt Verner	14		Bergerac D/A, Bordeaux & Strip to Angers	
	AA822	Burrows, Capt Daniel	22	F-5 42-67107	Vitry-en-Artois, Berck A/F, Douai/Dechy(FW), Denain/Prouvy, Abbeville/Drucat, Beauvoir	
	AA823				Nantes,-/Chateau Bougon A/F	
	AA824				Chateaudun, Orleans/Saran, Orleans/Bricy A/Fs	
	AA825	Gonzalez, Lt Hector	13		Beaumont-sur-oise, Cormeilles-en-Vexin A/Fs	
	AA826				Conches A/F(FW), Poitiers-Bourges area, Fecamp, Le Mans	
	AA827				Chateaudun A/F, Poitiers-Bourges area	
	AA828				Le Havre, Le Mans, Poitiers-Rochelle area	
	AA829	Blyth, Lt John S	22	F-5 42-67108		
	AA830	Smith, Capt Robert R	22	F-5 42-67254	Quimper-Brest area	
8	AA831	Graves, Lt Willard	14	Spit XI	Anywerp/Deurne A/F, Brunswick, Bernsberg, Aschersleben areas	
	AA832				Quackenbruck A/F(FW), Hopsten A/F, Lexden Hibesumon area	
	AA833	Parker, Lt Charles	14	Spit XI MB 952	Berlin	
	AA834	Bruns, Lt Waldo	22	F-5 42-67108	Gelsenkirchen area, Bielefeld area, Ruhr to Flushing	
	AA835				Le Touquet, Pas de Calais area	
9	AA836	Nelson, Lt Robert R	14		Coblenz & Stuttgart area	
	AA837	Nesselrode, Capt George	14	Spit XI MB 955		Con

326

Sortie List 1944

DATE	SORTIE	PILOT	SQ	A/C	TARGETS	INCIDENTS
9	AA838	Sears, Lt Bert	22	F-5 42-67244	Rouen (FW)	
	AA839	Gonzalez, Lt Hector	22		Cognac/Chateau Bernard A/F, Bergerac A/F(FW)	
	AA840				Amiesn-Rheims	
	AA841				Tours-Chateauroux	
12	AA842	Simon, Capt Walter	14			Canc
	AA843					Canc
	AA844	Snyder, Lt Eugene	22			Canc
	AA845	Hartwell, Maj Norris	22	F-5 42-67107	Boulogne,-/Loco Depot, St Omer/Ft Rouge(FW), Wizernes, Le Touquet, Le Treport, W/T 1	
	AA846	Weitner, Maj Walter	14		Dieppe area	
	AA847	Haugen, Maj Cecil T	22		Heligoland D/A	Ld away
	AA848	Burks, Lt Douglas D	27			Crash bail out
	AA849				Chateauroux area	
	AA850					
	AA851	Rowe, Lt David	22	F-5 42-67244	Bourges area, A/F S of Paris, Beaumont-sur-Oise A/F	
	AA852	Snyder, Lt Eugene	22	F-5 42-67121	Chartres area	
	AA853	Diderickson, Lt Robert W	14		Amiens area	u/s Cloud
	AA854			Spit XI	Yvrench/Conteville, Cramont, Flixecourt/Donart-en-Ponthieu, Amiens/Longueau M/Y, Bonn area	
	AA855	Dixon, Lt Robert	14			
16	AA856	Chapman, Capt Carl	22	F-5 42-13289		u/s Weather
18	AA857	Hairston, Lt Richard	22	F-5 42-67566		u/s Eng trbl
	AA858					u/s Eng trbl
	AA859				Cambrai/Niergnies, Conches A/Fs(FW) St Quentin area	
	AA860	Chapman, Capt Carl	22	F-5 42-13289	Brest (FW), Vannes area	
	AA861	Burrows, Capt Daniel	22			Canc
	AA862	Thies, Lt Everett	22	F-5 42-67119	Le Havre(FW),-/Octeville A/F, Bernay/St Martin A/F, Caen area,	
	AA863	Bliss, Capt Kermit	14			u/s Cloud
19	AA864	Graves, Lt Willard	14		Mayenne to Bayeux	
	AA865	Hughes, Lt Malcolm D	22	F-5 42-13316		u/s Cloud
21	AA866	Simon, Capt Walter	14	Spit XI MB 946	Bordeaux area	
22	AA867				Flushing(FW), Coast S of Den Hague, Strip Soesterberg area to coast at Overflakke	
	AA868	Sheble, Capt Richard	14	Spit XI	Osnabruck area, Den Hague (Strip)	
	AA869	Parker, Lt Charles	14			u/s
23	AA870	Parker, Lt Charles	14	Spit XI PA 841	Wiesbaden A/F(FW), Frankfurt, Bonn, Coblenz area	
	AA871				Hook of Holland	
	AA872	Davidson, Lt Verner	14			u/s Intc
	AA873	Nelson, Lt Robert	14	Spit XI MB 952	Frankfurt	
	AA874	Dixon, Lt Robert	14	Spit XI MB 955	Ruhr area	
	AA875					u/s
	AA876				Dieppe	
24	AA877					u/s Cloud
	AA878				A/Fs Coulommiers/Voisin, Chateaudun, Orleans/Bricy, Le Bourget(FW)	
	AA879				St Malo(FW), Brest area	
	AA880	Burrows, Capt Daniel	22	F-5 42-67119	Compiegne area, Beaumont-sur-Oise A/F	
	AA881	Parsons, Lt Edward B	22	F-5 42-67114	Chartres area	
	AA882	Weitner, Maj Walter	14	Spit XI	Nancy-Le Touquet area	
	AA883	Smith, Capt Robert R	22	F-5 42-67132	Alencon area, Caen/Carpiquet A/F	
25	AA884	Adams, Lt Gerald	14	Spit XI	Soesterburg A/F D/A	
	AA885	Aubrey, Lt Lawrence	22	F-5 42-67119		u/s
	AA886	Hawes, Lt Clark	22	F-5 42-67114	Brest area, Quimper, Pluguffan A/F	
	AA887	Aubrey, Lt Lawrence	22	F-5 42-67132	Alencon area	
	AA888	Simon, Capt Walter	14	Spit XI	St Didier area, Strip E of Rheims	
	AA889	Graves, Lt Willard	14			Canc
	AA890	Diderickson, Lt Robert	14			u/s
	AA891	Sheble, Capt Richard	14			u/s
	AA892				Isle de Croix(FW), Quimper area	
26	AA893	Blyth, Lt John S	22	F-5 42-67244	Dieppe	

327

Eyes of the Eighth

DATE	SORTIE	PILOT	SQ	A/C	TARGETS	INCIDENTS
26	AA894					u/s
	AA895	Bruns, Lt Waldo	22	F-5 42-67107	A/Fs Buc, Toussus/Le Noble, Bretigny/Le Plessis Pate(FW), Chateauroux area	
	AA896				St Quentin area, Laon/Athies A/F	
	AA897				Calais(FW), Sedan area, Calais M/Y SD	
	AA898	Sears, Lt Bert	22	F-5 42-67119		u/s
	AA899	Richards, Lt John R	13	F-5B	Brest area, Quimper A/F, Brest/Lanveoc Poulmic A/F&U/Y	
	AA900			Spit XI	Nancy/Essay A/F, St Dizier/Robinson A/F	
	AA901					u/s
	AA902	Hairston, Lt Richard	22	F-5 42-67132	Calais-Le Havre area	u/s
	AA903	Rowe, Lt David	22	F-5 42-67114	Le Mans M/Y, Parthenay area	
	AA904				Lumes M/Y, Denain/Prouvy A/F, Sedan area	
	AA905	Graves, Lt Willard	14			u/s Rec
	AA906	Diderickson, Lt Robert W	14			Canc
	AA907	Sears, Lt Bert	22			Canc
	AA908				Paris area, Oisemont/Neuville-au-Bois	
	AA909				Orly A/F, Paris-Rheims area, Le Crotoy, Amiens/Glissy A/F, area S of Albert-NE of Abbeville	
	AA910					u/s
	AA911	Snyder, Lt Eugene		F-5 42-67131	Ghent area, Liege/Bierset A/F	
	AA912	Thies, Lt Everett	22	F-5 42-67246	Bayeux, Angers-Parthenay area	
	AA913				Le Havre, Dieppe, Rouen-Paris area, A/Fs in Evreux area	
	AA914	Goffin, Lt Charles J J	14	Spit XI MB 952	Nuncq A/F, Pas de Calais, St Omer & St Pol areas, Helfaut, Bois de Belieul	
	AA915	Burrows, Capt Daniel	22	F-5 42-67111	Den Hague area/Utrecht	
	AA916				Tours-Angers area	
27	AA917	Smith, Capt Robert R	22	F-5 42-67244	Poitiers area, Honfleur	
	AA918	Hughes, Lt Malcolm D	22	F-5 42-67114	Cognac/Chateau Bernard A/F(FW), La Rochelle area	
	AA919	Parsons, Lt Edward B	22	F-5 42-67107		u/s RT
	AA920				Rheims	
	AA921					u/s RT
	AA922					Canc
	AA923				Fecamp (FW), Auxerre area	
	AA924	Parsons, Lt Edward B	22	F-5 42-67107	Chateauroux area	
	AA925					u/s Mechanical
	AA926				Bourges area	
	AA927	Diderickson, Lt Robert W	14	Spit XI MB 946		u/s Rec
	AA928	Hawes, Lt Clark	22	F-5 42-67108	Nevers area, Le Havre area	
	AA929	Chapman, Capt Carl	22	F-5 42-68205	La Rochelle,-/Laleu A/F, Bordeaux/Merignac A/F D/A, St Nazaire, La Pallice	
	AA930	Aubrey, Lt Lawrence	22	F-5 42-67566	Chartres A/F, Tours/Parcay A/F D/A,(FW), Tours-Cabourg	
28	AA931	Blyth, Lt John	22	F-5 42-67246	Ypres/Vlamertinghe A/F(FW), Ath area	
	AA932				St Jean D'Angley A/F D/A(FW), Cognac area	
	AA933	Bruns, Lt Waldo	22	F-5 42-67111	Charleroi area, A/Fs St Omer/Ft Rouge,-/Clairmarais, W/Ts 7,8	
	AA934	Haugen, Maj Cecil T	27		Rheims area, Strips Le Crotoy to Amiens, Paris to Dieppe	
	AA935				Chateaudun A/F, Orleans area, Chartres A/F(FW)	
	AA936					u/s Intc
	AA937				Nantes/Chateau Bougon A/F, Poitiers-Angouleme area	
	AA938	Rowe, Lt David	22	F-5 42-67116	Le Havre, Le Mans, Tours, Poitiers area, Le Mans M/Y	
	AA939				Le Havre(FW), Chartres A/F D/A, Chartres area	
	AA940	Diderickson, Lt Robert W	14	Spit XI MB 948	Dijon/Longvic A/F D/A, Rheims A/F D/A	
	AA941	Parker, Lt Charles	14		Laon/Athies A/F, St Dizier area	
28	AA942	Snyder, Lt Eugene	22	F-5 42-67132	Chateaudun A/F, Limoges A/F, & area	
	AA943	Dixon, Lt Robert	14	Spit XI MB 955	Munster area	
	AA944	Davidson, Lt Verner	14		Osnabruck area	
	AA945	Nesselrode, Capt George	14		Coblenz, Louvain, Maastrict	
	AA946					Canc
30	AA947	Graves, Lt Willard	14		Osnabruck, Hopsten	
	AA948	Weitner, Maj Walter	14		Munster D/A, Handorf A/F D/A, Hamm M/Y D/A	
	AA949	Diderickson, Lt Robert W	14		A/Fs Berlin/Tempelhof, Doberitz, Werneuchen(FW)	
	AA950	Dixon, Lt Robert	14		Leipzig/Mockau,-/Gobelwitz A/Fs(FW)	
	AA951	Sheble, Capt Richard	14			
	AA952	Simon, Capt Walter	14			
	AA953					
	AA954	Lawson, Lt Col George	22	F-5 42-13313		
	AA955	Thies, Lt Everett	22	F-5 42-67108		

328

Sortie List
1944

DATE	SORTIE	PILOT	SQ	A/C	TARGETS	INCIDENTS
30	AA956	Burrows, Capt Daniel	22	F-5 42-67107		
	AA957					
	AA958					
	AA959	Richards, Lt John R	13	F-5B		
APR						
1	AA960	Simon, Capt Walter	14		Amsterdam, Ijmuiden, Achmer A/F, Brunswick area	
	AA961	Adams, Lt Gerald	14	Spit XI MB 950	Osnabruck area	
	AA962	Diderickson, Lt Robert W	14	Spit XI	Coblenz area, Nieder.Breisig A/F	
	AA963				Troyes-Dijon area	
	AA964	Smith, Capt Robert R	22	F-5 42-67244	A/Fs Laon/Couvron, Clastres/St Simon, Abbeville, Amiens	
	AA965					u/s
8	AA966	Davidson, Lt Verner	14	Spit XI MB 948	Halberstadt A/F, Munster, Aschersleben A/F, Bernberg, Handorf/Munster A/F	
	AA967					u/s O/F
	AA968					u/s Ins
	AA969	Chapman, Capt Carl	22	Spit Xi PA 842	Quackenbruck, Oldenburg A/Fs, D/A, Wilhelmshaven U/Y	
	AA970	Weitner, Maj Walter	14			u/s Intc
	AA971				Brunswick,-/Waggum A/F D/A, vicinity Dummer Lake	
10	AA972				Melun/Villaroche A/F, Strip Paris area	
	AA973	Hughes, Lt Malcolm D	22	F-5 42-67114	Brussels,-/Melsbroek,-/Evere,-/Gourselles, Maldegham, Charleroix/Gosselies, Florennes/Juvincourt	
	AA974	Nelson, Lt Robert	14			Canc
	AA975					u/s
	AA976	Haugen, Maj Cecil T	27		Avord A/F, Bourges A/F, Dieppe Tours/Usine Lictard, Orleans,Strip Tours-Ouistreham	
	AA977	Dixon, Lt Robert	14	Spit XI MB 955	A/Fs Oldenburg, Quackenbruck, Hopsten, Hesepe, Ochmer Twente/Enschede	
	AA978	Parker, Lt Charles	14	Spit XI PA 841	A/Fs, Rheine, Amsterdam/Schipol Twente/Enschede, Quackenbruck Hopsten, Hesepe,	
	AA979	Nelson, Lt Robert	14		Knocke Harbor, Coblenz area	
	AA980	Goffin, Lt Charles J J	14	Spit XI MB 948	Munster, Twente/Enschede A/F, Rotterdam	
	AA981				Fecamp, Nevers to Orleans area, A/Fs in Rouen area, Illiers/L'Eveque A/F	
	AA982	Crane, Lt Charles M	13		A/Fs Rheims, Abbeville/Drucat, Amiens/Glisy, Juvincourt	
	AA983	Aubrey, Capt Lawrence	22	F-5 42-67254	Coast at Le Touquet	
	AA984	Chapman, Capt Carl	22	F-5 42-67336	Gutersloh A/F	
11	AA985				Brunswick D/A,-/Brotizen A/F, Hannover/Langenhagen A/F D/A,	
	AA986	Smith, Maj Robert R	22	F-5 42-67108	Rheims area	
	AA987	Hawes, Lt Clark	22	F-5 42-67131	Chalons-Troyes area	
	AA988					
	AA989				Laon/ Athies,-/Chambry A/F, Auxerre area, Troyes area to Rouen area	
	AA990				Nevers	
	AA991					u/s
	AA992	Bruns, Lt Waldo	22	F-5 42-67119	Douai/Dechy A/F(FW), Sedan area, Dunkirk, Floreens/Juzaine A/F	
	AA993				Poitiers, Limoges & area, near Romorantin	
	AA994	Adams, Lt Gerald	14		Coblenz area	
	AA995				Biscarosses, Bordeaux area, Cazaux A/F	
	AA996	Simon, Capt Walter	14		Furth A/F D/A, Frankfurt/Rebstock A/F (FW)	
	AA997				Bourges A/F & area, Canteauroux/La Martinerie A/F, Fecamp, Montlucon	
	AA998				Le Havre, Orleans/Bricy A/F, Chateaudun A/F	
	AA999	Weitner, Maj Walter	14		Frankfurt area & to Ghent, Lachen/Speyerdorf A/F(FW)	
NOTE	All sorties are now BB					
	BB16	Dixon, Lt Robert J	14	Spit XI MB 925		
	BB17	Parker, Lt Charles	14	Spit XI PA 841	Stendahl A/F(FW), Brunswick/Waggum A/F,-/Brotizen A/F, Gardelegen A/F, Sachau A/F	
	BB18	Davidson, Lt Verner	14			u/s
	BB19	?Gonzalez, Lt Hector	13		Tours M/Y,-/Parcay A/F, Bourges A/F(FW), Le Havre	
	BB20	Rowe, Lt David	22	F-5 42-67244	Rheims-Verdun area, Le Crotoy-Cap Gris Nez	
12	BB21	Chapman, Capt Carl	22	F-5 42-68205	A/Fs Elbing, Landau/Ganacker, Regensburg/Obertraubling, Schwabitz/Hall, Straubing, Strip Northern Italy, Nancy	Shuttle
	BB22	Warburton, F/L Adrian	7			MIA KIA
	BB23	Chapman, Capt Carl	22	F-5 42-68205	St Andre-de-L'Eure, Dijon-Paris area, Chartres, Orleans/Bricy,-/Saran, Evreux/Fauville	
	BB24	Warburton, F/L Adrian	7		Warburton's planned return sortie from Sardinia	
	BB25	Parsons, Lt Edward B	22	F-5 42-67132	Roermond area	
	BB26	Haugen, Maj Cecil T	27		Nevers area	
	BB27				Villacoublay A/F, Dieppe, Guyancourt/Caudron A/F(FW)	
	BB28	Richards, Lt John R	13	F-5B	Royan, St Brieuc/La Plaine A/F, Bordeaux area, Laval, Le Verdon	
	BB29	Snyder, Lt Eugene	22	F-5 42-67107	Coxyde/Furnes A/F	

329

Eyes of the Eighth

DATE	SORTIE	PILOT	SQ	A/C	TARGETS	INCIDENTS
12	BB30	Sheble, Capt Richard	14		Mannheim area	
	BB31	Thies, Lt Everett	22	F-5 42-67128	Achiet A/F(FW), Berck-sur-Mer, Arlons & Sedan area	
	BB32				Avord A/F, Orleans/Bricy A/F, Clermont/Ferand area, Conches A/F	
	BB33	Burrows, Capt Daniel	22	F-5 42-67111	Amiens/Glisy A/F, Le Treport, Berck-sur-Mer, Le Touquet, Nancy area	
	BB34	Graves, Lt Willard	14		Rheine, Hopsten, Plantlunne A/Fs, Den Hague	
	BB35				Ouistreham (FW), Caen to La Fleche	
	BB36					u/s
	BB37				Rouen, Orleans/Bricy A/F, Romorantin A/F D/A, Orleans-Tours area, Dreux	
	BB38	Goffin, Lt Charles J J	14		St Trond/Brustheim A/F (FW)	
	BB39	Hawes, Lt Clark	22	F-5 42-67566	Area N of Paris, Le Treport	
	BB40	Aubrey, Lt Lawrence	22	F-5 42-67122	Chaumont-Neufchateau area, Compeigne/Margny A/F	
	BB41					u/s Intc
	BB42	Bruns, Lt Waldo	22	F-5 42-67119	Brussels area	
	BB43	Smith, Maj Robert R	22	F-5 42-67246	Dunkirk, Watten, Wizernes, Siracourt, St Omer/Longuenesse A/F (FW)	
13	BB44	Adams, Lt Gerald	14	Spit XI MB 955		u/s Cloud
	BB45	Nelson, Lt Robert	14	Spit XI	Handorf-bei-Munster A/F, Hopsten A/F, Oostvoorne area, Osnabruck area	
17	BB46			Spit XI	Bernay area	
18	BB47				Gutersloh A/F(FW), Arnhem area	
	BB48				Rheine A/F D/A, Utrecht area, Deelen/Arnhem A/F, Amsterdam, Ijmuiden	
	BB49	Rowe, Lt David K	22	F-5 42-67128	A/Fs Dienst/Schaffen, Brussels area,-/Evere,-/Melsbroek	
	BB50	Parker, Lt Charles	14		Rheine, Fallersleben, Munster,-/Loddinheide, Oschersleben, Huls A/F & area, Bielefeld	
	BB51	Diderickson, Lt Robert	14		Fire 25m N of Hannover, Stendal A/F, Rheine to Den Hague, Twente/Enschede A/F(FW)	
	BB52	Simon, Capt Walter	14		Osnabruck area, Berlin area, Hannover, Amsterdam, Vorden, Brandenburg/Briest A/Fs	
	BB53				A/Fs Montdidier, Beaumont-sur-Oise (FW), Beauvais area	
19	BB54	Adams, Lt Gerald	14		Gutersloh A/F	
	BB55					
	BB56	Parsons, Lt Edward B	22	F-5 42-67111	Beaumont-sur-Oise, Beauvais/Tille A/Fs	
	BB57	Gonzalez, Lt Hector	13		Romorantin A/F, Orleans area	
	BB58	Davidson, Lt Verner	14		Volkel, Gilze/Rijen, Lippstadt A/Fs	
	BB59	Sheble, Capt Richard	14		Vorden A/F, Den Hague, Dummer Zee, Rathenow area	
	BB60	Snyder, Lt Eugene	22	F-5 42-67121		CL Mount Farm
	BB61					
	BB62					
	BB63				Rotterdam to the Ruhr	
	BB64				Rotterdam area	
	BB65				Aachen area, Brussels/Evere A/F	
	BB66				Diest/Schaffen A/F, Venlo A/F, Munchen Gladbach area	
	BB67	Parker, Lt Charles	14	Spit XI MB 950	Basdorf, Werder, Weisswarte, Rotterdam,-/Waalhaven A/F, Klein, Machnow, Erkner, Wildau, Rathenow/Arado	
	BB68	Thies, Lt Everett	22	F-5 42-67128	Amiens/Glisy, Paris area, Le Touquet, Boulogne, Crecy-en-Ponthieu, Yvrench, Montdidier	
	BB69	Burrows, Capt Daniel	22	F-5 42-67115	Boulogne area, Maison Ponthieu, Noyelle-en-Chausee, W/Ts 1,11	
	BB70					
	BB71	Aubrey, Lt Lawrence	22	F-5 42-67116	Strip W of Verdun, & A/F, Achiet A/F	
	BB72	Goffin, Lt Charles J J	14		Werl A/F, Dortmund area, Ostende, Lippstadt A/F	
	BB73	Weitner, Maj Walter	14		Kassel/Waldau, Handorf/Bei Munster, Werl, Gutersloh Munster,-/Loddinheide A/F, A/Fs	
	BB74				Chalons-Nancy area, Amiens/Glisy A/F, Trouville	
	BB75				Dieppe, Roye/Amy A/F, St Dizier area & -/Robinson, Compeigne area, Beauvais/Tille, Rheims	
	BB76				Gravelines, Cap Gris Nez, Watten, Marquise Mimoyecques	
	BB77				Chievres A/F, Trier area, Namur, Libremont	
	BB78				Ecalles-sur-Buchy, Grand Parc, Le Bourget A/F, N of Paris, Melun/Villaroche A/F	
	BB79	Hawes, Lt Clark	22	F-5 42-67122	Cologne area, Flushing	
20	BB80					u/s
	BB81	Simon, Capt Walter	14	Spit XI	Wittenberghe, Perleberg A/F D/A	
	BB82				Dunkirk, St Omer/Longuenesse A/F	
	BB83	Burrows, Capt Daniel	22	F-5 42-67115	Knocke coastal area	
21	BB84	Gonzalez, Lt Hector	13		Dunkirk, Lille/Vendeville A/F	
	BB85	Dixon, Lt Robert	14	Spit XI	RR Quackenbruck to Heeke & Hesepe to Hollage, Achmer A/F, Handorf/Bei Munster A/F	

Sortie List 1944

DATE	SORTIE	PILOT	SQ	A/C	TARGETS	INCIDENTS
21	BB86	Bruns, Lt Waldo	22	F-5 42-67119	Commercy area	
	BB87	Rowe, Lt David K	22	F-5 42-67244	Strip S of Rheims & Rouen, Dieppe, Mourmelon-le-Grand A/F, Abbeville/Drucat	
	BB88	Emerson, Lt Jack G	27	F-5B 42-67367		MIA-POW
	BB89				Cholet to Rochefort, Royan, Leverdon, Blaye, Rochefort, Bordeaux/Merignac A/F(FW)	
	BB90				St Lo, Samur area	
	BB91	Smith, Maj Robert R		F-5 42-67254	Brussels area, St Quentin to Abbeville	
	BB92				Poitiers area	
	BB93				Terneuzen, Breskins(FW), Antwerp to Flushing	
	BB94				Auxerre area, Strip to Alps	
	BB95	Adams, Lt Gerald	14	Spit XI MB 946	Essen area, S of Rotterdam	
	BB96				Bordeaux, Pauillac(FW), Caen,-/Carpiquet A/F	
	BB97					u/s Cloud
	BB98				Amsterdam,-/Schipol, Bremen,-/Nevenlanderfeld, Delmenhorst, Soesterburg, Rotterdam	
	BB99	Weitner, Maj Walter	14	Spit XI	Vechta, Diepholz A/Fs, Osnabruck area	
	BB100	Parsons, Lt Edward B	22	F-5 42-67246	Rheims/Champagne A/F, Fourmies & Rheims area	
	BB101					u/s
	BB102				Foret de Helle, Le Treport, Pommbreval, Les Petits Moraux,	
	BB103	Leasor, Lt John R	13		Cherbourg,-/Maupertus A/F, Jobourg	
	BB104	Matthews, Lt James B	22	F-5 42-67114	Marquise, Mimoyecques	
	BB105	Cosby, Lt Irl	22	F-5 42-67128	Dannes, Le Touquet	
	BB106	Miller, Lt Glenn E	22	F-5 42-67115	Wizernes, Heifaut, Heuringhem	
	BB107				Boulogne, Lottinghem, Desvres, Boulogne M/Y	
	BB108	Nelson, Lt Robert	14		Le Havre	
	BB109	Sheble, Capt Richard	14	Spit XI	Kassel area	
	BB110	Diderickson, Lt Robert	14			Canc
	BB111	Davidson, Lt Verner	14			Canc
22	BB112				Steenwijk, Meppel area, Zwolle	
	BB113	Wicker, Lt James	22	F-5 42-67122		
	BB114	Kann, Lt Alexander		F-5 42-67246	Calais, Coastline to Cap Gris Nez	
	BB115				N Cherbourg Pen. & 15-20m of shore	
	BB116				Le Havre & Strip to Etretat, Le Havre/Octeville A/F	
	BB117				Valognes, La Glacerie	
	BB118				A/Fs St Omer/Longuenesse,-/ Ft Rouge, Boulogne	
	BB119				Obliques of coast Cap Gris Nez to Walcheren	
	BB120				Obliques of coast Cap Gris Nez to Le Havre	
	BB121	Miller, Lt Glen	22	F-5 42-67115	Boulogne, Bryas/Sud A/F (FW)	
	BB122	Cosby, Lt Irl	22	F-5 42-67131	Calais,-/Fontinetnes M/Y, Bois D'Esquerdes, Wizernes, Cormette Supasques, Setques, Boulogne	
	BB123	Matthews, Lt James B	22	F-5 42-67119	Cap Gris Nez area, Linghem, Bois des Huits Rues	
23	BB124					
	BB125				Le Verdon, Royan, Shipping in Gironde Estuary, Bordeaux area	
	BB126	Thies, Lt Everett	22	F-5 42-67128	Commercy area, Gisors	
	BB127				Dijon area	
	BB128				Nevers area, nr Bloix, Fecamp-Le Havre area	
	BB129				Koblenz, Zeebrugge area	
	BB130				Caen/Carpiquet A/F, Parthenay-Bordeaux area	
	BB131				Strip Le Crotoy, Strip NE of Paris to SW Le Treport, Beauvais/Nivilliers,-/Tille A/F	
	BB132	Burrows, Capt Daniel	22	F-5 42-67115	Dunkirk, Rheims/Champagne A/F, Denain/Prouvy, Lille/Nord,-/Vendreville, Amiens/Glisy A/F	
	BB133				Boulogne,-/Loco Depot,-/Outrau M/Y, Laon/Athies, W/T 7,9, Cambrai/Niergnies A/F & M/Y	
	BB134	Bruns, Lt Waldo	22	F-5 42-67119	Bastogne area, Cap Gris Nez, Virton to Boulogne	
	BB135	Haugen, Maj Cecil T	27		Dieppe,-/Rouxmasnil M/Y, Abbeville M/Y,-/Drucat, Amiens/Glisy A/Fs, Auxerre area.	
	BB136				Dieppe(FW), Nevers area, Orleans,-/Bricy A/F	
	BB137				Le Mans M/Y & A/F(FW), Coast W of Trouville, Pontiers-Periguex area	
	BB138				Neurberg-Frankenthal area, Roubaix M/Y	
	BB139				Chateaudun A/F, Tours/Parcay A/F(FW)	
	BB140					u/s
	BB141					u/s
	BB142	Chapman, Capt Carl	22	F-5 42-68205		u/s
	BB143					u/s
	BB144	Smith, Maj Robert R	22	F-5 42-67254		u/s
	BB145					u/s
	BB146					u/s
	BB147	Aubrey, Capt Lawrence	22	F-5 42-67116		u/s

Eyes of the Eighth

DATE	SORTIE	PILOT	SQ	A/C	TARGETS	INCIDENTS
23	BB148	Rowe, Lt David K	22	F-5 42-67244		u/s
	BB149	Nesselrode, Capt George	14			u/s
	BB150				Caen,-/Carpiquet A/F(FW), Samur, Ouistreham, S of Le Mans, Strips in Bordeaux area	
	BB151	Kann, Lt Alexander	22	F-5 42-67246	Dunkirk, Flushing, Ostende, Zeebrugge(FW), Nieuport	
	BB152	Matthews, Lt James B	22	F-5 42-67114	Yvrench area, Vlissingen A/F	
	BB153				Dieppe area	
	BB154	Wicker, Lt James	22	F-5 42-67119	Dieppe(FW)	
	BB155				Bergerac, Le Havre, A/Fs Conches Tours/Parcay, Romorantin, Chateauroux/La Martinerie (FW)	
	BB156	Parsons, Lt Edward B	22	F-5 42-67131	Strip over Lille to Coast	
	BB157	Blyth, Lt John S	14	Spit XI	Laon/Athies A/F, S of St Quentin	
	BB158				Cherbourg,-/Maupertus A/F (FW)	
	BB159	Cosby, Lt Irl	22	F-5 42-67115	Berck-sur-Mer, Vacquarie-la-Boucq, Eclimeux	
	BB160					u/s
	BB161	Miller, Lt Glenn E	22	F-5 42-67246	Vernon, Rouen, Eletot (FW)	
	BB162	Bruns, Lt Waldo	22	F-5 42-67114	Le Bourget A/F(FW), Le Crotoy	
24	BB163	Chapman, Capt Carl	22	F-5 42-68205	Trier-Nancy-Dijon area	
	BB164				Trier-Nancy-Dijon area	
	BB165					u/s
	BB166	Nesselrode, Capt George	14		Nancy-Dijon area	
	BB167				Nancy-Dijon area	
	BB168	Bruns, Lt Waldo	22		Nancy-Dijon area, wood on fire SE of Rouen	
	BB169				Lille-Trier-Nancy-Auton-S of Dieppe	
	BB170	Smith, Maj Robert R	22		Nancy-Dijon area	
	BB171				Nancy-Dijon Chartres area	
	BB172	Aubrey, Capt Lawrence	22		St Dizier/Robinson A/F(FW), Nancy-Dijon-Chartres area	
	BB173				Rennes area	
	BB174					u/s
	BB175					pos Ld Bari
	BB176					pos Ld Bari
	BB177					pos Ld Bari
	BB178				Brest Pen.	
25	BB179	Hawes, Lt Clark	22	F-5 42-67122	Peronne	
	BB180				Strip in Morlaix area	
	BB181				Brest(FW), Strip Brest Pen., Morlaix area	
	BB182				Brest-Quimper area	
	BB183	Wicker, Lt James	22	F-5 42-67116	Strip St Brieuc	
	BB184	Graves, Lt Willard	14		Le Treport(FW), Preise River Valley	
	BB185	Richards, Lt John	14		Dieppe, Rouen(FW)	
	BB186	Nelson, Lt Robert	14		Mannheim	
	BB187				Strips Le Havre to Pointe et Raz, Le Havre to Fecamp	
	BB188				Strip St Brieuc, Bayeux	
26	BB189	Bruns, Lt Waldo	22	F-5 42-67246		Rec
	BB190	Smith, Maj Robert R	22	F-5 42-67254		Rec
	BB191	Chapman, Capt Carl	22			u/s Weather
	BB192	Bliss, Capt Kermit	14			u/s Weather
	BB193	Burrows, Capt Daniel	22	F-5 42-67115	Mont-de-Marsan A/F, Bordeaux, St Jean D'Angely A/F, Bayonne, Biarritz/PavPontLong A/F	
	BB194				Le Mans-Caen	
	BB195	Matthews, Lt James	22	F-5 42-67114	Parthenay area	
	BB196				Cahors-Bourges area	
	BB197	Kann, Lt Alexander	22	F-5 42-67116	Brest Pen., Paimpol, Guincamp	
	BB198					Canc
	BB199				Brest Pen., Morlaix/Ploujean A/F	
	BB200				Morlaix area	
	BB201				Brest Pen., Coast nr St Brieuc, Boats S of Channel Islands	
	BB202	Haugen, Maj Cecil T	27		Coast Etretat to Cherbourg	
	BB203					u/s
	BB204				Brest,-/Lanveoc Poulmic A/F, Chateaulin River(FW)	
	BB205	Cosby, Lt Irl	22	F-5 42-67246	Brest Pen.	
	BB206	Miller, Lt Glenn E	22	F-5 42-67119	St Malo(FW), St Nazaire, Jersey	
	BB207					Canc
	BB208				Brest Pen.	
	BB209	Parker, Lt Charles	14	Spit XI	Tergnier, Beaumont-sur-Oise, Boulogne,-/Loco Depot, Tirlemont,-/Gossoncourt A/F	

Sortie List
1944

DATE	SORTIE	PILOT	SQ	A/C	TARGETS	INCIDENTS
27	BB210			F-5 42-67116	Brest Pen.	
	BB211				Bordeaux, Angers A/F, St Jean D'Angely A/F, Caen, Royan,-/Medis A/F, Le Verdon	
	BB212				Limoges area, La Blanc, Caen,-/Carpiquet A/F	
	BB213					u/s
	BB214	Diderickson, Lt Robert	14	Spit XI	Dijon A/F D/A, Romilly-sur-Seine A/F, Merlemont, Le Treport	
	BB215	Dixon, Lt Robert J	14	Spit XI MB 955	Metz/Frascati A/F D/A, Nancy/Essey A/F D/A, Coastal strip Le Treport to Dieppe	
	BB216	Simon, Capt Walter	14		Neckarsulm, Landau, Karlsruhe, Ghent area	
	BB217	Hawes, Lt Clark	22	F-5 42-67122	St Malo, Gael A/F(FW), Strip Brest Pen	
	BB218	Bruns, Lt Waldo	22	F-5 42-67246	Strip Rennes area, Rennes M/Y	
NOTE	New numbering begins Prefix is now squadron or group preceded by US, i.e. 13/1219. The numbers pick up at 219+1000.					
27	13/1219	?Crane, Lt Charles	13		Brest Pen.	
	22/1220	Burrows, Capt Daniel	22	F-5 42-67254		
	13/1221		13		A/Fs Montdidier, Roye/Amy, Peronne en Chaussee (FW)	
	13/1222		13			
	13/1223		13		Lamballe area, Cherbourg Pen.	
	13/1224		13		Brest Pen., Brest	
	22/1225	Wicker, Lt James	22	F-5 42-67246	Dinard/Pleurtuit A/F(FW), Dinard	
	22/1226		22		Le Havre, St Nazaire, Donges(FW), E of Nantes, S of St Laurent	
	13/1227		13		Brest Pen.	
	22/1228	Matthews, Lt James	22	F-5 42-67114	Moulins area	
	14/1229	Goffin, Lt Charles J J	14		Dieppe, Beaumont-sur-Oise A/F(FW), Creil area	
	22/1230	Cosby, Lt Irl	22	F-5 42-67566	Flottemanville-Hague, La Glacerie, Sottevast, Aldernay	
	13/1231		13		Brest Pen.	
	13/1232		13		Bourges-Tulle area, Bourges A/F, La Courtine le Fagettes	
	27/1233		27			u/s
	22/1234	Smith, Maj Robert R	22	F-5 42-67254	St Malo, Nantes area	
	22/1235	Miller, Lt Glenn E	22	F-5 42-67111	St Michel area, Aldernay	
	27/1236	Haugen, Maj Cecil T	27		Brest Pen.	
	13/1237		13		Brest Pen.	
	22/1238	Bruns, Lt Waldo	22	F-5 42-67119	Brest Pen.	
	22/1239	Kann, Lt Alexander	22	F-5 42-67122	Brest Pen.	
	22/1240	Aubrey, Capt Lawrence	22	F-5 42-67116	Nantes area, St Nazaire, Donges	
	13/1241	Leaser, Lt John R	13			u/s CR on takeoff
	13/1242		13		Brest Pen.	
28	7/1243	Bliss, Capt Kermit	7		Tours/Parcay, Meslay A/F(FW) Le Mans area	
	27/1244		27			u/s
	22/1245	Hawes, Lt Clark	22	F-5 42-67122	St Malo, Dinard/Pleurtuit A/F(FW)	
	13/1246		13		Lannion area	
	22/1247	Parsons, Lt Edward B	22	F-5 42-67566		u/s
	13/1248		13			Canc
	13/1249		13		Morlaix-Brest area	
	22/1250	Burrows, Capt Daniel	22	F-5 42-67116	Dinard/Pleurtuit A/F(FW), Rennes area	
	14/1251	Weitner, Maj Walter	14	Spit XI	Abbeville/Drucat A/F(FW), Nancy area, S of Nevers	
	27/1252		27			
	13/1253		13		A/Fs Conches, Chateauroux, Tours,-/Parcay, Trouville, Chartres	
	22/1254	Parsons, Lt Edward B	22	F-5 42-67114	Mellin/Villaroche A/F(FW), Fecamp, S Moulins area	
	27/1255		27		Cognac area,-/Chateaubernard A/F, Landes de Bussac A/F, Bordeaux area	
	14/1256	Nesselrode, Capt George	14	Spit XI		u/s Cloud
29	7/1257	Chapman, Capt Carl	7	Spit XI PA 944	Avord A/F D/A (FW)	
	22/1258	Wicker, Lt James	22	F-5 42-67240		u/s Intc
30	22/1259	Wicker, Lt James	22	F-5 42-67119	Vannes,-/Meucon A/F(FW), Brest Pen. Lambeth	
	22/1260	Kann, Lt Alexander	22	F-5 42-67116	Brest Pen.	
	27/1261		27			u/s
	27/262	Haugen, Maj Cecil T	27		Angouleme-Bordeaux area	
	22/1263	Matthews, Lt James	22	F-5 42-67566	Brest	
	14/1264	Richards, Lt John	14	Spit XI	Chateaudun A/F, St Andre de L'Eure A/F, Tours,-/Parcay A/F (FW), Rouen	
	13/1265		13		Guincamp area	
	13/1266		13		Carhaux to Guimperle	
	13/1267		13		Brest Pen.	
	22/1268	Cosby, Lt Irl	22	F-5 42-67122	Foret du Garre area, Rennes/St Jacque A/F	
	27/1269		27		Brest Pen.	
	22/1270	Miller, Lt Glenn E	22	F-5 42-67115	Area between St Nazaire and St Gilles	
	13/1271		13		Areas Batz Elorn, Chateaulin, Quimper, Brennilis	
	27/1272		27		Nantes-Parthenay area	

333

Eyes of the Eighth

DATE	SORTIE	PILOT	SQ	A/C	TARGETS	INCIDENTS
30	13/1273		13		N of Lorient	
	13/1274		13		Guincamp area, Cherbourg Pen. To Lorient	
	13/1275	Smith, Maj Robert R	13	F-5 42-67114	St Nazaire area, St Malo area	
	13/1276		13		Brest Pen.	
	22/1277	Aubrey, Capt Lawrence	22	F-5 42-67116		
	22/1278	Wicker, Lt James	22	F-5 42-67122	Krimpen, Rotterdam	
	22/1279	Dixon, Lt Robert	22		Rotterdam, Venlo A/F(FW), Castrop, Rauxel	
	27/1280		27		Ostende/Middelkirke A/F	
	14/1281	Sheble, Capt Richard	14		A/Fs Nancy/Essey, Toul/Croix de Metz	
	27/1282	Hawes, Lt Clark	27		Strip Brest Pen.	
	13/1283		13			u/s
	7/1284	Bliss, Capt Kermit	7			
	14/1285	Adams, Lt Gerald	14	Spit XI	Chalons, Blainville M/Y, A/Fs Nancy/Essey, Toul/Croix de Metz	
	22/1286	Burrows, Capt Daniel	22	F-5 42-67115		u/s
	22/1287		22		Le Havre, A/Fs Orleans/Bricy, Chateaudun(FW), Trouville, SW Argentan area	
	27/1288		27		Chateaudun & A/F, Nantes area, Le Havre, Laval, Orleans/Bricy A/F, Strip Caen to coast	
May						
1	27/1289		27		A/Fs Orleans/Bricy, Avord(FW), Nevers	
	14/1290	Nelson, Lt Robert	14	Spit XI	A/Fs Nancy/Essey, Rheims/Champagne(FW), Amiens/Glisy, Merkwiller	
	22/1291	?Gonzalez, Lt Hector	27		Orleans/Bricy, , Cormeilles-en-Vexin, Chateaudun, Chartres Chateauroux/ La Martinerie(FW)	
	22/1292	Parsons, Lt Edward B	22	F-5 42-67566	Le Creusot area	
	14/1293	Graves, Lt Willard	14		Chalons, Sens area	
	22/1294	Mathews, Lt James	22	F-5 42-67116	Le Bourget A/F(FW), Paris, Dijon area	
	27/1295		27		Montluçon area	
	13/1296		13		Limoges A/F(FW), Coast nr Le Havre	
	27/1297		27		Compaigne, Dijon area	
	14/1298	Parker, Lt Charles	14	Spit XI	Ludenscheide, Castrop, Hamm M/Y, Ghent, factories between Hamm and Castrop	
	13/1299		13		Ghent, Rotterdam A/Fs St Denis/Westrem, Le Culot(FW), Brussels	
	22/1300	Cosby, Lt Irl	22	F-5 42-67122	Lyons area	
	13/1301		13		SW Paris area to SW Le Havre	
	27/1302		27		A/Fs betw Rheims & Amiens	
	14/1303	Blyth, Lt John S	14	Spit XI	M/Ys Troyes-Rheims D/As	
	14/1304	Weitner, Maj Walter	14	Spit XI	Brussels M/Y, vicinity Liege M/Y D/A	
	7/1305	Bliss, Capt Kermit	7	Spit XI	Le Crotoy	
2	22/1306	Kann, Lt Alexander	22	F-5 42-67566	Clermont Ferrand area	
	27/1307				Bordeaux area, Angouleme A/F	
	13/1308				St Ettienne area, S edge of Paris	
3	14/1309	Diderickson, Lt Robert	14	Spit XI	Brussels, Liege, Dunkirk	
	22/1310	Smith, Maj Robert R	22	F-5 42-67114	Lorient area	
	22/1311	Hawes, Lt Clark	22	F-5 42-67116	Lorient area	
	13/1312					Canc
	13/1313				Lannion & Lorient area	
	27/1314				St Nazaire area	
	27/1315				Vannes area	
	14/1316	Nesselrode, Capt George	14		Avranches area	
	14/1317	Nelson, Lt Robert	14			u/s
NOTE	Photo titling change to conform to RAF form. New prefix is 7.					
4	7/1318	Bruns, Lt Waldo	22	F-5 42-67246	St Dizier/Robinson A/F(FW), Chaumont area	
	7/1319				Rouen area	
	7/1320				St Quentin area	
	7/1321	Davidson, Lt Verner	14		Hagenau A/F(FW), Merkwiller	
	7/1322	Dixon, Lt Robert J	14		Bremen, Cuxhaven, Hamburg, Brunsbuttel(FW), Harburg, Lemwerder A/F	
	7/1323	Graves, Lt Willard	14		Strip S of Amiens	
	7/1324				Beauvais area	
5	7/1325	Goffin, Lt Charles J J	14	Spit XI	Brussels/Melsbroek A/F(FW),-/Schaerbeek M/Y, A/Fs Courtrai/Nevelghem	
6	7/1326				Strip Boulogne area to Cap Gris Nez area	
7	7/1327				Boulogne(FW), Lens-St Omer-Samur area	
	7/1328	Hughes, Capt Malcolm D	22	F-5 42-67114	Brest Pen.	
	7/1329				Lens to Coast	

334

Sortie List 1944

DATE	SORTIE	PILOT	SQ	A/C	TARGETS	INCIDENTS
7	7/1330	Burrows, Capt Daniel	22	F-5 42-67115	A/Fs Morlaix/Ploujean, St Brieuc, Brest area	
	7/1331	Miller, Lt Glen	22	F-5 42-67116	St Malo, Denain/Prouvy A/F, Brest area	
8	7/1332	Wicker, Lt James	22	F-5 42-67246	Rouen area	
	7/1333					MIA
	7/1334	Aubrey, Lt Lawrence	22	F-5 42-67115	Brest area	
	7/1335				Abbeville-Rouen area, Rouen, Fecamp	
	7/1336	Dixon, Lt Robert J	14	Spit XI	Le Havre(FW)	
	7/1337	Matthews, Lt James	22	F-5 42-67114	Brest Pen., Rennes Area, Channel Islands	
	7/1338	Parsons, Lt Edward B	22	F-5 42-67131	Brest Pen.	
	7/1339	Cosby, Lt Irl	22	F-5 42-67111	Brest Pen.	
	7/1340	Kann, Lt Alexander	22	F-5 42-67108	Brest Pen.	
	7/1341	?Batson, Lt Charles	13		Watton, Siracourt	
	7/1342	Hawes, Lt Clark	22		Montlucon Area, Le Havre	
	7/1343	Farley, Lt Donald	27		Hamburg, Brunsbutel, Bremen, Zuiderzee	
	7/1344	Simon, Capt Walter	14	Spit XI	Knocke-Le Havre (Obl)	
	7/1345	Parker, Lt Charles	14	Spit XI		Recalled
	7/1346	Richards, Lt John	14	Spit XI	Reims Area, Fire at Cambrai, Lens	
	7/1347	Weitner, Maj Walter	14	Spit XI		Canc.
	7/1348	Bruns, Lt Waldo	22	F-5 42-67108	Dieppe, S of Rouen	
	7/1349	Smith, Maj Robert R	22	F-5 42-67116	Brest Pen.	
	7/1350				Gladbeck, Recklinghausen, Barges at Rees, Hamm Area, S of Nijmegan	
	7/1351				S of Brussels	
	7/1352		27		Munster(D/A), Osnabruck(D/A), N of Nijmegan, Flushing	
	7/1353	Parker, Lt Charles	14	Spit XI	Le Molay Area, Cherbourg Pen. (Obl)	
	7/1354	Weitner, Maj Walter	14	Spit XI	Brest Pen. (Obl)	
	7/1355	Bruns, Lt Waldo	22	F-5 42-67108	Chateauroux-Limoges Area	
	7/1356	Hughes, Capt Malcolm D	22	F-5 42-67116	Brest-Vannes Area, Fires nr St Brieuc & S of Brest	
	7/1357	?Proko, Lt Bernard	13			A/C Missing-POW
	7/1358	?Leasor, Lt John R				KIA
	7/1359	Burrows, Capt Daniel	22	F-5 42-67108	Brest Area, Morlaix	
9	7/1360	Nelson, Lt Robert	14	Spit XI	Berlin/Templehof A/F(FW), Berlin D/A, Hannover, Den Hague	
	7/1361	Diderickson, Lt Robert	14	Spit XI		u/s
	7/1362	Sheble, Capt Richard	14	Spit XI	Leipzig, Schelde	
	7/1363	Adams, Lt Gerald	14	Spit XI	Brunswick area, Coast at Scheldts	
	7/1364	Miller, Lt Glen	22	F-5 42-67108	Chartres A/F, Bourges A/F Orleans/Bricy,-/Sarau(FW), Clermont/Ferrand area,	
	7/1365	Blyth, Lt John S	14	Spit XI	Fulda, Kassel,-/Rothwestent A/F	
	7/1366	Bliss, Capt Kermit	7		St Brieuc-Lorient area	
	7/1367				Hamm(FW), Ludensheid Soest	
	7/1368					u/s
	7/1369	Wicker, Lt James	22	F-5 42-67114	Vichy Area, Dieppe	
	7/1370	Didericksen, Lt Robert	14	Spit XI	Fallersleben, Oranienburg, Brandenburg, W edge Berlin, Michendorf, Brunswick/Waggum A/F	
	7/1371	Aubrey, Capt Lawrence	22	F-5 42-67116	St Malo Area	
	7/1372				Mannheim/Stadt,-/Sandhofen(FW) A/Fs, Darmstadt/Greisheim, Ostend	
	7/1373	Parsons, Lt Edward B	22	F-5 42-67111	Brest Pen.	
	7/1374	Nesselrode, Capt George	14	Spit XI	Paimboeuf, Donges, Rennes/St Jacques A/F(FW)	
	7/1375	Simon, Capt Walter	14	Spit XI	St Nazaire Area	
	7/1376	Davidson, Lt Verner	14	Spit XI		u/s
	7/1377					Landed Away
	7/1378					Landed Away
	7/1379				Liege D/A,-Bonn Area, Wetzlar, Cap Gris Nez, Flushing	
	7/1370				St Dizier/Robinson A/F(D/A)(FW), Chaumont Area, Compeigne Area S, Le Crotoy	
	7/1381	Gonzalez, Lt Hector	13		Thionville A/F & M/Y D/A, Luxembourg D/A, Florennes A/F D/A, Laon/Athies,-/Couvron A/Fs	
	7/1382					u/s
	7/1383				Florennes/Juzaine A/F, Trier-Neustadt Area	
	7/1384	Matthews, Lt James	22	F-5 42-67108	Blois, LeHavre, Montlucon Area	
	7/1385	Cosby, Lt Irl	22	F-5 42-67116	Brest Pen	
	7/1386	Davidson, Lt Verner	14	Spit XI	A/fs Bernberg, Oschersleben, Helmstedt. Brunswick	
	7/1387	Graves, Lt Willard	14	Spit XI		u/s
	7/1388		27		S of Brussels to Ostend, then to Calais	
	7/1389		27		Hamm area, N of Essen to Scheldts	
	7/1390	Dixon, Lt Robert J	14	Spit XI	Brunswick, Fallersleben, Rheine A/F	Canc
	7/1391	Parker, Lt Charles	14	Spit XI	Eder Dam, area S of Leipzig, Ruhland	Canc
	7/1392	Weitner, Major Walter	14	Spit XI	Strip betw Lorient & Vannes	

335

Eyes of the Eighth

DATE	SORTIE	PILOT	SQ	A/C	TARGETS	INCIDENTS
9	7/1393	Goffin, Lt Charles J J	14	Spit XI	Antwerp, Zeebrugge, N of Cologne	
	7/1394	Kann, Lt Alexander	22	F-5 42-67111	Brest Pen	
	7/1395				A/Fs Juvincourt, St Dizier/Robinson, strips Verdun area, Chalons-sur-Marne to Le Crotoy	
10	7/1396					u/s E/A
	7/1397	Hawes, Lt Clark	22	F-5 42-67108	Fecamp	Eng Trbl
	7/1398					u/s
	7/1399	Haugen, Maj Cecil T	27			u/s
	7/1400				St Hellier, A/Fs Guernsey, Laon/Athies,-/Couvron(FW), Verdun, -Chaumont area	
	7/1401				Le Crotoy, N of Abbeville area, -/Drucat A/F, Amiens area	
	7/1402	Richards, Lt John	14	Spit XI	Guernsey, Alderney, Le Havre to Cap de la Hague	
	7/1403	Hughes, Capt M D	22	F-5 42-67114	Bordeaux(FW), & area	
	7/1404	Smith, Maj Robert R	22	F-5 42-67254		u/s
	7/1405				Halle/Nzetleben(FW), Giesen, Steinbach, Merseberg, Fulda, Nordhausen, Paderborn, Leipzig	
	7/1406				A/Fs Amiens/Glisy, Roye/Amy, Romilly, Compeigne/Margny(FW), Boulogne, Amiens to coast	
	7/1407	Smith, Maj Robert R	22	F-5 42-67115	Bordeaux-Biarritz area	
	7/1408	Graves, Lt Willard	14	Spit XI	Guernsey, Ile de Brehat to Brest	
11	7/1409	Hawes, Lt Clark	22	F-5 42-67114	Chateauroux area, Granville	
	7/1410	Bruns, Lt Waldo	22	F-5 42-67116	Clermont/Ferrand(FW), W of Lyons area	
	7/1411		13		Denain/Prouvy(FW), Luxembourg - Commercy area	
	7/1412				Amiens area, Small boats in canal NE of Paris	
	7/1413				Boulogne area	
	7/1414				Lille/Vendeville(FW), Dunkirk, Brussels/Schaerbeck M/Y, Aachen area	
	7/1415	Wicker, Lt James	22	F-5 42-67108		u/s
	7/1416				Dieppe(FW), Amiens-Beauvais area	
	7/1417		27		Dunkirk, Merville, Frankfurt area Lille/Vendreville(FW)	
	7/1418					Landed overseas
	7/1419					Landed overseas
	7/1420					u/s Intc
	7/1421	Wicker, Lt James	22	F-5 42-67108	Brest Pen.	
	7/1422					Landed overseas
	7/1423	Parsons, Lt Edward B	22	F-5 42-67111	St Brieul - Lorient area, Brest Pen, Lorient	
	7/1424				Dusseldorf area, Brussels M/Y	
	7/1425	Burrows, Capt Daniel	22	F-5 42-67115	Evereux/Fauville A/F, Le Mans to Caen	
	7/1426				Gutersloh area, Scheldt	
	7/1427	Sheble, Capt Richard	14	Spit XI	Brehat to Brest	
	7/1428	Miller, Lt Glenn E	22	F-5 42-67108		
	7/1429				Amiens-Rouen area, A/Fs Amiens/Glisy, Beauvais/Tille, Poix, Rouen/Bois	
	7/1430				Frankfurt area, Scheldt area	
	7/1431				Eindhoven area	
	7/1432				Epinal, Mulhouse, Belfort, Chaumont (D/As), S of Boulogne, Laon A/Fs, N of Dieppe	
12						
	7/1433	Matthews, Lt James B	22	F-5 42-67254	Caen(FW), Montlucon area	
	7/1434	?Brink, Lt Fred	13		Brussels M/Y, Lille/Vendeville A/F, Liege M/Y, Douai, Merville	
	7/1435				Flushing, Antwerp(FW), Cologne	
	7/1436				Ruhr area, Cologne, Aachen, Liege	
	7/1437	Richards, Lt John	14	Spit XI	Hanover/Vahrenwalderheide A/F, Brunswick, Hanover	
	7/1438				Boulogne(FW)	
	7/1439	?Clark, Lt Albert C	13		Luxembourg M/Y	u/s Intc
	7/1440	Cosby, Lt Irl	22	F-5 42-67111	St Peter Port, Guernsey A/F(FW), Landevant to Ploermel to St Malo	
	7/1441				Nevers area, Berneval to Le Crotoy	
	7/1442				Wengerohr A/F(FW)	
	7/1443					Landed overseas
	7/1444					Landed overseas
	7/1445		27		Volkel A/F(FW), Schouwen Island	
	7/1446				Dijon area, A/F N Troyes & Soissons	
	7/1447					
	7/1448				Sterreken, Antwerp/Deurne A/F(FW), W of Aachen, Limburg to Scheldts	
	7/1449	Davidson, Lt Verner	14	Spit XI	Brux D/A, Zweikau D/A	Longest sortie
	7/1450	Adams, Lt Gerald	14	Spit XI	Merseburg, Lutzkendorf, Bohlen(D/A), Magdeburg	
	7/1451	Nelson, Lt Robert	14	Spit XI	SE of Lippstadt	
	7/1452					u/s
	7/1453	Blyth, Lt John S	14	Spit XI	Ehrang M/Y, Konz Karthaus M/Y, Luxembourg M/Y(FW)	

336

Sortie List 1944

DATE	SORTIE	PILOT	SQ	A/C	TARGETS	INCIDENTS
12	7/1454					u/s
	7/1455				Belfort, Epinal, Mulhouse(D/As) Montlucon area, Boulogne	
	7/1456	Kann, Lt Alexander Jr	22	F-5 42-67566	Vichy,-/Rhue A/F(FW), Dieppe, Clermont/Ferrand, Nevers	
	7/1457	Farley, Lt Donald A	22	F-5 42-67114	Roanne area	
	7/1458	Diderickson, Lt Robert	14	Spit XI	Ruhr area	
	7/1459				Strip Sens to Dieppe	
	7/1460	Miller, Lt Glenn E	22	F-5 42-67115		u/s
	7/1461					Canc
	7/1462				Brussels M/Ys D/A	
	7/1463				Saarbrucken D/A, Strasbourg & area, Trier to Calais	
	7/1464	Haugen, Maj Cecil T	27	F-5B	Brussels M/Y, Liege M/Y(D/A), A/F SW of Brussels, strip Liege to Zeebrugge	
	7/1465					
	7/1466				Strip Arras to Calais	
13	7/1467	Weitner, Maj Walter	14	Spit XI	Brunswick D/A, Misburg	
	7/1468		27	F-5	Liege area, Breda area, A/Fs Brussels/Melsbroek,-/Evere, -/Woensdrecht(FW), Brussels M/Y	
	7/1469				Compeigne/Margny A/F, Chaumont area	
	7/1470					u/s
	7/1471		27		Brussels, Ghent, Knocke, Rotterdam, Ludenscheid area	
	7/1472		27		Antwerp, Brussels, Ghent, Zeebrugge area	
	7/1473	Goffin, Lt Charles J J	14	Spit XI	Eindhoven-Roermond area	
	7/1474		27		Boulogne, Saarbrucken	
	7/1475				Coblenz, Liege, Antwerp/Deurne A/F, Coblenz-Trier area	
	7/1476	Haugen, Maj Cecil	27	F-5C	Osnabruck D/D	
	7/1477	Hawes, Lt Clark	22	F-5 42-67114	Bar de luc-Chaumont area, A/F s betw Rheims & Boulogne	
	7/1478				Le Havre, Rouen, A/Fs Berck-sur-Mer, Bernay/St Martin, Letrait area	
	7/1479	Smith, Maj Robert R	22	F-5 42-67115	Cayeux-Nancy area	
	7/1480					Canc
	7/1481				Gilze/Rijen, Huls, Osnabruck M/Y(D/A), Munster, A/Fs -/Handorf, Achmer, Hespe, Vorden	
	7/1482				Verdun area	
15	7/1483	Hughes, Capt M D	22	F-5 42-67115	Brest Pen	
	7/1484	Aubrey, Capt Lawrence	22	F-5 42-67111	Rouen area	
17	7/1485					u/s weather
	7/1486					Canc
19	7/1487	Parker, Lt Charles	14	Spit XI	Osnabruck, Misburg, Brunswick. -/Waggum A/F(D/A), Rotterdam, Hague to Zuiderzee	
20	7/1488	Nesselrode, Capt George	14	Spit XI	Merseberg/Leuna D/A(FW), Bohlen D/A, Lutzkendorf D/A	
	7/1489				Dieppe, Orly, Villacoublay D/A	
	7/1490				The Hague-Osnabruck area D/A	
	7/1491	Gonzalez, Lt Hector	13	F-5	Boulogne, Charleroi/Gosselies, Florennes/Juzaine, Thionville D/A(FW)	
	7/1492				Coast nr Dieppe	
	7/1493					Canc
	7/1494				Town S of Antwerp	
22	7/1495	Vassar, F/O Edgar	13	F-5B 42-67395	Ostend Coastal area	
	7/1496	Anderson, Lt J L	13	F-5B 42-67389	Hasselt RR Bridge, Scheldts	
	7/1497	Moss, Lt Robert E	13	F-5B 42-68265	Ghent, Dunkirk coastal area	
	7/1498	Setchell, Lt Col		F-5B 42-67316		Pilot Rtd Bari
	7/1499	Oakley, Capt		F-5B 42-67337		Pilot Rtd Bari
	7/1500					u/s
	7/1501	O'Brien, Lt L D		F-5C 42-67110		Pilot Rtd Bari
	7/1502	Alley, Lt Max P	27	F-5C 42-67124	Kiel town & port area D/A, U/B Y/Ds 16, 17. Pos Borkum A/F	
	7/1503	McBee, Capt Lawrence	27	F-5B 42-67196	Kiel town & port area D/A, U/B Y/Ds 16, 17. Leeuwarden, Meldorf area	
	7/1504	Chapman, Capt Carl J	22	F-5B 42-68205	Hasselt M/Y & RR Bridge, strips betw Hasselt & Ostend	
	7/1505	Cassaday, Capt C G	27	F-5B 42-67366	Hasselt town, M/Y & RR Bridge	
23	7/1506	Graves, Lt Willard	14	Spit XI MB950		u/s Weather
	7/1507	Dixon, Lt Robert J	14	Spit XI PA944		u/s Cloud Ld Bradwell Bay, Rd
	7/1508	Simon, Capt Walter J	14	Spit XI MB946		u/s
	7/1509	Sommerkamp, Lt Frank M	13	F-5B 42-68207		u/s
	7/1510	Rickey, Lt K J	27	F-5C 42-67242	The Hague area	
	7/1511	Parsons, Lt Edward B	22	F-5C 42-67108	Brest area	
	7/1512	Cosby, Lt Irl	22	F-5C 42-67524	Le Havre	

337

Eyes of the Eighth

DATE	SORTIE	PILOT	SQ	A/C	TARGETS	INCIDENTS
23	7/1513	Matthews, Lt J B	22	F-5C 42-67115	Brest Pen	
	7/1514	Sommerkamp, Lt Frank M	13	F-5B 42-68265	Nancy area	
	7/1515	Weitner, Maj Walter	14	F-5C 42-67566	Rennes A/F(FW), Rennes area	
	7/1516	Graves, Lt Willard	14	Spit XI MB950	Photos on course to Hanover	
	7/1517					u/s
	7/1518	Clark, Lt Albert W	27	F-5C 42-67324		Recalled
	7/1519	Kann, Lt Alexander Jr	22	F-5C 42-67119	A/Fs Avord, Bourges, Chateauroux/Deols,-/La Martinerie(FW)	
	7/1520	Farley, Lt Donald A	22	F-5C 42-67246	River Loire nr Orleans, Strip Paris to Fecamp	
	7/1521	Simon, Capt Walter	14	Spit XI MB956	Paderborn, Halle(FW)	
	7/1522	Crane, Lt Charles M	13	F-5B 42-67319	Troyes area	
	7/1523	Floyd, Lt Robert C	27	F-5C 42-67123	Hasselt RR Bridge D/A, Strip to Antwerp	
	7/1524	Hughes, Capt M D	22	F-5C 42-67114	Strip Hasselt to Overflakke	
	7/1525	Bliss, Capt Kermit	7	F-5B 42-68205	Hasselt RR Bridge D/A, -/M/Y, Knocke/Le Zoute	
	7/1526					Canc
24	7/1527					Recalled
	7/1528	Cassaday, Capt Charles G	27	F-5B 42-67366	Politz, Stettin, Luneberg, Tutow A/F, Travemunde, Lubeck, Wismar,-/A/F, Prival/Patenitz	
	7/1529	Miller, Lt Glenn E	22	F-5C 42-67115	Cognac/Chateaubernard A/F(FW), Bordeaux, St Malo, St Jean D'Angely A/F, Dinard/Pleurtuit	
	7/1530	Clark, Lt Albert W	27	F-5B 42-68265		u/s Intc
	7/1531	Bruns, Lt Waldo C	22	F-5C 42-67119	Bourges FAF, Orleans/Bricy A/F, Bourges to Dieppe	
	7/1532	Hawes, Lt Clark J	22	F-5C 42-67131	Orleans	
	7/1533	Aubrey, Capt Lawrence	22	F-5C 42-67116	St Brieuc-St Nazaire-Brest area	
	7/1534	Matthews, Lt J B	22	F-5C 42-67122	Toussus le Noble A/F, Buc A/F, Strip Creil to Dieppe, Orly A/F, Melun/Villaroche A/F	
	7/1535	Parsons, Lt Edward B	22	F-5C 42-67246	Caen/ Carpiquet A/F D/A(FW), Rennes area	
	7/1536				Rheims D/A(FW), St Dizier A/F, Chaumont M/Y D/A	
	7/1537	Davidson Lt Verner K	14	F-5B 42-67399	Verberie RR Bridge Dive bombing, Nr Le Treport, Abbeville/Drucat A/F	
	7/1538	Weitner, Maj Walter	14	F-5C 42-67566	Soissons RR Bridge, Soissons-Dunkirk area	
	7/1539	Childress, Capt Hubert M	27	F-5C 42-67342	Beaumont-sur-Oise RR Bridge(FW) Creil M/Y	
	7/1540	Cosby, Lt Irl R	22	F-5C 42-67119	Toussus le Noble A/F,-/Paris A/F, Chateaudun A/F D/A, Rouen, Guyancourt/Caudron, Orleans/Bricy A/F	
	7/1541	Brink, Lt Fred B	13	F-5B 42-68207	Laon/Couvron A/F(FW) Soissons-Dunkirk area	
	7/1542	Campbell, Capt J L	27	F-5C 42-67107	Creil M/Y, Creil-Le Crotoy area	
	7/1543	Brewster, Lt Edgar L	27	F-5C 42-67124	Osnabruck D/A, Soesterburg A/F, Twente/Enschede A/F, Volkel A/F	
	7/1544	Smith, Maj Robert R	22	F-5B 42-68265		u/s
	7/1545	Batson, Lt Charles R	13	F-5B 42-67319	Canal de Bruges, Saarbrucken D/A, Bettembourg M/Y D/A, Ostend, Dunkirk, Calais	
	7/1546	Kendall, Lt Ralph D	13	F-5B 42-67324	Venlo A/F	
25	7/1547	Kann, Lt Alexander Jr	22	F-5	Dieppe(FW),Le Treport, E Nevers area	
	7/1548	Hughes, Capt Malcolm D	22	F-5	A/Fs Bordeaux,-/Merignac, Cognac/Chateaubernard(FW)	
	7/1549	Farley, Lt Donald A	22	F-5C 42-67254	Granville, Samur A/F(FW), Tulle-St Malo, Bordeaux	
	7/1550	?Cassaday, Lt Charles	27	F-5		Landed abroad
	7/1551	Richards, Lt John	14	F-5B 42-68202	St Valery-en-Caux A/F & gun positions, pos Fecamp	
	7/1552	Sommerkamp, Lt Frank M	13	F-5B 42-67395	M/Ys Bettembourg, Thionville, Saarguemines; Metz, Hagenau A/F	
	7/1553	Crane, Lt Charles M Jr	13	F-5B 42-67389	M/Ys Liege, Montignies-sur-Sambre, Brussels D/A, Dunkirk	
	7/1554	Smith, Maj Robert R	13	F-5B 42-68265	M/Ys Blainville, Belfort, Mulhouse; A/Fs Nancy/Essay St Dizier/Robinson; Colmar	
	7/1555	Blyth, Lt John S	14	F-5B 42-67399	M/Ys Montignies-sur-Sambre, Liege, Troyes; St Dizier -Troyes-Etampes area, area A/Fs	
	7/1556	Bruns, Lt Waldo	13	F-5 42-67119		Canc Weather
27	7/1557	Miller, Lt Glenn E	22	F-5C 42-67566	Bordeaux area, St Malo, Jersey, Shipping at Cancale, Guernsey	
	7/1558	Bruns, Lt Waldo	13	F-5C 42-67119	A/Fs Evereaux/Fauville, Avallon Auxerre, Etampes/Montdesir, Beaumont-sur-Oise, Bretigny	
	7/1559	Wicker, Lt James E	22	F-5C 42-67246	Bordeaux, Bec D'Ambes, La Pallice, La Rochelle,-/La Leu, Cognac/Chateaubernard A/Fs	
	7/1560	Clark, Lt Albert W	27	F-5? 43-28333		u/s
	7/1561	Brink, Lt Fred B	13	F-5B 42-67324		u/s
	7/1562	Vassar, F/O Edgar L	13	F-5B 42-67395		u/s
	7/1563					Canc
	7/1564	Vassar, F/O Edgar L	13	F-5B 42-67389	Mulhouse area, S of Albert, Le Crotoy	
	7/1565	Brink, Lt Fred B	13	F-5B 42-67395	Freiburg area, Mulhouse, Le Crotoy	
	7/1566	Hawes, Lt Clark J	22	F-5C 42-67131	Strip SW from Commercy	
	7/1567	Aubrey, Capt Lawrence E	22	F-5C 42-67116	Chaumont area	
	7/1568	Alley, Lt Max P	27	F-5C 42-67124		u/s Intc
	7/1569	Cameron, Lt Jack T	27	F-5C 42-67550	Poix A/F(FW)	
	7/1570	Parsons, Lt Edward B	22	F-5C 42-67254	Abbeville/Drucat A/F(FW)	
	7/1571	Batson, Lt Charles R	13	F-5B 42-67319	Konz Karthus, Saarbrucken, Neunkirchen, Woippy D/As, Mapping Metz area	

Sortie List 1944

DATE	SORTIE	PILOT	SQ	A/C	TARGETS	INCIDENTS
27	7/1572	Kendall, Lt Ralph D	13	F-5B 42-68207	Hagenau A/F, Karlsruhe & area, Strasbourg, Ludwigshaven, Mannheim D/As	
	7/1573	McBee, Capt Lawrence S	27	F-5B 42-68196	Dieppe, Fecamp(FW), Chalons-sur-Saone area	
	7/1574	Didericksen, Lt Robert	14	Spit XI	Saarbrucken D/A, Boulogne, Nevenkirchen D/A	
	7/1575	Nelson, Capt Robert	14	Spit XI	Boulogne(FW)	
	7/1576					Canc
	7/1577	Matthews, Lt James B	22	F-5C 42-67122	Epernay area	
	7/1578	Rickey, Lt Irvin J	27	F-5C 42-67242		u/s
	7/1579	Floyd, Lt Robert C	27	F-5B 42-67366	Chalons area, Le Crotoy	
	7/1580	Crane, Lt Charles M	13	F-5B 42-68265	Verdun-Strasbourg area	
	7/1581	Clark, Lt Albert W	27	F-5B 42-67324		u/s
	7/1582	Childress, Capt Hubert M	27	F-5C 42-67124	Neunkirchen, Saarbrucken, Konz Karthus, Woippy, D/As, Hagenau A/F, Frankfort-Metz area, Ludwigshaven, Mannheim	
	7/1583	Cosby, Lt Irl	22	F-5C 42-67114	Cherbourg, Granville; A/Fs Rennes, Dinard/Pleurtuit(FW)	
	7/1584	Cassaday, Lt Charles G	27	F-5C 42-67242	Lyons area, Poix A/F D/As, A/Fs Lyons/Bron, Romilly, Creil	
	7/1585	?Cameron, Lt Jack L	27	F-5C 42-67107	Mulhouse/Habsheim A/F(FW)	
	7/1586	Brewster, Lt Edgar L	27	F-5B 42-68213	Lyons area	
	7/1587	Weitner, Maj Walter L	22	F-5C 42-67566	Brest-Lorient area	
	7/1588	Grayson, Lt Benton C	22	F-5C 42-67119	Rouen area, Fecamp	
	7/1589	Witt, Capt Harry A	13	F-5E 43-28331		u/s
	7/1590	Cameron, Lt Jack L	27	F-5B 42-68196		u/s Intc
	7/1591	Alley, Lt Max P	27	F-5B 42-67366		u/s
28	7/1592	Haugen, Maj Cecil T	14	F-5B 42-67319	Cologne	1st sortie in 14th Sq
	7/1593	Smith, Maj Robert R	13	F-5B 42-68235	Cologne	
	7/1594	Chapman, Capt Carl J	7	F-5B 42-68207	Cologne	
	7/1595	Tymowicz, Lt Adam P	13	F-5E 43-28331	Cologne	
	7/1596	Miller, Lt Glen E.	22	F-5C 42-67119	A/Fs Abbeville/Drucat(FW), Estrees/St Denis; Chaumont area	
	7/1597	Kann, Lt Alexander Jr	22	F-5C 42-67131	Boulogne, Calais,-/Marck A/F, St Omer/Clairmarisa A/F, Bar-le-Duc,Verdun, Chaumont, Gravelines, St Dizier	
	7/1598	Sommerkamp. Lt Frank M	13	F-5B 42-67389	Boulogne, St Omer/Fort Rouge, Lille/Vendreville A/Fs, Charleroix/Boulogne area	
	7/1599					u/s
	7/1600	Sheble, Capt Richard N	14	Spit XI PA 944	Berlin D/A	
	7/1601	Hughes, Capt Malcolm D	22	F-5C 42-67566	Chalon area	
	7/1602	Farley, Lt Donald A	22	F-5C 42-67254	Chalon area	
	7/1603				Amiens/Glisy A/F(FW), Le Crotoy Mulhouse-Bar le Duc- area	
	7/1604	Anderson, Lt John L		F-5B 42-67382	SE Nancy-Baste-Freiburg area, Le Crotoy, Le Touquet, A/Fs N of Rambervillers, Luneville A/F	
	7/1605	Hawes, Lt Clark	22	F-5B 42-67116	Angers/Avrille A/F(FW), St Malo	
	7/1606	Mitchell, Maj Ray C	22	F-5C 42-67123		u/s pilot ill
	7/1607	Parsons, Lt Edward B	22	F-5C 42-67246	Paris, Le Creusot area	
	7/1608	Grayson, Lt Benton C	22	F-5C 42-67114	Rouen area	
	7/1609	Moss, Lt Robert E	13	F-5B 42-68265	Liege D/A,-/Speyerdorf A/F D/A, Montignes D/A, Hagenau A/F	
	7/1610	Cameron, Lt Jack T	27	F-5C 42-67550	Bremen area	
	7/1611	McBee, Capt Lawrence S	27	F-5B 42-68196	A/Fs Steenwijk, Bergen/Alkmaar, Meppel & Alkmaar area	
	7/1612	Brewster, Lt Edgar L	27	F-5B 42-68213	Groningen, Emdem area	
	7/1613	Campbell, Capt J L		F-5B 42-67379	Groningen-Coevorden area, Hopsten to Bergen	
	7/1614	Cassaday, Capt Charles G	27	F-5C 42-67124		
	7/1615					u/s
	7/1616	Rickey, Lt Irvin J	27	F-5C 42-67242	Den Helder, Tessel Island, N end of Zuiderzee, Groningen area	
	7/1617	Parker, Lt Charles F	14	Spit XI PL767		Canc
	7/1618	Adams, Lt Gerald M	14	Spit XI MB955		
	7/1619	Graves, Lt Willard	14	Spit XI MB950		
	7/1620	Goffin, Lt Charles J J	14	Spit XI MB952		
	7/1621	Childress, Capt Hubert M	27	F-5C 42-67123	Gelsenkirchen	
	7/1622	Batson, Lt Charles R	13	F-5B 42-67389		
	7/1623	Wicker, Lt James E	22	F-5C 42-67246		u/s
	7/1624	Wicker, Lt James E	22	F-5C 42-67246		
	7/1625					Canc
	7/1626	Bruns, Lt Waldo	13	F-5B 42-67319		
29	7/1627	Davidson, Lt Verner K	14	Spit XI MB946	Lutzkendorf, Zeitz, Gera D/As	
	7/1628	Alley, Lt Max P	27	F-5C 42-67124		u/s
	7/1629	Kendall, Lt Ralph D	13	F-5B 42-67382	Antwerp, Liege Kinkempos M/Y, Woensdrecht A/F(FW), Montignies M/Y D/A	
	7/1630	Brink, Lt Fred B	13	F-5B 42-68207	Mannheim & area, Dunkirk vicinity	
	7/1631	Alley, Lt Max P	27	F-5C 42-67107	Rotterdam(FW), Dortmund area	
	7/1632	Matthews, Lt J R	22	F-5C 42-67119	Etampes/Mondesir D/A, Creil area D/A, Bretigny A/F D/A, strip Creil to Le Crotoy	
	7/1633	Cassaday, Capt Charles G	27	F-5B 42-67366		u/s

DATE	SORTIE	PILOT	SQ	A/C	TARGETS	INCIDENTS
29	7/1634	Childress, Capt Hubert M	27	F-5B 42-68213	Politz, Tutow D/As, Rostock, Wernemunde, Lubeck; Rerik/West, Tarnevitz A/Fs	
	7/1635	Hawes, Lt Clark J	22	F-5C 42-67131	Nancy-Karlsruhe area, Boulogne	
	7/1636	Bliss, Capt Kermit	7	F-5E 43-28311	Nancy-Karlsruhe area	
	7/1637	Campbell, Capt J L	27	F-5B 42-67379	Nancy-Karlsruhe area	
	7/1638	Bruns, Lt Waldo	13	F-5B 43-28324	Nancy-Karlsruhe area	
	7/1639	Aubrey, Capt Lawrence E	22	F-5C 42-67116	Nancy-Karlsruhe area, Rheims	
	7/1640	Farley, Lt Donald A	22	F-5C 42-67108	Nancy-Karlsruhe area, Calais	
	7/1641	McBee, Capt Lawrence S	27	F-5B 42-68196	Luxembourg-Karlsruhe-Nancy-Longuyon, Boulogne	
	7/1642	Cameron, Lt J T	27	F-5C 42-67550		u/s
	7/1643	Tymowicz, Lt Adam P	13	F-5E 43-28331	Luxembourg Karlsruhe-Freiburg-Nancy area	
	7/1644	Rickey, Lt Irwin J	27	F-5C 42-67242	Zwolle area, Ijmuiden, Amsterdam	
	7/1645	Vassar, F/O Edgar L	13	F-5B 42-68235	Nr Ostend	
	7/1646	Simon, Capt Walter J	14	Spit XI PA944	Berlin D/A	
	7/1647	Parker, Lt Charles F	14	Spit XI PL790	Lutzkendorf,-/Heiterblick D/A, Brux, Gera, Moblis, Saalburg Dam & M/Y, strip Lutzkendorf to Weser, Leipzig/Mockau A/F	
	7/1648					u/s
	7/1649	Sommerkamp, Lt Frank M	13	F-5B 42-68207	Mannheim area, Dunkirk	
	7/1650	Batson, Lt Charles R	13	F-5B 42-67389	Dortmund-Ludenscheid area, Ghent, Bruges, Blankenburg, Knocke, Antwerp, Ostend, Dunkirk, Nieuport	
	7/1651	Clark, Lt Albert W	27	F-5E 43-28333	Liege-Wiesbaden area	
	7/1652	Blyth, Lt John S	14	Spit XI MB948		u/s
	7/1653	Moss, Lt Robert E	13	F-5B 42-68265	Belfort-Neufchateau area, St Dizier	
	7/1654	Anderson, Lt J S	13	F-5B 42-67382	Calais, Cologne, Frankfurt area	
30	7/1655	Cassaday, Capt C G	27	F-5B 42-67342	Osnabruck, Posen, Cottbus, Sarau, Brunswick/Broitzen A/F, Misburg, Hanover A/F & M/Y	
	7/1656	Nelson, Capt Robert R	14	Spit XI PL790	Politz D/A, Hamburg, Stettin, Warren, Diepholz D/A, Soesterburg	
	7/1657	Kendall, Lt Ralph D	13	F-5B 42-67324		u/s
	7/1658	Floyd, Lt Robert C	27	F-5C 42-67107	Steenwijk/Havelte A/F(FW), Assen-Lingen area	
	7/1659	Brewster, Lt Edgar L	27	F-5C 42-67242	Bremen area	
	7/1660	Cameron, Lt J T	27	F-5C 42-67550	Soesterburg A/F, Bergen/Alkmaar A/F, Amsterdam/Schipol A/F D/A, Zwolle area	
	7/1661	Smith, Maj Robert R	13	F-5E 43-28324	Calais, Antwerp, Ghent, Ostend, Coxyde/Furnes A/F, Brussels M/Y, Liege area	
	7/1662	Hughes, Capt Malcolm D	22	F-5C 42-67114	Creil RR Br D/A, Bourg area	
	7/1663	Farley, Lt Donald A	22	F-5C 42-67108	Bourg area	
	7/1664	Weitner, Maj Walter L	22	F-5C 42-67254	Rheims M/Y D/A, Troyes M/Y D/A, Besancon area	
	7/1665	Cosby, Lt Irl	22	F-5C 42-67119	Le Crotoy, Rheims/Campegne A/F M/Y, A/Fs: St Dizier/Robinson, Abbeville/Drucat, Amiens/Glisy; Besancon	
	7/1666	Alley, Lt Max P	27	F-5C 42-67366	A/Fs Munster/Handorf, Diepholz; Osnabruck area	
	7/1667	McBee, Capt Lawrence S	27	F-5B 42-67379	Rotenburg A/F D/A, Oldenburg A/F D/A, Bad Zwischenahn SPB Bremen area	
	7/1668	Kendall, Lt Ralph D	13	F-5E 43-28331	Eindhoven A/F, Koblenz area	
	7/1669	Brink, Lt Fred B	13	F-5B 42-68207	Luxembourg area	
	7/1670	Blyth, Lt John S	14	Spit XI PA841	Halberstadt, Dessau D/A, Bitterfeld, Oschersleben	
	7/1671	Diderickson, Lt Robert W	14	Spit XI PA892	Halberstadt A/F, Junkers plant, Oschersleben factory A/F, Dessau FA/F, Fallersleben D/As	
	7/1672	Schultz, Lt Donald A	27	F-5B 42-68213	Flushing, The Hague	
	7/1673	Bruns, Lt Waldo	13	F-5E 43-28333	Strike attack, St Valery-Gris Nez area	
	7/1674	Chapman, Capt Carl J	7	F-5E 42-68235	Strike attack	
	7/1675	Parsons, Lt Edward B	22	F-5B 42-67116	Strike attack	
	7/1676	Childress, Capt Hubert M	27	F-5C 42-67550	Strike attack	
	7/1677				Boulogne, Calais, Dunkirk, Ostend	
	7/1678	Campbell, Capt J L	27	F-5C 42-67124	Bremerhaven area	
	7/1679	Mitchell, Lt R L	22	F-5C 42-67114	Le Havre, Fecamp	
31	7/1680	Sheble, Capt Richard N	14	Spit XI PL790		u/s radio
	7/1681	Cassaday, Capt C G	27	F-5C 42-67124		
	7/1682	Floyd, Lt R C	27	F-5C 42-67550		
	7/1683	Brewster, Lt Edgar L	27	F-5B 42-68213		
	7/1684	McBee, Capt Lawrence S	27	F-5C 42-67242		
	7/1685	Schultz, Lt Donald A	27	F-5B 42-67342		
	7/1686	Moss, Lt Robert E	13	F-5B 42-68265		
	7/1687	Anderson, Lt J L	13	F-5B 42-67389		
	7/1688	Brink, Lt Fred B	13	F-5E 43-28324	Stuttgart-Munich area, Strasbourg	
	7/1689	Batson, Lt Charles R	13	F-5B 42-67382		
	7/1690	Kendall, Lt Ralph D	13	F-5B 42-68325		
	7/1691	Sommerkamp, Lt Frank M	13	F-5B 42-68207		
	7/1692	Kann, Lt Alexander Jr	22	F-5C 42-67116	Nurnberg-Mannheim area	
	7/1693	Miller, Lt Glenn E	22	F-5C 42-67111	Nurnberg-Mannheim area	
	7/1694	Vassar, F/O Edgar	13	F-5E 43-28331		

Sortie List 1944

DATE	SORTIE	PILOT	SQ	A/C	TARGETS	INCIDENTS
31	7/1695	Bruns, Lt Waldo	13	F-5E 43-28333	Nurnberg-Mannheim area	
	7/1696	Bliss, Capt Kermit E	7	F-5E 43-28311	Beaumont-sur-Oise RB, Melun RB, Troyes, Precy-sur-Oise	
	7/1697	Parker, Lt Charles F	14	Spit XI PL790	Politz	
	7/1698	Sheble, Capt Richard N	14	Spit XI PL767	Cottbus D/A, Sorau.	u/s drop tanks
	7/1699	Richards, Lt John R	14	Spit XI PA892	M/Ys Hamm, Osnabruck, Soest Schwerte D/As; Ruhr, Factory S of Osnabruck	
	7/1700	Wiebe, Lt Glen E	13	F-5B 42-67324	Ostend, Antwerp(FW), Brussels	
	7/1701	Weitner, Maj Walter L	22	F-5C 42-67566		u/s
	7/1702	Tymowicz, Lt Adam P	13	F-5B 42-67895	A/F Osnabruck area, Ijmuiden	
	7/1703	Childress, Capt Hubert M	27	F-5B 42-67342	Gatow(FW), Berlin & Hamburg area	
	7/1704	Cameron, Lt J T	27	F-5B 42-67366	Celle(FW), Berlin & Hamburg area	
	7/1705	Campbell, Capt J L	27	F-5C 42-67107	Vechta(FW), Berlin & area, Groningen	
	7/1706	Alley, Lt Max P	27	F-5C 42-67124	Schonwalde, Staaken, Doberitz(FW); Berlin & Hamburg area	
JUNE						
1	7/1707	Wiebe, Lt Glen E.	13	F-5B 42-67324	Area S of Antwerp	
	7/1708	Haugen, Maj Cecil T	14	Spit XI MB956		u/s cloud
	7/1709	Adams, Lt Gerald	14	Spit XI PL782		u/s
	7/1710	Rowe, Lt David K	22	F-5C 42-67338	Montlucon area, Orleans-Fecamp	
2	7/1711	Childress, Capt Hubert M	27	F-5B 42-67342	Low-level Obl Bridges on Loire River	A/C damaged by ground fire
	7/1712	Batson, Lt Charles R	13	F-5B 42-68265	Low-level Obl Bridges on Loire River	
	7/1713	Wiebe, Lt Glen E	13	F-5E 43-28331		
4	7/1714	Cosby, Lt Irl	22	F-5C 42-67119	Orleans/Les Aubrais rail facility	
	7/1715	Matthews, Lt J B	22	F-5C 42-67116	Tgts in France	
	7/1716	Wicker, Lt James E	22	F-5C 42-67246	Tgts in France	
	7/1717					?Landed Sardinia
	7/1718	Crane, Lt Charles M Jr	13	F-5B 42-67332	Tgts in France	
	7/1719	Clark, Lt Albert W	27	F-5E 43-28331	Tgts in France	
	7/1720	Kann, Lt Alexander Jr	22	F-5C 42-67131	Beaumont-sur-Oise A/F	
	7/1721	Rowe, Lt David K	22	F-5C 42-67338	Tgts in France	
	7/1722	Anderson, Lt J L	13	F-5B 42-68207	Tgts in France	
	7/1723	Brewster, Lt Edgar L	27	F-5C 42-67242	Tgts in France	
	7/1724	Alley, Lt Max P	27	F-5B 42-67366	Tgts in France	
	7/1725	Mitchell, Lt R L	22	F-5C 42-67111	Conches A/F	
	7/1726	Windsor, Lt Robert D	22	F-5C 42-67122	Tgts in France	
	7/1727	MacDonald, Lt W M	27	F-5B 42-67379	Tgts in France	
	7/1728	Floyd, Lt Robert C	27	F-5B 42-68196	Tgts in France	
6	7/1729				Caen,-/Carpiquet A/F(FW), Ouistreham, Beachhead area	
Dday	7/1730	Shoop, Lt Col Clarence A	7	F-5B 42-67382	Bayeux(FW), Caen,-/Carpiquet A/F, Beachhead betw Montebourg & Trouville	
	7/1731	Miller, Lt Glenn E	22	F-5C 42-67108	Nevers/La Charite area, RR Nevers-Orleans	
	7/1732	Hawes, Lt Clark	22	F-5C 42-67131	Vichy area	
	7/1733	Hartwell, Maj Norris	7	F-5	Caen, coast betw Caen & Cherbourg Pen, Coutances area	
	7/1734	Hoover, Capt John R	8W	F-5B 42-68207	Ste Mere Eglise, Picauville, Carentan, Coast to Ouistreham, Coutances, St Lo, Caen, Pte de la Perce, Crepon, beaches	
	7/1735	Parsons, Lt Edward B	22	F-5C 42-67114	M/Ys	
	7/1736	Weitner, Maj Walter L	22	F-5C 42-67566	Le Mans-Chartres	
	7/1737	Grayson, Lt Benton C	22	F-5C 42-67116		u/s cloud
	7/1738	Cassaday, Capt Charles G	27	F-5B 42-67366	Beaches Le Havre area to Cherbourg	
	7/1739				St Malo coastal area	
	7/1740	Mitchell, Lt B L	27	F-5C 42-67119	Granville coastal area, area betw Rouen & Chartres	
	7/1741					u/s
	7/1742	Smith, Maj Robert R	13	F-5B 42-67395	Coastal strips Caen to Cherbourg Pen	
	7/1743	Cameron, Lt J T	27	F-5C 42-67550	Carentan-Cabourg	
	7/1744	Campbell, Lt J L	27	F-5C 42-67107	Caen area D/A, St Lo, Vire	
	7/1745	Brewster, Lt Edgar L	27	F-5C 42-67242	Caen D/A,-Trouville-Lisieux D/A & coastal strips	
	7/1746	Childress, Capt Hubert M	27	F-5C 42-67124	Beachhead Courselles-sur-Mer area, Caen,-/Carpiquet A/F, Bayeux, Mezidon M/Y, St Lo, Airel, Les Dunes de Varreville	
	7/1747					Canc
	7/1748					Canc
	7/1749	Witt, Capt Harry A	13	F-5B 42-68235		Canc
	7/1750	Haugen, Maj Cecil T	14	Spit XI PL767	Caen, coast betw Cabourg & Montebourg, Le Havre	
	7/1751	Adams, Lt Gerald M	14	Spit XI MB955	Cherbourg, Caen area D/A, Le Havre, Fecamp	
	7/1752	Blyth, Lt John S	14	Spit XI MB948		Recalled
	7/1753	Didericksen, Lt Robert	14	Spit XI PL790		u/s
	7/1754	Wicker, Lt James	22	F-5C 42-67426	(Chateaudun)	MIA-POW

341

Eyes of the Eighth

DATE	SORTIE	PILOT	SQ	A/C	TARGETS	INCIDENTS
6	7/1755	Cosby, Lt Irl	22	F-5C 42-67254	Orleans-Chateaudun	
	7/1756	Kann, Lt Alexander Jr	22	F-5C 42-67122	Orleans-Lemans area	
	7/1757	Windsor, Lt Robert	22	F-5C 42-67114	Rouen	
	7/1758	Batson, Lt Charles R	13	F-5B 42-67382	Eindhoven M/Y, area E of Woensdrecht A/F	
	7/1759	Tymowicz, Lt Adam P	13	F-5B 42-68207		u/s cloud
	7/1760	Bliss, Capt Kermit E	7	F-5E 43-28311	Flers, Vire, Pontaulbault Brs; Isigny-sur-Mer, Pte de Perce, RR Thury-Harcourt	
	7/1761	McBee, Capt Lawrence	27	F-5B 42-67379	Argentan, Falaise, Lisieux, Pon L'Eveque D/As, Caen,-/Carpiquet Mezidon, Villy	
	7/1762	Goffin, Lt Charles J J	14	Spit XI PA892		u/s cloud
	7/1763	Simon, Capt Walter J	14	Spit XI MB948	Melun, Bretig...	
	7/1764	Davidson, Lt Verner	14	Spit XI PL790	Villeneuve ... ersailles, Orly A/F, Maissy, Palaiseau	
7	7/1765	Brink, Lt Fred B	13	F-5B 42-67382	Coast nr Veere	
	7/1766	Tymowicz, Lt Adam P	13	F-5B 42-67319	Esschen-Herenthals-Alphen	
	7/1767	Moss, Lt Robert E	13	F-5B 42-68265	RR Antwerp-Lierre	
	7/1768	Batson, Lt Charles R	13	F-5B 42-67395	Antwerp-Lierre-Flushing	
	7/1769	Hawes, Lt Clark	22	F-5C 42-67131	Falaise, Conde-sur-Moireau, Flers, Vire, Caen; Fires at many towns	
	7/1770	Aubrey, Capt Lawrence	22	F-5C 42-67116	Conde-sur-Moireau, Falaise, Flers, Caen, Bayeux, Foligny	
	7/1771	Floyd, Lt Robert C	27	F-5C 42-67123	Argentan, Lisieux, Alencon, L'Aigle Br	
	7/1772	Alley, Lt Max P	27	F-5C 42-67124		Intc Ld Manston
	7/1773	Shoop, Lt Col Clarence	7	F-5C 42-67332	RR Trouville-Lisieux, Mezidon, Caen; LG N of Bayeux, Beachhead	
	7/1774	Hartwell, Maj Norris	22	F-5B 42-68213	Beachhead, Caen, Lisieux, St Lo, Bayeux, Pont l'Eveque, Ecausseville	
	7/1775	Chapman, Maj Carl	7	F-5B 42-68205	Caen, Coast Port-en-Bessin to Cabourg, M/Y Mezidon, Lisieux, Pont l'Eveque, St Lo, Trouville	
	7/1776	Blyth, Lt John S	14	Spit XI MB948	A/Fs Bourges, Orleans/Bricy	
	7/1777	Graves, Lt Willard	14	Spit XI MB950	Paris area, Acheres D/As	
	7/1778	Sheble, Capt Richard	14	Spit XI PA842	A/Fs Versailles/Matelots, Buc, Toussus; Acheres Junction, Paris area D/As	
8	7/1779	Haugen, Maj Cecil T	14	Spit XI PL 767	A/Fs Avord, Romorantin, Bourges; Orleans M/Y D/A	
	7/1780	Nelson, Capt Robert R	14	F-5A 42-12981	Esschen, Hasselt	MIA-KIA
	7/1781	Cassaday, Capt Charles	27			MIA-KIA
	7/1782	Grayson, Lt Benton C	22	F-5C 42-67108	A/Fs Le Mans/Arnage, Houssay; Balbac	
	7/1783	Farley, Lt Donald A	22	F-5C 42-67254	Le Havre, Brs Tours & Cinque Mars, Le Mans/Arnage A/F D/A, L'Aigle, Alencon	
	7/1784	Sommerkamp, Lt Frank M	13		A/Fs Rennes/St Jacques, Laval, Le Mans/Arnage; Angers, Nantes, Pontaulbault; Failliers & Cinque Mars Brs	
	7/1785	Vassar, F/O Edgar L	13	F-5B 42-67319		
	7/1786	McDonald, Lt W M	27	F-5C 42-67123		u/s
	7/1787	Campbell, Capt J L	27	F-5C 42-67107		
	7/1788	Clark, Lt Albert W	27	F-5E 43-28333		
	7/1789	Bruns, Lt Waldo,	13	F-5E 43-28331		
	7/1790	Diderickson, Lt Robert	14	F-5B 42-67399		
	7/1791	Crane, Lt Charles	13	F-5B 42-67332		
	7/1792	Dixon, Capt Robert J	14	Spit XI PL782		
	7/1793	Weitner, Maj Walter L	22	F-5C 42-67566		Canc
	7/1794	Miller, Lt Glen E	22	F-5C 42-67111		Canc
	7/1795	Brewster, Lt Edgar L	27	F-5C 42-67124	Rennes A/F, Nantes D/As	
	7/1796	Richards, Lt John R	14	Spit XI PA842	Palaiseau, Bretigny, Villeneuve, Avord, Bourges A/F D/As	
	7/1797	Weitner, Maj Walter L	22	F-5C 42-67566	Orleans M/Y, Tours Le Mans A/F, Orleans/Bricy A/F	
	7/1798	Miller, Lt Glen E	22	F-5C 42-67111	Le Mans A/F, Brs at Orleans, Montlouis, Tours, Cinque Mars, Flyover at Tours	
	7/1799	Tymowicz, Lt Adam P	13	F-5B 42-68196	A/Fs Kerlin/Bastard, Vannes, Rennes, St Malo/St Jouan	
	7/1800	Mitchell, Lt R L	22	F-5C 42-67115	Coutances, Pontaulbault, Vire, Fleurs D/As	
	7/1801	Cosby, Lt Irl R	22	F-5C 42-67119	Coutances, Pontaulbault, Vire, Falaise, Tinchebray	
9	7/1802	Anderson, Lt J L	13	F-5B 42-68235		u/s Weather
	7/1803	Bruns, Lt Waldo C	13	F-5C 42-67324		u/s Weather
	7/1804	Childress, Capt Hubert M	27	F-5B 42-68207		u/s Weather
	7/1805	Alley. Lt Max P	27	F-5B 42-67332		u/s Weather
	7/1806	Chapman, Maj Carl J	7	F-5B 42-68205		u/s Weather
10	7/1807	Matthews, Lt J B	22	F-5C 42-67108	Dinard/Pleurtuit D/A, Granville	
	7/1808	Hughes, Capt Malcolm D	22	F-5C 42-67114	Dinard/Pleurtuit D/A, Granville	
	7/1809	Bruns, Lt Waldo C	13	F-5B 42-68207	RR Yds S of Antwerp, Malines, N of Ghent to coast off Walshero	
	7/1810	Nesselrode, Capt George H	14	F-5B 42-67332	RR Yds S of Antwerp, Malines, Convoy on autobahn S of Hulst	
	7/1811	Campbell, Capt J L	27	F-5B 42-68196	Capellen	
	7/1812	Anderson, Lt J L	13		Capellen, Breskens	
	7/1813	Cleveland, Col W H	8W	Mosquito NS 568	Le Crotoy, Pont Authou, Falaise area, Road St Lo-Lessay-Barneville	Night photo, 25BG A/C
	1813	Hoover, Maj John R	8W			
	7/1814	Witt, Capt Harry	13	F-5E-43-28331		u/s cloud

Sortie List 1944

DATE	SORTIE	PILOT	SQ	A/C	TARGETS	INCIDENTS
10	7/1815	Parsons, Lt Edward B	22	F-5C-42-67115		u/s cloud
	7/1816	Cameron, Lt J T	27	F-5C-42-67550		u/s cloud
	7/1817	Wiebe, Lt Glen E	22	F-5E-42-68333		u/s cloud
	7/1818	Bliss, Capt Kermit E	7	F-5E-43-28311		u/s cloud
11	7/1819	Bliss, Capt Kermit E	7	F-5E 43-28311		u/s Weather
	7/1820					u/s Weather
	7/1821	Parsons, Lt Edward B	22	F-5C 42-67111		u/s Weather
	7/1822					u/s Weather
	7/1823	Davidson, Lt Verner K	14	Spit XI PA944	Merlimont Plage, Berck-sur-Mer, Le Touquet, Paris, A/Fs Poix/Nord, Beauvais/Nevilliers	
	7/1824	Adams, Lt Gerald	14	Spit XI MB955	Beauvais/Nevilliers A/F, Poix, Le Touquet, Abbeville, Paris, Merlimont Plage	
	7/1825	Nesselrode, Capt George	14	F-5B 42-67399	Venables & Elbeuf Tunnels D/A	
	7/1826	Smith, Maj Robert R	13	F-5B 42-68207	Venables & Elbeuf Tunnels D/A	
	7/1827	Brewster, Lt Edgar L	27	F-5B 42-68213		u/s cloud
	7/1828	Floyd, Lt Robert C	27	F-5B 42-67379		u/s cloud
	7/1829	Shoop, Lt Col Clarence A	7	F-5E 43-28311	Troyes, Montpellier	Landed overseas
12	7/1830	Tymowicz, Lt Adam P	27	F-5B 42 68196	A/Fs Evereux/Fauville, Conches, Bernay/St Martin, Beaumont-le-Roger D/A; St Andre, Pont Audemer area, Nerey, Rolleboise	
	7/1831	McDonald, Lt W M	27	F-5C 42-67123	Hoboken, Roosendaal M/Y D/A, Antwerp	
	7/1832	Simon, Capt Walter J	14	Spit XI MB956	A/Fs Cormielles-en-Vexin, Beaumont-sur-Oise, Creil, Beauvais/Tille,-/Villiers D/As	
	7/1833	Graves, Lt Willard E	14	Spit XI MB946	Pontaulbault RB(FW), Flers A/F, Thury/Harcourt D/A, strip Bayeux-Carentan	
	7/1834	Kann, Lt Alexander Jr	22	F-5C 42-67122	Porcarro, Rennes, St Malo D/A; A/Fs Gael, Redon, Rennes/St Jacques; Viconte-sur-Rance RBs	
	7/1835	Windsor, Lt R D	22	F-5C 42-67111	Lorient, A/Fs Vannes,-/Meucon, Kerlin/Bastard(FW) D/A; St Brieuc M/Y	
	7/1836	Cameron, Lt J T	27	F-5C 42-67242	Caen & area to NW, Bayeux-St Lo-Carentan	
	7/1837	Witt, Capt Harry A	13	F-5E 43-28331	Beachhead area Cambrewer-Carentan	
	7/1838	Parsons, Lt Edward B	22	F-5C 42-67254	Beachhead area Troarn-St Lo	
	7/1839	Bliss, Capt Kermit E	7	F-5C 42-67107	Caen/Bayeux, Isigny, Carentan, Beachhead area	
	7/1840	Alley, Lt Max P	27	F-5C 42-67107	Dieppe, A/Fs Chartres, Dreux, St Andre de Favril, -/de L'Eure, Chateaudun, Illiers/L'Eveque D/A	
	7/1841	Blyth, Lt John S	14	Spit XI PA841	La Huichetiere, Nantes A/F, Le Port Boulet Br D/A, Loire Br from Nantes to Tours	
	7/1842	Wiebe, Lt Glen E	22	F-5B 42-67324	A/Fs Evereux/Fauville, St Andre de L'Eure,-/Le Favril, Conches, Illiers/L'Eveque, Dreux & M/Y	
	7/1843	Kendall, Lt Ralph D	13	F-5E 43-28324	Boulogne, A/Fs Vitry-en-Artois, Lille/Nord, /Vendreville, Cambrai/Epinoy, -/Niergnies	
	7/1844	Grayson, Lt Benton C	22	F-5C 42-67119	Porcarc Br(FW), A/Fs Merignac, Rennes/St Jacques; Montfort, Pontaubault, Ploermel, Coutances area	
	7/1845	Dixon, Capt Robert J	14	Spit XI PL782	A/Fs Lille/Nord, /Vendreville, Cambrai/Epinoy, -/Niergnies, Amiens/Glisy, Rossieres-en-Santerre	
	7/1846	Brink, Lt Fred B	13	F-5E 42-28333	A/Fs Amiens/Glisy, Roye/Amy, Rossieres-en-Santerre, Abbeville, Montdidier,	
	7/1847	Brewster, Lt Ed L	27	F-5B 42-68213	Falaise, Caen/Carpiquet A/F, St Lo, Flers, Dinard/Pleurtuit A/F, Bayeux, Alencon M/Y D/A, Granville, Argentan	
	7/1848	Hartwell, Maj Norris E	22	F-5B 42-68205	Laval, M/Ys Rennes, Montford, St Malo; A/Fs Dinard/Pleurtuit, Rennes/St Jacques, Gael, Nantes/Chateau Bougon	
	7/1849	Haugen, Maj Cecil T	14	F-5B 42-67399	Nantes, Angers Br; W of Rennes, Dinard/Pleurtuit A/F D/A, Caen, Abbaritz, Thury-Harcourt	
	7/1850	Mitchell, Lt R L	22	F-5C 42-67131	A/Fs Beaumont-le-Roger,-/Oise, Beauvais/Tille, /Nivilliers, Vitry-en-Artois; , Villeneuve M/Y, E Paris area	
	7/1851	Weitner, Maj Walter	22	F-5C 42-67566	A/Fs Beaumont, Vitry-en-Artois, Villeneuve M/Y, M/Y NE Paris	
	7/1852	Moss, Lt Robert E		F-5B 42-668207	A/Fs Orleans/Bricy, Beaumont-le-Roger, Chateaudun, Blois St Denis, Bernay/St Martin	
	7/1853	Sheble, Capt Richard N	14	Spit XI PA842		u/s
	7/1854	Schultz, Lt Donald A	27	F-5E 43-28331	A/Fs Le Bourget, Beaumont-le-Roger, Bernay/St Martin; M/Ys Villeneuve/St George, Paris	
	7/1855	Childress, Capt Hubert M	27	F-5C 42-67124	A/Fs Gilze/Rijen, Guttersloh, Lippstadt, Stormede, Werl, Endhoven; M/Ys Geseke, Schwerte, Ahlen, Hoboken	
	7/1856	Mitchell, Maj R C	27	F-5B 42-68213		u/s
	7/1857	Campbell, Lt J L	27	F-5B 42-68196	Vire, St Lo, Carentan, Valognes	
	7/1858	Batson, Lt Charles	13	F-5B 42-67332	A/Fs Beauvais, -/Tille	
13	7/1859	Aubrey, Capt Lawrence	22	F-5C 42-67116		u/s Intc
	7/1860	Diderickson, Lt Robert	14	Spit XI PL790		u/s
	7/1861	Adams, Lt Gerald	14	F-5B 42-68202	Russelheim	
	7/1862	Davidson, Lt Verner	14	Spit XI PA944	Zeitz, Brux	
	7/1863	Floyd, Lt Robert C	27	F-5B 42-68196	Tutow, Politz, Stettin area, Kummerower See	
	7/1864	Sommerkamp, Lt Frank M	13	F-5B 42-68207		u/s
	7/1865	Didericksen, Lt Robert	14	Spit XI PL767	Schwerte M/Y(FW), Ruhland area, Leipzig	
	7/1866	Bruns, Lt Waldo	13	F-5B 42-67324	Kassel, Brussels area	
	7/1867	Crane, Lt Charles M Jr	13	F-5B 42-67322	Munster-Rotterdam area, Oranienburg-Zuiderzee	

343

Eyes of the Eighth

DATE	SORTIE	PILOT	SQ	A/C	TARGETS	INCIDENTS
13	7/1868	Tymowicz, Lt Adam P	13	F-5B 42-67379		MIA-EE
	7/1869	Sommerkamp, Lt Frank M	13	F-5B 42-67319	Cormeilles-en-Vexin D/A,	
	7/1870	Vassar, F/O Edgar L	13	F-5B 42-67332	Cormeilles-en-Vexin D/A, Evreux/Fauville D/A	
	7/1871	Hawes, Lt Clark	22	F-5C 42-67131	Viconte-sur-Rance, Vannes, St Nazaire	
	7/1872	Miller, Lt Glen E	22	F-5C 42-67114	Blain, Rennes, St Malo, Jersey, Aldernay	
	7/1873	Hoover, Maj John	8W	B-25C 42-53357	Night photo Carentan area	
	1873	Chapman, Maj Carl C	7			
	7/1874	Shoop, Lt Col Clarence	7	F-5E 43-28311	Alghero, Arles, St Etienne, Lyons, Le Creusot, Paris, Pontoise area	Italy shuttle flight
14	7/1875	Kendall, Lt Ralph D	13	F-5B 42-68207		u/s
	7/1876	Brewster, Lt Edgar L	27	F-5B 42-68213	A/Fs Zwevezeele, Maldeghem, Yres/Lamertinghe	
	7/1877	Cosby, Lt Irl	22	F-5C 42-67119	A/Fs Courtrai/Wevelghem, St Denis/Westrem, Coxyde/Furnes; Terneuzen; RR Junc Ghent area, Rouen area, strip to Dunkirk	
	7/1878	Farley, Lt Donald A	22	F-5C 42-67254	RR Junc Ghent area	
	7/1879	Moss, Lt Robert E	13	F-5B 42-67324	Ghent M/Y, Terneuzen, Dunkirk area	
	7/1880	Richards, Lt John R	14	Spit XI MB946	Lille, coast N of Dunkirk	
	7/1881	Sheble, Capt Richard	14	Spit XI MB952		u/s
	7/1882	Kendall, Lt Ralph D	13		Ostend & Scheldt areas	
	7/1883	Witt, Capt Harry A	13	F-5E 43-28333	Brs Bruges to Terneuzen	
	7/1884	Alley, Lt Max P	27	F-5C 42-67242	A/Fs Tours, Dreux, Laon/Couvron, Peronne, Achiet, Castres, Le Mans/Arnage; Saumur	
	7/1885	Wiebe, Lt Glen	22	F-5B 42-67389	Cormeilles-en-Vexin A/F	
	7/1886	Cameron, Lt J T	27	F-5C 42-67550	Scheldt area	
	7/1887	Matthews, Lt J B	22	F-5C 42-67116	A/Fs Laon/Athies,-/Couvron, Lille/Vendreville; Tergnier M/Y & RR	
	7/1888	Hughes, Capt Malcolm D	22	F-5C 42-67566	A/Fs Brussels/Melsbroek, St Trond, Lille/Vendreville, Namur	
	7/1889	Kann, Lt Alexander Jr	22	F-5C 42-67122	St Peter Port, Viaduct at Morlaix, W of Rennes, Montfort	
	7/1890	Smith, Maj Robert R	13	F-5E 43-28324	A/Fs Orly, Guyancourt, Caudron; M/Y SW of Paris	
	7/1891	?Nesselrode, Capt George H	14	F-5B 42-67399	A/Fs & M/Ys around Paris	u/s
	7/1892	Simon, Capt Walter	14	F-5B 42-68202		
	7/1893	White, Lt W G	27	F-5C 42-67107	Cap Gris Nez, Dieppe, Berck-sur Mer, Le Treport, Le Crotoy, Le Touquet, Boulogne	
	7/1894	Wigton, Lt Irv	27	F-5B 42-68213	A/Fs Cherbourg/Maupertus, Cherbourg	
	7/1895	Haugen, Maj Cecil T	14	Spit XI MB952	Cambrai/Epinoy A/F, Merville, Blois, St Denis, Doullens D/A	
	7/1896	Gilmore, Lt Louis M	13	F-5E 43-28333	Blois, St Denis D/A	
	7/1897	Elston, Lt Allan V	13	F-5E 43-28331	Blois, St Denis D/A	
	7/1898	Schumacher, Lt Wesley A	27	F-5C 42-67550	Le Crotoy, Le Touquet, Calais	
	7/1899	Simon, Capt Walter	14	Spit XI MB956	Bretigny A/F(FW), Paris, coast E of Dieppe	
	7/1900	Quiggins, Lt R S	22	F-5C 42-67115	Le Touquet, Boulogne	
	7/1901	McKinnon, Lt M E	22	F-5C 42-67111	Calais to Boulogne	
	7/1902	Cleveland, Lt Col W H	8W	F-5C 42-67254	La Possoniere Viaduct, Segre, strip Hilaire to Cherbourg	
	7/1903	Schultz, Lt Donald A	27	F-5E 43-28331	Ghent M/Y, Le Culot A/F	
	7/1904	Windsor Lt	22	F-5B 42-67111	Creil A/F, Beauvais, Aumole	
	7/1905	Sheble, Capt Richard	14	Spit XI MB955	A/Fs Chateaudun, Orleans/Bricy; Dieppe	
	7/1906	McDonald, Lt W M	27	F-5C 42-67550	Emmerich, Eindhoven, Roosendaal	
	7/1907	Childress, Capt Hubert M	27	F-5C 42-67242	A/Fs Evreux/Fauville, Illiers/L'Eveque	
	7/1908	Clark, Lt Albert	13	F-5B 42-67332	Br Ham-sur-Somme	
15	7/1909	Dixon, Capt Robert J	14	Spit XI PL782	Factory in Leipzig vicinity	Ref Bradwell Bay
	7/1910	Graves, Lt Willard	14	Spit XI MB950	A/F E of Leipzig, coast nr Boulogne	
	7/1911	Blyth, Lt John S	14	Spit XI MB948	Hanover area N of Nienburg	
	7/1912	Anderson, Lt J L	27	F-5B 42-68235	Area W of Berlin	
	7/1913	Smith, Maj Robert R	13	F-5E 43-28333	Leipzig area, strips Rhine to Scheldt	
	7/1914	Batson, Lt Charles R	13	F-5B 42-67315	Delmenhorst, Oranienburg, Neuruppin & A/F, The Hague, Bremen/Neulanderfeld A/F	
	7/1915	Brink, Lt Fred B	13	F-5B 42-67332		u/s
	7/1916	?Kendall, Lt Ralph D	13			Landed Russia
	7/1917	?Hoover, Maj John R	8W			Landed Russia
	7/1918	Campbell, Capt J L	27	F-5C 42-67107	Nantes/Chateau Bougon A/F, Nantes Brs, La Possoniere Viaduct	
	7/1919	Alley, Lt Max P	27	F-5C 42-67242	A/Fs Orleans/Bricy,-/Liconcy, or -/St Sigismond, La Frillier; Brs Tours/La Riche, Cinq Mars, Le Port Boulet, Blis/St Denis	
	7/1920	Goffin, Lt Charles J J	14	Spit XI PA892	A/Fs Guyancourt/Caudron, Buc, St Cyr, Villacoublay, Toussus le Noble; Boissy/Mauvdisin Tunnel	
	7/1921	Cameron, Lt J T	27	F-5B 42-68213	A/Fs Creil, Le Bourget, Beaumont-sur-Oise, Poitiers area, Le Crotoy	
	7/1922	Floyd, Lt Robert C	27	F-5B 42-67399	Doullens, Etapes, Corbie Brs; Frevent Junction, Le Crotoy; A/Fs Abbeville/Drucat, Amiens/Glisy;	
	7/1923	Parsons, Lt Edward B	22	F-5C 42-67115		
	7/1924	Weitner, Maj Walter L	22	F-5C 42-67566	Terneuzen, Ghent, Courtrai, Bruges, Ostend & area	
	7/1925	Farley, Lt Donald A	22	F-5C 42-67108		
	7/1926	Stamey, Lt E K	27	F-5C 42-67550	Calais, Dunkirk, Ostend, Zeebrugge, Gravelines	
	7/1927	Crane, Lt Charles M Jr	27	F-5E 43-28331	RR Bruges-Maldeghem-Eecloo-Sas van Gent-Terneuzen-Ostend	

Sortie List
1944

DATE	SORTIE	PILOT	SQ	A/C	TARGETS	INCIDENTS
15	7/1928	Diderickson, Lt Robert	14	Spit XI PL790		KIA
	7/1929	Brewster, Lt Edgar L	27	F-5B 42-68231		
	7/1930	McDonald, Lt W M	27	F-5C 42-67550		
	7/1931	Bruns, Lt Waldo	13	F-5B 42-67332		
	7/1932	Brink, Lt Fred B	13	F-5E 43-28324		
	7/1933	Grayson, Lt Benton C	22	F-5C 42-67122		
	7/1934	Simon, Capt Walter	14	Spit XI PA944		
17	7/1935	Adams, Lt Gerald M	14	Spit XI MB955	St Leger/Sud-Aubigny-La Felze area	
	7/1936	Purdy, Lt Ira J	27	F-5C 42-67242	Cherbourg,-/Maupertus A/F, -/Querqueville A/F	
	7/1937	Florine, Lt Robert N	27	F-5B 42-67399	St Peter Port, Guernsey/Le Bourg A/F	
	7/1938	Graves, Lt Willard E	14	Spit XI MB950	Morlaix area	
	7/1939	Blyth, Lt John S	14	Spit XI MB948		u/s cloud
	7/1940	Davidson, Lt Verner K	14	Spit XI PA944	Creil A/F D/A, Neufchatel to Dieppe	
	7/1941	Richards, Lt John R	14	Spit XI MB946	A/Fs Le Mans, Laval D/A, Dieppe	
	7/1942	Batson, Lt Charles R	13	F-5E 43-28331		u/s cloud
	7/1943	Gilmore, Lt Louis M	13	F-5B 42-67332	Eindhoven	u/s cloud
	7/1944	Matthews, Lt J B	22	F-5C 42-67108		u/s cloud
	7/1945	Quiggins, Lt R S	22	F-5C 42-67122	Nr Soesterburg	
	7/1946	Bliss, Capt Kermit	7			u/s
	7/1947					Canc
	7/1948	Sommerkamp, Lt Frank M	13	F-5E 42-28324		u/s Weather
	7/1949	Vassar, F/O Edgar L	13	F-5B 42-67389	Coast nr Brignaugan to Lesneven	
	7/1950	Cosby, Lt Irl	22	F-5C 42-67119		u/s
	7/1951	Mitchell, Lt R L	22	F-5C 42-67115	Pontusval Point-Loctuoy	
	7/1952	Miller, Lt Glen E	22	F-5C 42-67114		u/s Intc
	7/1953	Campbell, Lt J L	27	F-5C 42-67107	Strip Plouesent-Quimper	
	7/1954	Cameron, Lt J T	27	F-5C 42-67550		u/s
	7/1955	Floyd, Lt Robert C	27	F-5C 42-67124		u/s Intc
	7/1956	White, Lt W E	27	F-5B 42-68213		u/s
	7/1957	Hartwell, Lt Col Norris E	7	F-5B 42-68265		
18	7/1958	Bruns, Lt Waldo	13	F-5B 42-67395	Brest Pen	
	7/1959	Crane, Lt Charles M Jr	13	F-5B 42-68235	Odet River nr Benodet(FW), Brest Pen	
	7/1960	Clark, Lt Albert W	27	F-5E 43-28324	Brest,-/Pen	
	7/1961	Chapman, Maj Carl	7	F-5E 43-28331	Brest Pen	
	7/1962	McDonald, Lt W M	27	F-5C 42-67107	Brest (FW), -/Pen	
	7/1963	Alley, Lt Max P	27	F-5C 42-67124	Brest Pen	
	7/1964	Brewster, Lt Edgar L	27	F-5B 42-68213	Brest Pen	
	7/1965	Kann, Lt Alexander, Jr	22	F-5C 42-67122	Brest Pen	
	7/1966	Parsons, Lt Edward B	22	F-5C 42-67115	Brest Pen	
	7/1967	Weitner, Maj Walter	22	F-5C 42-67566	Brest Harbor,-/Pen	
	7/1968	Windsor, Lt Robert W	22	F-5C 42-67131	Brest Pen; Laval, Angers, Rennes A/Fs, St Malo, Lessay, Barneville	
	7/1969	Floyd, Lt Robert C	27	F-5C 42-67242	Strip Cherbourg Pen	
	7/1970	Elston, Lt Allan V	13	F-5B 42-68265	Brest area	
	7/1971	Haugen, Maj Cecil T	14	Spit XI PL767		u/s cloud
19	7/1972					Canc
	7/1973	Aubrey, Capt Lawrence	22	F-5C 42-67116		Canc
	7/1974	Nesselrode, Capt George H	14	Spit XI MB950	Hamburg D/A, Leuwarden A/F, Nr Freeburg, Brunsbuttelkoog	
	7/1975	Sheble, Capt Richard N	14	Spit XI PA841		u/s Intc
	7/1976	Dixon, Capt Robert J	14	Spit XI PL982	Schwerin area, Hagenow A/F, Bremen D/A, Neuenland A/F	
	7/1977				Venegond A/F	
	7/1978	Childress, Capt Hubert M	27	F-5C 42-67124	Misburg D/A, Magdeburg, A/Fs Soesterburg, Twente/Enschede, Leuwarden	
	7/1979	Goffin, Lt Charles J J	14	Spit XI PA892	Brunsbuttel, Bremerhaven; D/As, A/Fs Leuwarden, Nordholz; Wilhelmshaven	
20	7/1980	Brink, Lt Fred B	22	F-5E 43-28314	Lutzkendorf, Merseburg, Bohlen, Halle	
	7/1981	Hartwell, Lt Col Norris E	7	F-5B 42-68265	Cottbus, Sorau D/As; Misburg, Osnabruck, Hamm, Rotterdam, Paderborn A/F	
	7/1982	Aubrey, Capt Lawrence	22	F-5C 42-67116	Ostermore, Hamburg D/As, Harburg (FW)	
	7/1983	McKinnon, Lt M E		F-5C 42-67122	A/Fs Bergen/Alkmaar, Twente/Enschede, Soesterburg, Deelen; The Hague; nr Oudewater	
	7/1984	Grayson, Lt Benton C	22	F-5C 42-67111		u/s
	7/1985	Gilmore, Lt Louis M	13	F-5B 42-68235	A/Fs Twente/Enschede, DeKooy, Alkmaar, Soesterburg; Teuge, Ijmuiden	
	7/1986	Simon, Capt Walter J	14	Spit XI MB956	D/As Misburg, Fallersleben, Konigsborn; Magdeburg, Brunswick M/Y	
	7/1987	Campbell, Capt J L	27	F-5B 42-67342	Politz D/A, Bremen-Politz area	
	7/1988	Hughes, Capt Malcolm D	22	F-5C 42-67114	Malines, Ghent, Courtrai RR, Ghent area	
	7/1989	Smith, Maj Robert R	13	F-5E 43-28333	St Denis Westrem A/F, Malines, Ghent, Courtrai RR, Ghent area	

345

Eyes of the Eighth

DATE	SORTIE	PILOT	SQ	A/C	TARGETS	INCIDENTS
20	7/1990	Wigton, Lt Irv	13	F-5B 42-67331	Woensdrecht A/F (FW)	
	7/1991	Elston, Lt Allan V	13	F-5B 42-67389	A/Fs Vokel, Gilze/Rijen; Breda, Hertogenbosch, Tillburg, Goes, Rotterdam, Nijmegan, Flushing, Voorne	
	7/1992	Graves, Lt Willard E	14	Spit XI MB950	Hanover area	
	7/1993	Adams, Lt Gerald M	14	Spit XI MB955	Dummersee area	
	7/1994	Grayson, Lt Benton C	22	F-5C 42-67254	D/As Emmerich, Eindhoven A/F (FW)	
	7/1995	Floyd, Lt Robert C	27	F-5C 42-67242	D/As Ham-sur-Somme, Peronne; Le Bourget, Monchy/Breton, Aubigny LG, St Quentin A/Fs	
	7/1996	Stamey, Lt Earl K	27	F-5B 42-68213	D/As Holque, Chievres A/F	
	7/1997	Schumacher, Lt Wesley A	27	F-5C 42-67550	Florennes A/F D/A	
	7/1998	Quiggins, Lt Richard S	22	F-5C 42-67115	Laon/Athies, St Quentin A/Fs; Le Treport	
	7/1999	Davidson, Lt Verner K	14	Spit XI PA944	Dieppe, strip Neufchatel to French coast	
	7/2000	Richards, Lt John R	14	Spit XI MB946	A/Fs Guyancourt, Bretigny, Evere/Fauville, Chateaudun, Illiers/Leveque	
	7/2001	Blyth, Lt John S	14	Spit XI MB948	A/Fs Beaumont-sur-Oise, Le Bourget, Coulommiers, Morigny Le Chatel LG, Melun/Villaroche	
	7/2002				A/Fs Dijon/Lonvic, Romilly, Amiens/Glisy, Rheims/Champagne	
	7/2003	Haugen, Maj Cecil T	14	Spit XI PL767	Lonrai LG, S-Essay LG, LeHavre	
	7/2004	Schultz, Lt Donald A	13		Heuzelais (D/A), Rennes	
	7/2005	Wiebe, Lt Glen E	13	F-5B 42-67332	A/F: Tours/Meslay Parcay A/F, Coudron/Chavannes, Avord	
	7/2006	Sommerkamp, Lt Frank M	13		La Selve LG, Beaulieu LG, Reims	
	7/2007	Chapman, Maj Carl J	7			u/s
	7/2008	Shoop, Lt Col Clarence A	7			u/s
	7/2009	Purdy, Lt Ira J	27	F-5E 43-28311	Chievres A/F, Florennes A/F, Beaulieu LG	
21	7/2010	Moss, Lt Robert E	13	F-5B 42-68265	A/Fs: La Rochelle/La Leu, Landes de Bussac, Bordeaux/Merignac, La Pallice	
	7/2011	Richards, Lt John R	14	Spit XI MB955	Dole/Tavaux A/F, Givet, Saarbrucken & area	
	7/2012	Mitchell, Maj Raymond C	13	F-5C 42-67242		u/s cloud
	7/2013	Cameron, Lt John T	27	F-5E 43-28311		u/s
	7/2014	Hawes, Capt Clark	22	F-5C 42-67254	Unid A/Fs N, NW & S of Chalons, NW of Reims	
	7/2015	Sheble, Capt Richard	14	Spit XI MB956	LeBourget A/F(FW)	
	7/2016	Goffin, Lt Charles J J	14	Spit XI PA841		u/s
	7/2017	Anderson, Lt John L	13	F-5B 42-67332	Lutskendorf, Merseburg, Bohlen, Kassel, Munden, Hamm, Rotterdam	Film destroyed
	7/2018	Batson, Lt Charles	13	F-5E 43-28333	Brusnbuttel, Ostermoor, Politz, Bremen, Rostock	
	7/2019	Farley, Capt Donald A	22	F-5C 42-67108	Misburg, Magdeburg, M/YS of Hanover	
	7/2020	Mitchell, Lt Raymond L	22	F-5C 42-67119	Unid A/F W of Hamburg	
	7/2021	Nesselrode, Capt George	14	Spit XI MB952	Helmstedt	
	7/2022	Dixon, Capt Robert J	14	Spit XI PL782	Brunswick, Deelen A/F, Strips S of Rotterdam	
	7/2023	Mc Donald, Lt Warren M	27	F-5C 42-67124		u/s
	7/2024	Brewster, Lt Edgar L	27	F-5B 42-68213		u/s cloud
	7/2025	Cosby, Lt Irl	22	F-5C 42-67111	Brussels, Cambrai, Achiet	
	7/2026	Cameron, Lt John T	27	F-5C 42-67550		u/s cloud
	7/2027	Matthews, Lt James B	22	F-5B 42-67399	A/Fs Melun/Villaroche, Bretigny, Guyancourt/Caudron	
	7/2028	Matthews, Lt James B	22	F-5B 42-67399		u/s
	7/2029	Alley, Lt Max P	27	F-5B 42-68196		u/s
	7/2030	Floyd, Lt Robert C	27	F-5C 42-67550	Montargis LG, NW tip Cherbourg Pen	
	7/2031	Vassar, F/O Edgar L	13	F-5B 42-68235	Dieppe area, Asmiens area, unid town W of Paris	
	7/2032	Simon, Capt Walter J	14	Spit XI PL767	Lgs: Le Plessis/Belleville, Clyde/Souilly, Chamant, Senlis; Chateau de Thibault, Vannes A/Fs	
	7/2033	Adams, Lt Gerald M	14	Spit XI PA 892		u/s
22	7/2034	Miller, Lt Glenn E	22	F-5C 42-67115	Landes de Bussac, Cazaux, St Malo, Bordeaux/Merignac, Rennes A/F, Gironde shipping, pos 2 destroyers in Channel	
	7/2035	Matthews, Lt James B	22	F-5B 42-68202	Pos Pilotless planes (V-1s)	
	7/2036	Alley, Lt Max P	27	F-5B 42-68196	V-1 & search	
	7/2037	Witt, Capt Harry A	13	F-5B 42-68235	RR Junction, Montauban D/A, Dinard/Pleurtuit, St Malo	
	7/2038	Childress, Capt Hubert M	27	F-5B 42-68213		u/s
	7/2039	Weitner, Maj Walter L	22	F-5B 42-67399		u/s
	7/2040	Campbell, Capt Jack L	27	F-5B 42-68196		u/s
	7/2041	Hughes, Capt Malcolm D	22	F-5B 42-67395		u/s
	7/2042	Adams, Lt Gerald M	14	Spit XI MB955	Guyancourt/Caudron, A/Fs: Buc, Toussus/Paris,-/Le Noble, Illiers; St Cyr Junction	
	7/2043	Parsons, Lt Edward B	22	F-5C 42-67254	St Denis/Westrem A/F, Ghent-Malines area	
	7/2044	Alley, Lt Max P	27	F-5C 42-67242	A/Fs: Achiet, Valenciennes, Lille/Vendreville, Amiens/Glisy, Cambrai	
	7/2045	Clark, Lt Albert W	27	F-5B 42-68235	Ghent-Courtrai area, Strip nr Cap Gris Nez	
	7/2046	Hawes, Capt Clark J	22	F-5C 42-67131	Brest area	
	7/2047	Cosby, Lt Irl	22	F-5C 42-67119	Brest Pen	
	7/2048	McKinnon, Lt Max E	22	F-5C 42-67116	Brest Pen	
	7/2049	Quiggins, Lt Richard S	22	F-5C 42-67111	Brest Pen	
	7/2050	Purdy, Lt Ira J	27	F-5E 43-28311	Odet River off Benodet, Brest Pen	

Sortie List 1944

DATE	SORTIE	PILOT	SQ	A/C	TARGETS	INCIDENTS
22	7/2051	Cameron, Lt John T	27	F-5C 42-67550	Brest Pen	
	7/2052	Florine, Lt Robert W	27	F-5B 42-67331	Brest Pen	
	7/2053	Elston, Lt Allan V	13	F-5B 42-68265	Brest Pen, Ile de Sein	
	7/2054	Gilmore, Lt Louis M	14	F-5E 43-28332		u/s airborne
	7/2055	Brink, Lt Fred B	13	F-5B 42-67389	Brest Pen, Ile de Sein	
	7/2056	Crane, Lt Charles M	13	F-5B 42-67332	Brest Pen	
	7/2057	Grayson, Lt Benton C	22	F-5C 42-67122	W coast Brest Pen, Le Conque to Lanilout	
	7/2058	Sheble, Capt Richard N	14	Spit XI MB952	Dieppe	
	7/2059	Graves, Lt Willard E	14	Spit XI MB950	Paris/Gennevilliers,-/St Oven, Dieppe,	
	7/2060	White, Lt William G	27	F-5B 42-68213	Guernsey	
	7/2061	Blyth, Lt John S	14	Spit XI MB948	Lille, Holque, Mazingarbe, Pont A Vendin, Abbeville, Rouen, Special targets	
	7/2062	Haugen, Maj Cecil T	14	Spit XI PL767	Rouen, Abbeville, Frevent, Tingry, Special targets	
23	7/2063	Bruns, Lt Waldo C	22	F-5B 42-67395	Mille Vaches area	
	7/2064	Smith, Maj Robert R	13	F-5B 42-68235	Mille Vaches area	
	7/2065	Campbell, Capt J L	27	F-5B 42-68342	Dijon	
	7/2066	Brewster, Lt Edgar L	27	F-5B 42-68196	E of Chateau Thierry	
	7/2067	Anderson, Lt John L	27	F-5B 42-67389		u/s
	7/2068	Cameron, Lt John T	27	F-5B 42-68196		u/s
	7/2069	Davidson, Lt Verner K	14	Spit XI PA944	Saumur D/A, Tours D/A,-/A/F	
	7/2070				Lyons to Gien	
	7/2071	Smith, Maj Robert R	13	F-5B 42-68235	Lyons to Gien	
24	7/2072	Alley, Lt Max P	27	F-5E 43-28311	Bremen, Oldenberg area, Obisfelde area, Verdel-Langwedel area	
	7/2073	Floyd, Lt Robert C	27	F-5C 42-67242		u/s cloud
	7/2074	Moss, Lt Robert E	13	F-5E 43-28331	Chateaudun, Orleans/Bricy A/Fs; Saumur, Tours La Riche Br D/As; St Malo	
	7/2075	Matthews, Lt James B	22	F-5C 42-67108	Bourges A/F(FW), Chavannes/Coudron LG	
	7/2076	Windsor, Lt Robert D	22	F-5C 42-67131		u/s weather
	7/2077	Richards, Lt John R	14	Spit XI MB946	Romilly-sur-Seine A/F(FW), Dieppe	
	7/2078	Goffin, Lt Charles J J	14	Spit XI MB841	2 Landing strips SE of Paris & W of Seine	
	7/2079	Anderson, Lt John L	27	F-5B 42-68202		u/s
	7/2080	Cameron, Lt John T	27	F-5C 42-68196		u/s
	7/2081	Weitner, Maj Walter L	22	F-5E 42-29018		u/s
	7/2082	Campbell, Capt J L	27	F-5C 42-68196		u/s
	7/2083	Hughes, Capt Malcolm	22	F-5C 42-67114		u/s
	7/2084	Hawes, Capt Clark J	22	F-5C 42-67131		u/s
	7/2085	Dixon, Capt Robert J	14	Spit XI MB782	Tournau-en-Brie M/Y, Sens M/Y, Strip Marigny to La Pavillon, Villeroche A/F	
	7/2086	Graves, Lt Willard	14	Spit XI MB950	Buc, Guyancourt/Caudron, Etampes/Mondesir, Toussus/Le Noble A/Fs; St Cyr	
	7/2087	Batson, Lt Charles R	13	F-5E 43-28331	Strip Montargis to Nevers	
	7/2088	Vassar, F/O Edgar L	13	F-5B 42-67399	Cherbourg, Alderney, Sark, Jersey, Guernsey	
	7/2089	Gilmore, Lt Louis M	13	F-5B 42-67389	Strip Belle Isles, St Brabdon area, Pontivy area, Minard	
	7/2090	Farley, Capt Donald A	22	F-5C 42-67111	Brest Pen	
	7/2091	Cosby, Lt Irl	22	F-5C 42-67566	Strip Brest Pen	
	7/2092					Canc
	7/2093					Canc
	7/2094					Canc
	7/2095					Canc
	7/2096	Schultz, Lt Donald A	13	F-5E 43-28324	Strip Brest Pen	
	7/2097	Sommerkamp, Lt Frank M	13	F-5C 42-68235	S of Brest	
	7/2098	Kann, Lt Alexander A Jr	22	F-5C 42-67122	Nr Juvincourt & Dunkirk	
	7/2099	Campbell, Capt J L	27	F-5E 43-28333	Brest area	
	7/2100	Hughes, Capt Malcolm D	22	F-5C 42-67114	Brest area	
	7/2101	Hawes, Capt Clark	22	F-5C 42-67131	Strip Tours to Poitiers	
	7/2102	Blyth, Lt John S	14	Spit XI MB948	Brest area	
25	7/2103	Childress, Capt Hubert M	27	F-5B 42-68196		
	7/2104	Campbell, Capt J L	27	F-5E 43-28619		
	7/2105	Anderson, Lt J L	27	F-5E 43-28993	Abbeville/Drucat(FW), Beach nr Dunkirk	
	7/2106	Clark, Lt Albert W	13	F-5B 42-67324		u/s
	7/2107	Parsons, Lt Edward B	22	F-5C 42-67114		
	7/2108	Miller, Lt Glenn E	22	F-5C 42-67566		
	7/2109	Crane, Lt Charles M Jr	13	F-5B 42-67389	Abbeville area D/A	
	7/2110	Clark, Lt Albert W	13	F-5B 42-67324	Holque, Ghent M/Y D/As	
	7/2111	Goffin, Lt Charles J J	14	Spit XI MB948	Paris, Guyancourt A/F D/As, Rouen, Dieppe	
	7/2112	Weitner, Maj Walter J	22	F-5C 42-67131	Abbeville-Evereux area, Rouen, Dieppe, Coulommiers A/F, Nanteuil, Fismes, Marigny-le-Chatel, Montargis	
	7/2113	Mitchell, Maj Ray C	27	F-5C 42-67550		u/s

347

Eyes of the Eighth

DATE	SORTIE	PILOT	SQ	A/C	TARGETS	INCIDENTS
25	7/2114	McKinnon, Lt Max E	22	F-5C 42-67115	Chalons-sur-Marne	
	7/2115	Moss, Lt Robert E	13	F-5E 43-28324	Sens-Lezinnes	
	7/2116	Crane, Lt Charles M Jr	13	F-5E 43-28993		u/s
	7/2117	Childress, Capt Hubert M	27	F-5C 42-67242	Orleans/Bricy, Avord, Bourges, Caudron/Charannes D/A	
	7/2118	Cameron, Lt JT	27	F-5B-42-67202		u/s
	7/2119	Parsons, Lt Edward B	22	F-5C 42-67122		
	7/2120	Elston, Lt Allan V	13	F-5B 42-68235	Bretigny/Plessis Le Pate, Lyon area	
	7/2121	Matthews, Lt James B	22	F-5E 43-29018	(Lyons area)	MIA-POW
	7/2122	Quiggins, Lt Richard S	22	F-5C 42-67115	Shipping in mid-Channel	
	7/2123	Cosby, Lt Irl	22	F-5C 42-67131	Nevers, Commeilles en Vexin, Clermont/Ferrand, Vichy/Rhue, St Georges A/Fs	
	7/2124	Grayson, Lt Benton C	22	F-5C 42-67254	Clermont-Thiers-St Bonnet-Marsac-Ettenne, Gien BR	
	7/2125	Hughes, Capt Malcolm D	22	F-5 43-29002	Toulouse/Francazal,-/Blagnac A/Fs, Montbartier D/A	Landed overseas
	7/2126	Sommerkamp, Lt Frank M	13	F-5B 42-67324	Le Creusot-Dijon area, A/F E of Le Crotoy	
	7/2127	Windsor, Lt Robert W	22	F-5C 42-67111	Orleans & Rovere areas, Bourges-Nevers-Montargis, Fires 15m S of Paris	
	7/2128	Stamey, Lt Earl K	27	F-5	Lille-Doullens area	
	7/2129	Gilmore, Lt Louis M	13	F-5E 43-28324	Romilly-St Sur-Dijon area	
	7/2130	Kann, Lt Alexander A Jr	22	F-5C 42-67108	RB Bridges at Nogent, Sens, Coulanges sur Yonne, Auxerre	
	7/2131	Goffin, Lt Charles J J	14	Spit XI		u/s
26	7/2132	Adams, Lt Gerald M	14	Spit XI PL767	Berlin,-/Johannistal A/F,-/Templehof A/F, Basdorf D/A, Genshagen, Fallersleben	
	7/2133	Nesselrode, Capt George H	14	Spit XI MB952		u/s
	7/2134	Simon, Capt Walter J	14	Spit XI MB956	Bremen, Hamburg,-/Altona A/F,-/Finkenwarder A/F, Hitzacker, Achim, Hoperhofen A/F	
	7/2135	Carney, Capt Franklyn K	7	F-5C 42-67107		
	7/2136	Brewster, Lt Edgar L	27	F-5E 43-28311	Minderheide A/F, Osnabruck & Bielefeld areas	
	7/2137	Farley, Capt Donald A	22	F-5C 42-67566	Stettin(FW), Arnimswalde	
	7/2138	Nesselrode, Capt George H	14	Spit XI MB950		u/s cloud
	7/2139	Wiebe, Lt Glen E	13	F-5B 42-68235	Rotterdam (FW), Wesel & Rhine area	
27	7/2140	Batson, Lt Charles R	13	F-5B 42-68235		
27/28	7/2141					Night photos
28	7/2142	Sheble, Capt Richard N	14	Spit XI MB955	Nanteuil, Romilly-sur-Seine?	Landed away
	7/2143	Haugen, Maj Cecil T	14	Spit XI EP767?		A/C Crashed
	7/2144	Schultz, Lt Donald A	13	F-5E 43-28324		Landed away
	7/2145	Bruns, Lt Waldo C	22	F-5E 43-28331	Ostend & area, Malines-Ghent, Diest/Schaffen, Grimbergen	
	7/2146	White, Lt Willie E	27	F-5E 43-28619	Bremerhaven,-/ Wessermunde A/F, Wessermunde, Cuxhaven, Ostend, Orly	Landed away
	7/2147	Floyd, Lt Robert C	27	F-5C 42-67123	Bremen, Walsrode, Achim	
	7/2148	Mitchell, Lt Ray C	22	F-5C 42-67122		Landed away
	7/2149	Aubrey, Capt Lawrence	22	F-5C 42-67114	Bourges A/F D/A (FW)	Landed away
29	7/2150	Miller, Lt Glen E	22	F-5C 42-67111		MIA-KIA
	7/2151	Brink, Lt Fred B	22	F-5E 43-28311	Ruhland, Halberstadt A/F, Amsterdam/Schipol A/F	
	7/2152	Alley, Lt Max P	27	F-5E 43-28311	Kassel/Waldau A/F, Bohlen, Leuna, Lutzkendorf, Muchein to Kassel	
	7/2153	Davidson, Lt Verner K	14	Spit XI PA 944		u/s
	7/2154	Childress, Capt Hubert M	27	F-5	New Kuhren, Kamp, Kolburg, Jesa, Danzig, Heilegenbiel, Bialystock, Konigsberg	Landed Poltava
	7/2155	Hawes, Capt Clark J	22	F-5C 42-67131	Laon/Couvron,-/Athies A/Fs, Juvincourt A/F D/A, Beaulieu LG	
	7/2156	Wigton, Lt Irv	22	F-5C 42-67123		u/s cloud
	7/2157	Smith, Maj Robert R	13	F-5E 43-28993	Soissons, A/F Compeigne area	
	7/2158	Matthews, Lt James B	22	F-5E 43-29018		u/s cloud
	7/2159	Hughes, Capt Malcolm D	22	F-5E 43-29002		u/s weather
30	7/2160	Anderson, Lt John L	13	F-5B 42-68213	5 V-1s in flight, 1 crashed and exploded	
	7/2161	Schumacher, Lt Wesley	27	F-5B 42-67324	V-1 in flight	
JULY						
2	7/2162	Wigton, Lt Irv	27	F-5E 43-28311	Unid A/Fs	Landed away
	7/2163	Windsor, Lt Robert D	22	F-5C 42-67131	Bourges/Nohant, St Solinge, Aubilly, Chateauroix/La Martinerie A/Fs	Landed away
	7/2164	Vassar, F/O Edgar L	13	F-5E 43-28331	Le Treport area, Troyes-Faverny-Pon de Re-Freidburg-St Oie-Semilly-Soissons-Abbeville	Landed away
3	7/2165	Cameron, Lt J T	27	F-5C 42-67124	S Bremen, N Magdeburg, Rotterdam area	
	7/2166	Davidson, Lt Verner K	14	Spit XI PA944		u/s Weather
	7/2167	Batson, Lt Charles R	13	F-5E 43-28993		u/s Weather
	7/2168	Brewster, Lt Edgar L	27	F-5E 43-28619		Landed away
	7/2169	Matthews, Lt James R	22	F-5C 42-67115		u/s
	7/2170	Cosby, Lt Irl	22	F-5C 42-67119	Unid A/Fs	
	7/2171	Anderson, Lt John L	13	F-5E 43-28333	Wittermer/Arado & M/Y, Taucha, Meiter	

Sortie List 1944

DATE	SORTIE	PILOT	SQ	A/C	TARGETS	INCIDENTS
3	7/2172	Matthews, Lt James R	22	F-5C 42-67116		u/s
	7/2173	Childress, Capt Hubert M	27	F-5B 42-68196	Islands in Adriatic Sea	2 /7 to Poltava-San Severo
	7/2174	Childress, Capt Hubert M	27	F-5B 42-68196	M/Y S France	San Severo Rd MF
4	7/2175	Mitchell, Lt Ray L	22	F-5C 42-67114	Chateau La Vallierie	
	7/2176	Adams, Lt Gerald M	14	Spit XI MB955	Le Grismont-Bois d'Esquerdes-Zudausques-Cormette area	
	7/2177	Goffin, Lt Charles J J	14	Spit XI MB950	Chateau de Bosmelet	
	7/2178	Richards, Lt John R	14	Spit XI MB946	Ferme du Forster area	
	7/2179	?Florine, Lt Robert N	27			u/s cloud
	7/2180	Blyth, Lt John S	14	Spit XI MB948	Gorenfelds area, Woods S of Domleger & Domvast	
	7/2181	Weitner, Maj Walter L	22	F-5C 42-67566		u/s cloud
	7/2182	Batson, Lt Charles R	13	F-5B 42-67395	RR Courtrai-Ghent, Roubaix	
	7/2183	Elston, Lt Allan V	13	F-5B 42-67324	V-1 hunt	Film destroyed
	7/2184	McKinnon, Lt Max E	22	F-5E 43-28998	V-1 hunt	Film destroyed
	7/2185	Schumacher, Lt Wesley H	27	F-5B 42-68213	V-1 hunt	V-1 in flight
	7/2186	?Kendall, Lt Ralph D	27		Odessa, Compina	Rd Russia-Italy
	7/2187	Purdy, Lt Ira J	27	F-5E 43-29026	Louvain area	
	7/2188	Nesselrode, Capt George H	14	Spit XI MB952	Montorgueil area, Large installation with Red Cross nr Foret de Crecy	
	7/2189	Davidson, Lt Verner K	14	Spit XI PA944	Crepy-Bamieres area	
	7/2190	Simon, Capt Walter J	14	Spit XI MB956	Zudauques-Cormette-Le Grismont-Esquerdes area	
	7/2191	Bliss, Maj Kermit E	14	Spit XI PA841	Chateau Bernapre area	
	7/2192	?Florine, Lt Robert N				u/s
	7/2193	Moss, Lt Robert E	13	F-5B 42-67332	Obl Dunkirk & coast to Cap Gris Nez, Aeltre, Thouout-Bruges, Roullers-Ypres-Hazebrouck	
	7/2194	Kann, Lt Alexander A Jr	22	F-5C 42-67119		u/s cloud
	7/2195	Stamey, Lt E K	27	F-5E 43-28311		Film destroyed
5	7/2196	Clark, Lt Albert W	13	F-5E 43-28331	Coastal Strip Le Treport to Dieppe	
	7/2197	McKinnon, Lt Max E	22	F-5C 42-67108	A/Fs: Vitry-en-Artois, Achiet, Albert/Meaulte, Clastres, St Simon, Cambrai/Epinoy; Le Crotoy, St Quentin M/Y	
	7/2198	Wigton, Lt Irv	27	F-5E 43-28311	A/Fs: Evereux/Fauville, Conches, Illiers/L'Eveque, Beaumont le Roger, St Andre de l' Eure; Caudebec area	
	7/2199	White, Lt Willie G	27	F-5B 42-68213	Dieppe, SW of Paris	
	7/2200	Adams, Lt Gerald M	14	Spit XI PA842	Pas de Calais area	
	7/2201	Simon, Capt Walter J	14	Spit XI PL782	Pas de Calais area	
6	7/2202	Schumacher, Lt Wesley A	27	F-5E 43-28619		
	7/2203	?Mitchell, Maj Ray C	27			Canc
	7/2204	Goffin, Lt Charles J J	14	Spit XI MB950	A/Fs St Trond/Brustheim, Tirlemont/Gossancourt, Le Culot,-/Ost & M/Y; Hasselt, Louvain, Aerschot, Diest	
	7/2205	Davidson, Lt Verner K	14	Spit XI MB948	Eindhoven; Volkel, Gilze/Rijen, Dulmen A/Fs	
	7/2206	Richards, Lt John R	14	Spit XI MB946	Dunkirk, Ghent/Meirelbeke, Sterreken A/F, Courtrai M/Y, Lille-Esschen RR	
	7/2207	Windsor, Lt Robert D	22	F-5C 42-67115	Rouen area, Dieppe/St Aubin, Evereau/Fauville, Dreux, Etampes/Mondesir, St Andre de l'Eure,-/Favril, Illiers/ Le Vaque	
	7/2208	Matthews, Lt James B	22	F-5C 42-67114	Evereau/Fauville, Conches, Creil M/Y & A/Fs: Le Bourget, St Andre de l'Eure, Crepon, Villacoublay, Beaumont-sur-Oise	
	7/2209	Elston, Lt Allan V	13	F-5B 42-68265	A/Fs: Soesterberg, Wetzendorf, Twente/Enschede, Bockel, Munster/Lager, Hitzacker, Lingen, Valkenburg	
	7/2210	Florine, Lt Robert N	27	F-5C 42-67124		u/s
	7/2211	Grayson, Lt Benton C	22	F-5C 42-67108	A/Fs: St Omer/Longuenesse, Florennes/Juzaine, Ypres/Vlamertinge Denain/Prouvy; Hazebrouk M/Y, Cassel, Boulogne,	
	7/2212	Stamey, Lt Earl K	27	F-5C 42-29026		u/s
	7/2213	Quiggins, Lt Richard S	22	F-5C 42-67108	A/Fs: Melun/Villaroche, Nogent, Montdidier, Vuillery, Esternay, Auxerre D/A	
	7/2214	Moss, Lt Robert E	13	F-5E 43-28331	Met Flight Boulogne area	
	7/2215	Mitchell, Lt Ray L	27	F-5E 43-29002	A/Fs: Gray/St Adrien, Arnay/Le Duc, St Dizier; Honfleur-Le Havre, Chelles-Compons-Beauvais-Beaumont sur Oise	
	7/2216	Purdy, Lt Ira J	27	F-5E 43-29027	Dijon area	
	7/2217	White, Lt Willie? G	27	F-5E 43-28999	Besancon area	
	7/2218	Kann, Lt Alexander A Jr	22	F-5E 43-28577		
	7/2219	Bliss, Maj Kermit E	14	Spit XI PA841	Pas de Calais area D/A	
	7/2220	Nesselrode, Capt George H	14	Spit XI MB952	Pas de Calais area	
	7/2221	Simon, Capt Walter J	14	Spit XI MB955	Pas de Calais area	
	7/2222	Adams, Lt Gerald M	14	F-5B 42-68202	Mimoyecques, Wizernes, Watten, Siracourt	
	7/2223	Blyth, Lt John S	14	Spit XI PA944	Pas de Calais area	
	7/2224	Parsons, Lt Edward B	22	F-5E 43-29018	Dijon area	
	7/2225	McKinnon, Lt Max E	22	F-5C 42-67566	Dijon area	
	7/2226	Hartwell, Lt Col Norris E	7	F-5B 42-68205	A/Fs: Evereux/Fauville, Caen, -/Carpiquet, Cormielles-en-Vexin; Calais-Fecamp, Paris, Achere M/Y, Neucanales-Mureux-Mantes/Gassicourt, Vernon	
	7/2227	Vassar, F/O Edgar L	13	F-5B 42-67395	Amiens,-/M/Y,-/Glisy A/F, Calais, Le Havre	

Eyes of the Eighth

DATE	SORTIE	PILOT	SQ	A/C	TARGETS	INCIDENTS
6	7/2228	Richards, Lt John R	22	F-5B 42-76399	Cap Gris Nez-St Valery area, Fecamp	
	7/2229	Anderson, Lt John L	13	F-5B 42-67324	Dunkirk-Beauvais-Le Havre area	
	7/2230	Weitner, Maj Walter L	22	F-5E 43-28998	Calais-Grandvilliers-Fecamp area	
	7/2231	Brewster, Lt Edgar L	27	F-5B 42-67331	Cap Gris Nez-Aumale-Eletot area	
	7/2232	Wiebe, Lt Glen E	13	F-5B 42-68235	Gravelines-Amiens-Fecamp	
	7/2233	Alley, Lt Max P	27	F-5B 42-68213	Dunkirk-Beauvais-Le Havre area	
	7/2234	Wigton, Lt Irv	27	F-5E 43-28619	Calais-Grandvilliers-Amiens	
	7/2235	Brink, Lt Fred B	13	F-5B 42-67332	Calais-Abbeville-Fecamp area	
	7/2236	Sommerkamp, Lt Frank M	13	F-5E 43-28993	Bremerhaven, Den Helder; A/Fs: Leuwarden, Norg; Wessermunde, Lundingworth, Hammelwarden	
	7/2237	Gilmore, Lt Louis M	13	F-5E 43-28333	Kiel D/A, Brunsbuttel	
	7/2238	Davidson, Lt Verner K	14	Spit XI MB948	M/Y on spur nr Lommel D/A, Haanstede A/F	
	7/2239	Kann, Lt Alexander A Jr	22	F-5C 42-67119	A/Fs: Saarguemines, Hagenau, Saverne/Steinborn, Karlsruhe; Teterchen, Saarbrucken D/A, Fecamp-Calais area	
	7/2240	Schultz, Lt Donald A	13	F-5E 43-28616	A/Fs: Steenwijk/Havelte, Lingen; Dummer Lake area, Levern, Steinhuder Lake area, Enkhuisen	
	7/2241	Stamey, Lt Earl K	27	F-5B 42-68213	Dreux A/F, Lonrail & Essay LGs	
	7/2242	Goffin, Lt Charles J J	14	Spit XI PA842	Ghent M/Y, St Denis/Westreham A/F	
	7/2243	Hawes, Capt Clark J	22	F-5C 42-67116	Le Havre-Beauvais-Dunkirk area	
	7/2244	Quiggins, Lt Richard S	22	F-5C 42-67116	Calais-Amiens area	
	7/2245	Florine, Lt Robert N	27	F-5E 43-28999	A/Fs: Avord, Aubilly; Bourges M/Y	
	7/2246	Schumacher, Lt Wesley A	27	F-5E 43-28311	Roanne-St Etain area	
	7/2247	Windsor, Lt Robert D	22	F-5C 42-67114	Lyons area	
	7/2248	Matthews, Lt James B	22	F-5C 42-67566	A/Fs: Friedrichshafen/Manzell,-/Lowenthal,-/Zepplindorf, Laupheim; Risstissen (FW2)	
	7/2249	Bliss, Maj Kermit E	14	Spit XI	A/Fs: Ellrich, Nietieben, Rotha, Brandis, Leipzig, Bohlen, Lutzkendorf	
	7/2250	Clark, Lt Albert W	13	F-5B 42-67332	Magdeburg/Neustadt, Wittenburg A/C & Eng Factories, Fallersleben, Stendahl A/F, Basdorf/Berlin, Genshagen	
	7/2251	Smith, Maj Robert R	13	F-5B 42-68235	A/Fs: Staaken, Werder/Potsdam, Berlin/Templehof	
	7/2252	Batson, Lt Charles R	13	F-5E 43-28331	Oschersleben, Magdeburg, Wittenburg	
	7/2253	Cosby, Lt Irl	22	F-5E 43-28577	A/Fs: Hailfingen, Feiburg, Vitry-en-Artois, Douai/Dechy	
	7/2254	Nesselrode, Capt George H	14	Spit XI MB952	Pas de Calais area	
	7/2255	Adams, Lt Gerald M	14	Spit XI PL782	Pas de Calais area	
7	7/2256	Farley, Capt Donald A	22	F-5E 43-28998	?Neuabing, Oberpfaffenhofen, Oberaderach, Friederichshafen	
	7/2257	Dixon, Capt Robert J	14	Spit XI MB955	A/Fs: Gottingen, Nordhausen; Fact. N of Nordhausen, Leipzig, Bohlen, Lutzkendorf D/A	
	7/2258	Blyth, Lt John S	14	Spit XI MB955	Aschersleben D/A, Bad Harzburg, A/Fs: Quedlinburg, Halberstadt	
	7/2259	Simon, Capt Walter J	14	Spit XI PA842	A/Fs: Paderborn, Ellrich, Halle, Kolleda; Leuna, Lutzkendorf	
	7/2260	Kendall, Capt Ralph D	13	F-5E 43-28616		u/s
	7/2261	Bruns, Lt Waldo C	13	F-5B 42-68235	A/Fs: Rechlin,-/Larz, Parchim, Damm; Berlin area, Hanover, Frankfurt-on-Oder, Oldendorf, Furstenwalde	
	7/2262	Moss, Lt Robert E	13	F-5B 42-68265	A/Fs: Ladbergen, Hildesheim, Giehorn, Eschede, Wesendorf	
	7/2263	Hartwell, Lt Col Norris E	7	F-5B 42-68213	Ferme du Forestel, Fresnoy	
	7/2264	Richards, Lt John R	14	F-5B 42-67331	Ferme du Forestel, Fresnoy	
	7/2265	Wiebe, Lt Glen E	13	F-5B 42-67423	Strip Bergen to Groningen, Vicinity Essen, Spiekeroog Isle	
8	7/2266	Brink, Lt Fred B	13	F-5B 42-67359	A/Fs: Travemunde,-/Priwall, Niendorf, Schleswigland, Lubeck/Blanken, Kaltenkirchen, Nordholz/Medlum; Kiel, Elmshorn Utersen	
	7/2267	Vassar, F/O Edgar L	13	F-5E 43-28993		
	7/2268	Sheble, Capt Richard	14	Spit XI PA842	Pas de Calais area	
	7/2269	Graves, Lt Willard	14	Spit XI MB950	Forest D'Huvy	
	7/2270	Davidson, Lt Verner K	14	Spit XI PA944	Pas de Calais area	
	7/2271	Goffin, Lt Charles J J	14	Spit XI MB956		u/s
	7/2272	Adams, Lt Gerald	14	Spit XI MB955	A/Fs: Kassell/Dornberg, Gotha, Kolleda, Erfurt/Nord, Weimar, Jena/Rodigen, Eisenach	
	7/2273	Grayson, Lt Benton C	22	F-5C 42-67566	D/As: Boulogne, Doullens, Frevent	
	7/2274	Anderson, Lt John L	13	F-5B 42-68235		u/s
	7/2275	Blyth, Lt John S	14	Spit XI MB946		u/s cloud
	7/2276	Dixon, Capt Robert J	14	Spit XI		Canc
9	7/2277	Farley, Lt Donald A	22	F-5C 42-67566	Sully-sur-Loire D/A, Rouen, Caudebec, area E of Paris	
	7/2278	Windsor, Lt Robert D	22	F-5C 42-67108	Yvetot	
12	7/2279	Sommerkamp, Lt Frank M	13	F-5B 42-68202		Canc Weather
	7/2280	Elston, Lt Allan V	13	F-5B 42-67389		Canc Weather
	7/2281	Schumacher, Lt Wesley A	27	F-5C 42-67550		Canc Weather
	7/2282	Parsons, Lt Edward B	22	F-5C 42-67115		Canc Weather
	7/2283	Mitchell, Maj Ray C	27	F-5C 42-67242	Grosley-sur-Risle, Nogent-le Rotrou, Chateaudun, Angers-Ranches-Cherbourg, Coutrances, Lessay	

Sortie List
1944

DATE	SORTIE	PILOT	SQ	A/C	TARGETS	INCIDENTS
12	7/2284	Aubrey, Capt Lawrence E	22	F-5C 42-67116	Rouen/Sotteville, Gien, Auxerre	
13	7/2285	Stamey, Lt Earl K	27	F-5E 43-28619	Chateaudun A/F D/A, La Possonier RB (FW)	
	7/2286	McKinnon, Lt Max E	22	F-5E 43-28577	Dijon area	
	7/2287	Rickey, Lt Irv J	27	F-5C 42-67242	Orleans BR, Nevers area, Chateaudun	
	7/2288	McDonald, Lt Warren M	27	F-5C 42-67550	Orleans/Bricy A/F, Orleans area	
	7/2289	Purdy, Lt Ira	27	F-5E 43-29026	Bourgneuf area, St Malo area	
	7/2290	Hughes, Capt Malcolm D	22	F-5E 43-29004		Landed overseas
	7/2291					Landed overseas
	7/2292					Landed overseas
14	7/2293	Chapman, Maj Carl	22	F-5B 42-68205	Geneva, Torina areas	Landed overseas
	7/2294	Stamey, Lt E K	27		Limoges & area, LG 5m N of Bayeux	
	7/2295	Florine, Lt Robert	27			
16	7/2296	Purdy, Lt Ira J	27	F-5C 42-67550	Conches A/F, Clermont/Ferrand area	
	7/2297	Florine, Lt Robert N	27	F-5C 42-67242		u/s Eng trbl
	7/2298	Florine, Lt Robert N	27	F-5E 43-28311		u/s Eng trbl
	7/2299	Wigton, Lt Irv	27	F-5E 43-29027	Limoges area	
17	7/2300	Bliss, Maj Kermit E	14	Spit XI PA841	Courtrai/Wevelghem, St Denis/Westrem A/Fs; Ghent-Malines-Brussels	
	7/2301	Simon, Capt Walter	14	Spit XI MB956	Hasselt to Esschen, M/Y on spur, Factory NE of Moll D/A	
	7/2302	Cosby, Lt Irl	22	F-5C 42 67119	A/Fs: Coulommiers/Vesnil, Gy, Le Bourget, Dole/Travaux, D/A, Gray/St Adrien; Paris, Le Treport, Dijon area	
	7/2303	Matthews, Lt J B	22	F-5C 42 67108	A/Fs: Valkenborg/Katwijk Creil, Amberieu; Lyon area	
	7/2304	Schultz, Lt Donald A	13	F-5E 43 28331	The Hook of Holland (FW), ships nr Nordwal	
	7/2305	McDonald, Lt W M	27	F-5B 42 68231	A/Fs: Nogent-le-Rotrou, Tours Meslay Parcay, Herbouville; Cloyes BR, La Possonniere Viaduct	
	7/2306	Quiggins, Lt Richard S	22	F-5C 42 67114	Strasbourg area	
	7/2307	Richards, Lt John R	14	Spit XI MB946	A/Fs: Koblenz/Kartihaus,-/Guzs, Hochast/Oberau; Cologne	
	7/2308	Mitchell, Lt R L	22	F-5C 42 67115	A/Fs: Freiburg, Amiens/Glisy, Roye/Amy, Montdidier; Cayeux, Abbeville	
	7/2309	Kann, Lt Alexander A Jr	22	F-5E 43 28577	Lumbres	
	7/2310	Weitner, Maj Walter L	22	F-5E 43 29002	Metz area, Saarbrucken M/Y D/A	
	7/2311	Windsor, Lt R D	22	F-5C 42 67566	Belfort area	
	7/2312	Cameron, Lt J T	27	F-5C 42 67550	Brest Pen	
	7/2313	Campbell, Capt J L	27	F-5B 42 67342	St Malo	
	7/2314	Rickey, Lt Irv J	27	F-5E 43 29026	Brest Pen	
	7/2315	Brewster, Lt Edgar L	27	F-5B 42 58196	Brest Pen	
	7/2316	Sheble, Capt Richard	14	Spit XI PA842	Lille/Vendreville A/F & M/Y, RR lines in Lille & Roubaix	
	7/2317	Graves, Lt Willard E	14	Spit XI MB950	A/Fs: Brussels/Melsbroek, Antwerp/Deurne; Antwerp, Louvain, Roosendaal	
	7/2318	Schumacher, Lt Wesley A Jr	27	F-5E 43-28619	Alerted for Special mission	Canc
	7/2319	Sommerkamp, Lt Frank M	13	F-5B 42-28616		Canc
	7/2320	Adams, Lt Gerald	14	F-5B 42-67399		Canc
	7/2321	Parsons, Lt Edward B	22	F-5C 42-67116		Canc
	7/2322	Elston, Lt Allan V	13	F-5B 42-67359		Canc
	7/2323	McKinnon, Lt Max E	22	F-5C 42-67122		u/s
	7/2324	Dixon, Capt Robert J	14	Spit XI MB955	Cormeilles-en-Vexin A/F, Conflans, Fienvillers, Grand Parc, Beaumont-road-woods	
	7/2325	Clark, Lt Albert W	13	F-5B 42-68265	Brest Pen	
	7/2326	Kendall, Capt Ralph D	27	F-5B 42-67324	E of Brest Pen	
	7/2327	Brink, Lt Fred B	13	F-5B 42-67395	E of Brest Pen	
	7/2328	Wiebe, Lt Glen E	13	F-5B 42-68235	E of Brest Pen	
	7/2329	Davidson, Lt Verner K	14	F-5E 43-28993	Soesterberg, Valkenberg A/Fs; Arnhem to Zutphin	
	7/2330	Hawes, Capt Clark	22	F-5C 42-67131	A/Fs: Ypres/Vlamertinghe D/A, Nuncq, Coxyde/Furnes; Beauvoir, St Pol, Doullens-Frevent	
	7/2331	Farley, Capt Donald A	22	F-5E 43-28998	Vannes area	
	7/2332	Stamey, Lt Earl K	27	F-5C 42-67254	Vannes area, Guincamp, Paimpol	
	7/2333	Mitchell, Maj Ray C	27	F-5E 43-29027	Brest Pen, Auray to Sillow-de-Talbert	
	7/2334					Canc
	7/2335	Goffin, Lt Charles J J	14	Spit XI PA944	Brs: Sully-Gien, Neury, Surl, Coulanges, Cheny; Auxerre & A/F	
	7/2336	Blyth, Lt John S	14	Spit XI MB948	Brs: Anizy, Beautor, Jussy, Hamm, Peronne, Manteuil, Les Foulone, Frevent D/D, Nogent; A/Fs: Connantre, Marigny, Mons	
	7/2337	Purdy, Lt Ira J	27	F-5B 42-68231	Brest Pen, Rennes area	
	7/2338	McKinnon, Lt Max E	22	F-5C 42-67131	Northern France mapping	
	7/2339	Kann, Lt Alexander A Jr	22	F-5C 42-67119	Northern France mapping	
	7/2340	Smith, Maj Robert R	13	F-5E 43-28333	Northern France mapping	
	7/2341	Schultz, Lt Donald A	13	F-5E 43-28324	Northern France mapping	
	7/2342	Quiggins, Lt Richard	22	F-5C 42-67115		Canc
	7/2343	Bliss, Maj Kermit E	14	Spit XI PL782	Bougival, Beaumont	

Eyes of the Eighth

DATE	SORTIE	PILOT	SQ	A/C	TARGETS	INCIDENTS
17	7/2344	Cameron, Lt J T	27	F-5C 42-67550	Brest Pen, Granville	
	7/2345	Campbell, Lt J L	27	F-5B 42-67342	Brest Pen	
	7/2346	Rickey, Lt Irv J	27	F-5E 43-29026	Brest Pen	
	7/2347	Brink, Lt Fred B	13	F-5B 42-67395	Guernsey	
	7/2348	Clark, Lt Albert W	13	F-5 42-68265	Northern France mapping	
18	7/2349	Sheble, Capt Richard	14	Spit XI PA842		u/s
	7/2350	Graves, Lt Willard	14	Spit XI MB950	Gilze/Rijen A/F(FW), Tilburg-Roosendaal	
	7/2351	Dixon, Capt Robert J	14	Spit XI PL482	A/Fs: Bonninghardt, Venlo(FW), Wesel, Lichtenau, Echameder; Kassel, Neuss, strip Eindhoven to coast	
	7/2352	Davidson, Lt Verner K	14	F-5E 43-29009	A/Fs: Frankfurt,-/Rebstock, Roth-bei-Nurnberg, Schwaback, Untersch-Laverback	
	7/2353	Cosby, Lt Irl	22	F-5C 42-67119	Munich D/A, Stuttgart D/A, Bad Cannstatt, Saarbrucken/St Arnaul, Geislingen, Weisenhorn	
	7/2354	Cameron, Lt J T	27	F-5C 42-67550		u/s cloud
	7/2355	Alley, Lt Max P	27	F-5B 42-67342		u/s cloud
	7/2356	Rickey, Lt Irv J	27	F-5E 43-28619		u/s cloud
	7/2357	McDonald, Lt Warren M	27	F-5C 42-68131		u/s cloud
	7/2358	Mitchell, Lt R L	22	F-5C 42-67122		u/s
	7/2359	Moss, Lt Robert E	13	F-5E 43-28616	Berlin, Basdorf D/A, Stendal D/A, Schobwalde A/F	
	7/2360	Bruns, Lt Waldo	13	F-5B 42-68265	Berlin, Genshagen, Cottbus D/A, Schonefeld A/F, Ijmuiden port	
	7/2361	Stamey, Lt Earl K	27	F-5E 43-28311	Tulle area	
	7/2362	White, Lt Willie G	27	F-5E 43-29027	Grosley-sur-Risle, M/Y E of Nogent-le Routrou D/A, Herbouville A/F	
	7/2363	Richards, Lt John R	14	F-5B 42-68202	Liege/Bierset A/F (FW)	
	7/2364	Weitner, Maj Walter L	22	F-5E 43-29002	A/Fs: Marigny/Le Grand, Anity-Le Chateau (FW)	
	7/2365	Smith, Maj Robert R	13	F-5E 43-28324	A/Fs: Vesbeck, Eickeloh, Minderheide, Mildesheim, Eschede; Rodewald	
	7/2366	Matthews, Lt James B	22	F-5C 42-67108	RBs: Oissel, Neuvy-sur-Loire, Rouen; Griage A/F; Sotteville M/Y D/A; Arny-le-Duc	
	7/2367	Mitchell, Lt R L	22	F-5C 42-67116	A/Fs: Belval, Sedan/Douzy, Stenay, Etain/Rouvres, Thionville/Basse Yutz; RR Mezieres to Langly	
	7/2368	Anderson, Lt John L	27	F-5E 43-28333	A/Fs: Fursternau, Ladbergen; Activity Bohmte?, Hasselunne, Ohrte	
	7/2369	Simon, Capt Walter	14	Spit XI MB946	Lutzkendorf Oil Plant, Bernberg D/A, Muhlhausen, Holzminden, Ellrich, Eswege	
	7/2370	White, Lt Willie G	27	F-5E 43-29026	Eswege, Crosley-sur-Risle D/A embankment and bridge, Nogent D/A, Muhlhausen, Holzminden, Ellrich	
	7/2371	Schultz, Lt Donald A	13	F-5B 42-67395	Lille/Fives M/Y, Lumbries, Lille	
	7/2372	Quiggins, Lt Richard	22	F-5C 42-67114	M/Ys: Belfort D/A, Vitry le Francois, Chalons sur Marne; St Dizier A/F	
	7/2373	Gilmore, Lt Louis	14	F-5B 42-68202	St Dizier/Robinson A/F, Ghent, Terneuzen, Antwerp-Esschen, Bergen-op-Zoom, Zeebruge, Strip of coast Blanken Berghe	
	7/2374	Blyth, Lt John S	14	Spit XI MB948	Ghent to Antwerp, RR Ghent to Terneuzen	
	7/2375	Goffin, Lt Charles J J	14	Spit XI PA841	Bruges-Ghent-Brussels RR	
	7/2376	Sheble, Capt Richard	14	Spit XI PA842	Ostend, Ghent-Eccloo-Bruges RR, strip Bruges to Ostend	
	7/2377	Nesselrode, Capt George H	14	Spit XI MB952	Ostend, Ghent to Bruges, Ghent- Brussels-Malines, Bruges M/Y, Malines/Muysen M/Y	
	7/2378	Hawes, Capt Clark J	22	F-5C 42-67116		
19	7/2379	Bliss, Maj Kermit E	14	Spit XI PA944	Brussels M/Y, A/Fs: Aeltre, St Denis/Westreham; Bruges, Ghent, Terneuzen, Antwerp	
	7/2380	Graves, Lt Willard	14	Spit XI MB950		u/s
	7/2381	Simon, Capt Walter	14	Spit XI MB956	A/Fs: Belcele, Sterreken; Terneuzen-Ghent-Antwerp	
	7/2382	Dixon, Capt Robert J	14	Spit XI MB955	A/Fs: Bruges/St Croix, Maldeghem; Ghent-Malines	
	7/2383	Hawes, Capt Clark J	22	F-5C 42-67131	A/Fs: Feiburg, Cambrai/Niergnies; Saarbrucken M/Y, Calais	
	7/2384	Davidson, Lt Verner K	14	Spit XI PA841	A/Fs: Bonn, Koblenz; Schweinfurt, Ebelsbach, Russelheim	
	7/2385	Sheble, Capt Richard	14	Spit XI	Russelheim, Heidelberg	
	7/2386	Kendall, Capt Ralph D	13	F-5B 42-67319	Boulogne area (V-1 sites)	Low lvl Obl
	7/2387	Blyth, Lt John S	14	Spit XI	Ghent-Courtrai-Roubaix, Antwerp-Roosendaal	
	7/2388	Stamey, Lt Earl K	27	F-5E 43-29026	Le Mans, Cadbourg-St Pierre	
	7/2389	Windsor, Lt Robert D	22	F-5E 43-29016	Doullens M/Y, Tergnier RR Junc., Laon/Couvron A/F	
	7/2390	Batson, Lt Charles R	13	F-5E 43-28331	Stade, Wilhelmshaven, Eickelon area; A/Fs: Bohmte?, Minderheide, Rodewald	
	7/2391	Bruns, Lt Waldo C	13	F-5B 42-67319	Blanc Rignon Ferme, Cauchie D'Ecques (Noball)	Dicing
	7/2392	Bliss, Maj Kermit E	14	Spit XI	Breda-Roosendaal-Esschen	
	7/2393	Purdy, Lt Ira J	27	F-5E 43-28311	Caen area	
	7/2394	Farley, Capt Donald A	22	F-5C 42-67254	Kempten, Hollriegelskreuth, Munich, Leipheim, Stuttgart, Sindelfingen, Augsburg factories	
	7/2395	Clark, Lt Albert W	13	F-5E 43-28333	Hemmingstadt, Stade, Emden, Bremerhaven	Sighted convoy for attack
	7/2396					u/s Weather
	7/2397	Vassar, F/O Edgar L	13	F-5E 43-28616	Plantlunne, Valkenburg, strip Hasselunne to Egmond; Harskamp A/F	Buzz hit control tower
20	7/2398	Adams, Lt Gerald	14	Spit XI MB955	Dessau D/A, Kothen D/A	
	7/2399	Goffin, Lt Charles J J	14	Spit XI MB948	Lutzkendorf, Merseburg/Leuna, A/Fs: Leipzig,-/ Grossenzehocher, Mockau D/As	
	7/2400	Grayson, Lt Benton C	22	F-5C 42-67115	Saarbrucken M/Y, Strasbourg A/F D/As; Nr Sedan	
	7/2401	Richards, Lt John R	14	Spit XI MB946	Antwerp-Esschen-Tillberg, Woensdrecht A/F	
	7/2402	Nesselrode, Capt George H	14	Spit XI PA842	Blankenberghe, RR lines Ypres-Courtrai, Andenarde-Brussels-Ghent.	

Sortie List
1944

DATE	SORTIE	PILOT	SQ	A/C	TARGETS	INCIDENTS
20	7/2403	Dixon, Capt Robert J	14	Spit XI PL782	Blankenberghe, Maldeghem A/F, Bruges-Ghent-Terneuzen	
	7/2404	Davidson, Lt Verner K	14	Spit XI PA944	RR lines: Bruges-Ghent, Lille-Mouscrow, Ghent-Deynze	
	7/2405	Blyth, Lt John S	14	Spit XI PA841	RR lines Ghent-Malines	
	7/2406	Florine, Lt Robert N	27	F-5B 42-67342	Bourges, Caen area D/A, A/Fs: Herbouville, Salbris; Nogent-le-Routrou M/Y D/A	
	7/2407	Parsons, Lt Edward B	22	F-5C 42-67116	Valenciennes-Brussels-Deynze-Roubaix, Coast Dunkirk to Calais	
	7/2408	McKinnon, Lt Max E	22	F-5C 42-67108	Valenciennes-Brussels-Deynze-Courtrai-Dixmunde to coast	
	7/2409	Childress, Capt Hubert M	27	F-5B 42-67319	Cauche D'Ecques	
	7/2410	Elston, Lt Allan V	13	F-5E 43-28331	Eickelon, A/Fs: Ladbergen, Hildesheim/Mikkelsthur, Vesbeck, Rodewald	
	7/2411	Sommerkamp, Lt Frank M	13	F-5B 42-68207	Bremen Oil Depot, A/Fs: Markscamp, Bergen/Alkmaar, Medemblick, Achmer	
	7/2412	Gilmore, Lt Louis M	14	F-5B 42-68202		u/s Intc
	7/2413	Mitchell, Lt R L	22	F-5E 43-29108		A/C Crashed KIA
21	7/2414	Weitner, Maj Walter L	22	F-5C 42-67566	Strasbourg, Konz/Karthaus D/A, Trier A/F	
	7/2415	Graves, Lt Willard E	14	Spit XI PA944	Eisenach, Fact W of Cologne, strip S of Gotha, A/Fs: Gotha, Erfurt/Nord, Kolleda D/A	
	7/2416	Sheble, Capt Richard N	14	Spit XI MB955	Dessau, Kothen	
	7/2417	Richards, Lt John R	14	Spit XI MB948	Leipzig, Leuna, Lutzkendorf, Nordhausen D/A, Gottingen, Hamm	
	7/2418	Davidson, Lt Verner K		F-5E 43-29009	Schweinfurt, Ebelsbach; Duren, Liblar areas; Darmstadt A & A/F; Russelheim D/A	
	7/2419	Cosby, Lt Irl R	22	F-5C 42-67119	Strasbourg M/Y, Dam D/A; A/Fs: Florennes/Juzaine, Strasbourg/Neuhof	
	7/2420	Adams, Lt Gerald	14	Spit XI PL782		Recall
	7/2421	Dixon, Capt Robert J	14	Spit XI PL782	Bruges-Ecloo-Ghent-Neuzen Rrs, Bruges M/Y, Haldeghen A/F	
	7/2422	Blyth, Lt John S	14	Spit XI MB948	Bruges-Aeltre RRs	
	7/2423	Nesselrode, Lt George H	14	F-5B 42-68202	Ostend, Ecloo, Ghent-Bruges-Aeltre RRs	
	7/2424	Adams, Lt Gerald M	14	Spit XI MB955	Ostend-Bruges-Aeltre RRs	
	7/2425	Brink, Lt Fred B	13	F-5B 42-68265	Amsterdam-Bergen/Aan Zee; A/Fs: Soesterburg, Twente/Enschede, Harskamp & area.	
	7/2426	Wiebe, Lt Glen E	13	F-5B 42-68235	Hannover area, A/Fs in Holland	
23	7/2427	Schultz, Lt Donald A	13	F-5E 43-28993	D/As: Zinnowitz, Stralund, Kiel, Peenemunde, Hemmingstadt; A/Fs: Putnitz, Barth	Flak prevented cover of some targets
24	7/2428	Alley, Lt Max P	27	F-5E 43-28999		u/s
	7/2429	Wigton, Lt Irwin	27	F-5E 43-29027	Brest Pen	
	7/2430	Rickey, Lt Irv J	27	F-5B 42-67331	Rennes/St Jacques A/F, Vitry M/Y	
	7/2431	White, Lt Willie G	27	F-5E 43-28311	Brest Pen	
	7/2432	Alley, Lt Max P	27	F-5E 43-29000	Brest Pen	
	7/2433	Quiggins, Lt Richard S	22	F-5C 42-67114		u/s cloud
	7/2434	Williams, Lt Eugene S	22	F-5E 43-28998	Granville	
	7/2435	Brunell, Lt Richard H	22	F-5E 43-29006	Vicomte-sur-Rance, Brest Pen area	
	7/2436	Aubrey, Capt Lawrence E	22	F-5C 42-67116	Brest Pen	
	7/2437	Schumacher, Lt Wesley A	27	F-5E 43-29026	St Lo area D/A	
	7/2438	?Stamey, Lt Earl K		F-5E 43-28311		Canc
	7/2439	Matthews, Lt James B	22	F-5C 42-67108	Bridge over La Vilaine River, area N of St Lo	
	7/2440	Durst, Lt Edward	22	F-5	(St Malo area)	KIA anoxia
	7/2441	Weir, Lt Harold G	22	F-5C 42-67131		
	7/2442	Kann, Lt Alexander A Jr	22	F-5E 43-29002		
	7/2443	Anderson, Lt J L	13	F-5E 43-28333		
	7/2444	Smith, Maj Robert R	13	F-5B 42-67395	Rennes-Chateaulin	
	7/2445	Brink, Lt Fred B	13	F-5B 42-67319	Rennes-Chateaulin	
	7/2446	Wiebe, Lt Glen E	13	F-5B 42-68235	Brest Pen	
	7/2447	Elston, Lt Allan V	13	F-5B 42-67324	Rennes-Pte Pennors, Crozan, Douarnenez, Brest Harbor, strip Brest-Plouaret	
	7/2448	Cameron, Lt J T	27	F-5E 43-28619	Dol-Guincamp, Pontrieux-St Malo	
	7/2449	Purdy, Lt Ira R	27	F-5E 43-29029	Dol-Guincamp, Pontrieux-St Malo	
	7/2450	Florine, Lt Robert N	27	F-5B 42-68196	Dol-Guincamp, Pontrieux-St Malo	
	7/2451	McDonald, Lt W M	27	F-5C 42-67132	Dol-Guincamp, Pontrieux-St Malo	
	7/2452	Childress, Capt Hubert M	27	F-5B 42-67331	St Leu D'Esserent I D/A, St Pol area	
25	7/2453	Rickey, Lt Irv J	27	F-5E 43-28619	Conde sur Noireau(FW), Brest area	
	7/2454	Schumacher, Lt Wesley A	27	F-5C 42-67550		u/s cloud
	7/2455	Florine, Lt Robert N	27	F-5B 42-68196		u/s cloud
	7/2456	Purdy, Lt Ira J	27	F-5E 43-29027		u/s cloud
	7/2457	Ross, Lt John H	22	F-5E 43-29016		u/s cloud
	7/2458	Hawes, Capt Clark J	22	F-5C 42-67131	Creil, A/Fs Laon/Couvron,-/Athies, Juvincourt	
	7/2459	Ness, Lt D A	27	F-5C 42-67132	Rouen/Sotteville M/Y(FW)	
	7/2460	Alley, Lt Max P	27	F-5E 43-29000	St Lo Area	
	7/2461	White, Lt W G	27	F-5E 43-28311	St Lo Area	
	7/2462	Campbell, Capt J L	27	F-5E 43-29026	Brest Pen	
	7/2463	Wigton, Lt Irv	27	F-5B 42-68196	Brest Pen	
	7/2464	Cameron, Lt J T	27	F-5C 42-67550	Brest Pen	

353

Eyes of the Eighth

DATE	SORTIE	PILOT	SQ	A/C	TARGETS	INCIDENTS
25	7/2465	Schumacher, Lt Wesley A	27	F-5B 42-67331	Brest Pen	
	7/2466	Weitner, Maj Walter L	22	F-5C 42-67566	Brest Pen	
	7/2467	Parsons, Lt Edward B	22	F-5B 42-67116	Brest Pen	MIA-POW
	7/2468	Carlgren, Lt Robert F	22	F-5E 43-29006	Brest Pen, Dinan/Trelivan A/F	
	7/2469	Cosby, Lt Irl	22	F-5E 43-67108	Brest Pen	
	7/2470	Fish, Lt Bruce B	14	F-5E 43-29009	Brest Pen	
	7/2471	Balogh, Lt Paul A	14	F-5B 42-67399	Brest Pen	
	7/2472	Nesselrode, Capt George H	14	F-5B 42-68202	Brest Pen	
	7/2473	Grayson, Lt Benton C	22	F-5E 43-28998	Brest Pen	
	7/2474	Moss, Lt Robert E	13	F-5E 43-28990	Brest Pen, Danmark	
	7/2475	Kendall, Capt Ralph D	13	F-5E 43-29030		u/s cloud
	7/2476	Facer, Lt Robert H	13	F-5E 43-28331		u/s cloud
	7/2477	Bickford, Lt Wilbur E	13	F-5		u/s cloud
	7/2478	Anderson, Lt J L	13	F-5E 43-28333		u/s cloud
	7/2479	Elston, Lt Allan V	13	F-5B 42-67324		Canc
	7/2480	Adams, Lt Gerald M	14	F-5B 42-67395		Canc
	7/2481	Matthews, Lt James B	22	F-5B 42-67114		Canc
	7/2482	Brink, Lt Fred B	13	F-5B 42-68265		Canc
	7/2483	Wiebe, Lt Glen E	13	F-5B 42-67319		Canc
	7/2484	Bliss, Maj Kermit E	14	Spit XI PA841	Ghent-Aeltre-Bruges RR, Brussels, A/Fs Aeltre, St Denis/Westrem; Bruges/St Michel, Ghent/Meirelbeke M/Ys	
	7/2485	Brewster, Lt Edgar	27	F-5C 42-67132	Brest Pen	
	7/2486	Mitchell, Maj R C	27	F-5E 43-29027		u/s Weather
	7/2487	Alley, Lt Max P	27	F-5E 43-29000	Pontorson-Domfort-Bonnemain	
	7/2488	McDonald, Lt Warren M	27	F-5E 42-28311	Brest Pen	
	7/2489	Brunell, Lt Richard H	22	F-5C 42-67122	Brest Pen	
	7/2490	Williams, Lt E S	22	F-5E 43-29016	Brest Pen	
	7/2491	McKinnon, Lt Max E	22	F-5E 43-28577	Brest Pen	
	7/2492	Farley, Capt Donald A	22	F-5C 42-67254	Brest Pen	
	7/2493	Batson, Lt Charles R	13	F-5E 42-28324	Brest Pen	
	7/2494	Belt, Lt Taylor M	13	F-5E 42-28331	Brest Pen, La Chapelle-Falaise, Vassay-Littry	
	7/2495	Budrevich, Lt Gerald J	13	F-5E 42-29030	Brest Pen, St Cosme-Torigini	
	7/2496	Wiebe, Lt Glen E	13	F-5E 42-28333	Brest Pen	
	7/2497	Kendall, Capt Ralph D	13	F-5E 43-28998	Brest Pen, Fougeres-Alancon	
	7/2498	Facer, Lt Robert H	13	F-5B 42-67395	Brest Pen, Fougeres-Alancon	
	7/2499	Bickford, Lt Wilbur E	13	F-5E 43-28324	Brest Pen, Fougeres-Alancon	
	7/2500	Anderson, Lt J L	13	F-5B 42-68265	Brest Pen, Argentan area	
	7/2501	Schumacher, Lt Wesley A	27	F-5E 43-29026	Brest Pen,	
	7/2502	Campbell, Capt J L	27	F-5E 43-29027	Brest Pen, Flers area	
	7/2503	Graves, Lt Willard E	14	F-5B 42-68202	Brest Pen, Rennes/Flers area	
	7/2504	Simon, Capt Walter J	14	F-5B 42-67399	Brest Pen, Rennes/Flers area	
	7/2505	Matthews, Lt James B	22	F-5C 42-67108	Desures & Dieppe areas	
26	7/2506	McDonald, Lt Warren M	27	F-5B 42-68196		Met Flight
	7/2507	Wigton, Lt Irv	27	F-5E 43-29027	Angers & strip Tours area	
	7/2508	White, Lt Willie G	27	F-5E 43-28311	Millevaches area	
	7/2509	Florine, Lt Robert N	27	F-5B 42-68196	St Lo area (FW)	
	7/2510	Quiggins, Lt Richard S	22	F-5C 42-67114	Munich D/A, Neuaubing, Allach, 2 Munich A/Fs	
27	7/2511	Parker, Lt Grover P	27	F-5C 42-67550	Brest harbor, unid town & M/Y S & A/F W of Brest	
	7/2512	Brogan, Lt Richard W	27	F-5B 42-68235	Le Havre-Rouen-Fecamp	
	7/2513	Weir, Lt Harold G	22	F-5E 43-79006	Creil A/F, Le Treport, & 2 unid A/Fs in between	
28	7/2514	Aubrey, Capt Lawrence E	22	F-5C 42-67114		u/s cloud
	7/2515	Dixon, Capt Robert J	14	Spit XI PL782		u/s cloud
	7/2516	Bliss, Maj Kermit E	14	F-5B 42-67399	Walcheren Island	
29	7/2517	Richards, Lt John R	14	Spit XI MB955	Merseburg, Leuna D/A, Halle, Leipzig,-/Mockau A/F	
	7/2518	Clark, Lt Albert W	13	F-5E 43-28333	Bremen Oslebshausen D/A, Bad Zwischenahn A/F	
30	7/2519	Purdy, Lt Ira J	27	F-5	A/Fs: Dreux, Chateaudun, Herouville, Tours/Parcay Meslat, & unid A/F nr Chartres	
	7/2520	Hughes, Capt Malcolm D	22	F-5E 43-29004		u/s weather
	7/2521	Stamey, Lt Earl K	27	F-5		Met Flight
	7/2522	White, Lt Willie G	27	F-5	Vannes area	
	7/2523	McDonald, Lt Warren M	27	F-5	Lorient area	
31	7/2524	Windsor, Lt Robert D	22	F-5E 43-28577	Meaux area, Compeigne	Met Flight

Sortie List
1944

DATE	SORTIE	PILOT	SQ	A/C	TARGETS	INCIDENTS
31	7/2525	Alley, Lt Max P	27	F-5E 43-29000	St Malo	
	7/2526	Belt, Lt Taylor M	13	F-5E 43-28616	Mapping Brest Pen	
	7/2527	Batson, Lt Charles R	13	F-5E 43-29030	A/Fs: Dinard/Pleurtuit, Dinan/Trelivian; Dinan-Quentin	
	7/2528	Brink, Lt Fred B	13	F-5E 43-28990	Brest Pen	
	7/2529	Bickford, Lt Wilbur E	13	F-5B 42-67324	A/Fs: Dinard/Pleurtuit, Dinan/Trelivian; Dinan-Quentin	
	7/2530	Anderson, Lt J L	13	F-5E 43-28324	Mapping Brest Pen	
	7/2531	Elston, Lt Allan V	13	F-5B 42-68275	Mapping Brest Pen	
	7/2532	Facer, Lt Robert B	13	F-5E 43-28993	Mapping Brest Pen	
	7/2533	Brogan, Lt Richard W	13	F-5E 43-28337	Mapping Brest Pen	
	7/2534	Hawes, Lt Clark J	22	F-5C 42-67131	Mapping Brest Pen	
	7/2535	Ross, Lt John H	22	F-5E 43-79006	Mapping Brest Pen	
	7/2536	Kann, Lt Alexander A Jr	22	F-5C 42-67123	Mapping Brest Pen	
	7/2537	Carlgren, Lt Robert F	22	F-5E 43-28998	Mapping Brest Pen	
	7/2538	Graves, Lt Willard E	14	Spit XI MB950		u/s
	7/2539	Nesselrode, Capt George H	14	Spit XI PL866		u/s
	7/2540	Dixon, Capt Robert J	14	Spit XI MB948	Brest Pen	
	7/2541	Simon, Capt Walter J	14	Spit XI PL782	Brest Pen	
	7/2542	Bliss, Maj Kermit E	14	Spit XI PA841	Brest Pen	
	7/2543	Blyth, Lt John S	14	Spit XI PA944	Brest Pen	
	7/2544	Weitner, Maj Walter L	22	F-5C 42-67566	Mapping Brest Pen	
	7/2545	Cosby, Lt Irl R	22	F-5C 42-67108	Laval A/F, Granville, Brest Pen	
	7/2546	Leatherwood, Lt Arthur K	14	Spit XI 43-29009		
	7/2547	Egan, Lt Fabian J	14	F-5B 42-67202	Rennes-Laval area	
	7/2548	Brewster, Lt Ed L	27	F-5C 42-67124	Mapping Brest Pen, Granville	
	7/2549	Florine, Lt Robert N	27	F-5E 43-29027	Mapping Brest Pen	
	7/2550	Rickey, Lt Irwin J	27	F-5E 43-28311	Mapping Brest Pen	
	7/2551	Schumacher, Lt Wesley A	27	F-5E 43-29026	Granville, Rennes area	
	7/2552	Farley, Capt Donald A	22	F-5C 42-67114	Le Mans-Redon area	
	7/2553	Ward, Lt Walter B	27	F-5C 42-67550	Le Mans-Redon area	
	7/2554	Parker, Lt Grover P	27	F-5E 43-28619	Rennes M/Y, Rennes/St Jacques A/F, Le Mans-Redon area	
	7/2555	Williams, Lt E S	22	F-5E 43-29016	Northern France	
	7/2556	Adams, Lt Gerald M	27	F-5B 42-68196	Lorient, Brest Pen	
	7/2557	Wigton, Lt Irving	27	F-5B 42-67319	Vannes/Meucon A/F, St Brieug	
AUG						
1	7/2558	Simon, Capt Walter J	14	Spit XI PL872	Laval area	
	7/2559	Goffin, Lt Charles J J	14	Spit XI MB956		u/s
	7/2560	Blyth, Lt John S	14			u/s
	7/2561	Purdy, Lt Ira J Jr	27	F-5E 43-28311	Skryostrup, Hemmingstedt, Hage A/F	
	7/2562	Stamey, Lt Earl K	27	F-5B 42-67331	Skryostrup, Hemmingstedt D/A; Hage, Husum A/Fs	
	7/2563	Sommerkamp, Lt Frank M	13	F-5E 43-28616	Laval area	
	7/2564	Belt, Lt Taylor M	13	F-5B 42-67359	Laval area, strip Fougeres, vicinity Coutances	
	7/2565	Budrevich, Lt Gerald J	13	F-5B 42-67324	Laval area	
	7/2566	Schultz, Lt Donald A	13	F-5E 43-28993	Laval-Rennes area	
	7/2567	McKinnon, Lt Max E	22	F-5C 42-67108	Chateau Gontier area,	
	7/2568	Brunell, Lt Richard H	22	F-5E 43-28998	Rennes/St Jacques A/F, Chateau Gontier area, strip W coast Cherbourg Pen	
	7/2569	Weir, Lt Harold G	22	F-5E 43-79006	Chateau Gontier area, strip vicinity Dul to coast	
	7/2570	Wiebe, Lt Glen E	13	F-5E 43-28331	Lorient area	
	7/2571	Facer, Lt Robert H	13	F-5E 43-28990	Lorient area	
	7/2572	Brogan, Lt Richard W	13	F-5B 42-68207	Lorient area	
	7/2573	?Gilmore, Lt Louis	14			u/s
	7/2574	Schumacher, Lt Wesley H	27	F-5E 43-29026	Mapping Brest Pen	
	7/2575	White, Lt Willie G	27	F-5E 43-29027	Lorient area	
	7/2576	Rickey, Lt Irwin J	27	F-5C 42-67132	Lorient area	
	7/2577	Alley, Lt Max P	27	F-5C 42-67550	Lorient area	
	7/2578	Quiggins, Lt Richard S	22	F-5C 42-67114	Chateaubriant area, Isle St Anne, A/C off Cap de la Hague	
	7/2579	Windsor, Lt Robert D	22	F-5E 43-29016	Chateaubriant area, Avranches, Granville	
	7/2580	Ross, Lt John H	22	F-5C 42-67122	Chateaubriant	
	7/2581	Nesselrode, Capt George H	14	Spit XI PA842	Quimperle area	
	7/2582	Dixon, Capt Robert J	14	Spit XI MB948	Quimperle area	
	7/2583	Graves, Lt Willard E	14	Spit XI MB946	Quimperle area	
	7/2584		14	Spit XI	Quimperle area	
	7/2585	Weitner, Maj Walter L	22	F-5C 42-67566	Vannes area, Rennes A/F, strip Redee-Dul	
	7/2586	Hawes, Capt Clark J	22	F-5C 42-67131		u/s
	7/2587	Williams, Lt E S	22	F-5E 43-28577	Vannes area, Plateau-des-Minqueres, shipping off Meloir-des-Ondes	
	7/2588	Brewster, Lt Ed L	27	F-5E 43-28619	Vannes area	
	7/2589	Ness, Lt Donald A	27	F-5E 43-29000		u/s

355

Eyes of the Eighth

DATE	SORTIE	PILOT	SQ	A/C	TARGETS	INCIDENTS
1	7/2590	Bickford, Lt Wilbur E	13	F-5B 42-68265	Vannes area	
	7/2591	Kann, Lt Alexander A Jr	22	F-5E 43-79006	A/Fs: Chartres, Orleans/Bricy, Chateaudun, Tours/Parcay Meslay D/A	
	7/2592	Quiggins, Lt Richard S	22	F-5C 42-67114	Ploermec-Brulon, Jersey	
	7/2593	Windsor, Lt Robert D	22	F-5E 43-29016		A/C crashed Pilot killed
	7/2594	McKinnon, Lt Max E	22	F-5C 42-67254	Vannes area	
	7/2595	Brunell, Lt Richard H	22	F-5C 42-67122	Vannes area, Avranches	
	7/2596	Weir, Lt Harold G	22	F-5E 43-28998	Vannes area, St Malo-Jersey	
	7/2597	Batson, Lt Charles R	13	F-5B 42-28616	St Malo, Fougeres area	
	7/2598	Elston, Lt Allan V	13	F-5B 42-67324	Fougeres area, Mt St Michel	
	7/2599	Clark, Lt Albert W	13	F-5B 42-67359	Fougeres area, Mt St Michel, St Malo	
	7/2600	Anderson, Lt J L	27	F-5E 43-28993	Mt St Michel	
	7/2601	Florine, Lt Robert N	27	F-5B 42-67331	Redon area	
	7/2602	Wigton, Lt Irv	27	F-5B 42-68196	Redon area	
	7/2603	Parker, Lt Grover P	27	F-5E 43-29000	Redon area	
	7/2604	Ward, Lt Walter B	27	F-5C 42-67124	Rennes/St Jacques A/F	
	7/2605	Ricetti, F/O John	27	F-5E 43-28999		u/s cloud
2	7/2606	Matthews, Lt James B	22	F-5C 42-67108		Met flight
	7/2607	Cosby, Lt Irl R	22	F-5E 43-28998	Orleans/Bricy A/F D/A	
	7/2608	Chapman, Maj Carl J	22	F-5B 42-68205	Annecy area-Avranches	
	7/2609	Bruns, Lt Waldo C	13	F-5E 43-28331	Dudwigshaven M/Y & Chemical Works, Mannheim & M/Y, Bullay Br D/A, St Denis/Westrem A/F	
	7/2610	Clark, Lt Albert W	13	F-5E 43-28616	Wetzlar, Giessen A/F D/A	Intc
	7/2611	Wiebe, Lt Glen E	13	F-5E 43-28993	Rhine River, Koblenz M/Y, Wiesbaden RR, Russelheim Fact., Geinsheim, Kastelaun	
	7/2612	Goffin, Lt Charles J J	14	Spit XI MB956	Saarbrucken, Konz/Karthaus M/Ys; Metz area, Trier A/F	
	7/2613	Richards, Lt John R	14	Spit XI PA841	Neuvy sur Loire RB, Montrerau-Font-Yonne RR facility, Paris Oil tanks,-/ Gennevilliers Petrol Depot, Le Bourget A/F	
	7/2614	Balogh, Lt Paul A	14	F-5E 43-29009	Area SE of Cambrai, Grass A/F, St Ghislain M/Y	
	7/2615	Blyth, Lt John S	14	Spit XI PA944	Rouen, Melun/Villeroche, Nogent D/A, Fourneval/Bois de Mont, Creil	
	7/2616	Adams, Lt Gerald M	27	F-5E 43-28999	Quedlingberg, Eicmelon, Wolfesburg, Morse, Eschede A/F, Halberstadt	
	7/2617	McDonald, Lt Warren M	27	F-5C 42-67550	Utrecht, Delft area	
	7/2618	Budrevich, Lt Gerald J	13	F-5E 43-29030		u/s Intc
	7/2619	Purdy, Lt Ira J	27	F-5E 43-28311	A/Fs: Travemunde,-/Priwall, Lubeck/Blanken,-/ Palingen, Tarnewitz/Bottenhagen, Alhorn, Rerik West	
	7/2620	Childress, Capt Hubert M	27	F-5B 42-68196	Wismar, Warelbusch, Sage, Brunsbuttel, Wildeshaven	
3	7/2621	Bliss, Maj Kermit E	14	Spit XI PA842	A/Fs: Laon/Couvron,-/Athies, Cleres, Crex; Rouen	
	7/2622	Stamey, Lt Ernie K	27	F-5B 42-67331	A/Fs: Varrelbusch, Teuge, Ohrte, Twente/Enschede, Alhorn; M/Ys: Deventer, Apeldorn; Noordwal	
	7/2623	Ness, Lt Donald A	27	F-5E 43-28999	Soesterberg, Utrecht, A/Fs: Hesepe/Bramstr, Bissel, Vechta, Aalhorn; Handorf/Munster	
	7/2624	Hughes, Capt Malcolm D	22	F-5E 43-29004		Canc
	7/2625	Graves, Lt Willard E	14	Spit XI MB946	Remy, Corbie, Amiens/Glisy A/F	
	7/2626	Saxton, Lt J W	27	F-5C 42-67550	A/Fs: Texel, Amsterdam/Schipol; Amsterdam, Ijmuiden, Den Helder	
	7/2627	Simon, Capt Walter J	14	Spit XI PL792	Saarbrucken, Strasbourg, Merkwiller, A/Fs: Ensheim, Hagenow, Saarebourg	
	7/2628	Dixon, Capt Robert J	14	Spit XI MB948	Nancy/Essy A/F, Mulhouse M/Y	
	7/2629	Gilmore, Lt Louis M	14	F-5B 42-68202		u/s cloud
	7/2630	Fish, Lt Bruce B	14	F-5E 43-29009	Paris	
	7/2631	Batson, Lt Charles R	13	F-5E 43-28333	Lille-Tournai-Ath-Grammont-Melle-Malines-Antwerp RR, Ghent-Terneuzen, Tremonde, Brussels	
	7/2632	Sommerkamp, Lt Frank M	13	F-5E 43-28990	A/Fs: Wahen, Lippe, Fulda, Breitsheid, Ettinghausen; Fulda, Geussen, Duren	
	7/2633	Brink, Lt Fred B	13	F-5B 42-67324	Ludwigshaven, Mannheim, Antwerp, Bruges, Ostend, Dunkirk, A/Fs: Maitzborn, Biblis, Kastellaun	
	7/2634	Floyd, Lt Robert C	27	F-5C 42-67123		u/s cloud
	7/2635	Alley, Lt Max P	27	F-5B 42-68196	Misburg, Ehra, Halberstadt, Fallersleben, Harskamp, Arnheim, Munster	
	7/2636	White, Lt Willie G	27	F-5C 42-67124	Gifhorn, Ehra, Halberstadt, Quedlinburg, Munster, Arnheim	
	7/2637	Elston, Lt Allan V	13	F-5B 42-68265	A/Fs: Marville, Roubaix, St Omer, Chievres, Nivelles, Liege/Bierset, Rauhe/Kwipp, Niedermedig	
4	7/2638	Rickey, Lt Irvin J	27	F-5E 43-28311	Hanover M/Y, Hesepe area	
	7/2639	Brewster, Lt Edgar L	27	F-5B 42-68196	Hanover-Dummer Lake	
	7/2640	Schultz, Lt Donald A	13	F-5E 43-28990	Schweinfurt, Ebelsbach, Duren, Frankfurt, Weisbaden, A/Fs: Vogelsang, Hanau, Glenhausen, Rauhe/Kwipp	
	7/2641	Leatherwood, Lt Arthur J	14	Spit XI PA842	Lille area	
	7/2642	Goffin, Lt Charles J J	14	Spit XI MB956	Strasbourg, Merkwiller D/A, Haguenay M/y	
	7/2643	Belt, Lt Taylor M	13	F-5B 42-28333	A/Fs: Wahn, Lippe, Breitsheid, Ettingshausen, Giessen, Fulda; Duren D/A	
	7/2644	Harmon, Lt Ronald W	27	F-5B 42-67342	A/Fs: Texel, Leeuwarden	
	7/2645	Florine, Lt Robert N	27	F-5E 43-28999	D/As: Bremen, Hamburg, Kiel; A/Fs: Husum, Olderup; Freidrichsor	
	7/2646	Ward, Lt Walter B	27	F-5C 42-67550	D/As: Bremen, Hamburg; Husum A/F	

Sortie List 1944

DATE	SORTIE	PILOT	SQ	A/C	TARGETS	INCIDENTS
4	7/2647	Farley, Capt Donald A	22	F-5C 42-67254	Paris, Le Havre, A/Fs: Ascheres le Marche, Chateauroux/La Martinerie	
	7/2648	Adams, Lt Gerald M	27	F-5C 42-67242		
	7/2649	Anderson, Lt J L	22	F-5E 43-28616		
	7/2650	Batson, Lt Charles R	13	F-5B 42-67395		
	7/2651	Matthews, Lt James B	22	F-5C 42-67108		u/s
	7/2652	Childress, Capt Hubert M	27	F-5E 43-29000	Schwerin, Anklam, Stralsund, Rostock, Wismar, Lubeck, Leeuwarden	
	7/2653	Purdy, Lt Ira J	27	F-5C 42-67122	Wilhelmshaven, Peenemunde, Stralsund, Rostock, A/Fs: Lubeck/Blankensee, Kaltenkirchen	
	7/2654	Wigton, Lt Irv	13	F-5B 42-67331	A/Fs: Blankensee, Kuinre area; Schwerin, Wismar, Rostock D/A	
	7/2655	Schumacher, Lt Wesley A	27	F-5E 43-29026	D/As: Schwerin, Wismar; N of Lubeck	
	7/2656	Brink, Lt Fred B	13	F-5E 43-29030		u/s
	7/2657	Hawes, Lt Clark	22	F-5C 42-67131	Stargard, Amsterdam/Schipol A/F	
	7/2658	Moss, Lt Robert E	13	F-5B 42-67332		u/s
	7/2659	Egan, Lt Fabian J	14	Spit XI PA841	A/Fs Amiens area	
	7/2660	Richards, Lt John R	14	Spit XI MB955	Juigny, Bacy sur Armoncon, Troyes, St Florentin	
	7/2661	Brogan, Lt Richard W	13	F-5B 42-67359	Ghent-Lille RR, Boulogne	
	7/2662	Facer, Lt Robert H	13	F-5E 43-28993	Antwerp-Ghent RR, Dunkirk, Calais, Coxyde/Furnes A/F	
	7/2663	Sommerkamp, Lt Frank M	13	F-5B 42-68235		u/s
	7/2664				Coast Dunkirk to Dieppe & to Somme River then to Serqueux	
	7/2665				Stendal area, Ehra area	
	7/2666	Stamey, Lt Earl K	27	F-5C 42-67132	A/Fs: Ehra, Wesendorf, Gardeligen, Weisseswarte; Vorsfelde Canal, Gifhorn, Stendal	
	7/2667	Wiebe, Lt Glen E	13	F-5B 42-67332	Strips S of Scheldts-Turnhout, Strip N of Dusseldorf	
	7/2668	Bickford, Lt Wilbur E	13	F-5B 42-68265	Trier A/F, Mannheim area, St Omer-Boulogne	
	7/2669	Blyth, Lt John S	14	Spit XI PA842	Watten, Marquise/Mimoyecques, Wizernes (Aphrodite targets)	
5	7/2670	Kann, Lt Alexander A Jr	22	F-5E 43-29002		Met flight
	7/2671	White, Lt Willie G	27	F-5E 43-28619	Paris area	
	7/2672	Saxton, Lt John W	27	F-5B 42-68195	Paris area	
	7/2673	Parker, Lt Grover P	27	F-5C 42-67124	Paris area	
	7/2674	Alley, Lt Max P	27	F-5B 42-67342		u/s cloud
	7/2675				SW Paris area	
	7/2676	Ness, Lt Donald A	27	F-5E 43-29026		u/s cloud
	7/2677	Rickey, Lt Irwin J	27	F-5E 43-28311	Paris area	
	7/2678				Paris-Orleans	
	7/2679	Matthews, Lt James B	22	F-5C 42-67108	Chartres-Chateaudun area	u/s cloud
	7/2680	Cosby, Lt Irl R	22	F-5C 42-67566		u/s cloud
	7/2681	Weir, Lt Harold G	22	F-5E 43-28998		
	7/2682	Williams, Lt Eugene S	22	F-5E 43-28577	Beaumont/Le Roger A/F, Evereux area	
	7/2683	Farley, Capt Donald A	22	F-5C 42-67254	Paris area	
	7/2684	Carlgren, Lt Robert F	22	F-5E 43-28972		u/s cloud
	7/2685	Bruns, Lt Waldo C	13	F-5B 42-68265		u/s
	7/2686					u/s
	7/2687	Brogan, Lt Richard W	13	F-5B 42-67319		u/s
	7/2688	Clark, Lt Albert W	13	F-5B 42-28333	Mayenne area	
	7/2689	Budrevich, Lt Gerald J	13	F-5E 43-29030	Mayenne area	
	7/2690	Elston, Lt Allan V	13	F-5E 43-28616	Avranches-Fougeres-Bretagne area	
	7/2691	Brink, Lt Fred B	13	F-5E 43-28990	Paris area	
	7/2692	Schultz, Lt Donald A	13	F-5E 43-28993	Paris area	
	7/2693	Belt, Lt Taylor M	13	F-5B 42-68207	Paris area	
	7/2694	Quiggins, Lt Richard S	22	F-5C 42-67122	Paris area	
	7/2695	Ross, Lt John H	22	F-5E 43-79006	Chartres area	
	7/2696	Bliss, Maj Kermit E	14	Spit XI PA841	Toul/Croix de Metz A/F D/A, Metz area, Saarbrucken area, Etain/Rouvres A/F	
	7/2697	Fish, Lt Bruce B	14	F-5B 42-68202	Jussy, Beautor, Tregnier D/A, Amiens area, A/F nr Douai, St Pol to coast	
	7/2698	Facer, Lt Robert H	13	F-5B 42-67359	Paris area	
	7/2699	?Brogan, Lt Richard W	13		Senonches-St Amand	
	7/2700	Graves, Lt Willard E	14	Spit XI PL782	Eisenach, Kolleda A/F D/A	
	7/2701	Nesselrode, Capt George H	14	Spit XI PL842	Hamburg, Harburg D/A, Elbe Estuary, Brunsbuttel	
	7/2702	Dixon, Capt Robert J	14	Spit XI MB956	Hemmingstedt D/A, Brunsbuttel, Cuxhaven & area	
	7/2703	Adams, Lt Gerald M	27	F-5E 43-28999	Plantlunne, Nienburg, Brunswick,-/Waggum, Magdeburg, Hanover/Langenhagen	
	7/2704	Brewster, Lt Edgar L	27	F-5E 43-29026	Amsterdam, Meppel area	
	7/2705	Vassar, F/O Edgar L	13	F-5E 43 28993	Ghent-Terneuzen Canal, Hoboken-Steen-Bergen, Vilvorde D/A, Goes D/A, Brussels, Merchtem	
	7/2706	Simon, Capt Walter J	14	F-5B 42-68202	Belloy-sur-Somme, Monterolier/Buchy	
6	7/2707					Canc
	7/2708	Matthews, Lt James B	22	F-5E-43-28998		No Photos
	7/2709	Anderson, Lt J L	13	F-5E-43-29030	Special targets	

357

Eyes of the Eighth

DATE	SORTIE	PILOT	SQ	A/C	TARGETS	INCIDENTS
6	7/2710	Brink, Lt Fred B	13	F-5E-43-28990	Special targets	
	7/2711					Canc
	7/2712	Cosby, Lt Irl R	22	F-5C-42-67254	Le Mans, Paris area	
	7/2713	Weir, Lt Harold G	22	F-5C-42-67122	Le Mans, Paris area	
	7/2714	Quiggins, Lt Richard S	22	F-5E-43-28577	Le Mans, Paris area	
	7/2715	Ross Lt John H	22	F-5E-43-79006	Le Mans, Paris area, Orleans	
	7/2716	Grayson, Lt Benton C	22	F-5E-43-28972	Le Mans, Paris area	
	7/2717	Brunell, Lt Richard H	22	F-5C-42-67566	Le Mans, Paris area	
	7/2718	Clark, Lt Albert W	13	F-5E-43-28333	Le Mans, Paris area	
	7/2719	Elston, Lt Allan V	13	F-5B 42-67359	Dreux-Blois area	
	7/2720	Budrevich, Lt Gerald J	13	F-5B 42-68207	Dreux-Blois area	
	7/2721	Purdy, Lt Ira J	27	F-5E 43-28311	Le Mans, Paris area, Rouen	
	7/2722	Florine, Lt Robert N	27	F-5C 42-67124	Paris-Le Mans area	
	7/2723	Ward, Lt Walter B	27	F-5C 42-67132	Paris-Le Mans area	
	7/2724	Schumacher, Lt Wesley A	27	F-5E 43-28619	Paris-Le Mans area	
	7/2725	Harmon, Lt Ronald W	27	F-5B 42-67342		u/s
	7/2726	Wigton, Lt Irwin	27	F-5B 42-67331	Paris-Le Mans area	
	7/2727	Campbell, Capt J L	27	F-5C 42-68196	Paris-Le Mans area	
	7/2728	Saxton, Lt John W	27	F-5E 43-28999	Paris-Le Mans area	
	7/2729	Batson, Lt Charles K	13	F-5B 42-67319	Paris-Le Mans area	
	7/2730	Bickford, Lt Wilbur E	13	F-5E 43-28616	Paris-Le Mans area	
	7/2731	Schultz, Lt Donald A	13	F-5E 43-28324	Paris-Le Mans area	
	7/2732	Blyth, Lt John S	14	Spit XI PA944	Nienberg, Stendal, Brandenburg, Genshagen, Berlin, Basdorf, Fallersleben, Gifhorn	
	7/2733	Simon, Capt Walter J	14	Spit XI MB948	Schweinfurt, Ebelsbach; A/Fs: Gerolzhofen, Kolitzheim, Bad Nauheim, Manau/Langendiebach, Seligenstadt, Holzkirchen	
	7/2734	Richards, Lt John R	14	Spit XI MB956	Halberstadt, Magdeburg, Fallersleben, Brunswick, Dollbergen	
	7/2735	Ricetti, F/O John	27	F-5C 42-67132	A/Fs: Husum, Cuxhaven; Hamburg, Kiel Canal, Kiel/Holtenau,-/Wik	
	7/2736	White, Lt Willie G	27	F-5C 42-67242	Hamburg, Kiel Canal, A/Fs: Kiel/Holtenau,-/Wik; Bremen, Osebshausen Husum, Cuxhaven, Bergen/Alkmaar	
	7/2737	Parker, Lt Grover P	27	F-5E 43-28311	Hamburg, Emden	
	7/2738	McDonald, Lt Warren M	27	F-5C 42-67124	Peenemunde, Anklam, Nprdholz, Wilhelmshaven, Gustrow A/F	
	7/2739	Kann, Lt Alexander A Jr	22	F-5C 42-67122		u/s
7	7/2740	Schultz, Lt Donald A	13	F-5B 42-67359	Le Mans-Paris area, Dreux A/F	
	7/2741	Bickford, Lt Wilbur E	13	F-5E 43-28997	Le Mans-Paris area, Le Havre area	
	7/2742	Wiebe, Lt Glen E	13	F-5B 42-68207	Le Mans-Paris area, Chartres A/F	
	7/2743	Brink, Lt Fred B	13	F-5B 42-67332	Le Mans-Paris area	
	7/2744	Budrevich, Lt Gerald J	13	F-5B 42-67395	Le Mans-Paris area	
	7/2745	Vassar, F/O Edgar L	13	F-5E 43-28331		
	7/2746	Anderson, Lt J L	13	F-5		Canc
	7/2747	Facer, Lt Robert H	13	F-5E 43-28616	Le Mans-Paris area	
	7/2748	Brogan, Lt Richard W	13	F-5E 43-28324	Nogent-le-Rotrou RR M/Y	
	7/2749	Farley, Capt Donald A	22	F-5C 42-67566	Le Mans-Paris area, Orleans/Bricy A/F	
	7/2750	Matthews, Lt James B	22	F-5E 43-28577	Romorantin/Prunier A/F D/A	
	7/2751	Grayson, Lt Benton C	22	F-5C 42-67114	Le Mans-Paris area	
	7/2752	Weir, Lt Harold G	22	F-5E 43-28998	Orleans to Selles, Granville, Caen area	
	7/2753	Carlgren, Lt Robert F	22	F-5E 43-28972	Le Mans-Paris area	
	7/2754	Ross, Lt John H	22	F-5E 43-79006		
	7/2755	Ness, Lt Donald A	27	F-5B 42-67331	Le Mans-Paris area	
	7/2756	Stamey, Lt Earl K	27	F-5E 43-28619		
	7/2757	Parker, Lt Grover P	27	F-5E 43-29026	Paris-Orleans area, A/F Sens area	
	7/2758	Ward, Lt Walter B	27	F-5E 43-28999	Paris area	
	7/2759	Hilborn, Lt Robert B	14	Spit XI MB948	Paris,-/St Ouen, Juvisy	
	7/2760	Glaza, Lt Gerald J	14	Spit XI MB956	Compieline, Fismes, Anizy-Le Chateau	
	7/2761	Gilmore, Lt Louis M	14	Spit XI PA842	Nanteuil, St Florentin, Sens, Juvisy D/A	
	7/2762	Rawlings, Lt Irving L	14	Spit XI PA944	Saleux, Corbie, Doullens, Frevent, Recques sur Course D/A	
	7/2763	Harmon, Lt Ronald W	27	F-5C 42-67124	Hamburg, Schulau, Hemmingstedt; A/Fs: Wensendorf, Nordholz	
	7/2764	Alley, Lt Max P	27	F-5E 43-28311		u/s
	7/2765	Leatherwood, Lt Arthur K	14	Spit XI PL782	Remilly D/A, Boulogne	
	7/2766	Bliss, Maj Kermit E	14	Spit XI PA944	A/Fs: Berlin/Schonefelde, Gatow, Staaken; D/As: Brandenburg, Genshagen, Marienfelde, Niederschoneweide	
	7/2767	Batson, Lt Charles R	13	F-5E 43-28616	Dreux area, St Andre de l'Eure A/F, St Valery-en-Caux	
	7/2768	Elston, Lt Allan V	13	F-5B 42-67359	Dreux area	
	7/2769	Sommerkamp, Lt Frank M	13	F-5E 43-28993	Paris area, Chartres area	
	7/2770	Davidson, Lt Verner K	14	F-5B 42-67339	Paris area, Cleres area	
	7/2771	Farley, Capt Donald A	22	F-5C 42-67566	Orleans/Bricy A/F, Orleans-Chartres area,	
	7/2772	Matthews, Lt James B	22	F-5C 42-28577	Paris area, Rouen	
	7/2773	Brunell, Lt Richard	22	F-5E 43-28998		Canc

Sortie List 1944

DATE	SORTIE	PILOT	SQ	A/C	TARGETS	INCIDENTS
7	7/2774	Weir, Lt Harold G	22	F-5C 42-67114	Paris area	
	7/2775	Cosby, Lt Irl R	22	F-5E 43-79006	Orleans-Chartres area, Rouen	
	7/2776	Carlgren, Lt Robert F	22	F-5E 43-28972	Orleans-Breux area	
	7/2777	Schumacher, Lt Wesley A	27	F-5B 42-68196	Paris area	
	7/2778	Alley, Lt Max P	27	F-5E 43-28619		
	7/2779	McDonald, Lt Warren M	27	F-5E 43-28999		u/s intc
	7/2780	Richards, Lt John R	14			Canc
8	7/2781	Dixon, Capt Robert J	14	Spit XI		u/s weather
	7/2782	Adams, Lt Gerald M	27	F-5E 43-29026	Paris area	
	7/2783	Purdy, Lt Ira J	27	F-5E 43-29000	Paris/La Chapelle M/Y, Paris area, A/Fs: Louvers, Rouen	
	7/2784	Wigton, Lt Irwin	27	F-5E 43-28999	Dieppe, Melun/Villaroche A/F, Paris area, Mezieres area	
	7/2785	Saxton, Lt John W	27	F-5B 42-67331	Paris area	
	7/2786	Quiggins, Lt Richard S	22	F-5C 42-67114	Paris-Rouen area	
	7/2787	McKinnon, Lt Max E	22	F-5E 43-28577	Evereux M/Y,-/Fauville A/F, Conflans, Elboeuf, Orival Br, Paris area	
	7/2788	Brunell, Lt Richard H	22	F-5E 43-28998	Paris area, Rouen-Dieppe	
	7/2789	Brink, Lt Fred B	13	F-5E 43-28990	Chateaudun-Blois area	
	7/2790	Budrevich, Lt Gerald J	13	F-5B 42-67395	Chateaudun area	
	7/2791	Vassar, F/O Edgar L	13	F-5E 43-28610	Paris area	
	7/2792	Wiebe, Lt Glen E	13	F-5B 42-68207	Fecamp, Vendome area	
	7/2793	Bickford, Lt Wilbur E	13	F-5B 42-67319	Fecamp, Paris area	
	7/2794	Schultz, Lt Donald A	13	F-5B 42-67359	Paris area	
	7/2795	Anderson, Lt J L	13	F-5E 43-29030	Evereux-Chartres area, St Valery-en-Caux area	
	7/2796	Clark, Lt Albert W	13	F-5E 43-28333	Dreux area	
	7/2797	Facer, Lt Robert H	13	F-5E 43-28993	Paris area	
	7/2798	Gilmore, Lt Louis M	14	Spit XI PA944	St Florentin, Barron, Marlott D/A	
	7/2799	Egan, Lt Fabian J	14	Spit XI PA842	Beuvry, Courchelles D/A, Boulogne	
	7/2800	Glaza, Lt Gerald J	14	Spit XI MB956	Frevent, Achiet A/F D/A	
	7/2801	Rawlings, Lt Irv L	14	Spit XI PL866	St Just-en-Chaussee, Jussy & Amiens Brs, La Mere area, Jussy Br D/A, Clastres A/F	
	7/2802	Brogan, Lt Richard W	13	F-5E 43-28331	Dulmen, Annaberg, Muhlberg, Mulhausen, Termonde, Ghent-Terneuzen Canal, Borkenberge A/F	
	7/2803	Grayson, Lt Benton C	22	F-5E 43-28972	La Roche-sur-Yon A/F, Le Havre area, Cognac-Falaise area	
	7/2804				Visual reconnaissance	
	7/2805				Visual reconnaissance	
	7/2806	Ross, Lt John H	22	F-5C 42-67566	Rocquancourt-St Pierre-Flers-Vire area	
	7/2807	Hartwell, Lt Col Norris E	22	F-5B 42-68235	Jussy Br, A/Fs: Clastres, La Perthe, Romilly-sur-Seine, St Andre de l'Eure, Villaroche, Villacoublay, Amiens/Glisy; M/Ys: Chauny, Tergnier, Choisy Lle Roi	
	7/2808	Chapman, Maj Carl J	22	F-5B 42-67399	Jussy Br, A/Fs: Amiens/Glisy, Clastres, Buc, Rosierres-en-Santerre, Villacoublay, Morane, Melun/Villaroche, St Quentin	
	7/2809	Matthews, Lt James B	22	F-5C 42-67131	Caen area D/A	
9	7/2810	Nesselrode, Capt George H	14	Spit XI PL866	A/Fs: Laupheim, Lechfield? Leck	
	7/2811	Dixon, Capt Robert J	14	Spit XI PA944	Neuanbing, Oberpffenhofen, Munich,-/Reim,-/Neubiberg A/Fs, Schleissheim	
	7/2812	Davidson, Lt Verner K	14	Spit XI PA842	Strasbourg, Quesnay	
	7/2813	Kann, Lt Alexander Jr	22	F-5E 43-28998	A/Fs: Chartres, Chateaudun	
	7/2814	Batson, Lt Charles R	13	F-5E 43-28333	A/Fs: Vitry, Denain/Prouvy; Lens, Valenciennes, Mons, La Louviere, Namur, Charleroix, Douai, Hautmont, Le Quesnay area	
	7/2815	Brogan, Lt Richard W	13	F-5B 42-67332	Bois de l'Houssaire, Chievres A/F, Ghent/Terneuzen Canal, Andenne	
	7/2816		13			u/s
	7/2817	Sommerkamp, Lt Frank M	13	F-5B 42-67395	Tours area	
	7/2818	Clark, Lt Albert W	27	F-5B 42-67359		KIA
	7/2819	Budrevich, Lt Gerald J	13	F-5E 43-28616	Courtrai-Ghent-Malines-Antwerp RR	
	7/2820	Elston, Lt Allan V	13	F-5B 42-68235	Dunkirk, & to Amiens; Cap Gris Nez, Le CroToy, Abbeville area to Gravelines, Dieppe	
	7/2821	Vassar, F/O Edgar L	13	F-5B 42-67319	Maubege-Charleroix-Namur, Liege RR, Maubege, Lille/Vendreville A/F	
10	7/2822	Hawes, Capt Clark T	22	F-5B 42-67131	Aigrefeville, Nantes, St Nazaire, Strip Castelli Pont-Muzillac-Sulniac-Ploermel	
	7/2823	Cosby, Lt Irl	22	F-5E 43-28998	Evereux area	
	7/2824	Carlgren, Lt Robert	22	F-5E 43-28577	Evereux area	
	7/2825	Farley, Capt Donald A	22	F-5C 42-67254	Evereux area	
	7/2826	Tostevin, Lt J F	14	Spit XI MB948	Bretigny A/F D/A, Longemil/St Marie A/A, Strip Longneil to Bretfuil	
	7/2827	Leatherwood, Lt Arthur	14	Spit XI MB955	D/As: Sens, Joigny, St Florentin	
	7/2828	Goffin, Lt Charles J J	14	Spit XI MB956	Calmency/Coulanges, Joigny, St Florentin, Sens, Pacy-sur-Armancon D/As	
	7/2829	McKinnon, Lt Max E	22	F-5C 42-67114	A/Fs: La Roche-sur Yon, Dav; St Loubes, Montbartier D/As	
	7/2830	Richards, Lt John R	14	Spit XI MB946	Luxembourg, Saarbrucken, Pirmanes, Karlsruhe D/As; A/Fs: Saargumines, Karlsruhe	
	7/2831	Weir, Lt Howard G	22	F-5E 43-28998	A/Fs: Bourges,-/Nohant, Avord, Orleans/Bricy, Chartres, Evereux/Fauville; Strip N of Guerbeville	
	7/2832	Brink, Lt Fred B	13	F-5E 43-28324	Area E of Luxembourg	

359

Eyes of the Eighth

DATE	SORTIE	PILOT	SQ	A/C	TARGETS	INCIDENTS
11	7/2833	Blyth, Lt John S	14	Spit XI PL866	Allach, Laupheim, Augsburg D/A, Moosburg, Saarbrucken	
	7/2834	Farley, Capt Donald A	22	F-5C 42-67254	Dijon area	
	7/2835	Brunell, Lt Richard H	22	F-5E 43-29004		u/s
	7/2836	Gilmore, Lt Louis	14	Spit XI PA944	Belfort D/A, Mulhouse strike	to Alghero
	7/2837	Rawlings, Lt Irv L	14	Spit XI MB956	St Florentin, Pacy-sur-Armancon D/A, Montdidier M/Y	
	7/2838	Fish, Lt Bruce B	14	Spit XI MB946	A/Fs: Toussus/Le Noble, Orly, Villacoublay, Grass, Coulommiers/Voisin D/A	
	7/2839	Quiggins, Lt Richard E	22	F-5E 43-28577	Montbartier D/A, St Nicholas-Tours-Le Mans area	
	7/2840	Brunell, Lt Richard H	22	F-5E 43-29006	Laval-Le Mans RRs	
	7/2841					Canc
	7/2842	Hilborn, Lt Robert B	14	Spit XI MB955		u/s
	7/2843	Ross, Lt John H	22	F-5E 43-28998	Mezidon-Argentan-Alencon RRs	
	7/2844	Grayson, Lt Benton C	22	F-5C 42-67114	Lamballe-Brest Rrs, Erquy A/F	
	7/2845	Wiebe, Lt Glen E	13	F-5E 43-28333	Rhine N of Koblenz, A/Fs: Bassenheim, Vogelsang/Eifel, Koblenz/Karthus; Speicker, Maitzborn	
	7/2846	?Bickford	13	F-5		Canc
	7/2847	Floyd, Lt Robert C	27	F-5B 42-67331	Ijmuiden	
	7/2848	Anderson, Lt J L	13	F-5E 43-28997	Ijmuiden, Cuxhaven	
	7/2849	Leatherwood, Lt Arthur K	14	Spit XI PA841	Strasbourg M/Y & Oil depot, Saarbrucken M/Y D/A & strip 8m to NW	
	7/2850	Matthews, Lt James B	22	F-5E 43-29002	A/Fs: Brest/Guipavas, Lanveoc/Poulmic; Brest Harbor D/A	
	7/2851	Farley, Lt Donald A	22	F-5C 42-67254	Coastal areas Cannes-St Raphael; Bourges area-Le Havre	
12	7/2852	Graves, Lt Willard E	14	Spit XI MB950		Rec
	7/2853	Tostevin, Lt J F	14	Spit XI PA841		Rec
	7/2854	Egan, Lt Fabian J	14	Spit XI MB946	Strikes on A/Fs: Laon/Couvron,-/Athies, Juvincourt, Mourmelon-le-Grande; La Perthe LG	
	7/2855	Goffin, Lt Charles J J	14	Spit XI PA866		A/C u/s
	7/2856	Parker, Lt Grover P	27	F-5B 42-68196	Targets in France	
	7/2857	Rickey, Lt Irv J	27	F-5C 42-67242	Targets in France	
	7/2858	Belt, Lt Taylor M	13	F-5E 43-28324	Targets in France	
	7/2859	Goffin, Lt Charles J J	14	Spit XI PL866	D/As: Saarbrucken, Strasbourg, Metz M/Y & RR shops	
	7/2860	Bickford, Lt Wilbur E	13	F-5B 42-68235	Calais, S of Ostend, Frankfurt, Gotha, Eisenach, Antwerp, strip Bruges-Calais	
	7/2861	Hartwell, Lt Col Norris E	22	F-5B 42-67319		MIA-POW
	7/2862	Chapman, Maj Carl J	22			
	7/2863	Robertson, Maj C T		F-5B 42-68265		
	7/2864	Gilmore, Lt Louis M	14	Spit XI PA944	Targets of Opportunity	Rtd frm Alghero
	7/2865	Hilborn, Lt Robert B	14	Spit XI MB950		
	7/2866	Kann, Lt Alexander A Jr	22	F-5E 43-29004	Dijon, Fecamp	
	7/2867					
	7/2868					Canc
	7/2869					Canc
	7/2870	Ricetti, F/O John	27	F-5E 43-29000		
	7/2871	Stamey, Lt Earl K	27	F-5E 43-29026	Paris area	
	7/2872	Ness, Lt Donald A	27	F-5C 42-67242		
	7/2873	Schultz, Lt Donald A	13	F-5B 42-28990		
	7/2874	Graves, Lt Willard E	14	Spit XI PL866	Targets in France	
	7/2875	Weir, Lt Harold G	22	F-5E 43-99006	Vernon RB, Paris area, Chartres-Gassicourt, Aincourt-Santeuil	
	7/2876	Carlgren, Lt Robert E	22	F-5C 42-67254		
	7/2877	McKinnon, Lt Max E	22	F-5B 42-28577		
	7/2878	Ross, Lt John H	22	F-5C 42-67131		
	7/2879	Ward, Lt Walter B	27	F-5B 42-67132	Paris/Tuvisy M/Y, Conflans RB, A'Fs: Beaumont-sur-Oise, Le Bourget	
	7/2880	Brink, Lt Fred B	13	F-5B 42-68207		
	7/2881					u/s
13	7/2882	Richards, Lt John R	14	Spit XI PL782	Strasbourg D/A, Luxembourg, A/Fs: Hagenau, Epinoy; Arras, Saarebourg, Metz, Boulogne Forest	
	7/2883	Hawes, Lt CLark J	22	F-5C 42-67115	Tonnerre-St Briste Le V?	
	7/2884	Facer, Lt Robert H	13	F-5E 43-28990	Besancon area, A/Fs: St Dizier, Vitry-le-Francois; Reims, Strip Amiens along Somme	
	7/2885	Tostevin, Lt J F	14	Spit XI MB955	Lgs: Mourmelon-le-Grande, Chamant; Etampes/Mondesir A/F, nr Evreux D/As	
	7/2886	Weitner, Maj Walter L	22	F-5C 42-67254	Paris area, Manintenont, Les Andelys to Dieppe	
	7/2887	Brunell, Lt Richard H	22	F-5C 42-29004	Rouen, Elbeuf, Pont Audemer, Le Havre	
	7/2888	Cosby, Lt Irl R	22	F-5E 43-29002	St Malo D/A, Jersey, Aldernay	
	7/2889	Dixon, Capt Robert J	14	Spit XI PA944	A/Fs: Trier, Amiens/Glisy; Metz M/Y, Mourmelon-le-Grande LG, Strip Amiens to Boulogne	
	7/2890	Glaza, Lt Gerald J	14	Spit XI PA841	Le Manon Bridge D/A, Rouen	
	7/2891	Williams, Lt Eugene S	22	F-5E 43-28577	Troyes-Dijon area, A/F N of Orleans	
	7/2892	Sommerkamp, Lt Frank M	13	F-5B 42-68207	Namur-Charleroi-Maubege RR; Le Culot, Courtrai A/Fs	
	7/2893	Elston, Lt Allan V	13	F-5E 43-29030	Courtrai-Ghent-Malines-Antwerp RRs	
	7/2894	Brogan, Lt Richard W	13	F-5E 43-28324	Malines-Brussels-Mons-Valenciennes RRs Valenciennes-Cap Gris Nez	
	7/2895	Matthews, Lt James B	22	F-5C 42-67131	Conches area to Fecamp	

Sortie List
1944

DATE	SORTIE	PILOT	SQ	A/C	TARGETS	INCIDENTS
14	7/2896	Batson, Lt Charles R	13	F-5B 42-68265	Beauvais area	
	7/2897	Budrevich, Lt Gerald J	13	F-5E 43-29030	Le Treport, Beauvais area	
	7/2898	Vassar, F/O Edgar L	13	F-5B 42-67395	Beauvais area	
	7/2899	Nesselrode, Capt George H	14	F-5B 42-68202	Lyon/Bron A/F D/A	
	7/2900	Brink, Lt Fred B	13	F-5E 43-28333	Beauvais area	
	7/2901	Facer, Lt Robert H	13	F-5E 43-28331	Beauvais area	
	7/2902	Bickford, Lt Wilbur E	13	F-5E 43-28993	Beauvais area	
	7/2903	Sommerkamp, Lt Frank M	13	F-5B 42-68265	Beauvais area	
	7/2904	Schultz, Lt Donald A	13	F-5E 43-28324	Beauvais area	
	7/2905	Wiebe, Lt Glen E	13	F-5B 42-68235		u/s
	7/2906	Quiggins, Lt Richard E	22	F-5E 43-67254	Beauvais area	
	7/2907	Grayson, Lt Benton C	22	F-5E 43-28577	Beauvais area	
	7/2908	Kann, Lt Alexander A Jr	22	F-5E 43-28972	Beauvais area	
	7/2909	Hughes, Capt Malcolm D	22	F-5E 43-29004	A/Fs: Beauvais/Tille,-/Nivilliers, Cormeilles-en-Vexin	
	7/2910	Alley, Lt Max P	27	F-5C 42-67123	Beauvais area	
	7/2911	Purdy, Lt Ira J	27	F-5C 42-67124	Beauvais area	
	7/2912	Ward, Lt Walter B	27	F-5C 42-67132	Beauvais area	
	7/2913	McDonald, Lt Warren M	27	F-5E 43-29000	Beauvais area	
	7/2914	Rickey, Lt Irwin J	27	F-5E 43-29026	Beauvais area	
	7/2915	Simon, Capt Walter	14	Spit XI PL866	A/Fs: Dijon/Longvic, Dole/Tavaux D/A, Arnay/Le Duc; Paris, Melun area	
	7/2916	McKinnon, Lt Max E	22	F-5E 43-29002	Mapping Belle Isle, Lorient Br, M/Y nr Channel Islands	
	7/2917	Balogh, Lt Paul	14	Spit XI PA892	Anizy, Fismes Brs D/A; Strip Fruges-Calais	
	7/2918	Fish, Lt Bruce B	14	Spit XI MB946		Canc
	7/2919	Matthews, Lt James B	22	F-5E 43-79006	Paris area	
	7/2920	Brunell, Lt Richard	22	F-5B 42-67131	Paris area, Rouen area	
	7/2921	Wiebe, Lt Glen E	13	F-5B 42-67395	Beauvais area	
	7/2922	Brogan, Lt Richard W	13	F-5B 42-68265	Beauvais area, Poix A/F	
	7/2923	Elston, Lt Allan V	13	F-5B 42-67332	Beauvais area	
	7/2924	Hawes, Capt Clark J	22	F-5E 43-29004	Seine & Oise River Brs, Paris area, Ainscourt, Le Manior, Le Mesnil, Courcelles sur Seine, Oissel	
	7/2925	Carlgren, Lt Robert C	22	F-5E 43-28972	Paris area	
	7/2926	Fish, Lt Bruce B	14	Spit XI MB955	Angouleme, Saintes D/A, Angers	
	7/2927	Anderson, Lt J L	13	F-5E 43-28997	Paris area	
	7/2928	Moss, Lt Robert E	13	F-5E 43-28993	Gregnon-Rouen-St Vallery-en-Caux	
	7/2929	Schumacher, Lt Wesley A	27	F-5C 42-67123	Paris area	
	7/2930	Cosby, Lt Irl	22	F-5E 43-28577	Paris area	
	7/2931	Florine, Lt Robert N	27	F-5C 42-67132		Canc
	7/2932	Smith, Capt Robert R	13	F-5C 42-28324	Brux	MIA POW
	7/2933	Bruns, Lt Waldo	13	F-5E 43-28331	Brux	KIA
	7/2934	Wigton, Lt Irwin	27	F-5C 42-67242	Travemunde, Langeoog, Anklam, Nordeney A/Fs; Schulau OR	
	7/2935	Harmon, Lt Ronald W	27	F-5E 43-29000	Schulau, Anklam A/Fs; Saintes	
	7/2936	Blyth, Lt John S	14	Spit XI MB950	Metz/Frecaty, Malesheim A/Fs; Kaiserlautern to Landstuhl	
	7/2937	Graves, Lt Willard E	14	F-5B 42-68202	Ostend, Ghent Marine Yd, St Denis/Westram A/F, Ostend-Bruges-Ghent RR	
	7/2938	Goffin, Lt Charles J J	14	Spit XI PL782	Malines-Brussels-Valenciennes RRs	
	7/2939	Gilmore, Lt Louis M	14	Spit XI PA892	Antwerp, A/Fs: Antwerp/Duerne, Grimbergen; Antwerp-Malines-Brussels RRs, Termond-Ghent RRs	
	7/2940					Canc
	7/2941	Parker, Lt Grover P	27	F-5B 42-67124	A/Fs: St Andre de l'Eure, Beaumont Le Roger, Conches; La Heunliere, Pont Authou	
	7/2942	Budrevich, Lt Gerald J	13	F-5B 42-67332	A/Fs: Calais,-/Marck, Ypres, Moorseele, Vlamertinghe, Trier, Euren, Courtrai/Welghem, Le Culot; Trier M/Y	
	7/2943	Schultz, Lt Donald A	13	F-5B 42-67395	Paris area	
	7/2944	Sommerkamp, Lt Frank M	13	F-5E 43-28990	Paris area	
	7/2945	Bickford, Lt Wilbur E	13	F-5B 42-67332	Paris area, Abbeville, Amiens, St Valery-A-Somme, Strip Amiens to Le Crotoy	
	7/2946	Farley, Capt Donald A	22	F-5C 42-67254	Paris area	
	7/2947	Williams, Lt Eugene S	22	F-5B 42-67115	Paris area	
	7/2948	Weitner, Maj Walter L	22	F-5E 43-79006	Paris area, Abancourt SD	
	7/2949	Quiggins, Lt Richard S	22	F-5B 42-67131	Paris area	
	7/2950	Kann, Lt Alexander A Jr	22	F-5E 43-29004		u/s
	7/2951	Grayson, Lt Benton C	22	F-5E 43-28972	Paris area	
15	7/2952	Vassar, F/O Edgar L	13	F-5B 42-68265	Venlo A/F, Buer Scholven, Noord Buerand, Eisenach/Stockhausen, Homburg	
	7/2953	Belt, Lt Taylor M	13	F-5B 42-67332	Walcheren area, Homberg, Buer Scholven, Turnhout area Gelsenkirchen/Nordstern	
	7/2954	Dixon, Capt Robert J	14	Spit XI PL866	A/Fs: Stuttgart/Echtringen, Hagenau, Metz/Frecaty, Baden-Baden, Sachsenheim	
	7/2955	Rawlings, Lt Irving L	14	Spit XI PA892	Area cover of Avernes, Garennes, Beaumont le Roger, Brionne, & Pont Audemer	
	7/2956	Brink, Lt Fred B	13	F-5E 43-28616	Compeigne-Pierre Fonds-Beaumont	
	7/2957	Facer, Lt Robert H	13	F-5E 43-29030	Compeigne-Qulchy le Chateau, Compeigne-Verberie, Le Treport	
	7/2958	Brogan, Lt Richard W	13	F-5E 43-28333	A/Fs: Amiens/Glisy, Montdidier, Rosierres en Santerre, Compeigne-Neuilly St Front	
	7/2959	Wiebe, Lt Glen E	13	F-5E 43-28933	Haute/Fontaine A/F, Compeigne-Villers Cotterets, Dieppe-Le Treport	

361

Eyes of the Eighth

DATE	SORTIE	PILOT	SQ	A/C	TARGETS	INCIDENTS
15	7/2960	McKinnon, Lt Max E	22	F-5C 42-67254	Marne-Seine Canal, Chalons-Chaumont, Reims-Le Crotoy	
	7/2961	Kann, Lt Alexander A Jr	22	F-5C 42-67122	Compeigne-Vitry Le Francois-Charmont	
	7/2962	Ross, Lt John	22	F-5E 43-28972	Chalons-St Dizier-Chaumont	
	7/2963	Weir, Lt Harold G	22	F-5E 43-79006	Compeigne-Chaumont	
	7/2964	Florine, Lt Robert N	27	F-5C 42-67123	Paris area	
	7/2965	Saxton, Lt John W	27	F-5C 42-67124	Paris area	
	7/2966	Childress, Capt Hubert M	27	F-5E 43-29026	A/Fs: Plantlunne, Vechta, Achmer, Wittmundhafen, Landeog, Bad Zinisthenahn, Diepholz	
	7/2967	Adams, Lt Gerald M	27	F-5C 42-67242	A/Fs: Twente/Enschede, Plantlunne, Munster/Handorf, Soesterberg, Harskamp, Deelen, Ladbergen	
	7/2968	Glaza, Lt Gerald J	14	Spit XI PA841		u/s
	7/2969	Egan, Lt Fabian J	14	Spit XI MB950	Ghent-Wetteren-Termonde-Malines-Antwerp-Malines RR	
	7/2970	Moss, Lt Robert E	13	F-5E 43-28990	Ostend, Bruges, Ghent	
	7/2971	Sommerkamp, Lt Frank M	13	F-5B 42-68207	Ghent-Brussels-Malines RR, Ecloo A/F, Zeebruge	
	7/2972	Batson, Lt Charles	13	F-5B 42-68205	Brussels-Mons-Valenciennes RR, Brussels/Melbrock A/F, Ostend	
	7/2973	Elston, Lt Allan V	13	F-5E 43-29030	Trier HQ, A/Fs: Furnes, Chievres, Florennes/Juzaine, St Trond/Brustheim, Brussels/Evere	
	7/2974	Matthews, Lt James B	22	F-5E 43-29006	Compeigne-Dormans, Seine/Marne Canal-Chalons	
	7/2975	Brunell, Lt Richard S	22	F-5C 42-67566	Compeigne-Chalons sur Marne-Amiens area-Le Crotoy	
	7/2976	Schultz, Lt Donald A	13	F-5E 43-28333	Compeigne-Chalons sur Marne	
	7/2977	Wiebe, Lt Glen E	13	F-5E 43-28993	Compeigne-Chalons sur Marne	
	7/2978	Leatherwood, Lt Arthur	14	Spit XI PL866		u/s
	7/2979	Floyd, Lt Robert C	27	F-5C 42-67132		u/s cloud
	7/2980	Brewster, Lt Edgar L	27	F-5E 43-29000	Beauvais area, Dieppe, Clermont area	
	7/2981	Carlgren, Lt Robert	22	F-5E 43-29002	Paris area, Beauvais area, Amiens/Abbeville, Amiens	
	7/2982	Bliss, Maj Kermit E	14	Spit XI MB955	Nancy, Metz	
	7/2983	Hilborn, Lt Robert B	14	Spit XI PL782	Luxembourg, Metz,-/Frescaty A/F	
	7/2984	Budrevich, Lt Gerald J	13	F-5E 43-28616	A/Fs: Niedermendig, Limburg, Nancy/Hazeville, Brugg/Ste Croix, Frankfurt/Rebstock,-/Rhein Main	
	7/2985	Williams, Lt Eugene S	27	F-5C 42-67122	Luxembourg M/Y, Nancy/Essay A/F, Nancy, Metz, Pont A Mousson, Essey, Le Treport	
	7/2986	Belt, Lt Taylor M	13	F-5B 42-68265	Luxembourg, Metz, Nancy-Lay St Remy	
	7/2987	Ricetti, F/O John	27	F-5C 42-67123	Namur-Givet-Mezierres RR	
16	7/2988	Carney, Capt Frank K	27	F-5B 42-67341		Landed overseas
	7/2989	Stamey, Lt Earl K	27	F-5C 42-67124	A/Fs: Zwischenahn D/A, Vechta D/A, Wittmundhafen D/A, Texel, Soesterburg, Langeroog, Ahlorn	
	7/2990	Moss, Lt Robert E	13	F-5E 43-28997	Munster, Minden, Brunsbuttel, Kropp; Strip Frisian Islands, Mouth of Elbe River	
	7/2991	Alley, Lt Max P	27	F-5B 42-68205	Munster, Minden, Brunsbuttel	
	7/2992	Brink, Lt Fred B	13	F-5E 43-28990	Ruhland, Halle, Sorau, Forst, Sagan, Muhlberg, Cottbus A/F D/A, The Hague, Amsterdam, Ijmuiden	
	7/2993	Brogan, Lt Richard W	13	F-5E 43-28333	A/Fs: Halle, Hadegast, Cottbus D/A; Muhlberg, Ruhland	
	7/2994	Facer, Lt Robert H	13	F-5E 43-28993	D/As: Halle, Bohlen, Zeitz Rositz, Delitzsch, Schkeuditz; Haarlem area, Hook of Holland area	
	7/2995	Cosby, Lt Irl	22	F-5E 43-29002	A/Fs: Hildesheim,-/Himmelsthur, Achmer/Bramsche, Burg bei Magdeburg; Magdeburg, Dessau, Kothen, Halberstadt D/As	
	7/2996	Weitner, Maj Walter L	22	F-5C 42-67566	Belle Isle	
	7/2997	Blackburn, Lt W F		F-5E 43-29006	A/Fs: Langeroog, Harskamp, Deelen, Soesterburg; Noordney	
	7/2998	Shoop, Lt Col Clarence A	7	F-5C 42-67132	A/Fs: Langeroog, Harskamp, Deelen, Soesterburg; Noordney	
	7/2999	Chapman, Maj Carl J	7	F-5B 42-68207	A/Fs: Langeroog, Harskamp, Deelen, Soesterburg; Noordney	
	7/3000	Anderson, Lt J L	13	F-5E 43-28616	A/Fs: Langeroog, Harskamp, Soesterburg	
	7/3001	Ness, Lt Donald A	27	F-5C 42-67242	Belle Isle	
18	7/3002	Elston, Lt Allan V	13	F-5E 43-29030		Intc
	7/3003	Schultz, Lt Donald A	13	F-5E 43-28993	Rositz (explosion at oil refinery)	
	7/3004	Bickford, Lt Wilbur E	13	F-5E 43-28616		
	7/3005	Budrevich, Lt Gerald J	13	F-5B 42-68207		
	7/3006	Belt, Lt Taylor M	13	F-5B 42-67332		
	7/3007	Quiggins, Lt Richard S	22	F-5E 43-29006		
	7/3008	Kann, Lt Alexander A Jr	22	F-5C 42-67122		
	7/3009	Florine, Lt Robert N	27	F-5E 43-29000	Derailed train nr Breny, Ammo train explosion & rail gap nr Chovilly	
	7/3010	Ward, Lt Walter B	27	F-5B 42-67342		
	7/3011	Leatherwood, Lt Arthur K	14	Spit XI MB955	A/F D/As: Frankfurt/Eschorn, Mannheim/Sandhofen, Dockendorf; Bassenheim, Kastellaun	
	7/3012	Schumacher, Lt Wesley A	27	F-5B 42-68205		
	7/3013	Moss, Lt Robert E	13	F-5E 43-28997		
	7/3014	Weir, Lt Harold G	22	F-5C 43-29004	Mantes-Gasicourt, RR at La Queve-Les Yvelines; Mapping Paris area	
	7/3015	McKinnon, Lt Max E	22	F-5C 42-67115		
	7/3016	Tostevin, Lt J F	14	Spit XI PA892		

Sortie List
1944

DATE	SORTIE	PILOT	SQ	A/C	TARGETS	INCIDENTS
18	7/3017	Facer, Lt Robert H	13	F-5E 43-28333	9AF Tac targets Rouen area; RR factory Serqueux; Ammo dump Marseille-en-Beauvais; Fuel dump Chantilly Forest, RB Pontoise	
	7/3018	Saxton, Lt John W	27	F-5E 43-28311	Paris/Pontoise,-/Achers; Conflans	
	7/3019	McDonald, Lt Warren M	27	F-5E 43-29027		
	7/3010	Ross, Lt John H	22	F-5E 43-29002		
	7/3021	Grayson, Lt Benton C	22	F-5C 42-67131		
	7/3022	Carlgren, Lt Robert F	22	F-5C 42-67108		
	7/3023	Brunell, Lt Richard H	22	F-5C 42-67254		
	7/3024	Parker, Lt Grover P	27	F-5C 42-67124		
	7/3025	Rickey, Lt Irwin J	27	F-5C 42-67550		
	7/3026	Ricetti, F/O John	27	F-5C 42-67132		
	7/3027	Simon, Capt Walter J	14	Spit XI PL782		
	7/3028	McKinnon, Lt Max E	22	F-5C 42-67115		
	7/3029	Quiggins, Lt Richard S	22	F-5C 42-67122		
	7/3030	Floyd, Lt Robert C	27	F-5C 42-67242		
	7/3031	Brewster, Lt Edgar L	22	F-5E 43-29002		
	7/3032	Richards, Lt John R	14	F-5B 42-67399	Le Mesnil Manger, Vauxillon/Margival Le Coudray	1st use Infra red film: Camouflage detection
	7/3033	Balogh, Lt Paul A	14	Spit XI PA841		
	7/3034	Gilmore, Lt Louis M	14	Spit XI PA944	RR Namur to Meziers; other targets	
	7/3035	Fish, Lt Bruce B	14	Spit XI MB952	Targets in France	
	7/3036	Graves, Lt Willard E	14	Spit XI MB950	Meuse River Br nr Namur; Brs: Namur to Mastricht	
	7/3037	Harmon, Lt R W	27	F-5B 42-67331		
	7/3038				Kothen, Paderborn & area, The Hague area, Osnabruck area, Amsterdam, Arnhem, A/Fs: Rheine, Goslar, Gutersloh	
	7/3039	*Stamey, Lt Earl K	27	F-5B 42-67331	Longpont-Beauvardes, Binson-Drquigny-Damery, Courtemont, Varennes-Comblizy	*Landed away
19	7/3040	Vassar, F/O Edgar L	13	F-5E 43-29030		
	7/3041	Rawlings, Irv	14	Spit XI MB948	Charleville-Vitry RRs	
	7/3042	Blyth, Lt John S	14	Spit XI PA944		
	7/3043	Dixon, Capt Robert J	14	Spit XI PA944		
	7/3044	Goffin, Lt Charles J J	14	Spit XI PL866	Vise RB, Liege/Seraing RB, Huy-Ciney-Dinant RR	
	7/3045	Williams, Lt Eugene S	22	F-5C 42-67115	Paris area mapping	
	7/3046	**Ross, Lt John H	22	F-5C 42-67108	Seine-Marne Canal, Epernay-Vitry le Francois	**Landed away
	7/3047	Grayson, Lt Benton C	22	F-5C 42-67566	Paris area mapping	
	7/3048	Brink, Lt Fred B	13	F-5E 43-28616	Magdeburg A/C factory, nr Paderborn; A/Fs: Hopsten, Hamberstadt, & routine airfields.	
21	7/3039	*Stamey, Lt Earl K	13	F-5B 42-67331		*Returned
	7/3046	**Ross, Lt John H	22	F-5C 42-67108		**Returned
	7/3049					
23	7/3050				Cannes, and along the beachhead to Toulon	
	7/3051	Shoop, Lt Col Clarence	7	F-5B 42-68205	Paris low level obliques	
	7/3052	Chapman, Maj Carl J	7	F-5B 42-67331	Paris low level obliques	
	7/3053	Childress, Capt Hubert H	27	F-5B 42-68213	Paris low level obliques	
	7/3054	Wiebe, Lt Glen	13			KIA
	7/3055	Williams, Lt Eugene S	22	F-5C 42-67131		Canc
	7/3056	Cosby, Lt Irl R	22	F-5E 43-28972	Brs: Foulbec, Pont Ademee & SE of Montfort, Pont Authou, Brionne; St Martin de la Lieux	
	7/3057	Matthews, Lt James B	22	F-5C 42-67254		u/s cloud
24	7/3058	Purdy, Lt Ira J	27	F-5B 42-67331	Brunsbuttel, Kiel, Heligoland Kropp-Frederickstadt	
	7/3059	Batson, Lt Charles R	13	F-5E 43-28997	Brunsbuttel, Heligoland, Kropp/Garding area	
	7/3060	Wigton, Lt Irv	27	F-5E 43-29027	Politz, Kiel & area, Amsterdam	
	7/3061	Farley, Lt Donald A	22	F-5E 43-28998	Politz, Kiel, Ooster-Hesselen, Kropp area	
	7/3062	?Ness, Lt Donald A	27	F-5	Dockendorf A/F	
	7/3063	Simon, Capt Walter J	14	SPIT XI PL782	Kolleda, Weismar, Brux, A/Fs: Paderborn, Lippstadt area	
	7/3064	Bliss, Maj Kermit E	14	SPIT XI PL866	Merseburg, Bohlen, Rositz, Weimar, Erfurt area	
	7/3065	Blyth, Lt John S	14	SPIT XI PA944	Freital, Ruhland, Brux, Plauen, Kothen A/Fs; Lonnewitz, Preytzch	
	7/3066	Glaza, Lt Gerald J	14	SPIT XI MB946	Misburg, Brunswick, Hanover/Lagenhagen A/F	
	7/3067	Ward, Lt Walter B	27	F-5C 42-67242	Hemingstadt, Shipping Heligoland-Busch, Cuxhaven	
25	7/3068	Graves, Lt Willard E	14	Spit XI PL782	Eisenach, A/F D/As: Gotha, Weimar; Erfurt A/F	
	7/3069	Egan, Lt Fabian J	14	Spit XI PA892	Nordhausen A/F D/A, Noordwaal, Rotterdam; Merseburg/Leuna D/A	
	7/3070	Hilborn, Lt Robert B	14	Spit XI MB948	D/As: Misburg, Goslar A/F	
	7/3071	Weir, Lt Harold G	22	F-5E 43-299002	D/As: Les Foulons, Gien, Pacy-sur-Armancon, Montereau, Sully- sur-Loire, Bourrow-Marlotte; Romilly-sur-Seine M/Y	
	7/3072	Kann, Lt Alexander J Jr	22	F-5C 42-67122	Compeigne-Dormans-Vitry le Francois-Chaumont Canal	

363

Eyes of the Eighth

DATE	SORTIE	PILOT	SQ	A/C	TARGETS	INCIDENTS
25	7/3073	Carlgren, Lt Robert F	22	F-5E 43-28972	Seine-Marne Canal in Chalons & St Dizier	
	7/3074	Batson, Lt Charles R	13	F-5E 43-28997	Brunsbuttel, Kropp	
	7/3075	Quiggins, Lt Richard S	22	F-5C 42-67566	D/As: St Dizier A/F, Juvigny, Marselle en Beauvais, Beauvais Tille A/F, Beatuor, Chauny, Fismes; Amiens area	
	7/3076	Schumacher, Lt Wesley A	27	F-5E 43-28619	D/As: Schwerin A/F, Wismar, Rostock/Marienehe, Travemunde/Potenitz A/F	
	7/3077	Harmon, Lt Ronald W	27	F-5E 43-28999	D/As: Schwerin A/F, Wismar, Rostock/Marienehe, Heligoland, Travemunde/Potenitz A/F	
	7/3078	Alley, Lt Max P	27	F-5C 42-67242	Politz, A/Fs: Neubrandenburg, Peenemunde D/A, Putnitz, Rechlin; Heligoland	
	7/3079	Florine, Lt Robert N	27	F-5C 42-67123	A/Fs: Schwerin D/A, Palingen; W of Ludwigslust	
	7/3080	Williams, Lt Eugene S	22	F-5C 42-67115	Seine-Marne Canal, St Dizier A/F D/A	
	7/3081	McKinnon, Lt Max E	22	F-5c-42-67131	Seine-Marne Canal in Chaumont-Chalon, St Dizier area	
	7/3082	Leatherwood, Lt Arthur K	14	Spit XI MB952	Bruges-Valenciennes RR	
	7/3083	Tostevin, Lt J F	14	Spit XI PA841	Bruges-Ghent RR; Willbroek	
	7/3084	Cosby, Lt Irl R	22	F-5C 42-67108	D/As: Henin Lietard, Tertre, Mons	
26	7/3085	Dixon, Capt Robert J	14	Spit XI PL782		
	7/3086	Rawlings, Lt Irv	14			Canc
	7/3087	Richards, Lt John R	14	Spit XI MB955	Saarbrucken & area, Siegfried Line	
	7/3088	Balogh, Lt Paul R	14	Spit XI PA892	Siegfried Line	
	7/3089	Goffin, Lt Charles J J	14	Spit XI MB952	Merzig-St Ingbet, Siegfried Line	
	7/3090	Gilmore, Lt Louis M	14	Spit XI MB950	Mapping Siegfried Line	A/C u/s & cloud
	7/3091	Schultz, Lt Donald A	13	F-5B 42-68207	Rhine Valley-Koblenz area	
	7/3092	Nesselrode, Capt George H	13	F-5E 44-23700	Rhine Valley-Koblenz area	
	7/3093	Brogan, Lt Richard W	13	F-5B 42-68235	Rhine Valley-Koblenz area	
	7/3094	Elston, Lt Allan	13	F-5E 42-67332	Rhine Valley-Koblenz area	
	7/3095	Matthews, Lt James B	22	F-5C 42-67108	Darmstadt/Griesheim A/F, Rhine Valley	
	7/3096	Williams, Lt Eugene S	22	F-5C 42-67115	Frankfurt-Speyer area, St Omer/Longueness A/F	
	7/3097	Ross, Lt John M	22	F-5C 42-67131	A/Fs: Mannheim/Stadt, Biblis; Rhine Valley	
	7/3098	Adams, Capt Gerald M	27	F-5E 43-28169	Strasbourg area, Buhl-Griesbach	
	7/3099	Ricetti, Lt John	27	F-5E 43-28311		u/s
	7/3100	Stamey, Lt Earl K	27	F-5C 42-67550	Strasbourg	
	7/3101	Shade, Capt Walter D	13	F-5E 43-28333	A/Fs: Babenhausen, Lille/Nord, Gensheim, Frankfurt/Eschborn,-/Rebstock; Mainz-Frankfurt area, Lille	
	7/3102	Gonzalez, Lt Hector R	13	F-5B 42-68265	Mainz-Frankfurt area	
	7/3103	Belt, Lt Taylor M	13	F-5E 43-28616	Bingen-Aschaffenburg area	
	7/3104	Grayson, Lt Benton C	22	F-5C 42-67566	Mannheim-Speyer area	
	7/3105	Quiggins, Lt Richard S	22	F-5C 42-67114		Canc
	7/3106	Carlgren, Lt Robert F	22	F-5E 43-28972		u/s
	7/3107	Rickey, Lt Irwin J	27	F-5C 42-67124	Boulogne, Zeebruge, Strasbourg	
	7/3108	Ness, Lt Donald A	27	F-5B 42-67331	Trier A/F (FW), Rhine Valley	
	7/3109	Wigton, Lt Irwin	27	F-5B 42-67342		u/s
	7/3110	McKinnon, Lt Max E	22	F-5E 43-28577	Boulogne, Lille, Trier, St Omer area, Ludwigshaven, Karlsruhe area	
	7/3111	Kann, Lt Alexander	22	F-5C 42-67122	Rhine Valley	
	7/3112	Weir, Lt Harold G	22	F-5E 43-28998	Hochenheim-Rosatt	
	7/3113	McDonald, Lt Warren M	27	F-5E 43-29026	A/Fs: Amiens/Glisy, Yvrench; Cambrai,-/Niergnies A/F; Amiens/Longeau M/Y	
	7/3114	Saxton, Lt John W	27	F-5E 43-29027		u/s cloud
	7/3115	Purdy, Lt Ira J	27	F-5E 43-29000		u/s
	7/3116	Blyth, Lt John S	14	SPIT XI PL866		u/s cloud
	7/3117	Fish, Lt Bruce B	14	SPIT XI MB946		u/s cloud
	7/3118	Powers, Maj A D	W	F-5B 42-68205	Fournival Bois de Mont Pol D/A, Beauvais/Nivilliers A/F, Manquenchy, St Gobain D/A, Juvignes, Fiemes, Beautor	
	7/3119	Cosby, Lt Irl R	22	F-5E 43-29006	Givet-Dinant	
	7/3120	Sommerkamp, Lt Frank M	13	F-5E 43-28997	Minden, Munster	
	7/3121	Parker, Lt Grover P	27	F-5B 42-68213	Minden, Munster	
	7/3122	Ricetti, F/O John	27	F-5B 42-67132		u/s cloud
	7/3123	Glaza, Lt Gerald J	14	Spit XI MB948	Moerdijk D/A	
27	7/3124	Ward, Lt Walter B	27	F-5E 43-29027	Rostock; Parow Putnitz A/Fs	
	7/3125	Schumacher, Lt Wesley A	27	F-5E 43-29026		u/s
	7/3126	McDonald, Lt Warren M	27	F-5C 42-67123	Motor vessel off Den Helder	
	7/3127	Harmon, Lt Ronald W	27	F-5B 43-67342	Lubeck/Rostock, Texel A/Fs; Shipping: off Texel, off Den Helder	
	7/3128	Ross, Lt John H	22	F-5E 43-28998	Brest area, motor vessel in Audierne Bay	
	7/3129	Vassar, F/O Edgar L	13	F-5B 42-68207	Foret de la Land, Coulommier A/F, Fismes, Sully, Rouen area, Fontainbleau	
	7/3130	Brink, Lt Fred B	13	F-5E 43-28333	Rouen area, Sully sur Loire, Le Havre, Mantes, Compeigne area, River N of Rouen	
	7/3131	Quiggins, Lt Richard S	22	F-5C 42-67566	A/Fs: Abbeville/ Drucat, Nuncq, Vitry-en-Artois, Douai/Dechy, Peronne, Retmel-Challerange, Attigny, Frevent	
	7/3132	Carlgren, Lt Robert F	22	F-5E 43-28972	Henin-Letard, A/Fs: Lockendorf, Verdun, Sedan, Boulogne; Ehrang M/Y, Metz area	

Sortie List
1944

DATE	SORTIE	PILOT	SQ	A/C	TARGETS	INCIDENTS
27	7/3133	Facer, Lt Robert H	13	F-5B 42-68235	Emmerich, Salzbergen, Moerdijk, Zaltbommel area	
	7/3134	Budrevich, Lt Gerald J	13	F-5B 42-68265	Eindhoven A/F, Moerdijk	
	7/3135	Thies, Lt Everett	22	F-5B 42-67128	A/Fs: Abbeville/Drucat, Laon, Dijon, St Dizier/Robinson, Rheims/Champagne; Chalons, Epernay, Vitry le Francois	
	7/3136				A/Fs: Rosieres en Santerre, Romilly sur Seine, Dijon, Celles, Troyes; Chateau Thierry, Amiens area	
	7/3137	Nesselrode, Capt George	13	F-5E 43-28997	Cherbourg, Omaha Brach, Utah Beach	
	7/3138				Marseilles, Toulon, Tours, Le Mans area	
28	7/3139	Bickford, Lt Wilbur E	13	F-5E 43-28333	Bolbec, Rouen, Brest D/As	
31	7/3140	Adams, Capt Gerald	27	F-5C 42-29000		Met flight
	7/3141	Trimble, Capt H H	22	F-5C 42-67566	D/As: Boulogne Boursin, Forest D'Arqnes, Doullens	
SEPT						
1	7/3142	Chapman, Maj Carl J	7	F-5E 43-29006	St Denis/Westrem A/F, Zeebrugge area	
	7/3143	Florine, Lt Robert N	27	F-5B 42-68213	Chievres A/F, Zeebrugge area	
	7/3144	Purdy, Lt Ira J	27	F-5B 42-67331	Zeebrugge area	
	7/3145	Floyd, Capt Robert C	27	F-5C 42-67124	Courtrai M/Y, Zeebrugge area	
	7/3146	Parker, Lt Grover P	27	F-5E 43-29000	Zeebrugge area	
	7/3147	Wigton, Lt Irv	27	F-5B 42-67342	Zeebrugge area	
	7/3148	Brink, Lt Fred B	13	F-5E 43-28990	Zeebrugge area	
	7/3149	Elston, Lt Allan V	13	F-5E 43-28333	Zeebrugge area	
	7/3150	Brogan, Lt Richard W	13	F-5E 43-28616	Zeebrugge-Ghent area	
	7/3151	Batson, Lt Charles R	13	F-5E 44-23609	Zeebrugge area, Lille/Vendreville A/F	
	7/3152	?Sommerkamp, Lt Frank M	13	F-5	Zeebrugge area, Ursel A/F, Lille,-/Vendreville A/F	
	7/3153	?Moss, Lt Robert	13	F-5	Lille/Vendreville A/F, Aeltre, Zeebrugge	
	7/3154	Quiggins, Lt Richard S	22	F-5E 43-28577	Lille/Vendreville A/F, Ypres area, Strip Zeebrugge-Lille, Factory in Roulers area	
	7/3155	Kann, Lt Alexander Jr	22	F-5E 43-?39004		
	7/3156	Williams, Lt Eugene S	27	F-5E 43-28972	Bruges, Zeebrugge-Tournai area	
	7/3157	Burrows, Capt Daniel W	22	F-5E 43-23603	Zeebrugge area, Flushing	
	7/3158	Brunell, Lt Richard H	22	F-5B 42-67254		Canc
	7/3159	Matthews, Lt James B	22	F-5C 42-67108	Zeebrugge area	
	7/3160	Hoover, Maj John R	W	F-5B 42-68235	A/Fs: Cambrai/Niergnies, Vermand/Etriellers, Clastres, St Quentin/Roudy, Launching site SW St Omer area	
	7/3161			F-5		u/s cloud
3	7/3162	Brunell, Lt Richards H	22	F-5C 42-67254	Brest D/A & area	
5	7/3163	Rickey, Lt John J	27	F-5E 43-67242	Eindhoven A/F, Diest/Schaffen area	
	7/3164	Saxton, Lt John W	27	F-5C 42-67124		u/s cloud
	7/3165	Hilborn, Lt Robert	14	Spit XI PL782	(Stuttgart, Karlsruhe, Ludwigshaven)	MIA-POW
6	7/3166	Bliss, Maj Kermit	14	Spit XI MB946	Stuttgart D/A	
	7/3167	Bayne, Lt Donald B	13	F-5E 43-28333	Crozon area D/A, Anse de Cabestant D/A, Brest	
	7/3168	Austin, Capt J C	13	F-5E 43-28616	Brest area D/A	
	7/3169	Madden, Lt Ross	13	F-5E 43-28990		u/s cloud
	7/3170	Weir, Lt Harold G	22	F-5E 43-28998	Dune Island, Heligoland D/A	
	7/3171	Shade, Capt Walter D	13	F-5E 43-28993	St Quentin to Paris RR, Boulogne, Nunce A/F, Achiet A/F, Peronne M/Y	
	7/3172	Budrevich, Lt Gerald J	13	F-5B 42-67395	Arras to Moyencourt RR, Le Crotoy, Boulogne, Abbeville	
	7/3173	McBee, Capt Lawrence S	7	F-5B 42-67342	Paris-Troyes-Metz area	
8	7/3174	Florine, Lt Robert N	27	F-5E 43-29000	Rhine Valley	
	7/3175	Stamey, Lt Earl K	27	F-5C 42-67124	Rhine Valley	
	7/3176	White, Lt Willie G	27	F-5E 43-28311	A/Fs: Hagenau, Oppenburg/Baden, Strasbourg/Entzheim; Strasbourg M/Y, Hagenau-Colmar	
	7/3177	Ward, Lt Walter B	27	F-5C 42-67132		u/s
	7/3178	Ricetti, F/O John	27	F-5B 42-68213		u/s
	7/3179	Ness, Lt Donald A	27	F-5C 42-67124	Rhine Valley, Hagenau-Colmar	
	7/3180	Tostevin, Lt James F	14	Spit XI MB946	Ensheim A/F, Siegfried Line	
	7/3181	Dixon, Capt Robert J	14	Spit XI PL866	Siegfried Line, Merzig-Bitche	
	7/3182	Graves, Capt Willard E	14	Spit XI MB950	Siegfried Line	
	7/3183	Egan, Lt Fabian J	14	Spit XI MB948	Saarbrucken/Karlsruhe area	
	7/3184	Gilmore, Lt Louis G	14	Spit XI MB955	Siegfried Line	
	7/3185	Goffin, Lt Charles J J	14	Spit XI MB952	(Mapping Siegfried Line)	MIA-KIA
	7/3186	Cosby, Lt Irl R	22	F-5E 44-23695	Strasbourg-Mannheim	
	7/3187	Carlgren, Lt Robert F	22	F-5E 43-28972	Rhine Valley, Lauterburg-Strasbourg	
	7/3188	McKinnon, Lt Max E	22	F-5E 43-28577	Rhine Valley	

365

Eyes of the Eighth

DATE	SORTIE	PILOT	SQ	A/C	TARGETS	INCIDENTS
8	7/3189	Farley, Capt Donald A	22	F-5C 42-67566	Strasbourg-Mannheim	
	7/3190	Grayson, Lt Benton C	22	F-5C 42-67131	Strasbourg-Mannheim	
	7/3191	Ross, Lt John H	22	F-5E 43-29006	Strasbourg-Mannheim	
	7/3192	Bayne, Lt Donald B	13	F-5E 43-28616		u/s cloud
	7/3193	Anderson, Lt John L	13	F-5E 44-23693	D/As: Mainz, Russelheim, Bois de la Houssiere; A/Fs:Coxyde, Ypres/Poperinghe, Nivelles, Erbenheim; Calais, Gravelines	
	7/3194	Gonzalez, Lt Hector R	27	F-5E 44-23701	A/Fs: Giessen, Ettinghausen D/A	
	7/3195	Rawlings, Lt Irving L	14	Spit XI PA944		u/s cloud
9	7/3196	McDonald, Lt Warren H	27	F-5B 42-68196	Rhine Valley, Strasbourg	
	7/3197	Harmon, Lt Ronald W	27	F-5B 42-67342	Rhine Valley, Wasselonne-Mulhouse	
	7/3198	Parker, Lt Grover P	27	F-5C 42-67124		MIA EE
	7/3199	Wigton, Lt Irv	27	F-5E 43-29027	Rhine Valley, Hagenau-Mulhouse-Ettenheim Schliengen	
	7/3200	Floyd, Capt Robert C	27	F-5C 42-67123	Rhine Valley, Boulogne	
	7/3201	Saxton, Lt John W	27	F-5B 42-67331	Rhine Valley, Strasbourg-Mulhouse, Swiss Alps	
	7/3202	Matthews, Lt James B	22	F-5C 42-67108	Rhine Valley, Strasbourg area	
	7/3203	Williams, Lt Eugene S	22	F-5C 42-67115	Rhine Valley, Renche-Bischwiller-Wasselonne	
	7/3204	Quiggins, Lt Richard S	22	F-5C 42-67114	Rhine Valley, Strasbourg area	
	7/3205	Burrows, Capt Daniel W	22	F-5E 43-29006	Rhine Valley, Hagenau-Strasbourg-Schneeberg	
	7/3206	Carlgren, Lt Robert F	22	F-5C 42-67122	Rhine Valley, Mannheim-Strasbourg	
	7/3207	Weir, Lt Harold G	22	F-5E 43-28998	Rhine Valley, Strasbourg-Germersheim-Vandenheim-Landau	
	7/3208	Batson, Lt Charles R	13	F-5E 44-23609	Rhine Valley, Canal nr Cologne, E of Antwerp	
	7/3209	Bickford, Lt Wilbur F	13	F-5E 43-28333	Rhine Valley, Cologne-Frankfurt, Antwerp, Scheldt	
	7/3210	Belt, Lt Taylor M	13	F-5B 42-68265	SE of Koblenz	
	7/3211	Johnson, Maj O G	W	F-5E 43-28616	Rhine Valley	
	7/3212	Sommerkamp, Lt Frank M	13	F-5B 42-68207		Rec Rhine sortie
	7/3213	Bayne, Lt Donald R	13	F-5C 42-67332		Rec Rhine sortie
	7/3214	Schultz, Lt Donald A	13	F-5E 43-28990		Rec Rhine sortie
	7/3215	Blyth, Lt John S	14	Spit XI MB956		u/s
	7/3216	Fish, Lt Bruce B	14	Spit XI MB946	Ludwigshaven D/A, Rhine	
	7/3217	Facer, Lt Robert H	13	F-5E 44-23700		u/s cloud
	7/3218	Leatherwood, Lt Arthur K	14	Spit XI MB948	Misburg D/A, & area, Learte M/Y	
	7/3219	Purdy, Lt Ira J	27	F-5E 43-28311	Rhine Valley, Strasbourg area	
	7/3220	Nolan, Lt John D	27	F-5E 43-28999	Brest D/As	
	7/3221	Way, Lt Ian P	22	F-5C 42-67566	Brest area D/A	
	7/3222				Chalons-sur-Saone, Le Havre	
10	7/3223					Canc
	7/3224	Kann, Lt Alexander A Jr	22	F-5E 43-29002		Canc
	7/3225	Hall, Lt Robert W	22	F-5C 43-28972	Brest D/A	
	7/3226	Powers, Maj A D	W	F-5E 43-28577	Le Havre-Commercy RR	
	7/3227	Kann, Lt Alexander K Jr		F-5C 42-67122	Stuttgart, Gaggenau D/A, Ensheim A/F, Saarbrucken, Luxembourg area	
	7/3228	Brunell, Lt Richard H	22	F-5C 42-67254	Ludwigshaven, Mannheim, Heilbronn, Karlsruhe, Gaggenau D/A	
	7/3229	Glaza, Lt Gerard J	14	Spit XI MB956	Ludwigshaven-Heilbronn	
	7/3230	Blyth, Lt John S	14	Spit XI PA944	Mannheim-Wurtburg-Schweinfurt	
	7/3231	Balogh, Lt Paul A	14	Spit XI PL866	Frankfurt area	
	7/3232	?Elston, Lt Allan	13	F-5	Worms, Nurnberg, Giebelstadt, Furth, Dornburg Bei Hardheim A/F	Overnight Paris
	7/3233	?Brogan, Lt Richard W	13	F-5	Furth/Industriehafen A/F, Worms, Giebelstadt, Nurnburg	Overnight Paris
	7/3234	Schultz, Lt Donald A	13	F-5E 43-28993	Ettinghausen D/A, Mainz town, M/Y & Ord Depot; Gustauburg Fac, A/Fs: Gelnhausen, Bad/Nauheim	
	7/3235	Crane, Lt Charles M Jr	13	F-5B 42-68207	Ettinghausen D/A, Mainz town, M/Y & Ord Depot; Gustauburg Fac, A/Fs: Gelnhausen, Bad/Nauheim	
11	7/3236	Schumacher, Lt Wesley A	27	F-5C 42-67242	Sarreguemines M/Y, Hanau-Vacha	
	7/3237	Bliss, Maj Kermit	14	Spit XI PA944	Wurzburg-Bamberg	
	7/3238	Tostevin, Lt James E	14	Spit XI PA892	Cologne/Arnsberg/Brilon area	
	7/3239	Farley, Capt Donald A	22	F-5E 43-29002	Frankfurt area	
	7/3240	Gilmore, Lt Louis M	14	Spit XI MB948	Koblenz-Giessen	
	7/3241	Egan, Lt Fabian J	14	Spit XI MB955	Bonn-Betzdorf	
	7/3242	Sommerkamp, Lt Frank M	13	F-5B 42-68207	Ettinghausen A/F, Gelnhausen, Bad Nauheim, Dusseldorf	
	7/3243	Brink, Lt Fred B	13	F-5E 44-23700	A/Fs: Ettinghausen, Altenstadt, Hanau/Langendiebach	
	7/3244	Graves, Capt Willard	14	Spit XI PL866	Karlsruhe, Sindelfingen, Ulm, Heilbronn, Ludwigsburg	
	7/3245	Fish, Lt Bruce B	14	Spit XI MB950		u/s
	7/3246	Leatherwood, Lt Arthur	14	Spit XI PA892	Siegen to Frankenburg	
	7/3247	Alley, Lt Max P	27	F-5E 43-29000	Eisenach,-/Stockhausen, Misburg, Hanover	
	7/3248	Ricetti, F/O John	27	F-5E 43-28999		u/s Eng trbl
	7/3249	Stamey, Lt Ernest K	27	F-5E 43-28619	Rotterdam	
	7/3250	Ness, Lt Donald A		F-5E 43-29027	Rotterdam, Goringen, Tiel Nijmegen, Arnhem, Recklinghausen	

Sortie List 1944

DATE	SORTIE	PILOT	SQ	A/C	TARGETS	INCIDENTS
11	7/3251					Canc
	7/3252	Kraft, Lt Robert E	14	F-5E 43-29009	Pontoise to St Quentin	
	7/3253	Grayson, Lt Benton C	22	F-5 42-67114	Chalons-sur-Marne to Metz	
	7/3254	Waldram, Lt Byron L	22	F-5 42-67122	(Paris to Vitry RR)	A/C u/s
	7/3255	Murray, Lt Claude C	22	F-5 42-67115	Paris to Chalons-sur-Marne	
	7/3256	Brunell, Lt Richard	22	F-5E 44-23603	Vitry Le Francois to Metz	
	7/3257	McKinnon, Lt Max E	22	F-5 43-29006	Neufchateau to Metz	
	7/3258	Hall, Lt Robert E	22	F-5E 43-29004	Paris to Troyes	
	7/3259	Trimble, Capt H W		F-5C 42-67566	Troyes to Neufchateau	
	7/3260	Bayne, Lt Donald B	13	F-5B 42-67395	A/Fs: Cologne,-/Butzweiler, Putz/Troisdorf, Niedermendig, Gymnich	
	7/3261	Madden, Lt Robert	13	F-5B 42-68235	A/Fs: Vogelsang, Eudenbach, Euskirchen, Windhagen/Ettelschoss	
	7/3262	Austin, Capt J G	13	F-5B 42-68265	A/Fs: Woensdrecht, Kessel	
	7/3263	Fellwock, Lt James G	14	F-5B 42-68202	Le Havre to Amiens	
	7/3264	Florine, Lt Robert N	27	F-5B 42-68196	Arnhem-Nijmegen-Venlo RR, Moerdijk, Dordrecht Brs	
	7/3265	Carney, Capt Frank K	27	F-5C 42-67123	Rotterdam to Arnhem to Zutphen RR	
	7/3266	Ward, Lt Walter B	27	F-5B 42-67342	Munster/Loddenheide A/F, Arnhem to Wesel to Munster RR, Dulmen, Vianen to Rotterdam to Hook of Holland	
	7/3267	White, Lt Willie G	27	F-5B 42-67331	Special targets	
12	7/3268	Fish, Lt Bruce	14	Spit XI	A/Fs: Nellingen, Karlsruhe, & M/Y; Mannheim-Stuttgart	
	7/3269	Dixon, Capt Robert J	14	Spit XI	Wertheim A/F, Aschaffenburg-Bettingen	
	7/3270	Bliss, Maj Kermit E	14	Spit XI	Limburg A/F, Koblenz-Alsfeld	
	7/3271	Egan, F/O Fabian J	14	Spit XI	Solingen-Ludenscheid	
	7/3272	Blyth, Lt John S	14	Spit XI	Hanau-Eisenach	
	7/3273	Balogh, Lt Paul A	14	Spit XI	Aschaffenburg-Schweinfurt	
	7/3274	Cosby, Lt Irl C	22	F-5E 43-29002	D/As: Fulda, Ettinghausen, Bad Nauheim; Fulda-Neustadt-Eisfeld, Bonn,-/A/F, nr Bruhl	
	7/3275	Ricetti, F/O John	27	F-5E 43-28999	A/Fs: Nordhausen, Goslar; D/As: Hanover, Misburg; Gelsenkirchen area, Rotterdam area, Zeigenhain	
	7/3276	Purdy, Lt Ira J	27	F-5C 42-67123	A/Fs: Nordhausen, Goslar; D/As: Hanover, Misburg; Gelsenkirchen area, Rotterdam area, Zeigenhain, Wuppertal M/Y	
	7/3277	Nolan, Lt J D	27	F-5B 42-68196	A/Fs: Bergen/Alkmaar, De Kody, Amsterdam/Schipol, Woensdrecht, Hilversum/Loosdrecht, Kessel	
	7/3278	Gilmore, Lt Louis M	14	Spit XI	Frankfurt & Bonn areas	
	7/3279	Moss, Lt Robert E	13	F-5E 43-28990	Dusseldorf,-/Loghausen A/F, D/As: Bad Nauheim, Gelnhausen, Giebelstadt, Ettinghausen; Eindhoven A/F	
	7/3280	Nesselrode, Capt George H	13	F-5E 43-28993	Dusseldorf,-/Loghausen A/F, D/As: Bad Nauheim, Gelnhausen, Giebelstadt, Ettinghausen; Eindhoven A/F	
	7/3281	McDonald, Lt Warren M	27	F-5E 43-28619	Venlo-Nijmegen-Arnhem RR	
	7/3282	Schumacher, Lt Wesley A	27	F-5E 43-29000	Arnhem-Wesel-Munster RR, Amsterdam	
	7/3283	Wigton, Lt Irvin	27	F-5B 42-67342	Rotterdam-Lochen RR	
	7/3284	Waldram, Lt Byron L	22	F-5C 42-67254	Paris-Vitry RR	
	7/3285	Tostevin, Lt James F	14	Spit XI	Bonn-Erndlebruck Highway	
	7/3286	Way, Lt Ian P	22	F-5E 43-29006	A/Fs: Venlo D/A, Woensdrecht, Kessel, Bonninghart; Scheldt area	
	7/3287	Madden, Lt Ross	13	F-5B 42-68235	A/Fs: Euskirchen/Opendorf, Neiderbreisig, Limburg; Hadamar, Ettinghausen D/A, Rhine S of Cologne	
	7/3288	Sanford, Lt Robert E	14	F-5E	Troyes-Andelot RR	
	7/3289	Roberts, Lt Jack H	14		Paris-Fontainbleu RR	
	7/3290	Hughes, Lt Harry T	13	F-5B 42-68207	A/Fs: Wesserkruppe, Meiningen, Helmwersmaus; Oberhassfeld, Rotterhausen, Fulda M/Y D/A	
	7/3291	Bayne, Lt Donald B	13	F-5B 42-67395		
	7/3292	Budrevich, Lt Gerald J	13	F-5E 44-23693	E of Eindhoven (Market Garden)	
	7/3293	Shade, Capt Walter D	13	F-5B 42-68205	Eindhoven (Market Garden)	
	7/3294	Graves, Capt Willard	14	Spit XI	Koblenz-Montanur-Limburg, Griessen-W of Hersfeld	
	7/3295	Leatherwood, Lt Arthur K	14	Spit XI MB946		Landed away
	7/3296	Murray, Lt Claude C	22	F-5C 42-67128	Thionville area, Nancy area	
	7/3297	Hall, Lt Robert W	22	F-5E 43-28998	St Wendel D/A, area NE of Thionville & Nancy	
	7/3298	Quiggins, Lt Richard S	22	F-5C 42-67114	D/As: Thionville, Diekirch, Luxembourg	
	7/3299	Ross, Lt John	22	F-5C 42-67254		Ditched in Channel
	7/3300	Matthews, Lt James B	27	F-5C 42-67566	D/As: Leeuwarden, Heligoland, Hemmingstadt, Wilhelmshaven; A/Fs: Westerland Nord, Wykauffohr; Amrun Island, Nr DenHelder & Emden	
13	7/3301	Rickey, Lt Irwin	27	F-5B 42-68213		
	7/3302	Dixon, Capt Robert J	14	Spit XI PL866		
	7/3303	Fish, Lt Bruce B	14	Spit XI MB956	Mapping highway Cologne to Brilon	
	7/3304	Blyth, Lt John S	14	Spit XI PA842		
	7/3305	Weir, Lt Harold	22	F-5E 43-29002		
	7/3306					
	7/3307					

Eyes of the Eighth

DATE	SORTIE	PILOT	SQ	A/C	TARGETS	INCIDENTS
13	7/3308	Egan, F/O Fabian J	14	Spit XI MB948	Mapping Wertheim to Wurzburg	
	7/3309					Canc
	7/3310					Canc
	7/3311	Crane, Lt Charles M Jr	13	F-5B 42-67332	(Jet centers in Germany)	cloud
	7/3312	Brogan, Lt Robert W	13	F-5E 44-23609	(Jet Centers in Germany)	cloud
	7/3313	Facer, Lt Robert H	13	F-5E 43-28990	(Coast nr Ostend, Ludwigshafen, A/F fact at Stuttgart)	cloud
	7/3314	Belt, Lt Taylor M	13	F-5E 43-28993	(Coast nr Ostend, Ludwigshafen, A/F fact at Stuttgart)	cloud
	7/3315					
	7/3316					
	7/3317	Bliss, Maj Kermit	14	Spit XI		Canc
	7/3318	McKinnon, Lt Max E	22	F-5C 42-67566		
	7/3319	Kann, Lt Alexander	22	F-5E 43-28998		
	7/3320	Carlgren, Lt Robert	22	F-5 43-28577		
15	7/3321	Brink, Lt Fred B	13	F-5B 42-68205	Ooltgensplaat, Willemstad, Willemsdorf, Gertruidenburg, Hertogenbosch, Arnemuiden D/A	
	7/3322	Bickford, Lt Wilbur E	13	F-5B 42-67395	Willemsdorf, Arnemuiden D/A	
	7/3323	Batson, Lt Charles R	13	F-5E 44-23701	Darmstadt/Greisheim A/F, Mainz area, shipping on Rhine	
	7/3324	Brogan, Lt Robert W	13	F-5E 44-23609	A/Fs: Darmstadt/Greisheim, Biblis, Geinsheim; Mainz area, shipping on Rhine	
16	7/3325	Adams, Capt Gerald M	27	F-5E 43-29000	Lutzkendorf, Merseberg A/F, Muhlberg, Ruhland	
	7/3326	White, Lt Willie G	27	F-5E 43-28999	Muhlberg, Ruhland	
	7/3327	Schumacher, Lt Wesley A	27	F-5E 43-28311	Delitzch, Magdeburg	
	7/3328	McDonald, Lt Warren M	27	F-5C 42-67242	Nordhausen A/F, Delitzch, Magdeburg	
	7/3329	Gilmore, Lt Louis M	14	Spit XI PL866	D/As: Stuttgart/Boblingen, Ulm, Weissenhorn, Sindelfingen; activity Weissenhorn	u/s cloud
	7/3330	Waldram, Lt Byron L	22	F-5C 42-67128	Brest area	
	7/3331	Bayne, Lt Donald	13			KIA
	7/3332	Madden, Lt Ross	13	F-5E 43-28993		u/s cloud
	7/3333	Elston, Lt Allan	13	F-5B 42-67332	Cologne area	
	7/3334	Sommerkamp, Lt Frank M	13	F-5B 42-68207		u/s cloud
	7/3335	Rawlings, Lt Irv L	14	Spit XI PA842	Unid Town & M/Y	
	7/3336	Belt, Lt Taylor M	13	F-5E 44-23609		u/s cloud
	7/3337	Batson, Lt Charles R	13	F-5E 44-23701		u/s cloud
	7/3338	Facer, Lt Robert H	13	F-5E 44-23693		u/s cloud
	7/3339	Tostevin, Lt James F	14	Spit XI PA892		u/s cloud
	7/3340	Way, Lt Ian P	22	F-5C 42-67114	Paris-Vitry	
	7/3341	Murray, Lt Claude C	22	F-5C 42-67115	Paris-St Menehould-Metz	
	7/3342	Hall, Lt Robert W	22	F-5C 42-67131	Paris-Troyes	
17	7/3343	Williams, Lt Eugene S	22	F-5E 43-29004		
	7/3344	Ward, Lt Walter B	27	F-5C 42-67132		
	7/3345	Nolan, Lt John D	27	F-5E 43-29027		
	7/3346	Chapman, Maj Carl J	22	F-5B 42-68205	Market Garden targets	
	7/3347	Parker, Lt Grover P	27	F-5B 42-67331	Market Garden targets	
	7/3348	Harmon, Lt Robert W	27	F-5B 42-67342		
	7/3349	Gonzalez, Lt Hector	27	F-5C	Scheldt area, Arnhem	
	7/3350	Powers, Maj A D	W	F-5B 42-67399	Market Garden	
	7/3351	Johnson, Maj O G	13	F-5E 43-28993	RR line E from Paris to forward lines for repair & construction estimates	
	7/3352	Brogan, Lt R W	13	F-5E 44-23693	RR line E from Paris to forward lines for repair & construction estimates	
	7/3353	Moss, Lt Robert E	13	F-5E 43-28997	RR line E from Paris to forward lines for repair & construction estimates	Low-level with Nose camera
18	7/3354	Brink, Lt Fred B	13	F-5B 42-68265	Rotterdam, Noordwal, Scheldt, Harnis, Ooltgensplaat	Flak
	7/3355	Burrows, Capt Daniel W	22	F-5E 43-29006	A/Fs: Wyk auf Fohr, Lutjenholm, Olderup, Schleswig/Land, Husum, Hohn, Rendsburg; Kiel D/A	
	7/3356	Purdy, Lt Ira J	27	F-5B 42-68213	Scheldt area, Nijmegan, Arnhem, D/As: Arnemuiden, Woensdrecht; Schouwen Island	
	7/3357	Florine, Lt Robert N	27	F-5E 43-28619	Scheldt area, St Oedenrode, Nijmegen, Arnemuiden D/A, Arnhem bridges	
	7/3358	Wigton, Lt Irv	27	F-5E 43-29027	Scheldt area, Grave, Nijmegen, Arnhem, Veghel, St Oedenrode bridges	
	7/3359	Johnston, Lt Ernest E	27	F-5B 42-67331	Scheldt area	
	7/3360	Ricetti, F/O John	27	F-5E 43-29000	Eindhoven,-A/F, St Oedenrode Br, Schouwen Island	
	7/3361	Saxton, Lt John W	27	F-5C 42-67107	Bridges: Veghel, Grave, Arnhem, Son, Oedenrode area, Ede area, Woensdrecht area D/A, Eindhoven area & A/F D/A	
19	7/3362	Stamey, Lt Earl K	27	F-5E 43-29000		KIA
	7/3363	Nolan, Lt John D	27	F-5C 42-67132	A/Fs: Vol , Eindhoven, Veghel; St Oendenrode, Richtersgut, Horst, Wolfeze, Elden, Arnhem, Nijmegen, West Schouwen	
	7/3364	Glaza, Lt Gerald J	14	Spit XI PL866	Ulm, A/Fs: Stuttgart/Boblingen -/Sindelfingen D/A,-/Echterdingen, Werden	
	7/3365	Leatherwood, Lt Arthur	14	Spit XI	Liege, Aachen	
	7/3366	Balogh, Lt Paul A	14	Spit XI MB955	(Bitche, Zweibrucken, St Wendoz)	KIA

Sortie List 1944

DATE	SORTIE	PILOT	SQ	A/C	TARGETS	INCIDENTS
19	7/3367	Fish, Lt Bruce B	14	Spit XI MB946		u/s
	7/3368	Shade, Capt Walter D	13	F-5B 42-67395	Darmstadt D/A, Mainz area, Trier area, Rhine River Lorch to St Goarshausen	
	7/3369	Elston, Lt Allan	13	F-5B 42-68207	Darmstadt D/A, Ludwigshafen D/A, Mannheim area, Heidelburg area	
	7/3370	Facer, Lt Robert H	13	F-5B 42-68265	Darmstadt D/A, Ludwigshafen D/A, Mannheim area, Heidelburg area	
	7/3371	Sommerkamp, Lt Frank M	13	F-5E 44-23609	Darmstadt D/A, Ludwigshafen D/A, Mannheim area, Heidelburg area	
	7/3372	Campbell, Capt J ?L	13	F-5E 43-23993	Darmstadt D/A, Mainz area	
	7/3373	Schultz, Lt Donald A	13	F-5B 42-67332	Mainz area	
	7/3374	Budrevich, Lt Gerald J	13	F-5B 42-67341	Darmstadt D/A, Koblenz & area to the west	
	7/3375	Batson, Lt Charles R	13	F-5E 44-23701	Darmstadt, Ludwigshafen, Halle A/F D/A, Heidelburg, Scheldt area, Biebrich, Koblenz, Duren, Aachen, Gielenkirchen	
	7/3376	Bickford, Lt Wilbur E	13	F-5E 43-28616	Darmstadt, Ludwigshafen, A/Fs: Halle D/A, Niedermendig, Darmstadt/Greisheim	
	7/3377	Fish, Lt Bruce B	14	Spit XI MB956	Unid area	
	7/3378	White, Lt Willie G	27	F-5C 42-67242	Nijmegen, Arnhem, area W of Munster	
	7/3379	Childress, Capt Hubert	27	F-5C 42-67123		u/s weather
	7/3380	Rickey, Lt I J	27	F-5E 43-28311		u/s weather
	7/3381	Blackburn, Lt H F	27	F-5B 42-68196		u/s weather
	7/3382	Rickey, Lt Irvin J	27	F-5E 43-28311	Veghel, Grave, Nijmegen, Arnhem, Woerdijk, area E of Asperen	
	7/3383	Parker, Lt Grover P	27	F-5B 42-67342	(Market Garden area)	MIA-EE Holland
20	7/3384	Ness, Lt Donald A		F-5B 42-67331	Scheldt area, strip W from Nijmegen, obliques coastline Scheldt	
	7/3385	Ward, Lt Walter B	27	F-5E 43-29027	Arnhem, Nijmegen, Deelen A/F, Rotterdam area	
	7/3386	Graves, Capt Willard E	14	F-5B 42-67399	Metz & Thionville area, Nancy, Metz/Frescaty A/F	
	7/3387	Dixon, Capt Robert J	14	F-5E 43-29009	Metz/Frescaty A/F, Metz area, Diekirch area, Nancy,-/Essey A/F	
	7/3388	Florine, Lt Robert N	27	F-5C 42-67123	Rotterdam area	
	7/3389	Schumacher, Lt Wesley A	27			u/s weather
21	7/3390					
	7/3391	Ness, Lt Donald A	27	F-5E 43-28311		
	7/3392	Gonzalez, Lt Hector R	27	F-5B 42-68213	Arnhem, Nijmegen	
22	7/3393	Belt, Lt Taylor M	13	F-5E 44-23693	Koblenz M/Y D/A, Mainz area	
	7/3394	Madden, Lt Ross	13	F-5B 42-67395		u/s cloud
	7/3395	Kraft, Lt Robert E	14	Spit XI MB946		u/s cloud
	7/3396	Fellwock, Lt James G	14	Spit XI MB948	Unid A/F & Town	
	7/3397	Egan, F/O Fabian J	14	Spit XI PA 842	Saarbrucken area	
	7/3398	Alley, Lt Max P	27	F-5C 42-67123	Nijmegen-Arnhem area, Overasselt	
	7/3399	Harmon, Lt Ronald W	27	F-5C 42-67132	Nijmegen-Arnhem area, Overasselt	
	7/3400	Carney, Capt Franklyn K	27	F-5B 42-67389	Debrechen M/Y & A/F, Szolnok M/Y & A/F	*Shuttle Italy
23	7/3401	Carney, Capt Franklyn K	27	F-5B 42-67389	Berre Lake, Marseilles, Targets in France & Italy	*Shuttle Italy
	7/3402	Adams, Capt Gerald M	27	F-5B 42-67331		u/s cloud
	7/3403	Purdy, Lt Ira J	27	F-5C 42-67123	Grave area	
24	7/3404	Johnston, Lt Ernest E	27	F-5B 42-67123	Holland	MIA KIA
	7/3405	McDonald, Lt Warren M	27	F-5C 42-67331	Holland	MIA KIA
25	7/3406	?Grayson, Lt Benton C	22			
SEPT						
26	7/3407	Brunell, Lt Richard H	22	F-5E 43-28972	Photos of clouds for Met information	Met
	7/3408	Wigton, Lt Irv	27	F-5E 43-29027	Nijmegen, Arnhem area, Calais	
	7/3409	Saxton, Lt John W	27	F-5E 43-28619	Nijmegen, Arnhem area	
	7/3410	Johnson, Maj O C	13	F-5E 44-23693	Eschweiler, Duren, Cologne area, Munchen/Gladbach	
	7/3411	Moss, Lt Robert E	13	F-5E 44-23701	Eschweiler, Duren, Cologne area, Liege	
	7/3412	Cosby, Lt Irl R	22	F-5E 43-29002	A/Fs: Osnabruck, Wildeshausen, Fassburg, Bremen/Neulanderfeld, Munster Lager, Wittmern Hafen; Bremen, Ostendorf area, Hasted	
	7/3413	Humbrecht, Maj George W	7	F-5E 44-23609	Wiesbaden, Mainz, & area	
	7/3414	Floyd, Capt Robert C	27	F-5E 43-29206	Hamm, Gutersloh A/F, Osnabruck M/Y	
	7/3415	Rickey, Lt Irv J	27	F-5C 42-67247	Hamm, Osnabruck M/Y	
28	7/3416	Schumacher, Lt Wesley A Jr	27	F-5C 42-67107	A/Fs: Twente/Enschede, Achmer, Nordhorn, Vorden, Hildesheim; Hanover, Osnabruck D/A, Hengelo-Enschede	
	7/3417	Ward, Lt Walter B	27	F-5C 42-67132		u/s
	7/3418	Carney, Capt Franklyn K	27	F-5E 43-28619	Unna, Kassel D/A, Kassel/Waldau A/F	
	7/3419	Nolan, Lt John D	27	F-5E 43-29027	Unna, Kassel D/A, Kassel/Waldau A/F	
	7/3420	Weir, Lt Harold G	27	F-5E 43-29006	A/Fs: Hustedt, Wildeshausen Oldenburg,-/Kayhauserfeld, Hoya	
	7/3421	Rawlings, Lt Irv L	14	Spit XI MB948		u/s E/A
	7/3422	Tostevin, Lt James F	14	Spit XI PA892		u/s cloud

Eyes of the Eighth

DATE	SORTIE	PILOT	SQ	A/C	TARGETS	INCIDENTS
28	7/3423	Bliss, Maj Kermit E	14	Spit XI MB946		u/s
	7/3424	Belt, Lt Taylor M	13	F-5B 42-67332	Duren, Dillenburg, Wetzlar, Limburg D/A	
	7/3425	Budrevich, Lt Gerald	13	F-5B 42-67395	Duren, Dillenburg, Wetzlar D/A, area of French coast	
	7/3426	Bickford, Lt Wilbur E	13	F-5B 42-68235		u/s A/C u/s
	7/3427	Sommerkamp, Lt Frank M	13	F-5B 42-68207	Duren, Cologne D/A	
	7/3428	Facer, Lt Robert H	13	F-5E 44-23700	Frankfurt D/A, Mainz	
29	7/3429	Glaza, Lt Gerald J	14	Spit XI PA892	Zweibrucken M/Y	
	7/3430	Gilmore, Lt Louis M	14	Spit XI PA842	D/A Metz, St Wendel, Thionville, Saarbrucken area	
	7/3431	Nesselrode, Capt George H	13	F-5E 44-23700	Mainz, Koblenz, Frankfurt, Gustavsberg, Augsburg, Nurnberg	
	7/3432	Brink, Lt Fred B	13	F-5E 44-23609	Mainz M/Y, Koblenz A/F, Koblenz/Mosel M/Y,-/Rhein M/Y, Frankfurt	
	7/3433	Blyth, Lt John S	14	Spit XI PL865	Landau, Brischal, Pforzheim, Baden Baden, Malschback	
	7/3434	Shade, Capt Walter D	13	F-5E 43-28333		Eng Trbl
30	7/3435	Leatherwood, Lt Arthur K	14	Spit XI PL866	A/Fs: Lechfeld, Augsburg, Landsberg, Memmingen; M/Ys: New Ulm, Augsburg; Weissenhorn D/A	
	7/3436	Shade, Capt Walter D	13	F-5E 43-28333		u/s weather
	7/3437	Carlgren, Lt Robert F	22	F-5E 43-29002	Lingen A/F	
	7/3438	Florine, Lt Robert N	27	F-5E 43-28999		u/s cloud
	7/3439	Floyd, Capt Robert C	27	F-5E 43-28311		u/s weather
OCT						
2	7/3440	Fish, Lt Bruce B	14	Spit XI PA892	Bremen, A/Fs: Oldenburg, Oldenburg/Kayhauserfeld	
	7/3441	Farley, Capt Donald A	22	F-5E 44-23603	Arnhem Br, Hopsten A/F, area E of Zuiderzee	
	7/3442	Matthews, Lt James B	22	F-5E 44-23695	Hamm, Soest, Kassel, A/Fs: Venlo, Kirchellen, Bonninghardt	
	7/3443	Harmon, Lt Ronald W	27	F-5C 42-67123		u/s cloud
	7/3444	Gonzalez, Lt Hector R	27	F-5C 42-67107	Ghent, Cologne, Mulheim, Dillenberg, Euskirchen	
3	7/3445	Purdy, Lt Ira J	27	F-5C 42-67242	Brussels, Ghent	
	7/3446	Wigton, Lt Irv	27	F-5B 42-68196	Brussels M/Y, Ghent	
	7/3447	Quiggins, Lt Richard S	22	F-5E 43-29006		u/s weather
	7/3448	McKinnon, Lt Max E	22	F-5E 43-29002		u/s weather
5	7/3449	Williams, Lt Eugene S	22	F-5E 43-29002	Minden area, Bielefeld, Munster	Intc
	7/3450	Ross, Lt John H	22	F-5E 43-28616	Handorf A/F, Munster town & M/Y, Amsterdam, Hamm area	Intc
	7/3451	Waldram, Lt Byron L	22	F-5E 43-29006	Bremen area to Ruhr	Intc
	7/3452	Saxton, Lt John W	27	F-5E 44-23698	Lippstadt area	Intc
	7/3453	Carney, Capt Franklyn K	27	F-5B 42-68196	Lippstadt/Paderborn area	u/s FD
	7/3454	Batson, Lt Charles R	13	F-5E 44-23701	Noord/Beveland, Lille/Fives, Tournai, Brussels, Mons, Valenciennes, Armentieres	u/s FD
	7/3455	Cosby, Lt Irl R	22	F-5E 44-23695	Noord/Beveland, Valenciennes, Lille, Armentieres	
6	7/3456	Dixon, Capt Robert J	14	Spit XI PL866	Berlin area tgts, A/Fs: Gatow D/A, Schonewalde, Brunswick, -/Waggum, -/Broitzem; Misburg, Hanover, Osnabruck	
	7/3457	Nesselrode, Capt George H	14	Spit XI PL959	Berlin D/A, Hanover	
	7/3458	Kraft, Lt Robert E	14	Spit XI MB948	D/As: Bremen, Hamburg; Hamburg/Wandsbeck A/F	
	7/3459	Egan, F/O Fabian J	14	Spit XI PA842	Hamburg, Wenzendorf, Bremen D/A, Bremen Westertimke	
	7/3460	White, Lt Willie G	27	F-5E 43-28999	Flushing	
	7/3461	Ricetti, F/O John	27	F-5C 42-67123	Mapping	
	7/3463	Murray, Lt Claude C	22	F-5C 42-67128		MIA EE Holland
	7/3463	Hall, Lt Robert W	22	F-5C 42-67131	Utrecht	Intc
	7/3464	Carlgren, Lt Robert F	22	F-5E 44-23603	Magdeburg D/A, Oschersleben, Schoneberg, Helmstedt	
	7/3465	Rickey, Lt Irwin J	22	F-5E 43-29026	Cologne area	
	7/3466	Ward, Lt Walter B	27	F-5E 43-28311	Cologne area, Euskirchen, Winnhagen/Vittelschloss A/F	
	7/3467	Brunell, Lt Richard H	22	F-5E 43-29006	Kassel, Fritzlar D/A, Dortmund area	
7	7/3468	Bliss, Maj Kermit E	14	Spit XI PL866	Berlin D/A, A/Fs: Staaken, Gatow, Stendal, Gardelingen, Burgdorf	
	7/3469	Purdy, Lt Ira J	27	F-5C 42-67242	Bonn area, Cologne area	
	7/3470	Brogan, Lt Richard W	13	F-5E 43-28616	Bonn area, Cologne area, strip Bonn-Heimbach	
	7/3471	Harmon, Lt Ronald W	27	F-5E 43-28999		u/s
	7/3472	Schumacher, Lt Wesley A Jr	27	F-5E 44-23698	Louvain, Brussels, Unid town nr Koblenz	
	7/3473	Rawlings, Lt Irv L	14	Spit XI PA841	Hamburg, Stade A/F, *Wenzendorf	*ME262 seen here 1st time
	7/3474	Fellwock, Lt James G	14	Spit XI PA842	Hamburg, Stade A/F, Wenzendorf	Landed away
	7/3475	Tostevin, Lt James F	14	Spit XI PA892	Leverkusen-Brilon	
	7/3476	Madden, Lt Ross	13	F-5B 42-67332		u/s Eng threw rod
	7/3477	Sommerkamp, Lt Frank M	13	F-5B 42-68207	Kassel-Frankfurt areas	
	7/3478	Matthews, Lt James B	22	F-5E 44-23695	Kassel area	
	7/3479	Weir, Lt Harold G	22	F-5C 42-67108	Kassel-Frankfurt areas, strip Kassel-Mengeringhausen	

Sortie List
1944

DATE	SORTIE	PILOT	SQ	A/C	TARGETS	INCIDENTS
7	7/3480	Schultz, Lt Donald A	13	F-5E 43-28333	Kassel-Frankfurt areas	
	7/3481	Grayson, Lt Benton C	22	F-5E 43-29026	Kassel-Frankfurt areas	
	7/3482	Quiggins, Lt Richard S	22	F-5C 42-67114	Kassel area, A/F nr Bonn, Dunkirk	
	7/3483	McKinnon, Lt Max E	22	F-5E 44-23603	Kassel-Frankfurt areas	
	7/3484	Facer, Lt Robert H	13	F-5E 44-23693	A/Fs: Ettinghausen, Wetzlar; Freidburg-Giessen, Allendorf-Ulrichstein, Schotten-Braunfels	
	7/3485	Bickford, Lt Wilbur E	13	F-5E 44-23609	Giessen area, Frankfurt area, Kassel area, Dunkirk	
	7/3486	Budrevich, Lt Gerald J	13	F-5E 43-28993	Kassel-Frankfurt areas, Dunkirk, Giessen area, Beilstein-Ruppertenrod	
	7/3487	Wigton, Lt Irv	27	F-5B 42-68196		u/s
	7/3488	Saxton, Lt John W	27	F-5E 42-67123	Aschaffenburg-Hanau	
	7/3489	Sanford, Lt Robert	14	F-5E 43-29009	Gienhausen-Lauterbach, shipping in Rhine River nr Cologne	*Landed away
	7/3490	Florine, Lt Robert N	27	F-5E 43-29026	Giessen-Marburg-Fulda area, Hanau area, Frankfurt area	
	7/3491	White, Lt Willie E	27	F-5E 43-29027	Bonn area, A/F nr Koblenz area	
	7/3492	Ward, Lt Walter B	27	F-5E 43-28311	Hanau area	
	7/3493	Gilmore, Lt Louis M	14	Spit XI MB946	Munster-Weidenbruck-Hamm-Ruhr	
	7/3494	Blyth, Lt John S	14	Spit XI MB950	Hagen-Meschede	
	7/3495	Glaza, Lt Gerald	14	Spit XI MB956		u/s cloud
	7/3496	Ross, Lt John	22	F-5E 43-28577	Hanover, Magdeburg, Stendal A/F	**Landed away
	7/3497	Williams, Lt Eugene S	22	F-5E 43-28972	Eisenach, Kassel, Oberhausen area	
	7/3498	Burrows, Capt Daniel W	22	F-5E 43-29002	Dortmund D/A, Dusseldorf, Munden, A/F in Recke area	
	7/3499	Crane, Lt Charles M Jr	13	F-5B 42-67395		u/s O/F
	7/3500	Vassar, F/O Edgar L	13	F-5E 42-68235		u/s
	7/3501	Belt, Lt Taylor M	13	F-5E 44-23700		u/s mech failure
	7/3502	Shade, Capt Walter D	13	F-5E 44-23701		u/s
	7/3503	Anderson, Lt John L	13	F-5E 44-23701	Walcheren Island, Zuid Beveland, Dunkirk	
8	7/3496	Ross, Lt John	22	F-5E 43-28577		**Rd
	7/3504	Nolan, Lt John D	27	F-5E 44-23698	Flushing, Walcheren Island	
9	7/3505	Vassar, F/O Edgar L	13	F-5B 42-68235	Bitche area (through holes)	u/s cloud
	7/3506	Crane, Lt Charles M Jr	13	F-5B 42-67395		u/s mech trbl
	7/3507	Shade, Capt Walter D	13	F-5E 44-23607		u/s cloud
	7/3508	Belt, Lt Taylor M	13	F-5E 44-23693		u/s cloud
12	7/3509	Waldram, Lt Byron L	22	F-5C 42-67566	Bielefeld D/A,-/Windelsbleiche, -/Quelle A/F, Soest M/Y D/A, Apeldorn area	
	7/3510	Alley, Lt Max P	27	F-5E 43-29027	A/F D/As: Mannheim/Stadt, Speyer; D/As: Wesseling, Mainz, Gustavburg, Euskirchen; Aachen, Bonn area	
	7/3511	Leatherwood, Lt Arthur K	14	Spit XI PL959	Bremen D/A, A/Fs: Zwischenahn D/A, Neuenland/Bremen	
13	7/3512	Graves, Capt Willard E	14	Spit XI PL866	Rotterdam, Leipzig area, Scheldt area, Abernburg A/F	
	7/3513	Egan, Lt Fabian J	14	Spit XI PA842		u/s cloud
	7/3514	Fish, Lt Bruce B	14	Spit XI PL959	Zwickau, Gera & M/Y D/A, Weimar	
	7/3515	Farley, Capt Donald A	22	F-5E 43-29004		u/s cloud
14	7/3489	*Sanford, Lt R E	14	F-5E 43-29009		*Rd (7/10)
	7/3516	Hall, Lt Robert W	22	F-5E 43-29002	Osnabruck area	
15	7/3517	Campbell, Capt J D	13	F-5E 43-28997		Nose camera
	7/3518	Brogan, Lt Richard W	13	F-5B 42-68265	Special targets	
	7/3519	Gonzalez, Lt Hector R	27	F-5E 44-23720	Cologne D/A,-/Butzweilerhof,-/Ostheim, Lachen/Speyerdorf D/A, A/Fs; Monheim D/A	
	7/3520	Richards, Lt John R	14	Spit XI PL959	A/F D/As: Neubrandenberg, Stargaard, Rechlin.-/Larz, Bremen, Wenzendorf, Hagenow	
	7/3521	Grayson, Lt Benton C	22	F-5E 44-23695		MIA POW
	7/3522	Brunell, Lt Richard H	22	F-5E 44-23603	Dortmund A/F, Soest M/Y, Gelsenkirchen M/Y	
19	7/3523	Weir, Lt Harold G	22	F-5E 44-23716	A/Fs: Kassel, Noordhuizen; Utrecht area, Soest area	
21	7/3524	Carlgren, Lt Robert	22	F-5E 44-23709	Utrecht area, Apeldorn area, The Hague	
26	7/3525					Canc
	7/3526	Matthews, Lt James B	22	F-5C 42-68205		Canc
	7/3527					Canc
	7/3528					Canc
	7/3529	Quiggins, Lt Richard E	22	F-5C 43-29002		u/s FD
27	7/3530	Dixon, Capt Robert J	14	Spit XI PL866	Politz D/A	
28	7/3531	Shade, Capt Walter D	13	F-5E 44-23609	Cologne & M/Y, Neuss, Reisholz, Monheim D/A, Venlo	

371

Eyes of the Eighth

DATE	SORTIE	PILOT	SQ	A/C	TARGETS	INCIDENTS
29	7/3532	Williams, Lt Eugene S	22	F-5E 44-23729		MIA-POW
	7/3533	Matthews, Lt James B	22	F-5E 44-23716	A/Fs: Handorf bei Munster, Gutersloh, Handorf; Munster, Hamm, Bielefeld	
	7/3534	?Facer, Lt Robert	13		Koblenz, Wiesbaden, Mainz, Gustavsburg	
	7/3535	Vassar, F/O Edgar L	13	F-5B 42-68205		u/s Eng turbo out
	7/3536	Batson, Lt Charles R	13	F-5E 44-23701	Pforzheim, Karlsruhe, Baden Baden, Zweibrucken, Sarreborg, Gaggenau, Sindelfingen, Offenburg, Sauerne	
	7/3537	Nesselrode, Capt George H	13	F-5E 44-23700	Stuttgart/Boblingen A/F, Baden Baden, Gaggenau, Sindelfingen, Karlsruhe, Saarbrucken, Sauerne, Neunkirchen	
	7/3538	Elston, Lt Allan	13	F-5E-43-28333	Kaiserslautern D/A, Gaggenau D/A, Pforzheim, Bruschal, Landau, Zweibrucken area, Saarbrucken	Landed away
	7/3539	Budrevich, Lt Gerald J	13	F-5E 44-23609	Pforzheim, Bruschal, Landau, Kaiserslautern	
	7/3540	Schultz, Lt Donald A	13	F-5B 42-68235	Mannheim, Ludwigshaven, Rhine River nr Mainz, Heidelburg area, Schweinfurt	V-2 trails
	7/3541	Crane, Lt Charles M Jr	13	F-5B 42-67389	Heidelburg, Mannheim, Ludwigshaven	V-2 trails, ref Bradwell Bay
	7/3542	Burrows, Capt Daniel W	22	F-5E 44-24227	Terneuzen, Inid town & factory	
	7/3543	Hall, Lt Robert W	22	F-5C 43-29002	Minden, Hanover, Brunswick, Osnabruck, A/F W of Misburg	
	7/3544	Tostevin, Lt James F	14	Spit XI	Hamburg, Neumunster, Heligoland, Bremen, Oldenburg/Kayhauserfeld A/F	ref Bradwell Bay
	7/3545	Roberts, Lt Jack H	14	Spit XI	Hamburg, Neumunster, Heligoland, Oldenburg/Kayhauserfeld A/F	ref Bradwell Bay
	7/3546	Shade, Capt Walter D	13	F-5E 43-28616	Bonn, Gelsenkirchen, Bottrop, Wesseling, Duisberg-Hamburg	Film poor-cloud
	7/3547	Sommerkamp, Lt Frank M	13	F-5E 44-23604	Bonn area, Wesseling, Gelsenkirchen	Film poor-cloud
?30	7/3548	Ross, Lt John	22			u/s
31	7/3549	?Brogan, Lt Richard W	13			u/s
						u/s
NOV						
1	7/3550	?Facer, Lt Robert	13	F-5	Hamburg, Wesermunde, Wilhelmshaven A/F, Leer, Stade, shipping nr Elbe River	
	7/3551	?Brogan, Lt Richard W	13	F-5	Hamburg, shipping in Schilling Roads, Hamburg-coast N of Bremerhaven	
5	7/3552	Rawlings, Lt Irving	14	Spit XI	Aplerbeck, Maastricht	
	7/3553	Waldram, Lt Byron L	22	F-5E 44-23709	Unid town	
	7/3554	Cosby, Lt Irl	22	F-5E 44-23603	Kitzingen A/F, Wiesbaden	
	7/3555	?Carlgren, Lt Robert F	22	F-5E 43-29004	Lechfeld	
6	7/3556	Sanford, Lt Robert E	14	Spit XI	Teuge A/F, Apeldorn area	
	7/3557	Belt, Lt Taylor	13	F-5	Heligoland	Intc
	7/3558	Bickford, Lt Wilbur E	13	F-5		u/s Eng trbl
	7/3559	Elston, Lt Allan	13	F-5	Misburg, Rheine M/Y, Hamburg D/A, Apeldorn area, Cuxhaven, Wesermunde, Wilhelmshaven, A/Fs: Marx, Broekeetel	V-2s nr Rheine
	7/3560	Glaza, Lt Gerald	14	Spit XI	A/Fs: Bonn/Hanover, Bonn area	
	7/3561	Bliss, Maj Kermit E	14	Spit XI	(Bottrop, Sterkrade, Castrop Rauxel, Gelsenkirchen)	u/s cloud
	7/3562	Gilmore, Lt Louis	14	Spit XI	Apeldorn, Barneveld area	
	7/3563	Vassar, F/O Edgar	13	F-5	Wangerooge A/F, Bremerhaven, Wilhelmshaven, A/Fs: Borkum, Broekeetel	
	7/3564	Johnson, Maj O J	7	F-5	A/Fs: Euskirchen, Niedermendig, Niederbreistig	
	7/3565	Brogan, Lt Richard W	13	F-5 42-68265		MIA
	7/3566	Batson, Lt Charles	13	F-5	A/Fs: Putz/Troisdorf, Gymnich, Niedershambach, Niedermendig, Euskirchen, Blankenheim, Unid strip betw Duren-Euskirchen	
	7/3567	Budrevich, Lt Gerald J	13	F-5 42-67395		MIA KIA
9	7/3568	Leatherwood, Lt Arthur K	14	Spit XI		u/s cloud
	7/3569	?Sommerkamp, Lt Frank M	13	F-5	Neumunster & A/F D/A	
	7/3570					u/s cloud
	7/3571	Matthews, Lt James B	22	F-5E 44-24335	Strasbourg/Neuhof A/F, Strips Saverne area-Strasbourg, Forbach-Teterchen (Saarbrucken area)	

Verifiable records of sorties fall off after October 1944 and become sparse by February 1945. This is partly due to missing Group sortie records for all of 1945 and only partial squadron records of the same period. Therefore, it is impractical to print such incomplete lists in this book. The author has information on many sorties not printed here, which she will make available upon application through the publisher.

Notable events are indicated below:

4000th sortie flown on 24 February 1945 by Lt. Jack Roberts.

4016, the last sortie flown under old numbering system flown on 25 February by Lt. Robert Hall who failed to return. Hall became a POW, repatriated at the end of the war.

Beginning 27 February 1945, ACIU numbered all 7th Group sorties by individual squadron numbers to conform with the system begun with the 27th Squadron's move to France. Each squadron now begins with 1 and its newly assigned suffix.

13th Squadron's 1B flown on 2 March by Major Lawrence McBee.

14th Squadron's 1C flown on 27 February by Capt. Gerald Adams.

22nd Squadron's 1D flown on 27 February by Lt. Richard E. Brown.

Last numbered combat sorties flown are:

27th Sq. 314A ?Workman, Lt Raymond 25 April 1945
13th Sq. 161B Vaughn, Lt Thomas 26 April 1945
14th Sq. 116C Wilcox, Lt Roger 25 April 1945
22nd Sq. 149D Sherman, Lt Denver 25 April 1945

All sorties flown after 26 April 1945 carried the prefix LOC, began again at 1 and carried the squadron's suffix. There is only very sketchy data on the number and date of these.

Wartime Casualties

Key:
Unk=Unknown KIA= Killed in action MIA=Missing in action KLOD=Killed in line of duty FTR= Failed to return EA=Enemy aircraft SE=Single engine
*=MACR Missing Air Crew Report on file Colo Spgs AA Base=Peterson Field '43

KILLED IN ACTION OR IN LINE OF DUTY

NME	SQ.	DATE	TYPE	PLACE	CAUSE	AIRCRAFT
Allen, Glenn F.	13	24 Nov 43	KLOD	Mt Farm	Unk	F-5
Anderson, Roy C.	1274	44	KLOD	Mt Farm	Unk	
Balogh, Paul A*	14	19 Sep 44	KIA	Langkamp, Ger.	FTR	Spit Mark XI MB955
Batson, Charles R.	13	6 Jun 45	KLOD	Near Chalgrove	Mid-air collison	F-5
Bayne, Donald B.	13	16 Sep 44	KIA	Mainz	Unk	F-5
Bernau, Donald C.	27	5 Feb 44	KLOD	Near field	Bicycle/truck accident	
Blickensderfer, Wend. W.	22	19 Jan 44	KIA	West Wycombe, UK	Weather	F-5 42-51360
Borgerding, William H.	14	16 Sep 42	KLOD	Col Spgs A A Base	Near collison stall	L-4 Piper Cub
Bowen, Burton Jr.	13	9 Jan 43	KLOD	Podington	Engine trouble	P-38 J-DS 44-23515
Brink, Fred B.*	13	26 Oct 44	KIA	North Sea	Flak	F-5A-42-12779
Brogan, Robert C.*	13	20 Jun 43	KIA	Vegesack, Ger.	EA	F-5B-43-28331
Bruns, Waldo C *	13	17 Aug 44	KIA	Wettringen, Ger.	EA	F-5B 42-67395
Budrevich, Gerald *	13	6 Nov 44	KIA	Wilhelmshaven, Ger.	Poor Visibility	F-5
Burnette, Kenneth V.	13	15 Jan 43	KLOD	Near Burtonwood	EA	F-5A 42-12775
Campbell, Jack	13	4 Apr 43	KIA	Antwerp, Bel.	Unk	F-5B-42-67366
Cassaday, Charles G. *	27	8 Jun 44	KIA	Holland	SE EA	F-5B-42-67359
Clark, Albert W. *	27	9 Aug 44	KIA	Nogent Le Rotrou Fr.	Engine failure	
Copeland, R. J.	13	15 Sep 42	KLOD	Col Spgs A A Base	EA	F-5E-43-29026
Crowell, Jeryl D. *	27	24 Dec 44	KIA	Somme Leuze, Bel.	Unk	Spit Mark XI PL790
Didericksen, Robert W.	14	15 Jun 44	KIA	Paris area	Possible anoxia	F-5C-42-67119
Durst, Edward W. *	22	24 Jul 44	KIA	Near St Malo, Fr.	Unk	F-5
Eugenedes, Xenophon S.	27	11 Sep 45	KLOD	Aberporth, Wales	Weather	F-5A-42-13312
Fricke, Harlan J.	14	11 Dec 44	KIA	Didcot, UK	Gun accident	
Gault, Russell	13	21 Aug 43	KLOD	Mt Farm	Eng Trbl	F-5E 44-24284
Gentille, Albert L.	22	8 Jan 44	KIA	1 mile frm Mt Farm		Spit Mark XI MB952
Gillin, Cecil	1274	44	KLOD	Mt Farm	Unk	F-5A-42-12780
Goffin, Charles J.J. *	14	8 Sep 44	KIA	Mersch, Bel.	Unk	Spit Mark XI PL767
Haight, Edward L. *	13	17 Jul 43	KIA	Holland	Unk	
Haugen, Cecil	14	28 Jun 44	KIA	Combe, Oxfordshire	Flak nr Liege (Courier)	B-25 42-53357
Heil, Thomas C.	27	20 Apr 45	KLOD	Valenciennes, Fr.	Mid-air collision	F-5
Hicks, Mark C.	381	26 Oct 44	KIA	Mourmelon Le Grande, Fr.	Unk	F-5A 42-13222
Howard, Robert J.	13	6 Jun 45	KLOD	Chalgrove	Unk	F-5B 42-68213
Jamison, Jack T.	22	31 Dec 44	KIA	Severn Valley, UK	Eng failure	F-5C 43-28998
Johnston, Ernest E.	27	23 Sep 44	KIA	Nr Graves, Hol.	Trnsf to Fighter Group	
Kann, Alexander Jr.	22	13 Sep 44	KIA	Mt Farm	Flak	B-25 42-53357
Kingham, Lloyd C.	2244	KIA	Unk	Unk	
Kraft, Robert	14	26 Oct 44	KIA	Mourmelon Le Grande, FR.	Near collision stall	L-4 Piper Cub
Leaser, John Robert	13	8 May 44	KIA	Lyon, Fr.	Unk	F-5A 42-12776
Lott, Howard	13	9 Jan 43	KLOD	Podington	Unk	F-5C 42-67331
Mazurek, Raymond A. *	13	13 Apr 44	KIA	Le Havre, Fr.	FTR	F-5C 42-67111
McDonald, Warren M. *	27	24 Sep 44	KIA	Near Graves, Hol.		F-5E 43-29108
Miller, Glenn E. *	22	29 Jun 44	KIA	Unk	Propeller accident	
Mitchell, Robert L.	22	20 Jul 44	KIA	2 Miles W Mt Farm		
Mousley, James	13	14 Jul 43	KLOD	Mt Farm	Low-level prob flak	F-5A 42-12981
Myers, Alfred W.	14	18 Sep 42	KLOD	Col Spgs A A Base	Test flt.(Struct. failed)	F-5A
Nelson, Robert R. *	14	8 Jun 44	KIA	Antwerp, Bel.	Eng failure on take-off	F-4
O'Bannon, Thomas B.	13	24 Jul 43	KLOD	Near Warwick, UK	Test Flight Unk	F-5E 44-23746
Peterson, Edward B.	14	8 Aug 42	KLOD	Colo Spgs A A Base		Spit Mark XI PA851
Schumacher, Wesley A. *	27	22 Nov 44	KLOD	Denain/Prouvy, Fr.	Jeep accident	
Scott, Steven A.	22	23 Dec 43	KIA	North Sea	Unk	F-5A 42-12768
Sears, Bert E.	13	24 Nov 44	KlOD	Near Mt Farm	Weather	F-5 42-67378
Shaffer, John W. *	13	29 Jun 43	KIA	St Nazaire, Fr.		F-5E 43-29000
Skiff, Earl V.	22	19 Jan 44	KIA	Watlington, UK	Unk	Spit Mark XI PL962
Stamey, Earl	27	19 Sep 44	KIA	Holland	Unk	F-5B 42-67345
Tostevin, James F.	14	14 Jan 45	KIA	Lille, Fr.	Eng Trbl	F-5
Wagner, Harvey M. *	13	7 Jan 44	KIA	Nantes, Fr.	Unk	F-5B 42-67325
Waldron, Arthur S.	13	5 Feb 44	KIA	Swindon, UK	Hit power line over Rhine	P-51D 44-63627
Warburton, Adrian (RAF)	7PG	12 Apr 44	KIA	Munich area	Weather	F-5C 42-67115
Ward, Walter B.	27	19 May 45	KIA	Rhine River	EA	F-5E 43-29030
Way, Ian B.	22	30 Sep 44	KIA	Lefrety, Fr.	Eng failure on approach	F-5E 43-29016
Wiebe, Glenn E. *	13	23 Aug 44	KIA	Near Freiburg, Ger.		
Windsor, Robert W.	22	1 Aug 44	KIA	Near Culham		

Eyes of the Eighth

PRISONERS OF WAR
Key: B=Stalag Luft I(Barth) S=Stalag Luft III(Sagan) O= Stalag VIIA(Moosburg) M= VIIB(Memmingen) N=Stalag VIIID(Nurnburg)

NME	SQ.	DATE	TYPE	PLACE	CAUSE	AIRCRAFT
Brogan, Richard W.	13	6 Nov 44	POW	2 Miles SE Aachen	Unk	F-5 42-68265
Brown, Richard E.	22	20 Apr 45	POW	Asperen		F-5E 44-23709
Byington, Telford S. (N)	13	16 May 44	POW	France	SE EA	F-5A 42-12769
Carlgren, Robert F. *	22	26 Dec 44	POW	Near Hanover		F-5C 44-23603
Davidson, David T. *	13	16 Apr 45	POW	Rosenheim, Ger.		P-51K 44-11569
Dixon, Robert J. (O)	14	14 Feb 45	POW	Halle, Ger	Flak	Spit Mark XI PL866
Emerson, Jack G.	27	21 Apr 44	POW	Nevers, France		
Hairston, Rich. M. @ (S)	(22)	17 Jun 44	POW	Amiens, Fr.	@ (20th Fighter Gp)	P-38J Fighter
Hall, Robert W.	22	25 Feb 45	POW	Aschaffenburg, Ger		F-5E 43-29004
Hartwell, Norris (B)	22	12 Sep 44	POW	Pas de Calais, Fr	Flak Low level	F-5B 42-67319
Hilborn, Robert B. * (B)	14	5 Sep 44	POW	Feurbach, Ger.	EA	Spit Mark XI PL782
Kinsell, Robert J. * (SNO)	13	29 Jun 43	POW	St Nazaire	EA	F-5A 42-12773
Madden, Ross *	13	15 Feb 45	POW	Paderborn, Ger.		
Mecham, Evan *	13	7 Mar 45	POW	Wittenburg		P-51D 44-15579
Parsons, Ed B. * (SNO)	22	25 Jul 44	POW	St Malo, FR.	Flak	F-5C 42-67116
Proko, Bernard (S)	13	8 May 44	POW	S. Rheims area		F-5
Rickey, Irvin * (BO)	27	26 Nov 44	POW	Pforzheim, Ger	Flak	F-5E 43-28619
Smith, Robert R. (SO)	22	17 Aug 44	POW	Geitheim, Ger.	EA	F-5E 43-28324
Turner, Hershel L. * (SNO)	13	11 Jun 43	POW	North Sea Coast Germany	EA	
Van Wart, Frank K. *	14	1 Mar 44	POW	Germany	FTR	Spit Mark XI MB945
Watkins, Willard H.	14	#4 Apr 45	POW		Fighter Escort	P-51D 44-
Wicker, James W. (S)	22	6 Jun 44	POW	Chateaudun, Fr.	Flak Low level	F-5 42-67246
Williams, Eugene S. *	22	29 Oct 44	POW	Minden, Ger.		F-5 E 44-23729

EVADED/ESCAPED, INTERNED
Key: EE=Escaped and evaded EV=Evaded IT=Interned U=Underground

Elston, Allan V. *	13	22 Nov 44	IT	Sweden	Eng. Trbl.	F-5 43-28616
McGlynn, John A. Jr. *	13	14 Feb 44	EV	SE of Paris	Flak	F-5B 42-67361
Murray, Claude C. *	22	6 Oct 44	EV	Zuiderzee, Hol	EA	F-5 42-67128
Parker, Grover P.	27	9 Sep 44	EV	Bordeaux, Fr (FFI)	Flak	F-5C 42-67124
Parker, Grover P.	27	19 Sep 44	EE	Dordrecht (Dutch U)		F-5B 42-67342
Parker, Grover P.*	13	21 Feb 45	EV	Nr Politz, (Russ)	EA	F-5E 44-23718
Tymowicz, Adam P.	27	13 Jun 44	EV	France (French U)		F-5C 42-67379

RESCUED FROM WATER

Giles, Clyde T.	13	16 Mar 44		English Channel	Bailed out/rescued	F-5
Ross, John H	22	12 Sep 44		North Sea	Bailed out/rescued	F-5C 42-67254

P-51

Index

A

Adams, Gerald M. 43, 67, 68, 141, 146, 154, 155, 182, 201, 214, **269**, 271, 276, 279, 305, 308
Adams, Richard 113
Aircraft problems: F-5 altitude limits 53; auto-pilot 94; camera glass 12; engine cooling 16, 114; gun packages 260, **261**; radio 13; trim tab 53, 54, 59, 60: Spitfire tire blow-outs 154; vapor-lock 174: YP-80 jet failure 260, 261
Airfield photos: Mount Farm **9**, Podington **7**
Alix, Richard R. 26
Allen, Glenn F. 70, 75, 373
Alley, Max 113, 139, 145, 147, 152, 186, 201, 214, 278
Alston, Robert C. 25, 63, 86
Alvino, Daniel 77
Ambrose, Al **233**
Ames, Al **69**
Ames, Ted **65**
Anders, Joseph 53
Anderson, Earl 58
Anderson, J. L. 155, 158, **161**, 194
Anderson, John G. 49, 106, 129, 189, 226
Anderson(Football) **227**
Anderson, Roy C. 373
Andrew, Willard 149
Angelich, John R. **227**
Anthony, Charles W. 68
Arbach, Lt. 116
Archambeau, Donald M. 307
Ardennes (Battle of the Bulge) 228-233, 236, 238, 247, 248, 250, 251, 256, 257, 260, 264, 278
Arnold, Gen. Henry H."Hap" 80, 115, 260
Arnold, Wallace **177**
Arnott, Robert G. 34, 36, 164
Arrieta, Albert 27, **28**
Asplund, G. E. 148
Astrella, Robert **38**
Aubrey, Lawrence 68, 88, **106**
Austin, John G. 169
Axelson, Lt. 44

B

Babington Smith, WAAF F/O C. 86, 87
Bailey, Gordon 75
Bailey, Richard T. 43
Baird, James A. ?43, 283
Balogh, Paul A. 148, 185, 373
Banfill, Gen. Charles F. **245**
Bankiewicz, Frank L. **3**
Barancyk, Joe **106**
Barendrest, Pete 23
Barnes, Allen E. 291
Barton, T.H. 224
Batson, Charles "Chick" **69**, 106, 121-**123**, 129, 130, 145, 155, 156, 158, 175, 193, 206, 211, 214, 280, 287, 305, 373
Battle of the Bulge, *see* Ardennes
Bayne, Donald B. 169, 175, **182**, 190, 373
Bean, Clarence 56, 189
Becker, Julius 37
Beckley, Raymond E. 14, **69**, 70, 72
Beckwith, William D. 53
Belt, Taylor 147, 149, 169, 175, 185, 210, 211, 233, 239, 262, 272, 280
Bennett, Richard M. 266, 280, 289
Berlin: photo **99**
Bernau, Donald 91, 373
Bernheim, Lt. 23
Betz, Albert 53
Bickett, Robert D. 3, 10
Bickford, Wilbur E. 147, 156, 169, 175, 210, 214, 281, 293
Bigham, Robert F. 117
Bight, Sgt 223
Bijl, Gosse 197
Binder, Warren W. 23, 36
Bishop, Julie 157, 190
Black, Vernon 42, 54, 55, 57,
Black, Willard W. 262
Black, William F. 23, 68, 70, 152
Blackburn, Henry 34, 36
Blackburn, W.F. 161, 163
Blackburn, H. F. 185
Blackmon, John D. **181**
Blickensderfer, Wendell W. 39, **61**, 68, 77, **88**, 373
Bliss, Kermit 25, 54, **64**, 74, 107, 113, 139, 141, 142, 145, 148, 164, 166, 176, **178**, 203, 204, 205, 211, **268**, 296, 302, 305
Block, Edward F. Jr. 292
Blyth, John **61**, 68, 88, **94**, 96, 106, 127, 141, 154, 156, 158, 169, 170, **178**
Bock, Edward W. 251
Boggan, John **107**
Boggess, Shelby F. Jr. 292
Bognar, Joe 149
Booher, W.J. 48
Borgerding, William H. 23, 373
Boutwell, Roy 33
Bova, Ed **227**
Bowen, Burton M. Jr. 6, 8, 373
Bowen, John M. 292
Brabham, John W. 241, 248, 266, 267, 280, 282, 288, 289
Bradley, Gen. Omar 152, 172, 175, 192, 256, 260, 278, 279
Brady, Harold 23
Braund, Turney 212
Brechy, Sidwell 116
Bredeman, Paul L. 258
Breig, Woodrow 145
Brereton, Gen L. N. 192
Bresee, Charles E. 3, 10, 18
Breslin, Arthur J. 258
Brewster, Edgar L. 77, 113
Briggs, Gilbert P. 58
Brink, Fred B. 109, 147, 155, 158, 167, 169, 182, 184, **201**, 202, 206, 373
Brogan, Richard W. 147, 169, 175, 177, 182, 184, 198, 209, 211, 374
Brogan, Robert C. 5, 10, 12, 19, 373
Brooks, C.H. 291
Brooks, David N. **198**
Brown, Bernard 148
Brown, L.J. 148
Brown, Richard E. 243, 244, 264, 277, 279, 287, 298, 300, 374
Brown, Richard M. 115, 116, 119, 137, **165**, **166**, 167, 208, 217, 223, 224, 272,
Brunell, Richard M. 23, 25, 230, 272, 289
Bruno, F.E. 224
Bruns, Waldo C. 90, 112, 129, 147, 149, **160**-163, 373
Buck, William R. 223, 236, 241, 264, 271, 273, 277, 284, 287
Buckallew, Donald H. **107**
Budd, John C. 305
Budrevich, Gerald 147, 155, 156, 178, 194, 205, 210, **211**, 373
Buley, N.O. 56, **60**, 63
Bullard, Lt. 108
Bullock, Mark A. 241
Burks, Douglas D. 102, 107
Burleson, Charles A. **205**
Burnette, Kenneth V. 8, 373
Burns, Samuel 117, **165**, **166**, 208, 223
Burns, Tevis G. 252
Burrows, Dan **61**, 74, 88, 89, 104, 105, 112, 184, 206, **225**, 228, 242
Buster, Alan A. 23, 25, 26, 27, 117, 136-138, 166
Butler, R.F. 224
Buzzing: 9, restriction 10; Hughes 103-105; Vassar 149
Byers, Jackson **223**, 302, 305
Byington, Telford S. 8, 14, **16**, 17, 51, 294, 374

C

Cadorette, Joseph H. 108, 252
Cain, Bernard F. 231
Calannio, Paul **227**
Calderwood, Francis R. 145
Callan, William D. 240
Cameron, John T. 43, 91, 113
Campbell, Frank R. 43, 44, 46. 77, 113, **135**, 214
Campbell, Jack Lewis 91, 129, 130, 199
Campbell, Jack R. 8, 10, 12, 14, 44, 373
Campbell, James Maxie 30, 31, 35, 52, 56, **57**, **60**, 62, 70, 71
Campbell, Paul **226**, **227**
Campbell, J.D. 198
Carder, Fred 37
Carlgren, Robert F. 151, **180**, 181, 190, 210, 223, 233, 239, 298, 374
Carlson, LaVerne S. 292
Carnes, Roger H. 77, 201
Carney, Franklyn K. 43, 44, 91, 108, 119, 136, 139, 177, 227
Carr, Irvin **3**, 28, **161**, **188**
Carson, Robert (RAF) 187
Carsten, Alf 219, 241, 248, 264, 273, 280, 288, 302
Case, Ben H. 43
Cassaday, Charles G. 43, 44, 77, 110, 112, 113, 120, 129, 373
Casteloin, P. 48
Cate, Harry B. 289
Chapman, Carl J. **54**, 55, 57, **61**, 66, 82, 101, 107, 112, 123, 126, 132, 161, 167, 168, 189, 202, **215**, 245, 250, 264, 302
Chapman, Roy 110
Checkoway, Naphtail 149
Chestnut, Howard 258
Childress, Hubert 43, 44, 88, 91, 113, **121**-**123**, 130, 136, 139, 145, 149, 152, 167, 168, **175**, 185, 188, 199, 214, 228, 232, 234, **235**, 257, 271, 272, **278**, 279, 285, 286, 292, 296, 305
Cicetti, Carl W. 241
Cihlar, William O. 37
Clark, Col. Albert P. 253
Clark, Albert W. 146, 149, 155, 157, 158, 373
Clark, Floyd R. 285, 286
Clark, Robert R. 14, 70, 147, 156, 289
Clark, William M. 283
Cleveland, William H. 163, 282
Cofoni, Salvator R. 73
Cohen, Ted 263
Cole, Charles H. 266, 287
Coleman, James **290**
Collingswood, Charles 167, 168
Collins, M Gen Lawton 256
Collins, Alfred 272
Comanitsky, M.F. 148
Comen, Martin H. 80, 252
Comstock, Ira 289
Conners, James M. 258, 259
Conners, Thomas 107
Conners, James F. **156**
Conners, Johnny **161**
Conrad, Rodney 68
Conrath, Joseph T. 26, 28, **188**
Conway, James 271
Cook, William H. 231
Cooper, Luther A.C. **81**
Cooper, RAF Sq/Ldr. 9
Copeland, R.J. 5, 373
Copen, James D. 272
Cornwell, Thomas S. 264
Cosby, Irl R. 106, 127, 128, 210
Cotton, Sidney 52
Cowling, George 258
Coyne, Bob 207
Crane, Charles 175, 177, 205, 206, 211, 212
Cronlotac, Andrew J. 240
Crosby, Bing **198**
Cross, (Football) **227**
Croteau, Arthur 149
Crowell, Jeryl D. 233, 234, 256, 373
Cullen, Paul T. 80, **84**, 85, 86, 90, 94, 96, 109, 114-116, 118, 119, **139**, 208
Cumbers, Douglas 117, **165**-187, 223
Cunningham, Gerald T. **3**, **213**, **215**
Curry, Ben Jr. 272
Curtis, Oakley C. 252, 257

D

Damon, Kenneth 28, **29**
Davidson, David T. 233, 262, 280, 287, 290, 374
Davidson, Harold **114**, **217**
Davidson, Verner K. 68, 101, 134, 141, 158
Davis, Arthur A. 217
Davis, Hurlie J. 10
Davis, Ike M. 214, **251**
Davis, Walter C. 286
Deane, John R. 114, 115, 133
Dembkowski, Michael 241, 248, 264, 273
Dengrove, Charles H. 252
Deriacomo, B.J. 235
Derosier, Arnold N. 36
DeSimone, Victor A. 272
Deune, Robert P. 258
Devault, Howard 252
Devine, Lt. 37
Dhority, William 75
Dickey, Andress 23
Diderickson, Robert W. 68, 96, 101, 133, 134, 373
Dieter, Kenneth H. 258
Dietrich, Marlene 234, **235**,
Dietz, Mevrouw, Jaap, and Peter 263
Diggs, Clarence 305
Disney, (Walt) emblem design **14**; rocket bomb 264, 265, 266
Dittrich, William F. 272
Dixon, Robert J. **88**, 106, 141, 158, 175, **178**, 190, 194, 201, 224, 225, **236**, 241, 245, 247, 264, **268**, 269, 270, 271, 272, 280, 294, 296, 300, 374
Dizette, L.J. 240, 242
Dobber, Jan and Jacob 197
Dochod, (Football) **227**
Doherty, Francis B. 241
Domagalski, Walter P. 77
Donovan, Gerald F. 75, 252
Doolittle, Lytton "Pappy" **65**, **69**, 95, 104, 105, 140, 148, 157
Doolittle, Lt. Gen. James 103, 133, 139, 158, 161, 203, **215**, 260, 282, 287
Dornberger, Gen Walter 205
Douma, Dominee 197
Dout, Robert E. 149
Douttiel, Ed 164, **239**
Dow, George W. 282
Driver, Herbert R. 189, 207
Dubruell, Paul B. 258
Dunn, James J. 258
Duquette, Maynard 23
Durst, Edward W. 150, 373
Dutcher, Robert C. 240

375

E

Eaker, Maj Gen Ira C. 7, 8, 10, 11, *21*, *35*, 80, 103, 136
Eaton, W.B. 68
Edwards, Ellis Bruce 218, 239, 243, 244, 262, 280, 283, *292*
Egan, Fabian John 148, 175, 212, 232, 235, 236, 264, 269, 272
Eidson, Harry T. 2, 4
Eisenhower, Gen Dwight 103, 111, 222, 230, 250, 256, 258, 260, 287, 298
Elchel, Jacob J. 81
Ellerd, Amos L. 48
Elston, Allan V. 145, 156, 169, 175, 177, 182, 185, 206, 210, 215, 216, *218*, 219, 374
Emerson, Jack G. 106, 120, 294, 300, 374
Epsom, George 74, 93, 134, 145, *227*
Erwin, Edgar C. 37, 164
Esposito, Ralph E. 8, *58*, *64*, 78
Esque, Willie 189, 207
Etten, Jan van 263, 295, *298*
Eugenedes, Xenophon S. 308, 373
Exner, Lawrence J. 58, 258
Expitia, Jessie R. 37
Eyerman, George F. 240

F

Facer, Robert 147, 185, 194, 206, 209, 225, 233, 238, 241, 245, 247, 284
Fahnlander, Leo 37
Farley, Donald A. 44, 91-93, 112, 153, 191, 196, 242
Farrell, Joe *77*
Farrow, Vern 234, 235, 286
Fegette, Jasper L. 149
Feinsheimer, Herbert S. 272
Fellwock, James G. 231, 233, 261, 271, 256
Feltham, Ian 264, 271, 278
Fenn, Howard 145
Fenter, Malcolm *213*
Fergal, Edward 27
Finley, Charles B. 169
Fish, Bruce 148, 158, 185, 212, 219, 220, 236, 259, 266
Fishlock, Arthur & Tom 82
Flanagan, Ralph E. 30, 31
Florine, Robert N. 147, 148, 155, 177, 184, 190, 214, 220, 233, 234, 241, 251, 272, 278, 285, 292
Flowers, James W. 264, 273, 280, 289
Floyd, Robert C. 91, 112, 113, 156, 175, 186, 188, 190, 230, 231, 278, 288, *290*
Foltz, John L. 23, 25, 26, 29
Football champions 226, *227*
Fox, Harold *181*
Frail, Ray *227*
Frank, Capt. 115
Franklin, Ross J. 29, 164
Frazier, James 226
Fredo, Sam *28*
Fresh, Jay C. 257
Fricke, Harlan F. *57*, 63, *78*, 79, 373
Fritsche, Carl "Doc" 75, 120, *130*, 214, 220, 234, 235, 296
Fulton, Ottaw E. 251, 282

G

Gaccione, Frank 278
Gaghan, Joseph F. 210
Gallagher, Hubert L. 81
Galloway, James 77, 252
Gardner, Wendall P. 33
Garreth, Ross 34, *161*
Garrett, Edgar R. 241
Gault, Russell 373
Gauss, John A. 279, 280, 288, 289
Geary, Leonard J. 35, 56, 73

Gentille, Albert L. 242, 373
Gentry, Cpl 43
Gephart, Roland M. 26, 33
Geyer, Robert J. 149
Ghiardi, John 258
Giada, Buster A. *217*
Gibbons, RAF F/O 96
Gidley, Arnold M. *213*,
Giles, Clyde T. 70, *101*, 102, 109, 374
Gillean, Thomas J. 34, *161*, 188
Gillick, Robert B. 243, 264, 276, 282, 287, 289
Gillin, Cecil 373
Gilmore, James 224
Gilmore, Louis 145-148, 158, 175, 188, 211, 233, 261, 266, 281
Gimbel, E.L. 240
Ginex, J.C. 163, 207
Gingerich, Shelton M. *177*
Glaza, Gerard 148, 185, 211, 232, 233, 290
Gloetzner, Henry *76*
Glover, RAF F/O A., 53
Goddard, George 189, 203
Goebel, Jerome 283
Goetz, William T. 29, *161*, *227*
Goffin, Charles J.J. 141, 145, 155, *175*, 176, 190, 373
Goldsworth, R.G. 240
Gonzalez, Hector *61*, 68, 70, 78, 93, 94, 107, 112, 169, 184, 185, 191, 204, 230, 232, 256, 278, 279, *286*, *290*-292
Goodison, William C. 262, 287, *288*
Goodrich, Charles G. 274
Grant, Leslie *81*
Gras, Victor 214
Graves, Willard R. 68, 101, 141, 175, 202, 207, 225
Graveson, Forrest "Archie" 56, 79, 86, 175
Gray, Leon C. 305
Grayson, Benton C. Jr. 112, 163, 188, 199, 207, 242
Green, Abram 58
Green, Bernard *213*
Green, Harold M. 241
Greenburg, Milton J. 217
Gregg, George *49*, 50, *64*, *65*, 70, *72*, 78
Grondella, Jan 295
Grubb, Vernon D. 35, 55, 73, 96
Guss, Harry O. 264
Gwynn, Edward O. 48, *64*, 78, 257

H

Haight, Edward L. Jr. 49, 373
Hairston, Richard M. *54*, 55, 68, 70, 112, 374
Hakkila, Raymond *219*, 225, 247, 283-285, 287, 305
Halbig, John A. *227*
Hall, James G. 4, *5*, 7-*11*, 12, 16, 18, 19, *21* CO 7Gp, 33, *35*, *41*, 48, *49*, 53, *58*, 61, *64*, *65*, 68, 102
Hall, Robert W. *193*-195, 206, 217, 232, 233, 239, 248, 276, 277, 280, 374
Hampton, Joseph *106*, 276
Hanson, Howell R. Jr. 257, *290*
Hanson, Al 233, *251*
Hardee, Lt. 43
Harkins, William J. 281, 289
Harkrader, Vernon 29, 164
Harmon, Ronald W. 175, 184, 256, 286
Harriman, W. Averell 114, 115
Harris, Delmar B. 111, 163, *164*
Harstad, Casper 53, 70
Hart, W.A. 89, 204
Hartung, Paul 106
Hartwell, Norris *41*, 42, 53, 54, 57, 58, *64*, 70, 72, 89, *90*, 109, *121*, 123-127, 140, *141*, 143, 145,

146, 157, 158, *160*, 190, 296, 297, 300, 374
Hatch, Leroy *135*
Haugen, Cecil T. 43, 44, 70, 74, *75*, 77, 90, 111, *130*, 139, 148, 164, 373
Haughton, Perry 53, 212
Hawes, Clark 68, 97
Hawkinson, Eric 282
Hayes, James J. 58
Hayslip, Conley 75, 110, *120*, 163
Hazlett, Stanley 189
Hearst, Lorelle 204
Hearst, Wm. Randolph 204
Heath, Raymond E. 29, 164
Heidelbach, Frank 75, 77, 80, 231, 251, 252
Heil, Thomas C. 373
Heinrich, Carl F. 305
Heller, E.H. "Doc" 204, 205
Henry, Earl W. *213*
Heraty, Warren E. 34, 80, 81, 124
Hermeling, Arnold 82
Hesemann, Bernard 149
Hester, Roy E. 240
Hibo, Julius P. 252
Hickey, Walter P. 44, 75, 91, 104, *120*, 186, 188, 231, 235
Hicks, Mark 132, *199*, *203*-205, 373
Hilborn, Robert B. 148, 174, 190, 300, 374
Hill, A.M. *64*, *85*
Hinchee, Charles 29, *161*
Hines, Ben B. 3, 10
Hitler, Adolph 205, 228, 229, 250, 256, 257, 264, 265, 296, 302
Hitt, Carter E. 236, 239, 247, 287, 289
Hix, James S. 217
Hixon, Frederick *64*
Hoagland, Everett W. 23, *29*
Hoagland, Harold 23
Hodges, Lt Gen Courtney 260, 283
Hoffman, Ed 198, 199, 203
Holt, T.C. 201, 202, 220
Hood, RAF Sq/Ldr M.D.S. 53
Hoover, John *125*-127, 132, 133, 136, 167, 245, 284, 288
Hope, Bob *48*, 49
Hotaling, James H. 58
Hough, Cass 163, 200, 292
Howard, Robert J. 305, 373
Hughes, Harry 108
Hughes, Malcolm D. "Doc" 39, 54, 58, *59*, 60, 68, 70, 97, 101, *103*, 104, 105, *106*, 109, 149, 157, 171
Humbrecht, George W. 202, 207, 214, *215*, 242, *245*, 250, 271, 272, 276, 277, 285, 205
Hunter, John F. Jr. 29
Hynds, Ray 306

I

Intelligence: naval 12, 15, 20, 215, 266
Irons, Lt. 108

J

Jamison, Jack T. *82*, 373
Janick, Chester D. *227*
Janota, Leon A. 307, 308
Jeske, Howard 186, 215
Jewell, Paul 33
Johnson, Alvin 149
Johnson, Glenn E. 282
John, Johnson *227*
Johnson, Major 211
Johnson, O.J. 184
Johnson, Oscar G. 242, 243
Johnson, Philip B. 73
Johnson, Robert E. 217
Johnson, Rogers W. 306
Johnson, Tom 281
Johnson, (Football) *227*
Johnston, Ernest E. 107, 108, 109,

136, 184, *186*, 188, 190, 373
Jones, Sandy 252
Judson, Harry *78*
Jung, Robert *3*
Just, Pvt 29

K

Kammler, *Obgrfr*. Hans 205, 210
Kann, Alexander Jr. 106, 146, 150, 180, 190, 373
Kaplowitz, Harry 235, 305
Kappes, James W. 43
Karales, Raymond E. 10
Kasch, H. 201, 202
Kator, W.C. Jr. 22
Keel, Elbert 81, 214, 231
Keller, Charles L. 210
Kendall, Ralph 70, 132, 133, 136, 145, 147, 149, 224, 260, 287, 288
Kendig, Benjamin F. 302, 307
Kendrick, James M. 23, 26, 30, 164
Kennedy, Joseph P. Jr. 158, 159
Kinder, Earl 33, 56, 86, 163
Kindervater, Julius 124
Kingham, Lloyd C.. 373
Kinsell, Robert C. 5, 8, 16, 19, 20, *21*, *49*, 50, 51, 294, 300, 374
Kirby, A.H. 207
Kirkpatrick, John B. 292
Knight, Edgar 31, 33, 271
Korczyk, Raymond J. 98
Korsvick, Robert S. 214
Koskela, Arnold 201
Kostrzewski, Casimir 108, 252
Kraft, Robert 203-205, 207, 269, 373
Krug, Albert 5
Kugler, Albert 81
Kunkel, Leslie 37, 53, 58
Kunze, Francis 201-203
Kurjack, Augie 293
Kurylo, Joseph T. 240
Kuter, Gen Laurence S. 7
Kwiatek, B.L. 214, *227*

L

La Vier, Jesse 145
Landwehr, Virgil *69*, *101*
Langford, Frances *48*, 49
Lanham, William *64*, *65*, *69*, *215*, *245*
Lapis, Alexander J. Jr. 258
Larkin, John B. 282
Larkin, John V. 149, *217*
Lawson, George A. 37, 39, *41*, 42, 53, 57, 58, *61*, 96, 106, 109
Leaser, John R. 106, 110, 373
Leatherwood, Arthur 147, 148, 158, 185, 190, 230, 272, 279, 299, 300
Leggett, John 269
Lehman, George *188*
Leonard, James R. 13
LeVier, Tony 292
Lewis, RAF F/Lt. 89
Libbert, Bill 56
Lindahl, John C. 306
Lindahl, R.W. 198
Litowa, William S. 117, *165*
Little, RAF F/O 93
Litton, William 223
Litvin, Edward J. 241
Livingston, William J. 13, 93
Lombard, Gordon *28*
Longfellow, Gen. Newton 7
Longmate, Norman, *Hitler's Rockets* 212
Lott, Howard E. 6, 8, 373
Love, Thomas M. 268
Loyd, Robert N. *64*,
Luber, Vernon 5, 6, 8, 10, 19, *21*, 64, *69*, 70, *72*
Lucyk, A. *199*, 202, 204
Lyon, Lt. 159
Lyons, Ben 212

M

Macias, Taurina S. 240
Mackowiak, Ralph 241
Madden, Ross 169, 182, 194, 204, 205, 219, 247, 269, 271, 280, 300, 374
Madrela, Walter B. 252
Magers, D.M. 214
Mahoney, James D. 22, 31, **65**, 154
Malone, William V. 244, 287
Manassero, Peter 70, 106
Marder, Harry **78**, 89,
Martin, J.C. 56
Masefield, John (Poet) 62, 257
Maskrey, John J. **81**, **227**
Mason, William C. 217
Mates, John 25, 27, **67**, **236**, 271
Matthews, James B. 106, **141**, 146, 150, 155, 191, 192, 202, 204, 206, 232, 239, 262, 300
Maus, Almon **111**
May, Joe G. 23
Mayden, Russell E. 56, 73, **78**, 189
Mayer, Martin 240
Mazilly, James A. **205**
Mazurek, Raymond A. 14, 16, 373
McBee, Lawrence S. 43, 44, 91, 113, **130**, **153**, 204
McCaffery, Joseph S. **81**, 82
McConn, Fred M. 91
McCoy, Orville B. 70
McDonald, Warren M. 175, 186, 188, 190, 373
McFatter, Thomas M. 283
McGarry, Paul J. 307
McGee, John S. 77
McGivern, William 37, 53
McGlynn, John A. 94, **95**, 374
McGuire, Troy B. 233, 242, 264, 266, 273, 276, 288, 308
McKinley, William E. 228
McKinney, Samuel C. **78**, 89, 207
McKinnon, Max E. 145, 171, 180, 217, 225, 243, 264, 272, 273
McLaughlin, Al 174
McManus, Robert E. 112, 212, **227**
Meacham, James I. 117
Mecham, Evan 233, 283, 286, 300, 374
Megginson, Leon G. 272
Menjou, Adolph **48**, 49
Michael, Raymond 29, 223
Michaels, James..108
Michener, Ben 3, 10, 12, 70, **72**
Miles, Marion G. 217
Milford, Lonnie 132, 149, 189, **198**, 199, 214
Miller, Glenn (band leader) **189**, 293
Miller, Glenn E. 106, 198, 373
Miller, Herbert J. 228
Miller, J.D. 56, 148
Milligan, R.J. 163
Mitchell, Ray C. 5, 10, 12, 15, 20, **21**, 64, 70, 75. **101**, 111, **135**, 152
Mitchell, Robert L. 112, 149, 373
Mitchell, Wallace 149
Mitchell, Willy 58
Mittnach, Paul V. 37
Mock, Guy L. 163, 166, 193, 207
Model, Field Mar.Walter 177, 183, 188
Moeller, Edwin 149
Mollitor, Nicholas D. **217**, **227**
Montgomery, Field Marshal Bernard 7, **141**, 170, 173, 176, 178, 183, 192, 222, 229, 250, 256, 260, 279, 284, 296
Montgomery, Ross 53, 73, **78**
Moorehouse, John 266, 286
Moorehouse, Hugh J. 283
Morel, Pvt 26
Morelli, Henry R. 68
Morrison, Chester 212
Morton, James M. 53, 98

Moser, Joseph B. 240
Mosier, Henry **181**
Moss, Robert E. **69**, 106, 127, **129**, 147, 163, 182, 184, 219, 242
Mousley, James 49, 373
Mulligan, Peter 58
Murdock, Edward R. **251**, 291
Murray, Claude C. (Jan Pieter Smit) **193**-**197**, 207, 263,**298**, 300, 374
Murray, George J. **217**
Myers, Alfred W. 373
Myers, Clair L. 29, 73, 148

N

Nagler, Daniel 149
Napolitano, Melio 33, **79**,
Nattkemper, John U. 81, 257
Navarrot, Henry 35, 48, 52, 56, 73
Naylor, Bill **78**, 148
Neault, Bob 106
Neece, Horace 33
Neff, John M. 23, 25, 134
Neff, Noble **62**
Neill, Dennis V. 80, 82, 252
Neilson, Gordon 58, 64, 117, 163, 223
Neilson, Howard **21**, 64, 70, **72**, 75
Nelson, E.J. 73, **78**, 89
Nelson, Richard B. 210
Nelson, Robert R. 68, 101, 148, 154, 174, 373
Nelson, W.A. 48, 72, 73, 74, 201
Nerbovig, William R. 27, 49, 73
Ness, D.A. 185, 286
Nesselrode, George 52, **57**, **60**, 64, **69**, 74, 104, 105, 129, 141, 155, 158, 163, 189, 194, 206, 232, 302
Neuser, Robert A. 37
Newberg, George **205**
Nichols, James 56
Niehaus, Robert 77, **108**
Niehus, Robert O. 241
Nissoff, Eugene 148, 201, 207
Nix, Archie N. 283
Noble, Daniel L. 117, **166**, 193, 223
Nolan, John D. 233, 272
Noll, William **209**, 210
Nooner, Daryl **198**, 199, 235
Nordsten, Carl **79**, 185, **269**
Nordwall, Elbert 36, **81**
Norton, James A. 53, 97
Novak, Harry 79, 98, 174

O

O'Bannon, Thomas B. 8, 16, 18, 19, **21**, 53, 54, 60, 373
O'Bryan, Joseph P. 305
O'Conner, Thomas 90
O'Conner, Phillip 90
Olsen, Carl **217**, 228
Olsen, Glen A. 68
Operation: Bodyline 87; Bolero 7; Clarion 273; Cobra 152, 153; Crossbow 87, 108; Frantic 115,116 (Joe) 136, 208; Goodwood 152; Grapefruit 107, 108; Grenade 279; *Herbstnebel* 229; Market Garden 181-188, 191, 192, 205, 222, 229; Overlord 40, 103; Plunder 284; Point Blank 57, 114, 209; Torch 7; Varsity 284; *Wacht am Rein* 228
Orth, John F. **156**
Overy, R.J. *The Air War 1939-1945* 20
Owen, George F. 8, 14, 19, 64, 70, **72**
Owen, Melvin G. 286
Owen, S.E. 214
Ozinga, Richard 268, 269

P

Packer, Lt. 108
Parchman, William Jr. 256
Parker, Charles 70, 77, **89**, 100, 119

Parker, Grover P. 175, 182, 184, 185, 187, 190, 247, 272, 273, 280, 374
Parker, Shannon N. 247
Parks, Julian H. 68
Parsons, Edward B. 70, 97, **150**-**152**, 218, 253, 274, 275, 293, 294, 300, 374
Parsons, Herchell E. 5, 6, 12, 15, **18**, **21**, 48, 64, 70, 75
Patton, Gen George 82, 84, 222, 230, 235, 250, 256, 257, 279, 284, 293
Pavlowich, Clifford 241
Perkins, Ray W. 217
Pesicka, Adolph J. 240
Peskin, Jules 23
Peters, Eugene **107**
Peterson, Edward J. Jr. 22, 29, 373
Peterson, E.L. "Pete" 48, 55, **62**, 73
Peterson, Noble 247
Petty, Don 214
Philpott, Ewin L. 77
Piffer, MSgt, (6PR Line Chief) 24
Pipes, Donald G. 223, 238, 243, 262, 273, 280, 289, 308
Pircio, Tony 231, 251, 256, 278, 279
Piscitelli, Patsy **28**, 33, **78**, 212
Pittman, Joe F. 10, 13, **80**
Politt, Byron H. 272
Pongracz, Charles 214
Porter, B.E. "Pop" 32, 48, 54, 55, 70, 74, 154
Post, Dick **188**
Powers, Arthur 282
Price, Evan A. 164, **205**
Proko, Bernard 70, 110, 146, 147
Puffer, Gordon 49, 158, 163, 226
Purdy, Ira J. 147, 175, 184, 185, 233-135, 241, 251, 285
Purlia, Sam 262, 273, 287, 289
Pyle, James R. 189

Q

Queen, Archie 81, 82
Quiggins, R.S. 163, 217, 219, 220, 225, 241, 272, 273, 276, 277
Quindt, Sam, 35, **56**, 57, 78, **79**, 163

R

Radke, Arthur **213**
Raff, Albert S. 58
Raith, Alex 23, 34
Rawlings, Irving L. 148, 158, 188, 210, 225, 240, 241, 244, 287
Reardon, Lt. 25
Redmond, Larry 29, 71, 73, 108, 146
Reed, C.D. 56, **62**
Rees, John F.S. 30, **64**,
Regtuyt, Gysbertus "Gys" 195, 295; Willie, Eppie and Tina 295
Reilly, Stanley J. 262, 264, 266, 273, 276, 280, 288
Rhoades, David G. 226, 305
Ricetti, John 184, 256, 279
Richards, John R. 71, 134, 135, 140, 141, 146, 149, 152, 158, **190**, 201, **309**
Richards, Robert J. **227**
Richardson, Lewis H. 4
Richmond, Mervin 81, 82
Rickey, Irvin J. 185, **221**, 297, 298, 300, 374
Riggins, James W. **181**
Riley, R.W. 241, 244, 287
Rivers, Elmar 27
Roberts, Ben H. 240
Roberts, Jack H. 206, 224, 230, 233, 235, 236, 261, 264, **276**, 283
Roberts, Robert M. 23
Robertson, Jim **188**
Robinson, Clarence W. **217**
Robinson, John L. 56, 85
Robison, John L. 264

Rockoff, Harry 58
Rogers, W.M. 214
Romig, Winfield A. **217**
Roos, Theodore 68
Roos, Thomas **111**
Roosevelt, Brig Gen. Elliott 103, 109, 115, **130**, 146, 157, 161, 163, 189, **198**, 203, 204, 213, **215**, 218, 245, 260, 281-293 *passim*, 306
Roosevelt, Pres. F. D. 103, 115, 204, 289
Rosenbaum, Robert G. **217**
Rosenberger, Carl **156**
Ross, John 157, 178-180, 190, 193, 207, 217, 223, 241, 248, 262, 264, 266, 272, 276, 280, 287, 288, 374
Rowe, David K. 108, 109, 120, **138**, 139, 145, 167
Rozendaal, Johannis 196, 197, 263, (wife) "Mother" 263
Rudeck, William 149,
Rudnicki, William R. 34, 117, 136, **165**, 166
Russell, Thomas "Trip" 141, 154, **213**, **215**
Rydstrom, Herbert W. 308

S

Sajdak, Stanley J. 13, **76**
Samplonius, Pete 295
Sanders, Homer L. **65**, 72, 73, **76**, 80, **84**
Sands, Charles L. 117, 137, 223
Sandys, Duncan 87
Sanford, Robert E. 211, 230, 233, 276
Sarber, Charles A. 236, 264, 288
Sary, Nicholas, 25, 36, 80, 81
Satterfield, John H. 272
Savage, James R. "Doc" 29, **226**, 296
Saxton, John W. 175, 184, 233, 256, 278, 285, 286
Scharf, Abraham 210
Schlenger, Albert H. Jr. 272
Schoenbeck, Theodore H. 163, 240
Schultz, Donald D. **4**, 6, **69**, 147, 156, 169, 175, 177, 194, 205, 206, 211, 212, 224, 225, 238, 280
Schumacher, Wesley 144, 145, 231
Scott, Steven A. 42, 54, 55, 57, **61**, 79, 80, 101, 373
Scott, Walter H. 282
Sears, Bert 68, 94, **218**, 373
Seese, Frederick M. 36, 98
Selzer, Richard S. **227**
Seyss-Inquart, *Reichkommisar* Dr. 177
Shade, Dale 13, 14, **69**, 70, 75, 106, 112, 169, 175, 178, 185, 190, 206, 219, 230, 239, 264, 287, 302, 307
Shaffer, John W. 19, **21**, 51, 373
Sharp, Francis R. 268
Shatynski, John J. 169, 269
Sheble, Richard 62, 141
Shepherd, Edward M. 3, 5, **64**, 226
Sherman, Denver R. 241, 242, 244, 264, 281, 302
Shipley, Edward V. **214**
Shipway, Lt. 2
Shoop, Clarence **123**-125, 132, 139, 140, 157, 158, 161, 163, 167, 168, **189**, 190, **198**, **201**, 202, 244
Silliman, Sam 281
Simon, Walter 60, **78**, 141, 168, 170
Simonds, George A. 241
Sirica, William R. 36
Skiff, Earl V. 70, 88, 89, 373
Sleeper, Sgt 308
"Smit, Jan Pieter," *See* Murray, Claude

Smith, Freeman *81*, 252
Smith, George 23, 34
Smith, Leo G. 23, 34, 36, *81*
Smith, Richard L. 61
Smith, Robert R. 41, 54, *55*, 57, 58, 96, 104, *106*, 107, 111, 134, 145, 147, 150, *153*, 160-163, 187, *218*, 294, 296, 300, 374
Smith, William C. 276
Snyder, Eugene P. 68, 76, 97, *112*
Snyder, Lloyd S. 145, 235
Sommerkamp, Frank 106, *130*, 145, 157, 158, 163, 164, 175, 182, 185, 194, 206, 218, 262, 264
Sommers, Norman A. 75, 252
Spaatz, Carl 103, 11, 115, 116, 159, 160, 189, 238. 260, 281, 282, 284, 293
Spaeth, Ernest P. 23
Specht, Capt. 139
Spellerburg, Richard A. 10, 81, 82
Spooner, Tony, *Warburton's War*, 302
Spoor, Daan 197, 263
Springer, Bernard Q. 281, 289
Spurlock, James T. 35, 48, 52, 56
Squadron emblems *246*
St. Clair, James 39
Staab, Walter J. *38*, 98
Stallcup, W.B. 201, 219, 220
Stamey, Earl K. 149, 185, 190, 373
Steen, John F. 53
Steiert, Anthony U. 23, 26, 29, 30, 36, *76*
Steinbach, R.L. 56, 73, 85
Stelle, Arthur 34
Stevens, Alfred *227*
Stickle, Donald M., *227*
Stokely, Vernon M. . 3
Stolte, Art 70, *72*
Strong, Gen. Kenneth 103
Strucke, A.A. 214
Student, Gen. Kurt 177
Stutman, Sidney 68, *81*, 257
Swartz, Ralph R. 305
Syverud, Warren 210

T

Taper, James J. 77
Tappero, George J. 240
Taylor, Elmer F. 58
Taylor, Gen. Maxwell 186
Teague, William H., Jr. 214, 231
Tedder, RAF Air Marshal Sir Arthur 103
Teitelbaum, Sol 13
Terry, RAF F/Lt A.J. 55, *85*
Thayer, Richard V. 258
Thielen, Eugene 23, 34, 36
Thies, Everett 108, 109, 136, *166*, 242
Thomas, David F. 244, 264, 271, 273, 288
Thomas, Garth 201
Thomas, Owen B. 49, *78*
Thomas, Samuel A. 26, *34*
Thompson, Early 18
Thompson, James W. 23, 36, 98
Thorngren, Paul M. 39
Tilley, D'Arsey 82
Tooke, Walter 14, 70, 75, 110
Tostevin, James F. 175, 206, 244, 373
Toubman, Harry 77
Tracy, Lt. 37
Trident Conference 40
Tubbs, Shirley 291
Turner, Hershel L. *4*, 14, 19, *20*, 51, 294, 374
Tymowicz, Adam P. 43, 44, 110, 130, *131*, 374

U

U.S. Air Force Units:
Fighter: 4th FG 240; 20FG 240; 55FG 212; 55FG-343Sq 268; 78FG *112*; 349FG 289; 353FG *112*; 355FG 240, (358Sq) 247, 283; 356FG *112*, 272; 357FG 107, 240, 284; 359FG *112*, *113*; 361FG 107, 112, *113*; 364FG 264; 479FG 297; 56FG *112*, 297
Bomber: 1BD 98, 190. 232, 236, (1 Air Div) 238, *242*, *244*, 247, 248; 2BD 98, *185*, 232; 3BD 98, 224, 232, (3 Air Div) 238, *242*, 247, 248; 1st Bomb Wing 7, 9, 18, 19; 2nd Bomb Wing 19; 3rd Bomb Wing 203; 4th Bomb Wing 18; 41 Combat Wing 266, *273*; 95BG 239; 96BG 224; 100BG 63; 303BG 15, 107; 305BG 15, 266; 306BG 15, 266; 379BG 107; 384BG 107; 390BG 63; 397BG 239; 466BG 97; 482BG 68; 15Bsq 7
Other: 90th Photo Wing 281, (12AF) 5th Photo Group-15th Mapping Sq 108, 109; 25BG 198, 203, (654Sq) 220, 234, 250, 272
Urquhart, Maj. Brian 178, 183

V

Vagt, David *110*
Van Wart, Franklyn 70, 96, 300, 374
Vandenburg, Gen. Hoyt S. 163
Vanderpool, Richard 287, 290, 308
Vasileski, Edward S. *177*
Vassar, Edgar *69*, 130, *148*, 149, 169, 201, 206, 210, 211
Vaughn, Marcus 230, 233, 299, 308
Vaughn, Thomas D. 239, 251, 293
Vigorito, Fleming *181*
Vincent, Clark *111*

W

Wagner, Harvey M. *69*, 70, 75, *85*, 373
Wald, Charles *177*
Waldram, Byron Lee *193*, 210, 223, 224, 247, 264, 276, 280, 289
Waldron, Arthur S. 70, 71, *72*, 77, 78, 84, *93*, 373
Waldrop, Nathan S. 258
Walker, Alfred 283
Walls, Leonard 80, *227*
Walsh, Robert L. 115, 133
Waraske, Anthony A. 252
Warburton, Adrian 302, 373
Ward, Alfred 10, 27, 177, 185, 251
Ward, James E. 302
Ward, Walter B. 241, 285, 286, 291, *292*, 373
Waraske, Anthony A. 252
Warren, Ellis A. *177*
Washmon, James F. 26, 30, 33
Wasilieff, Edgar W. 53
Waters, K.T. 224
Watkins, Willard H. 289, 290, 300, 374
Watts, John H. 14, 70
Way, Ian P. 188-190, 373
Wayne, Marshall 29, 30, 52, 53, *56*, *57*, 72-74, 79, 86, 194, 203
Webb, Paul 37 104, 127, 217
Webb, Russell H. 272, 273
Weber, Robert H. 77, 214
Weddle, Howard E., 23, *81*
Wedekind, Norman 77
Weeks, John *238*, 261, 262, 289, 293, 307, 308
Weindel, Eugene O., 13
Weir, Harold 180, 223, 248, 266, 272, 276, 280, 288
Weisstein, Nathan 26, 30
Weitner, Walter 24, 25, 86, *98*, 100, 111, 151, *180*, 203
Wendel, Bernard T. 23, *81*, 82, 98
Werner, Donald W. 264
Wetzel, Carroll *65*
White, "Willie" G. 148, 152, 182, 185, 214, 233, 241, 251, 286
Whitehead, Fred *188*
Whitehouse, Lt. *24* (buzzes camp), 25
Whitmore, Harold E. 272, 273
Whitson, John R. 293, 302
Whittier, Clarence R. 68, *81*
Wicker, James E. 106, 127, 374
Wiebe, Glenn E. 112, 120, 147, 155, 167, 168, 373
Wigton, Irv 175, 184, 247
Wilcox, Jacob B. 302
Wilcox, Roger L. 261
Williams, D.M. 240, 242
Williams, Eugene S. "Willie" 171, 192, 199, *200*, 206, 207, 300, 301, 374
Williams, Julian P. 252
Williams, Marshall *206*, 307
Williams, R. *227*
Williams, Willie?? *227*
Willis, Richard W. 22, 43
Willy, W.J. 159
Windsor, Robert W. 112, 153, 154, 373
Winspear, RAF Fl/Lt Beresford 150
Winterbottom, Fred 52
Witt, Harry 34, *35*, 52, *69*, 75, 70, 106, *148*
Wolcott, Edwin L. 163
Wolfer, W.J. 148
Workman, Raymond 291, 292
Wegman, Kurt H. 241
Wright, James S. 12, 15, *21*, *41*, 48, *64*, 70, 72, 78

Y

Yonkers, Edward H. 201
Young, Arthur K. 220
Young, Manuel D. 258

Z

Zabloski. Harold *106*
Zeidler, W.H. 201, 220
Zemke, Hub 297
Zetek, John 77
Zientkiewicz, Eugene S. 10
Zimny, Alfred C. 214, *227*

378